CLARENDON STUDIES IN THE HISTORY OF ART

General Editor: Dennis Farr

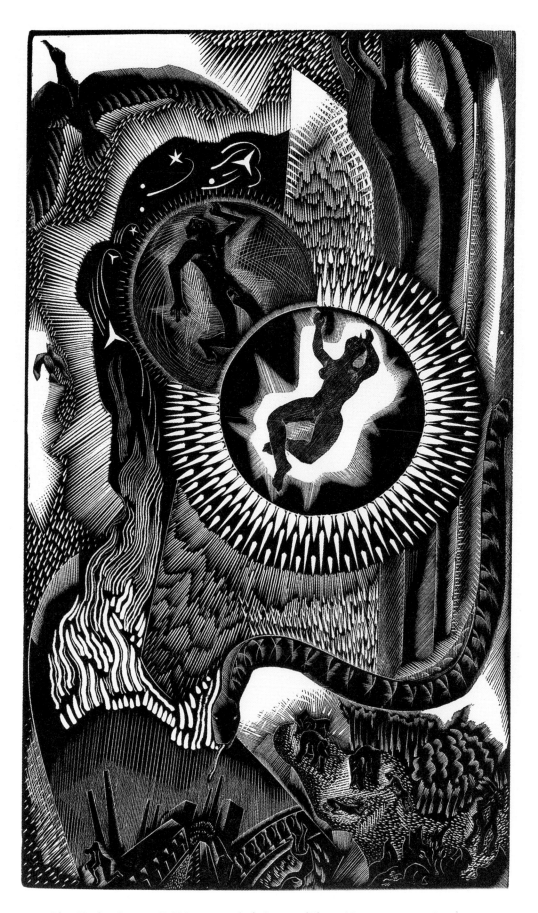

Blair Hughes-Stanton: D. H. Lawrence, *Birds, Beasts and Flowers* (Cresset Press, 1930). 228 × 133

BRITISH WOOD-ENGRAVED BOOK ILLUSTRATION 1904–1940

A Break with Tradition

JOANNA SELBORNE

CLARENDON PRESS · OXFORD

1998

Oxford University Press, Great Clarendon Street, Oxford OX2 6DP

Oxford New York

Athens Auckland Bangkok Bogotá Buenos Aires Calcutta
Cape Town Chennai Dar es Salaam Delhi Florence Hong Kong Istanbul
Karachi Kuala Lumpur Madrid Melbourne Mexico City Mumbai
Nairobi Paris São Paulo Singapore Taipei Tokyo Toronto Warsaw
and associated companies in
Berlin Ibadan

Oxford is a trade mark of Oxford University Press

Published in the United States
by Oxford University Press Inc., New York

British Library Cataloguing in Publication Data
Data available

Library of Congress Cataloging in Publication Data
Selborne, Joanna
British wood-engraved book illustration, 1904–1940: a break with
tradition/Joanna Selborne.
(Clarendon studies in the history of art)
Includes bibliographical references and index.
1. Wood-engraving, British. 2. Wood-engraving—20th century—
Great Britain. 3. Book illustration—20th century—Great Britain.
4. Artists' illustrated books—Great Britain. I. Title.
II. Series.
NE1143.S45 1997 769.941'90'04—de21 97–27187
ISBN 0–19–817408–X

1 3 5 7 9 10 8 6 4 2

Typeset by Selwood Systems, Midsomer Norton
Printed in Great Britain
on acid-free paper by
Butler & Tanner Ltd,
Frome and London

To John, William, George,
Luke, and Emily

Acknowledgements

This book is based on my doctoral thesis submitted to the Courtauld Institute of Art in 1992. It could not have been completed without the help of numerous people, many of whom, over a period of fifteen years, have moved to different posts, retired, or died. I am particularly indebted to Ann Ridler who enabled me to study and photograph items from her husband's collection of private press books (now held at the Central Library, Birmingham), and to Hilary Paynter who allowed access to the Society of Wood Engravers' Archive. The loan by Roderick Cave of the typescript (co-written with Sarah Manson) of their history of the Golden Cockerel Press was invaluable. Special thanks are due to Ian Rogerson, former Librarian of Manchester Polytechnic (now Manchester Metropolitan University), David Knott, Rare Books Librarian, Reading University, Peter Foden, Oxford University Press Archivist, and Lindsay Newman, Assistant Librarian, Lancaster University, for their continuous advice and support and for the provision of photographic material.

Of the many other librarians and library staff who have readily supplied information the following deserve mention: Pam Williams and Nicky Rathbone (Central Library, Birmingham Public Libraries), Sally Brown (Manuscript Collections, British Library), Tom Maxwell (Camberwell School of Arts and Crafts), Peter Gautrey, Elizabeth Leedham-Green, and D. J. Hall (Cambridge University), Sylvia Backemeyer and Maxwell Proctor (Central Saint Martins College of Art & Design), John Bidwell (William Andrews Clark Memorial Library, Los Angeles), James Tyler (Cornell University, Ithaca, New York), Jane Kimber (Hammersmith and Fulham Archives and Local History Centre), David Good (King's School, Canterbury), David Steel (Lancaster University), Pat Baily (London College of Printing), Julia Walworth and Simon Baily (Department of Special Collections, University of London Library), John Chalmers, Cathy Henderson, and other members of staff (Harry Ransom Humanities Research Center, University of Texas at Austin), Michael Bott (Department of Archives and Manuscripts, Reading University), Stella Lancashire and Eugene Rae (Royal College of Art), Peter McNiven (John Rylands University Library, Manchester), James Mosley and Nigel Roche (St Bride's Printing Library), Olive Geddes (National Library of Scotland), Murray Watson (Slade School of Fine Art), James Davis (Department of Special Collections, University of California Library, Los Angeles), and Timothy McCann (West Sussex Records Office, Chichester). Acknowledgements are due to these libraries and their trustees, and to other libraries and societies cited in the footnotes or in the list of photographic sources, which have granted permission to reproduce archival or illustrative material.

I would particularly like to thank the following members of staff of museums and art galleries: Anne Stevens (Ashmolean Museum, Oxford), Antony Griffiths, Frances

Carey, and Paul Goldman (British Museum), Sarah Hyde (Courtauld Institute of Art, and previously Whitworth Art Gallery, Manchester), Craig Hartley (Fitzwilliam Museum, Cambridge), Kathleen Gee (Harry Ransom Humanities Research Center, University of Texas at Austin), Jennifer Booth and Sarah Fox Pitt (Tate Gallery Archives), Martyn Anglesea (Ulster Museum), and staff of the Prints, Drawings and Paintings Department of the Victoria and Albert Museum. I owe much to specialist print and book dealers, notably Austin/Desmond Contemporary Books, Jonathan Blond (Blond Fine Art), Duncan Campbell (Duncan Campbell Fine Art), Robin Garton (Garton & Co.), Hilary Chapman (The 20th Century Gallery), Rupert Otten (Wolseley Fine Arts), and The Redfern Gallery who have searched records and provided photographs.

Publishers have been a valuable source of information, most especially John Charlton (Chatto & Windus), Simon Cobley (J. M. Dent & Sons Ltd.), John Bodley (Faber and Faber Ltd.), Victor Gollancz Ltd., Roger Smith (William Heinemann Ltd.), and John Handford (Macmillan Publishers Ltd.). I gratefully acknowledge all publishers who have given permission to reproduce illustrations, and likewise private press copyright holders or their executors, in particular Sir Simon Hornby (Ashendene Press), Dr Eberhard Fuchs (Cranach Press), Thomas Yoseloff (Golden Cockerel Press), the National Library of Wales, Aberystwyth (Gregynog Press), and Dame Alix Meynell (Nonesuch Press).

I am indebted to the following artists, their heirs, executors, relations, and friends, and to others who have drawn on their recollections for me, answered questions, offered hospitality, provided photographic material, and given permission to reproduce copyright images and quote from manuscripts: (for Mabel Annesley) Mrs Gerald Annesley; Edward Bawden, deceased; (for Vanessa Bell) her daughter, Angelica Garnett; Hazel Biggs, widow of John R. Biggs; Douglas Percy Bliss, deceased, and his daughters, Prudence and Rosalind Bliss; (for Stephen Bone) Sylvester Bone, on behalf of the Mary Adshead Estate; (for John Buckland Wright) his son Christopher Buckland Wright; (for Dora Carrington) Frances Partridge; Ellen T. M. Craig, on behalf of the Edward Gordon Craig, CH Estate; (for Desmond Chute) Colin McFadyean; (for John Farleigh) Barbara and John Kane; (for Roger Fry) his granddaughter, Annabel Cole; (for Ray Garnett) her son, Richard Garnett; (for Robert Gibbings) Patience Empson; (for Eric Gill) his daughter and grandson, Petra and Adam Tegetmeier; (for Vivien Gribble) her daughter, Cressida Warner; Philip Hagreen, deceased, and his son, John Hagreen; (for Joan Hassall) Brian North Lee; (for Gertrude Hermes) her children, Simon Hughes-Stanton and Judith Russell; (for Blair Hughes-Stanton) his daughter, Penelope Hughes-Stanton; (for Norman Janes and Barbara Gregg), their daughter, Marion Janes; (for David Jones) Anthony Hyne on behalf of the David Jones Estate; (for Thomas Jones) Eirene White; Clare Leighton, deceased, and her nephew and niece, David Leighton and Elizabeth Gornall; (for Iain Macnab) his wife, Helen Macnab, deceased; Enid Marx; Marion Stancioff (née Mitchell), deceased; (for Elinor Monsell) her daughter and grandson, Ursula Mommens and Philip Trevelyan; (for Gwenda Morgan) John Randle; (for John Nash) Ronald Blythe, on behalf of the Trustees of the John Nash Estate; (for Paul Nash)

John Sibley, on behalf of the Paul Nash Trust; (for William Nicholson) his daughter Elizabeth Banks, and Desmond Banks; (for Agnes Miller Parker) Ann D. Quickenden; John O'Connor; (for Hilary Pepler) his daughter Susan Falkner and Laurence Pepler; (for Lucien Pissarro) John Bensusan-Butt; (for Gwen Raverat) Sophie Gurney and Elisabeth Hambro (daughters), Emily Pryor and Nelly Trevelyan (granddaughters), Christopher Cornford, deceased, Hugh Cornford, Stephen Keynes, and Milo Keynes; (for Eric Ravilious) his children, John and James Ravilious and Anne Ullmann; (for Noel Rooke) his wife, Celia M. Rooke; Lettice Sandford, deceased, and her son, Jeremy Sandford; The Society of Authors on behalf of the Bernard Shaw Estate; The Stanley Spencer Estate; (for Leon Underwood) his son, Garth Underwood; The Estate of Edward Wadsworth; (for Geoffrey Wales) his wife Marjorie Wales; David Alexander, Martin Andrews, Simon Brett, Lelage Buckley, David Chambers, Enfys Chapman, Douglas Cleverdon, deceased, Brooke Crutchley, Yvonne Deane, John Dreyfus, Michael Dudley, Timothy Elphick, David Esselmont, Albert Garrett, deceased, James Hamilton, Edgar Holloway, Michael Holroyd, Justin Howes, Dan H. Laurence, Simon Lawrence, Stanley Lawrence, deceased, Fiona MacCarthy, Joan McGuinness-Smith, Ruari McLean, Barrie Marks, Charles Pickering, Doris Pleydell-Bouverie, Monica Poole, Anthony Powell, Robert Reedman, Anthony Reid, Michael Renton, James Richards, Vivian Ridler, Godfrey Rubens, Meg Ryan, Brocard Sewell, Christopher Skelton, deceased, Frances Spalding, Peter Tucker, Basil and Saria Viney, Margaret Wells, and Susan Wyatt. While every effort has been made to trace copyright holders, I apologize to any who might have been overlooked.

I am especially grateful to Dennis Farr for his patient supervision of my thesis and for help and guidance in the preparation of this book, and to Anne Ashby, Paul Cleal, and their colleagues at the Oxford University Press who have seen it through the press. To my examiners I owe a particular debt: Dorothy Harrop for her bibliographic advice and indexing skills and Thomas Gretton for some wise and helpful suggestions. Finally, greatest thanks must go to my husband, John, and children, William, George, Luke, and Emily, for their encouragement and tolerance during the long gestation of this work and to whom I dedicate it with affection.

J. S.

Photographic Acknowledgements

Ashmolean Museum, Oxford: 34, 36, 37, 42, 43
Austin/Desmond Contemporary Books: 24
Blond Fine Art: 174
The Bodleian Library, University of Oxford: 18, 79, 96, 115, 159, 165, 173, 203
Garton & Co.: 44
Sophie Gurney and Elisabeth Hambro: 29, 32
David Knott: 117
David Leighton: 204
London University Library: 3, 10, 158, 184
Manchester Metropolitan University Library: 5, 35, 73, 74, 93, 205, 206, 207, 208, 209, 210, 212
National Library of Scotland, Edinburgh: 211
Oxford University Press: 58, 59
Harry Ransom Humanities Research Center, The University of Texas at Austin: 103, 108, 109
Reading University Library: 4, 7, 8, 12, 13, 16, 52, 57, 69, 72, 75, 76, 80, 86, 87, 94, 95, 97, 98, 99, 100, 101, 102, 104, 105, 106, 107, 110, 111, 116, 118, 120, 121, 122, 124, 125, 126, 129, 132, 133, 136, 137, 138, 139, 140, 149, 156, 171, 172, 191, 194, 195, 202
Vivian Ridler: 166
The William Ridler Collection, Birmingham Public Libraries: *Frontispiece*, 11, 14, 15, 47, 48, 50, 51, 53, 54, 55, 56, 60, 65, 77, 81, 88, 92, 112, 113, 114, 127, 128, 130, 150, 151, 152, 153, 154, 155, 160, 163, 164, 167, 168, 170, 176, 180, 182, 183, 185, 187, 188, 189, 196, 197, 198, 199, 200, 201
Royal College of Art Library: 146
Garth Underwood: 175
Wolseley Fine Arts: 22, 25, 28, 119, 123.

A Note on the Typeface

Typeset in ITC Golden Cockerel, based upon typefaces commissioned from Eric Gill in 1929 for the Golden Cockerel *Four Gospels*, with ornaments from wood-engravings by Eric Gill.

Contents

List of Illustrations

Unless otherwise stated the medium reproduced is wood-engraving. All dimensions are in millimetres, height preceding width. Where possible open books are shown against a dark background to indicate the full extent of the pages. Whole pages and double-page spreads are measured from the paper edges, single prints from the outer edges of the image. Titles of prints which illustrate specific poems are given in single quotation marks. The illustrator is the author where none is cited. References to the illustrations appear in the margins to the text.

Abbreviations

AMPA	Agnes Miller Parker Archive (National Library of Scotland, Edinburgh)
BLMC	British Library Manuscript Collections, London
BM	British Museum
BN	Bibliothèque Nationale, Paris
BSC	Burgunder Shaw Collection (Cornell University, New York)
CIA	Courtauld Institute of Art, University of London
CUL	Cambridge University Library
CUPA	Cambridge University Press Archives (Cambridge University Library)
DCA	Douglas Cleverdon Archive (Tate Gallery Archives)
FA	Faber Archives (Faber and Faber Ltd.)
FCA	Frances Cornford Archive (British Library Manuscript Collections)
FM	Fitzwilliam Museum, Cambridge (Department of Prints and Drawings)
GCPA	Golden Cockerel Press Archive (Harry Ransom Humanities Research Center, University of Texas at Austin)
GRP	Gwen Raverat Papers (Darwin Archives, Cambridge University Library)
HRHRC	Harry Ransom Humanities Research Center (University of Texas at Austin)
JCA	Jonathan Cape Archive (Reading University Library)
JRUL	John Rylands University Library of Manchester
KP	Kessler Papers (Newberry Library, Chicago)
LECA	Limited Editions Club Archive (Harry Ransom Humanities Research Center, University of Texas at Austin)
MA (BLMC)	Macmillan Archives (British Library Manuscript Collections)
MA (RUL)	Macmillan Archive (Reading University Library)
MP	Macmillan Publishers' Archive (Macmillan Publishers Ltd.)
MPA	Margaret Pilkington Archive (John Rylands University Library of Manchester)
NAL	National Art Library (Victoria and Albert Museum, London)
NL	Newberry Library, Chicago
NLS	National Library of Scotland, Edinburgh
NLW	National Library of Wales, Aberystwyth
NYPL	New York Public Library, New York
RAGL	Richard A. Gleeson Library (Donahue Rare Books Room, University of San Francisco)

RUL	Reading University Library
SWE	Society of Wood Engravers
SWEA	Society of Wood Engravers' Archive
TGA	Tate Gallery Archives, London
TJP	Thomas Jones Papers (National Library of Wales, Aberystwyth)
UCLAL	University of California Los Angeles Library (Department of Special Collections)
ULL	University of London Library
VAM	Victoria and Albert Museum (Department of Prints, Drawings and Paintings)
VGA	Victor Gollancz Archive (Victor Gollancz Ltd.)
WACML	William Andrews Clark Memorial Library (University of California, Los Angeles)

INTRODUCTION

Of all forms of illustration, wood-engraving, like woodcutting, is physically most closely allied to the book. Intaglio prints, for example copper engravings and etchings, and planographic prints such as lithographs, must be printed separately from type, on a different kind of press. Cut or engraved woodblocks, on the other hand, being in relief, can be printed on an orthodox press[1] simultaneously with a page of type and, with careful cutting, can be made to harmonize with it. The final image should remain true to the artist's work and only the paper, ink, and printing can change its appearance on the final page.

During the nineteenth century wood-engraving was used almost entirely for illustrative purposes, mainly in a reproductive manner by skilled copyists. In the early part of the twentieth century, however, various British artists embarked, in the words of Eric Gill, on an 'adventure of discovery',[2] in the course of which they re-invented wood-engraving as an autonomous medium. Although much of their most innovative work was for single prints, they carried their experiments over to illustration. Stimulated by the typographical renaissance which flourished between the wars, and with initial encouragement from the private presses, these artists broke with the traditional concept of wood-engraving. Their wide-ranging experiments affected the appearance of the printed page and in so doing created a new book art which had a significant influence on modern standards of production in Britain and abroad.

Since the founding of the Society of Wood Engravers (1920) to raise the status of the medium to a level with that of etching and other graphic arts, perennial arguments over the relative merits of 'wall' prints versus book illustration have abounded, most especially in the period under discussion when wood-engravers were attempting to define their role. More than that of other artists the fate of wood-engravers has been inextricably bound up with printing technology. In terms of popular culture the medium has moved in and out of favour in accordance with new developments in the printing industry and their consequent repercussions on the publishing trade. Until the mid-1920s society in general was largely unaware of the 'new' wood-engraving. Overshadowed by cheaper photomechanical illustrative methods, it lurked in the background, seen mainly by an élite few in private press and other limited publications and

[1] A press which must be suitable for letterpress printing such as a platen, cylinder, or proofing press. See following chapter. For a useful discussion on presses see James Moran, *Printing Presses* (London, 1973). For the process of printing wood-engravings see Walter Chamberlain, *Manual of Wood Engraving* (London, 1978), 151–62, and Graham Williams, 'The Printing of Wood-Engravings', *Matrix*, 5 (1985), 100–8.

[2] Eric Gill, Foreword to catalogue, *An Exhibition of Woodcuts by the Society of Wood Engravers and Other Artists* (Liverpool: Basnett Gallery, Bon Marché, Feb. 1927), unpaginated. Herbert Furst described this younger generation of practitioners as 'Artist-Venturers' in his seminal article 'The Modern Woodcut: Part 2', *Print Collector's Quarterly*, 8 (1921), 267–98, p. 292.

in occasional exhibitions. A time-consuming, craft-related medium, its exponents did not enjoy the wide popularity gained by those of the more publicity-conscious etching movement. Not till the 1930s did wood-engraving begin to be recognized as a popular art form, largely through commercially produced books, magazines, and advertisements. The proliferation of offset and filmsetting methods of printing after the Second World War rendered the use of relief woodblocks economically unviable for such publications: with their demise went the fashion for wood-engraving.

Nowadays many historians and wood-engravers seek to disconnect the medium from illustration, as if to be associated with it is somehow 'old-fashioned' and consequently demeaning to the art. Yet, as will be seen, most of the best practitioners of the 1920s and 1930s contributed to books, and not always purely for economic reasons. Ironically, when the aim of many wood-engravers was to emancipate themselves through the production of single prints, it was commercial publishers who, recognizing the market value of illustrated books, did most to popularize their work—an indication of the fact that wood-engraving, being inherently vulnerable to social and economic pressures, owed its existence to illustration.

The British wood-engraving movement was not greatly affected by continental influences. The most successful practitioners were more concerned to exploit the linear possibilities of the medium than to follow trends in painting for their own sake: for them the medium *was* the message. Even when modernist tendencies emerged, as for example in the work of Paul Nash, Robert Gibbings, Gertrude Hermes, or Blair Hughes-Stanton, these artists developed individual styles for which there was no exact foreign equivalent. To some extent this insularity, in the early days of the revival at any rate, was a cultural legacy of traditional woodcutting. It reflected also the conventional attitudes that were still prevalent amongst the majority of publishers, printers, and, indeed, critics. Notwithstanding this climate of taste, these pioneers produced some of the most exciting and innovative prints of the period, a large proportion as illustration. Their understanding of the inherent aesthetic qualities peculiar to wood determined their modernness, not necessarily the images *per se*.

The role of individual artists in this small but significant movement in British graphic art has been unjustifiably neglected and their importance underestimated. Monographs are all too often absent or insubstantial. Although bibliographies and lists of prints and books illustrated are available in some instances, with notable exceptions artists' work and practices in this field have been under-researched. James Hamilton's work has helped to put the wood-engraving movement in context,[3] but until now no comprehensive study of twentieth-century wood-engraved illustration has been attempted. The purpose of this book is to survey the subject in relation to its historical background and in the light of the typographical renaissance which prospered in the 1920s and 1930s, with particular reference to the more innovative artists (some of whom are known only

[3] James Hamilton, *Wood Engraving & the Woodcut in Britain, c.1890–1990* (London, 1994). Albert Garrett's survey, *A History of British Wood Engraving* (Tunbridge Wells, 1978; new edn., 1986), is an idiosyncratic and often inaccurate overview by a practising wood-engraver who, in his introduction, 21–3, makes no claim to scholarship.

through their book illustration). The experimental approach of the first generation is evaluated in the light of contemporary attitudes towards wood-engraving and the teaching of it.

Despite problems of size, intractability, and lack of colour, wood-engraving is arguably the most versatile of the graphic media. It is also one of the more individualistic, enabling relatively easy identification. In this discussion artists have been categorized stylistically, thereby emphasizing the wide scope possible within the limitations of the medium, and the distinctive styles which emerged from the art schools in particular. (Woodcuts and linocuts are included only where they throw light on the development of wood-engraving.) The work of individual illustrators is surveyed chronologically so as to reveal the overall shift in style and technique which came about over the decades.[4] In general a reasonably exhaustive and descriptive book-by-book method of analysis has been chosen rather than a thematic one: a deliberate attempt to give a complete picture of the artists' *œuvre* and to establish the chronology and relevant biographical information previously unknown or else often overlooked.[5]

The narrow perception of wood-engraving 'as a quaint rural craft which has somehow survived the 19th century, like thatching and smock-making'[6] has only served to downgrade the status of its practitioners. By including only the more inventive artists an attempt has been made to redress the balance in their favour, and at the same time to point out the unique qualities and versatility of a medium inherently suited to book illustration. Although the more conventional Bewick-style pictorial artists have been purposely omitted, literal neo-Bewick or symbolist Blakean elements are never far from the minds of most of those illustrators discussed who, consciously or unconsciously, are steeped in English pastoral and literary tradition. Due largely to this inheritance and to the widespread interest in typography and printing, wood-engraved book illustration between the wars was essentially a British phenomenon.

[4] With the more important artists, an inevitable imbalance in the length of chapters arises where a significant body of unpublished material exists, notably with Eric Gill, Eric Ravilious, Clare Leighton, and Agnes Miller Parker; or where the existing literature fails adequately to survey and evaluate the artist's illustrative work as, in particular, with Robert Gibbings and John Farleigh.

[5] Douglas Martin in his essay on 'The Critical Interpretation of Book Illustration' in *The Telling Line: Essays on Fifteen Contemporary Book Illustrators* (London, 1989), 30, advocates a 'contemporary study of individual illustrators and their work, so that the documentation of sufficient and diverse cases begins to map out and define the outlines of this fascinating area of practice'. This discipline, particularly lively in West Germany and Austria, 'where it is seen as a mixture of detective work, biographical empathy, critical detachment and archival scrupulousness', is respected by the present author.

[6] A view denigrated by Peter Forster, contemporary parodist and wood-engraver, in *A Publicity Vignette* (London, 1986), unpaginated.

PART I

THE BACKGROUND

WOOD-ENGRAVING AND WOOD-ENGRAVERS

Wood-engraving is often confused with woodcutting, largely through ignorance of the techniques involved. The frequent use of the word 'woodcut' as a generic term to describe both processes—one much favoured by critics in the 1920s and 1930s—only serves to perpetuate the confusion.[1] While both are relief printmaking methods, the two techniques are significantly different, resulting in their own distinctive look.[2] White-line wood-engraving is like drawing with chalk on a blackboard: lines and textures which are incised with engraving tools into the end-grain of hardwood appear white when an impression is taken from the inked surface of the block.[3] The hardness of the wood enables the engraver to achieve much greater detail and tonal refinement than is possible with woodcutting, for which the design is cut on the plank of softer wood with a knife or gouge. With either medium, when black lines are required the *Plate 1* white background on either side is laboriously removed enabling the lines to be printed in relief. As a result, both black-line wood-engravings and -cuts can bear strong similarities, although the overall effect of woodcut blocks, which often reveal the grain of the wood, is generally coarser and more robust.

Although various hardwoods can be used for wood-engraving blocks, boxwood is the most suitable: being exceptionally hard and fine grained it provides a smooth and durable printing surface. The diameter of the trunk is never large, hence the smallness associated with wood-engraved prints. Where larger surfaces are required composite blocks are made up.[4] Between the wars the foremost suppliers were the blockmakers T. N. Lawrence & Son, whose small workshop in Bleeding Heart Yard, London, according to Chamberlain, was 'the hub of the wood-engraving world'.[5] Many engravers sent their blocks to the firm to be resurfaced or for mistakes to be removed and plugged for reworking. Woodblocks were generally supplied type-high to facilitate their use for illustrative purposes. In commercially printed books, where long runs were required, duplicate blocks were usually made from electro- or stereotypes in case of damage to the original.[6]

[1] See, for example, three influential books on wood-engraving by the foremost contemporary critics, Campbell Dodgson's *Contemporary English Woodcuts* (London, 1922), Herbert Furst's *The Modern Woodcut* (London, 1924), and Malcolm Salaman's *The New Woodcut* (London, 1930).

[2] Technical manuals are listed in the Select Bibliography. Walter Chamberlain's *Manual of Wood Engraving* (London, 1978) is among the most informative. The most recent British publication, Simon Brett, *Wood Engraving: How to Do It* (Swavesey, Cambridge, 1994), is a wide-ranging and well-illustrated account by a practising engraver, with an emphasis on the design element.

[3] For further discussion on white-line technique see Ch. 3.2, 'Thomas Bewick'.

[4] See Ch. 3.3, 'Victorian Reproductive Engravers'.

[5] Chamberlain, *Manual of Wood Engraving*, 77. The firm still supplies material to wood-engravers from a new address. Another supplier of tools was Buck & Co., a first-class ironmonger in Tottenham Court Road, London WC1, patronized by Gwen Raverat and Edward Gordon Craig. For general requisites Clare Leighton in *Wood-Engraving and Woodcuts* (London, 1932), 23, lists also Cornelissen & Sons, W. Lawrence, Lechertier Barbe, Ltd., W. Y. Rhind, and C. Roberson & Co.

[6] For a description of these processes see Ch. 3.3, 'Victorian Reproductive Engravers'.

Plate 2

Wood-engraving requires only a few tools: the type and number of sizes employed differ from artist to artist. Square or lozenge-shaped in section, gravers (derived from the burin or metal engraving tool) cut lines of varying width and are useful for dotted and jabbed textural effects; the spitsticker with its round belly is designed for engraving both fine and curved lines and cuts more fluently than a graver; a bullsticker is a heftier version of a spitsticker; the tint tool, beloved of the Victorian reproductive wood-engravers, cuts shallow tints and delicate lines of uniform width; scorpers—flat or rounded in section—also known as gouges, are used for cutting broad white lines and bolder textures, as well as for clearing larger areas of white; unusually large areas can be gouged out with a chisel; the multiple tool or *vélo* is like a small chisel with a multi-grooved belly which cuts several parallel lines at a time.

The design is drawn, traced, or photographically transferred on to the block. Once engraved, the surface is then inked with a roller and an impression either taken by hand[7]—by rubbing a burnishing tool over the back of paper placed on the block—or printed in a platen, cylinder, or proofing press. The printing of blocks designed as illustrations to be set in with type necessitates the use of a press. In comparison with hand-burnishing, a great deal of preparatory work, including packing and overlays or 'make-ready', is required when setting up the block on the bed of the press to compensate for any uneven pressure.[8] Many wood-engravers of the period under discussion did not own hand presses. None the less, when cutting blocks for illustration they had to learn to adjust their technique to suit the demands of printing by press. Some were more skilful than others, but in many instances of unsuccessful printing it was the fault either of the printer or the publisher: for example, by over- or under-inking,[9] or through an injudicious choice of paper, or by a failure to dampen it sufficiently.[10] A harmonious balance between the weight of lines on the cut block and the area of type was another consideration.

In contrast to intaglio work, wood-engraving offers the unique opportunity of drawing with light; the tonal possibilities held particular fascination for early twentieth-century printmakers for whom the medium provided an entirely new means of expression. The wide variety of styles which they went on to develop, from the robust to the delicately intricate, is revealed in later chapters, as are the ongoing dissensions amongst practitioners and critics alike over the relative merits of white-line versus black-line, conservatism versus modernism, or the use of the multiple tool, to name but a few.

For all its creative potential wood-engraving stands apart from painting and less technically demanding media, being inherently craft related.[11] Compared also with

[7] Excellent photographs and description of the process are contained in Leighton, *Wood-Engraving and Woodcuts*, 14–19. For the viewpoint of a printer see Graham Williams, 'The Printing of Wood-Engravings', *Matrix*, 5 (1985), 100–8.

[8] For an account of this procedure see Chamberlain, *Manual of Wood Engraving*, 165–6.

[9] Leighton's examples of good and bad inking reproduced in

Wood-Engraving and Woodcuts, 89, 91, and 93, and accompanying comments are particularly instructive.

[10] See Chamberlain, *Manual of Wood Engraving*, 137–8, on appropriate paper. The problem of undampened paper is discussed further in Ch. 3.2, 'Thomas Bewick'.

[11] This has always been a sensitive issue amongst practitioners anxious not to be perceived purely as craftsmen. For instance

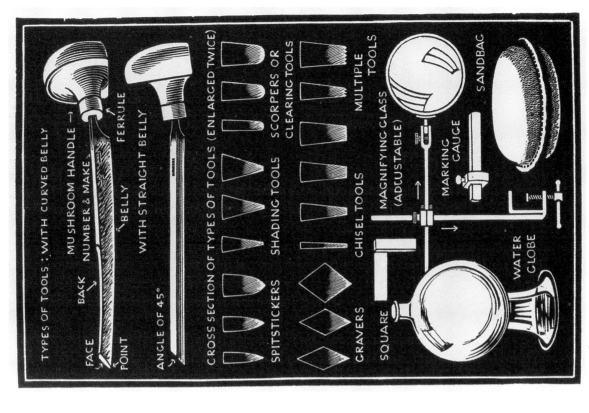

Pl. 2. Selection of wood-engraving tools and equipment. From Mark Severin, *Your Wood Engraving* (Sylvan Press, 1953). 150 × 97

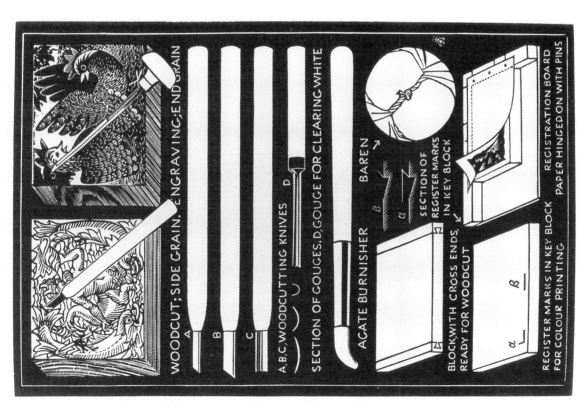

Pl. 1. Examples of woodcut and wood-engraved blocks, woodcutting knives, and other equipment. From Mark Severin, *Your Wood Engraving* (Sylvan Press, 1953). 150 × 97

other graphic media, it is one of the most direct. To engrave on hard and often minute blocks requires exacting manual dexterity and an ability to think in black and white and in reverse, to design, to draw, and to understand printing techniques: processes which are often more easily assimilated by practice rather than through teaching. As Gill suggests, unlike other types of practitioner, 'the wood-engraver is forced to have some respect for the thing itself and to place an absolute value upon the art of drawing'.[12] The medium allows little room for error. 'It appeals to any artist who loves strong, clean, deliberate drawing', as Clare Leighton indicates, 'for it is impossible on the wood block to "codge" or re-state.'[13] Yet its very limitations seem to have encouraged exponents. Iain Macnab's observations in his students' guide to the medium could be said to represent the credo of the new practitioners:

It may sound paradoxical, but the more limitations an artist imposes upon himself by reason of an intractable medium, and the more he observes these limitations, the greater degree of freedom will he discover. By expressing himself in terms of the medium he leaves himself free to simplify his forms, and to choose symbols which will explain these forms: symbols which will be beautiful in themselves in their arrangement of form and pattern, and which will bring out the inherent beauty of that medium. To force the medium by concentrating on the mere copying and representation of appearances is more likely to rob it of its own peculiar charm and to destroy its aesthetic qualities.[14]

Robert Gibbings, in particular, appreciated the discipline that wood-engraving instilled:

When I came over from Ireland about the year 1911 I found Rooke at the Central School of Arts not only teaching the craft but emphasising to youngsters like myself that it provided a discipline of thought that was necessary to every artist. Discipline in art: was that what I'd come to London for? Impressionism was what I thought I was after. I couldn't think what all this hard labour on wood was about. There was no tradition at the time; it seemed a lot of finicky gouging to get a few lines that might have been obtained more easily with a pen or brush. But slowly a love of the wood came upon me. I began to enjoy the crisp purr of the graver as it furrowed the polished surface. I began to appreciate the cleanness of the white line that it incised: even the simplest silhouettes had an austere quality, a dignity, that could not be achieved by other means. Clear, precise statement, that was what it amounted to. Near enough wouldn't do: it had to be just right.[15]

Many others have written of the sensuous physical aspects of engraving on wood. D. P. Bliss, for instance, enjoyed 'the sweet, sharp movement of the well-ground tool upon the block. The resistance of the iron-hard wood to the graver sets up a tension that is curiously exciting',[16] while John Farleigh wrote lyrically: 'The tool has a subtle voice. It will only confide in the understanding craftsman. It can become the only living

Brett, *Wood Engraving*, 11, emphasizes the point that this element does not make wood-engraving a craft activity.

[12] Eric Gill, 'The Society of Wood Engravers', *The Architect*, 104 (1920), 300.
[13] Leighton, *Wood-Engraving and Woodcuts*, 96. According to Gwen Raverat, 'Wood Engraving of To-Day', *Studio*, 117 (1939), 42–51, p. 46, 'there is no better school for precision of ideas than wood-engraving'.
[14] Iain Macnab, *Wood-Engraving* (London, repr. 1947), 2.
[15] Robert Gibbings, 'Thoughts on Wood', *The Saturday Book*, 17 (1957), 207–13, repr. *Matrix*, 9 (1989), (8–10, p. 9).
[16] Douglas Percy Bliss, *Wood-Engraving* (Leicester, [1952]), 11.

thing about you. All feeling and life; all action and intensity can pass into the tool until the body clouds up and only the point of the tool is in focus. It is then that the tool will talk and all is well.'[17]

The craft element appealed to a certain type of artist. The process of subtraction or cutting away held an attraction for sculptors, Robert Gibbings, Eric Gill, Gertrude Hermes, and Leon Underwood being notable examples. Wyndham Lewis described the act of designing on wood like creating a 'miniature sculpture'.[18] For Paul Nash wood seemed 'to yield to the evolution of an abstract design or a decorative arabesque as stone excites the sculptor to the creation of pure form'.[19] Pattern makers such as Nash and Eric Ravilious enjoyed using wood-engraved marks in the same way that embroiderers employ stitches.

The small-scale, domestic nature of wood-engraving, with minimal equipment necessary, made it easy to practise at home without the need for a studio. Partly for this reason a significant number of female exponents were drawn to the medium, several of whom were among the most respected wood-engravers of the period.[20] At a time when women were finding it hard to make their mark in painting, no doubt for some, wood-engraved printmaking offered another avenue into the art world.[21]

As Rodney Engen suggests, 'wartime shortages meant large-scale work was impossible and many artists turned to the more convenient and challenging wood blocks for their experiments'.[22] Only a few well-established painters, however, chose to take up wood-engraving seriously. Of those that did, most, including the Nash brothers and Ravilious, felt unable to sustain an interest in such a constricting medium for any length of time. In Britain there was not really an equivalent to the French *peintre-graveur*, as the following words by the contemporary critic Gui St Bernard partly explain:

It is often said that British people are at their best when expressing themselves in simple terms. Our artists, for example, can claim world-leadership in the use of black and white media, especially wood-engraving. This is not to imply that they cannot use colour or other complicated means, or that every print they produce is an unchallengeable masterpiece. It is rather, that the very limitations of black and white, and the consequent necessity for careful distillation of ideas, raise just the problems which put British artists on their mettle.[23]

Significantly, apart from Lucien Pissarro who pursued nineteenth-century practices, few wood-engravers of the period chose to work with colour; a fact reinforced by the general absence of instruction in technical manuals, and, not least, the positive

[17] John Farleigh, *Graven Image* (London, 1940), 18–19.

[18] Wyndham Lewis, *Blast*, 1 (1914), 136.

[19] Paul Nash, 'Woodcut Patterns', *The Woodcut*, 1 (1927), 30–8, p. 33.

[20] See in particular Patricia Jaffé, *Women Engravers* (London, 1988), and '*Shall we Join the Ladies': Wood Engraving by Women Artists of the Twentieth Century*, introd. Betty Clark with essays by George Mackley and Dorothea Braby (Oxford, 1979).

[21] Gwen Raverat, for instance, described in *Period Piece: A Cam-*

bridge Childhood (London, 7th edn., 1953), 129, how she longed to be a man, 'then I might be a really good painter. A woman had not much chance of that'.

[22] Rodney Engen, 'Wood Engraving', in Robin Garton (ed.), *British Printmakers, 1855–1955* (London, 1992), 81–5, p. 83.

[23] Gui St Bernard in 'Coming Events', Jan. 1937, quoted by Albert Garrett in *Wood Engravings and Drawings of Iain Macnab of Barachastlain* (Tunbridge Wells, 1973), 36.

disapproval of many practitioners and critics.[24] Macnab, for example, wrote that 'coloured wood-engravings may be quite legitimate and may often be interesting, but to my mind they have none of the dignity and power of those printed in black ink',[25] whilst Furst considered that the method absorbed too much of the cutter's attention and made him 'a slave to process'.[26] For a modern practitioner's view Simon Brett suggests that:

most artists use wood-engraving as a black and white medium, valuing an impact and a subtlety which can get lost when printmaking in colour. . . . The repertoire of tint and stipple which has been developed in wood-engraving relies on full black for its effect, and few artists have thought through a different approach to cutting and printing which would allow colour to intensify the impact of an engraving rather than disperse it.[27]

Leon Underwood, one of the more experimental printmakers of the new generation, broke new ground in the field of commercially printed illustration with his wood-engravings in four colours for *Red Tiger* (Hodder & Stoughton, 1929). Ten years later Gwen Raverat, having trained as a painter, also experimented with colour and was the only other British wood-engraver seriously to employ the medium for book illustration. Yet, as will be seen from the correspondence relating to her designs for *The Bird Talisman*, the complex process was time-consuming, and expensive on labour and materials, particularly boxwood blocks, and not, therefore, cost-effective.[28] Improvements in commercial printing meant that most artists who made colour prints for illustrative purposes tended to use line block or lithographic methods. Few trade publishers freely commissioned colour wood-engraving; nor evidently did private press owners.[29] Whether for purist or economic reasons, only a few books of the period contain such illustrations which, together with individual colour prints, deserve closer investigation than is possible within the scope of this work.

Although parallels existed between the wood-engraving and etching revivals of the 1920s, the movements differed in scope and intention. The longer-established Royal Society of Painter-Etchers and Engravers was a businesslike organization.[30] Professional etchers were well supported by specialist dealers and collectors: a thriving market existed for editioned prints, those of D. Y. Cameron, Muirhead Bone, and James McBey fetching

[24] The vogue for colour wood- and linocutting gave rise to specialist societies, notably the Society of Graver Printers in Colour (founded 1909) and the Colour Woodcut Society (founded 1920). However Japanese colour techniques in particular (see Ch. 4 n. 19) were frowned upon by the founder members of the Society of Wood Engravers as, according to Sarah Hyde in 'British Wood-Engraving in the Early Twentieth Century', *Apollo*, 130 (1989), 242–8, p. 244, they 'were seen to run counter to the Society's claim for artistic integrity and originality'.

[25] Macnab, *Wood-Engraving*, 49.

[26] Herbert Furst, 'The Modern Woodcut: Part 1', *Print Collector's Quarterly*, 8 (1921), 151–70, p. 170.

[27] Brett, *Wood Engraving*, 124–5 n. 43. This note highlights technical matters concerning the composition of coloured inks

(both for commercial and hand printing purposes) and the different methods of printing. Chamberlain, *Manual of Wood Engraving*, 169–79, includes a useful chapter on colour printing.

[28] For further elaboration see Ch. 10. See also Joanna Selborne and Lindsay Newman, *Gwen Raverat, Wood Engraver* (Denby Dale, 1996) for discussion of Raverat's methods of colour printing. The colour illustrations of other wood-engravers are discussed in chapters on individual artists.

[29] A few experiments include those by Ethelbert White for the Golden Cockerel Press (*The Wedding Songs of Edmund Spenser*, 1923) and by the French artist, René Ben Sussan, also for the Golden Cockerel Press (*Metamorphosis of Pygmalion's Image*, 1926) and for the Blackamore Press (*The Pilgrim on the Earth*, 1929).

[30] The aims of the society are discussed in Ch. 3.8, 'British and Continental Illustration around 1900'.

some of the highest prices in the world for contemporary prints.[31] The Society of Wood Engravers' efforts to promote awareness of wood-engraving for both single prints and illustration were less ambitious and entrepreneurial: membership was small and exclusive, rules restrictive, its main forum a small annual exhibition. Catalogues of those held between 1925 and 1930 at the Redfern Gallery indicate that edition sizes of prints varied between ten and two hundred, fifteen to seventy-five being the most usual. Prices were low in comparison to those for etching, the highest being three guineas (apart from five guineas paid in 1925 for the only impression of Paul Nash's *Arches*). These remained relatively static: the average price of one guinea for a small Gwen Raverat print, for example, was the same in 1920 as in 1938.[32] As Clare Leighton admitted, 'no artist [in the 1930s] could live on the proceeds of the sale of his prints. Economic pressures drives all of them into illustration.'[33] For the effort involved, book illustrating was not especially remunerative either: Eric Gill earned just over £200 for two years' work on the engravings for *The Four Gospels*, for example, and Raverat £210 for twenty-nine blocks for *Les Amours pastorales de Daphnis et Chloé*, whilst Lynton Lamb was offered a fee of £50 for a minimum of twelve blocks for a projected book in the 1938 Penguin Illustrated Classics Series.

With the change from professional to artists' engraving the status of wood-engravers was raised. Yet, unlike many etchers, few could afford to pursue wood-engraving alone as a career: there was 'no money in it' as R. J. Beedham warned aspiring practitioners in his seminal manual on wood-engraving.[34] The best known mostly relied on other work, particularly teaching, to supplement their income. The result of not being dependent on the art market to the same extent as etchers was a bolder and more varied approach, and very often a higher standard of work. Similarly, the economic depression also had a less adverse effect on wood-engravers, since their prices were more affordable and illustration enabled further outlets.

The specialist skills required for wood-engraving account to a large extent for the relatively small but dedicated number of exponents in both the period under discussion and the present day. For non-practitioners an insight into the physical nature of the medium and its intimate relationship with type and, by extension, the process of printing should help to explain wood-engraving's affinity with illustration and book production, and also to determine why, over and above financial considerations, so many practitioners have instinctively been drawn to this field. To think of them just as wood-engravers is to deprive them of their cultural significance.

[31] For further discussion see Engen, 'Wood Engraving', 83, and Frances Carey and Antony Griffiths, Introduction to *Avant-Garde British Printmaking, 1914–1960* (London, 1990), 12 ff. According to Engen, 126, D. Y. Cameron's *Five Sisters, York Minster* fetched $2,500 (£660) in 1928.

[32] In 1922 Eric Gill suggested 10s. 6d. to be a fair price for a print for both artists and buyers (Minutes of the Society of Wood Engravers, 25 Oct. 1922, Society of Wood Engravers' Archive, henceforth SWEA).

[33] Clare Leighton, 'Wood Engravings of the 1930s' (London, 1936), 99.

[34] R. John Beedham, *Wood Engraving* (London, 5th rev. edn., 1938),

12. Douglas Percy Bliss, 'The Last Ten Years of Wood-Engraving', *Print Collector's Quarterly*, 21 (1934), 251–71, p. 260, suggests that many wood-engravers defected for financial reasons. The claim of Carey and Griffiths, *Avant-Garde British Printmaking*, 10, that wood-engraving in the 1920s was 'socially superior' is debatable and of no relevance to the fact that leading figures such as Gwen Raverat 'were very well connected indeed'. As with other media, practitioners emanated from a wide variety of backgrounds. Documentary material indicates that in many cases, regardless of social status, wood-engravers acknowledged that financial problems were an inevitable symptom of their chosen profession in a minor art form.

❧ 2 ❧

THE ROLE OF ILLUSTRATION

Derived from *lustrare*—to light up or illuminate—'illustrate' has come to mean explain, elucidate, interpret, or decorate. With such a wide application all visual art could be said to be illustrative. In a narrower sense, however, illustration signifies the pictorial adornment of books or other printed matter. Strictly speaking it clarifies the content while decoration merely embellishes the page. But, as Bland indicates, 'it is not safe to identify illustration with the representational and decoration with the abstract elements of art. ... Both elements may be mingled in one design, and in fact must be if it is to be good.'[1] Eric Ravilious's designs for *Twelfth Night* provide an excellent example of this synthesis. As will be seen, artists differed in their perception of their role as illustrator. John Harthan's view that this can be likened to that of a publisher who mediates between author and reader, in the same way that the stage director mediates between playwright and audience, is especially apt.[2]

Beyond decoration and literal interpretation lies the imaginative: an extension of the text, describing visually something more than words alone can express; an approach most tellingly applied by William Blake and, amongst twentieth-century wood-engravers, Blair Hughes-Stanton and Gertrude Hermes. The capacity to work from darkness to light imbued wood-engraving with a spiritual quality, making it a particularly appropriate illustrative medium through which to translate poetic texts.

The pervasive cultural inheritance of narrative literature and the conservatism of publishers and readers alike led to the tendency of British illustrators to subordinate image to text, generally in a representational way, whether in a conventional or modernist style. The physical balance between picture and type was also a consideration. In France, however, the visual image was often more important than the written word, as in the luxurious *éditions de luxe* which were more like artists' picture books; the typographer's role was minimal.

Book illustrations must be viewed from a different perspective from that of single prints. Analysis of them as isolated images, so often the case in critical studies of wood-engraving,[3] cannot give a true evaluation of the product.[4] In this discussion the main criterion for illustration is a wood-engraved image which interprets text of a literary nature rather than of a purely informational kind as, for example, in educational books, magazines, or journals.[5] Prints which are placed in books for no purpose other than to

[1] David Bland, *The Illustration of Books* (London, 2nd rev. edn., 1953), 12.

[2] John Harthan, *The History of the Illustrated Book: The Western Tradition* (London, 1981).

[3] See Albert Garrett, *A History of British Wood Engraving* (Tunbridge Wells, 1978), as an example of this type of study.

[4] Edward Hodnett, *Image and Text: Studies in the Illustration of English Literature* (repr. Aldershot, 1986), makes this point very forcefully throughout this useful critique.

[5] The inclusion of examples from magazines and journals, etc., occurs only where stylistic or cultural factors are of particular relevance.

adorn the page are not generally reviewed, nor are decorative designs, unless part of a larger interpretative scheme.

Illustrations are analysed as works of art in the context of the book, both in relation to the text and to the *mise en page*. As a vehicle to convey these pictures the book itself will generally be considered: its physical qualities such as paper and typeface, together with the technical aspects of design, layout, typography, inking, printing, and the like. A study of the working methods of individual artists is of especial value, offering an insight into the whole process of book production, as well as into the minds of artists, authors, publishers, and printers.[6] Correspondence, in particular, provides a rich and relatively untapped source of information. Primary sources indicate the number of wood-engravers who were drawn to book illustration (and the meticulous research that it often entails) from a genuine interest in literature and sometimes also in book design, not simply for financial reasons: this applied particularly to author-illustrators such as Eric Gill, Clare Leighton, and Robert Gibbings. Cultural trends emerge. The passages of text which artists chose and their mode of interpretation reveal as much about themselves as the publishers' choice of literature for illustration does about contemporary reading habits. Close inspection of the working relationship between artist and publisher discloses not only artistic and technical processes, but also social and economic factors such as marketing and fees, and the extent to which the illustrator's work and, more widely, the whole direction of wood-engraving were affected by the publishing business. The problem of their relative roles is best summed up by Christopher Sandford and Owen Rutter, joint owners of the Golden Cockerel Press:

The borderline of responsibility for the illustrations, as between the publisher and his selected artist, is often hotly contested. The artist wants a free hand, and to him his illustrations are the most important feature of the book. The publisher, however, recognizes the necessity for himself to coordinate the various aspects of the book he has designed. We believe that, when we have chosen the artist who we think will best illustrate a particular book, and when we have impressed on him our conception of the text and how it should be treated, then, but only then, our function ceases. When, as rarely occurs, the illustrations turn out, as we think, unsuitable, we blame only ourselves for having selected the wrong artist, or for having tried to illustrate what should have been printed plain. But we cannot say *for certain* that the illustrations are bad or unsuitable. The artist himself is a sensitive and artistically developed organism, whose perception may on occasion be more cognizant than our own.[7]

Book design, until recently, has resisted modernization more than any other art form. Certainly this applied in Britain before the Second World War, despite the many innovations brought about as a result of the typographical renaissance. George Nelson suggests that the reason for the static nature of the book is because, like the wheelbarrow,

[6] John Farleigh's chapter entitled 'Illustrating a Book' in *Graven Image* (London, 1940), 295–382, throws light on working procedure. For further discussion see Ch. 9.
[7] Source un-relocatable.

scissors, umbrella, or needle, it is a traditional object whose functional form was achieved years ago and and has not altered appreciably.[8]

Throughout this study it should be borne in mind that with book illustration the nature of the commission—generally to interpret a literary subject in a representational fashion—more often than not required a conventional approach. British taste for classic fiction and 'countryside' books was inevitably reflected in the way they were illustrated. As Clare Leighton admitted, 'working for book reproduction is distinctly hampering'.[9] Hence the dismissive view of many art historians that 'in the perspective of the history of painting, book illustration is usually regarded as a "minor art" which labours under the constraint of representing a set subject'.[10]

Yet, considering the restrictions placed on illustrators, the innovative wood-engraved book work of many was all the more remarkable and quite as exciting as that done for advertising, magazines, and posters in the inter-war years. Just as a number of painters were uninhibited by the boundaries of the frame, so illustrators found their own ways to overcome the limitations caused by the confines of the rectangular cover. Literary texts offered a variety of new subject matter, whilst the *mise en page* challenged both technique and style. To this extent illustrative work not only kept wood-engraving alive but was a governing factor in determining the stylistic direction of the medium. Through its use as illustration wood-engraving continued to maintain its traditional role as a means of communication, albeit in an individualistic and original manner largely denied to nineteenth-century reproductive engravers.

[8] George Nelson, Preface to *Books for Our Time*, quoted from an essay by William A. Bostick, 'Contemporary Book Arts and Their Roots', in Frances J. Brewer (ed.), *Book Illustration* (Berlin, 1983), 63. Using an analogy with architecture he arguably surmises that because 'book' like 'house' has come to mean something intractable and unchangeable, modern expressions in the graphic arts have been limited largely to advertising matter, posters, magazines, and catalogues.

[9] Clare Leighton, *Wood-Engraving and Woodcuts* (London, 1932), 95.

[10] Gordon Ray, *The Illustrator and the Book in England from 1790–1914* (Oxford, 2nd rev. edn., 1991), p. xv.

THE ENGLISH TRADITION: HISTORICAL
BACKGROUND UP TO *c.*1900

A key factor in the development of woodblock printmaking is its close interrelationship with printing technology. Throughout their history cross-fertilization between the two media has accounted for revolutionary technological changes, particularly in areas relating to the manufacture of paper and the introduction of new printing methods.[1] In turn such changes, coupled with social and economic factors, have radically affected their growth and progress. A study of woodblock printmaking up to 1900 reveals the extent to which its course was interwoven with that of printing and its natural ally illustration.[2]

Up till this time wood-engraving, like woodcutting from which it evolved, was largely used as a means of communication, to convey visual information and ideas as repeatable images to a mass public either as single prints or as book illustration.[3] Various styles and techniques were commonly adopted to suit both the medium and the market. Wood-engraved and indeed most other kinds of illustrated books were affected by the format of early printed books and, indirectly, manuscripts on which these were based. Structure, layout, and pictorial design including figurative scenes, decorative borders, historiated initials, and title-pages, all of which developed out of these early productions, became accepted formulae for the structural and compositional make-up of subsequent books. Despite the more creative, technically innovative approach of modern British wood-engravers, many of the pictorial conventions persisted into the twentieth century. Such a recurrence of themes and stylistic elements is evidence of the lasting impact of traditional woodcutting, especially on book illustration. It does not necessarily reflect an old-fashioned attitude to wood-engraving but, rather, an innate understanding of the intrinsic quality of the medium and its appropriateness for certain illustrative tasks. A survey of the historical background in Britain serves to reveal the common strands running through woodblock printing. More importantly it defines the way in which twentieth-century wood-engravers, drawing from the past, at the same time succeeded in breaking with tradition.

It is worth noting at this point the English traits, inherent in vernacular woodcuts, which permeate the country's art, most particularly its wood-engraving and book illustration. Despite the reliance of the early printers on foreign woodcut imagery,

[1] For the early years see in particular Elizabeth L. Eisenstein, *The Printing Revolution in Early Modern Europe* (Cambridge, 1983; repr. 1993).

[2] For a detailed investigation of the early background see Arthur M. Hind, *An Introduction to a History of Woodcut* (2 vols.; London, 1935; repr. New York, 1963); Douglas Percy Bliss, *A History of Wood-Engraving* (London, 1928; repr. 1964) is a useful survey of woodblock printing up to the early 20th cent.

[3] See William M. Ivins's seminal book *Prints and Visual Communication* (London, 1953).

certain characteristics evident in many of their illustrated books can clearly be traced to English illuminated manuscripts, and to contemporary art and architecture.[4] Stylistically, the distinctive black outline is not only imitative of continental woodcut style but also a natural development of linear design in which English artists have always excelled. A delight in surface patterning reflects decorative work such as the seventh-century *Lindisfarne Gospels*, and *opus anglicanum* embroidery. Geometrical black and white design is a feature of Tudor timber-framed houses. Small-scale pictures have had a continuous fascination, from the ornamented borders of manuscripts, through miniatures, to eighteenth-century watercolours. Observations of rural life, as exemplified by scenes from the *Luttrell Psalter* (*c*.1340), have remained popular themes, just as quirky figurative subject matter, evident in equal measure in misericords, popular prints, and caricatures, appeals to the British sense of humour. As will be seen, all these characteristics re-emerge in modern wood-engraving.

Historically, the concern for art as story-telling has always been part of the British cultural tradition. Consequently, perhaps more than in any other European country, illustration has largely been subordinated to the accompanying text. From the earliest years, a canon of literary works suitable for illustrating began to evolve, much of which remained popular into the twentieth century.

3.1. *Early English Woodcuts*

The introduction of printing with movable type a little over twenty years after its invention initiated the use of woodcut illustration in England where no tradition in this field previously existed. The general quality, however, was inferior to anything produced by the best craftsmen in Europe, and, initially at any rate, was considered of secondary importance by early printers, who often were more interested in the text itself and in keeping down the price of their books than with their presentation. Illustrations were mainly printed from foreign woodblocks or from copies of the originals and were generally of little artistic merit. Most of the earliest printed English books were translations of popular continental works. A large number of Books of Hours which had been specially printed for the English market were imported from France but they had little influence on indigenous woodcut style which remained singularly provincial, no doubt partly because the cutters were less experienced than their foreign counterparts, while the demands on them were less great.

William Caxton (*c*.1422–91) learnt his trade in the Low Countries, where illustration was not as advanced as in France and Italy, before setting up the first English press at Westminster in 1476. Primarily concerned to make unfamiliar literature available to

[4] See, in particular, Nikolaus Pevsner, *The Englishness of English Art* (London, 1956; repr. Harmondsworth, 1964 and 1976).

readers, his emphasis was on text rather than illustration, hence the small number of books which contain woodcuts. Simple and two-dimensional though many of these are, a strong decorative sense and feeling for black and white in relation to the black letter type is apparent from such books as *The Game and Playe of the Chesse*,[5] *Canterbury Tales*, *The Golden Legend*, and *The Subtyl Hystoryes and Fables of Esope*. Of the small devotional books, *The Fifteen O's* (1490) contains Caxton's only ornamental woodcut borders, adorned with birds, beasts, and flowers. Wynkyn de Worde (died 1534), his foreman, inherited his press in 1491, together with some of his woodcut blocks, many of which appear in de Worde's books alongside French and English cuts acquired later, showing little regard for uniformity. He believed rather more than Caxton did in the popularizing power of illustration. His most distinguished editions include Bartholomaeus Anglicus's *De Proprietatibus Rerum* (1495) with cuts copied from continental originals, Sir Thomas Malory's *Morte d'Arthur* (1498), and the first illustrated edition to appear in England of Manderville's *Travels* (1499) with woodcuts taken from a German translation printed in Augsburg in 1482.[6] Appointed the King's Printer in 1508, Richard Pynson (died 1530) was more concerned with the appearance of the printed page than either Caxton or de Worde. Probably his most important contribution was the introduction of the roman letter (*c.*1509) on which all modern printing types are based. His purchase of Holbein woodcut borders also had considerable influence on later English book design. He, too, published Chaucer's *Tales of Canterburie* (*c.*1492), and an edition of *Fables of Aesop* illustrated with Caxton's blocks, titles which continued to be favoured by modern wood-engravers. Standards of printing and woodcut illustration improved significantly towards the end of the sixteenth century, exemplified by the books printed and published by John Day. Foxe's *Book of Martyrs* (1563) contains probably the best interpretative woodcuts made in England up to that date.

Plate 3

Towards the end of the sixteenth century woodcutting in Britain, as throughout the rest of Europe, was gradually replaced by copper engraving for most illustrative purposes. However, the medium continued to flourish as a means of illustrating ballads, broadsides, and chapbooks well into the nineteenth century. Though originally produced for a less literate audience, these were subsequently bought and read by a much wider public.[7] The subject matter of chapbooks—slim, paper-bound volumes with small woodcuts interspersed in the text—was generally based on popular medieval romances and English legends, for example *Dick Whittington* and *Robin Hood*. The directness and simplicity of these cheap, crudely handled, black-line prints is particularly apparent in the rhyme sheets, songs and games, and many ABCs made for children. Such 'slovenly stamps', as Horace Walpole described them, nevertheless had a significant influence on later wood-engravers and book designers who revived the chapbook tradition. The style and subject matter of these popular prints, and indeed of early woodcut illustration in

[5] Caxton's first English edition was published in Bruges in 1474, the second edition in Westminster *c.*1483.
[6] He was the first London printer to use italic type and borders of type ornament.
[7] Political and satirical in connotation, broadsides in many ways were the forerunner of the tabloid newspaper and often contained sensational stories. For a fuller discussion of popular prints see Thomas Gretton, *Murder and Moralities: English Catchpenny Prints, 1800–1860* (London, 1980).

320. HISTORY OF QUADRUPEDS.

own kind, has been known to produce a mixed race, confifting of Hounds and Terriers.—We barely mention thefe, to fhew, that too much caution cannot be ufed in forming general characters or fyftematic arrangements; and we leave it to the experience of the moft inattentive obferver to detect fuch palpable abfurdities.

THE

Pl. 3 (*above*). Artist unknown: Jacobus de Cessolis, William Caxton (trans.): *The Game and Playe of the Chesse*, 2nd edition (William Caxton, c.1483). Woodcut. 102 × 122

Pl. 4 (*right*). Thomas Bewick: *A General History of Quadrupeds* (S. Hodgson and others, 1790). 206 × 124

general, reflect some of the earliest indigenous characteristics of English art which lie at the root of all British wood-engraving, albeit in a more refined manner.

In the seventeenth and eighteenth centuries for reasons of economy wood-engraved blocks were often used in place of expensive and less hard-wearing copper plates for ornamental initials which were subject to heavy wear through repeated use by publishers. The most distinguished examples were those introduced by Dr John Fell (1625–86) to the University Press at Oxford.[8] Balston claims William Howell's *Medulla Historiae Anglicanae* (1712) to be the first wood-engraved illustrations in England;[9] according to the Bookseller's Preface, these were used purely as an economy because 'copper would be more beautiful and more expensive'. In 1775, the Society for the Encouragement of Arts offered a prize for 'the best engraving on wood or type capable of being worked off with letterpress'; an indication of the growing recognition of wood-engraving as a respectable and potentially viable method of illustration.[10] The prize was won by Thomas Bewick, with five wood-engravings based on Elisha Kirkall's white-line prints for Samuel Croxall's *The Fables of Aesop and Others* (1722).[11]

3.2. *Thomas Bewick*

The achievements of Thomas Bewick (1753–1828), universally acknowledged to be the founding father of wood-engraving, are well documented.[12] Yet, ironically, the immense popularity of his wood-engravings, which for many practitioners, collectors, and critics alike remain the archetype, has in many ways been counter-productive to the cause of the modern movement. More significant than any stylistic influence are the lessons learnt from his innovative techniques. As a consequence of being in the right place at the right time, Bewick unwittingly instigated the revolutionary change that was needed to recharge the batteries of woodblock printing. Through his experiments he demonstrated the 'fitness for purpose' of wood-engraving for book illustration and in so doing popularized illustration in general and the medium in particular.

In 1767 Bewick began an apprenticeship with the Newcastle metal engraver, jeweller, and enamel painter, Ralph Beilby. Had he not acquired an understanding of workshop practices and gained experience, both technical and stylistic, in the intricate work

[8] Fell was Dean of Christ Church, Oxford, Vice-Chancellor of the University, Delegate and part-director (1672–90) of the Oxford University Press. See Stanley Morison, *John Fell: The University Press and the 'Fell' Types* (Oxford, 1967).

[9] Thomas Balston, *English Wood-Engraving, 1900–1950* (London, 1951), 4.

[10] In France Jean Baptiste Michel Papillon's attempts to proselytize wood-engraving in his *Traité historique et pratique de la gravure en bois* (3 vols.; Paris, 1766) were unsuccessful at the time.

[11] For a long time considered to be wood-engravings, these have now been proved to be relief metal cuts through evidence

of nail heads which pinned the plates to the block. G. C. Johnson, 'Croxall's Fables of 1722', *Book Collector*, 32 (1983), 315–22.

[12] See Sidney Roscoe, *Thomas Bewick: A Bibliography Raisonné of Editions of 'The General History of Quadrupeds', 'The History of Birds', and 'The Fables of Aesope', issued in his Lifetime* (Oxford, 1953; repr. 1973). In particular, see Montague Weekley, *Thomas Bewick* (Oxford, 1953), and (ed. and introd.), *A Memoir of Thomas Bewick written by Himself* (London, 1961); Iain Bain, *The Workshop of Thomas Bewick: A Pictorial Survey* (Newcastle upon Tyne, 1979; repr. Cherryburn, Northumberland, 1989).

required for engraving on copper and silver, Bewick might never have discovered the potential of white-line engraving. His familiarity with the small-scale work of trade engravers and with design conventions, such as the oval shapes and borders commonly used on trade cards and silver, doubtless inclined him towards using vignettes as head- and tailpieces, a practice pursued by many subsequent illustrators.[13] Newcastle upon Tyne was a renowned centre of printing and publishing, recognized especially for its output of popular literature. The expertise of fellow Novacastrians such as William Bulmer, one of England's finest printers, proved invaluable for Bewick.[14] A brief spell in London provided useful contacts in the book world, in particular the eminent engraver and book illustrator, Isaac Taylor, who encouraged him to illustrate and probably introduced him to eighteenth-century French rococo design.[15]

Plate 4

Bewick was quick to recognize the value of wood-engraving as a vehicle to instruct and moralize, and as a means to raise the standard of illustration in contemporary books, particularly those for children.[16] The relative cheapness of quality books illustrated with woodblocks made them accessible to a wider, newly literate public. Bewick's aim to communicate visual information based largely on his own observations is evident from his most important work: illustrations to *A General History of Quadrupeds* (1790) and the two volumes of *The History of British Birds* (1797 and 1804), all with text by Beilby. Doubtless the demand for these was increased by the vogue for natural history books following the publication of Gilbert White's *The Natural History of Selborne* in 1789.[17] More individualistic than his precise depictions of animals and birds are the tiny head- and tailpieces: humorous figurative scenes of country life reminiscent of the *Luttrell Psalter* imagery. Recognizing that the vignette was particularly suited to pastoral subject matter, Bewick transformed it into a new, more anecdotal form. In the course of his career he developed a style which particularly appealed to English taste and vision: scientific yet romantic, realistic yet picturesque, at the same time capturing the spirit of the subject matter.

First and foremost a craftsman, Bewick's most far-reaching achievements were technical, most notably the introduction of white-line wood-engraving. Though strongly influenced by the conventions of copper engraving, he did not imitate this technique. Rather, in an attempt to describe tone, or what he called 'colour', he studiously avoided the usual methods such as cross-hatching. His refined technique, with its use of certain formulae to describe trees and foliage, sky and clouds, fur and feathers, inadvertently prepared the way for the more facile tonal work of many of the nineteenth-century facsimile engravers. The high standards required to print his and his immediate fol-

[13] Most probably the vignette developed from the ornamental *cul de lampe*. The average size of Bewick's tailpieces was three inches by two—sometimes less.

[14] Bulmer (1757–1830), a native of Newcastle, had established the Shakespeare Printing Office in St James's, London in 1790, under the firm of W. Bulmer and Co.

[15] Taylor was a pupil of the French engraver Hubert Gravelot (1699–1773) who worked for twenty years in England.

[16] His earliest work in wood was for illustrations to various unsophisticated children's story books and reading instructors, principally for the Newcastle printer Thomas Saint.

[17] According to Bewick (Weekley, *A Memoir of Thomas Bewick*, 131), the drawings and copper engravings for White's book 'much pleased' him. Some of the illustrations were copied from woodcuts from Count de Buffon's *Histoire naturelle* (published in 15 vols., 1749–67, and first translated into English in 1775) with the ironical result that they were far from accurate representations.

lowers' intricate, white-line cuts inevitably led to improvements in printing technology.[18] Not himself a printer, Bewick was nevertheless aware of the importance of good presswork. In the early days, in order to overcome the problem of lack of precision when printing with wooden presses, he devised a technique of lowering the block in the areas which needed to appear lighter. He took care to train pressmen to ink and print his engravings, often supervising the printing himself. Though the final results were not always perfect, mainly owing to problems with paper[19] (perennial difficulties which, as will be seen, continued to bother modern wood-engravers), his move from laid paper to smooth wove paper[20] (which he first used in *Quadrupeds*) not only helped to improve the quality of printing but made the use of such fine work economically practical.

Bewick's most valuable service to wood-engraving was to popularize illustration. Modern practitioners directly or indirectly owe their existence to illustrated books, the demand for which arose from the revolutionary technological advances following his discoveries.

3.3. *The Victorian Reproductive Engravers*

Bewick's apprentices, among them his brother John, his son Robert Elliott, Luke Clennell, Charlton Nesbit, William Harvey, Ebenezer Landells, and John Jackson, acted as a link between Newcastle and the London book trade. They designed many of their own blocks but for commercial reasons their successors reverted entirely to reproductive engraving. Technological changes had turned woodblock printing into a thriving industry—an essential medium for the dissemination of pictorial information, a role later assumed by photography. The capability of mass producing wove-surface paper had enormous repercussions,[21] but the invention which most affected the progress of wood-engraving was the power-driven cylinder printing press (as opposed to the hand-operated platen screw-press) devised by Frederick Koenig, a German resident in England, and first used to print *The Times* on 29 November 1814.[22] By speeding up the whole process of printing, mass-produced books became a commercially viable proposition. Following

[18] Two of William Bulmer's publications, *Poems by Goldsmith and Parnell* (1795) and Somervile's *The Chase* (1796), to which Thomas Bewick contributed set out specifically to 'raise the Art of Printing'. The latter was renowned for its high standard of typography, printing, and paper.

[19] Proper conditioning (i.e. dampening) of paper to be printed was essential. Bain, *The Workshop of Thomas Bewick*, 36, points out that in Bewick's books alternate openings are often more weakly printed, probably due to the paper drying out before the back-up impression was taken.

[20] First manufactured in England by James Whatman in *c*.1756 to replace the grainier, laid variety. See Jacob Kainen, 'Why Bewick Succeeded: A Note in the History of Wood Engraving',

in 'Contributions from the Museum of History and Technology' in *United States National Museums Bulletin*, 218 (1959) 186–201.

[21] A power-operated paper-making machine, the first on which it was possible to make a continuous roll of paper, was invented in France in 1798 and perfected in England by Henry and Sealy Fourdrinier in 1806.

[22] The rate of production of *The Times* was increased to 1,100 impressions an hour as compared with the maximum of 250 of the hand-operated Stanhope press, the first iron printing press. See Colin Clair, *A History of Printing in Britain* (London, 1965), 212–14. By the middle of the 1860s, in the trade only expensive gift books were printed by hand press.

the publication in 1832 of Charles Knight's weekly *Penny Magazine* with wood-engraved pictures, illustrated periodicals burgeoned: *The Saturday Magazine, The Illustrated London News, The Graphic, Punch, The Cornhill Magazine*, and *Good Words*, to name but a few. Social and economic factors, such as the sharp rise in population, increased literacy, and the availability of cheaper publications, contributed to the growth of production of both periodicals and books. As a result of the increasing demand for rapidly produced illustration, a vast body of professional wood-engravers sprang up. Many had Bewick or Northumbrian connections, as had several of those who developed and controlled the increasing number of engraving firms to service the industry, the Dalziel Brothers in particular. Most engravers worked in total anonymity, either cutting drawings done by artists direct on to the block, or translating the tone from the artists' pencil and wash drawings with immense skill but with little scope for individuality—a return to black-line facsimile work and a division of labour that echoed Renaissance workshop practices.

Emphasis was on speed and quantity rather than on quality. In order to hasten publication Victorian publishers often employed several different firms to engrave separate blocks for a particular book. Frequently very large illustrations were required for magazines, in which case a number of small blocks were bolted together for the design to be drawn on the surface. The blocks were then distributed to various engravers before being put together and completed by a master engraver. From about 1830 stereotypes were often made to avoid damaging the original block through pressure from the presses. A plaster cast taken from the block was used as a mould in which type metal was poured to harden and produce an exact duplicate. The most successful method of duplication, developed in about 1839 by Thomas Spencer of Liverpool and others, was the electrotype. In this technique a wax mould of the block was taken and a copper skin deposited on it by electrolysis; this formed the face of the plate. This important invention became the most common method of printing wood-engravings commercially from the second half of the nineteenth century until well into the next.[23]

Much has been written on the technology and cultural significance of Victorian reproductive wood-engraving.[24] Its development is only relevant to the modern period in that the refinement of tonal technique and the subsequent demise of the medium owing to the introduction of photomechanical processes account for the swing back to creative, autographic wood-engraving at the beginning of the twentieth century. For this reason only a few salient points are discussed here.

The most distinguished wood-engraved illustration was produced between about 1850 and 1870. This graphic movement, known as The Sixties, which included artists of the Idyllic or Open Air school such as George Pinwell, Arthur Boyd Houghton, Frederick Walker, J. W. North, and George du Maurier, was dominated by the Pre-

[23] For further discussion on printing methods see Geoffrey Wakeman, *Victorian Book Illustration: The Technical Revolution* (Newton Abbot, 1973).

[24] See, in particular, Percy Muir, *Victorian Illustrated Books* (London, 1971; rev. edn, 1989), and Paul Goldman, *Victorian Illustrated Books, 1850–1870: The Heyday of Wood-Engraving* (London, 1994) and *Victorian Illustration: The Pre-Raphaelites, the Idyllic School and the High Victorians* (Aldershot, 1996).

Raphaelites.[25] The drawings of Dante Gabriel Rossetti, Frederick Sandys, Arthur Hughes, and John Everett Millais, in particular, were admirably suited for translation into wood-engraving. Two designs from Tennyson's *Poems* published by Edward Moxon in 1857, Millais's *Saint Agnes' Eve*, and Rossetti's *Saint Cecilia*, with large elongated figures confined *Plate 5* into a small space, strong contrasts of light and shade, and emotional intensity, display characteristics of the early Pre-Raphaelite style which were to influence many later illustrators. Millais's later work, especially that for *Good Words*, became looser and more impressionistic. In a similar vein to Charles Keene's etchings, his free-flowing line was less suited to wood-engraving. The Pre-Raphaelites were essentially literary artists and their emphasis on narrative illustration was a potent influence on modern wood-engravers.

The use in the 1860s of a method of photographing drawings on to a block for engraving in effect moved the final product another step away from the artists' original intention, since the size of the image could be altered. But it was the introduction of photomechanical processes that ultimately spelled disaster for wood-engraving. A number were developed, including collotype, photo-engraving, half-tone, and line-block, the last of which could accurately reproduce a pen and ink line.[26] The 1880s witnessed the change from manually engraved illustration to photographic repro-duction. By the turn of the century the course of woodblock printing had once again radically altered, causing one of the brothers Dalziel to admit sadly that 'we have to bow to the new light which we had long felt would come ... we feel that our occupation is gone'.[27]

3.4. *William Blake and Edward Calvert*

During the time that wood-engraving developed and declined commercially, a few independent-minded artists successively managed to keep the flame of autographic wood-engraving alight. That their influence was disproportionate to the size of their output is most clearly evidenced from the effect that William Blake's few minute wood-engravings had on his successors.[28] The impact of these prints was such that Blake (1757–1827) could be said to rival Bewick in importance as a catalyst.

Though essentially a metal engraver, Blake produced seventeen wood-engraved

[25] See, in particular, Rodney Engen, *Pre-Raphaelite Prints* (London, 1995), and Goldman, *Victorian Illustration*.

[26] With process engraving 'a drawing or photograph could be projected on to a photo-sensitized metal plate and then etched into the metal in such a way that the surface would hold enough ink to give a printed impression, either intaglio or relief' (Walter Chamberlain, *Manual of Wood Engraving* (London, 1978), 40). For descriptions of processes see also John R. Biggs, *Illustration & Reproduction* (London, 1950) and Wakeman, *Victorian Book Illus-tration*.

[27] George and Edward Dalziel, *The Brothers Dalziel: A Record of Fifty Years' Work, 1840–1890* (London, 1901), p. vii.

[28] In the exhibition catalogue, *William Blake: Wood Engravings for Dr Robert Thornton's Third Edition of Virgil's Pastoral Poems 1821* (Exeter: Exeter University, Oct.–Nov. 1977), C. G. Campbell lists the Blake-inspired work of 20th-cent. wood-engravers including Eric Gill, D. P. Bliss, Blair Hughes-Stanton, Gwen Raverat, and Ralph Chubb.

Plate 6 blocks for the third edition of Dr Robert Thornton's schoolbook, *The Pastorals of Virgil* (1821).[29] Rhythmic figures softly illuminated by prominent suns and moons evoke a mystical quality and intensity of spirit which is absent from Bewick's earthy rural scenes. In comparison with Bewick's painstaking tonal rendering, Blake's crudely handled white line and his heavy blacks appear startlingly modern and expressive. The importance of these works was later recognized by those artists who appreciated freer, more imaginative wood-engraving. As Basil Gray observed, Blake was 'the first Englishman to make the print the vehicle of universal themes'.[30]

The idyllic mood of the *Virgil* woodblocks had a profound affect on The Ancients— a group of visionary artists in the circle of Samuel Palmer (1805–81), who, inspired by the countryside round Shoreham, Kent, painted romanticized pastoral landscapes.[31] Edward Calvert (1799–1883) produced seven diminutive wood-engravings, all executed in an extraordinarily meticulous technique: with several different tools he evolved a wide range of tones, from black to silvery-grey, using flicks and dots reminiscent of *manière criblée*.[32] His masterpiece, *The Chamber Idyll* (1831), a rustic honeymoon scene, is one of the most evocative images in the history of British printmaking. David Cecil notes that 'Calvert's vision of the Golden Age differed from Palmer's and Blake's, in that it centred around sex; sex glorified and idealised, tender, innocent and passionate'.[33] This is a significant factor which anticipates the particular interest in the nude figure shown by a number of twentieth-century wood-engravers. Though not specifically for book illustration, Calvert's work was undoubtedly influential on later illustrators in the way in which it combined Christian and pagan elements with pastoral and sensual qualities.

3.5. *Joseph Crawhall, William Nicholson, and Edward Gordon Craig*

The robust style of Joseph Crawhall, William Nicholson, and Edward Gordon Craig was in complete contrast to the sensitive romanticism of Blake and Calvert. Joseph Crawhall the Elder (1821–96) was another native of Newcastle, whose illustrations in *Plate 7* books such as *Chap-book Chaplets* and *Old ffrendes wyth Newe Faces* (both printed on coarse buff paper and published in 1883) are modelled on English ballad and chapbook designs, and possibly also on manuscript drawings and early woodcuts.[34] Crawhall's boldly cut

[29] Twenty images were originally engraved in groups of four on single woodblocks. Thornton objected to Blake's designs which he felt displayed 'less art than genius'. He arranged for them to be recut by professional engravers but only three were replaced. Blake's blocks were cut down to fit the width of the page. See n. 28 and Geoffrey Keynes, Introduction to *The Illustrations of William Blake for Thornton's Virgil* (London, 1937).

[30] Basil Gray, *The English Print* (London, 1937), 85.

[31] Samuel Palmer's only wood-engraving, *The Harvest* (c.1826), was not for book illustration.

[32] A method of making relief metalcuts with punched decoration, probably derived from the practice of medieval metalsmiths, particularly niellists.

[33] David Cecil, *Visionary & Dreamer: Two Poetic Painters: Samuel Palmer & Edward Burne-Jones* (London, 1969), 53.

[34] See Edward Hodnett, *Five Centuries of English Book Illustration* (Aldershot, 1988), 148.

Pl. 5. Dante Gabriel Rossetti: *Saint Cecilia* for 'The Palace of Art'
from Alfred, Lord Tennyson, *Poems*, known as *The Moxon Tennyson*
(Edward Moxon, 1857). 93 × 80

Pl. 6. William Blake: *Colinet and Thenot* from *The Pastorals
of Virgil*, edited by Dr Robert Thornton (F. C. &
J. Rivingtons and others, 1821). 32 × 72

NEVER a word fpak' bonnie Jeanie
 Roole,
 But---" Shepherd let us gang : "
An' never mair, at a gloamin' buchte
Wad fhe fing another fang.

Pl. 7. Joseph Crawhall: *Old ffrendes wyth Newe Faces* (Field & Tuer, 1883). 154 × 97

designs and comic inventiveness qualify him as 'the first engraver to be artfully naive and deliberately unaccomplished'.[35] A meeting with Andrew Tuer, publisher and owner of the Leadenhall Press and historian of popular literature, led to many commissions in the 1880s. Here for the first time illustrator and publisher can be seen working hand in hand to match type with woodblock, both in weight and style, with a real feeling for the *mise en page*. The use of heavily cut type in conjunction with equally solid woodblocks became a feature of certain German Expressionist books. But, apart from Paul Nash's *Genesis* (1924), the method was rarely exploited by the more conservative pre-Second World War British publishers and printers.

Crawhall's adventurous approach to wood-engraving was carried a step further by William Nicholson (1872–1949).[36] Like Crawhall, he appreciated the primitive qualities of the medium with the possibilities it afforded for contrasts of dark and light. But, as a painter, his daring use of large flat areas of black and white was more sophisticated, influenced as he was by the French poster art of Toulouse-Lautrec, in particular, and by Japanese prints.[37] In 1894 he joined forces with his brother-in-law, James Pryde (1866–1941). Under the pseudonym 'J. & W. Beggarstaff' they produced posters of revolutionary simplicity and boldness which greatly influenced commercial design. Nicholson's introduction by Whistler to the publisher William Heinemann in 1896 led to important commissions, especially *An Alphabet*, *The Almanack of Sports*, and *London Types* (all published in 1898). His large, square, whole page designs are coloured by hand for limited editions and by lithographic methods for trade editions. Though they resemble woodcuts, they are in fact cut with a graver on the end grain, hence the density of the blacks.[38] The influence of Crawhall's chapbook style can be seen in Nicholson's own hand-cut types used, in some cases, as accompanying text. Nicholson's experiments with combining wood-engraving and lithography anticipated modern printing methods. His simplification of design was perhaps more influential on European graphic art than on British book illustration.

Plate 8

Edward Gordon Craig (1872–1966), one of the most unorthodox of British wood-engravers, was profoundly affected by Nicholson's art. Son of the actress Ellen Terry and the architect Edward Godwin, Craig began his career as an actor. Lessons from Nicholson inspired him to use wood-engraving as a means of expressing his ideas on theatre and art; he realized its potential to evoke the synthesis of light and dark, form and movement that he aimed for in his stage and costume designs. Whistler's monochromatic colour schemes and emphasis on form may well have had an influence.

Craig enjoyed especially the spontaneity of making a rough drawing on the block

[35] Bliss, *A History of Wood Engraving*, 177. A letter dated '1882' in which Crawhall mentions 'a passion for wood-engraving' suggests that some of his work could be engraved rather than cut. The author is grateful to Barrie Marks for allowing access to this correspondence.

[36] See Colin Campbell, *William Nicholson: The Graphic Work* (London, 1992).

[37] Between 1889 and 1890 he had studied at the Académie Julian in Paris.

[38] For a fuller description of his technique see Edward Anthony Craig, *William Nicholson's 'An Alphabet': An Introduction to the Reprint from the Original Woodblocks* (Andoversford, 1978), 4–5.

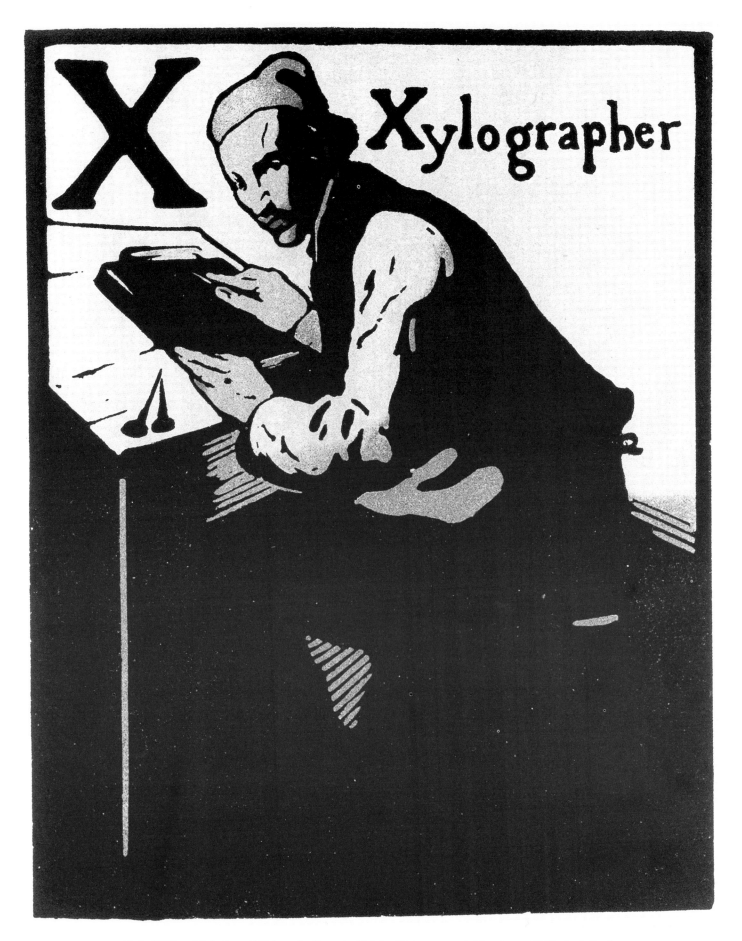

Pl. 8. William Nicholson: *X Xylographer* from *An Alphabet* (Heinemann, 1898). 248 × 197. © Elizabeth Banks

and then varying the design and working up details as he engraved. Like Nicholson he eschewed reproductive methods, particularly cross-hatching, to achieve tonal effects. Many of his prints evolved as a result of tireless experiments: techniques used for his early wood-engravings included speckled dot work in the style of *manière criblée* prints, and white lines combed against flat black areas. Prominent use of black, frequently offset against stark white or varying shades of grey, is perhaps the most startling aspect of his work at this time.[39] Craig's comments in *Woodcuts and Some Words* on his favourite *Plate 9* print, *Pyramid*, reveal his stylistic objectives: 'If I have an ideal in wood-engraving, it is to make my black line and my white spaces so equal in their strength that a strong grey is achieved. And I would like my black line to be about as thick as the capital letter I used on this page.'[40] The emphasis on dominant forms and masses apparent in many of his prints is derived from the illustrative work of Nicholson whose influence can be seen in the flat blocks of hand-colouring and square format used for the designs (mostly wood-engraved) for *Gordon Craig's Book of Penny Toys* (1899).

The prodigious output of around two hundred wood-engravings which Craig produced between 1898 and 1900 includes some remarkable studies of literary and historical figures, among them portraits of distinguished actors. For *Henry Irving as Dubosc in 'The Lyons Mail'* (1898), for example, he used a combination of black outline, massed blacks and whites, and a series of bold parallel lines as background. Many of his small, vignette-like landscapes and figurative scenes, which were more tightly handled than his later work, were used to decorate the various journals he designed and edited, in particular *The Page* and *The Mask*. For typographical inspiration he looked to Leadenhall rather than to Kelmscott, preferring to use everyday type and rough papers, his page designs retaining characteristic 'foursquare solidity'; for him 'thick black line and the style of the street seemed best'.[41]

The innovative woodblock prints of Blake, Calvert, Crawhall, Nicholson, and Craig were isolated examples in a sea of nineteenth-century reproductive work. Though differing in outlook, these artists shared a belief in the creative potential of the medium and proved it to be one of the most expressive forms of printmaking. Despite their valuable contributions to books, their influence was on the whole more decisive on style and technique in general than on illustration in particular. With careers that straddled the divide between the nineteenth and twentieth centuries, Nicholson and, most especially, Craig acted as vital links between traditional and modern practitioners.

[39] The modernity of his approach can be seen from his statement that 'the black as used by Vallotton or Nicholson or Crawhall is gay enough for me—perfectly glorious, but it would have depressed Mr Ruskin beyond all words' (Edward Gordon Craig, *Woodcuts and Some Words* (London, 1924), 117).

[40] Ibid. 118–19.

[41] Colin Franklin, *Fond of Printing: Gordon Craig as Typographer & Illustrator* (London, 1980), 38–9. Franklin considers that *The Page* represents an anti-art or anti-aesthete approach to printing.

Pl. 9. Edward Gordon Craig: *Scene* (1908) reproduced in
Woodcuts and Some Words (J. M. Dent, 1924). 127 × 84

3.6. *William Morris and the Arts and Crafts Movement*

The role that William Morris (1834–96) and the Arts and Crafts movement played in the revival of original wood-engraving was crucial. At a time when photomechanical processes were rendering wood-engraving commercially unviable, their championship of fine book production encouraged the use of the medium for illustration in hand-printed books. A brief assessment of their achievements should help to explain the impetus behind the early twentieth-century craft revival, the founding of new art schools, notably the Central School of Arts and Crafts, and more especially the typographical renaissance, all vital factors for the survival and development of wood-engraving.

The Arts and Crafts movement stemmed from a widespread dissatisfaction with the quality of manufactured goods and a nostalgic admiration for the works of medieval craftsmen and their guilds and apprentices. For Morris and other like-minded designers the new technology had taken its toll, not least on individual workmanship. Their intention was to raise the status of craftsmen to that of artist. In October 1884 the Art-Workers' Guild was founded by a group of architects, pupils, and assistants to Richard Norman Shaw, to create a forum where architects could meet artists and craftsmen with the purpose of unifying the various arts of painting, sculpture, architecture, and design. The most valuable contribution of the Guild was its offshoot, the Arts and Crafts Exhibition Society, which started in 1888 and developed into a valuable showcase for the Arts and Crafts movement. Among other exhibits it included examples of fine printing, typography, and illustration. Many of the best designers and craftsmen of the day exhibited and works from other guilds were included, notably C. R. Ashbee's recently formed Guild and School of Handicraft. The exhibition catalogues contained articles by W. R. Lethaby, Reginald Blomfield, Walter Crane, and T. J. Cobden-Sanderson among others. In the preface to the catalogue of the first exhibition in 1888 Crane summed up the society's philosophy as that 'the true root and basis of all Art lies in the handicrafts'—a sentiment close to the heart of wood-engravers.[42]

A lecture entitled 'Letterpress Printing and Illustration' given by Emery Walker at this exhibition heralded the foundation of the private press movement. William Morris was present and was so enthralled by the enlarged examples of fifteenth-century Italian type thrown up by the lantern slides that he determined to design his own type;[43] he had been dissatisfied with the balance between type and wood-engravings in the edition of *Earthly Paradise* which he had been planning since 1865, and also with the printing of his books by the Chiswick Press.[44] Consequently, in 1891 he set up his own 'little

[42] Walter Crane, Preface to *Catalogue of the First Exhibition of the Arts & Crafts Society* (1888), 7–8.

[43] Walker showed photographic enlargements of lines from Morris's copy of Aretino's *Historia Fiorentina*, printed in 1476 in Venice by Jacobus Rubens. See John Dreyfus, 'A Reconstruction

of the Lecture Given by Emery Walker on 15 November 1888', *Matrix*, 11 (1991), 27–52.

[44] The Chiswick Press was one of the finest 19th-cent. presses. Its books, many of them printed by Charles Whittingham, are notable for their simplicity and readability.

typographical adventure',[45] the Kelmscott Press, with Emery Walker as adviser and William Bowden as pressman.

It is generally acknowledged that Morris more than anyone else was responsible for the revival of interest in fine printing and typography, but Walker's importance is often overlooked.[46] He was a shy, reticent man with a vast knowledge of early printing and a practical understanding of all aspects of the printing trade. His famous lecture was later included in *Arts and Crafts Essays* (1893) entitled *The Revival of Printing* and should be considered the first definitive statement of the printing revival.

Morris's own theories on the Book Beautiful, many of which were borrowed from Walker, were propounded in three principal works, *The Ideal Book* (1893), *Essay in Printing* (1893), and *A Note on the Aims of Founding the Kelmscott Press* (1898). His conception of the book as a composite of architectural elements echoes the unifying philosophy of the Art-Workers' Guild.[47] Emphasis on the importance of good workmanship, materials and tools, the fusion of the various parts of the book as a whole, and the integration of type, text, and illustration came to be accepted as the conventional aesthetic of book design during the twentieth-century typographical renaissance.

The Kelmscott Press is best remembered for its few elaborately ornamented books, their design inspired by illuminated manuscripts and early printed books. Several share the same format, as exemplified by the press's most successful production, *The Works of*
Plate 10 *Geoffrey Chaucer* (1896), in which each two-page spread is treated as a single unit.[48] As a decorator rather than an illustrator, Morris designed the borders and initials, title-page, inscriptions, and printer's mark. His chief illustrator Edward Burne-Jones produced eighty-seven pencil drawings which were cut by W. H. Hooper, one of the old school reproductive wood-engravers.[49] Despite his aversion to modern processes, Morris accepted that a photographic method should be used to transfer the designs on to the blocks.[50] It is an irony, therefore, that the painstaking preparation of the drawings by various hands which this process required should have tautened Burne-Jones's fluent line.

Such was the impact of Morris's revivalist black-line style, based on medieval and Italian Renaissance woodcut illustration, that it attracted many imitators; draughtsmen even began to copy the style in pen and ink for photomechanical reproduction. The decorative aspect of the pages with their tapestry-like patterning and use of ornamental

[45] This was Morris's description when offering Bowden his post. See Roderick Cave, *The Private Press* (2nd rev. edn., New York and London, 1983), 106.

[46] For an assessment of Walker's achievements see Dorothy A. Harrop, *Sir Emery Walker 1851–1933* (London, 1986); Colin Franklin, *Emery Walker: Some Light on His Theories of Printing and His Relations with William Morris and Cobden-Sanderson* (Cambridge, 1973). For further discussion see Ch. 6.1.

[47] Morris's convictions were affirmed by Cobden-Sanderson in *The Ideal Book or Book Beautiful* printed by the Doves Press in 1900.

[48] Morris's ideas and working methods are well documented,

notably by William S. Peterson, *The Kelmscott Press: A History of William Morris's Typographical Adventure* (Oxford, 1991).

[49] As well as several ornamental designs, Morris occasionally cut illustrations himself, rare examples of which are some of the blocks for Burne-Jones's designs for *The Story of Cupid and Psyche* (not published until 1974).

[50] Emery Walker introduced a photographic process known as platinotype. He also persuaded Morris to use electrotype to reproduce his designs for initials and ornaments. For a fuller description of the transfer procedure see Duncan Robinson, *William Morris, Edward Burne-Jones and the Kelmscott Chaucer* (London, 1982), 33–4.

Pl. 10. Edward Burne-Jones and William Morris: *The Works of Geoffrey Chaucer* (Kelmscott Press, 1896), 420 × 570

borders most probably influenced wood-engravers such as Gwenda Morgan, Eric Ravilious, Eric Gill, and Robert Gibbings.

Morris's exacting standards and his painstaking attention to detail were an example to many subsequent private press owners, as was his insistence on supervising every aspect of book production.[51] His meticulous research and knowledge of early printing, and the design of his own typefaces encouraged a greater awareness of typography and stimulated much literature on the subject.[52] The printing revival which began in the 1890s and 1900s was led in America by Daniel Updike and Bruce Rogers, and in England by Cobden-Sanderson and Emery Walker with the Doves Press (founded in 1900). New publishing firms also emerged producing machine-printed books in a pseudo-Kelmscott style. Yet despite the many publishers and printers who were inspired by Morris's book work, his characteristically overcrowded and elaborate page layout had comparatively little influence on British typographers and printers of the 1920s and 1930s who were mostly aiming at clean, functional design. Their interest lay rather in the Morrisian ideal of the Book Beautiful. However, the luxuriousness of the Kelmscott books made them accessible to only a few, thereby negating Morris's socialist theories about art and crafts for the working man.

Perhaps the most far-reaching outcome of the Arts and Crafts movement was the formation of new art societies and schools throughout the country. One of the first of the municipal art schools was the Birmingham Central School of Arts and Crafts, founded in 1884 under the direction of E. R. Taylor who introduced the teaching of drawing and crafts side by side. A distinctive Birmingham school of painters and craftsmen evolved and much interesting book illustration was produced, although, as Ian Rogerson suggests, 'the artistic and literary preoccupation with medievalism… appeared to hang on in Birmingham rather longer than elsewhere'.[53]

Arthur Gaskin, Charles Gere, and Bernard Sleigh, all teachers at the School of Arts and Crafts, were illustrators in the black-line tradition, their wood-engravings easily confused with some of their line drawing work. Gaskin provided a link with Morris through his designs for the Kelmscott Press *The Shepheardes Calendar*, while Gere worked for C. H. St John Hornby's Ashendene Press.[54] Gaskin's pupil Bernard Sleigh (1872–1954) was perhaps the most original wood-engraver of the trio. Trained as a trade engraver, his work is of particular interest since it bridges the gap between nineteenth-century reproductive and twentieth-century creative wood-engraving. As a teacher and writer on the subject he provided a valuable link between the two traditions. His attempt at balancing black-line illustration with textual lettering in Amy Mark's *The Sea-King's*

[51] He had paper specially made by Joseph Batchelor to a Bolognese model of 1473, vellum supplied by Henry Bland of Brentford, and ink made from special old-fashioned pure ingredients by Jaenecke of Hanover.

[52] Morris's three founts were Golden Type (based on Nicholas Jenson's roman letter of c.1476) and Troy and Chaucer (both Gothic in character); his Subiaco type was abandoned.

[53] Ian Rogerson, 'The Origins and Development of Modern British Wood-Engraved Illustration', Ph.D. thesis (University of Loughborough, 1984), 92. Morris had been President of the Birmingham Society of Arts, Burne-Jones had strong connections with the city, and affluent new industrialists and professional classes particularly favoured Pre-Raphaelite works.

[54] Founded in 1894. Hornby, a partner in the firm of W. H. Smith, encouraged links between the arts and crafts and the business world. See Ch. 6.

Daughter (1895) is especially successful.[55] Between 1894 and 1896 the School of Arts and *Plate 11*
Crafts produced a house journal entitled *The Quest*. Each issue was decorated with
illustrations, borders, and vignettes by the leading members of the school: Arthur
Gaskin, Georgina Cave (Mrs Gaskin), Charles Gere, E. H. New, Sidney Meteyard, Bernard
Sleigh, Henry Payne, Mary Newill, and Joseph Southall. Significantly Payne's cover
design for volume 1 is similar in style to Selwyn Image's radical woodcut design for the
cover of the Century Guild's journal *The Hobby Horse* (April 1884) which anticipates art
nouveau—one of many examples of cross-fertilization between the Arts and Crafts
movement and art nouveau.[56]

The Birmingham Central School did little directly to further original white-line
wood-engraving although its many well-designed, small-scale publications may have
had an influence on commerical publishers. More importantly, however, it harboured
an interest in printing which was to be revived by Leonard Jay at the Birmingham
School of Printing of which he was the first Head in 1925.[57]

Out of the growing interest in printing, typography, and book design created by
Morris and the Arts and Crafts movement and nurtured by the private presses sprang
wood-engraving as a creative art form.

3.7. *The Vale Group: Charles Ricketts, Lucien Pissarro, and Thomas Sturge Moore*

In his *A Defence of the Revival of Printing* Charles Ricketts (1866–1931) explained his direct
approach to wood-engraving: 'No discussion is needed to prove that the final carrying
out of design by the designer is a desirable thing in itself; you will see how the "warmth"
of the line may be preserved thereby, how the entire substance of the design will be
knit or welded in a way that cannot be obtained otherwise.'[58] Certainly Ricketts's
engraved lines are more spontaneous than those of the facsimile engravers whom
Morris chose for the Kelmscott books. Yet, despite his seemingly artistic approach, his
wood-engravings, though cut by him, merely reproduce his black-line drawings and
lack tonal variety. In other words, neither he nor Morris understood the true nature of
wood or its creative potential. As designers of hand-printed books, they acknowledged
the suitability of wood blocks but used them in a retrograde way to express the con-
trasting styles of art nouveau and Arts and Crafts.[59]

John Russell Taylor in *The Art Nouveau Book in Britain* suggests that there is much
common ground between the two movements, not the least in their revivalist

[55] Sleigh cut the blocks with L. A. Talbot and the book was
printed at the Birmingham Guild of Handicraft Press.

[56] Arthur Mackmurdo founded the Century Guild in 1882, with
the aim of raising crafts to a similar status as painting and sculp-
ture. The Birmingham Guild of Handicraft was an offshoot. *The
Hobby Horse* was edited by Mackmurdo, with typeface by Herbert
Horne and woodcuts by Selwyn Image.

[57] See Ch. 6.1.

[58] Charles Ricketts, *A Defence of the Revival of Printing* (London,
1899), 32.

[59] Stephen Calloway, *Charles Ricketts: Subtle and Fantastic Decorator*
(London, 1979) contains useful chapters on Ricketts's book work.

Pl. 11. Bernard Sleigh: Amy Mark. *The Sea-King's Daughter* (Birmingham Guild of Handicraft Press, 1895), 242 × 366

tendencies.[60] The refined, highly mannered art nouveau is more sophisticated and
eclectic than the solidly craftsmanlike Arts and Crafts style: the sinuous line of the
former reflects the aesthetic of Blake or continental symbolism rather than of medieval
art. Art nouveau designers, Ricketts in particular, respected the white page, with the
result that their books are on the whole much lighter and airier in effect than Arts and
Crafts productions.

Ricketts's love of white space is particularly apparent in *Daphnis and Chloe* (1893). *Plate 12*
His illustrations were unashamedly based on the black-line woodcuts for Francesco
Colonna's *Hypnerotomachia Poliphili* which was printed by Aldus Manutius in Venice in
1499.[61] The importance of this book lies in the fact that it was the first in modern times *Plate 13*
to be designed throughout by the same artists who drew and cut its wood-engravings.
From 1896 to 1904 Ricketts managed the Vale Press with his partner Charles Shannon
(1863–1937) from their house in Chelsea. In 1889, the same year that the Kelmscott Press
was founded, the two men issued their first independent artistic statement, *The Dial*,
which ran till 1897. As an outlet for contemporary original wood-engraving ('printed
from the wood') and lithography it was quite unlike any previous illustrated magazine,
with contributions by Thomas Sturge Moore and Lucien Pissarro among others. Trained
as a reproductive wood-engraver,[62] however, Ricketts's backward-looking approach to
the technique was of little interest to later practitioners.

None the less Vale Press books, their decorative borders and illustrations closely
linking them to Morris's work, were much admired. Through his early work as a book
designer with various commercial companies Ricketts gained a sound knowledge of
typography and book production. He later had types cast to his own design—Vale,
Avon, and King's—though he never owned a printing press himself and continued to
use trade printers, the Ballantyne Press, to set and print his books under his strict
supervision. His willingness to co-operate with commercial publishers and to design for
them set him aside from fellow private press owners.[63] The idiosyncratic typographical
arrangements of James McNeill Whistler (1834–1903) and his unusual disposition of
black and white on the page affected Ricketts's approach to book design, if not directly,
then via Oscar Wilde's interest and publications.[64]

In 1898 Ricketts collaborated with Lucien Pissarro in writing an essay for the press
entitled *De la typographie de l'harmonie de la page imprimée; William Morris et son influence sur
les arts et métiers*. This treatise was significant since it was the first in Britain 'to go beyond
the Morris-Walker canon and to show the influence of the new ideas on both functional

[60] John Russell Taylor, *The Art Nouveau Book in Britain* (London, 2nd edn., 1979), 56–7.

[61] This book, an object lesson in typographical design, *mise en page*, and presswork, and a model for many later book designers, had been rediscovered in the 1870s and reproduced in a facsimile edition in England in 1888.

[62] In 1882 he was apprenticed to Charles Roberts at the recently founded City and Guilds of London Institute for the Advancement of Technical Education where he met Shannon. In *Self Portrait: Letters and Journals of Charles Ricketts, RA, Collected & Compiled by T. Sturge Moore* (London, 1939), 69, ed. Cecil Lewis, Sturge Moore

describes Ricketts's long, drawn-out process of designing a wood block which involved many alterations before being cut.

[63] *The Sphinx*, for instance, which Ricketts designed for Oscar Wilde, was published in 1894 by John Lane.

[64] See Taylor, *The Art Nouveau Book in Britain*, 54. Whistler made no wood-engravings; six he designed for *Good Words* and *Once a Week* were engraved by Swain. His influence on typography and book production was in some ways more far-reaching than Morris's since his books were designed to be read by the general public, using type normally available to commercial printers.

and "expressive" book design and typography then current in Europe, particularly in France'.[65]

Early in his career, Lucien Pissarro (1863–1944), son of Camille, became interested in printmaking and illustration (particularly for children's books), inspired by etchings of Charles Keene and the colour work of Kate Greenaway and Walter Crane. He was taught wood-engraving in Paris by Auguste Lepère and learnt colour printing from Manzi. Disappointed with the reception of his illustration for *La Revue Illustrée* (15 June 1886) and having heard of a group of young artists who were ardently engaged in the revival of wood-engraving in England, he settled in London in 1890, encouraged by his father who believed that the English public were more receptive to the graphic arts.[66] Soon he became involved in Charles Ricketts's circle which was receptive to his interest in French Symbolist literature. In 1894 he set up his own Eragny Press at Hammersmith using mainly Ricketts's Vale type for his earlier books.[67] After the demise of the Vale Press Lucien set about designing his own Brook typeface which would harmonize with his wood-engraving and would at the same time be clear and easy to read.[68]

Most of the illustrations to his books were wood-engraved by Lucien or his wife Esther, mainly from his photographically transferred drawings but also from those of Camille Pissarro and friends such as Sturge Moore. Foliate borders as in the first book printed in the new Vale type, *The Book of Ruth and Esther* (1896), reveal the influence of Morris (though Lucien's designs are clearer and more simple), while certain Pre-Raphaelite elements are evident in the dense figurative scenes. Homely groups evoke Normandy peasants rather than Morris's medieval or Ricketts's classical models, but despite his father's advice to look to nature and Impressionism, the incisive black-line treatment in much of his illustrative work is stylized and decorative.

Plate 14

Lucien's specialization in colour printing placed him apart from the English black and white tradition.[69] For this reason, and also because his wood-engraving is largely imitative of his drawing style, he offered no new technical ideas with the result that his work little affected the modern movement, although he played a key role in its foundation. None the less, his influence on British book design, and particularly on colour illustration, is indisputable. He brought to it a freshness, simplicity, and sense of style not previously encountered—a unique synthesis of French and English aesthetics.

An artist of greater significance who, like Pissarro, acted as a link between the nineteenth and twentieth centuries was Thomas Sturge Moore (1870–1944).[70] Enormously

[65] Quoted by Geoffrey Perkins, Warrack & Perkins autumn catalogue no. 17, 1981.

[66] See Thomas Sturge Moore, *A Brief Account of the Origin of the Eragny Press and a Note on the Relation of the Printed Book as a Work of Art to Life* (London: Eragny Press, 1903), 4. See also *Camille Pissarro: Letters to his Son Lucien*, ed. John Rewald (London, 1944) and *Letters of Lucien to Camille Pissarro, 1883–1903*, ed. Anne Thorold (Cambridge, 1993).

[67] Llewellyn Hacon, Ricketts's new partner at the Vale Press, agreed to handle the business side, supply ink and paper, and arrange distribution of the books which were marketed by John Lane at the Bodley Head. See *The Wood Engravings of Lucien Pissarro and a Bibliographical List of Eragny Books*, selected with an intro-

duction by Lora Urbanelli (Swavesey, Cambridge, and Oxford, 1994), 26–8.

[68] According to Colin Franklin, *The Private Presses* (London, repr. 1970), 98, 'it is arguable that the Brook type, on the white paper of the small pages of the Eragny books, was the most beautiful fount invented in this whole period'.

[69] Lucien's artistic approach derived from Camille's Impressionism but he continued throughout his life to apply pointilliste principles gained from association with Georges Seurat, Paul Signac, and Félix Fénéon.

[70] See Malcolm Easton, 'Thomas Sturge Moore, Wood Engraver', and David Chambers, 'Check List of Books Illustrated by T. Sturge Moore', *Private Library*, 4 (1971), 24–37, 38–46.

Pl. 12 (*left*). Charles Ricketts: Longus, *Daphnis and Chloe* (Vale Press, 1893). 285×215

Pl. 13 (*above*). Artist unknown: Francesco Colonna, *Hypnerotomachia Poliphili* (Aldus Manutius, 1499). Woodcut. 128×130

PAN INSPIRES THE SHEPHERDS WITH A MURDEROUS RAGE OR FRENZY WHO LIKE DOGS OR CRUEL WOLVES FALL UPON THE NYMPH ECHO AND TEAR HER TO PIECES.

Eagle; then, flinging his arms about her and clasping her to him, kist her as he did Lycenium in that sweet sport that he was lately at, for that he might do, because that seemed to have no danger in it. But Chloe fits the chaplet on his head, and then kisses his locks as fairer and sweeter then Violets, and, out of her scrip, she gave him of her Cakes and Simnels

65

It was given me to be born in the caves of these mountains. As with the river of this valley, whose first drops flow from some rock weeping in a deep recess, the earliest moments of my life fell upon the gloom of a secluded abode, and that without disturbing its silence. When the mothers of our race feel themselves about to be delivered, they keep apart, and near the caverns; then in the most forbidding depths, in the thickest of the darkness, they bear, without a cry, offspring as silent as themselves. Their mighty milk enables us to surmount the early straits of life without languor or doubtful struggle; nevertheless we leave our caverns later than you your cradles. For it is generally received among us, that one should withhold and every way shield existence at the outset, counting those days to be engrossed by the gods. My growing-up ran almost its entire course in that darkness wherein I was born. Our abode

5

Boaz buyeth the inheritance.

I cannot redeem it.
✻VII Now this was the manner in former time in Israel concerning redeeming and concerning changing, for to confirm all things; a man plucked off his shoe, and
xxii

Pl. 14 (*above*). Lucien Pissarro: *The Book of Ruth and Esther* (Eragny Press, 1896). 172 × 92

Pl. 15 (*right*). Thomas Sturge Moore: Maurice de Guérin. *The Centaur and the Bacchante* (Vale Press, 1899). 228 × 134

versatile, he was also a dramatist, poet, and distinguished critic of art and literature. Taught to wood-engrave at the Lambeth School of Art by Ricketts, he became a lifelong friend both of his teacher and of Shannon, contributing to *The Dial* from 1893 and to the Vale and Eragny Presses. Taylor considers him to be an art nouveau book designer;[71] certainly the elongated figures, flowing lines, and poetic, dreamlike quality of his wood-engraved illustrations such as *The Centaur's First Love* are in an aesthetic vein.[72] But in his approach to technique he is more imaginative and less consciously decorative than any of his contemporaries. He could rightly be considered the first wood-engraver of his time to use wood in a natural way. He appreciated the subtleties of the white line; this he often uses sparingly in large black areas which contrast with white to create effects of moonlight or setting sun. Ricketts recognized Sturge Moore's originality when writing of his wood-engravings in *The Pageant* in 1897: 'They aim at effect brought about by white cutting into black, or by black lines showing the work of the tool in their shaping and we have here no imitation of chalk or wash drawing or of steel engraving or of photography.'[73]

Plate 15

Sturge Moore's penchant for looming rocks and mountains, swirling trees, and water reveals Ricketts's influence. In his painterly handling and use of chiaroscuro he has perhaps more in common with French wood-engravers, especially Lepère, than with his contemporaries. A lyrical, romantic tendency is possibly the outcome of his admiration for the work of Blake and Calvert. But despite his originality, it is debatable whether he had much impact on subsequent engravers. Certainly he had no obvious influence on book design; his often rather heavy wood-engravings display a singular lack of interest in the relationship of illustration to type. Since most of his prints were for books it would seem that as a poet-artist, Sturge Moore, like Blake, acknowledged the emotional ties between wood-engraving and text. It was this symbolist, often sensuous, quality of art nouveau which struck a chord with certain progressive modern wood-engravers.

3.8. *British and Continental Illustration around 1900*

The climate of taste for the decorated page created by William Morris and the Vale group helped to rescue wood-engraving from oblivion. Yet, paradoxically, by transferring it from popular books to the exclusive domain of the private presses and esoteric magazines, the medium was inadvertently removed from the public eye. A few enterprising publishing companies such as John Lane and Elkin Matthews, and Macmillan, attempted to bridge the gap between the privately and commercially

[71] Taylor, *The Art Nouveau Book in Britain*, 112.
[72] From Maurice de Guérin's *The Centaur and the Bacchante* (Vale Press, 1899).
[73] Charles Ricketts, 'Note on Original Wood Engraving', *The Pageant* (1897), 253–66, p. 266.

Pl. 16. Edmund Sullivan: George Borrow, *Lavengro* (Macmillan, 1896).
126 × 85

produced illustrated books. Clemence Housman (1861–1955), for example, one of the last of the old school of wood-engravers, was initially employed to cut a number of her brother Laurence's designs for the popular market, though the publishers soon began to favour his unmistakably 1890s-style pen and ink drawings, presumably for reasons of speed and economy.[74] As C. T. Jacobi pointed out in the early 1900s, 'the demand for "pictures" in a book has undoubtedly stimulated the development of modern methods of engraving'.[75] For some time, however, the aesthetic of wood-engraving continued to be broadcast in an imitative way through a quantity of line-drawn illustrations.

Aubrey Beardsley (1872–98) was one of the first of the new generation of illustrators to grasp both the advantages and the limitations of photomechanical methods.[76] The success of his line block illustrations spelled disaster for the old methods based on wood-engraving. New artists specializing in art nouveau book design sprang up, notably those of the Glasgow School such as Talwin Morris and Jessie King. But their esoteric subject matter had a limited appeal and their work was not always readily accessible, particularly that of Beardsley, much of which appeared in rarefied periodicals such as *The Savoy* or *The Yellow Book*. As Bland observes, 'in the nineties the doctrine of "art for art's sake" was preached, "aestheticism" became a catchword, and the gap widened between art and the ordinary man'.[77]

Popular stories, novels, and children's books were more appealing to the general reader, as were the numerous literary magazines and journals which abounded at this time. Lower costs of reproduction enabled publishers to produce many new and cheaper editions of standard works, though the speed with which they appeared accounted for a distinct loss of quality and a lowering of typographical standards. An increasing number of draughtsmen devoted their time and talents entirely to illustration. Significantly, as early as 1883 the first edition of Macmillan's *English Illustrated Magazine* had included line drawings, notably those of Hugh Thompson and Linley Sambourne. In 1892 a new weekly review was introduced entitled *Black and White* which gave a prominent place to such varied illustrators as Thompson, Ricketts, Harry Furniss, G. F. Watts, George du Maurier, Walter Crane, and Lord Leighton.[78] Other 1890s illustrators included Edmund Sullivan, Austin Dobson, Charles Robinson, Robert Anning Bell, Phil May, and Edwin Abbey.[79] Nostalgia for the works of Charles Dickens, William Makepeace Thackeray, Jane Austen, and Mrs Gaskell, in particular, led several to work in a picturesque, anecdotal style.[80]

Plate 16

[74] Laurence Housman's line-drawn illustrations to Christina Rossetti's *Goblin Market* (Macmillan, 1893) are some of the best examples of his work.

[75] Charles Thomas Jacobi, *Some Notes on Books and Printing* (London, rev. edn., 1902), 33. Wakeman, *Victorian Book Illustration*, 146, observes that 'by the 1890s all the technical innovations of lasting importance had been made in picture printing, with the exception of three-colour halftone'. He notes also the increase in the number of photographic illustrations and proportional decrease in original artists' work except in the field of art nouveau.

[76] The illustrations in Henry Blackburn's *The Art of Illustration* (London, 1894; rev. edn., 1901) highlight what should and should not be attempted by 'process'.

[77] David Bland, *The Illustration of Books* (London, 2nd rev. edn., 1953), 79.

[78] Other popular illustrated literary magazines included *Ladies Pictorial*, *Strand Magazine*, and *Pall Mall Magazine*.

[79] For further discussion see James Thorpe, *English Illustration: The Nineties* (London, 1935), and Simon Houfe, *Fin de siècle: The Illustrators of the 'Nineties* (London, 1992).

[80] The Cranford school of illustration was established by Hugh Thompson with his drawings for Mrs Gaskell's *Cranford* (Macmillan, 1891) following the success of those for Oliver Gold-

An indication of the increasing status of illustration was the appointment of Joseph Pennell as the Slade lecturer on the subject. Moreover, in 1894–5 the Society of Illustrators was founded, with J. D. Linton as President, James McNeill Whistler, Francis Seymour Haden, and Laurence Housman as Vice-Presidents, and F. W. Sullivan as Secretary. Lithography, line engraving, and etching were comparatively little used for book illustration, mainly due to the expense of printing. At the same time as photomechanical processes were rendering wood-engraving obsolete, Seymour Haden (1818–1910), Whistler's brother-in-law, made the first effective protest in favour of original graphic work. In a paper read before the Society of Arts in 1883 entitled 'The Relative Claims of Etching and Engraving to Rank as Fine Arts' he defined the *peintre-graveur* tradition and suggested that the aim of the newly formed Society of Painter-Etchers (1880) 'to return to the original form of engraving, as it was practised by the great masters of painting, would be an advantage to art'.[81] He objected not so much to the reproductive engraving used in books but to the engraved imitation of paintings. The new etching movement was dominated by Seymour Haden, Whistler, and Alphonse Legros, an important figure in the revival of French etching before becoming Principal of the Slade in 1876—a post he held until 1894. Their success in gaining recognition for etching and engraving as autonomous art forms,[82] and in raising the status of printmaking in general, laid the foundations for the new graphic societies which sprang up in the first few decades of the twentieth century.[83] Although in many ways their aims anticipated those of the Society of Wood Engravers (founded 1920),[84] the general attitude and objectives of the two movements were none the less significantly different, not least because the wood-engraving revival,' unlike that of etching, was determined by technical developments.

As in England, few distinguished books seem to have resulted from the vogue for etching in France and Germany. Although French artists were less reluctant than English to turn their attention to illustration and were more adventurous about using different processes (eminent painters such as Daumier and Toulouse-Lautrec, for instance, frequently used lithographic methods), reproductive wood-engraving was used for the great majority of book illustration.[85]

Auguste Lepère (1849–1918) was largely responsible for promoting original wood-engraving in France in the 1890s.[86] Trained as a professional engraver, he had a remarkable ability for reproducing tones and textures of paintings and drawings. In contrast to their

smith's *The Vicar of Wakefield* (Macmillan, 1890) which had become an immediate best-seller.

[81] Francis Seymour Haden, 'The Relative Claims of Etching and Engraving to Rank as Fine Arts', *Journal of the Society of Arts* (1 June 1883), 714–23, p. 718.

[82] In 1888 Queen Victoria granted a royal title to the Society of Painter-Etchers and in 1898 its name was enlarged to include engravers.

[83] In 1908, for instance, through the efforts of Pennell, the Senefelder Club, named after the inventor of lithography, was formed to arrange exhibitions and further promote the medium.

[84] See Ch. 5.1.

[85] The wood-engraved drawings of Gustave Doré (1832–83) were especially admired and published in England, notably those for Miguel de Cervantes's *Don Quixote* (1863) and Samuel Taylor Coleridge's *The Rime of the Ancient Mariner* (1876), as were his contributions to *The Illustrated London News*.

[86] For further discussion on Lepère's work see in particular Jacquelyn Baas and Richard S. Field, exhibition catalogue, *The Artistic Revival of the Woodcut in France, 1850–1900* (Ann Arbor: The University of Michigan Museum of Art, 1984, 40–1). Lepère initiated publication of *L'Estampe Originale* to exploit the creative possibilities of printmaking. For his contribution see essays by Patricia Eckert Boyer and Phillip Dennis Cate in *L'Estampe Originale: Artistic Printmaking in France, 1893–1895* (Zwolle, Waanders, 1991).

British contemporaries, French wood-engravers were uninhibited about treating the medium in a free and painterly way, doubtless because the Bewick tradition was not part of their culture. In 1897 the Société des Graveurs sur Bois was founded in Paris by Lepère and Pierre Gusman, another veteran engraver, to promote the art of wood-engraving and protect the interests of practitioners—aims which echo those of the etching movement and reflect a characteristic French *peintre-graveur* attitude to the medium.[87] *L'Image*, a journal illustrated with wood-engravings which was published by the society under the artistic directorship of Tony Beltrand, ran for only a year but its effect was considerable. As Salaman observed 'not only bibliophile societies luxuriating in the "edition de luxe", but such leading Parisian publishing houses as those of Pelletan, Pichon, Crès, Meynial, and Vollard were before long giving practical recognition to the woodcut as an essential component of the *livre d'art*'.[88] This comment reveals a growing divergence of ways between French and English book illustration: French artists and publishers were more concerned with illustration *per se* rather than the typographic Book Beautiful as advocated by Morris and his followers.

Meanwhile in Britain facsimile engraving and photomechanical processes had all but killed off wood-engraving as an economically practicable medium. The low esteem in which it was held by artists and critics alike is summed up by A. L. Baldry's comments in a *Studio* article of 1898 on the future of the medium: 'It can hardly be denied that there is in the present condition of the art of wood-engraving very serious cause for lamentation.'[89] It could only be revived, he observed perceptively, if artists were 'prepared to recognize certain qualities which no other printing medium will give'.[90] A note of optimism was struck when, in the same year, the Vale Press held what it confidently called 'The First Exhibition of Original Wood Engraving',[91] although, with the exception of Nicholson's and Sturge Moore's contributions, the prints were largely black-line book illustrations.

Lucien Pissarro chose to settle in London on account of the opportunities afforded by English private presses to wood-engravers who were especially interested in quality book illustration. The limited market for exclusive hand-printed books in effect drove the medium underground but, since in the early years it was relatively unaffected by social and economic constraints, the private press movement was one of the major factors which helped to keep autographic wood-engraving alive until the pioneering efforts of the 'new' wood-engravers were fully recognized in the mid-1920s. Charles Holmes, writing in 1899 on original wood-engraving, considered it 'too laborious a process to have any future in England except as a medium of expression of a peculiar kind, and any attempt to revive it on a commercial basis is foredoomed to failure'.[92] How right he was on the first count, how wrong on the second.

[87] In the same year, however, Félix Bracquemond's *Étude sur la gravure sur bois* recognized the importance of wood-engraving for illustration.

[88] Malcolm C. Salaman, *Modern Woodcuts and Lithographs by British and French Artists* (London, 1919), 67.

[89] A. L. Baldry, 'The Future of Wood Engraving', *Studio*, 14 (1898), 10–16, p. 10.

[90] Ibid. 15.

[91] 'The First Exhibition of Original Wood Engraving' was organized by E. J. Van Wisselingh at the Dutch Gallery, 14 Brook Street, London, W1.

[92] C. J. Holmes, 'Original Wood Engraving', *Architectural Review*, 6 (1899), 106–16, p. 106.

PART II

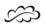

CONTEMPORARY INFLUENCES ON THE
WOOD-ENGRAVING REVIVAL

PIONEERING WOOD-ENGRAVERS, 1904–1920

4.1. *Early Teaching: Sydney Lee, Noel Rooke, and the Central School of Arts and Crafts*

In March 1897 Auguste Lepère declared prophetically to Camille Pissarro that 'the English [wood-engraving] movement is waking up the sleepy heads and there will certainly be a serious revival'.[1] The year 1904 heralded its arrival. An exhibition held by the Society of Twelve included lithographs and wood-engravings, some by Sturge Moore and Craig, 'for the first time', according to Laurence Binyon's catalogue introduction, 'giving representative effect to the revival of original work on stone and wood which has been one of the most notable symptoms in recent art'.[2]

In the same year Sydney Lee (1866–1940) broke new ground with his magnificent print *The Limestone Rock*. Measuring $13\frac{1}{8}'' \times 17''$ it is unusually large for such an early date and shows the artist's extraordinary technical skill in achieving textures and controlled effects of light and shade far in advance of most other 'original' wood-engravers' explorations at this time.[3] Nowadays Lee is known mainly for his large landscape paintings, often of mountain scenery, while, apart from his colour woodcuts, his prints have unjustifiably gained little attention. Yet he was greatly admired by contemporary critics: Furst in *The Modern Woodcut* (1924) recognized his talent, while Bliss in 1928 mentions him as being 'early in the field' with many followers.[4] As an artist-printmaker he did no book illustration but as one of the first official teachers of modern wood-engraving in art schools he played a leading role in its development.

Plate 17

When in 1904 Noel Rooke (1881–1953) initiated a campaign to revive wood-engraving on 'autographic' principles he was unaware of the impact his teaching was to have on the future of the medium. Son of the watercolourist Thomas Matthew Rooke, who had acted as a studio assistant to Burne-Jones, he was well acquainted with the fine productions of William Morris and his close neighbour, Lucien Pissarro. He had a part-English, part-French education, spending summers in France studying medieval sculpture and architecture. Realization of the importance stressed by W. R. Lethaby (for whom he made drawings of the Chapter House at Westminster Abbey) of the way

[1] Camille Pissarro to Lucien Pissarro, 16 Mar. 1897. Quoted from *Camille Pissarro: Letters to his Son Lucien*, ed. John Rewald (London, 4th edn., 1980), 310.

[2] The exhibition was held at Messrs Obach & Co. Alphonse Legros was the Honorary Member. Other members were Muirhead Bone, D. Y. Cameron, George Clausen, Charles Conder, William Strang, Augustus John, Craig, Sturge Moore, Nicholson, Ricketts, and Shannon.

[3] Lee's practice is described by Malcolm Salaman, 'The Woodcuts of Sydney Lee, A.R.E.', *Studio*, 63 (1914), 19–26. See also Sydney Lee, Foreword to exhibition catalogue, *Aquatints, Etchings, Mezzotints, Wood-Engravings and Woodcuts by Sydney Lee, RA, RE* (London: P. & D. Colnaghi, 1937).

[4] Herbert Furst, *The Modern Woodcut* (London, 1924), 82; Douglas Percy Bliss, *A History of Wood-Engraving* (London, repr. 1964), 224–5.

'structure governed form and its enhancements' led Rooke to make discoveries about form and design which he later applied to wood-engraving.[5]

Wood-engraving was rarely taught at the few existing art schools and then only by reproductive engravers such as W. H. Hooper[6] or R. J. Beedham, instructor in wood-engraving at Bolt Court. This institution was founded in 1894 by a group of craftsmen as a technical school for process block engraving and photolithography which was just emerging. It was the first specialized printing school in London.[7] In 1904, after attending part-time art classes at the Slade School from 1899 to 1903, Rooke joined Beedham's evening classes at Bolt Court, in which pupils 'had first-rate technical instruction and nothing at all about the subject as "art"'.[8] Dissatisfied with photomechanical process as a means of artistic expression, he resorted to wood-engraving, having been encouraged by Pissarro to experiment with techniques, including 'graduated' printing, woodcutting on the side-grain of boxwood, and colour printing. With a wide knowledge of both original and process engraving,[9] Rooke concluded 'that wood-engraving offered the best means of book decoration and illustration for the future, but on condition that it was done from a new point of view'.[10]

It was Edward Johnston's principles in calligraphy[11] that first 'suggested a revival of wood-engravings on a fresh basis' and inspired Rooke 'to make engravings on wood on the same basis as calligraphy, that is designing and producing in terms of the strokes of a brush or a pen and pencil'.[12] From 1900 to 1905 he had attended Johnston's Illuminating class at the Central School of Arts and Crafts.[13] This class covered not only manuscript writing but also the whole theory of book production and structure. The lessons were a revelation to Rooke and caused an immediate response amongst the pupils. Out of these revolutionary classes 'sprang as well as the modern movement in calligraphy, all of Gill's "glorious types" and Rooke's revival of wood-engraving'.[14]

The strategic choice of Johnston had been made by W. R. Lethaby.[15] In his capacity as an art inspector for the Technical Education Board of the newly created London County

[5] From notes written by T. M. Rooke on Noel Rooke in the possession of Celia M. Rooke, n.d. For Rooke's views on Lethaby see Noel Rooke, 'The Work of Lethaby, Webb and Morris', *Journal of the Royal Institute of British Architects*, 57 (1950), 167–75.

[6] See Ch. 3.6, 'William Morris'.

[7] In Apr. 1900 the name of the school was changed from Bolt Court Technical School to the LCC School of Photoengraving and Lithography. It was also opened for part-time art classes. See Rupert Cannon, *The Bolt Court Connection: A History of the LCC School of Photoengraving and Lithography, 1893–1949*, privately printed by the London College of Printing (London, 1985). St Bride School, also founded in 1894, offered only part-time evening instruction until 1917.

[8] Joan Hassall, Introduction to *Joan Hassall: Engravings & Drawings*, compiled by David Chambers (Pinner, 1985), p. vii. Hassall attended Beedham's classes in the 1920s. See also Ch. 4.2.

[9] He contributed technical drawings for various textbooks and other illustrations for Messrs Walker and Cockerell. Some of his most accomplished illustrations were drawn in 1905 for Johnston's seminal book, *Writing & Illuminating, & Lettering* (London, 1906; rev. edn., 1994).

[10] From notes written by T. M. Rooke. See n. 5.

[11] See Priscilla Johnston, *Edward Johnston* (London, 1959; 2nd edn., 1976) and Justin Howes, *Edward Johnston: A Catalogue of the Crafts Study Collection and Archive* (Bath: Crafts Study Centre, 1987), and *Edward Johnston* (London, 1996).

[12] *The Qualifications and Experience of Noel Rooke*, n.d. In the possession of Celia M. Rooke. Justin Howes feels that this statement must be qualified in the light of Lethaby's direct influence on both Rooke and Johnston. From 'A Teacher Taught', Introduction to exhibition catalogue, *Noel Rooke, 1881–1953* (Oxford: Christ Church Picture Gallery, 22 Oct. 1984), unpaginated.

[13] Fellow students included T. J. Cobden-Sanderson, Eric Gill, Laurence Christie, and Graily Hewitt. See Justin Howes, 'Edward Johnston's First Class at the Central School on 21 September 1899' in Sylvia Backemeyer (ed.), *Object Lessons: Central Saint Martins Art and Design Archive: A Centenary Publication* (London, 1996), 33–7.

[14] Justin Howes, 'Noel Rooke: The Early Years', *Matrix*, 3 (1983), 118–25, p. 120.

[15] For further discussion on Lethaby's role, see Theresa Gronberg, 'William Richard Lethaby and the Central School of Arts and Crafts' in exhibition catalogue, Sylvia Backemeyer and Theresa Gronberg (eds.), *W. R. Lethaby, 1857–1931: Architecture, Design and Education* (London, 1984), 14–23.

Pl. 17. Sydney Lee: *The Limestone Rock* (1904–5). 333 × 432

Council, Lethaby had set about expanding the capital's art education and reorganizing existing art schools which had been almost non-existent and non-vocational. Technical lectures were organized by Thomas Way on lithography, Gleeson White on posters, Cobden-Sanderson on bookbinding, Emery Walker on typography, Morris on early illustration, and Joseph Pennell on modern illustration. According to Godfrey Rubens, Lethaby's appointment 'marked, in London, the beginning of a profound change in educational ideas carried forward by the new teachers'.[16]

The Technical Education Board, acting on suggestions proposed by Lethaby and George Frampton (both on its Board of Management) and following on from the successful experiment at Bolt Court 'to provide specialized art teaching in its application to particular industries', opened the Central School of Arts and Crafts in 1896 with Lethaby as its first Principal.[17] He introduced a programme of workshop training with an emphasis on the direct handling of tools and materials—a central element to his philosophy and one of great relevance to wood-engraving. In this and in all his teaching he acknowledged a debt to Morris. Initially classes were held in the evenings so that staff and students could work in the day. This way Lethaby was able to appoint highly skilled craftsmen as teachers: his influence and perspicacity in the choice of staff and courses were immense.

In the first year the syllabus concentrated on subjects associated with the building trade but Lethaby soon expanded the courses to reflect his interests and the students' demands. Bookbinding, woodcuts in colour, and embroidery were added in the second session (1897–8) and soon other crafts including writing, illuminating, and printing appeared. Lethaby's interest in art education developed partly as a result of his involvement with the Art-Workers' Guild and the Arts and Crafts Exhibition Society which he helped to found, the aims of which are still to bring architects, artists, and craftsmen together and 'to advance education in all the visual arts and crafts'.[18] The Artistic Craft Series of technical handbooks which Lethaby edited from 1900 to 1916 shows his innovative approach to the teaching of crafts to a wider community. This series did not include wood-engraving—an indication, perhaps, of the general lack of interest in the subject in the early days. Frank Morley Fletcher's *Wood-Block Printing* (1916), on the other hand, is considered to be one of the definitive books on the subject. Whereas black and white wood-engraving was suffering a decline at the turn of the century, coloured woodcuts were enjoying great popularity, mainly due to the experimental work of J. D. Batten who, together with Morley Fletcher, pioneered the Japanese method in England.[19]

According to the 1904–5 prospectus of the Camberwell School of Arts and Crafts, Sydney Lee was teaching both woodcuts in colour and wood-engraving 'to add this

[16] Godfrey Rubens, 'W. R. Lethaby and the Revival of Printing', *Penrose Annual*, 69 (1976), 219–32, p. 220.

[17] Technical Education Board Minutes, 1896, 156.

[18] The Art-Workers' Guild Prospectus, revised by Patrick Keely (London, 1975). See also Ch. 3.6, 'William Morris'.

[19] In *Wood-Block Printing* (London, 1916), 2, Morley Fletcher mentions a pamphlet by T. Tokuno published by the Smithsonian Institute, Washington, DC, as their textbook, since reprinted in

Matthi Forrer (ed.), *Essays on Japanese Art presented to Jack Hillier* (London, 1982). Japanese woodcuts were cut with knives on the plank of the wood and printed by hand-burnishing with a baren, a smooth circular pad made of bamboo fibres. Water and paste made from rice flour were used rather than oil-based inks. See Alan Guest's essay 'The Colour Woodcut', in Robin Garton (ed.), *British Printmakers, 1855–1955* (London, 1992), 217–35.

knowledge to colour work'.[20] The Camberwell School, which was opened in January 1898 by Sir Edward Poynter, had similar aims to the Central School. The emphasis in the early stages was on the teaching of trade subjects, especially those relating to the building industry, but the 1904 extension enabled courses such as Lee's to be added to the syllabus; others included 'Design: Book Illustration' (under Reginald Savage), and 'Lettering and Illumination' (under Graily Hewitt). By the 1905–6 session, a class in typography was started for those employed in printing, mainly to study its theory and practice and also artistic layout but, so the prospectus runs, 'further tuition will be given in the essentials of a perfectly printed book to those who require it'.[21] By the 1930s the Typographic Department was so large it required a prospectus of its own. Despite the similarity of courses with the Central, the emphasis at Camberwell was more on illustration in general, with the result that few well-known wood-engravers emerged from its classes in these early days.

The Central School played a more formative role in the history of wood-engraving.[22] Considered to be one of the most progressive European art schools of its day, the work of the School of Book Production, in particular, attracted attention from abroad.[23] In 1905 under the heading 'Printing, Book Binding and Allied Crafts', the prospectus mentions a class in 'Book Illustration, Lettering, Black and White, etc.' under Rooke, and a new printing class under J. H. Mason.[24] Also listed is a class in 'Woodcuts in Colour and Wood Engraving' under Sydney Lee. Here is the first record of an official wood-engraving teacher, yet it is Lee not Rooke: a fact overlooked by art historians who make no mention of him (except as a teacher of colour woodcutting in the Japanese method), considering Rooke to have been the first to take on this role. By 1911, Lee had left the Central (he departed from Camberwell in 1909) and Lethaby had resigned as Principal. His resignation led to a complete reorganization of classes under Fred Burridge with more full-time day classes. The 1911–12 prospectus shows 'Woodcuts and Wood Engraving' listed as an option if enough applicants applied. In the 1912–13 session Rooke is responsible for the teaching of lettering and wood-engraving in the Day Technical School.[25] As Head of the School of Book Production from 1914, he taught woodcutting and engraving under a general heading of 'Woodcutting for Reproduction', as well as book illustration and poster design. Even then the prospectus plays down the significance of wood-engraving as an original art form. Not in fact till the 1920–1 session does the timetable show Rooke specifically teaching 'Woodcuts and Wood Engraving'.

Why was it such a problem for Rooke to introduce creative wood-engraving into the

[20] LCC Camberwell School of Arts and Crafts Prospectus, 1904–5.

[21] LCC Camberwell School of Arts and Crafts Prospectus, 1905–6.

[22] For further discussion see Joanna Selborne, 'The Wood Engraving Revival', in Backemeyer (ed.), *Object Lessons*, 42–6.

[23] See Sylvia Backemeyer, 'The School of Book Production and its Influence', in (ed.), *Object Lessons*, 38–41.

[24] The *Prospectus and Timetable of the Central School of Arts and Crafts*, London County Council, was produced annually from 20 Dec. 1896.

[25] In 1909 the LCC formed a consultative committee on Book Production, including three masters, three trade unionists, and three members of the LCC Representatives. These included Douglas Cockerell, Emery Walker, C. T. Jacobi, and C. H. St John Hornby. On their advice the Day Technical School for Boys in Book Production was established. It was mainly concerned with bookbinding, printing, typography, and general knowledge, but in the second and third years attention was also paid to lithography, engraving and process engraving, estimating, and the history of the book.

curriculum? He admits that in the first eight years from 1904 progress was extremely slow since the revival of the medium was 'considered by competent judges to be impossible and I was told so very firmly'.[26] Until Lethaby's departure he was only able to teach it by slipping it covertly into his book illustration classes. Yet Lethaby would not have disapproved of wood-engraving *per se* since he was always trying to revive or preserve dying crafts. In 1884, at a meeting to discuss the formation of the Art-Workers' Guild, he expressed the hope that painters might turn their attention to wood-engraving,[27] while as early as 1899 the Central prospectus mentions wood-engraving under 'Other Classes' if 'a sufficient number of students will apply'.[28] Lethaby had had to defend his decision to set up Johnston's class.[29] While Lee's class was operating it is possible that he could not justify introducing a further wood-engraving class. Lee was, after all, one of the most brilliant wood-engravers at that time, whereas Rooke was just embarking on his career. No doubt also Lethaby met with opposition from publishers and printers who were heavily committed to process methods of illustration. An exhibition was held on 13 May 1912 in an attempt to make the work of the Book Production Department more widely known to the industry and the public. In the catalogue preface Emery Walker despairs of the trade's ignorance: 'At first these craft classes, hampered by legislative restrictions, were not treated seriously, and much of the work turned out barely reached a bazaar standard. The trade ignored or laughed at the classes, although had they seen it, there was much they could have learnt by attending them.'[30]

Ironically, Mason's purist approach to fine printing in his classes may well have been an obstacle to Rooke. As a compositor at the Doves Press with Emery Walker and Cobden-Sanderson Mason learnt to avoid the heavy decorative work of Morris and Ricketts, and to aim for greater simplicity of the page with no decoration beyond large lettering and colour.[31] Rooke admitted that Mason's teaching initially received considerable criticism for its lack of flamboyance and its simplicity.[32] Certainly a study of the books produced under his direction from 1906 reveals a limited amount of illustration: mainly black-line wood-engraving, with occasional initials designed by the book illustration class. Not till about 1916 did the illustrations begin to become more sophisticated. A copy of *Pericles* (finished in 1917) contains a frontispiece woodcut by M. C. Haythorne: a black-line portrait which shows traces of white cutting in the beard and hair.[33]

[26] *Qualifications*. This opposition was confirmed by his wife, Celia M. Rooke. Celia M. Rooke to the author, 2 Feb. 1984.

[27] H. J. L. Massé, *The Art-Workers' Guild, 1884–1934* (Oxford, 1935), 10.

[28] *Prospectus and Timetable of the Central School of Arts and Crafts*, 1899.

[29] G. M. Ellwood in 'Famous Contemporary Art Masters: Noel Rooke', *Drawing & Design*, 4 (1924), 236–8, p. 237.

[30] *Catalogue of a Book Exhibition at the Central School of Arts and Crafts with a Short Account of the History of the LCC Classes in Book Production, 13 May 1912*, printed at the Central School of Arts and Crafts, London, 1912. Walker writes that the beginning of the City and Guilds of London Institute exams did much to encourage craftsmen to study the theory and practice of their trades.

[31] Previously, in 1888, he had joined the Ballantyne Press as proofreading boy, where he was stimulated by contact with Ricketts's Vale Press books. He had attended Johnston's class.

[32] L. T. Owens, *J. H. Mason 1875–1951, Scholar-Printer* (London, 1976), 68.

[33] The colophon mentions Rooke as the teacher and states: 'The completed work is an example of the co-operative work of the school.' Charles Pickering confirms that by this date Rooke's classes were having an effect on Mason's attitude. 'I think it was possibly due to growth of Rooke's illustration classes that [Mason] became interested in marrying text, type and illustration—and a few efforts combining them emanated in the 1920s—becoming much more an influence when (officially) the School of Book Production was formed with Noel Rooke as

The slow recognition of wood-engraving as an acceptable art school subject was indicative of the conventional attitudes facing aspiring young wood-engravers at the time. But from within the confines of Rooke's class, affectionately known as 'The Rookery', there quietly emerged a whole new discipline in which illustration played a central part. Rooke stressed the importance of its unity with the book: 'weight of line, tone, harmony with areas of lettering and of blank paper, familiarity with which the student can best gain by engraving his drawings on wood, which illustration can best practise in wood-engraving'—words which represent, perhaps, the first manifesto of the new school of wood-engravers.[34]

Rooke made a lasting impression on his students, among them Leon Vilaincourt who remembered 'his precision as a teacher, not simply in the manipulation of techniques, but far more important, in the wide far-reaching skill of research for reference materials and general literary preparation of the students' minds'.[35] His importance in encouraging pupils to break into the world of publishing cannot be too strongly emphasized. Although interested in letterpress, he also advocated modern printing techniques, his practical attitude towards the commercial press summed up thus:

When photomechanical methods of illustration swept all competitors from the field, I initiated the movement to make autographic wood-engraving a means of illustrating industrially produced books, and trained among others Robert Gibbings, later of the Golden Cockerel Press, John Farleigh and Clare Leighton, who all studied under me for periods of several years. As soon as it became possible I taught the students not only to design and engrave their illustrations, but to print them on modern power driven platen presses, so that they might understand modern conditions and the differences introduced by automatic inking, etc. As a result the best books are now illustrated by wood-engraving.[36]

Although Sydney Lee can be recognized as the first to teach autographic wood-engraving at a London art institute, Noel Rooke was initially responsible for raising its status as an independent and teachable graphic medium. Lethaby's main contribution to the history of wood-engraving was his recognition of the importance of printing and lettering. The emphasis placed on the production of the printed page in turn produced an interest in letterpress and thence wood-engraving. The significance of Rooke's classes is borne out by the fact that the Central was the breeding ground for so many distinguished wood-engravers. Through his efforts to introduce their work to publishers, many of his students went on to pursue illustration or other forms of book production, thereby bringing the medium to the attention of a wider public.[37]

Head of Department.' Charles Pickering to the author, 20 Oct. 1985. Pickering, one-time pupil of Mason, taught part-time at the Central School and in Guildford and Kent before his appointment as Head of Mid-Kent Region Printing Department. He was the first HM Inspector to be appointed as a national specialist for printing subjects.

[34] Quoted from a specimen broadsheet sent by the Central School to every major Arts and Crafts exhibition in Britain and the Continent. Sample in the possession of Celia M. Rooke. The author is grateful to Justin Howes for this information.

[35] Leon Vilaincourt to the author, 16 Jan. 1986.

[36] Quoted from 'General Statement given by Noel Rooke'. Typescript in the possession of Celia M. Rooke.

[37] For Rooke's influence on textile block printing see Mary Schoeser, 'Block Printing 1910–1950', in exhibition catalogue, *Bold Impressions* (London: Central Saint Martins College of Art & Design, 3–31 Oct. 1995), unpaginated.

The Old Vicarage, Grantchester
A Woodcut by Noel Rooke

Pl. 18. Noel Rooke: Rupert Brooke, *The Old Vicarage, Grantchester* (Sidgwick & Jackson, 1916). c.170 × 238

Owing to pressure of teaching and his dedication to helping his students, Rooke's own output was small. Most of his extant wood-engravings are single prints, several of which found their way into journals such as the *Studio*.[38] For his first venture into book illustration he designed lettering and a black-line roundel of an elf-like creature for the title-page of *Romaunt de la Rose* published by the Florence Press[39] in 1908. His only other pre-1920 illustration was for a double-page frontispiece to Rupert Brooke's *The Old Vicarage, Grantchester* (Sidgwick & Jackson, 1916), the first in the more robust white-line *Plate 18* style which characterizes most of his early wood-engravings. This weighty pre-dominance of black was much imitated by some of his pupils (doubtless in reaction to the fine-toned facsimile approach) but was not always successful in its balance with the accompanying text. For all Rooke's concern for wood-engraved illustration, he only produced one important book, *The Birth of Christ* (1925), which will be discussed in a later chapter together with the work of his pupils.[40]

4.2. *Eric Gill, David Jones, and the St Dominic's Press Illustrators: The Early Years*

One of the earliest wood-engravers to be inspired by Noel Rooke was Eric Gill (1882–1940), probably the most widely known of all in the 1920s and 1930s. He is recognized as much for his prints as for his sculpture, lettering, voluminous writings on art, religion, and sociology, and for his eccentric lifestyle. Although his most important work was produced after about 1924, his output and that of the St Dominic's Press at Ditchling before that date reveal a little known outcrop of original wood-engravings. Significantly, many of these were produced initially as illustrations rather than as single prints at a time when there were still comparatively few books being published with wood-engraved illustrations. Gill left Ditchling in 1924 for Capel-y-ffin in Wales, this coinciding with the purchase of the Golden Cockerel Press by Robert Gibbings with whom he was to collaborate on his most important illustrated work. After 1924 his direction changed when he bought his own printing press and also began to be commissioned regularly by other presses.

Gill was born in Brighton on 22 February 1882, the son of a nonconformist minister whose advice to fear God and sharpen pencils had a more far-reaching effect than he could ever have imagined. He wanted Gill to be an artist and taught him perspective. From an early age Gill made meticulous detailed drawings of locomotives, buildings, and churches, while a short spell at the Technical Art School in Chichester revealed a passion for lettering. His artistic training groomed him well for the exacting skills

[38] One of his earliest blocks, *The Start* (1906), later appeared in a Central School broadsheet (see n. 34). The first block which he contributed to a periodical was *Man Ploughing* which was published in *The Open Window*, 1 (Oct.–Mar. 1910–11). See Howes, 'Noel Rooke: The Early Years', 123.

[39] An imprint of Chatto & Windus. The book also contained colour plates by Keith Henderson. In 1909, in collaboration with Gill, Rooke engraved a few small blocks of lettering by Edward Johnston for the Dove's Press *Shakespeare's Sonnets*.
[40] See Ch. 8.

required for wood-engraving. He learnt draughtsmanship while an apprentice at the London drawing office of W. D. Caröe, architect to the Ecclesiastical Commissioners, and masonry at the Westminster Institute. At the same time he studied lettering in the Illuminating class of Edward Johnston who, he felt, 'profoundly altered the whole course of my life and all my ways of thinking'.[41]

As a result of managing 'to hit on something which no one else was doing and which quite a lot of people wanted' he was soon in sufficient demand as an inscriptional stonemason to be able to set up independently in 1903. Early lettering commissions developed in several other directions: for example, painted fascia boards for shops, most notably for W. H. Smith. When he started wood-engraving it was, he wrote, 'for the sake of lettering'.[42] Dissatisfied with designing letters for photographic reproduction for books, he was naturally drawn to the medium, encouraged by Count Harry Kessler for whose *Insel Verlag* series he engraved title-pages and initial letters.[43] According to his *Autobiography* this, in turn, 'led to pictorial engraving and all my future work for the St Dominic's Press at Ditchling and the Golden Cockerel Press, and, later still, for my son-in-law René Hague's press'.[44] In 1908 Hilary Pepler received a wood-engraved Christmas card from Eric and Mary Gill consisting of simple lettering framed by two panels of artists' tools.[45] Among Gill's first figurative commissions was a Christmas card for Roger Fry in 1910, a delicate, white-line nativity scene.

Doubtless Gill's grounding in draughtsmanship, stone carving, and lettering enabled him to handle the technique of wood-engraving instinctively. He does not mention any tuition in the *Autobiography* but Rooke and Johnston evidently played a large part in his early experiments. An entry in Johnston's work diaries suggests that he and Gill 'sat down together at the same table on the same evening in 1906 and tried their hands at wood-engraving for the first time'.[46] Interestingly some hitherto unpublished entries in Gill's diary mention classes with Rooke at Clapham once a week on Tuesdays at 10.30 a.m., from 16 November 1907 for a year.[47]

In the same year Gill moved to Ditchling in Sussex, whilst his friend and neighbour from Hammersmith, Hilary Pepler,[48] a Quaker involved in social work for the LCC, co-founded a club for working people in the district, enlisting the help of G. K. Chesterton, Hilaire Belloc, William Rothenstein, and E. H. Haywood. During the war the club developed into the Hampshire House Workshops for Belgian refugee craftsmen and, from 1915, a printing works was run by Pepler. Despite his move, Gill retained his workshop in Hammersmith. He kept in close contact with Pepler who in 1915 com-

[41] Eric Gill, *Autobiography* (London, 1940), 119.

[42] Eric Gill, Preface to *Engravings by Eric Gill* (Bristol, 1929), 4.

[43] Kessler introduced Gill to the French sculptor Maillol with the intention of his becoming Maillol's pupil assistant. Although Gill greatly admired his work this idea came to nothing but he did engrave initials on Maillol's blocks for *Die Odyssee* and cut his designs for Kessler's 1926 edition of Virgil's *Eclogues*.

[44] Gill, *Autobiography*, 179.

[45] In 1908 he also engraved a tiny white-line self-portrait, a bookplate for Angela and Betty Manners, and a columned front-ispiece for the cover of the Fabian Society's *Fabian Tracts*.

[46] Quoted from Michael Renton, 'Edward Johnston and Wood Engraving', *Multiples*, 2 (1994), 67–70, p. 68.

[47] Eric Gill's diary is held by the William Andrews Clark Memorial Library, University of California, Los Angeles, henceforth WACML. A microfilm is held in the Tate Gallery Archives, henceforth TGA.

[48] *Aylesford Review*, 7 (1965) is dedicated to Pepler and contains several essays. See n. 59. See also Susan Falkner's essay, 'My Father', and Brocard Sewell's introduction to *Saint Dominic's Press: A Bibliography, 1916–1937*, compiled by Michael Taylor and Brocard Sewell (Risbury, 1995).

missioned him to illustrate his sociological satire, *The Devil's Devices*, published under the imprint of the Hampshire House Workshops but printed by Gerard Meynell at the Westminster Press. According to Thomas Balston this slim volume, together with Frances Cornford's *Spring Morning* (illustrated by Gwen Raverat and published in the same year by the Poetry Bookshop), were the first books to contain modern wood-engravings.[49] If so they represent a milestone in the history of twentieth-century book illustration. Although it is difficult to assess the accuracy of this statement it is most likely to be correct, since Balston, as a director of Duckworth's, was vastly knowledgeable about the publishing world and a champion of the 1920s and 1930s wood-engravers.[50] Certainly white-line illustration was practised in Rooke's classes before 1915, but his students had had little opportunity of breaking into publishing by this date.

It is no coincidence that Raverat and Gill should have achieved the same ends simultaneously. They first met, in 1910 or 1911, through Gwen's husband Jacques (and probably also through her cousin Frances Cornford).[51] A firm friendship evolved between the three artists who shared many interests, particularly religion. For a brief time Raverat's and Gill's work show stylistic similarities,[52] but there is little common ground between either the subject matter or the style and technique of their respective illustrations for *Spring Morning* and *The Devil's Devices*.

An entry in Gill's 1913 diary mentions a weekend in March spent with the Raverats at Croydon, near Royston, where 'Cookham' (Stanley) Spencer was also staying: '[we] discussed our plans for illustrating the Gospels. Came to deadlock about the "version" to be printed. They want "Authorized" which is imposs. for me.'[53] Later he mentions discussing the Gospel woodcuts with Wilfred Meynell and continues with the project until 3 August: 'Gospel woodcuts all day—& came to conclusion that project too big for one to undertake. Must make it a smaller book and confine myself to initials and frontispiece.'[54] Apparently nothing came of this project,[55] but even at this early stage it may well have given Gill the idea for his masterpiece, *The Four Gospels* of 1931.

Pepler's *The Devil's Devices* is an indictment of the evils of the capitalist political system; as such it especially appealed to Gill. Like the chapbook illustrators before him he evolved a style which gave the message maximum impact. Effective use is made of silhouette on the title-page and for four other illustrations, these last having details picked out in fine white line, leaving hands and faces white. *The Purchaser* depicts an *Plate 19*
affluent business-man, clasped by the devil, tempting the working man and woman with money to prostitute themselves to his make-believe authority. Yorke aptly describes

[49] Thomas Balston, *English Wood-Engraving, 1900–1950* (London, 1951), 9.
[50] See Ch. 5.3.
[51] For further discussion see Ch. 4.3.
[52] It is arguable that Gwen Raverat's archaic religious wood-engraved interpretations of Jacques's designs inspired Gill who at this early period was still experimenting with line and silhouette. Certainly they anticipated his black-line style for which he is best known. He acknowledged his appreciation of the Raverats in his title-page dedication to Frances Cornford's

Autumn Midnight in 1923 which reads 'to J. & GR from FC and EG'. For comparative influences see Ch. 4.3.
[53] Diary, 18 Mar. 1913. WACML.
[54] Diary, 3 Aug. 1913. WACML.
[55] The alphabet of initials was sold to Burnes & Oates and used in 1915 in their edition of G. K. Chesterton's *Poems*. Another block, *The Slaughter of the Innocents*, was used as anti-German propaganda on the cover of a catalogue for an exhibition in aid of Belgian refugees.

these figure styles as 'didactic caricatures'.[56] Even in these early illustrations Gill reveals an ability to suit the nature of his engravings to the text. Stiff, angular legs and gesturing arms accentuate the satirical aspect. There is something faintly comical about these figures dressed in contemporary fashion,[57] rare in Gill's prints, as is the modern-life scene of a tenant sitting in his back garden which is crudely cut and executed in a style more reminiscent of Rooke's pupils.

The Devil's Devices heralded Gill's involvement with Pepler and the private press world which increased when Pepler moved the press to a disused stable in Ditchling in January 1916. That Gill's input determined the future of the press is testified by Pepler in an essay on *The Hand Press*: 'I might have been a wood-engraver had I not had Eric Gill as a neighbour; he had not cut, I think, more than a dozen blocks before my press plumped itself into the village but he was immediately able to meet its demands.' On 20 January Gill wrote: 'To Ditchling in the evening to see Pepler's printing press. Did my first piece of printing.'[58]

Despite his aversion to factory methods, Pepler was not anti-machinery *per se*; none the less he firmly believed in the intrinsic value of hand-printed books.[59] The Ditchling Press, as it was initially called, consisted of a century-old Stanhope hand press and fount of Caslon Old Face type. Pepler used only the best materials, including handmade paper made by Joseph Batchelor in Kent. He inherited a veteran printer of about seventy known as 'Old Dawes' from whom he learnt the finer points of hand printing. Primitive methods, lamp-black, and linseed oil ink applied by home-made dabbers soon gave way to commercially prepared inks and rollers. A double royal Imperial press was later added for printing posters, a particular penchant of Pepler's. Printing was a slow and intensive task. It took four men to operate and no more than five hundred copies of anything were produced.

Pepler became a Catholic in 1917 in the wake of Gill. The following year he joined the Dominican order as a tertiary or lay member, together with Eric and Mary Gill and Desmond Chute.[60] The Guild of St Joseph and St Dominic which they later formed in 1921 was described in their magazine *The Game* as 'primarily a religious fraternity for those who make things with their hands'.[61] The press was renamed the St Dominic's Press.[62] Pepler was contemptuous of the artistic pretensions of the élitist private press owners, many of whose books were only available to rich collectors. St Dominic's books were more down to earth, often on subjects dealing with craft, welfare, and religion, in particular Catholic pamphlets and liturgical books. Pepler aimed to have direct personal

[56] Malcolm Yorke, *Eric Gill: Man of Flesh and Spirit* (London, 1981), 174.

[57] Some of his idiosyncratic views on clothes were published, for example in *Clothes* (1931), illustrated with his wood-engravings.

[58] Diary, 20 Jan. 1916. WACML. Possibly the emblems from *The Devil's Devices* for *Emblems Engraved on Wood by Eric Gill*, the first Ditchling Press publication, which he helped Pepler print on the Feast of the Purification, 1916.

[59] See Edward Walters, 'Hilary Pepler, Printer' in 'Hilary Pepler and the St Dominic's Press', *Aylesford Review*, 7 (1965), 31–2.

[60] See Timothy Elphick, 'The Formation and Early Years of the Guild of Saints Joseph and Dominic to 1924', BA dissertation (University of Cambridge, 1984).

[61] *The Game*, 4: 9 (1921), 126.

[62] For the religious connection see Timothy Elphick's essay 'The St Dominic's Press and the Guild of St Joseph and St Dominic', in exhibition catalogue, *The Illustrators to the St Dominic's Press* (London: Wolseley Fine Arts, Rocket Press Gallery, 4–22 Apr. 1995), 16–21.

control over the press but he was not snobbish about trade commissions, printing ephemera as diverse as broadsheets, Christmas cards, calendars, posters, and beer bottle labels.[63]

Initially Pepler relied on Gill to provide all the illustrative material but, later, other members of the community such as David Jones, Desmond Chute, Philip Hagreen, and Mary Dudley Short contributed to its publications. Although Gill provided wood-engravings, the press was essentially Pepler's creation and his practical knowledge of printing was learnt under Pepler. Gill obviously enjoyed the free rein he was given, confessing that with the exception of *The Devil's Devices* and *Adeste Fideles*, 'I did not engrave anything for any reason but to please myself, and I had no line to toe, for the printer to whom I handed the blocks (I had no press of my own in those days) took whatever I gave him and used it as best he could'.[64]

Pepler was not a stickler for perfection but his work was never shoddy and he possessed an instinctive typographical 'feel'. His admiration for the early medieval printers and belief in the value of woodcuts as the 'art of the people' as used in block-books such as *Biblia Pauperum* led often to a contrived naïvety in many of the Guild's publications. Some of the presswork of the earlier publications was poor, yet on the whole the overall effect was one of simple elegance and grace. Brocard Sewell, who worked the press from 1932 for five years, recalled Pepler's remarkable sense of design: '[He] could create a beautiful title-page or a striking poster extempore; standing at the composing frame and improvising, he never used any preparatory designs or layouts.'[65]

Pepler's 'no-nonsense' attitude to art naturally appealed to Gill whose discipline and perfectionist approach to working methods in turn affected Pepler:

The first thing which must have struck an observer of Gill at work was the sureness and steadiness of his hand at minute detail; the assurance and swiftness of a sweep of line is one thing (and in this he was past master) but the hairs of an eyelash another—and he liked to play about with rays and hairs which can hardly be distinguished with a magnifying glass. He was always obliging. When I wanted a tail piece to end a chapter or an initial letter with which to begin one, he would tumble to the point at once, improve upon my suggestion, supply the block ready for the press within an hour, and come in to see it being printed the same afternoon.[66]

In 1916 various St Dominic's Press publications contained illustrations by Gill, notably *Adeste Fideles, A Christmas Hymn*—four slim pages headed by small, square, very simple white-line wood-engravings—and *Concerning Dragons*.[67] Both books, designed in a deliberately childlike manner, maintain a similar format.[68] Of greater social significance than these publications was *The Game*, an occasional magazine edited by Pepler, Gill, and, for a few years, Johnston (who had also moved to Ditchling), which ran from October 1916

[63] For a comprehensive list see *Bibliography, 1916–1937*.
[64] *Engravings by Eric Gill*, 7.
[65] Brocard Sewell, 'My Days at the St Dominic's Press', *Matrix*, 2 (1982), 82–8, p. 85.
[66] H. D. C. Pepler, 'Eric Gill', *Aylesford Review*, 7 (1965), 37–9, p. 37.
[67] One of a series of rhyme booklets by Pepler also issued as broadsheets.

[68] Pepler later wrote that Gill had happened to see these verses which he had written 'as a teasing comment on a nurse's idea of ghosts' and produced four engravings the next day which 'set the poems and lines to music'. Quoted by Stephen Setford, 'Hilary Pepler and the St Dominic's Press', BA thesis (Oxford Polytechnic, 1982), p. no. unrelocatable.

to January 1923 at more or less monthly intervals. The editors intended to print views 'about things in general which we regarded, as all men regard games, of supreme importance'. It was, in fact, an organ for their religious and Distributist views with practical aims of social reforms, written mostly by Pepler and Gill. In these little volumes illustrations, some whole page, are repeated several times. The second edition contains a wood-engraving of the holy stable illustrating a dialogue in verse of Mary and Joseph and the animals—a charming though unsophisticated white-line engraving. An interesting circular device includes a calligraphy pen (Johnston), printer's dabber (Pepler), and a graver (Gill). On the whole Gill's engraving style at this time is heavily weighted towards black with little feeling for the type.

Plate 20 The beginnings of his more typical hard-edged black-line engraving can be seen in the infamous *Nuptials of God*: an explicit image of a naked woman embracing the crucifix, literally illustrating the passage 'The Rood His marriage bed, | On which He doth enfold His spouse naked.'[69] Gill's controversial interpretation of the marriage of the Catholic Church and Christ brought *The Game* to an abrupt end having 'killed itself by an overdose',[70] not however before Desmond Chute and David Jones had made their own distinctive contribution to the magazine.

Gill's fascination for medieval art was reflected not only in his attitude to workshop practices but in his own sculpture, lettering, and wood-engraving. Decisive to his thinking was *Art et Scholastique* by the Catholic philosopher Jacques Maritain which he first read early in 1922.[71] Maritain looked back to the Middle Ages for his models, this being 'relatively the most *spiritual* period to be found in history'. Maritain concerned himself also with the creative process and his philosophical ideas on art provided a vital stimulus to the Ditchling artists, most especially Gill and Jones.

Gill's figures seem often to be confined within the block, whether of stone or boxwood. With stiff elongated limbs, large almond eyes, and linear drapery patterns, even his later, more sophisticated depictions maintain an iconic quality about them. Certain historians write of his neo-Byzantinism.[72] In defence of his Westminster Cathedral sculptures Gill observed of his critics: 'They thought I was carving in the Byzantine style on purpose! Certainly I was carving in what I called an archaic manner; but I wasn't doing it on purpose, but only because I couldn't carve in any other way.'[73] He appreciated the spirituality and anonymity of medieval craftsmen. It would seem that much of his figurative work, particularly that for book illustration, was inspired by Romanesque rather than Byzantine art. A comparison of the early twelfth-century stone frieze of *The Raising of Lazarus* in Chichester Cathedral, which he admired in his youth, with the relief sculptures of *The Stations of the Cross*, shows strong similarities in conception. By hardening the outlines, however, Gill deliberately avoids the expressive

[69] *The Game*, 6: 34 (1923), 3.
[70] Philip Hagreen to the author, 4 July 1986.
[71] The St Dominic's Press published the first English translation by the Revd. John O'Connor in 1923 as *The Philosophy of Art* with an introduction by Gill.
[72] See, for example, Yorke, *Eric Gill*, 75. Herbert Furst in 'The

Modern Woodcut: Part 2', *Print Collector's Quarterly*, 8 (1921), 267–98, 294, complained that most of Gill's works 'grate on one a little by reason of a persistent affectation of ascetic Byzantine mannerisms'.
[73] Gill, *Autobiography*, 200.

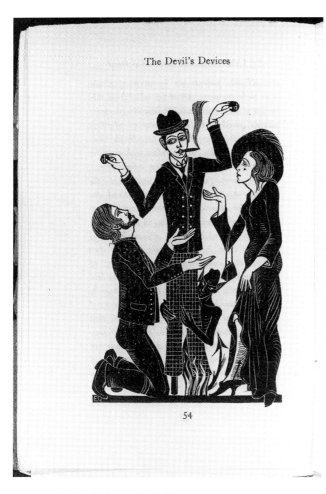

54

ΒΑΣΙΛΕΙ ΟΣΤΙΣ
ΕΠΟΙΗΣΕΝ

ΓΑΜΟΥΣ ΤΩ ΥΙΩ
ΑΥΤΟΥ [1]

THE NUPTIALS OF GOD

NOW doth Almighty God invite[2]
all sinners to His Wedding Feast.
Is there great joy on this night
when God showeth His delight
in man whom He has made,
or by the greatest as the least
is He betrayed?

1. "... a King who made a marriage for his son." *Matt. xxii*, 2.

2. Our Blessed Lord begins the parable of the King who made a marriage for his son with the words "The Kingdom of Heaven is like unto...." Those first to be invited would not come, they even killed the servants who announced that the feast was ready, but the King "destroyed those murderers and burnt their city." Guests both bad and good were then gathered from the highways, and when a "Friend" who had not a wedding garment had been bound and cast into exterior darkness we may suppose all obstacles to the guests' enjoyment of the marriage had been removed. It will be noted that the parable is entirely occupied with the guests. It is for this reason that the verses are concerned with the King's Son and His Bride. God goes to His Wedding betrayed by one disciple and denied by the rest. Nevertheless the Wedding was and is consummated; it is perpetuated in the Feast and Sacrifice of Holy Mass, when God again embraces His Bride, Our Holy Mother the Church. This is the Feast to which all sinners are now invited. Many refuse that invitation, being too occupied with their own affairs, too proud in their own conceits. Some would accept, but rejecting the obedience and seemliness of that outward conformity demanded by the Guest Master they are precluded from either material or spiritual participation in the Wedding. No Wedding garment is however necessary in the exterior darkness to which these are condemned.

3

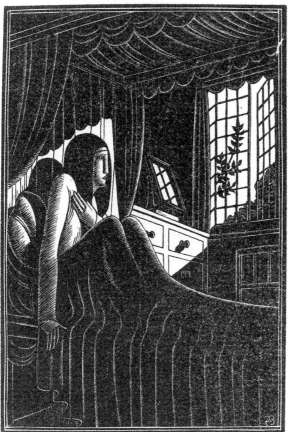

Pl. 19 (*above, left*). Eric Gill: Hilary Douglas Pepler, *The Devil's Devices* (Hampshire House Workshops, 1915). 187 × 125

Pl. 20 (*above, right*). Eric Gill: *The Nuptials of God* from *The Game*, 6: 34 (1923) (St Dominic's Press). 232 × 142

Pl. 21 (*left*). Eric Gill: Frances Cornford, *Autumn Midnight* (The Poetry Bookshop, 1923). 114 × 77

impact of the Chichester carving, his intention being to convey piety, not emotion. For this reason he deliberately made costumes historically timeless and facial expressions impassive. His engravings of all the Stations were published in 1917 in a press booklet, *The Way of the Cross*, where a stylized neo-Romanesque style is apparent. At this stage he was less concerned with aesthetics than with symbolism. 'The significance of things' was to him more important than the work itself.[74]

The St Dominic's Press provided a valuable outlet for Gill's idiosyncratic views on religion, art, and politics, many of which he was able to express visually through illustration. Through working for Pepler he discovered the power of wood-engraving as a means of communication. The press issued a series of Welfare Handbooks of which *Riches* (1919) contained a wood-engraved version of *Christ Charging the Money Changers from the Temple*; this he later controversially used as a model for the Leeds University War Memorial (1922–3). He often worked on the same subject at one time in different media, sometimes using religious subjects to voice propaganda for his own political ideals.

An interest in Hindu art was fostered by Ananda Coomaraswamy, the philosopher, critic, and expert on arts and crafts in India, whom he met initially in 1908. Their friendship resulted in Gill's first overtly sexual book illustration, *Spirit and Flesh*, for a poem by Coomaraswamy published at Ditchling in 1918.[75] In his work Gill interpreted religious and spiritual subjects with the sensuousness and eroticism of Hindu art, attempting in his writings to justify this approach by invoking Roman Catholic ideologies. This penchant becomes particularly apparent in some of his later illustrations for the Golden Cockerel Press. Paradoxically, owing to his hieratic approach to art, his depictions of human figures often appear cold and impersonal, even in drawings from life which he did not attempt till some time later. He felt that models for wood-engravings were unnecessary and difficult, a 'mere likeness to nature' being more easily achieved in drawings than with a graver on wood.

From this view follows an inevitable lack of interest in Impressionism (which he described in *Art Nonsense* as 'that last dying flare of the idolaters'[76]) and naturalistic rendering of light and shade. He felt that a wood-engraver must be prepared to start with the wood and the graver and his sense of what is beautiful in itself and not strain after effects.[77] Although he makes play of light in the magically atmospheric frontispiece to Frances Cornford's *Autumn Midnight* (printed at the St Dominic's Press for the Poetry Bookshop, 1923), the actual engraving is not naturalistic. The book also contains some miniature figurative initials. Gill disliked these illustrations, considering them 'too spotty and scrappy', yet they are some of his most attractive and possess an intimacy rarely seen in his later work. As an example of hand printing the book is one of Pepler's typographical masterpieces.

In the frontispiece the monumentality of the woman sitting bolt upright in bed

Plate 21

[74] Ibid. 160.

[75] In 1920 he contributed two sensuous wood-engravings to Coomaraswamy's *Three Poems* and a bookplate.

[76] Eric Gill, *Art Nonsense and other Essays* (London, 1929), 99.

[77] Eric Gill, Introduction to R. John Beedham, *Wood Engraving* (7th rev. edn., London, 1948), 12.

resembles Stanley Spencer's figurative style.[78] A rare wood-engraving of 1914 by Spencer of *Joachim and the Shepherds*,[79] showing strong similarities with the Tate study of the same subject in 1912, was published in the literary journal *The Beacon* in 1922, a year before the publication of *Autumn Midnight*.[80] Spencer and Gill exhibited in Roger Fry's rearranged 'Second Post-Impressionist Exhibition' at the Grafton Gallery in January 1913 which gave greater prominence to French Cubist works than had the original 1910 exhibition,[81] together with works of some of the leading members of the Bloomsbury Group. Both men, however, were more influenced in their early work by Giotto and the early Italian painters than by modern art which Gill considered for the most part 'soft as slime, sentimental as cocoa, & illogical as angry women'.[82]

As befits his contradictory nature, Gill was not averse to exhibiting his works despite his professed dislike of museums, galleries, and critics; he was publicity conscious even at this stage. In May 1918 a one-man show of his drawings and engravings was held at the Alpine Gallery. This exhibition was concerned with his work at Westminster Cathedral, although five illustrated books were displayed, together with about twenty wood-engravings, one woodcut, and various inscriptions. The following December he held yet another exhibition, 'Wood Engravings, Drawings and Images', at the Chelsea Book Club with Desmond Chute.

As much as Pepler's, Gill's charisma attracted key craftsmen to Ditchling, just as it drew them away when he left with his family for Wales. Chute (1895–1957), who studied at the Slade, met Gill in April 1918 and asked to be apprenticed to him.[83] He worked as his assistant, later joining the Guild and taking over Gill's workshop while he was away on military service. He left towards the end of 1921 to study for the priesthood at Fribourg. He contributed not only wood-engravings but several poems to the press publications. His illustrations are almost entirely religious and strongly influenced by Gill's work. Spencer, a close friend of Chute who spent many evenings with him reading classical literature, enthused about his drawing in a letter to Gwen and Jacques Raverat: 'He does drawings of heads; I have never seen anything in modern drawing so clear & exciting in their idea. You feel you would like to make carvings from them.'[84] This hard-edged precision no doubt suited his purposely hieratic style which is easily distinguished by its heavy black outlines and shading, and stiff figures, often Madonnas, as in *Purgatory* for *The Game* (1919). The major significance of his time with the Guild was *Plate 22* that he taught the young David Jones the rudiments of wood-engraving and exercised a deep and formative spiritual influence on both him and Gill.

Philip Hagreen (1890–1988), another convert to Catholicism, joined the community

[78] Spencer was undoubtedly affected, through Henry Lamb, by Gauguin's work.

[79] Reproduced in exhibition catalogue, *Stanley Spencer, RA* (London: Royal Academy of Arts, 1980), 50.

[80] See Ch. 4.3. Spencer knew Gill well and contributed a letter from Salonika (1917) to *The Game*, 3: 1 (1919), 1–8.

[81] See Ch. 4.4.

[82] Eric Gill to G. K. Chesterton, 6 Aug. 1924. Quoted from *Letters of Eric Gill*, ed. Walter Shewring (London, 1947), 178. Yorke's view,

Eric Gill, 150, that Gill experimented 'timidly' with Cubism and Léger's 'tubism' in his figure drawing seems unlikely given his dismissive attitude towards 'the poor little futurists and cubists—those fighters of the forlorn hope against mammon who have never heard of God ...'. *Letters*, 178.

[83] See John Dreyfus, 'Eric Gill and Desmond Chute', in John Dreyfus and Graham Williams, *Eric Gill for Father Desmond* (London, 1993), 11–29.

[84] Stanley Spencer to Gwen and Jacques Raverat [*c.*1916]. TGA.

in 1923: 'Heaven and earth took pity on me and I started to learn the alphabet, Eric taught me to do the lettering with a chisel and graver and I had the blessing of sharing a workshop with David Jones.'[85] As well as exhibiting oils with the International Society of Sculptors, Painters and Gravers, Hagreen had previously become caught up in the wood-engraving revival, having made a block as early as 1914. Edward Johnston's late work particularly impressed him, as did that of Gordon Craig and Ludovic Rodo, Lucien Pissarro's brother. But after his arrival at Ditchling he made a conscious decision to change direction. Convinced that 'art—right-making—is the making of what God wants us to make in the way He wishes us to make it',[86] he disclaimed any interest in his early wood-engravings which he felt lacked spirituality.[87] As he explained apologetically in later life: 'I tried to teach myself wood-engraving, but my ideas were all wrong.'[88] At Ditchling 'at last I was able to escape from the wrong ideas about pictorial art, but it was only after many experiments and failures that I could see the truth that is the common substance of all the arts. Then I made furniture, carvings in wood and ivory, silver ornaments and wood blocks. I had the zest of a learner but the slowness of a beginner.'[89]

All he learnt and did at Newlyn in Cornwall and the New Cross Art School and life classes at the Heatherley School of Art he later felt 'was tainted by the impressionist heresy—working from nature—painting what you see'.[90] Despite his protestations some of his most original work was produced under this influence. Early wood-engravings show an inherent feeling for the woodiness of the medium and the influence of impressionism in the shimmering light effects, as in *The Wind* (1918). This print appeared in the first annual exhibition of the Society of Wood Engravers in 1920 and was reproduced in *Contemporary English Woodcuts* (1922) and *The Modern Woodcut* (1924). Already early in 1919 Hagreen had contributed some illustrations to the two-volume magazine *Change*, together with Gill, Gibbings, Vivien Gribble, and other wood-engravers. Significantly these three publications were amongst the first to put modern wood-engravers on the map.[91] A tailpiece in *Change* entitled *The Waning Moon* which depicts a vase of flowers on a curtained window-sill against a black crescent-mooned sky is a playful domestic scene, in total contrast to his later, more spiritually inclined Ditchling illustrations. On an equally small scale, in *One of Our Conquerors* Hagreen caricatures the profiteer in a silhouette style not unlike that of William Nicholson. No doubt he learnt to engrave so incisively from Gill's lessons in letter cutting in stone. Yet, despite his admiration for Gill, he did not think of himself as 'one of his disciples but more a grateful pupil'.[92]

Plate 23

[85] Quoted by William T. Fletcher in Preface to William T. Fletcher and Graham Carey (eds.), *Philip Hagreen: The Artist and His Work* (New Haye, 1975), 5.

[86] Quoted by Graham Carey in 'Philip Hagreen: The Artist', in Fletcher and Carey (eds.), *Philip Hagreen: The Artist and His Work*, 8.

[87] Conversation between Philip Hagreen and the author, 12 June 1986.

[88] Quoted from Printer's Foreword, *The Book Plates of Philip Hagreen*, with introduction by John Bennett Shaw (Nappanee, 1982), 29.

[89] Fletcher and Carey (eds.), *Philip Hagreen: The Artist and His Work*, 5.

[90] Ibid.

[91] See Chs. 5.3 and 5.4.

[92] Conversation between Philip Hagreen and the author, 12 June 1986.

Pl. 23 (*above*). Philip Hagreen: *Change*, 2 (The Decoy Press, 1919). 44 × 37

Pl. 22 (*left*). Desmond Chute: *Purgatory* from *The Game*, 3: 2 (1919) (St Dominic's Press). 154 × 97

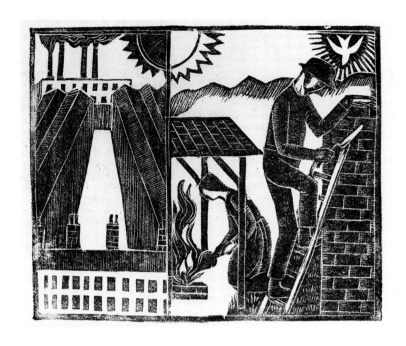

Pl. 24. David Jones: *Factory Town/Bricklayer on Ladder* from *The Game*, 5: 1
(1922) (St Dominic's Press). 77 × 94

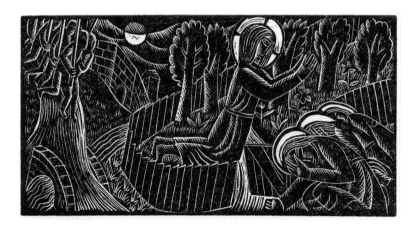

Pl. 25. David Jones: *The Agony in the Garden* from *A Child's Rosary Book*
(St Dominic's Press, 1924). 52 × 102

Gibbings, a close friend, enthusiastically welcomed Hagreen's idea of starting a wood-engraving society, which was actually formed in Hagreen's studio in 1920.[93] Between 1920 and 1922 Hagreen showed fourteen wood-engravings at the annual exhibitions but stopped decisively once he joined the Guild. He did little work at Ditchling in the early days since he moved with Gill to Capel-y-ffin in 1924, only returning for a further spell in 1932 from which time the majority of his book work was produced.

Indisputably David Jones was Gill's only really gifted pupil, although Jones himself considered him 'less an influence than a friend'.[94] Born in Brockley, Kent, he attended the Camberwell School of Arts and Crafts in 1909 where he would have become aware of contemporary French art through his tutor A. S. Hartrick, who had known Van Gogh and Gauguin. From Reginald Savage he discovered the Pre-Raphaelites and nineteenth-century illustrators such as Sandys and Beardsley. After serving on the Western Front with the Royal Welch Fusiliers he studied from 1919 to 1921 at the Westminster School of Art under Walter Bayes, Bernard Meninsky, and occasionally Sickert.[95] In 1921 he was received into the Roman Catholic Church and in the same year was introduced by Gill to the Ditchling fraternity where he stayed for four years.

A letter from Jones to Chute recalls: 'We sat in that red brick house of yours in the summer at Ditchling and you began to teach me wood-engraving.'[96] For an artist who had already attained an easy descriptive realism through art school training, wood-engraving was not an obvious medium to take up, but the limitations imposed forced him to concentrate on the essentials and employ simplicity of line and boldness of tonal contrast. The figures of Jones's early illustrations, no doubt partly influenced by Meninsky and also possibly by William Roberts, have a statuesque quality—one which is lacking in the conventional primitivism of Hagreen and Chute at this time but which he shared with Spencer and to a lesser extent Gill.[97] Jones contributed frequently to *The Game*, most significantly the title-pages for the year 1922: modern-day interpretations of *The Ten Commandments*. The January edition visually translates the words 'I am the Lord who brought thee out of the Land of Egypt and out of its house of bondage'. The block *Plate 24* is divided into two compartments: a dark industrial landscape on the left contrasts with the scene opposite of a couple working happily, the man building a brick wall, the woman making a fire, in a sunny rural setting. The figures in 1920s-style dress, though stylized, are not exaggeratedly caricatured as are Gill's in *The Devil's Devices*. Jones's moralizing is much more low key. His technical skill improves throughout this series, culminating in a particularly fine *Nativity*. The engravings are modern in approach: mainly loose white line with some cross-hatching around contours—not in the least hard-edged.

Pepler felt that with *The Ten Commandments* Jones was hampered by the idea of propaganda which the press imposed on him.[98] Certainly this would seem to be true of the

[93] See Ch. 5.1.
[94] Robert Speaight, *The Life of Eric Gill* (London, 1966), 112.
[95] At this time Jones became enthusiastic about Blake and the English watercolourists and was profoundly moved by El Greco's *The Agony in the Garden* (National Gallery).

[96] Quoted from *The Engravings of David Jones*, compiled by Douglas Cleverdon (London, 1981), 4.
[97] Gill was sufficiently impressed by this quality to engrave some of Jones's designs, for example, *Westward Ho* (1921).
[98] See *The Engravings of David Jones*, 4.

frieze-like neo-Romanesque figures in *A Child's Rosary Book* (1924), the first publication to be illustrated entirely by Jones. The fifteen mysteries are depicted in rectangular wood-engravings placed above the text on the right-hand page. Most are black with white line, although some are largely in black outline. The appearance is distinctly archaic, the figures often in profile with enlarged almond-shaped eyes, and there is little feeling for the balance of text with type. Cleverdon considered that 'possibly, with the medieval flavour, a certain mannered self-consciousness of the last five suggests that his commitment was weakening'.[99] Yet *The Agony in the Garden* signifies a new direction. Delaney points out that the rigid doubling and uniformity of the soldiers' figures shows the devices of repetition and of rhythmic grouping that Jones was to use in his greatest work, the illustrations to *The Chester Play of the Deluge*.[100] Another aspect which features in his later wood-engravings and watercolours is the two-dimensional quality: the flattened, up-tilted perspective and a weightlessness of piled-up objects, in this instance the figures at the top left who appear to be floating down the steep path. The closed-in feeling is reminiscent of early *hortus conclusus* woodcuts and medieval tapestries and embroideries which Gill exploited in his later work.

Both Delaney and Blamires claim that there is little individual style in Jones's wood-engravings up to *A Child's Rosary Book*. Delaney feels that his engraving efforts were unremarkable and lacked any real feeling and were all that could be expected in the work of an apprentice, while Blamires believes that they were hardly distinguishable from most of the Ditchling community's work and lacked Gill's fluid lines.[101] On the contrary, even at this early date Jones had developed a distinctive style of his own, inspired, perhaps, but not influenced by Gill and the rest of the community.

Jones's illustrations certainly tend to increase in decorative charm as their didacticism becomes less obtrusive. *Libellus Lapidum* (1924), a collection of satirical verses by Pepler, is one of the most appealing St Dominic's Press books.[102] Jones seemed to respond with relief to a secular commission and revealed a flair for engraving in a witty and affectionate style. Pepler's gibes at contemporary fashion and prominent public figures such as Jacob Epstein, John Drinkwater, Beatrice and Sydney Webb, Ronald Knox, and George Bernard Shaw are perfectly matched by Jones's humorous wood-engravings. These are distinctly more polished, both technically and stylistically, than earlier works, although an example from *In Petra* has been reused. Throughout the book whole-page illustrations on the left-hand page face the text on the right. A lively print on the cover, which shows Pepler carrying a quill pen and Jones with a graver mounted on a bucking horse (Pegasus), conveys a jerky sense of movement. Pepler's send-up of the Webbs is particularly amusing:

Plate 25

Plate 26

[99] Ibid. 8.
[100] Paul Delaney, 'Great Illustrators: David Jones', *Antiquarian Book Monthly Review*, 7 (1980), 480–7, pp. 480–1.
[101] Ibid. 480. David Blamires, *David Jones: Artist and Writer* (Manchester, 1971), 38–9.

[102] According to Blamires, only four illustrations are by Jones, while Cleverdon considers that all except one by an unidentified engraver were engraved by him. Douglas Cleverdon to the author, 22 Nov. 1986.

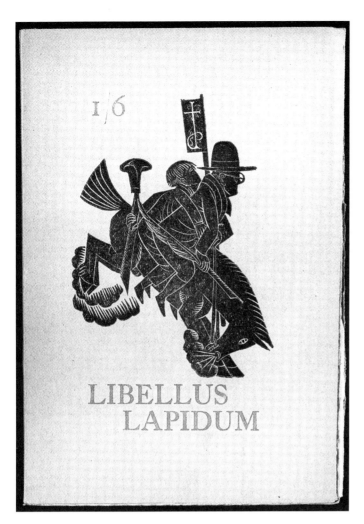

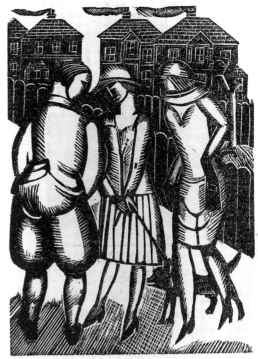

Pl. 26 (*left*). David Jones: *David Jones and Hilary Pepler Mounted on Pegasus*. Cover for Hilary Douglas Pepler, *Libellus Lapidum* (St Dominic's Press, 1924). 172 × 121

Pl. 27 (*above*). David Jones: 'Hampstead Garden Suburb' from Hilary Douglas Pepler, *Libellus Lapidum* (St Dominic's Press, 1924). 115 × 85

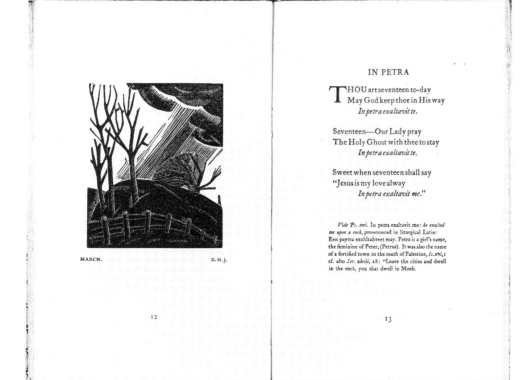

IN PETRA

THOU art seventeen to-day
 May God keep thee in His way
 In petra exaltavit te.

Seventeen—Our Lady pray
The Holy Ghost with thee to stay
 In petra exaltavit te.

Sweet when seventeen shall say
"Jesus is my love alway
 In petra exaltavit me."

Vide Ps. xvi. In petra exaltavit me: *he exalted me upon a rock,* pronounced in liturgical Latin: Een paytra exahltahveet may. Petra is a girl's name, the feminine of Peter, (Petrus). It was also the name of a fortified town to the south of Palestine, *Is.xvi,*1 cf. also *Jer. xlviii,* 28: "Leave the cities and dwell in the rock, you that dwell in Moab.

MARCH. D.M.J.

12 13

Pl. 28. David Jones: *March* for 'In Petra' from Hilary Douglas Pepler, *Pertinent and Impertinent* (St Dominic's Press, 1926). 210 × 260

We are for the PLEBS
Said the Webbs
The Mess they are in
Wants organisin'.
They shall toil while we spin
Any number of webs.

An industrial scene opposite depicts terraced houses and belching chimneys, whilst an additional note points out that 'there was no room to include the employer's residence or the contiguous villa inhabited by the Webbs'. These nevertheless share in the 'abundance' typified by the statue of a figure bearing a cornucopia. Jones, like Gill and Pepler, obviously relished an opportunity for social commentary. A strong period flavour is often reflected in his prints: the three figures wearing cloche hats, short skirts, and plus-fours illustrating 'Hampstead Garden Suburb', for instance, vividly evoke the 1920s.

Plate 27

Trained at an art school, Jones was consequently aware of contemporary trends in art, elements of which he adapted to suit his visual and literary subject matter.[103] *A View of Stairs*, for instance, is an uncharacteristically modernist design for a Ditchling publication of this date, with allusions to Paul Nash in the geometricality of contrasting angles, light, and shade, and suggestive also of Vorticism. Similarly Nash-like is a stark stormy landscape of 1923 entitled *March* which appeared later in *Pertinent and Impertinent*

Plate 28 (1926).

By December 1924 Jones had joined Gill and his family at Capel-y-ffin.[104] Apart from a frontispiece to W. H. Shewring's *Hermia and some other poems* (1930), he illustrated no more complete books for the press, although earlier wood-engravings were recycled in some later publications. A small print depicting Saint Dominic, engraved in an archaic woodcut style, was repeatedly used as the device for the press.

Jones was unmethodical in his working methods, hence there is a problem of dating, but, as has been indicated, his early St Dominic's style is easily distinguishable. Hagreen believed Jones to be a 'real genius', but he felt that in the early Ditchling days he did not worry enough about the typographical aspects of wood-engravings. (He was an exceptionally fast worker and could cut a block on the spot.) Fine, shallowly cut white lines and a predominance of black often made the blocks difficult to print. Pepler encouraged him to engrave more sympathetically for this purpose but, although in keeping with the sentiment of the text, his illustrations did not always harmonize with the type. Unlike his fellow Ditchling illustrators who rejected white line in favour of a cleaner black outline, Jones exploited the 'new' style. With experience he produced some of the most effective and personal wood-engraved images of the 1920s and 1930s, largely for illustration, most especially for the Golden Cockerel Press. Cleverdon maintained that, apart from some wall painting at Ditchling, Jones destroyed practically all

[103] In his introductory essay to the exhibition catalogue, *The Art of David Jones* (London: Tate Gallery, 21 July–6 Sept. 1981), 22, Paul Hills points to a passage in *In Parenthesis* in which Jones writes 'in terms of the syntax of Cubism, not only in its dehumanized geometry but also in its synthetic, dramatic lighting'.

[104] See Jonathan Miles, *Eric Gill and David Jones at Capel-y-ffin* (Bridgend, 1992).

his drawings and watercolours pre-1924.[105] As a result these Ditchling wood-engravings represent a fascinating and unique document of Jones's early *œuvre*.[106]

The arrival of R. J. Beedham, the reproductive wood-engraver,[107] amongst the Ditchling community had two important results. Initially he learnt lettering from Gill but was soon allotted the task of clearing out the white areas in Gill's blocks: a time-consuming job which required infinite patience and skill. It is arguable that Gill might not have been able to produce such a vast amount of pure black-line work without such a skilled translator. Confidence in Beedham encouraged him to pursue almost single-mindedly the black line. It is not often acknowledged that a significant proportion of Gill's and other practitioners' wood-engravings were intricately 'finished off' by another hand.[108]

In 1920, the same year in which the Society of Wood Engravers was founded, Beedham's *Wood Engraving*, was published by Pepler—a pioneering venture for the press. This seminal book, with an introduction by Gill, the earliest twentieth-century technical manual on the subject, ran into several editions and, from 1938, was published by Faber and Faber—an indication of its popularity and importance in proselytizing the medium, the later addition of a cover design of engraving tools drawing further attention to the craft.

The significance of the St Dominic's Press as one of the instigators of the wood-engraving revival in England is frequently overlooked. Stanley Morison and others acknowledged the fine printing that emerged from some of the publications, but the wood-engraved illustrations, particularly from the early pre-1925 period, tend to be given only scant mention and then usually out of the context of the page. Despite a fairly traditional house-style imposed by Pepler and Gill, the press acted as a breeding ground for talented artists. Working for Pepler undoubtedly helped to promote wood-engravers, most especially Gill and Jones for whom the Ditchling years were a time of experiment. Gill's subsequent interest in printing was founded on Pepler's advice, while his impeccable craftsmanship acted as a check to Pepler's imperfectionist approach. Jones meanwhile made his debut as a wood-engraver and illustrator at the press.

St Dominic's Press was unusual since, although private, its aim was to produce publications with a wide appeal at little cost. In fact, the books, which were produced in small numbers and which were often of a slightly esoteric or moralistic nature, had a limited market. Brocard Sewell points out that they 'were hardly advertised at all, as there was no cash to spare for that. I think there were occasional ads. in the TLS and G. K.'s Weekly. Nor were they widely reviewed.'[109] None the less St Dominic's played a pivotal role in the development of contemporary presses, and in the future of wood-engraving in

[105] Douglas Cleverdon to the author, 22 Nov. 1986.

[106] For a thorough investigation of his life and work see Jonathan Miles and Derek Shiel, *David Jones: The Maker Unmade* (Bridgend, 1995).

[107] Beedham contributed wood-engravings to various press publications from 1917. See also Ch. 4.1 n. 8.

[108] For Beedham's contribution see Appendix 2 in *The Engravings*

of Eric Gill, 505. Albert Garrett, *A History of British Wood Engraving* (Tunbridge Wells, 1978), 158, points out Beedham's long friendship with Gill and Gibbings and implies that 'some of the other creative engravers were anything but kindly disposed to a *Formschneider* in their midst'.

[109] Brocard Sewell to the author, 9 Nov. 1986.

particular.[110] The printer Edward Walters, who worked for a time at the press, recognized that it had more influence on English typography and wood-engraving than is immediately apparent: 'The truth which it demonstrated was that excellent printing and illustration need not, should not, be precious and must not be in a glass case. Pepler did not want to print "fine" books for the collector. He wanted something which was good and (so to speak) "didn't know it".'[111]

The remaining relevant productions of the press are discussed in later chapters.[112] It is, however, the pre-1925 work of Gill and particularly Jones which is most original and inventive for this period. During this time each was incubating his own unique style of wood-engraving, while first-hand experience of working for a private press set both on course as illustrators. Although their St Dominic's Press work was little known at the time, it certainly had a direct effect on subsequent illustration and deserves far greater recognition.

4.3. *Gwen Raverat: First Phase*

The soft, painterly wood-engraving style of Gwen Raverat (1885–1957) was in complete contrast to that of the Ditchling group. Unlike Gill and many fellow engravers, she took up the medium quite independently of Rooke's classes or other formal teaching. Her technique remained entirely individual: the result of self-tuition and a dogged determination to follow her own path. While not very conspicuous in the art world of the 1920s and 1930s, she made an indelible mark on the wood-engraving scene, most particularly in the field of book illustration.[113]

Gwen Raverat was an innovative printmaker. At the outbreak of the war in 1914 she had completed over sixty wood-engravings, a far greater output than any of her own generation of wood-engravers had achieved by this time. Apart from Lucien Pissarro, she was virtually the only practitioner in the early days of the revival to apply the lessons of Impressionism and Post-Impressionism and to retain an interest in light effects throughout her work. Her painterly handling set her aside from her contemporaries, with the notable exception of Sydney Lee, Sturge Moore, Frank Brangwyn, and Stephen Bone. Not only did she produce one of the first books to be illustrated with modern white-line wood-engravings, but her work was taken up by commercial publishers at a time when few acknowledged the medium as a viable method of illustration. They also frequently heeded her strong views on book design. With the publication of *The Bird Talisman* (1939) Raverat reinstated colour wood-engraved illustration as Pissarro had perfected it at the turn of the century.

Looking at her approachable prints, it is difficult to grasp that they were in any way radical. Yet her work was singled out by artists and critics alike as being novel and

[110] For further discussion see Joanna Selborne, 'The St Dominic's Press in the History of the British Private Press and Wood Engraving Movements Between the Wars', in *The Illustrators to the St Dominic's Press*, 9–18.

[111] Edward Walters, 'Hilary Pepler: Printer', 31.

[112] See in particular Ch. 6.2, 'Smaller Private Presses'.

[113] For fuller discussion on her technique and work see Joanna Selborne and Lindsay Newman, *Gwen Raverat, Wood Engraver* (Denby Dale, 1996).

inspiring. Malcolm Salaman, in the first exposition of modern wood-engravings, published by the *Studio* in 1919, considered her to be one of the most gifted and original artists using the medium creatively, while Herbert Furst inaugurated his new series, *Modern Woodcutters*, with a monograph on her work. Another champion of the medium, Campbell Dodgson, Keeper of Prints and Drawings at the British Museum, included *The Bolshevist Agent* in his seminal book, *Contemporary English Woodcuts* (1922). In 1920 the Society of Painter-Etchers and Engravers altered the rules to allow wood-engravings by Raverat, Lee, and Rooke to be exhibited. More significantly she was one of the founder members of the Society of Wood Engravers: she exhibited at every annual show between 1920 and 1940, contributing 122 wood-engravings, more than Gill or Gibbings, the next most prolific exhibitors.

Gwen Raverat was born in Cambridge in 1885, the daughter of the Plumian Professor of Astronomy, Sir George Darwin, Charles Darwin's son, and Maud du Puy, a lively and assertive American from a Philadelphian Huguenot background. In 1952, five years before her death, *Period Piece* was published: an engaging account of her Cambridge childhood and eccentric relations at the turn of the century, illustrated with her humorous line drawings. From an early age Raverat moved within an élite circle formed by her large but close-knit, intellectual family, and academic and artistic friends who were to provide her with useful contacts and work throughout her career. In 1909 she became involved with 'The Neo-Pagans', a group of students and members of the University, including Ka Cox, Frances Darwin (Cornford), David Garnett, Geoffrey Keynes, the Olivier sisters, and Jacques Raverat, who revolved round the charismatic figure of Rupert Brooke. Reacting against prudish Victorian attitudes, they joined in an idyllic cycle of parties, picnics, camping, and nude bathing—liberated yet with 'a strict, self-imposed chastity before marriage'.[114] This period, together with memories of her childhood at Newham Grange, imbued her with a deep and lasting love of Cambridge and the surrounding countryside which became the focal point of her life and formed the basis of her repertoire of subject matter.

Drawing was an essential ingredient of Raverat's art. From the age of nine, when she first attended drawing classes, she kept a sketchbook. A large Rembrandt exhibition in Amsterdam, visited when she was thirteen, was the beginning of a lifelong admiration for the artist's work. The discovery of a book of Bewick's wood-engravings awakened her interest in the medium, particularly its tonal possibilities.[115] In *Period Piece* she reveals an early interest in drawing from life and a capacity to observe the intricacies of nature and the world around her in minute detail: 'Long after I have forgotten all my human loves, I shall still remember the smell of a gooseberry leaf, or the feel of the wet grass on my bare feet; or the pebbles in the path. In the long run it is this feeling that makes life worth living, this which is the driving force behind the artist's need to create.'[116]

[114] See Paul Delany, *The Neo-Pagans: Friendship and Love in the Rupert Brooke Circle* (London, 1987), 68.

[115] An early watercolour of 1904, *The Curlew Wood*, with its simple pen outlines and plain flat colours is not unlike a coloured woodcut and already shows her interest in tonal values. In the possession of the family.

[116] Gwen Raverat, *Period Piece: A Cambridge Childhood* (London, 7th edn., 1953), 141–2.

This passage also reveals a passionate nature which often accounts for her choice of illustrative subject matter and the sensitive way in which she handles it.

In the face of opposition from her family, she studied from 1908 to 1910 at the Slade which at the time was enjoying a golden period: her contemporaries included such brilliant students as C. R. W. Nevinson, Mark Gertler, William Roberts, Edward Wadsworth, and Stanley Spencer. Under Henry Tonks the life drawing class formed the central focus of education. Printmaking played a subordinate role and no tuition in wood-engraving was provided. With the encouragement of her cousin by marriage, Elinor Monsell (Mrs Bernard Darwin), an ex-Slade student, who sent her some wood-engraving tools, she learnt the rudiments of the medium in the summer of 1909.[117] In 1903 a wood-engraving by Monsell of *Daphne and Apollo* was published in *The Venture*, an Annual for Art and Literature printed by James Guthrie's Pear Tree Press. Wood-engravings by Shannon, Savage, Ricketts, Pissarro, Sleigh, Craig, Sturge Moore, and Lee were also included. As might be expected, the first five artists illustrate in a 1890s-style reproductive manner, but Monsell and the rest employed the medium more imaginatively.[118] The strong feeling of movement in the figures and particular handling of light and sky which she achieved in this and other prints most probably inspired Raverat's interest in such effects, just as Monsell's domestic scenes such as *The Bath*, published in *The Modern Woodcut*, influenced her choice of subject matter.

Raverat meticulously pasted copies of most of her wood-engravings into volumes, and later dated them, which allows a comprehensive view of her work.[119] Balston mentions at least twenty blocks by her in 1908,[120] but her volumes and exhibition catalogues imply that 1909 was the starting date for her wood-engraving career. In that year she executed about twenty-six wood-engravings in a fairly loose, white-line technique, with a predominance of black areas. Some were engraved on soft pear wood which gives them more the appearance of woodcuts. Mostly they are imaginative and dramatic subjects: dreaming girls, solitary figures against stormy, cloudy skies, impassioned figures, some on bended knee, with melodramatic titles such as *Despair, The Murderer, Child Stealers, The Expulsion,* or *The Witch*. Raverat was romantic in a thoroughly non-sentimental way, although the subject matter of these early works tends to be rather intense and emotional. She hated anything 'pretty-pretty' or pretentious; as Furst wrote, 'there is no

[117] A letter from her cousin Frances Cornford mentions some woodcutting (meaning wood-engraving) tools which Elinor wanted her to send on to Gwen. Frances Cornford to Gwen Raverat, 8 June 1909. Gwen Raverat Papers, Darwin Archives, Cambridge University Library, henceforth GRP. Cited by kind permission of the Syndics of Cambridge University Library. Raverat's sister, Margaret Keynes, in *A House by the River* (Cambridge, reissued 1984), 115, confirms that she was virtually self-taught.

[118] Monsell also contributed wood-engravings to the periodical *The Dome*, and to *The Modern Woodcut* (1924) in which Furst recognizes her influence on Raverat. Her book illustrations were more often in crayon, pen and ink, or lithography and some of her later black and white figure drawings have strong affinities with Raverat's line-drawn illustrations. Although her wood-engrav-

ing output was small owing to pressure of work, according to Balston, she was quite progressive in her early use of white line. In *Wood-Engraving in Modern English Books* (Cambridge, 1949), 12 n. 1, he suggests that she was introduced to woodcutting as early as 1898 by Laurence Binyon, whose enthusiasm for Japanese prints she shared. Her daughter, however, believes that 'she was doing it in Ireland before taking up her Slade Scholarship' in 1896. An introduction to Lady Gregory and Synge 'got her the job of cutting and designing the block for the Abbey Theatre (which they still use)'. Ursula Mommens to the author, 9 Dec. 1986.

[119] In the possession of the family. Further albums made up by Geoffrey Keynes contain some additional early prints.

[120] Balston, *Wood-Engraving in Modern English Books*, 12.

romantic frippery or trimming' for her. She particularly admired Rembrandt's down-to-earth demythologizing approach to picture-making. Her extraordinarily vivid imagination and detailed memory is evident from *Period Piece* in which nightmares and other childhood horrors are clearly recalled. As a child, and throughout her life, she loved poetry, fairy tales, and ballads, which she drew on as source material for many of her wood-engravings, particularly in this early period.

Raverat's fascination for chiaroscuro was no doubt fostered partly by her admiration for Rembrandt's work. She would most probably have known Whistler's etchings, especially those of figures by lamplight and women seated by windows, which in turn were influenced by Fantin-Latour's *intimiste* interiors and Rembrandt's etchings. She owned two books containing original etchings by Goya, *Los Caprichos* and *Los Desastres de le Guerra*, and Christopher Cornford believed that she was inspired by the 'wonderful boldness in the light—dark—half-tone design; an eloquent simplicity that she herself achieves over and over again'.[121] Sickert's handling of interior light may also have been an influence. One of her earliest attempts at dramatic lighting can be seen from the second state of *Fair Margaret's Ghost* (1909): a window has been added to emit shafts of sunlight, indicated by scratchy diagonal line, which end abruptly in a crudely cut rectangular patch on the floor. Figures silhouetted by artificial light are used to particular effect in *Gypsies* of 1910 which shows an extraordinarily mature mastery of shadows and reflections for such an early date.

Gwen's marriage to Jacques Raverat in June 1911 signified a change of direction away from melodramatic narrative prints to more formal design. (Owing to recurring illness Jacques had been forced to abandon his mathematical studies at Cambridge and, after a period as an assistant at the Ashendene Press, he had joined Gwen at the Slade.) His influence on her mind and work was crucial at this time: both were highly intelligent, sharing many ideas and interests, particularly in literature and art. Their oil paintings at this time showed strong similarities, influenced as they both were by the Post-Impressionist emphasis on formal means of expression: line, colour, shape, space, and rhythm.

Between 1912 and 1914 the indirect influence of Gill is apparent in Gwen's series of 'meditating woodcuts'.[122] Balston states that she was unacquainted with Gill's work at this time.[123] Gill's diary, however, records meeting her on 28 April 1911, though they probably first met in Cambridge in August 1910 when he was working on an inscription for the portico of the Cornfords' house.[124] He spent several weekends with Gwen and Jacques at their house at Croydon, near Royston, and they also met frequently in London. It is doubtful whether she found him quite such a kindred spirit as Jacques did, intrigued as he was by Gill's views on aesthetics and religion. As a free-thinking Darwin Gwen was not a conventional believer, but under the two men's influence her

[121] Christopher Cornford to the author, 6 Mar. 1993.
[122] Gwen Raverat to Frances Cornford, [1913]. Frances Cornford Archive, British Library Manuscript Collections, henceforth FCA.

[123] Balston, *English Wood-Engraving, 1900–1950*, 9.
[124] Diary, 28 Apr. 1911. WACML.

Plate 29 work embarked on a religious phase, very often designed and inspired by Jacques, as in *Pietà* (1912), in which she experimented with bold black and white masses and black line. This rather austere and iconic Byzantine style is perhaps more characteristic of Jacques's way of thinking than hers. Certainly Frances Cornford warned her of the danger of being too abstract in *Pietà*: 'a great deal of abstractness *is* native to you, but not so much as to Jacques.'[125] It is arguable, however, that Gwen's interpretations inspired Gill's use of the black-line technique.[126]

The extent to which Stanley Spencer, a close friend from the Slade, was influenced by the Raverats, and Gwen's role in encouraging him to take up wood-engraving, have barely been acknowledged by scholars.[127] The medium, however, did not entirely suit Spencer: 'I am going to do some woodcuts but find that the lines have to go all more or less one way, which I do not like', he wrote; and later: 'What I cannot understand is how you get so deep down into the wood without in anyway injuring the sides. I want my cut to look clean—it looks so untidy.'[128] *Joachim and the Shepherds*[129] was probably his only serious attempt at wood-engraving, but it was sufficiently successful for his friend Darsie Japp to buy one for £1 and, more significantly, to be reproduced in the first volume of the journal, *The Beacon* (March 1922), beside the well-established wood-engravers Robert Gibbings and Vivien Gribble.[130]

Gwen Raverat's urge to illustrate was a natural outcome of her passion for literature. Her earliest attempts were thwarted. When at Tonks's suggestion she sent some proofs to the publisher Edward Arnold, he professed to prefer pen and ink drawings for illustrative purposes, no doubt for reasons of economy.[131] Her scheme to illustrate the *Gospels* came to nothing,[132] as did Elinor Darwin's idea for her to illustrate a Gospel for children.[133] The Raverats' suggestion of a version of Fitzgerald's *Ruba'iyat of Omar Khayyám* with drawings by Spencer, wood-engravings by Gwen, layout by Jacques, and lettering by Gill, was also rejected.[134] Having seen some of her religious prints Cosmo Gordon considered arranging for Oxford University Press to publish a Bible with her wood-engraved illustrations, but this idea did not materialize either.[135] Publishers of periodicals and journals were more willing to accept wood-engravings. *The Quarrel of Lord Thomas*
Plate 30 *and Fair Annet* appeared in the small first volume of *The Open Window* (October–March 1910–11), together with Rooke's *Man Ploughing*: a remarkable feat for such a novice and at a time when few of the new generation of wood-engravers had been published.

[125] Frances Cornford to Gwen Raverat, n.d. GRP.

[126] For Gwen Raverat's influence on Gill see Ch. 4.2 n. 52.

[127] Spencer frequently sought their advice, sending them preliminary sketches of his paintings, including *Joachim and the Shepherds*: their gift of Ruskin's *Giotto and his Work at Padua* with wood-engraved illustration by Dalziel was the inspiration for this painting. 'Send me some goodges [gouges] as soon as you can & tell me where to buy wood. I *am* going to paint Joachim.' Stanley Spencer to Gwen Raverat, 12 Jan. [?] TGA. His criticism of Gwen's prints was not always encouraging: 'I do not like either of your woodcuts but I hope you will take little notice of this. Goddamm.' Stanley Spencer to Gwen Raverat, n.d. TGA.

[128] Stanley Spencer to Gwen Raverat, n.d. TGA.

[129] Reproduced in exhibition catalogue, *Stanley Spencer RA*

(London: Royal Academy of Arts, 1980), 24.

[130] See also Ch. 4.2 n. 80. On 11 June Gilbert Spencer wrote to Gwen: 'My brother has not done any more woodcuts.' Gilbert Spencer to Gwen Raverat, 11 June 1913. TGA.

[131] Henry Tonks to Gwen Raverat, 8 Feb. 1911; Edward Arnold to Gwen Raverat, 18 Feb. 1911. GRP.

[132] See Ch. 4.2. Gwen and Jacques had hoped that the *Nouvelle Revue Française* would publish their Gospel. Gwen Raverat to Elinor Darwin (Monsell), [c.1912]. In the possession of the family.

[133] Gwen Raverat to Elinor Darwin (Monsell), [1912]. In the possession of the family.

[134] See Kenneth Pople, *Stanley Spencer* (London, 1991), 52.

[135] Cosmo Gordon to Gwen Raverat, 21 July [?]. GRP.

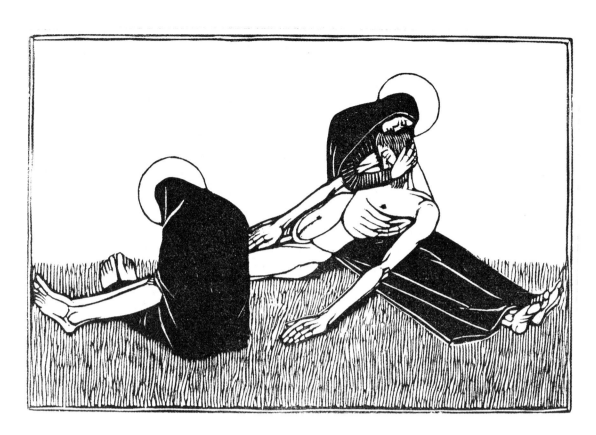

Pl. 29. Gwen Raverat: *Pietà*, drawn by Jacques Raverat (1912). 102 × 152

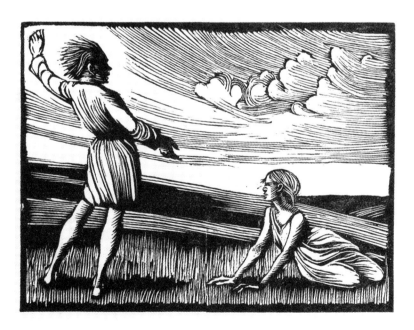

Pl. 30. Gwen Raverat: *The Quarrel of Lord Thomas and Fair Annet* from *The Open Window*, 1 (Oct.–Mar. 1910–11). 77 × 102

For her first book Raverat not only initiated the idea of a collaborative effort with her cousin and confidante, the poet Frances Cornford, but together they orchestrated its publication. 'I *wish so* much you'd write some real fairy tales (for Helena)', Gwen wrote. 'Id [sic] love them so much. I still have wishes to do a book with you—tho' I don't know really how it would work. P.S. If you write some fairy tales, I *will* illustrate them— tho' perhaps not in woodcuts—they take so long.'[136] Since they were an expensive way of illustrating, she could perhaps use existing wood-engravings: 'I want to know if you hold firmly to your view about the illustrations being *quite ezact* [sic] to the poem? I agree *if you* think of them as illustrations; but not if they are tailpieces? And its [sic] tailpieces I should like to do—just 4 or 5 little tiny ones to come at the end of the last verse. ... I have an idea too for the dogs barking in the night at the moon—very small.'[137]

In her delighted response Cornford suggested sending Raverat a few poems for her to illustrate afresh. She considered approaching Frank Sidgwick as a possible publisher.[138] In the event Harold Monro of the Poetry Bookshop agreed to publish the book entitled *Spring Morning* after the opening poem.[139] Raverat first learnt the value of exercising her own judgement on the appearance of her books when dealing with Monro. She dis-

Plate 31

agreed with him on a number of points, especially the design for the cover and lettering, feeling that it was absurd that he could not print the title in good capitals instead of using drawn ones: 'You see he just wants them to be *quaint* like the lettering on his notepaper.'[140] Monro's choice of green paper for the cover met with her approval, but when she received the proofs she was outraged with the layout. Although the prints were quite well printed,

every single one is put in crooked; and there is absolutely no sense of unity between the poems & the cut, because in each case the cut is put in the middle of the *page* (or nearly so); & the poem with a wide margin on one side & a narrow on the other. I have said to Monro: 'I hope you will agree with me that its no use taking *the centre of the page* as the point for placing the cut, but that you must take the axis of *gravity of the poem* & make it coincide with that of the block.' P.S. I like the look of our book, in spite of all this grumbling.[141]

Monro heeded her complaints and altered both the lettering and the layout.

Spring Morning is a slim paper-bound volume containing seventeen poems intended for young readers, to which Raverat contributed eight wood-engravings: a cover design, frontispiece, and six tailpieces. Some are clearly not literal translations; a few of her previous prints, for example, *Full Moon* and *November Day*, were included. She was of the firm opinion that while her illustrations should relate to the text they should express

[136] Gwen Raverat to Frances Cornford, 5 Dec. 1914. FCA.
[137] Gwen Raverat to Frances Cornford, [1915]. FCA.
[138] Amongst other publications Sidgwick produced two books of light verse, and several collections of ballads. He founded his own publishing firm, Sidgwick & Jackson, Ltd., in 1908.
[139] Harold Monro (1879–1932), writer and authority on poetry, and editor of *The Poetry Review* (later called *Poetry and Drama*), ran The Poetry Bookshop in Bloomsbury, and also a publishing

imprint, the first publication of which, *Georgian Poetry* (1911–12), included poems by Rupert Brooke who may well have been Cornford's contact. See Ch. 5.4. For further discussion see Joy Grant, *Harold Monro and The Poetry Bookshop* (London, 1967), and J. Howard Woolmer, *The Poetry Bookshop, 1912–1935: A Bibliography* (Revere, Pa., 1988).
[140] Gwen Raverat to Frances Cornford, [1915]. FCA.
[141] Gwen Raverat to Frances Cornford, [1915]. FCA.

Pl. 31. Gwen Raverat: Frances Cornford, *Spring Morning*
(The Poetry Bookshop, 1915). 210 × 155

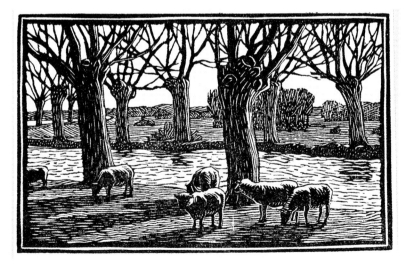

Pl. 32. Gwen Raverat: *Sheep by a River* (1919). 64 × 103

its *mood* rather than be subservient to it; an attitude which she continued to apply to her later books. Several of her blocks are over-black in relation to the type, a common characteristic of much wood-engraved illustration in the early years of the revival. With experience she later varied her treatment according to the nature of the text, the weight of the type, and the various demands of the publishers and printers.

Raverat's gentle lyricism could be said to mark her as the pictorial counterpart of many of the Georgian poets. A portrait of Rupert Brooke and an appropriately Neo-Pagan title-page for his posthumous *Collected Poems* (1919) was her only other venture into book illustration before 1920. Although on the fringes of Bloomsbury through her friendship with Brooke, among others, and Virginia Woolf, who became a confidante of Jacques before his death, Gwen never felt part of that world. Her letters reveal a certain cynicism about it and Bohemianism in general: 'I don't call being a Bohemian just being unconventional in order to be oneself.'[142] None the less her robust softwood prints, as exemplified by *Bathers* (1920), have much in common with the Omega woodcut style.[143] She was certainly avant-garde in her appreciation of French art at a time when there was so much misunderstanding and incomprehension about it in England. At the Slade Tonks actively discouraged his promising pupils from admiring Post-Impressionism. Yet Raverat wrote excitedly to Cornford of Roger Fry's first Post-Impressionist exhibition in 1910: 'The exhibition of Post Impressionists is a real event—of great importance to me psychologically. Gauguin is great. . . . I do wonder what art is evolving toward. It seems to me that these people are getting to something quite new and very wonderful. It's given me a splendid shock. You *must* go.'[144]

Despite this revelation, her wood-engraved work is much more inclined towards Impressionism, with its emphasis on the effects of light and shade in natural surroundings, particularly the tranquil landscapes of the Barbizon painters and etchers such as Charles-François Daubigny and Charles Emile Jacques. Even at boarding school, Raverat described a view of some sheep 'with frosty, winter light running along their *Plate 32* backs' in terms of a 'light' picture.[145] Pastoral scenes like *Sheep by a River* from about 1919 onwards literally translate this prescient description. By interpreting her perception of transient and poetic light in an impressionistic way, she showed an affinity with the pictorial style of French wood-engravers, most especially Auguste Lepère.

In 1920 Gwen Raverat held an exhibition of ninety-two wood-engravings at the Adelphi Gallery, revealing the extent to which she had developed her skills, as displayed in the exquisitely fine-lined *Poplars* (1916). In March she was invited to become one of the founder members of the Society of Wood Engravers. By the end of the year she and Jacques, by now an invalid, had moved to Vence in the Alpes Maritimes where he died in 1925. Not until the late 1920s did she take up book illustrating again. It is for this later work that she is best known, yet her wood-engravings up to 1920 show an intuitive feeling for the medium and technical and stylistic originality. Above all her involvement

[142] Gwen Raverat to Frances Cornford, n.d. FCA. [144] Gwen Raverat to Frances Cornford, 11 Nov. [1910]. FCA.
[143] See Ch. 4.4, The 'Bloomsbury Group'. [145] Raverat, *Period Piece*, 74.

in *Spring Morning* helped shape her decided views on illustration which had a significant influence on commercial book design.

The distinguished etcher, D. Y. Cameron, when thanking her for two prints which she sent him in 1915, summed up her wood-engravings perfectly: 'They have that kind of primitive simplicity, so refreshing amid the quantities of photographs & merely reproductive art without spirit with which we are overwhelmed in exhibitions.'[146]

4.4. *Modernist Trends*

The dilemma between the use of abstraction as a means of effecting a radical break with tradition, and the need to depict contemporary life, yet in a non-representational way, was a feature of modernism which had its roots in the first two decades of the century.[147] For historical and technical reasons, wood-engraving, especially for book illustration, was less widely affected by such issues as were painting and sculpture. As will be seen, wood-engravers and critics gradually evolved their own criteria for modernity relevant to the medium and its particular uses. None the less, as a new and experimental art form, wood-engraved and, indeed, woodcut prints from about 1910 to 1920 present some of the most arresting graphic images of the twentieth century. Largely single prints, owing to the limited demand for illustration, and, as a result, unfettered by woodcutting convention, they had a crucial effect on the development of the medium, inspiring much of the more innovative book work and advertising in the inter-war years. This section deals with those artists who, by choosing woodblock printing as a means of expressing modernist ideas, helped to establish new aesthetic criteria for wood-engraved illustration.

For all Gwen Raverat's appreciation of French painting and her novel approach to wood-engraving, her work was entirely unselfconscious and unaffected by fashion for its own sake. Meanwhile, at a time when wood-engraving was beginning to emerge as an autonomous graphic art, a small group of avant-garde artists were expressly applying modernist principles to the medium. It is no coincidence that these artists all emanated from the Slade, which had been put into a turmoil by Roger Fry's Grafton Gallery exhibition of 1910, 'Manet and the Post-Impressionists'. The exhibition included works by Gauguin, Van Gogh, and Cézanne, whom Fry presented as the founding fathers of the New Movement. Despite Tonks's objections and the outrage of the public and of many critics, this was just a rallying cry for the more radical students, C. R. W. Nevinson, Edward Wadsworth, William Roberts, Paul Nash, and Ben Nicholson, in particular.[148]

[146] D. Y. Cameron to Gwen Raverat, 10 June 1915. GRP.

[147] See Charles Harrison, *English Art and Modernism, 1900–1939* (2nd rev. edn., New Haven and London, 1994), 118. This book provides a useful study of the evolution of the concept of modernism, in particular ch. 3, 'Post Impressionism' and the 'New Movement'.

[148] According to Paul Nash, the Slade students 'were by no means a docile crowd and the virus of the new art was working in them uncomfortably'. Paul Nash, *Outline: An Autobiography and Other Writings* (London, 1949), 93.

The fever of rebelliousness was not just confined to art schools or the Bloomsbury set: the violently militant suffragette movement, for instance, threatened society as a whole, while continuing fear of German invasion caused further tension. Amongst artists a revolt had already begun against conventional art institutions with the founding of independent exhibition societies such as Vanessa Bell's Friday Club in 1905, the Society of Twelve, and, most important, the Allied Artists' Association based on the Paris Salon des Indépendants. Fry's 'Second Post-Impressionist Exhibition' (October 1912–January 1913), which was dominated by Cubist and Fauve works, most notably by Picasso, Matisse, and Braque, also included English artists, mainly of the Bloomsbury group: Fry, Duncan Grant, Vanessa Bell, and Henry Lamb, as well as Spencer Gore, Wyndham Lewis, Wadsworth, Gill, and Spencer. The English contribution was but a pale shadow of the continental but lessons had been learnt from Cubism, Fauvism, and Gauguin, in particular, while the move towards Fry's 'significant form'—the emphasis on the primacy of form and structure over narrative content—as stated in his introduction to the catalogue, was apparent. His advocacy of the Post-Impressionist aim which he expressed as 'the discovery of the visual language of the imagination',[149] a language which must be free from dependence on the actual appearance of things, and the value he placed on 'emotional elements' of design—rhythm, mass, planes, colour, light, and shade—vitally affected British art.

Following an exhibition of Italian Futurists,[150] Frank Rutter organized the 'Post-Impressionist and Futurist Exhibition' at the Doré Galleries in October 1913. In a foreword to the catalogue he stated: 'That "cubism" and "futurism" have already stirred English artists is shown by the contributions of Mr Wyndham Lewis, Mr Wadsworth, and Mr Nevinson and others.' These artists went on to form one of the most dynamic, though short-lived, movements in England, Vorticism. However, as will be seen, Fry was unable to concur with these English rebels.

Edward Wadsworth and Vorticism

On 22 January 1914, T. E. Hulme, poet and philosopher and a Vorticist champion, reinforced the movement's ideas in a lecture on 'Modern Art and its Philosophy'.[151] He forecast that the new 'tendency towards abstraction' would be oriented less towards simple geometric forms found in archaic art than towards machinery. Despite borrowings from Cubist and Futurist elements, abstraction was a uniquely English and individual style when practised by Vorticist artists.[152] Their aesthetic, which tended to

[149] Quoted by Harrison, *English Art and Modernism*, 54, from Dugald MacColl, *Confessions of a Keeper* (London, 1931). For wider discussion on the British reaction to 'Manet and the Post-Impressionists', and other exhibitions of modern art held around this time see *Modern Art in Britain, 1910–1914*, exhibition catalogue researched and written by Anna Gruetzner Robins (London: Barbican Art Gallery, 1977).

[150] The 'Exhibition of Works by the Italian Futurist Painters', London: Sackville Gallery, Mar. 1912, included works by Umberto Boccioni, Carlo Carrà, and Gino Severini.

[151] T. E. Hulme, 'Modern Art and its Philosophy', in *Speculations: Essays on Humanism and the Philosophy of Art*, ed. Herbert Read (London, 1924).

[152] See, in particular, William C. Wees, *Vorticism and the English Avant-Garde* (Manchester, 1972). In the exhibition catalogue, *Vorticism and its Allies* (London: Hayward Gallery, London, 27 Mar.–2 June 1974), 22, Richard Cork describes the Vorticists' aim as a 'synthesis poised half-way between the kinetic dynamics of Futurism and the static monumentality of Cubism'.

be less frenetic and *mouvementé* and more dehumanized than that of the Futurists, was particularly suited to graphic work. It was characterized in its most abstract phase by strong diagonals, angular motifs, hard-edged lines, and multifaceted surfaces. Hulme's admiration for the qualities of 'engineer's drawings, where the lines are clean, the curves all geometrical, and the colour, laid on to show the shape of a cylinder for example, gradated absolutely mechanically' appealed instinctively to Edward Wadsworth (1889–1949).[153] After studying machine drawing in Munich with the intention of joining the family spinning mill in Lancashire, he decided to embark on a career as artist. From the Bradford School of Art he won a scholarship to the Slade in 1909.

At the Knirr School of Art in Munich he had learnt various printmaking techniques, practising woodcutting in his spare time. In his introduction to the first monograph on Wadsworth Drey stated that all the prints in the book had been taken from blocks cut 'on the plank'.[154] Probably, however, most are wood-engravings. Albert Garrett, a practising wood-engraver, felt that the precision of the angles could not have been achieved with a knife or gouge.[155] According to Wyndham Lewis, not only did Wadsworth have 'machinery in his blood' but he was obsessively and meticulously tidy and precise.[156] He was evidently attracted to a medium that left 'nothing at all to accident':[157] the hardness of the material and the clean-cut linear potential of wood-engraving ideally suited his technical abilities and artistic intentions. With hindsight he felt that he had evolved something new out of the medium which he found 'very suitable for an expression of form and structure'.[158]

His earliest prints, several of northern industrial landscapes, date from the post-Slade period after he had broken away with the other rebels, Frederick Etchells, Cuthbert Hamilton, and Wyndham Lewis, from Fry's Omega Workshops in October 1913. Fry's emphasis on decorative form and structure appealed to these artists. Wadsworth built up flat planes and cubic geometrical shapes into black and white fragmented images devoid of tones. (With the occasional use of additional blocks he introduced lighter shades.) Various prints were shown alongside works by Marc, Pechstein, Bomberg, and Kandinsky in an exhibition entitled 'Modern German Art' held at the Twenty-One Gallery between February and March 1914. His visual vocabulary clearly owes a debt to continental printmakers, Robert Delaunay, Picasso, and Kandinsky, in particular. Some reflect Kandinsky's musical analogies to abstract art in *The Art of Spiritual Harmony*, as translated by Wadsworth for the first issue of *BLAST* (June 1914), Lewis's Vorticist manifesto.

Apart from the images which appeared in this publication, few illustrations emanated from Vorticist artists: their abstracted pictures were statements in themselves. The well-ordered *mise en page* favoured by the private presses was distinctly not a Vorticist concept.

[153] See, in particular, Richard Cork, 'Edward Wadsworth and the Woodcut', in Jeremy Lewison (ed.), *A Genius of Industrial England: Edward Wadsworth, 1889–1949* (Bradford, 1990).

[154] O. Raymond Drey (introd.), *Edward Wadsworth: Modern Woodcutters, No. 4* (London, 1921), unpaginated.

[155] Garrett, *A History of British Wood Engraving*, 164.

[156] Wyndham Lewis, 'Edward Wadsworth, 1889–1949', *Listener*, 30 June 1949.

[157] Quoted by Barbara Wadsworth, *Edward Wadsworth: A Painter's Life* (Salisbury, 1989), 73.

[158] Ibid. 77.

Pl. 33. Edward Wadsworth: *Illustration (Typhoon)* (1915). 280 × 255. © Estate of Edward Wadsworth 1998.

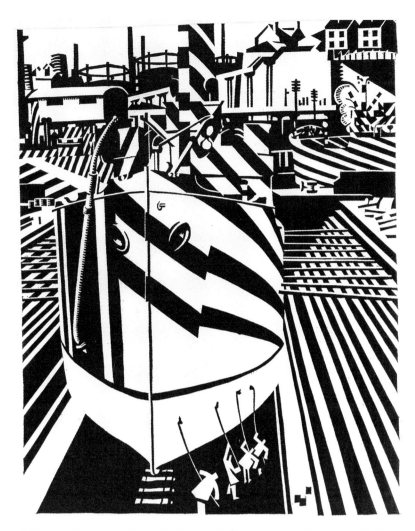

Pl. 34. Edward Wadsworth:
*Dazzleships in Drydock at
Liverpool* (1918). 254 × 201.
© Estate of Edward
Wadsworth 1998. All rights
reserved DACS

Pl. 35. Edward Wadsworth:
Blast Furnaces from *The Black
Country* (Ovid Press, 1920).
77 × 103. © Estate of Edward
Wadsworth 1998. All rights
reserved DACS

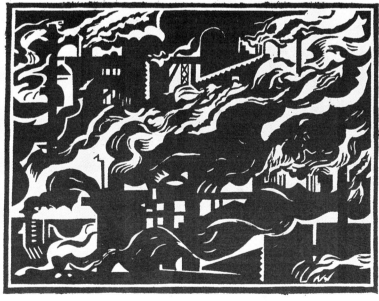

With loud and heavy type blatantly disarrayed on the pages of *BLAST*, Lewis fired a shot at typography and the printing establishment.[159] The use of bold sans serif type for a literary, as opposed to a commercial, publication, is, however, extremely avant-garde at this period in England, although Marinetti had contributed in the Futurist Manifesto of 1909 to the New Typography, as had the Dadaists.[160] Lewis's anti-typographical attitude is matched in the first issue by Wadsworth's coarsely executed abstract print, *Newcastle*, with its zigzag, sawtooth treatment. While it bears little resemblance to the fiery blast furnaces of the title, it no doubt relates to the manifesto's blessing of 'the great PORTS'. Appropriately it was included in the first exhibition of the Vorticist group in June 1915.

Plate 33 Wadsworth never specifically illustrated a book, but his wood-engraving entitled *Illustration* (1915), which interprets a quotation about a ship's engine-room from Joseph Conrad's short story *Typhoon*, accurately mirrors the text with its precise description of space and shape and its allusions to iron and machinery—an archetypal Vorticist composition admired by Henri Gaudier-Brzeska.

From June 1916 to the summer of 1917 Wadsworth served as a naval intelligence officer at Mudros on the Aegean island of Lemnos.[161] On returning to England he worked in the Liverpool and Bristol dockyards supervising 'dazzle' camouflage applied to ships. Such work was the inspiration for some of his most striking wood-engravings, as exemplified *Plate 34* by *Dazzleships in Drydock at Liverpool*. Startlingly geometric, his subjects are now less abstract and distorted and a sense of perspective is achieved through an ordered chessboard of solid black and white areas. Balston considers that this series was among the first modernist works to attract wide notice.[162] Certainly the reproduction of some of these as advertisements drew attention to Wadsworth's work,[163] as did the appearance of his work in contemporary periodicals.

A comprehensive exhibition of his prints held at the Adelphi Gallery in 1919 was well received. The following year a series of industrial landscape drawings entitled 'The Black Country' was exhibited at the Leicester Galleries. The catalogue, published as a book by the Ovid Press, with an introduction by Arnold Bennett, included some wood-engravings (or more probably woodcuts) in a very different vein from his taut, geometric style. In *Blast* *Plate 35* *Furnaces* undulating smoke pours out diagonally across a grimy landscape of fragmented factories and slag heaps. Wadsworth's bold depiction of energy and movement generated by a modern industrial scene was quite unprecedented in British woodblock printing. In the same year, also for the Ovid Press, he produced a colophon and some modernist decorative initials for T. S. Eliot's *Ara Vus Prec*.[164]

[159] Clan Meynell is amongst a list of names blasted; probably Gerard Meynell, of the Westminster Press, and his cousin Francis, founder of the Nonesuch Press, are the targets. See Ch. 6.2.3. Another target was 19th-cent. culture such as 'the pretty-pretty, the commonplace, the soft, the sweet, and mediocre, the sickly revivals of medievalism ... Aestheticism, the Pre-Raphelites, Neo Primitives ...' as described by Marinetti and Nevinson in 'A Futurist Manifesto, Vital English Art', *Observer*, 7 June 1914.
[160] For further discussion of British influence on the German typographical scene see Ch. 6.1.

[161] Five prints from this period, together with *Brown Drama* (c.1914–15), were used as illustrations for Ezra Pound's article, 'The Death of Vorticism', in *The Little Review* (Feb.–Mar. 1919), 45–51.
[162] Balston, *English Wood-Engraving, 1900–1950*, 9.
[163] *Liverpool Shipping* (1918), for instance, was printed lithographically in 1936 for a London Transport poster advertising the Imperial War Museum.
[164] According to Wadsworth, T. E. Lawrence admired these initials and asked permission of John Rodker, owner of the press,

In March 1920 Wadsworth turned down an invitation to become a founder member of the Society of Wood Engravers, having decided to abandon the medium. For Vorticist artists in general such intense and highly stylized design had limited scope, particularly within the constraints of wood-engraving.[165] Wadsworth's prints, which are among the most resolved products of the movement as a whole, were generally admired by contemporary critics, although Salaman viewed them with reactionary caution.[166] He had few immediate followers, but his and other Vorticist's graphic work acted as an impetus to the emergent linocutting movement, its aesthetic exemplified by the modernist prints of William McCance and Horace Brodzky, and the late 1920s colour linocuts of Claude Flight and his pupils at the Grosvenor School of Modern Art. A further area of influence was on woodcut design for posters, amongst the most successful being Edward McKnight Kauffer's startling image, *Flight* (1917), a reverse version of which was used to publicize the *Daily Herald* launch in March 1919.

Robert Gibbings

Robert Gibbings (1889–1958) briefly overlapped with Nevinson and Wadsworth at the Slade in 1912. He was a very different character, a countryman at heart, having been educated locally in Cork which remained his spiritual home, though his life was spent mostly in England or abroad. After failing his medical exams, he received tuition in drawing and painting until he was able to finance attendance at the Slade for two years from October 1911. In the second year he joined part-time etching classes at the Central School and attended Noel Rooke's class as one of his first pupils.[167] Later he recollected: 'I had never heard of engraving on wood and was not drawn to the idea. There would be further outlay on gravers & even at that time wood cost 1½d. or 2d. a square inch, and what was it all about anyway. I tried to excuse myself, but Rooke prevailed. "It is what your work needs", he said.'[168] Like Wadsworth, Gibbings relished the intractability of the medium. From Rooke he not only received instruction in technique and design but also learnt to appreciate the 'feel' of the printed page; from Mason, with whose help he set and printed his own poem and three-colour woodblock illustration, he learnt about typography and the practicalities of printing—firm foundations for his later work for the Golden Cockerel Press.

Gibbings chose to depict conventional subject matter, especially landscape and the human figure, in a recognizable manner. Yet his inventive treatment was such that his

to use them in his *Seven Pillars of Wisdom* (first published privately in 1926). Edward Wadsworth to [Eric] Newton, 9 Mar. 1936. Harry Ransom Humanities Research Center, University of Texas at Austin, henceforth HRHRC.

[165] Christopher Nevinson, one of the original artists to come under the influence of Cubism and the Italian Futurists, who exhibited at Rutter's 'Post-Impressionist and Futurist Exhibition', produced a few remarkable wood-engravings or woodcuts under this influence, particularly of subjects inspired by the war, but none was for illustration.

[166] Malcolm C. Salaman, *Modern Woodcuts and Lithographs by British and French Artists* (London, 1919), 22–3.
[167] He also learnt colour woodcutting in Morley Fletcher's class. *Retreat from Serbia* (1916) was printed from two blocks on a letter-copying press.
[168] Robert Gibbings, 'Some Recollections', from *The Wood Engravings of Robert Gibbings*, ed. Patience Empson with introduction by Thomas Balston (London, 1959), pp. xxx–xxxi.

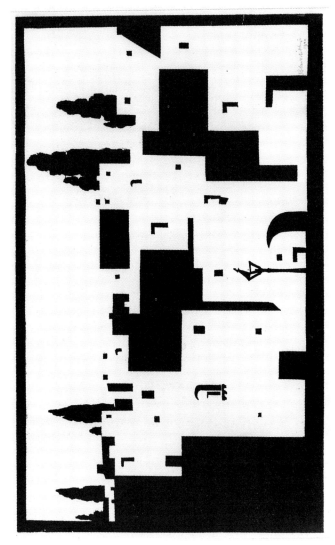

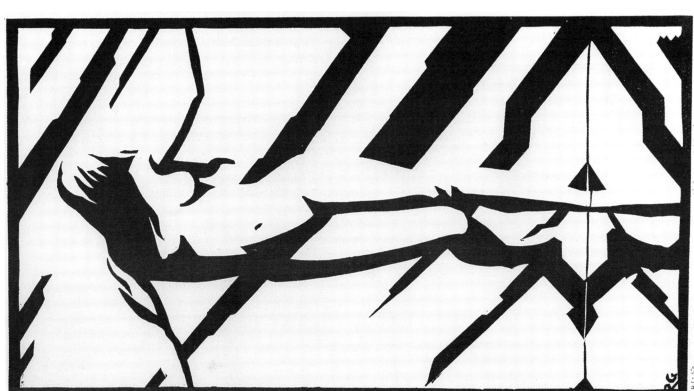

Pl. 36 (*above*). Robert Gibbings: *Hamrun* (1920).
177 × 292

Pl. 37 (*left*). Robert Gibbings: *Clear Waters* (1920).
245 × 134

early wood-engravings are amongst the most exciting graphic work of the period and compare favourably with other modernist prints. He would have learnt little about continental art at the Central which, though not backward looking, was fairly insular.[169] The unusual experience of dividing life between the Central and the Slade, one of the more advanced art schools, meant that his approach to wood-engraving at this time was more lively and fresh than that of most of his contemporaries. He recalled Spencer, Nevinson, Gertler, and Roberts thinking little of his abilities in the Life Class until Spencer happened to see one of his drawings of a cow.[170] A biographical note in *The Beacon* suggests it was his engraving, *Spot the Cow* (1913), inspired perhaps by the Slade drawing, which first aroused his interest in pattern. About this time he experimented with engraving in silhouette, affected in part maybe by William Nicholson's solid blacks. Certainly he was not interested at this stage in producing finely engraved tones or shading. *The Crest of the Hill*, with its unconventional low viewpoint and cut-off composition, predates Gill's best silhouette-style wood-engraving and shows greater originality in conception. Already, by concentrating on formal means, Gibbings was tending towards minimal representation which he aptly described as an 'exercise in elimination'.[171]

Through Slade circles Gibbings was clearly aware of contemporary artistic trends, most especially Vorticism and 'significant form'. With *Dublin under the Snow* (1918) and the wood-engravings designed in Salonica (where, after serving in Gallipoli, he was posted in January 1917) and Malta, Gibbings's highly individual style emerged. Of *Dublin under the Snow* he recalls: 'This was the first of my engravings in which pattern took ascendancy over subject; the first, too, in which I used what has since been called the vanishing line.'[172] With this technical device he omits the bounding line between two white (or black) planes leaving the spectator to work out and separate them—a method used by Wadsworth in 1914 in such prints as *A Yorkshire Village*, and *Rotterdam* which appeared in the second issue of *BLAST* (July 1915). Between about 1919 and 1922 Gibbings employed it frequently and with increasing confidence, as seen to best effect in *Melleha, Hamrun* and his *tour de force* in this minimalist style, *Clear Waters*, in which, with facial features and key outlines removed, white limbs dissolve into the luminous background, their contours deceptively implied. Remarkably, from the flattened perspective Gibbings manages to achieve a sculptural quality. His perception of these works as musical compositions echoes Kandinsky's aesthetic as translated by Wadsworth and reflects the language of Imagist poetry advocated by Ezra Pound: in Malta 'it was that I began to see the strong patterns of light and shade or rectangular houses almost in terms of music— major chords, minor chords, small windows or archways as the accidentals. The proportions of one rectangle were important in themselves; they were equally important in their relation to adjacent shapes. *Melleha* was born of this, so also *Hamrun*.'[173]

Plates 36, 37

[169] In *The Wood-Engravings of Robert Gibbings*, with introduction by Thomas Balston (London, 1949), 15 n. 1, the editor notes that neither Pissarro, who had been in England for about twenty years, nor Rooke who had passed much of his life in French circles in France, was aware, then, and for some years after, of the contemporary development of the modern woodcut in France which was to achieve such publicity during the First World War.
[170] Ibid. 14.
[171] *The Wood Engravings of Robert Gibbings*, ed. Empson, p. xxxv.
[172] Ibid., p. xxxiv. [173] Ibid., p. xxxv.

These startling prints put Gibbings in the forefront of the wood-engraving move-
ment.[174] His innovatory methods were appreciated by such discriminating critics as
Salaman, whose *Studio* article of 1919 represents the first critical appraisal of a modern
wood-engraver,[175] Furst, and Campbell Dodgson, who praised his Cubist or Post-
Impressionist style.[176] To a greater extent than his contemporaries, his work around 1920
featured in periodicals and journals, notably *Change*, *The Apple*, and *The Beacon*. He had
as yet attempted no book illustration; possibly his bold designs did not attract pub-
lishers, yet they resulted in several commissions for advertisements.[177]

The turning-point in Gibbings's career came in 1923 with his first commission to
illustrate a book. The exacting precision required to marry wood-engraving with type
led him away from massed blacks and whites to a greater use of white line, yet he never
lost sight of the solid three-dimensional feeling for space which he had mastered in his
Cubist-inspired works and which was generally absent in Vorticist prints.

The Bloomsbury Group

The row which caused the walkout by the Vorticist group of Lewis, Hamilton, Wads-
worth, and Etchells from Fry's Omega Workshops was the culmination of growing
differences of opinion between the two groups. Lewis's views on art were far more
radical and uncompromising and his attitude to 'form' more clearly defined. Fry's
pacifist nature did not endear him to the aggressive qualities of Futurism nor did he view
'significant form' in such abstract terms. Certainly, he had appreciated the Vorticists' use
of abstraction in their Omega works, which had rubbed off on other members of the
Workshops. In turn certain Omega tendencies, such as the 'stick-style' cubing of the
human figure, were picked up by the Vorticists.[178] Possibly it was their anti-social,
dehumanizing approach that was most alien to the Bloomsbury artists whose life
revolved around personalities. The existence of the Workshops after all depended on
the supplying of decorative domestic products such as furniture, rugs, textiles, pottery,
tiles, and screens to fashionable society and friends.

Apart from pure pattern, representational elements were generally present in Omega
designs, mostly figures, flowers, fruit, leaves, and such like: comfortable, homely subjects
yet up to date in appearance. One of Fry's aims for the Workshops was to 'keep the
spontaneous freshness of primitive or peasant work while satisfying the needs and

[174] *Dublin under the Snow* and *Hamrun* among other of his prints were shown in the 'Exhibition of Woodcuts by French Artists' held at the Little Art Rooms, Apr.–May 1920, together with works by Carlègle, Dufy, Galanis, and Hermann Paul.

[175] M. C. Salaman, 'The Woodcuts and Colour Prints of Captain Robert Gibbings', *Studio*, 76 (1919), 3–9.

[176] In contrast, a scathing review of his work in *Contemporary English Woodcuts* sums up the view of the traditionalist wing: 'In Mr Gibbings we get the unsophisticated "stunt"; he contributes

a townscape [*Hamrun*] and a nude [*Clear Waters*]. Every shadow is stuck on like a postage stamp, as though cut out in black paper; all outline, all half-tone is scrupulously omitted. If you restored them you would have two perfectly commonplace studies. Why Mr Campbell Dodgson should include such rubbish is the only mystery about it.' *Times Literary Supplement*, 7 Dec. 1922, 795.

[177] See Ch. 5.4.

[178] William Lipke, 'The Omega Workshops and Vorticism', *Apollo*, 91 (1970), 224–31, p. 227.

expressing the feelings of modern cultivated man'.[179] Strongly opposed to the per-
fectionist craftmanship advocated by Morris and the Arts and Crafts practitioners, and
the Central School emphasis on 'right-making', he hoped to establish an entirely new
idiom in decorative art, free from pastiche or imitation. Aesthetics rather than tech-
nique were his concern. This ideal manifested itself in vibrant colours and freely
handled brushwork which have much in common with Fauve painting and the eye-
catching stage and costume designs of such artists as Bakst, Benois, Picasso, and Derain
for Diaghilev's Ballets Russes which first performed in England in 1911.

When Fry decided to embark on a new venture of book production he naturally chose
woodcuts as a method of illustration rather than the small-scale, exacting medium
of boxwood-engraving. These woodcut prints by various Bloomsbury artists share
similarities with Expressionist woodcuts. The catalogue for the Twenty-One Gallery's
exhibition of 'Modern German Art' contained a note by Lewis on some of the woodcuts;
but Fry was not enamoured of these. The Omega artists were more likely to have been
inspired by French printmakers such as Vlaminck, Dufy, Matisse, and Derain. Derain's
woodcut *Création*, a bold-patterned Fauvist fantasy of birds and beasts, had appeared in
Rhythm (1911), with line-drawn decorations by British Fauvists such as J. D. Fergusson,
Jessica Dismorr, and S. J. Peploe.[180]

In keeping with the consciously amateur approach to interior decoration of the
Workshop artists, Fry was little concerned with fine printing when it came to book
production though he did actually consult Mason at the Central School before embark-
ing on his first book in 1915. The title was *Simpson's Choice*, a satirical poem by Arthur
Clutton-Brock, art critic of *The Times*, with woodcuts by Roald Kristian, whose work
Furst later described as imitating 'bushmen's or prehistoric mannerisms'.[181] Mason's
account of his involvement in the project reveals Fry's unadventurous approach to
typography:

I proposed using an old black letter type, which would have harmonised with the heavy black
of the full-page wood-engravings, and would have had a strong ironical flavour in being used
for such a context. Fry, I think, missed this, and only felt a reminiscence of sentimentalism in
black letter. So I followed, alternatively, with S and B [Stephenson and Blake] Old Style No. 5, a
thoroughly commercial type, I said. He jumped at this with eagerness in which I seemed to
detect a touch of an inverted sentimentality.[182]

Fry 'went into the job with gusto, and it was printed in Whitfield Street, by a commercial
printer, who also seemed to get some good fun out of the game'. Further publications
followed, culminating in *Original Woodcuts by Various Artists* in 1918. This is purely a picture

[179] Preface to the catalogue of the Omega Workshops, n.d. Held
in the National Art Library, Victoria and Albert Museum, hence-
forth NAL. Reproduced, as are all successive quotations from
the library's archival material, by kind permission of the Board
of Trustees of the Victoria and Albert Museum.
[180] Derain's first attempt at book illustration, 31 woodcuts for
Guillaume Apollinaire's *L'Enchanteur Pourrisant* (Kahnweiler,
1909), and Raoul Dufy's 39 woodcuts for Apollinaire's *Le Bestiare*

ou cortège d'Orphée (Deplanche, 1911), may have been an influence,
although John Lewis in *The Twentieth Century Book* (London, 1967),
162, believes that few if any English wood-engravers were yet
familiar with these two books.
[181] Furst, *The Modern Woodcut*, 182. Kristian's 7 woodcuts for *Men
of Europe* (1915) were executed in an abstract style.
[182] Owens, *J. H. Mason*, 24.

book: an assemblage of prints by the Omega artists, Fry, Grant, Kristian, Vanessa Bell, Edward Wolfe, Simon Bussy, and McKnight Kauffer. True to Fry's aesthetic, the expressive quality of the medium takes precedent over subject matter, as in McKnight Kauffer's

Plate 38 brooding *Study* and Vanessa Bell's semi-abstract *Dahlias*. This volume had originally been intended for publication by Leonard and Virginia Woolf's new Hogarth Press, but Vanessa disagreed with Leonard about who should retain artistic control and the production was taken over by the Omega Workshop.

The Hogarth Press started life as a hobby and therapy for Virginia, with a small handpress installed on their dining-room table in March 1917.[183] After only a month's practice the Woolfs felt competent enough to start work on a pamphlet containing one story by each of them which they would sell by subscription. Dora Carrington (1893–1932) produced four small blocks for the two stories, *The Mark on the Wall* by Virginia and

Plate 39 *Three Jews* by Leonard. Virginia refered to them as woodcuts but, since they are very small and quite finely handled with white line, they may well be wood-engravings.[184] The heavy black frames and dark inking rather overpower the small-sized typeface and convey a naïve chapbook-like appearance but, as Virginia wrote, 'they make the book much more interesting than it would have been without'.[185] She particularly liked the blocks of the servant girl and of the snail.

Two Stories was published in July 1917 and by the end of the month almost all of the edition had been sold. This encouraged the Woolfs to be more ambitious and to produce more illustrated books. Virginia mentioned a possible new press to Fry which was particularly good for reproducing pictures: 'Wouldn't it be fun to have books of pictures only, reproductions of new pictures—but we must get you to tell us a little about how one does this. Carrington is swarming with woodcuts. It is most fascinating work.'[186]

At this time Carrington was experimenting with initial letters and linocut designs for the press.[187] On 26 July Virginia wrote to Vanessa suggesting that she and Duncan do a book of woodcuts.[188] Without a large enough press this book did not materialize. In September she wrote again to suggest that they print various artists' woodcuts as separate sheets to sell in sets in envelopes. Although the Hogarth Press never printed these in this form, the blocks may well have formed the basis for the Omega *Original Woodcuts by Various Artists*.

Initially, Virginia looked to Vanessa to illustrate her own books, starting with the title-

Plate 40 page for *Kew Gardens*. The preliminary drawing was just in the mood she wanted: 'As a

[183] See Donna E. Rhein, *The Hand Printed Books of Leonard and Virginia Woolf at the Hogarth Press, 1917–1932* (Ann Arbor, 1985).

[184] In a letter to Virginia, Carrington mentions 'the man Lawrence who cuts my wood will get the exact size', meaning the blockmaker T. N. Lawrence of Red Lion Square, London. Dora Carrington to Virginia Woolf, [? Aug.] 1917. Quoted from *Carrington: Letters and Extracts from her Diaries*, ed. with introduction by David Garnett (London, 1970), 78.

[185] Virginia Woolf to Dora Carrington, 13 July 1917. Quoted from *The Letters of Virginia Woolf*, ed. Nigel Nicolson and Joanne Trautmann (London, 1976), 162.

[186] Virginia Woolf to Roger Fry, 22 July [1917]. *Letters*, 166.

[187] Various bookplates and other illustrative wood-engravings are reproduced in Jane Hill, *The Art of Dora Carrington* (London, 1994). These include a patterned cover and frontispiece (probably designed by Fry and cut by Carrington) to *Lucretius on Death* (Omega Workshops, 1917), 38, and another stylish cover design, printed in red, for Leonard Woolf's *Stories of the East* (Hogarth Press, 1921), 68. By 1919 she had given up wood-engraving, tired of its limitations and lack of colour.

[188] Virginia Woolf to Vanessa Bell, [26 July 1917]. *Letters*, 168.

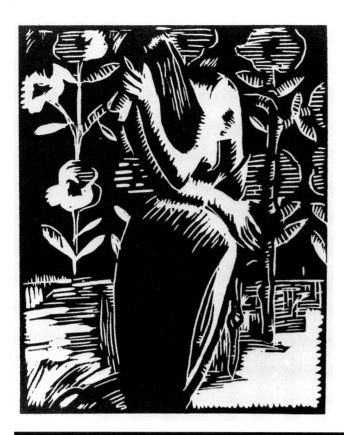

Pl. 38 (*left*). Edward McKnight Kauffer: *Study* from *Original Woodcuts by Various Artists* (Omega Workshops, 1918). 127 × 102

Pl. 39 (*below*). Dora Carrington: Leonard and Virginia Woolf, *Two Stories* (Hogarth Press, 1917). 220 × 285

18 THREE JEWS

"Dad, I want to marry a girl"—a really nice girl—"but she's not one of us: will you give me your permission and blessing?" Well I don't believe in it. Our women are as good, better than Christian women. Aren't they as beautiful, as clever, as good wives? I know my poor mother, God rest her soul, used to say: "My son," she said, "if you come to me and say you want to marry a good girl, a Jewess, I don't care whether she hasn't a chemise to her back, I'll welcome her—but if you marry a Christian, if she's as rich as Solomon, I've done with you—don't you ever dare to come into my house again." Vell, I don't go as far as that, though I understand it. Times change: I might have received his wife, even though she was a Goy. But a servant girl who washed my dishes! I couldn't do it. One must have some dignity."

He stood there upright, stern, noble: a battered scarred old rock, but immovable under his seedy black coat. I couldn't offer him a shilling; I shook his hand, and left him brooding over his son and his graves.

THE MARK ON THE WALL
By
VIRGINIA WOOLF

Perhaps it was the middle of January in the present year that I first looked up and saw the mark on the wall. In order to fix a date it is necessary to remember what one saw. So now I think of the fire; the steady film of yellow light upon the page of my book; the three chrysanthemums in the round glass bowl on the mantelpiece. Yes, it must have been the winter time, and we had just finished our tea, for I remember that I was smoking a cigarette when I looked up and saw the mark on the wall for the first time. I looked up through the smoke of my cigarette and my eye lodged for a moment upon the burning coals, and that old fancy of the crimson flag flapping from the castle tower came into my mind, and I thought of the cavalcade of red knights riding up the side of the black rock. Rather to my relief the sight of the mark interrupted the fancy, for it is an old fancy, an automatic

Pl. 41 (*above*). Roger Fry: *The London Garden* from *Twelve Original Woodcuts* (Hogarth Press, 1921). 139 × 102

Pl. 40 (*left*). Vanessa Bell: Virginia Woolf, *Kew Gardens* (Hogarth Press, 1919). 155 × 100

piece of black and white it is extremely decorative.'[189] The Woolfs found Vanessa's woodcut, with its predominance of black, difficult to print on their small press, so they had it run off by a local jobbing printer. When the book was published in May 1919 Vanessa was still disappointed with its greyness.[190] None the less it is an exceptional print cut in her unique rough-edged way, the two figures merging into a background of flowers like patterned floral wallpaper. This robust style did not quite harmonize with the press's thin typeface. Leonard and Virginia, however, were not unduly concerned with the *mise en page* of their books: a high standard of literary text, which they achieved with authors such as Katherine Mansfield[191] and T. S. Eliot among others, and emotionally atmospheric illustration were more their concern. A collection of Virginia's short stories published in 1921 as *Monday and Tuesday* contain four woodcuts by Vanessa Bell, two expressive female faces for 'A Society' being amongst the most memorable.

In October 1921 the Woolfs purchased a larger press and were finally able to print a picture book, Roger Fry's *Twelve Original Woodcuts*. With *Two Nudes* Fry sensitively cuts in the manner of white-line wood-engraving, defining the contours with fine parallel lines and cross-hatching; whereas in other prints, such as *The London Garden*, he retains bold *Plate 41* expressionist cutting and decorative two-dimensional patterning, in many ways fore-shadowing Paul Nash's illustrative style.

The Hogarth Press books up to this date cannot be considered exemplary models of fine printing. Yet, by encouraging the Bloomsbury artists to illustrate for publication, Leonard and Virginia Woolf uncovered and broadcast some remarkable printmaking talent. Whereas the hard-edged precision required for wood-engraving echoed the Vorticists' strident theories, the softer, rough-hewn qualities of woodcuts answered the more robust, primitive requirements of the Omega artists. Though neither group had direct followers, Paul Nash's wood-engraved book illustration style was partly the outcome of his awareness of both.

Paul and John Nash

Paul Nash's unique approach to wood-engraving brought a new dimension to the medium and most particularly to book illustration for which most of his prints were produced. As well as using line drawing, stencil, and lithography for illustrative purposes, he involved himself in many other aspects of book design including bookplates, pattern papers, dust wrappers, covers, and bindings and wrote eloquently on the subject. Although his first wood-engraved book was not published until 1921, his few single prints engraved before this time point the way to his startling modernist bookwork, in many ways the most innovative of the period.

An interest in the black and white illustrators, nurtured as a pupil at St Paul's School,

[189] Virginia Woolf to Vanessa Bell, [15 July 1918]. *Letters*, 258.
[190] The first edition was enthusiastically reviewed in *The Times Literary Supplement* and quickly sold out.

[191] The Woolfs disliked the woodcuts for *Prelude* by J. D. Fergusson whom Mansfield had chosen so printed only a few illustrated copies for her to distribute.

inspired Nash (1889–1946) to earn his living in this field. In 1907 he enrolled in an illustration class at the Chelsea Polytechnic where, drawn to the romantic work of the poet-painters, Blake and Rossetti, he worked in the Arts and Crafts tradition. At evening classes at Bolt Court which he later attended he learnt the technique of lithography and etching and the commercial aspects of printmaking. Here his talents were noted by William Rothenstein, while a pen and ink drawing illustrating a Rossetti poem was seen and admired by Selwyn Image. Nash's unpublished flower-bordered illustrations to Gordon Bottomley's play, *The Crier in the Night* (1910), were Pre-Raphaelite in conception, as were a series of bookplates. Andrew Causey suggests that two drawings of about this time which are imitative of wood-engraved blocks, especially those of Sturge Moore, probably evolved from a study of wood-engravings, in particular Blake's *Virgil* illustrations.[192]

A year at the Slade between 1910 and 1911 left Nash uninspired by the life classes and the work of his radical contemporaries. By his own admission he was untouched by the two Post-Impressionist exhibitions: 'I remained at the point I had reached and continued to make my monochrome drawings of "visions", some of which were supplemented by "poems".'[193] His work, however, did not go unnoticed. Following two exhibitions, the second held jointly with his brother John in the Dorien Leigh Gallery in 1913, Roger Fry recognized his talent for decorative composition and invited him to join the Omega Workshops in February 1914. At about this time Nash became involved in the ideas of a quasi-Cubist abstraction in his approach to construction: concepts which he retained throughout the war years and developed more fully after the Vorticist artists had largely abandoned their beliefs. War service jolted him into taking account of the modern movement in painting, particularly Cubo-Futurism as practised by Nevinson, whose war art he especially admired. He was not, however, in sympathy with the Vorticist preoccupation with machinery nor, with the exception of Roberts's work, was he impressed with the illustrations in *BLAST*. Nonetheless his frequent use of the diagonal indicates possible Vorticist influence,[194] as does the vital energy of his lineblock illustrations for Richard Aldington's *Images of War* (1919). These powerful images are redolent of Kandinsky's expressionist woodcuts which he most probably would have seen in the 'Modern German Art' exhibition.

Nash's concern for illustration stemmed from his abiding passion for literature, particularly poetry, and from an innate feeling for 'the mood of the landscape'. A remark from Sir William Richmond had encouraged him to 'go in for Nature'.[195] 'The whole organic life of the countryside were still, for me, only the properties and scenes of my "visions". Slowly, however, the individual beauty of certain things, trees, particularly, began to dawn upon me.'[196] The 'Personality of the Place' became implicit in all his works. He was fascinated by darkness and 'the dramas of the nocturnal skies', hence his

[192] Andrew Causey, *Paul Nash* (Oxford, 1980), 8–9.
[193] Nash, *Outline*, 93.
[194] See Alexander Postan, *The Complete Graphic Works of Paul Nash* (London, 1973), 9.
[195] Nash, *Outline*, 105. [196] Ibid. 94–5.

appreciation of the medium of wood-engraving with its implicit mysterious quality of working from darkness into light.

Nash first began wood-engraving in 1919, encouraged initially by Gordon Bottomley, who implied that his badly reproduced pen and ink illustrations for John Drinkwater's *Loyalties* would have had a richer quality if they had instead been engraved on wood.[197] He suggested that Paul and John set up a press of their own. Paul's earliest wood-engravings, which he sent to William Rothenstein, are fairly crudely handled with broad areas of black and white and open hatching, an expressive style which he retained albeit in a more refined manner. *Elms* (1919–20)[198] points to his preoccupation with trees and landscape; a proof of *Snow Scene* (1919–20) reveals an experiment to produce *Plate 42* contrasting tonal effects by partially wiping ink from the block in the sky and other areas.[199] For Nash the 'naturally abstract' forms inherent in landscape provided a pictorial basis for his formalized compositions, as exemplified by *Sea Wall* and *Promenade*, both of *Plate 43* 1920.[200] The angular wall and unearthly figures depicted in these Dymchurch scenes were motifs he used in various other media. As these engravings were reproduced in journals they cannot be considered illustrations as such, although the various versions of *Promenade* were most likely inspired by Osbert Sitwell's poem of the same name.

Paul and John Nash started to experiment with wood-engraving at about the same time, both probably instructed by Paul's Slade friends, Claughton Pellew and Rupert Lee.[201] In 1919 the brothers joined forces with Lee to illustrate *The Sun Calendar for the Year 1920* for the Sun Engraving Company. Though not strictly for a book, their designs, mainly line drawn, were intended to face the text of a poem on the opposite page, and count, therefore, as interpretative illustration. Paul's image for the cover is entitled *Device*. It consists of an apple silhouetted against a vast sun (or possibly moon) and *Plate 44* suspended over a jagged, wave-like landscape—weird scenery which most probably derives from two earlier watercolour drawings, a bookplate of 1910 (Victoria and Albert Museum), and *The Pyramids in the Sea* of 1912 (Tate Gallery). Such imagery, representing the creation of order and life, also formed the basis of design for *Dry Land Appearing*, and *Plate 127* anticipated Paul's surrealist phase, as discussed in Chapter 12. John contributed two of his earliest wood-engravings to the calendar, one of cats, and another, *The Three Carts*, the *Plate 45* latter an illustration to Edward Thomas's poem for the month of September.[202] The simple directness of his observation, his clarity of line, and stylized design appealed to

[197] Gordon Bottomley to Paul Nash, 11 June 1919. Quoted from *Poet & Painter: Being the Correspondence between Gordon Bottomley and Paul Nash, 1910–1946*, ed. Claude Colleer Abbott and Anthony Bertram (Oxford, 1955), 107–8.
[198] Reproduced (No. 25.6) in *Paul Nash: Book Designs*, exhibition catalogue researched and written by Clare Colvin (Colchester: The Minories, 1982), 81. The first state appeared in the Autumn 1919 issue of *Art and Letters*. This image is almost certainly derived from a watercolour drawing of 1914, *Elm Trees, Wood Lane* (reproduced as *Landscape at Wood Lane* in *Outline*, facing 129) with which, in reverse, it bears a strong resemblance.
[199] Colvin, *Paul Nash* (No. 25.7), 82. Reproduced in *The Apple*, 2

(1921), 2. The proof shown here which is held in the Prints and Drawings Department of the Ashmolean Museum, Oxford, is catalogued as *Elms* (1920).
[200] Reproduced in 1921 in *The New Keepsake* and *Form* respectively.
[201] In his introduction to *The Wood-Engravings of John Nash*, compiled by Jeremy Greenwood (Liverpool, 1987), 1, John O'Connor suggests that Lee probably started them engraving when they were staying with him near Princes Risborough in Buckinghamshire.
[202] Rupert Lee's image of a goat was the only other wood-engraving.

Pl. 42. Paul Nash: *Snow Scene* (1919–20). 97 × 127

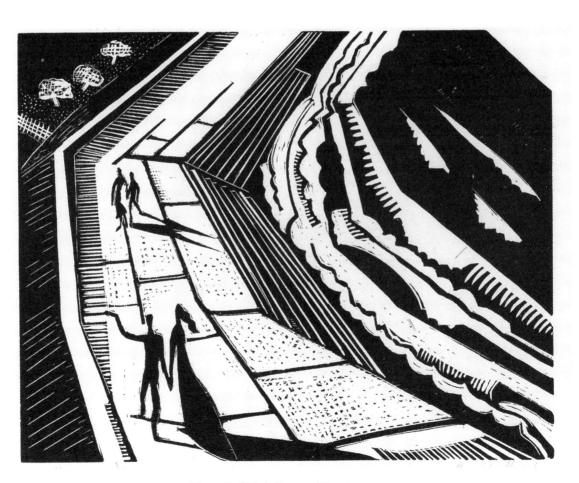

Pl. 43. Paul Nash: *Promenade* (1920). 115 × 145

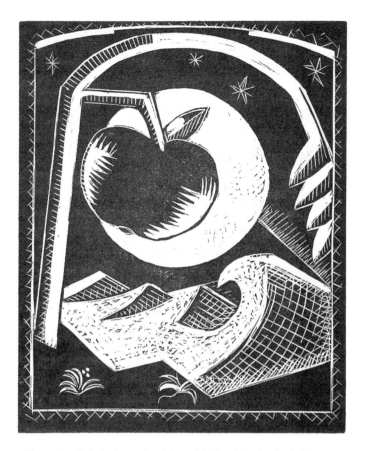

Pl. 44. Paul Nash: *Device* (1919) from *The Sun Calendar for the Year 1920*
(The Sun Engraving Company, 1920). 141 × 115

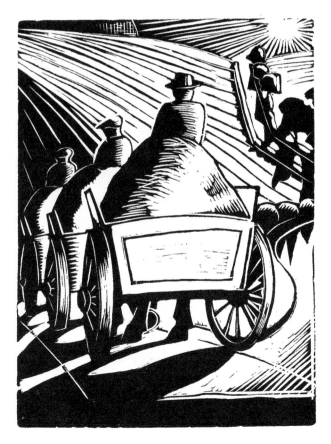

Pl. 45. John Nash: *The Three Carts* from *The Sun Calendar for the Year
1920* (The Sun Engraving Company, 1920). 141 × 115

Harold Gilman, with whom he exhibited at the Goupil Gallery in 1914, and from whom he gained much practical advice.

With no formal art training John was fortunate to be able to put his skills as a competent comic illustrator to use in *Dressing Gowns and Glue* (1919). These line-drawn illustrations were printed by the Westminster Press which was responsible also for reproducing the wood-engraving, *Cows*, in a promotional booklet, *Friends* (c.1920).[203] He did not receive his first commission for wood-engraved book illustration until 1925 but both his and Paul's work featured in several artistic and literary periodicals around 1920, most significantly the *London Mercury* for which he worked as art critic from 1919. Some of his early single prints show an affinity with Paul's, especially in their robust handling. With their imaginative interpretations the Nash brothers broke with the naturalistic landscape tradition, as earlier Edward Gordon Craig, a crucial influence on Paul, had done.

Edward Gordon Craig

Craig's perception of wood-engraving as an ideal means through which to express his ideas on the theatre determined a new and important aesthetic approach to the medium.[204] The 'light in motion' concept of the theatre (as opposed to the previous one of 'fixed light') which he introduced into his prints, had a radical effect on certain wood-engravers. In this and other ideas he shared similar aims with the Swiss-born Adolphe Appia, several of whose revolutionary designs for Wagner operas at Bayreuth, with the stage stripped bare and only basic three-dimensional forms of decoration used, had filled him with admiration.[205] Like Appia, Craig recognized the emotional value of shade and light. Fascinated by Isadora Duncan's dancing he saw an art closely related to his own, rhythm and movement being essential components of the art of the theatre as he envisaged it. Some of his most startling wood-engravings contain such notions of light, form, and movement, exemplified by the dramatically lit Stonehenge-like blocks

Plate 9 in a stage scene of 1908 and the gesturing figures dwarfed by angry whiplash clouds in *The Storm, 'King Lear'* (1920).

In 1907 Craig had begun to make model stages for imaginary productions on which he deployed screens and small wooden figures. The latter were cut in silhouette with a fretsaw from the plank of soft wood, their facial expressions and garment folds generally engraved (rather than cut with a knife) with minimal yet expressive lines. Experiments in printing these figures gave rise to his most important commission, his 'black figure'

Plate 46 illustrations to *Hamlet*.[206] On a visit to Craig in London in 1911 Count Harry Kessler

[203] Both this print and an experimental coloured wood-engraving also entitled *Cows* were exhibited at the first Society of Wood Engravers' exhibition (Nov. 1920).

[204] These views were widely known through his writings, most notably *The Art of the Theatre* (London, 1905), *On the Art of the Theatre* (London, 1911), *Towards a New Theatre* (London, 1913), and *Scene* (London, 1923).

[205] See Denis Bablet, *Edward Gordon Craig* (London, 1966), 174.

[206] Between 1907 and 1915 he cut about a hundred black figures for different projects. For a fuller account see *Black Figures: 105 Reproductions with an Unpublished Essay*, with introduction and documentation by L. M. Newman (Wellingborough, 1989). The author is grateful to Dr Newman for information provided on the artist's work.

realized the illustrative potential of these prints, but not before Craig had already conceived the idea of publishing a director's edition of *Hamlet*.[207] In January 1912, following the Moscow première of the play, and having failed to find a publisher for the book, he exchanged contracts with Kessler at whose Weimar-based Cranach Press it was to be printed, with woodcut illustrations and notes provided by Craig. The intervention of the war, however, delayed publication of the book until 1929. Since the overall idea for the project and the majority of Craig's free-standing figures were already in hand by 1914 his contribution is included in an assessment of pre-1920 work.[208]

Craig never considered himself to be an illustrator as such. His desire to control the whole, whether book or stage production, came from his wish to create a harmonious work of art. In his eyes this could only be achieved through total unity. Illustration was merely one way in which to express his creative imagination. Craig's interest in the overall treatment of books extended to the paper, page layout, printing, binding, and even to bookplates, about which, amongst other related topics, he wrote at length.[209] His approach was not dissimilar to that cherished by private press owners. With *Hamlet* Kessler's role was interchangeable with that of Craig, as their correspondence reveals.[210]

Craig took a passionate interest in every aspect of the book conceiving it as a live stage performance within its pages. Kessler's typographical model was based on various early printed books at the British Museum by Johannes Fust and Peter Schöffer in which the main text is edged with commentary in smaller type. Three new gothic typefaces were commissioned, all designed by Edward Johnston: these were cut by Edward Prince (who had worked for the Kelmscott Press) and, after his death, by George Friend, under the supervision of Emery Walker, whose photographic simulation of a double-page opening acted as the definitive model. Since Craig failed to produce any notes to flank the text, he suggested replacing these with sources.[211] Printer's wooden furniture[212] gave him the idea of arranging assorted rectangular or curved lengths and widths of wood as a typographical equivalent to his moveable screens. They were cut specially for his requirements by Lawrence. Engraved with vertical or horizontal lines of varying density, these were put together as composite blocks, sometimes with small black figures to serve as scenes in the play (as with his design for Polonius's entry in Act II, Scene ii), and *Plate 47* capable of filling gaps in the text. Some of the most effective illustrations are designed for double-page spreads, either as composite blocks or as characters alone.

For the purposes of printing his plank figures with the text Craig had them mounted to type height on blocks. When making these figures he considered the inherent beauty

[207] See his advertisement inside the front cover of *The Mask*, 1 (1908).

[208] The German version contained 75 woodcuts many of which show similarities with Craig's designs for his Moscow production. An English edition was published in 1930 with slightly altered layout and additional figures.

[209] For example, correspondence indicates the infinite trouble he took over the design of his book, *Nothing or the Bookplate* (1924), especially its wood-engraved device. Chatto & Windus Archive, Reading University Library.

[210] See *The Correspondence of Edward Gordon Craig and Count Harry Kessler, 1903–1937*, ed. L. M. Newman (Leeds, 1995). According to the colophon of the English edition Kessler 'planned the typographical arrangement', Craig 'designed and himself cut on wood the illustrations', and Gill 'cut the title'; 4 compositors, 4 pressmen, and 4 assistants were employed, compared with 2 of each for the German edition.

[211] See L. M. Newman, 'Artist and Printer: A Problem of the Cranach Press "Hamlet" Resolved', *Matrix*, 4 (1984), 1–12, p. 2.

[212] Wooden rectangles used by printers to fill up blank spaces in a forme around and between the pages of type. See *Craig/Kessler Correspondence*, 83.

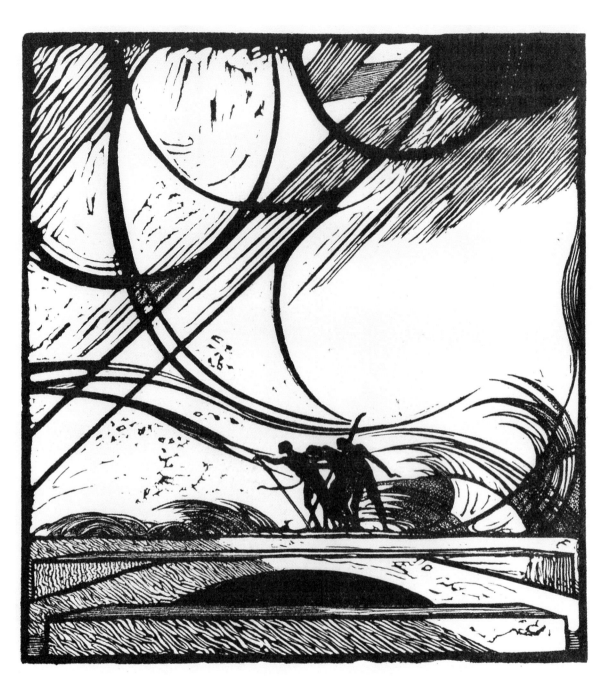

Pl. 46 Edward Gordon Craig: *The Storm, 'King Lear'* (1920). 168 × 158

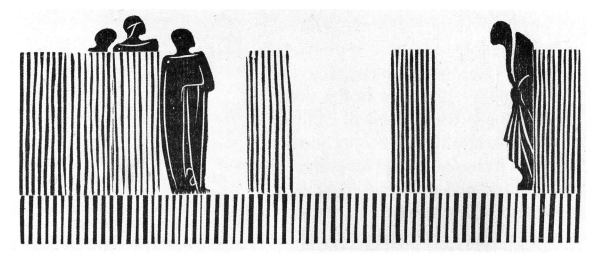

Pl. 47. Edward Gordon Craig: *Enter Polonius* (Act II, Scene ii) from William Shakespeare, *The Tragicall Historie of Hamlet, Prince of Denmarke* (Cranach Press, 1930). 60 × 150

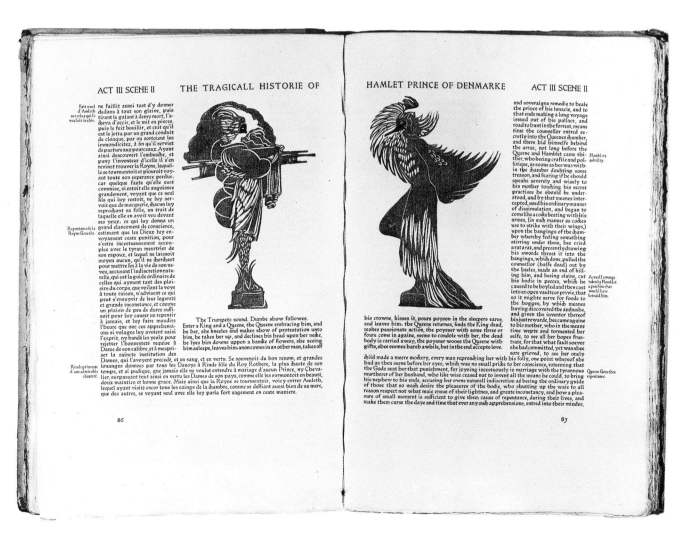

Pl. 48. Edward Gordon Craig: *Actor* facing *Bird Dancer* (Act III, Scene ii) from William Shakespeare, *The Tragicall Historie of Hamlet, Prince of Denmarke* (Cranach Press, 1930). 360 × 480

in the grain of the wood and its effect on paper. The reduced density of ink (the result of printing with soft wood rather than box) accounted for the comparatively muted blacks which appealed to Craig. He admitted to Emery Walker that he hated 'black blackness', preferring the block to be 'sometimes grey, sometimes a little black, sometimes more grey'.[213] Subtly varied tones were used with dramatic results: for instance, Craig's planing and sandpapering of the wood (preferably holly) produced an effect of 'fine grey rain';[214] the roughness of the handmade paper,[215] by mottling the film of ink on the blocks' surface when printed, accounted for the delicate flecks of white on certain figures. Skilful use of overlay and underlay by the chief pressman Gage-Cole (formerly of the Doves Press) accounted for extra-black areas, as with the masks of *Actor* and *Bird*

Plate 48 *Dancer*, figures which face each other dramatically across two pages.[216]

Kessler's enlightened collaboration resulted in one of the finest early twentieth-century books, presenting an exceptionally harmonious balance between type and illustration. Even fourteen years after their completion, Craig's boldly expressive images in such an unorthodox setting must have appeared strikingly avant-garde. Yet, emanating as it did from a German private press, *Hamlet* had comparatively little influence on British book production, despite the extensive input from English designers and craftsmen.[217]

Rather more relevant and influential to the development of wood-engraving are Craig's black figures as single prints. Many of these were widely available through exhibitions, in particular those held at the Dowdeswell Gallery (1915) and the Dorien Leigh Gallery (1920), and most prolifically at the Victoria and Albert Museum's International Theatre Exhibition (1922). Paul Nash, who was deeply affected by Craig's work, was first attracted to it through an exhibition of drawings and models for *Macbeth* and other plays at the Leicester Galleries (September 1911). A print entitled *Black Girl* shown at the Society of Twelve exhibition in 1915 anticipated John Farleigh's much-vaunted series of black girl illustrations first published in 1932.[218]

[213] Edward Gordon Craig to Emery Walker, 12 Oct. 1912. Newberry Library, Chicago. Quoted from Newman, *Black Figures*, 24.
[214] Edward Craig, 'Edward Gordon Craig's Hamlet', *Private Library*, 10 (1977), 35–48, p. 44.
[215] Pure hemp fibre and linen developed by Kessler together with Aristide and Gaspard Maillol and used for the ordinary copies. Because of its thickness and irregularity it first had to be blind-printed with a brass die to produce a smoother surface on which to print Craig's blocks. None the less chain lines can be detected in several instances.
[216] William Shakespeare, *The Tragicall Historie of Hamlet, Prince of Denmarke* (Weimar: Cranach Press, 1930), Act III, Scene ii, pp. 86–7. In 'Edward Gordon Craig's Hamlet', 47, Edward Craig describes the methods of printing the blocks both for the book and as individual prints. From 1920 he took over the printing of the latter from his father. For a discussion on the work of Edward Craig (pseudonym Carrick) see Ch. 12.8.
[217] The German edition, shown as single sheets, was judged the most beautiful book of the year by the German Foundation for the Art of the Book (Deutsche Buchkunststiftung). The English version, however, despite good publicity from Bumpus's bookshop in Oxford Street and favourable reviews, was con-

spicuously absent from the seminal exhibition, 'Wood-Engraving in Modern English Books', held at the National Book League in 1949, most probably because it was a German production. With regard to other book illustration Craig declined the suggestion of his friend, James Pryde, to illustrate a novel by Dumas. He never completed a series of small boxwood-engraved illustrations begun c.1925 in a purposely more traditional vein for an edition of Daniel Defoe's *Robinson Crusoe* which he proposed to Kessler as a sequel to *Hamlet*. A book which featured them was eventually published after Craig's death by the Basilisk Press in 1979 and, therefore, falls outside the scope of this book. For insight into Craig's working method see Edward Craig's introduction to this edition. Primary material, including dummy pages of the book and his Daybooks (1948–64), are held at the Bibliothèque Nationale, Paris. Earlier Daybooks (1908–43) are held at HRHRC.
[218] See Ch. 9. *Black Girl* (1913) and *Girl with a Stick* (1914) are the only two characters Craig cut for a possible Cranach Press edition of *Don Juan*. These two prints, together with *Eve* (1915)—all nude figures—were amongst the most popular of Craig's black figure prints in the 1920s.

Through his penchant for massed blacks touched up with white line—a pictorial style passed on from Crawhall and Nicholson—Craig helped to redefine the traditional chapbook aesthetic which appealed to some of the more expressionist wood-engravers. His striking images, products of his creative imagination, affected subsequent illustrators who, like him, were more concerned with the expression of human emotion than with literal interpretation. But perhaps the greatest impact made by Craig on the development of wood-engraving was as a champion and proselytizer, through extensive writings on the subject, and as a vociferous member of the Society of Wood Engravers and spokesman for the breakaway English Wood-Engraving Society.

THE BEGINNINGS OF RECOGNITION

5.1. *The Society of Wood Engravers and the English Wood-Engraving Society*

The early history of the Society of Wood Engravers is both a reminder of what a very young medium wood-engraving is as an independent graphic art and an illustration of the way in which any new medium has to struggle for recognition and to define its role.[1] Before 1920 the 'new' wood-engravers lacked a cohesive organization such as existed for etchers to promote their product and this accounted for their comparative obscurity. A growing interest in the practice and appreciation of graphic media highlighted their need for a society which would not only hold regular exhibitions but also provide a much-needed forum for debate. The Society of Wood Engravers, as Campbell Dodgson wrote in his introduction to its first exhibition catalogue, was 'a natural outcome of tendencies in contemporary English art, so clear as to be obvious to any thoughtful observer'.[2] With its formation wood-engraving was formally recognized as a socially desirable medium worthy of being collected alongside painting and sculpture and the more well-established printmaking techniques.

Initially a proposal had been made at a meeting convened by Mrs Austen Brown that Lucien Pissarro, Sydney Lee, and Noel Rooke should head a new society, but it soon became clear that a single organization could not adequately represent so many different ideas and techniques, particularly Japanese-style coloured engravings of which Austen Brown was an exponent. At a further meeting initiated by Philip Hagreen,[3] and held at his studio on 27 March 1920, the Bewick Club was established—a surprisingly retrograde name which was hastily altered to the Society of Wood Engravers—its stated purpose being 'to hold exhibitions devoted solely to woodcutting and engraving by the European method'.[4] The founder members were Hagreen, Gibbings, Rooke, Lee, Pissarro, Gill, Craig, Raverat, John Nash, and Edward O'Rourke Dickey.[5] The rules were formulated to keep numbers small and admit only members who had exhibited twice before or were well-known artists.[6] The selection of work was made in a general meeting at which the

[1] For a fuller account see Joanna Selborne, 'The Society of Wood Engravers: The Early Years', *Craft History*, 1 (1988), 153–68.

[2] Campbell Dodgson, Introduction to catalogue, *First Annual Exhibition of the Society of Wood Engravers* (London: Chenil Gallery, Nov. 1920).

[3] Philip Hagreen to the author, n.d., 1986.

[4] Minutes of the first meeting, 27 Mar. 1920. The Society of Wood Engravers' Archive, henceforth SWEA, from which all extracts from minutes have been quoted. For Japanese colour methods see also Ch. 1 n. 24, and Ch. 4.1 n. 19.

[5] Shannon, Ricketts, Sturge Moore, Wadsworth, Brangwyn, Ginner, and Ludovic Rodo were also asked to join but declined. Ginner became a member in 1921 and Rodo in 1922.

[6] This and various other information taken from an undated typescript [*c*.1962] of a lecture given by Margaret Pilkington on the history of the Society of Wood Engravers. Held in the Margaret Pilkington Archive and reproduced by permission of the Director and University Librarian of the John Rylands University Library of Manchester. John Buckland Wright in 'The Society of Wood Engravers', *Studio*, 146 (1953), 134–41, p. 134, considered the society almost a closed shop in the early days

hanging committee was elected consisting of two members and the Honorary Secretary, the first of whom was Robert Gibbings whose wife Moira carried out secretarial duties. In 1924 both posts were taken over by Margaret Pilkington,[7] though for a time Gibbings continued to preside over meetings and acted as the society's spokesman, with Craig, a vociferous and opinionated member, generally representing the more dissident element.

Ninety-one prints, including eighteen by non-members, were exhibited in November 1920 at the first annual exhibition held at J. Knewstub's Chenil Gallery in Chelsea: a wide cross-section of contemporary woodcuts and engravings, some in colour, priced on average between one and two guineas each. Although Campbell Dodgson's optimistic catalogue introduction gave authoritative approval to the exhibition, critics were firmly divided in their opinions as to the aesthetic value of the medium. Campbell Dodgson, for instance, considered that a woodcut looked as good on a wall as an etching, whereas Frank Rutter, writing in the *Sunday Times*, felt that black and white was no good for the public who want 'something bright, cheerful and attractive to hang on their walls'. 'While many of the works are impressive and scholarly', he continued, 'it is to be feared that few will be really popular in the pictorial appeal. There is a tendency to preciousness which should be guarded against, for if the new society is to be of real service it must appeal not only to collectors but also to the general public.'[8] Similarly another reviewer complained that the exhibitors were 'working in a very narrow and limited groove'.[9] In contrast the *Manchester Guardian* critic found some of the images 'wholly unacceptable ... so freed do they seem from the commonly accepted rules of picture-making'.[10] Certainly, as Sarah Hyde points out, the society's members 'had a very ambiguous attitude towards the degree of commercialization involved in making a wider "popular" appeal. They saw their role as rescuing a printmaking process from the cheapening effects of commercialization.'[11] Critics such as Rutter, whose wish was that wood-engraving in future might 'decorate the walls of the artisan's dwelling and the villager's cottage', assumed that its current limited popularity arose from what he considered to be the society's élitist attitude.[12] By thinking in such terms, however, he misunderstood not only the aims and objectives of modern practitioners but also the intrinsic qualities of the medium.

Despite reservations the exhibitions aroused considerable interest and in the early years of the society were the main means of publicity for wood-engravers. A magnificent coloured woodcut poster of a box tree pierced with a graver, designed by Gill for the second exhibition in November 1921 for display in the London Underground, exposed the existence of the society to a vast audience.[13] Apart from its annual shows, exhibitions were organized throughout the country and abroad, most significantly at the Carnegie

'due to Eric Gill's belief that engravers should pass through a long apprenticeship before election'.

[7] For Pilkington's role see also Ch. 5.3.

[8] *Sunday Times*, Nov. 1920. This and other extracts are quoted from a SWEA press-cuttings book in which no specific dates are stated.

[9] *Jewish Guardian*, Dec. 1920.

[10] *Manchester Guardian*, Nov. 1920.

[11] Sarah Hyde, 'British Wood-Engraving in the Early Twentieth Century', *Apollo*, 130 (1989), 242–7, p. 244.

[12] *Sunday Times*, Nov. 1920.

[13] Printed by Hilary Pepler at the St Dominic's Press. A smaller version is still used as the society's emblem.

Institute, Pittsburg, in April 1923, and the Whitworth Institute, Manchester, the following year. None the less a feeling existed amongst certain members that still more could be done to spread the word. Craig, for example, felt that the society should exhibit in 'cosy tea-rooms' rather than 'austere Temples of art—because selling is a low down business anyhow'.[14] He considered advertising by posters to be a waste of money; instead there should be more articles or interviews so that 'the busy London public would learn of their exhibitions and aims'.[15]

Fundamental disagreements existed amongst those members who looked upon the society as a means of advocating single prints and those who still valued the importance of wood-engraving as book illustration. Gill in particular considered that

The first thing is to establish agreement in the whole society that 'book work' is the chief concern and not the publishing of 'wall' prints with all the artificiality that entails—high prices & limited editions, etc. . . . We think that the society shd. meet for internal discussions & the reading of papers, etc., & not merely [be] a society for the establishment of cordial relations with art dealers & connoisseurs.[16]

At a meeting on 24 February 1923 it was proposed that Paul Nash be asked to write a pamphlet inviting London publishers to the next annual exhibition and explaining the advantages of wood-engraving as a medium of expression. In October a new Book Work Committee was formed consisting of Gill, Dickey, Rooke, and Hagreen to 'rouse public interest in the woodcut for book decoration'. The following year a talk was held at the Art-Workers' Guild entitled 'The Relation of Typography to Woodcuts and Wood Engravings in Book Illustration' and in January 1926 an exhibition, 'Modern Woodcuts and Book Decorations', was arranged at the Basnett Gallery, Liverpool. But while commercial firms had been quick to recognize the potential of the medium for magazines and advertisements, publishers were not yet so percipient. As Gill noted, the 'adventure of discovery' was being hampered by the lack of demand for the work, the book buyer still being enamoured of photo reproduction and the publisher and printer being hampered by the fact that it cost more to employ good engravers than good mechanics; hence the urge to regard the wood block not as a means to book illustration but as a means to wall pictures.[17] Unlike Gill, however, Craig among others felt that the society valued the illustrative aspects of wood-engraving too highly. Instead of promoting book illustrations through special exhibitions, he suggested that the ordinary annual exhibition should tour more widely, including to smaller towns.

The minutes reveal other areas of discontent amongst members which rumbled on and off throughout the 1920s and 1930s. The most lively were not theoretical but practical problems concerning gallery conditions, exhibiting terms, commissions, and fees. A break was made with the Chenil Gallery in favour of Arthur Howell's St George's Gallery, Hanover Square, where the fourth and fifth annual exhibitions were consequently held

[14] Edward Gordon Craig MS, 21 May 1924. SWEA.
[15] Edward Gordon Craig to Margaret Pilkington, n.d., 1924. SWEA.
[16] Eric Gill to Margaret Pilkington, 9 Mar. 1924. SWEA.

[17] Eric Gill, Foreword to catalogue, *An Exhibition of Woodcuts by the Society of Wood Engravers and Other Artists* (Liverpool: Basnett Gallery, Bon Marché, Feb. 1927), unpaginated.

in 1923 and 1924. But Rooke and Gibbings soon became unhappy about Howell's wish to eliminate prints designed as book illustration from exhibitions. It was resolved, therefore, to allow illustrations but editions should be very limited (twelve to twenty prints) and it was thought advisable to mention the name of the book for which the print was designed. Despite its attractive position and gallery space, a proposal to sever the connection with St George's Gallery was made on 19 March 1925, partly on the basis that Howell would not revert to the terms he had originally offered, that is, 25 per cent commission on London sales. More detrimental was his request that no wood-engravings shown in exhibitions should be reproduced in books or in any other form except in half-tone, and that cancelled blocks be deposited at the gallery to guarantee limitation of prints.[18] At Paul Nash's suggestion and encouraged by Gill, who personally disliked Howell, a move was made to Rex Nan Kivell's Redfern Gallery in Old Bond Street, although Craig thought that chopping and changing exhibition venues did no good to the society's reputation. He admired Howell's energy and commercialism and felt that the society should be more progressive and business-like: 'The notion of [not] turning out fresh loaves until the old ones are sold seems to me to show a total lack of economic sense. . . . I want especially for the younger and less successful members to have their wares pushed a bit more.'[19] Certainly the society's attitude to publicity and marketing was somewhat amateurish and self-effacing when compared with that of the Royal Society of Painter-Etchers and Engravers. But their aims and objectives were not entirely similar, the newer society struggling for recognition of the medium as a collectable art form.[20]

Despite Craig's pessimism a forum had by now been established for young wood-engravers to exhibit, each annual show exposing fresh talent. New contributors to the 1923 exhibition included Clare Leighton, Claughton Pellew, and Marion Mitchell. The names of Norman Janes, Clifford Webb, Gertrude Hermes, and Blair Hughes-Stanton appeared for the first time in the 1924 exhibition, only to disappear the following year as they had transferred their allegiance to the newly founded English Wood-Engraving Society.

The ongoing discord over galleries and commissions was only a minor cause of the split among the ranks of the Society of Wood Engravers. An increase in members had contributed to a diversity of aesthetic opinion absent in its early days. By 1925 new stylistic and technical ideas were emerging both independently and from art schools, in particular from Leon Underwood's Brook Green School whose pupils included Mitchell, Hughes-Stanton, Hermes, Henry Moore, and Mary Groom.[21] For these young artists the society had become old-fashioned[22] (Mitchell, for instance, considered prac-

[18] Minutes of meeting held on 3 Oct. 1929. SWEA.

[19] Edward Gordon Craig to Margaret Pilkington, 24 Oct. 1924. SWEA.

[20] See also Ch. 1 and Ch. 3.8; 'British and Continental Illustration'.

[21] See Ch. 13.1.

[22] Conversation between Yvonne Deane and Gertrude Hermes, 29 Nov. 1982. Quoted from exhibition catalogue, Yvonne Deane and Joanna Selborne, *British Wood Engraving of the 20's and 30's* (Portsmouth: Portsmouth City Museum and Art Gallery, 7 Oct.–27 Nov. 1983).

titioners such as Raverat and Daglish 'rather too tame and stuffy'[23]), and their use of the multiple tool was not very sympathetically received by some of the older members.[24] On 3 October, Mitchell, Craig, Pellew, and Ethelbert White resigned; by November the English Wood-Engraving Society had been formed. Not surprisingly Hughes-Stanton, Hermes, and Groom chose to join the more progressive society for which Mitchell, the driving force behind it, acted as secretary.[25] Believing that Howell would be more active in the promotion of members' work the group remained with St George's Gallery where the first and subsequent exhibitions were run concurrently with the Society of Wood Engravers' annual exhibitions at the Redfern Gallery. Initially exhibitors to the newly formed society were more innovative in their approach, contributing 'art prints' (often on a larger scale and with freer use of the tools) rather than book illustration, while the original society remained more book oriented. In practice, however, no distinct boundary existed between the two societies, some practitioners such as Gibbings and Daglish exhibiting in both, whilst the Society of Wood Engravers' committee recorded a resolution to maintain a friendly attitude towards the breakaway organization. For the time being it had lost some useful members but it gained some immensely talented ones in the next few years, notably John Farleigh, Eric Ravilious, Clare Leighton, and David Jones.

Rutter, reviewing the first of the rival exhibitions, saw the split into two societies as a natural process of 'growth by fission' which he regarded as a sign of strength rather than weakness'.[26] He approved of both exhibitions, noting that that of the English Wood-Engraving Society was larger, with a monopoly on the work of Craig, its self-appointed leader. He found the decorative quality the most attractive feature of the exhibitions. As yet the more abstract tendencies of the Underwood School and others had not made an impact. The subject matter of the Society of Wood Engravers' exhibits was largely representational, such as landscape, domestic scenes, figures, and the like, their conventionality hilariously satirized in comic-strip form in *Eve, the Ladies' Pictorial* (1926).

By 1927 wood-engraving was flourishing and beginning to be appreciated by a far wider public. As Campbell Dodgson had anticipated in his foreword to the Society of Wood Engravers' second exhibition catalogue, the size and comparative cheapness of framed wood-engravings made them ideally suited for 'the decoration of small rooms such as most of the world inhabits in days when the burden of taxes is heavy'.[27] Yet, though good for sales, the perception of their prints as cheap and cheerful products was somewhat demeaning to wood-engravers who were attempting to achieve an equivalent status for their art as had etchers and lithographers. Sturge Moore's conservative attitude as expressed in an opening address to an exhibition put on by the Society of Wood Engravers in Manchester in March 1927 did little to advance the society's reputation or

[23] Conversation between Marion Mitchell and the author, 19 Mar. 1985.

[24] See Ch. 13.1.

[25] The society was small and informal with no minutes; the committee relied on Howell to arrange exhibitions. Ibid.

[26] *Sunday Times*, Nov. 1926.

[27] Campbell Dodgson, Foreword to catalogue, *Second Annual Exhibition of the Society of Wood Engravers* (London: Chenil Gallery, Nov. 1921).

indeed the medium itself: to his way of thinking commercialism, popular taste, modern artistic trends, and, above all, theories conspired to produce bad art and should be avoided at all costs by wood-engravers. Though not shared by many practitioners, such perceptions added to the sense of apathy which was setting in amongst committee members. The idea of a change in officials was, however, rejected at a meeting in March 1928. In order to boost sales and enliven membership it was suggested that Agnes Miller Parker, Hermes, and Hughes-Stanton be invited to exhibit, since St George's Gallery had recently closed and the English Wood-Engraving Society, mainly through poor organization and the loss of a regular gallery, was now defunct. These artists duly joined the original society, becoming members in 1932. In June 1936 Ravilious sent in his resignation with a complaint about the lack of interest shown by the Redfern Gallery in the more progressive work and rather apathetic attitude to members in general. This was partly caused by the generally moribund market for prints since the Wall Street crash; in September 1931 the value of the pound had fallen by about a third, and art dealers and the book trade were particularly badly hit by stringent economies which inevitably affected sales. Rex Nan Kivell informed the society that he no longer wished to hold their exhibitions because of the amount of work involved for such small sales. As a marketing ploy Gibbings looked to illustration: he suggested that a stand might be taken at *The Times* Book Exhibition for a display of books illustrated by members. An opportunity was missed when in 1938 he was approached by Allen Lane to sell wood-engravings made for the Penguin Illustrated Classics series on separate sheets. The idea was rejected because unsigned prints at low prices would endanger the sale of signed ones, and there was also the question of artists' copyright.[28]

In the same year disappointment was expressed at poor sales at the new gallery, Zwemmers; the following year the twentieth annual exhibition was held instead at the Stafford Gallery. Times were hard for the society. Its vacillations reflected the increasing unrest and lack of direction within the wood-engraving movement as a whole, perhaps best summed up by a letter from Gibbings to Pilkington indicating that unless the society became rather more progressive and expansive there was a serious danger of another being formed.[29] After 1939 Pilkington kept in touch with members and arranged two exhibitions during the war at the Whitworth Art Gallery but no further annual exhibitions were held in London until 1947,[30] when the society, on Hughes-Stanton's recommendation, widened its scope to be renamed the Society of Wood Engravers and Print Makers. The previous year it had been incorporated, together with four other craft societies, into John Farleigh's newly founded Crafts Centre of Great Britain—an affiliation which was soon disputed by various members who objected to the association of wood-engraving with craft. Although in many ways present-day attitudes have

[28] Gibbings's editorship of this series is discussed in Ch. 6.3.
[29] Robert Gibbings to Margaret Pilkington, n.d. SWEA. Hughes-Stanton had suggested the formation of a wood-engraving club to include all types of reproductive techniques which had been vetoed by Rooke, whilst the secretary of the Painter-

Etchers and Print Collectors' Club wrote that in view of the Society of Wood Engravers' overdraft a new print club, the Wood-Engraving Club, could be formed in connection with the society.
[30] See n. 6.

changed, the perception of the medium by artists, critics, and the general public is still moulded by debates which simmered in the early years of the society.[31]

5.2. *Art School Teaching*

In the early days of the wood-engraving revival, lack of official teaching in the art schools led many artists to discover for themselves the pleasure of the medium, as did Rooke, Raverat, and the Nash brothers. Even when introduced into the curriculum, it was generally included as a minor part of a general illustration or graphic course. Yet without doubt art schools played a major role in encouraging artists seriously to consider wood-engraving as an art form and in many instances to make it their prime medium.

By far the most influential institution was the Central School of Arts and Crafts. The importance of Noel Rooke's teaching has already been discussed, as has Sydney Lee's at the Camberwell School of Arts and Crafts.[32] The Slade's prospectuses do not list any courses in wood-engraving nor even printmaking before 1920, only painting, sculpture, and ornamental design.[33] The name of W. T. Smith appears in 1921 as wood-engraving instructor to a class 'limited to ten students, twice a week in the first term and once a week in the second and third terms'. Like Beedham, Smith was one of the old school reproductive wood-engravers who no doubt gave thorough technical grounding without much artistic guidance. Printmaking was the one area where students had no life models or other arrangements from which to structure their compositions: they frequently depicted genre imagery in a fairly conventional manner, possibly because much of their work was undertaken with book illustration commissions in mind, or else to fulfil design prize categories.[34] Smith passed on his skills to Barbara Greg and Norman Janes,[35] who began teaching wood-engraving and other graphic processes at the school in 1938. A number of distinguished practitioners emerged from the Slade, in particular Gwen Raverat, Paul Nash, Leon Underwood, Clare Leighton, Ralph Chubb, Rupert Lee, and Claughton Pellew, but the school can claim little credit for teaching them.

Ravilious, Bliss, Bawden, Enid Marx, and John Greenwood likewise received no official teaching at the Royal College of Art. In his autobiography Greenwood mentions that in the years between 1908 and 1911 little information on wood-engraving was available at the college but he was introduced to the medium by a fellow student, C. W. Taylor,

[31] For a brief account of the later period see exhibition catalogue, *Engraving: Then & Now: The Retrospective 50th Exhibition of the Society of Wood Engravers*, with introduction by Simon Brett [1987].

[32] See Ch. 4.1. For John Farleigh's role as a teacher in the Book Department see Ch. 9.

[33] Slade prospectuses held by University College London Records. For a history of the Slade see Andrew Forge, 'The Slade', *Motif*, 4 (1960), 28–43.

[34] See exhibition catalogue, *Early Slade Wood Engraving 1920–49* (London: Strang Print Room, University College [1992]), which includes a selected list of students' prints. From 1931 Smith also offered classes in 'zinc and copper engraving, also in etching and aquatint'. Wood-engravings successively won the design prizes in these early years.

[35] The individual bookwork of the artists mentioned in this chapter is discussed in later chapters.

who had served an apprenticeship as a commercial wood-engraver.[36] Marx, a student in 1922 under William Rothenstein,[37] and contemporary of Ravilious, feels that Frank Short, then Professor of Engraving, 'taught prints not wood-engraving'.[38] She learnt from Ravilious who was in turn inspired by Paul Nash, teacher of Design at the college from 1924 to 1925.[39] Marx considered that Nash

was a great stimulus and inspiration. He did not do any hand demonstrations of 'how to do it' but he let us peer through his spectacles and imparted his principals [*sic*]. My own contact with [him] was not in the actual classroom. Paul had a cubby hole at the RCA and by a sort of magnetic force about 6 of us from different areas of the college were drawn to Paul.[40]

Although the college was not in the forefront of wood-engraving teaching, Bawden testifies that some tutors were still very much under the spell of William Morris and there was much talk about typography and fine book production.[41]

As well as the Central, two privately run art schools most directly affected the growth of wood-engraving. The first was Leon Underwood's Brook Green School.[42] Underwood, who had studied at the Regent Street Polytechnic (1907–10), the Royal College of Art (1910–13), and at the Slade (1919–20), opened his school at 12 Girdler's Road in Brook Green in 1921, simultaneously teaching part-time at the RCA and, for a short spell, evening classes at the Byam Shaw School. By all accounts he was a magnetic personality, attracting many students from classes elsewhere through his informal methods and unorthodox approach not only to drawing, painting, sculpture, and printmaking, but to the whole concept of art. Marion Mitchell remembered Underwood as 'an inspiring teacher' who 'made you see things'.[43] According to Annette Armstrong he stimulated the visual approach of his students by shock tactics, emphasizing analytical drawing which was never allowed to be an end in itself, being 'part of the meditative process from within'.[44] This spiritual approach and emphasis on movement of line are features which characterize his work and that of his students who broke away from traditional methods of representation to form, in a sense, their own 'school'. Although initially the group decried the use of wood-engraving for book illustration, Underwood, Hughes-Stanton, Gertrude Hermes, and Mary Groom soon produced some of the most inventive illustrative prints of the period. The school was run by Underwood until 1939 and briefly, during his absence in America, by Hughes-Stanton.

A second breeding ground for wood-engravers was the Grosvenor School of Modern Art opened by Iain Macnab in 1925 at 33 Warwick Square, which ran for fifteen years until the outbreak of the war.[45] It offered tuition in life drawing, painting, composition,

[36] John Greenwood, *The Dales are Mine* (London, 1952), 42.

[37] Principal of the RCA, 1920–35.

[38] Conversation between Enid Marx and the author, 12 Mar. 1986. For a discussion on her work see Ch. 12.5.

[39] For Nash's influence see Ch. 12.2.

[40] Enid Marx to the author, 27 Mar. 1992. See Enid Marx, 'Student Days at the RCA', *Matrix*, 16 (1996), 145–59. For Nash's influence on Ravilious see Ch. 12.4.

[41] Edward Johnston was teaching Lettering at this time. Douglas Percy Bliss, *Edward Bawden* (Godalming, 1979), 18–20,

describes the atmosphere at the college. In a report on *Continental Art Education* written in 1924, Rothenstein suggested that wood-engraving should play a central part in the life of the college.

[42] See Chs. 13.1 and 13.2.

[43] Conversation between Marion Mitchell and the author, 19 Mar. 1985.

[44] Annette Armstrong, Introduction to exhibition catalogue, *Leon Underwood* (London: New Art Centre, Nov. 1976).

[45] See Ch. 4.1.

printmaking, and other subjects, and encouraged students to express their own individual ideas rather than be forced to accept worn-out academic theories. 'Mac' was clearly another charismatic teacher, kindly and encouraging, with a good sense of humour. His staff included Hughes-Stanton, Graham Sutherland, Claude Flight (a pioneer of colour linocutting),[46] and Tom Chadwick, while among his pupils were Gwenda Morgan, Guy Malet, Peter Barker-Mill, Alison and Winifred McKenzie, Pauline Logan, Rachel Reckitt, and William Kermode, many of whom were to make names for themselves in the 1930s and 1940s. Gwenda Morgan joined the school part-time in 1929 after studying wood-engraving with J. G. Platt at Goldsmiths' College School of Art. Macnab initiated a wood-engraving class which he persuaded her to join. She recalled that there were seven or eight other students including Chadwick, and when Macnab 'told new students what tools etc., to buy he used to add "and a bottle of iodine". He said it would be needed sooner or later.'[47] Classes were conducted as in a Paris studio with no formal teaching.

In 1938 Macnab published a practical guide for students.[48] In it he suggested that the increase in popularity of wood-engraving was partly because the 'reaction against the vague formlessness into which Impressionism often degenerated had revived an instinctive pleasure in formal design' which the very severity of the medium allowed. 'Clarity and simplicity of statement, more clean-cut and precise draughtsmanship, and greater insistence on design'[49] were all qualities that became the hallmark of his students—the antithesis of the more amorphous style of Underwood's group.

Although wood-engraving was taught in provincial art schools it is difficult to assess how influential the classes were. In 1920 Paul Nash was invited by Albert Rutherston to teach wood-engraving at his Cornmarket School of Drawing and Painting in Oxford,[50] while from 1931 to 1933 he was again teaching the subject with Marx and Ravilious at the Ruskin School of Drawing in Oxford. Certainly the medium flourished at the Birmingham School of Art but staff there very much followed in the tracks of Morris and contributed little to the development of wood-engraving.[51]

Whereas during the 1920s wood-engraving was gradually being absorbed into the curriculum,[52] by the 1930s the medium was far more widely recognized by art schools as an artistic medium. More significantly, the interest was spreading at the roots, to the extent that in 1932 Campbell Dodgson noted: 'Wood engraving has been taught in all the schools, linoleum cutting in all the kindergartens.'[53]

[46] See Stephen Coppel, *Linocuts of the Machine Age: Claude Flight and the Grosvenor School* (Aldershot, 1995).

[47] Albert Garrett, *Wood Engravings and Drawings of Iain Macnab of Barachastlain* (Tunbridge Wells, 1973), 98.

[48] Iain Macnab, *Wood-Engraving* (London, 1938; repr. 1947).

[49] Ibid. 1.

[50] See letter from Nash to Gordon Bottomley [*c.* end July 1920], quoted in *Poet & Painter* (Oxford, 1955), 122.

[51] See Ch. 3.6, 'William Morris'.

[52] Lettice Sandford was taught, for instance, by Robert Day at the Chelsea Polytechnic.

[53] Campbell Dodgson, Introduction to Bernard Sleigh, *Wood Engraving since Eighteen-Ninety* (London, 1932), p. viii.

5.3. *Champions of the Cause: Dealers, Collectors, Critics, and Writers*

Wood-engraving had already begun to be recognized as an art form before 1920, but the founding of the two societies, coupled with an increase in the number of practitioners, gave the movement a sense of direction and encouraged more galleries to take an interest in the medium. Dealers, particularly J. Knewstub, Arthur Howell, and Rex Nan Kivell of the Chenil, St George's, and Redfern Galleries respectively, played a vital role in determining the market largely through their links with the wood-engraving societies.[54] St George's and the Redfern were the only galleries to deal regularly with wood-engravers; apart from the societies' annual shows, St George's included a joint exhibition for Gill and Jones in 1927. Various other galleries held occasional wood-engraving exhibitions. In the early 1920s the Goupil Gallery, run by William Marchant, exhibited and sold prints by John Nash and Gill, among others. Raverat's work was represented at an exhibition of International Woodcuts at Herbert Furst's Little Art Rooms in February 1924, together with the work of McKnight Kauffer, Ginner, Rodo, Brangwyn, Elinor Darwin, John Greenwood, Frank Kermode, and Clifford Webb. In the same gallery in 1926 she exhibited with Greenwood, Barbara Greg, Norman Janes, and C. W. Taylor. Over a period of time the work of Craig, Paul Nash, and Farleigh, to name a few, appeared at the Leicester Galleries. A major exhibition of Sydney Lee's graphic work was held in 1937 at Colnaghi's, the contemporary print publishers and specialists in Old Master prints, which had previously enabled the English Wood-Engraving Society to hold their annual exhibition in their gallery when St George's was closed for renovation in 1931. Zwemmers and the Stafford Gallery played temporary hosts to Society of Wood Engravers' exhibitions at the end of the decade. Robert Ross of the Carfax Gallery was another supporter of wood-engravers. Art school shows also helped to promote practitioners, whilst, as will be seen, several printing exhibitions generated by the typographical renaissance created a widespread interest in wood-engraved illustration, typography, and other book-related arts.[55]

Yet exhibitions alone were not enough to spread the word. A minor art needs its champions and those few who advocated wood-engraving in the early stages of the revival were largely responsible for its popularity in the 1920s and 1930s. Prominent among these was Thomas Balston (1883–1967), a driving force behind the publishing firm of Duckworth, of which he was a director between 1921 and 1934. In this capacity he was an energetic promoter of new literary and artistic talent, particularly of wood-engravers, commissioning among others Robert Gibbings,[56] Paul Nash, Ethelbert White, Vivien Gribble, Clare Leighton, and Eric Ravilious. As an amateur artist himself he was naturally drawn to the typographical and illustrative side of publishing. Anthony Powell, who worked in the firm

[54] Print values are discussed in Ch. 1. For a fuller account of general print dealing practices see Frances Carey and Antony Griffiths, *Avant-Garde British Printmaking, 1914–1960* (London, 1990), 10–17.

[55] See Ch. 6.1.

[56] For his connection with Gibbings see John Dreyfus (ed.), 'Some Correspondence between Robert Gibbings and Thomas Balston', *Matrix*, 9 (1989), 37–51.

from 1927 under Balston, believed that he had complete control in this area being the only partner interested in the arts.[57] As a result of his personal enthusiasm, Duckworth was one of the first commercial publishers to become involved in the revival.

An avid and varied collector with a wide knowledge of English book illustration and wood-engraving in particular, Balston wrote several books on the subject, including monographs on Gibbings and White and a seminal book *English Wood-Engraving, 1900–1950*, following his pioneering exhibition, 'Wood-Engraving in Modern English Books', held at the National Book League in 1949.[58] As early as 1922, he was responsible for the publication by Duckworth of Campbell Dodgson's *Contemporary English Woodcuts*, another classic of its time.

That Campbell Dodgson (1867–1948) was chosen to introduce the Society of Wood Engravers' first exhibition indicates the respect with which he was viewed by the wood-engraving fraternity. Balston considered him 'a warm supporter from the start'.[59] Since 1912 he had been Keeper of Prints and Drawings at the British Museum (a post he held until 1932), soon becoming the leading authority on early German graphic art.[60] A pioneer British collector of Impressionist prints and English twentieth-century print makers, especially etchers, he was also early to acquire wood-engravings: his bequest to the British Museum in 1949 included a comprehensive selection which to this day represents a large proportion of the modern British collection. As an administrator of the Contemporary Art Society Fund he was also responsible for purchasing drawings and prints for public collections: of wood-engravings several were acquired from the first Society of Wood Engravers' exhibition. A voluminous writer, particularly on graphic art, his informed views on the subject acted as an incentive to the print-buying public, his *Contemporary English Woodcuts*, in particular, inspiring a number of new collectors.[61]

Martin Hardie (1875–1952), curator of the Prints and Drawings Department at the Victoria and Albert Museum from 1921, and later at the Museum of London, was himself an etcher and watercolour painter. He admired and collected the work of various wood-engravers including Clare Leighton whose prints, among those of others, he bequeathed to the Ashmolean Museum, Oxford.

Amongst the most effective advocates of the medium were the art critics and journal-ists, especially Malcolm C. Salaman (1855–1940) and Herbert Furst (1874–1945). Salaman was art critic for the *Sunday Times* from 1883 to 1894, editor of *Fine Prints of the Year* before Campbell Dodgson, and contributor to many periodicals especially the *Studio* and *Apollo*. He was an honorary member of the Society of Graver Printers in Colour and the Colour Woodcut Society. As early as 1914 he wrote a perceptive article in the *Studio* on 'The

[57] Anthony Powell to the author, 25 Sept. 1987.

[58] Much of his collection he bequeathed to the nation, includ-ing some wood-engravings to the Ashmolean Museum, Oxford.

[59] Thomas Balston, *Wood-Engraving in Modern English Books*, introduction to exhibition catalogue, London: National Book League (Cambridge, 1949), 13.

[60] For fuller discussion see Frances Carey, 'Campbell Dodgson

(1967–1948)', in Antony Griffiths (ed.), *Landmarks in Print Collecting: Connoisseurs and Donors at the British Museum since 1783* (London and Houston, 1996), 211–35. A bibliography is included in n. 1 of this book.

[61] He edited *Print Collector's Quarterly*, 1921–36 and *Fine Prints of the Year*, 1923–38 in succession to Malcolm Salaman.

Woodcuts of Sydney Lee'; through a later article he brought Gibbings's work to light.[62] In a *Studio Special Number* of the same year entitled *Modern Woodcuts and Lithographs* (1919) he drew attention to the variety of work being produced in Britain and France before 1920. Mason, reviewing the book, considered it 'the first collection, with any claim to comprehensiveness, of the artistic work of the present renaissance of the woodcut'.[63] In *The New Woodcut* (1930) Salaman disclosed the striking developments that had occurred over ten years, most especially in Britain. His contribution was such that Furst acknowledged him as 'the indefatigable champion of print makers'.[64]

As an art publisher, critic, and editor Furst contributed many articles on graphic work.[65] In 1920 and 1921 he published a series of monographs entitled *Modern Woodcutters* on four wood-engravers: Raverat, Brangwyn, Sturge Moore, and Wadsworth. Articles in *The Print Collector's Quarterly* were published in 1924 as *The Modern Woodcut*, a bibliographic milestone in the literature of twentieth-century wood-engraving. D. P. Bliss described it as 'vastly stimulating' and having 'great influence': 'It was the first comprehensive account of the whole movement, defining and classifying, knocking the old dead reproductive fellows on the head, whooping up the "avant-garde" and providing them with a new aesthetic bristling with words of power.'[66] Four issues of *The Woodcut: An Annual* appeared between 1927 and 1930 which included examples of both British and foreign artists' work. Furst had Salaman to thank for bringing Raverat's work to his attention: her way of using wood-engraving as a means of 'free aesthetic expression' first aroused his curiosity for the medium.[67]

Perhaps the best promoters of their art are artists themselves. Gill was a voluble proselytizer of wood-engraving, both writing and lecturing frequently on the subject. Gibbings, first as the forceful Honorary Secretary of the Society of Wood Engravers and then, after 1924, as the owner of the Golden Cockerel Press, played a major part in encouraging an interest in book illustration in particular. His successor as Honorary Secretary, Margaret Pilkington, herself a competent wood-engraver, was dedicated to the society's cause and did more than anyone to spread the word out of London by promoting exhibitions in the provinces and abroad.[68] From a wealthy Manchester family, she was quiet, unassuming, and exceptionally generous both to wood-engravers and craftsmen, founding the Red Rose Guild of Artworkers and helping to keep the Society of Wood Engravers afloat through financially difficult years. As a Governor from 1925 and later (1935–59) Honorary Director of the University of Manchester's Whitworth Art Gallery she was responsible for the society's liaison with the gallery where its annual exhibitions were held for some years and to which, on her death

[62] Malcolm C. Salaman, 'The Woodcuts and Colour Prints of Captain Robert Gibbings', *Studio*, 76 (1919), 3–9. For a list of Salaman's writings relating to wood-engraving see Select Bibliography.
[63] *London Mercury*, 1 (1920), 359.
[64] Herbert Furst, *The Modern Woodcut* (London, 1924), p. v. A supplement volume, *The Woodcut of To-Day at Home and Abroad*, followed in 1927.
[65] Furst managed the London branch of Hanfstaengl, German publishers of fine art reproductions. Between 1920 and 1922 he founded and edited *The Apple* for which he commissioned wood-engraved illustration, and also edited *Apollo* (1935–9).
[66] Douglas Bliss, 'The Last Ten Years of Wood-Engraving', *Print Collector's Quarterly*, 21 (1934), 251–71, p. 255.
[67] Furst, *The Modern Woodcut*, p. v.
[68] See previous chapter. Her work is discussed in Ch. 8.

in 1974, she left her large collection of many of the best wood-engravings of the period.[69]

During the 1920s and 1930s various technical and historical books were written by wood-engravers. The most significant were John Beedham's *Wood Engraving* (first published in 1920), Craig's *Woodcuts and Some Words* (1924), Rooke's *Woodcuts and Wood Engraving* (from a lecture delivered to the Print Collectors' Club in January 1925), Bliss's *A History of Wood-Engraving* (1928),[70] and Clare Leighton's *Wood-Engraving and Woodcuts* (1932) and *Wood Engravings of the 1930s* (1936), the last two published by Studio Publications which was responsible also for many articles.[71] In 1938 Pitman published Iain Macnab's *Wood Engraving*, a clear and precise technical manual in The Student's Art Books Series. John Farleigh's idiosyncratic *Graven Image* (1940), an autobiographical journey through his early career as a wood-engraver, vividly conveys his love for the medium. By this time there was less need for propaganda than in the 1920s. A chapter by Frank Rutter,[72] entitled 'The Revival of Wood Engraving', appeared in his *Modern Masterpieces: An Outline of Modern Art* (1940)—an indication of the high standing of the medium as seen through the eyes of a respected critic at the beginning of the Second World War.

5.4. *Commercial Art: Illustrated Periodicals and Advertisements*

By 1915 only a few prints in magazines and various printed ephemera had given the general public a glimpse of the 'new look' of wood-engraving.[73] From the 1920s illustrated literary and art journals played a key role in disseminating the art. In 1919 a radical magazine *Change*, edited by John Hilton and Joseph Thorp, was published by the Decoy Press.[74] Only two small volumes were eventually issued but they contained illustrations by nine engravers, including Gill (designer of the Decoy duck pressmark), Gibbings, Gribble, Hagreen, and Rachel Marshall (Ray Garnett). The magazine appealed for a better and fairer post-war society and warned of the dangers of a wholly material outlook; in his editorial comment Thorp altruistically stated that the aim of the illustrations was to be cheaply available to those who would otherwise be unable to buy them.[75] His concern for the future of the medium is apparent:

The Editors would also like to draw the attention of those interested in modern English art,

[69] Lady Mabel Annesley, a close friend and fellow engraver, presented her fine collection of contemporary wood-engravings to the Belfast Museum and Art Gallery in two groups in 1932 and 1939. For a survey of her work see Ch. 8.

[70] Bliss's how-to-do-it leaflet, *Wood-Engraving*, was published by Dryad Handicrafts, Leicester [1952].

[71] A more comprehensive list is contained in the Select Bibliography.

[72] Rutter (1876–1937) was art critic of the *Sunday Times* from 1903, editor of *Art News*, Curator of Leeds Art Gallery (1912–17), and Chairman of the Allied Artists' Association. He was also a supporter of the New English Art Club.

[73] According to Kenneth Lindley, *The Woodblock Engravers* (Newton Abbot, 1970), 88, only a few professional reproductive wood-engravers were still working at the outbreak of the First World War.

[74] The Decoy Press, Plaistow, was Thorp's publishing imprint only, not a printing press, used sometimes by the Curwen Press when it was impolitic to use their own imprint. For further discussion on Thorp see Ch. 6.1 and Herbert Simon, *Song and Words: A History of the Curwen Press* (London, 1973), 148–9.

[75] Herbert Rooke's wood-engraving *He Stirreth Up the People* on p. 47 is in keeping with the socialist tenor of the magazine.

who are not merely patrons of the dead, to the woodcuts which embellish this little volume. There are a score or so of really competent wood-engravers and woodcutters in England, who have great difficulty in finding a market for their excellent work. Their names are unknown often even to the connoisseur, and a fine craft, now just raising its head, may be starved back again into oblivion through lack of the patronage of discerning folk. *Change* in its very modest way will continue its attempt to advertise this workmanlike and attractive process. Replicas of any woodcut appearing in *Change* may be had from the artist, pulled on India paper, mounted and framed in 'passe partout', on application to the Editors, who will put correspondents in direct touch with the artist himself. He will charge his own price, which will be a very modest one—too modest, in our opinion.[76]

The fact that Thorp was prepared to champion their cause *and* act as an agent, was obviously greatly beneficial to all wood-engravers.

Possibly the most significant periodical to champion the cause was the *London Mercury* which appeared from November 1919 to April 1939, edited by Sir John Squire, whose penchant for wood-engraving led him to feature the work of most of the leading practitioners including rare examples by John Piper[77] and Evelyn Waugh.[78] J. C. Squire was an intriguing man: a poet and formerly literary editor of the *New Statesman*, he was discriminating in his choice of both illustrators and writers on literary and artistic subjects for the *London Mercury*.[79] Some inspired choices were John Nash who wrote briefly on the Fine Arts, J. H. Mason on Booknotes (1919–20), and above all Bernard Newdigate who compiled Book Production Notes from May 1920 to November 1937. Mason and Newdigate, being printers foremost, were perhaps more concerned with typography than illustration, hence the attractive appearance of the periodical. The printing of wood-engravings, however, is often rather heavy and over-black, leading Bliss to write dismissively: 'Indeed, judging by what he reproduces in "The London Mercury", even that great amateur of engravings, Sir John Squire, seems to think that talent is required to get "amazing blacks".'[80]

Like Squire, Harold Monro was a poet and publisher with a discerning eye for illustrators. In 1913 he founded The Poetry Bookshop, publishing mainly volumes of poetry, notably five volumes of Georgian poetry. As early as 1915 he published *Spring Morning* with wood-engraved illustrations by Raverat, and in 1923 *Autumn Midnight* illustrated by Gill.[81] He also issued rhyme sheets and broadsides in the chapbook tradition. These took the form of single pages reproducing poems by classical and modern poets, with decorations at the head and foot of the text: generally line drawings in two or three colours by artists such as Claude Lovat Fraser, John and Paul Nash, Sturge Moore, David Jones, Edward McKnight Kauffer, Albert Rutherston, and Edward Bawden. It was, however, *The Monthly Chapbook*, first published in December 1919, which offered greater

[76] John Hilton and Joseph Thorp (eds.), *Change: The Beginning of a Chapter* (Plaistow, 1919), i. 103–4.

[77] *The Pond* (c.1923) and *Coldkitchen Farm* reproduced in *London Mercury*, 21 (1930), 235, 209.

[78] Reproduced in *London Mercury*, 8 (1923), 635. See Richard Emery, 'Evelyn Waugh and the Private Press World', *Matrix*, 15 (1995), 147–52.

[79] 'Jack Squire' was parodied by Hilary Pepler and David Jones on pp. 10–11 of *Libellus Lapidum*. He also edited the periodical *Land and Water* which contained contributions from leading illustrators.

[80] Bliss, 'The Last Ten Years of Wood-Engraving', 251.

[81] See Ch. 4.3 n. 139.

opportunities to wood-engravers.[82] The quality of paper and printing was high, with paper covers decorated by a different artist each month, Ethelbert White and Paul Nash producing particularly striking designs. Other wood-engravers included Craig, John Nash, and Hughes-Stanton. The magazine's editorial claim to be a critical survey of contemporary literature with numerous examples of the creative work of the period is fully justified.

Editors of several other journals and periodicals of the 1920s made a point of commissioning wood-engraved illustrations. *The New Leader Book* grew out of a periodical called *The New Leader*, the socialist literary and philosophical magazine, edited by Noel Brailsford.[83] As well as illustrated text, two volumes of 1924 and 1925 each contained a portfolio of twelve woodcuts and drawings printed on thick, yellowish laid paper. Artists included Gill, Greenwood, Leighton, J. F. Murphy, Dorothy Bedford, Claughton Pellew, C. W. Taylor, and, most prolifically, Gwen Raverat. A press-cutting enclosed in one copy declares: 'The New Leader Book (2s.6d.) is distinct from the majority of annuals in the genuine artistic excellence at which it aims its woodcuts and drawings, and the remarkably interesting exhibition of the former art which it contrives to furnish in a small compass.'[84] Raverat's work for the monthly magazine *Time and Tide*, a liberal and markedly feminist periodical founded by Lady Rhonda embracing social issues, politics, and the arts, did much to publicize her work and wood-engraving exhibitions in general.

Other periodicals which featured wood-engraving include *The Apple, The Beacon, The New Keepsake, Artwork*,[85] and *Golden Hind. Form* issued a special wood-engraving number in October 1921 including work by Rodo, Wadsworth, Daglish, and John and Paul Nash. Among other designs Gill engraved various motifs for the *Architects' Journal*, a cover design with titling for *Poetry* magazine in 1930, and a wheat ear device used from 1931 for *Greece and Rome*, a Clarendon Press classical journal.[86] Lesser known images included one by Norman Janes for Oxford University Press's promotional music magazine, *The Dominant* (1927–29), edited by Hubert Foss.[87] Ravilious's designs for John Murray's *The Cornhill Magazine* and for Wisden's *Cricketer's Almanack* are amongst the most memorable wood-engraved devices of the period. Despite the fact that all these are strictly decorations rather than illustrations as they tend not to have a direct connection with the text, the periodicals in which they appear should nevertheless be considered as an integral part of the whole wood-engraving movement. They certainly provided valuable work for practitioners and did much to publicize the art.

The small-scale nature of wood-engraving rendered it a natural medium for ephemera such as bookplates, cards, and leaflets—for many practitioners a significant proportion of their commissioned work and a further means of publicity. A far wider-reaching

[82] It later appeared as *The Chapbook (A Miscellany)*, first monthly and then sporadically until June 1923. Two larger annual volumes, 39 (Oct. 1924) and 40 (Oct. 1925), followed as hardbacks, published by Jonathan Cape.

[83] Brailsford's connection with Clare Leighton is discussed in Ch. 14.1.

[84] N.d. Held in Manchester Metropolitan University Library.

[85] Contains rarely seen work by Gibbings and Evelyn Waugh.

[86] Different versions of Gill's print *Belle Sauvage* were used by Cassell & Co., as an imprint for *Book Collector's Quarterly*, 1930–5. See Ch. 11.2 n. 92.

[87] See Ch. 6.3. The author is grateful to Peter Foden, Oxford University Press Archivist, for drawing the last two examples to her attention.

form of promotion came from advertising.[88] Regrettably, however, the expense of engraving on wood (compared with quicker methods of relief printmaking such as linocutting or scraperboard work, or black and white lineblock drawing), its smallness, and the lack of colour discouraged wide-scale use of the medium for advertising purposes, particularly posters.[89] No doubt, also, many firms intentionally disassociated themselves from what they perceived as old-fashioned illustrative techniques. Contemporary wood-engraving had to present a bold new face and not be purely imitative, hence some of the eye-catching designs which emerged during this period, much of the best printed at the Curwen Press.[90] This significant and under-researched field of commercial art deserves greater attention than is possible within the scope of the present book. A few examples, however, serve to indicate those areas of commerce which were attracted to the medium and some of the practitioners involved.

Robert Gibbings was one of the first in the field with three simply conceived scenes for Imperial Tobacco Company's Matinée Cigarettes (1920).[91] His most distinguished commercial prints were fourteen wood-engravings for the Orient Line (1932) which also employed Lynton Lamb. The increasing popularity of travel and family outings accounted for the abundance of advertisements put out by transport companies. In the early 1920s the London Underground group published a brochure illustrated by Gibbings with notes on how to reach the Zoo; later, the city's General Omnibus Company commissioned both Gwen Raverat and Clare Leighton to engrave a series of London scenes for newspaper advertisements. Eric Ravilious produced headpieces for a Southern Railway Company brochure entitled *Thrice Welcome*, and motifs for Green Line press advertisements for London Transport. Agnes Miller Parker designed a poster for the same company and John Farleigh some coloured posters, using a mixture of wood-engraving, lino, and lithography.[92] For their publicity campaign in the 1930s Shell-Mex used wood-engravings by Gibbings among others, whilst Gwenda Morgan produced a press advertisement for Pratt's Petrol.[93]

The medium appealed also to food and drink companies: Gibbings contributed four prints to a brochure advertising Findlater's port and three wood-engravings for a publicity booklet entitled *The Story of Bovril*. Among numerous designs for other companies, Ravilious engraved a stylized label for Fine Old Invalid Port for the Kemptown

[88] See Alan Horne's essay 'Commercial Art', in *The Dictionary of 20th Century British Book Illustrators* (Woodbridge, 1994), 26–34, and accompanying bibliography.

[89] G. M. Ellwood, 'Wood- and Lino-cuts in Advertising', *Penrose Annual*, 35 (1933), 92–5, p. 93, warns of cheap imitations: 'The evidence of the cutting must be apparent in the shapes which remain white in printing.' A suggested list of prices agreed upon by the Society of Wood Engravers is included in John Farleigh, *Graven Image* (London, 1940), 291–2: for example, Poster (25 gns.), illustration for book or advertisement, under 3" x 2" (2 gns.) in size up to under 7" x 6" (9 gns.), black and white book-jacket (6 gns.) or 2 or 3 colours (8 gns.), line-drawn book-jackets (3½ gns.) and in colour (5 gns.), 1 colour litho (6 gns.), 2 or 3 colours (8 gns.). The prices for

dust-jackets indicate the comparative expense of wood-engraving.

[90] See Ch. 6.3.

[91] Thorp commissioned him on behalf of the company. He was also responsible for procuring Gibbings's job for Eno's Fruit Salt. For an account of Thorp's involvement in the schemes see Robert Gibbings, 'Some Recollections', in *The Wood Engravings of Robert Gibbings*, ed. Patience Empson with introduction by Thomas Balston (London, 1959), p. xxxvi.

[92] The process described in Farleigh, *Graven Image*, 378–9.

[93] This and other examples were exhibited in 'A Fine Line: Commercial Wood Engraving in Britain', London: Victoria and Albert Museum, 10 Oct.–26 Mar. 1995.

Brewery in Brighton. John Nash's print *Empire Tobacco*[94] was commissioned by the Curwen Press to be reproduced in *The Times* for the Empire Marketing Board to whose advertising scheme Clare Leighton contributed some agricultural scenes.[95] Several humorous designs by Philip Hagreen in *The Laundry Journal* issued by Imperial Chemical Industries helped to promote the firm's products. In the financial field an abstract motif by Ravilious was used as a device by the Westminster Bank.

Some practitioners were commissioned purely to design covers for publicity booklets. The imaginative compositions of Ravilious and Hughes-Stanton for two BBC talks pamphlets[96] would have alerted the readers to the decorative possibilities of black and white, as would the many designs by various illustrators which appeared in the *Radio Times*. However, as with most of Eric Fraser's illustrations, these were largely lineblock drawings or scraperboard prints.

Since dust-jackets were a means of advertising books they acted as another useful, if comparatively small-scale promotional outlet for wood-engraving.[97] Through them, as John Farleigh (an advocate of the use of the medium for advertising) pointed out in 1940, 'the artist has discovered a new field for experiment, while the publisher has realized the display value of this new activity. So the glory that was once the binding is now the wrapper.'[98] Farleigh produced several, including one for Faber and Faber's *Progress of the Ploughboy* by William Cobbett (1934). Among other practitioners to produce dust-jackets, Ray Garnett worked for Chatto & Windus, as did Gibbings, who was also employed by Jonathan Cape and Constable, Ravilious worked for Duckworth, Allen & Unwin, and Jonathan Cape, Raverat for Macmillan and Faber and Faber, Clare Leighton for Gollancz, and Agnes Miller Parker for Oxford University Press. Such prominently placed wood-engravings would surely have attracted attention in the shops. Eye-catching repeat patterns for bindings and covers were most successfully designed by Paul Nash, Ravilious, Bliss, and Garwood in particular.

Publishers' devices did much to imprint wood-engraved design on the minds of the reading public.[99] William Collins's fountain (Fontana) colophon was commissioned from Gill, who in 1935 produced endpapers for the firm's Illustrated Pocket Classics, while variations of his nude print, *Belle Sauvage*, appeared in Cassell's publications.[100] Ravilious's crisp abstract compositions for Dent's Everyman Library were perhaps the most widely circulated. Similarly Gill's sprightly unicorn trade mark for the Curwen Press (one of a series by various artists) was known by many from copies of *Mrs Curwen's Pianoforte Method*. Illustrated prospectuses, newsletters, and calendars also helped to

[94] Illustrated in Francis Meynell, *The Typography of Newspaper Advertisements* (London, 1929).

[95] For further information see Stephen Constantine, *Buy & Build: The Advertising Posters of the Empire Marketing Board* (London, 1971). The Board's object was to boost sales of Empire products, but its success prompted British farmers to call for further posters to show the rural purity of domestic farm produce. The author is indebted to David Leigton for this information.

[96] R. M. Y. Gleadowe, *British Art* (1934) and Eric Newton, *An Approach to Art: A Pictorial Guide to Twelve Broadcast Talks and Discussions on the Artist and his Public* (1935).

[97] See Alan Horne's essay 'Book Jackets and Covers and Paper Wrappers', in Horne (ed.), *The Dictionary of 20th Century British Book Illustrators*, 34–46, and accompanying bibliography.

[98] Farleigh, *Graven Image*, 275. The cover for this book is an unusual example: a collage of 19th-cent. reproductive work combined with Farleigh's lettering and surrealist designs.

[99] The triumvirate of private presses, the Golden Cockerel, Gregynog, and Nonesuch, had an assortment designed by various illustrators.

[100] See n. 86.

popularize the medium, in particular those hand printed by private presses, though their circulation was limited. Ravilious's work for John Murray, the Curwen Press, and the Golden Cockerel Press once again made a special impact, as did his lively illustrations for the Kynoch Press Notebook and Diary, and the Lanston Monotype Corporation's Almanack. As well as prospectuses, the Golden Cockerel issued two series of greetings cards, enabling their illustrators' work to be known further afield.

While not a major influence on the development of wood-engraving, it is clear from the few examples mentioned here that advertising was an important contributory factor in keeping the medium alive and bringing it to the attention of the wider public—just as it was in the nineteenth century and indeed still is today.

$\mathcal{C}\mathcal{O}$ 6 $\mathcal{C}\mathcal{O}$

PUBLISHING AND WOOD-ENGRAVED BOOK ILLUSTRATION

6.1. *The Typographical Renaissance*

William Morris's ideals and the achievements of the Kelmscott Press indisputedly provided the impetus for the new generation of private presses which arose at the turn of the century. Yet, with some notable exceptions, their aesthetic standards of book production had little effect on general trade publishing and printing which had reached a low ebb in Britain by 1914. The choice of typefaces available commercially was limited and old-fashioned, and paper was often unsuitable for the job; more often than not process illustration of mediocre quality was used. Such unexacting standards acted as a spur to those few enthusiasts concerned to improve the overall quality of printing and book design and to narrow the gap between the private presses and commercial publishers. Opportunities existed for an immense technical and aesthetic advance in book production.

Emery Walker played a vital role in the renaissance of fine printing in England, having been the moving force behind Morris's interest in typography.[1] Through his early work for the Typographic Etching Company in the 1870s and subsequent involvement with Morris at the Kelmscott Press and Cobden Sanderson at the Doves Press, he had accumulated a vast store of knowledge of the processes and history of printing and was the *éminence grise* of typophiles, generously advising printers and publishers both at home and abroad. Rooke wrote in 1954 that his influence 'direct or indirect, exists in every well-designed page of type printed today. To him more than to any other single man is due the advance in everyday typographic design of the last half century.'[2] The initial bridging of the gulf between the private presses and the general printing trade was largely due to Walker.

A prominent leader of the printing revival to emerge before the First World War was Gerard Meynell, owner of the Westminster Press and one of the first printers to raise the standards of jobbing work.[3] He provided a wide variety of types and excellent typographical design for advertisements, journals, and books, among other printed

[1] See Ch. 3.6, 'William Morris'.

[2] Noel Rooke, 'Sir Emery Walker (1851–1933)', *Penrose Annual*, 48 (1954), 40–3, p. 40.

[3] See John Dreyfus, 'Gerard Meynell and The Westminster Press', *Matrix*, 10 (1990), 55–68. In an advertisement for the press in *The Chapbook*, 40 (1925) Squire wrote 'You have had a full share in securing the general upward movement in English book-printing which has marked the last ten years, and if I had a really fine book or periodical to produce I should be certain that at The Westminster Press, at least, something would be turned out which would better my best conceptions.'

matter.[4] In 1913 he launched *The Imprint*, a pioneer journal which was 'intended primarily to interpret the private press gospel in practical terms for the commercial printers'.[5] Articles by Meynell's co-editors, Edward Johnston[6] and J. H. Mason, and by Lethaby and Morison, were intended to provide encouragement to the trade. A special new type designed by Mason was cut by the Lanston Monotype Company, aptly christened Imprint Old Face, and made generally available to printers. But *The Imprint* was short-lived: in Thorp's view it was possibly a little too esoteric for the average commercial printer but 'it did unfurl a standard with the best possible intentions'.[7]

The advent of the war in 1914 delayed immediate progress in printing developments. In that year some members of the Arts and Crafts Society visited the Deutscher Werkbund's highly successful exhibition in Cologne. Largely as a result of their experience and through an exhibition of German industrial goods held in the Goldsmiths' Hall in the following year, the Design and Industries Association was founded in 1915 to promote a 'more intelligent demand amongst the public for what is best and soundest in design'.[8] Ironically it was the British who had inspired German design, especially Johnston and Emery Walker in the field of commercial printing.[9] The DIA, whose founder members included Ambrose Heal, Harry Peach, Frank Pick, Harold Curwen, and Joseph Thorp, advocated in its official statement the use of modern industrial methods. From now on the move was towards better design achieved through improved technology. The time-worn 'hand' versus 'machine' controversy rumbled on into the 1920s but was no longer really relevant by the 1930s.

The typographical renaissance was set in motion after the war by a surprisingly small but influential number of pioneers.[10] Joseph Thorp's seminal book, *Printing for Business* (1919),[11] represented 'the first attempt to introduce the theory and practice of printing to the layman, to attempt to show him what was good and what was bad, and why'.[12] Thorp had worked at the Arden Press under Bernard Newdigate, whom he greatly admired, and at the advertising agency of W. H. Smith which took over the press.[13] In 1922 he served on a committee appointed to select the best typefaces and mode of

[4] During the 1920s he worked for at least 30 London publishers including Chatto & Windus and Jonathan Cape.

[5] Roderick Cave, *The Private Press* (2nd rev. edn., New York and London, 1983), 160.

[6] Meynell advised Frank Pick, Commercial Manager of the London Underground (as it came to be known), to commission Johnston to design an alphabet of letters for station signboards, resulting in the distinctive sans serif typeface (1916) which was also used for publications. See n. 9 and also Ruari McLean, *Manual of Typography* (London, 1980), 64–5. Further imaginative designs for the Underground from various artists followed in the 1930s.

[7] Joseph Thorp, 'A Significant Period of Our Printing (1900–1914)', *Printing Review*, 50 (1945), 5–28, p. 24.

[8] For further information on the DIA see Gillian Naylor, *The Arts and Crafts Movement* (London, 1971), 180. The DIA's first exhibition, *Design and Workmanship in Printing*, which was held at the Whitechapel Gallery in 1915, included examples of typography from the Central School and the Vale and Eragny Presses, and assorted printed matter, mainly for commercial purposes, such

as posters by Brangwyn and Hartrick, a lettering poster by Johnston and an alphabet by Gill.

[9] An exhibition of the work of Johnston and Gill at Weimar in 1905 had made a considerable impact. Johnston's later sans serif type was taken up at Walter Gropius's Bauhaus as the typographical expression of the new movements in art, sculpture, and design. Typographers influenced included E. R. Weiss, Rudolph Koch, and his most distinguished pupil Bertholde Wolpe. English private press practices were followed by several German press owners, in particular Count Harry Kessler at his Weimar-based Cranach Press (established 1913).

[10] See Alison Timewall, 'The Revival of Printing Between the Wars', BA thesis (University of Manchester, 1982).

[11] Joseph Thorp, *Printing for Business* (London, 1919).

[12] Thorp, 'A Significant Period of Our Printing', 10. This little book greatly influenced Beatrice Warde, the beautiful and much respected American typographic expert. Ch. 11.2 n. 92. For further discussion on Thorp see Herbert Simon, *Song and Words* (London, 1973), 135–66.

[13] See also Ch. 6.2, 'The Shakespeare Head Press'.

display for government printing. In his capacity as freelance typographer and advertising agent his influence was widespread, especially during his time as printing consultant to the Curwen Press for three years from 1918. He surmised that wood-engraving would only survive if it abandoned its reproductive use and recovered its 'primitive character of simple line and broad massed effects, such as is found in Mr. Rooke's work'.[14]

The years from 1923 to 1933 were the high point in the history of the British printing renaissance. In 1923 Francis Meynell founded the Nonesuch Press, the first private press to operate on similar lines to trade publishing.[15] In the same year his book, *Typography*, was published by his previous press, the Pelican Press, and, more significantly, Oliver Simon of the Curwen Press launched the first edition of *The Fleuron* which Squire reviewed favourably in the *Observer* (17 June 1923). This magnificently produced typographical journal ran until 1930, Stanley Morison having taken over the editorship in 1925.[16] Morison's appointment as typographical adviser to the Monotype Corporation in 1923 was a turning-point in printing history.[17] For Monotype he successfully produced a series of new typefaces made to his own specifications, some based on old designs, others drawn by living artists, which were to become the most commonly used for book printing in Great Britain and to a large extent abroad. His introduction in 1932 of Times New Roman as the typeface for *The Times* radically affected the aesthetics of newspaper design. Morison's advice was sought throughout the world, and his voluminous writings included the classic *Four Centuries of Fine Printing* (1924) and *First Principles of Typography* (1936), as well as articles for *The Fleuron* and other journals. He was undoubtedly the key figure behind the typographical renaissance.

Bernard Newdigate learnt the technical processes of printing at the Arden Press, later joining W. H. Smith under St John Hornby. After the First World War he worked part-time at the Curwen Press and from 1920 as designer for the Shakespeare Head Press[18] which he raised to an impresssive standard, particularly with his judicious use of Caslon Old Face type. In the same year he began to compile Book Production Notes for the *London Mercury*, reviewing books not so much for literary content as for their typographical merit and contributing also articles on fine printing in general. He firmly believed that, with skill, books printed with machine-set type could be as attractive as those set by hand. In conjunction with Squire, he succeeded in producing a typographically appealing journal both in content and appearance and an important illustrative document of many of the best wood-engravers of the

[14] Thorp, *Printing for Business*, 105.
[15] See Ch. 4.4 n. 159, and Ch. 6.2, 'The Nonesuch Press'. For further discussion see Francis Meynell, *My Lives* (London, 1971). Gordon Bottomley considered that 'whatever the Meynells touch they make valuable (and to have impressed the British Printing Trade is a proof of positive genius)'. Gordon Bottomley to Paul Nash, 12 Dec. 1919, quoted from *Poet & Painter*, ed. Claude Colleer Abbott and Anthony Bertram (Oxford, 1955; repr. 1990), 116.
[16] See Grant Shipcott, *Typographic Periodicals Between the Wars: A Critique of 'The Fleuron' and 'Signature' and 'Typography'* (Oxford, 1980).

[17] The Monotype hot-metal composing machine revolutionized printing by casting single type. After earlier experiments Tolbert Lanston of Ohio built the first successful machine in 1899. The British Lanston Monotype Corporation (the name changed in 1931 to The Monotype Corporation Ltd.) was founded in 1897 and from 1900 machines began to be built at its new factory in England. See John Randle, 'The Development of the Monotype Machine', *Matrix*, 4 (1984), 42–53.
[18] See Ch. 6.2, 'The Shakespeare Head Press'.

period.[19] In 1938 the *Studio* published *The Art of the Book*, the culmination of his ideas on the subject.

The fact that machine printing was beginning to be considered aesthetically acceptable by typographers was reinforced by Newdigate in his writings. None the less, when reviewing the Islington Exhibition of Printing Trades in 1921 he pointed out how backward England was compared with Germany in this respect: 'We have many clever book illustrators in England: their work, however, for the most part is the weaker in its technique and the poorer in its reproduction for the artists' ignorance of printing, on the one side, and from the printers' want of sympathy with art on the other.'[20] He recommended that more British artists should turn to wood-engraving. In 1927 Morison was bemoaning the lack of unity in book production in England and maintaining that, unlike in Germany, there were no schools where all the elements of good book production could be studied, not as independent, but as correlated crafts; no English equivalent to the German *Buchkunstler* existed. Two schools he considered exceptional, however: the Birmingham School of Printing under Leonard Jay and the Leicester School of Art under B. J. Fletcher.[21]

Jay had studied typography and calligraphy under Mason and Johnston and wood-engraving under Bernard Adeney. In 1912 Mason invited him to become his first assistant in the Book Production School at the Central. By 1924 he had become a full-time teacher there, having already begun printing classes at Maidstone in 1922. As Head of the Birmingham School of Printing, to which he was appointed in May 1925, he was able to develop just the sort of courses which Morison thought necessary, combining printing with illustration, wood-engraving (under Sleigh) and lettering, using modern printing technology and bringing his students into contact with Monotype and Linotype.[22] From 1922 to 1953 many fine limited editions were produced which were much more adventurous than those printed at the Central.[23] The marriage of type and illustration was a noteworthy feature of these publications and was brought to perfection in *The Torch*, a three-volume periodical containing a miscellany of students' work, mainly specimen pages decorated with wood-engravings.[24] Although no outstanding wood-engravers emerged from these classes, the beauty of the medium as a method of illustration which could be used in conjunction with modern printing methods was revealed to printers and publishers the world over through their productions and exposed more widely at book exhibitions.

Amongst those exhibitions that made the greatest impact were a Medici Society one of British and foreign printed books (June 1923), and, in particular, an 'Exhibition of

[19] See Ch. 5.4.
[20] *London Mercury*, 4 (1921), 189.
[21] Stanley Morison's book, *Type Designs of the Past and Present*, reviewed by B. H. Newdigate in 'Problems of Modern Book Production', *London Mercury*, 15 (1927), 645–6.
[22] The Linotype machine is operated by means of a keyboard for setting and casting lines or slugs of words, etc. It was first developed in America by Otto Mergenthaler in 1886 and regular manufacture began in 1890. The following year the first Linotypes appeared in England.

[23] For a checklist of books see Leonard William Wallis, *Leonard Jay: Master Printer-Craftsman, 1925–53* (London, 1963). Several publications were illustrated with wood-engravings by Ivy Ellis, pupil and, later, wife of Sleigh with whom she collaborated after *c.*1933 to print items from their home in Edgbaston.
[24] The work of this school acquired international acclaim to the extent that the *American Printer* magazine suggested in 1930 that 'by far the finest collection of printed specimens received at this desk from any trade school has come from the Birmingham School of Printing, England'. Quoted in Wallis, *Leonard Jay*, 25.

Books Illustrating British and Foreign Printing, 1919–1929' held at the British Museum in 1929. Abroad, a stand was included in the Paris 'International Book Exhibition' (1935). The *Sunday Times* sponsored 'An Exhibition of Books and Book Production' at which the Golden Cockerel Press, among others, had a presence.[25] Of private press productions, a few specialist book dealers held shows, most notably J. G. Wilson of John & Edward Bumpus, Ltd., in London's West End, and these acted as a vital link between owners and the general public.[26] Printing exhibitions, too, helped to promulgate both typographical design and the art of wood-engraved illustration: for example, one held by the British Institute of Industrial Art on books and printing in 1921, and another on industrial art at the Victoria and Albert Museum the following year which included illustrated books. The official organ of the First Edition Club, *The Book Collector's Quarterly* (edited by Desmond Flower and A. J. A. Symons and published between 1930 and 1935 by Cassell & Co.), included occasional lists from the Fifty Books of the Year Exhibition in which wood-engraved illustration was represented.

By the late 1920s the enthusiasm for fine printing had spread from a small number of keen typophiles to a much wider audience, and was not only evident in the increasing number of finely printed books.[27] Of the wide range of advertisements and posters displaying good typography and design many were published by the Curwen Press. In 1935 Oliver Simon launched *Signature*, printed at the press. It became one of the most influential typographical journals and remained in the forefront of printing events until it ceased publication in 1940.

In 1924 a 'fraternity of experts in the several crafts of printing'[28] founded the Double Crown Club, a dining club where people interested in the Art of the Book could meet together.[29] The original members included Oliver Simon, Gerard and Francis Meynell, Morison, and artists such as Gibbings, Thomas Lowinsky, and Paul Nash. Balston acted as secretary from 1925 to 1928. Some distinguished addresses were delivered by members, who were responsible also for the diverse decorated menus in a wide variety of media, now collectors' items.[30] In spite of its limited membership the club, which continues to this day, did much to spread the word of fine printing beyond its confines.

Douglas Cleverdon perfectly sums up the exciting atmosphere of this period in British printing history: 'I wish I could convey to younger listeners—and indeed to those not quite so young—a sense of the vitality that marked this typographical renaissance and was reflected in the papers and discussions at dinners of the Double Crown Club'.[31] The cultural and economic climate created by this revival undoubtedly affected the direction of wood-engraving, most particularly in relation to the printed page, both in England and abroad.

[25] A photograph of the stand can be seen in an album of its press-cuttings held at the Archive of Art and Design, Victoria and Albert Museum.

[26] Further exhibition venues are discussed in Ch. 5.3.

[27] In the 1930s the Hand-Printers' Association was formed whose members included Hilary Pepler, Cyril Costick, James Guthrie (Pear Tree Press), and Geoffrey Higgins from Hove.

[28] Meynell, *My Lives*, 241.

[29] For further information see James Moran, *The Double Crown Club: A History of Fifty Years* (London, 1974).

[30] A collection of club menus and other printed ephemera is held in the John Johnston Collection, Bodleian Library, Oxford.

[31] Douglas Cleverdon, 'Stanley Morison and Eric Gill, 1925–1933', *Book Collector*, 32 (1983), 23–40, p. 31.

6.2. *Private Presses*

In 1911 the Medici Society held an exhibition of modern printing which included examples from the Daniel, Kelmscott, Vale, Eragny, Ashendene, Essex House, and Doves Presses.[32] By 1914 all except the Ashendene Press, which was temporarily suspended during the war, had ceased to function. Wartime economic restrictions such as the difficulties of acquiring paper, the cost of production, and the loss of customers were certainly a major factor in their demise. None the less the ideals of these turn of the century private press owners became entrenched in the minds of a new generation of typophiles who were responsible for the inter-war printing revival. Commercial publishers began to take an interest in quality printing, mainly because the new private presses had impressed them with their high standards and ability to capture a market, albeit limited.

Much has been written on the definition of a private press.[33] Dorothy Harrop's view describes its nature most succinctly:

A private press is one where the owner calls the tune without reference to outside let or hindrance. To break even in financial terms, or better still, to make a profit, which private presses have rarely done, may be part of the vision but is not the prime consideration. The owner's satisfaction, pleasure and education come first and are paramount in the creative endeavour. Private press books are seldom items of unparalled technical perfection but often flawed works which are of interest as much for what they reveal concerning the personality of their creator as for their aesthetic attributes. For this reason they must lie forever outside the wider bounds of general printing history.[34]

To deduce from this that because profit was not the overriding consideration, running a press was, therefore, merely a hobby for those with private means, is to simplify the issue. The newly emergent presses were not in the mould of those of the eighteenth century run by aristocratic owners for their own pleasure; nor were they run purely on Arts and Crafts Kelmscottian lines, to produce beautiful typographical masterpieces rather than readable books. The owners of the better known presses, though mainly middle class and well connected with artists, authors, publishers, and even sponsors, were in general socialistically inclined, and were concerned for their own particular products to be more widely accessible. On the other hand some of the smaller presses owned by artists were started up as a means of procuring further buyers for their work. Munificent endowments, such as those bestowed by the Davies sisters on the Gregynog Press or by Count Kessler on his Cranach Press, were rare. Operating between the wars,

<hr>

[32] See Robert Steele (introd.), *The Revival of Printing: A Bibliographical Catalogue of Works issued by the Chief Modern English Presses* (London, 1912), published in conjunction with exhibition.

[33] See in particular Colin Franklin, *The Private Presses* (London, 1969; rev. edn., Aldershot, 1991), and Roderick Cave, *The Private Press*. For a large and comprehensive collection of 20th-cent.

private press books see the William Ridler Collection of Fine Printing held at the Central Library, Birmingham, and accompanying catalogue compiled by Dorothy A. Harrop (Birmingham, 1989).

[34] Dorothy A. Harrop, *A History of the Gregynog Press* (Pinner, 1980), pp. xi–xii.

when their economic situation was exacerbated by the Depression, the majority of presses under discussion were under constant pressure to survive financially.[35]

A major factor which set private press books aside from most trade publications was their experimental nature. Many owners were self-taught or learnt the technicalities of printing and typography from other enthusiasts: Hilary Pepler, for instance, was instructed by a veteran commercial printer employed to help him set up what was to become the St Dominic's Press; Hal and Gay Taylor took lessons at Ditchling before starting the Golden Cockerel Press, whilst Gibbings in turn picked up the rudiments from the staff inherited from Taylor. Leonard and Virginia Woolf, on the other hand, taught themselves from a booklet which came with their Excelsior press, since they found that 'the social engine and machinery made it impossible to teach the art of printing to two middle-aged, middle-class persons'.[36] Apart from at art schools, no formal teaching of letterpress printing to amateurs was available. When the artists William McCance and Blair Hughes-Stanton were appointed to the Gregynog Press they were dispatched to commercial firms for intensive training in printing and typography.

In his essay on *The Hand Press* Pepler complained that the lack of master printers and apprentices in the industry had led to the disintegration of specialist skills: 'Of the thousands who call themselves printers few could produce a circular, let alone a book entirely on their own. They have chosen to admit into their craft a driven herd of operatives united in a desire for gain rather than a company of freemen enjoying the mystery and fellowship of craft.'[37] In contrast, private press owners by necessity combined a number of skills. The ability to have overall control of the book, supervise every detail of the printing, and produce only small editions enabled a higher standard of production than was generally possible with trade editions. Gibbings's belief that 'to be fine [books] must be limited' is, however, debatable.[38] None the less it was generally true so far as the printing of wood-engravings was concerned as this ideally required the use of original blocks rather than electrotypes,[39] individual attention when printing to obtain even inking and pressure, and dampened, good quality paper.

The personal involvement with each book allowed private press owners to experiment with a variety of papers: in Gibbings's day, for instance, the Golden Cockerel Press employed the best handmade or mould-made paper, much of it originally developed

[35] Roderick Cave and Sarah Manson, *The History of the Golden Cockerel Press* (in preparation; the author is grateful for the loan of the typescript), and John Dreyfus, *A History of the Nonesuch Press* (London, 1981), provide interesting analyses of the social and economic conditions of these two presses. The subject deserves a lengthier discussion than is possible within the scope of this book.

[36] Leonard Woolf, *Beginning Again: An Autobiography of the Years 1911 to 1918* (London, 1964), 233. The printing industry was particularly protective towards its members and did not welcome with enthusiasm the expanding amateur market. Learning to print through 'the Trade' traditionally required a seven-year apprenticeship from the age of fourteen; restrictive practices of

the time denied such training to women. See Cave and Manson, *History of the Golden Cockerel Press*.

[37] Hilary D. C. Pepler, *The Hand Press* (Ditchling, 2nd edn, 1952), 37.

[38] Robert Gibbings, 'The Art of the Book: The Golden Cockerel Press', *Studio*, 97 (1929), 98–101, p. 98. He thought that, save in exceptional circumstances, an edition of 500 was the most that could be printed with interest. Printing dry on machine-made paper, a modern machine could produce 4,000 per hour, whereas at the Golden Cockerel Press, he suggested, that number could only be produced in a week.

[39] For a technical description see Ch. 3.3.

by Batchelor for the Kelmscott Press, some specially made with GCP watermark;[40] otherwise Arnold's Unbleached or Van Gelder was mostly used, Sandford producing further variations. For unlimited editions machine-made paper was used on which type and illustrations could be printed dry, thereby easing the problems which the printers had with the often rough, hard-sized papers. Ravilious considered Sandford's introduction of Basingwerk[41] 'a great discovery' for wood-engravings.[42] Handmade paper used by the Gregynog Press for ordinary editions included Grosvenor Chater, Batchelor (some watermarked GG), Barcham Green, Portal's, and Arnold & Forster green-tinted. Japanese vellum, with a smooth, waxy surface, was used for several of the finest books, as it was for some of those of the Golden Cockerel.

Gregynog books were bound in the press bindery, just as, in a much more modest way, St Dominic's Press books were bound on site at Ditchling, many of those in paper wrappers by the granddaughter of the printer, Old Dawes.[43] Where hard covers were required, most of the larger presses sent printed sheets to professional binders: Gibbings, for instance, went to Douglas Cockerell at W. H. Smith & Son's Binding Department, and to Sangorski & Sutcliffe for more elaborate work, while Sandford occasionally used the firm of Zaehnsdorf[44] and had some ordinary editions cased by Leighton and Straker.

Between 1910 and 1922 Caslon was the most commonly used typeface for books in general.[45] Partly in order to harmonize text with image, and to give their productions an identity, proprietary types were introduced by various private presses, most notably the Golden Cockerel and Gregynog, as they were also by several commercial publishers and printers. Few, however, used these alone but resorted instead to Monotype's revivals of traditional typefaces cut in a wider range of sizes or to some of the excellent types becoming available from other founders. Monotype also cut new designs, Eric Gill's Perpetua, the parent of his Golden Cockerel type, being one of the most important from the 1920s.[46] The firm also made available good contemporary designs from continental founders. For the Nonesuch Press *Genesis* Francis Meynell used Rudolph Koch's Neuland typeface (issued by the Klingspor foundry in 1923) for the first time in England.

The close involvement of their illustrators perhaps, most of all, set hand-printed books apart from those that were mass-produced. Such co-operation of artist with book producer allowed an illustrative freedom not usually possible when dealing with commercial publishers, as Sandford's and Rutter's notes on the years 1933 to 1939 of the Golden Cockerel indicate:

We believe, as the partners in a private press, that our personal control of everything that goes to the making of the books, from the layout of the type to the inspiration of our authors and

[40] The printing of fine line engravings on the unsmooth surface of much of this paper required especially skilful presswork.

[41] Basingwerk parchment, a pure rag, soft-sized, wove, engine-finished paper.

[42] See Ch. 12.4 n. 120.

[43] See Ch. 4.2.

[44] For instance for Llewelyn Powys's *The Book of Days* and *The Golden Cockerel Greek Anthology* both published in 1937.

[45] Kenneth Jay (ed.), *Book Typography, 1815–1965, in Europe and the United States of America* (London, 1966), 165. Most St Dominic's Press books were set in Caslon Old Face.

[46] Typefaces which were regularly used in Golden Cockerel Press productions included Caslon (used in a little more than half the publications), Gill's designs (Golden Cockerel, Perpetua, and Gill Sans) and the Monotype revivals Poliphilus and Bembo. See Appendix in Cave and Manson, *History of the Golden Cockerel Press*, and Christopher Sandford, 'A Note on the Golden Cockerel Type', *Matrix*, 2 (1982), 23–5.

illustrators, has given our books a personal quality not to be achieved in those of general publishers, yet at prices which compare favourably with their *éditions de luxe*.[47]

With this last remark the authors make a valid point. Private presses are all too often unjustifiably considered to be élitist, their products rarified and available only to rich subscribers. Certainly this applied to the special editions, bound by hand in vellum or leather, often with tooling or stamped devices, and signed by the author and artist. Eighteen lavishly bound copies of the Gregynog Press *The Revelation of Saint John the Divine* (1933) printed on Japanese vellum, for example, cost twelve guineas each, or six guineas for the ordinary leather-bound editions. The Golden Cockerel Press asked the sum of eighty guineas each for twelve copies of *The Four Gospels* (1931) printed on vellum, full bound in white pigskin, and as much as one hundred guineas each for four boxed copies on vellum of *Paradise Lost* (1937), full bound in white pigskin—just below half the average annual earnings of a skilled manual worker, for example.[48]

From 1914 to 1935 book production costs more than doubled. As Marjorie Plant points out, 'increases in the prices of material were only partially offset by new and improved machinery and were accompanied by wage increases to printers and bookbinders'.[49] Yet, in spite of heavier costs, book prices tended to remain static throughout the period. Advertisements in book trade journals[50] show that from 1926 to 1936 7s. 6d. remained the average cost of a standard unillustrated novel, with cheap reprints costing about 3s. 6d.[51] Of the major private press owners Pepler at St Dominic's aimed to produce books for ordinary people at affordable prices. Considering the quality of materials these were certainly low compared with other presses, although publications were often small and with paper wrappers: *Libellus Lapidum*, for example, was priced at 1s. 6d. in 1924. By 1933 most of the press's smaller illustrated books cost between about 3s. and 7s. 6d., the elaborate *Horae Beatae Virginis Mariae* costing 30s. Under Gibbings's management ordinary quarter-bound illustrated Cockerels (edition size generally about 350 to 500) ranged from 8s. 6d. to three guineas, an approximate average price of about 18s. 6d. The first book in the very successful Guinea Series of illustrated modern authors was introduced in January 1931, printed on handmade paper in an edition of a thousand.[52] The following year, in an attempt to produce 'cheap Cockerels for small purses', Gibbings produced a limited edition of 1,000 unsigned copies of both *Consequences* and *Rummy* printed on machine-made paper; bound in cloth they cost 6s. These books were precursors to

[47] Quoted from *Aphrodite's Cockerel: A Pleasant Myth, Together with Some Notes on the Golden Cockerel Press Private Press Books*, compiled by Christopher Sandford and Owen Rutter (London, 1939), unpaginated.

[48] Examples of average annual earnings among occupational classes in 1935–6 listed by Guy Routh, *Occupation and Pay in Great Britain, 1906–79* (London, 1980), 121, include £308 for male lower professionals (e.g. qualified teachers), £192 for clerks, £195 for skilled male manual workers (e.g. bakers, bricklayers, railway engine drivers and guards, and compositors), and £129 for male unskilled workers (e.g. building workers, platform porters, brewery labourers). The overall average for male and female earnings combined was £162.

[49] Marjorie Plant, *The English Book Trade: An Economic History of the Making and Sale of Books* (London, 3rd edn., 1974), 405.

[50] *The Book Seller*, 1926, and *The Publisher's Circular*, 1936, were consulted among other journals.

[51] David Garnett in 'The Nonesuch Century', *Penrose Annual*, 39 (1937), 45–9, p. 45, confirmed that the standard cost of a novel after the First World War was 7s. 6d. This was most probably the price for an unillustrated edition. As an indication of trade prices for illustrated books in the 1930s, four of Raverat's books published commercially between 1932 and 1939 ranged from 6s. to 8s. 6d.

[52] *The Hundredth Story of A. E. Coppard*.

Sandford's unlimited editions, most priced between 7s. 6d. or 8s. 6d. and two or three guineas.[53] Machine printing enabled Sandford to maintain low prices. One of the main factors which sustained the press when others had fallen out was his policy of 'co-operating with the buying public—of producing books which they could afford to buy. . . . [I] have resisted the temptation to spend so much on the production of my books that they are inaccessible'.[54] Not all Nonesuch books were limited and the wide range of size and design accounted for the variety of pricing. Paul Nash's *Genesis*, limited to 375 copies and oversubscribed on publication, sold for £1. 5s. in 1924, while two volumes of Gilbert White's writings fetched £3. 10s. in 1938. Before 1940 standard copies of Gregynog books cost between £1. 5s. and two guineas.

Well-produced, hand-printed limited editions, these books appealed more to collectors than to the average reading public, yet they were not all exorbitantly expensive. They represented good value for money as well as being an investment, attracting a new group of potential buyers.[55] As collectors' items they were an entirely different type of commodity from the majority of mass-produced publications. Yet Sandford's and Rutter's need to justify their motives for producing such books shows the social constraints felt by some press owners:

In the minds of some—who *have* to confuse art with politics—expensive hand-work and the fostering of craftsmanship are taboo. For them it has become a sin to charge a guinea for a book, when the products of mass-production can be bought for sixpence. There is no longer any need, they say, for anyone to set a standard for printers when proletarian printing is now quite good enough.[56]

Apart from fine printing, the *raison d'être* of many private presses was to publish literature not commonly available. Some presses acted as outlets for their owner's writing and illustrating skills: Ralph Chubb's and John Biggs's presses, for instance, among the smaller ones. Several had specialist areas. Initially the primary objective of the Gregynog Press Board was to promulgate Welsh literature, at the same time making it accessible to the English-speaking public. Pepler started up St Dominic's Press partly as a means of proselytizing his political and philosophical ideas; the wide variety of religious material was perhaps the most distinctive product of the press, much of it targeted specifically at Catholic organizations and individuals. Both the Beaumont and Hogarth Presses aimed to publish work of contemporary authors. Unlike his predecessors at the Golden Cockerel, however, Gibbings did not set out specifically to promote new writers. He preferred rather to reprint established classics, and some minor works, although he retained A. E. Coppard as an author and introduced E. Powys Mathers, both known for their erotically inclined writing—a proclivity encouraged by

[53] A few smaller publications, including *Brief Candles*, were issued at only 3s. 6d.

[54] Christopher Sandford, 'Printing for Love', in *Cockalorum, being a Bibliography of the Golden Cockerel Press* (London, 1943), 85–99.

[55] For a fuller discussion on the economics of private presses see Cave and Manson, *The History of the Golden Cockerel Press*.

[56] *Aphrodite's Cockerel*.

both Gibbings and Sandford and one for which the press gained a reputation.[57] In this prudish climate of censorship, the limited circulation of private press books offered by subscription allowed opportunities for *risqué* publications which mainstream publishers could not afford to take.[58] Sexually explicit illustration, when embarked upon by Gill at Ditchling, caused shock waves. By the 1930s such improper work, some of a homosexual nature, was deemed perfectly acceptable by certain private press owners, its popularity encouraged by the vogue for D. H. Lawrence's writing.[59]

Further new literary talent fostered by Sandford and Rutter included H. E. Bates, T. E. Lawrence, L. A. G. Strong, Patrick Miller, Walter de la Mare, T. F. Powys, Christopher Whitfield, and Theodore Besterman. A new and interesting feature of their ownership was the series of logs, diaries, and personal documents of historical and geographical importance and human interest.

The intimate nature of poetry and the relatively small amount of type required to set it up made it a particularly suitable form of literature for books printed by hand, particularly those emanating from the smaller presses such as the St Dominic's Press. The individuality and collectible nature of the various press productions added to their appeal, guaranteeing a market, if a somewhat limited one. Yet most of these small-scale businesses could not have survived on their publications alone: the production of books for outside publishers, and other jobbing work such as bookplates, cards, and stationery helped to keep them afloat.[60]

Prospectuses and catalogues played an important role in promoting their publications. Often hand-printed, these were tangible evidence of the quality of the finished product and, as such, they became collectors' items. Exhibitions also brought the presses, especially some of the smaller ones, to the attention of a wider public.[61] The St Dominic's, Gregynog, and Golden Cockerel Presses, in particular, held occasional exhibitions, the London bookshop of John & Edward Bumpus hosting several. Among other venues the Golden Cockerel used St George's Gallery (1927), the Whitworth Art Gallery, Manchester (1928 and 1935), Sanders, Oxford (1930), and Foyle's bookshop in Charing Cross Road (1934). Not all privately printed books were sold by subscription. Once again Bumpus played a significant role in the sales of many of them. Gregynog books were offered to the retail trade at 25 per cent discount on orders of fewer than twenty copies.[62] Most Cockerels were sold through the retail book trade, some bookshops habitually ordering a few for stock. As Cave suggests, direct sales to the Continent and through the Empire were of less significance than those to America.[63]

[57] In Cave and Manson, *The History of the Golden Cockerel Press*, the authors discuss the attitude of the two men towards erotic literature and illustration and reveal the strength of interest in the whole field at that time. Sandford's fixation with the subject is confirmed in a series of letters to John Buckland Wright published in *Matrix*. See Ch. 13.6 n. 119.

[58] For the historical context see Cave's chapter 'Clandestine Presses II' in *The Private Press*, 78–84. A wry catalogue note of 1929 by Francis Meynell, 80–1, indicates the extent of literary censorship exercised by Sir Archibald Bodkin, Sir William Joynson-Hicks, and a Detective Inspector of Scotland Yard.

American censorship laws were yet more stringent. In 1936 *The Golden Bed of Kydno* with copper engravings by Lettice Sandford was seized by the New York Customs.

[59] See also Ch. 13.1.

[60] See Ch. 5.4. Hand lists of ephemera are included in *Saint Dominics's Press Bibliography* and Harrop, *A History of the Gregynog Press*.

[61] Ch. 5.3.

[62] Harrop, see *A History of the Gregynog Press*, 42.

[63] Cave and Manson, *The History of the Golden Cockerel Press*.

Both Meynell and Gibbings signed agreements with Bennett Cerf of Random Press for American distribution rights. St Dominic's Press produced flyers for the American market with dollar prices.

A number of bibliographic studies produced from the mid-1920s encouraged collectors both at home and abroad, in particular G. S. Tomkinson's *A Select Bibliography of the Principal Modern Presses, Public and Private, in Great Britain and Ireland*, with an introduction by Newdigate, published by the First Editions Club in 1928, and Will Ransom's *Private Presses and their Books*, published in New York the following year.[64]

The Depression badly hit all areas of publishing and printing. Gibbings paints a particularly gloomy picture of the way it affected the Golden Cockerel.[65] Reviewing the International Book Exhibition held in Paris in 1931 Newdigate expressed disappointment at the half-hearted British attempts at promotion: 'It is a great pity, since in one sphere of art at least, the production of books and printing, England is supreme, but through her apathy her art is often despised by ignorant people, and their admiration is wasted on something second-rate.'[66] Yet, despite his pessimism many presses flourished in the 1930s. The superior results which they so often attained had a marked influence on modern typography and book production and set standards for trade publishing and printing. As Rutter indicated in 1938: 'What the private press does today the commercial printer will try to do tomorrow—the function of the private press is to experiment and create.'[67]

The private presses' support for wood-engraved illustration, far from driving a wedge between the prestige and the popular book artist, as some critics have suggested,[68] 'bridged the gap between the commercial printer and "commercial" applications of engraving, and the "fine print" approach to engraving. The two extremes which were so apparent in the last century were brought together in a highly successful and productive marriage.'[69]

The private press movement was distinctly British, inspiring imitations and revivals of printing abroad and providing the perfect breeding ground for the essentially British art of wood-engraving. From its confines new artists and writers emerged offering a distinctive contribution to the artistic and literary scene. The advent of the Second World War, however, once again signalled the demise of most privately owned presses. With the introduction of new technology, and through a lack of expertise in letterpress printing, after the war their course was altered, and with it that of wood-engraved illustration.

Since the history of the most important private presses of the period has been well

[64] Influential articles include Charles Jacobi, 'The Work of the Private Presses: 7. The Golden Cockerel Press', *Penrose's Annual*, 30 (1928), 17–20, and Anna Simons, 'Moderne englische Pressen', *Imprimatur*, 2 (1931), 135–84, as well as several *Studio* articles and special numbers on modern English books. See also Ch. 5.3.
[65] See Ch. 11.1. The high costs incurred with fine printing can be seen from Blair Hughes-Stanton's list of expenditure for the production of *Epithalamion* at his Gemini Press in June 1934 quoted by Penelope Hughes-Stanton, *The Wood-Engravings of Blair Hughes-Stanton* (Pinner, 1991), 38.

[66] *London Mercury*, 25 (1931), 2.
[67] Owen Rutter, 'Phoenix and Cockerel', *Phoenix*, 12 (1938), p. no. unrelocatable.
[68] See, for example, David Bland, *A History of Book Illustration* (London, 1969), 371.
[69] Kenneth Lindley, *The Woodblock Engravers* (Newton Abbot, 1970), 112–13.

documented in individual monographs, the following account is necessarily brief. The illustrations themselves will be discussed in subsequent chapters under individual artists.

The Golden Cockerel Press

In the spring of 1928 an exhibition of engravings on wood and copper from books printed and published by the Golden Cockerel Press was held at the Whitworth Art Gallery, Manchester. In his Preface to the catalogue Campbell Dodgson wrote that the press 'has surpassed its predecessors among the recent English presses directed by artists or printers animated by high motives for the reform of that craft, in the zeal that it has shown for the art of original wood-engraving'.[70]

Since Harold and Gay Taylor had set up the press at Waltham St Lawrence in 1920 with enthusiasm but little expertise, most of the seventeen books issued under their direction lacked a distinctive style and were without illustration.[71] Gibbings bought the press from Taylor, whose health was failing, in January 1924, with financial support from an old friend from Ireland, Hubert Pike.[72] For £200 he also acquired the completed sheets and work in progress of Brantôme's *The Lives of Gallant Ladies*, the illustrations for which he was working on at the time of the sale, plus a stock of paper.

His reason for buying the press was the opportunity it afforded to produce illustrated books. In the 1925 prospectus Gibbings announced that 'the members of the Golden Cockerel Press would like to point out that they are a group of artists and craftsmen more interested in the aesthetic than the commercial aspects of book production'. By his own account 'almost completely ignorant of typography',[73] he wisely retained the existing staff: the two compositors, Frank Young and Harry Gibbs, who initially hand set in Caslon Old Face, and the pressman, Albert Cooper, who carried on the dampened handmade paper tradition, printing an occasional edition on dry antique paper.[74] Since Taylor's flat-bed cylinder Wharfedale press was not particularly suitable for printing wood-engravings on dampened paper Gibbings replaced it with a power-driven Phoenix platen press which, together with a Victoria platen press inherited from Taylor, was capable of producing superb impressions.[75] According to Cooper, Gibbings worked 'hand in glove' with his staff. He involved himself at every stage, marking up copy, designing layouts, reading proofs, scrutinizing typesetting, and checking formes and make-ready.[76]

Initially Gibbings's early books were experiments in balancing illustration with type

[70] Campbell Dodgson, Preface to *A Catalogue of an Exhibition of Engravings on Wood and Copper from Books Printed and Published by the Golden Cockerel Press* (Manchester: Whitworth Art Gallery, Spring 1928).

[71] For a fuller account of the press see Cave and Manson, *The History of the Golden Cockerel Press*.

[72] He paid £850 for the press and £40 for rent of the house and 11 acres of land.

[73] Robert Gibbings, 'The Golden Cockerel Press', *Colophon*, 7 (1931), unpaginated.

[74] Printing methods are well described by Cooper in 'Remi-niscences of Albert Cooper, Pressman at the Golden Cockerel Press', recorded by Sue Walker and Martin Andrews, *Matrix*, 9 (1989), 11–17, and A. C. Cooper, 'Notes on the Printing Methods of the Golden Cockerel Press', with an introduction by Patience Empson, ibid. 18–22.

[75] A Columbian press (with *c.*21" × 16" platen), on which the compositors pulled their proofs for authors' corrections, was used by Gibbings for proofing his wood-engravings.

[76] His wife Moira dealt with much of the editorial and admin-istrative work, writing and typing many of the letters. From 1927–30 they were assisted by a secretary, Lucy Cook.

using a variety of papers; as such they were not always successful, but his instinctive feel for typography, combined with an inherent understanding of wood-engraving, resulted in a number of fine illustrated books, many containing his designs.[77] The decorative papers and wood-engraved repeat patterns used for bindings was a distinctive feature of some editions. A series of prospectuses delightfully encapsulates the flavour of the press during his ownership.[78]

Plate 49

Gill's illustrations to his sister Enid Clay's *Sonnets and Verses* (1925) mark the beginning of a vital collaboration between artist and publisher which produced the press's distinguished masterpieces: *Troilus and Criseyde* (1927), *The Canterbury Tales* (1929–31), and, best known of all, *The Four Gospels* (1931), for which Gill designed the new Golden Cockerel type to combine with his wood-engraved blocks. He illustrated and helped to design a total of fifteen books for the press.

Plates 106, 107
Plate 112

Between 1924 and 1933 Gibbings published fifty books with wood-engraved illustrations: eighteen with his own designs and the rest mostly by John and Paul Nash, Gill, Farleigh, Annesley, Rooke, Jones, Ravilious, Lynton Lamb, Agnes Miller Parker, and Celia M. Fiennes.[79] Generally he discussed the design of the book and the number and placing of illustrations with artists who would then work with page proofs on which appropriate spaces had been left by the compositors—the ideal way to produce engravings which harmonized with type, although somewhat limiting for the illustrators.

Although Gibbings initially succeeded in making the press financially sound, he was badly hit by the Depression which particularly affected the book trade.[80] In August 1933 the press was sold to Christopher Sandford,[81] Francis Newbery,[82] and Owen Rutter and transferred to 10 Staple Inn in London where it began a further exciting and influential period until its sale yet again in 1959 to a New York publisher Thomas Yoseloff.[83] Sandford, who had learnt the basic elements of printing while working for the Chiswick Press, subsequently started up on his own in 1930 with the Boar's Head Press. He produced a number of books, several of which were illustrated with wood-engravings by his wife Lettice. In 1932, in partnership with Francis Newbery, he began the Golden Hours Press, mainly to produce the works of Marlowe, two volumes of which were very successfully illustrated by Ravilious and Hughes-Stanton.[84] Undeterred by those he considered die-hard Arts and Crafts purists, he did not hesitate to use mechanical composition for a large proportion of the books he published. For reasons of economy

[77] See Ch. 11.1. For Gill's illustrative work see Ch. 11.2.

[78] See Paul Johnston, 'The Golden Cockerel Prospectuses', *Book Collector's Packet*, 1 (1932), 13–14.

[79] See exhibition catalogues, *The Illustrators of the Golden Cockerel Press*, with foreword by Christopher Sandford (Oxford: Studio One Gallery, 9–21 Oct. 1978), and *The Illustrators of the Golden Cockerel Press* (Hereford: The Mayor's Parlour, 19 Apr.–10 May 1980).

[80] For his reactions see Joanna Selborne (ed.), 'Eric Ravilious and the Golden Cockerel Press: Correspondence with Robert Gibbings. Part 1: Selected Letters, 1926–29', *Matrix*, 14 (1994), 15–39, and 'Eric and Tirzah Ravilious and the Golden Cockerel Press: Correspondence with Robert and Moira Gibbings. Part 2: Selected Letters, Dec. 1929–Feb. 1933', *Matrix*, 16 (1996), 67–87. A biography of Gibbings by Martin Andrews is in preparation.

[81] Sandford offered to take over the Gregynog and Nonesuch Presses. In the first instance his offer was rejected and in the second it lapsed.

[82] General Manager of the Chiswick Press, of which F. J. Romanes was Managing Director and Sandford a Director. For a group photograph see Jeremy Sandford, 'In Memory of My Dad', *Matrix*, 2 (1982), 1–4, p. 3.

[83] In Aug. 1936 Christopher's brother Anthony joined the press as a partner in place of Newbery.

[84] See David Chambers, 'Boar's Head & Golden Hours', *Private Library*, 8 (1985), 2–33, including checklist, and 'Sandford, Gibbings, Newbery and Rutter', ibid., 34–40.

the bulk of the printing of both these presses was done by the Chiswick Press, a precedent which Sandford continued with the Golden Cockerel Press making it, in effect, simply an imprint rather than a private press in the proper sense. For unlimited editions he went over from handmade papers to pure soft-size, wove, engine-finished paper on which type and illustrations could be printed dry. He found that the wide range of Monotype faces gave him the variety of typographic effect he desired. To cut costs artists sometimes had to be commissioned *before* any type was set, allowing them little scope for imaginative page design and making rectangular illustrations virtually essential. None the less the high standard of wood-engraved book illustration achieved from these methods served as a model for commercial publishers and printers.

Like Gibbings, Sandford recognized and appreciated the potential of wood-engraving for illustration and the importance of collaboration with the artist. Text was chosen as a vehicle to demonstate the medium. He was concerned 'that the artist really should be given equal value with the author and printer'.[85] He was also determined to publish 'really good' literature, often new material, and, as already indicated, to produce books that people could afford to buy. With these aims he would go each year to the Society of Wood Engravers' exhibitions and 'then search out literary material calculated to inspire the artists of my choice'.[86]

In an Address entitled 'Printing for Love' given in 1947 Sandford states: 'It is an undying satisfaction to the Golden Cockerel to encourage and advise talented engravers, and, by displaying their work to the best advantage, to build up for them the reputations they deserve. . . . It is impossible for me to be sufficiently grateful for the privilege of being able in my small way to nurture this flowering and progressive art.'[87] He mentions in particular Gill, Gibbings, Ravilious, Jones, Hughes-Stanton, Miller Parker, John Nash, Webb, Buckland Wright, Reynolds Stone, Gwenda Morgan, Peter Barker-Mill, John O'Connor, and Dorothea Braby. Other artists he fostered included Hermes, Mary Groom, Helen Binyon, Geoffrey Wales, and Averil Mackenzie Grieve—a remarkably comprehensive list. For this reason the Golden Cockerel Press has earned a reputation as the breeding ground of many of the best wood-engravers of the period, remaining in production during the economic depression when most other presses had closed.

The Gregynog Press

The second of the triumvirate of great private presses to start up in the 1920s was the Gregynog Press, distinguished for its consistently fine standard of book production and design, and noted particularly for its decorative initials, wood-engraved illustration, and bindings.[88]

Unusually for a private press the appearance of its books owes very little directly to

[85] 'From County Cork to Chiswick and Cockerel: Reminiscences of Christopher Sandford', ed. with an introduction by Roderick Cave, *Matrix*, 6 (1986), 6–27, p. 21.
[86] Sandford, Foreword to *The Illustrators of the Golden Cockerel Press*, unpaginated.

[87] 'Printing for Love', 99.
[88] For a description of books and ephemera and checklist see Harrop, *A History of the Gregynog Press*.

Pl. 49. Eric Ravilious: Golden Cockerel Press Prospectus, 1932. 251 × 190

the owners of the press. The founders were two wealthy sisters, Gwendoline (Gwen) and Margaret (Daisy) Davies, whose original intention was to set up at their large country house of Gregynog near Newtown, Montgomeryshire, a Welsh cultural centre to encourage and teach arts and crafts including printing, binding, illustrations, and illumination. They asked Hugh Blaker, a talented artist, critic, and dealer, to recommend a printer who could run the centre. However, he thought an artist would be more suitable and suggested a painter, Robert Maynard, who was appointed in January 1921 and sent to London to study printing under Mason, and various other crafts.[89] Eventually, only a press, artists' studio, and bindery were established with the sisters providing the financial backing and leaning heavily on advisers, most importantly Dr Thomas Jones, then Assistant Secretary to the Cabinet, and Stanley Morison.

The first few publications to emanate from the press were printed on a folio Albion press using Kennerley type. But, like Gibbings, without purist ideals about traditional presses, Maynard soon installed a heavy power-driven Victoria platen press on which most of the books were subsequently printed. Having failed to persuade Edward Johnston to design a proprietary typeface[90] in 1924, a Monotype caster was purchased the following year to make new founts of type from the range of revived faces produced by the firm. Rather than use the typesetting machine, Maynard preferred to set by hand, probably to avoid white 'rivers' between words which could arise from machine setting. No expense was spared at the Gregynog Press and several projects were scrapped if not approved by the Davies sisters. The first book to be printed was *Poems by George Herbert*

Plate 50 (1923) with a small white-line wood-engraving and initial letters by Maynard—minimal ornament compared with subsequent books. Of forty-two books published between 1923 and 1940, almost all were illustrated or displayed decorative initial letters. Not only books, but a mass of ephemera including Christmas cards and concert programmes was also produced.

Horace Walter Bray joined Maynard in 1924 as resident artist.[91] He learnt wood-engraving from Maynard who had been largely self-taught. Together they formed a design partnership illustrating most of the books themselves with wood-engravings and initials, the latter often hand coloured. Their styles and technique were almost indistinguishable and, considering their lack of expertise in the early days, surprisingly competent, as can be seen from their joint contributions to *Chosen Essays by Edward Thomas* (1926). Charm rather than originality characterized their designs: Bray's illustrations to Charles Lamb's *Elia*, for instance, were based fairly accurately on old prints.

Plate 51 The two men frequently used black line, as did Bray for *The Misfortunes of Elphin* (1928). Answerable to the press board, both artists possibly felt constrained by not being free agents and by the nature of their commissions, although it is also likely that they lacked the artistic imagination and skill required to produce highly inventive designs.

As for commissioning other illustrators, it was probably not in their brief to look

[89] He was a member of Spencer Gore's and Harold Gilman's group and had worked under Walter Sickert at the Westminster School of Art.

[90] Gregynog type was eventually cut by Monotype in 1934.
[91] Another member of Gore's and Gilman's group.

Pl. 50 (*left*). Robert Maynard: *The Poems of George Herbert* (Gregynog Press, 1923). 71 × 102

Pl. 51 (*below, left*). Horace Bray: Thomas Love Peacock, *The Misfortunes of Elphin* (Gregynog Press, 1928). 242 × 155

Pl. 52 (*below, right*). Reynolds Stone: Don Antonio de Guevara, *The Praise and Happinesse of the Countrie-life* (Gregynog Press, 1938). 179 × 117

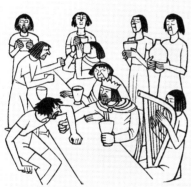

CHAPTER XIV

THE RIGHT OF MIGHT

The three triumphs of the bards of the isle of Britain : the triumph of learning over ignorance ; the triumph of reason over error ; and the triumph of peace over violence.—TRIADS OF BARDISM.

"FRIEND SEITHENYN," said the abbot, when, having passed the castle gates, and solicited an audience, he was proceeding to the presence of Melwas, "this task, to which I have accinged myself, is arduous, and in some degree awful; being, in truth, no less than to persuade a king to surrender a possession, which he has inclination to keep for ever, and power to keep, at any rate, for an indefinite time."

"Not so very indefinite," said Seithenyn; "for with the first song of the cuckoo (whom I mention on this

95

THE SECOND CHAPTER

The husband-man never wants good corne, and, which in great towns and courts is very rare, he is alwaies furnished with wel-rellishing bread and well baked; for in populous cities their corne is either mouldie or not wel-grinded, or their water with which they knead it is brackish and unwholesome, which oftentimes is the cause of divers diseases & mortalitie amongst the inhabitants. But that which is most worthy our observation

10

beyond Gregynog for artists. In a letter to Jones in June 1927 Maynard confesses: 'It is exceedingly difficult for Bray and myself, or perhaps even impossible for us, to undertake successfully the decoration of every type of book; the occasional employment of artists outside would, I think, sweeten the Gregynog cake.'[92] David Jones was the only outside artist to be commissioned under their regime, with a wood-engraved title-page and frontispiece for *Llyfr y Pregeth-wr* (1927), before they resigned in 1930 owing to artistic isolation and dissatisfaction with management. In their time at Gregynog they instilled high standards of typography, binding, and decoration, particularly initials, which were pursued by their successors.

Several artists were considered as replacements including Stephen Gooden, Donald Attwater (Gill's secretary and biographer), Bliss, and Hughes-Stanton. Joseph Thorp, who was consulted, recommended Bliss in partnership with Edward Bawden. Gwen Davies, a Calvinistic Methodist, was wary of Hughes-Stanton, having recently seen his illustration for Susannah and the Elders from the Cresset Press edition of *The Apocrypha* (1929). 'Oh dear!' she wrote to Thomas Jones. 'Do you think we can ever woo him from these delectable ladies? They will never do for Gregynog! That will have to be made perfectly clear.'[93]

Hughes-Stanton was given the job of resident artist and William McCance, a Scottish painter, sculptor, and one-time art critic of the *Spectator*, appointed controller,[94] although neither was typographically trained. Both artists were married to gifted wood-engravers, Hughes-Stanton to Gertrude Hermes and McCance to Agnes Miller Parker, who were also engaged professionally to work for the press for an annual retainer of £100 as an advance against work done.[95] Their period of office marks the highpoint of Gregynog Press illustration. Most noteworthy examples are Miller Parker's intricate designs for *Plates 207–8* *The Fables of Esope* (1931), 'the most conspicuously decorative volume of that kind',[96] and *Plate 182* Hughes-Stanton's technically astounding images, culminating in those for *The Revelation Plate 183 of Saint John the Divine* (1933) and *The Lamentations of Jeremiah* (1934). The printing of these finely engraved blocks, an exceptionally difficult task, was only possible due to the incomparable skill of the pressman, Herbert Hodgson.

The break-up of Gertrude Hermes's marriage regretfully prevented her from completing her illustrations to Gilbert White's *The Natural History of Selborne* with the result that she produced no illustrations for the press.[97] Agnes Miller Parker, on the other hand, was more fortunate in her commissions, producing some of the most magnificent illustrations to issue from the press, in particular, *The Fables of Esope*, even though her relations with the management were often strained.[98]

[92] Maynard to Jones, 14 June 1927. Thomas Jones Papers, National Library of Wales, Aberystwyth, henceforth TJP.

[93] Gwen Davies to Jones, 3 May 1930. TJP.

[94] See exhibition catalogue, *William McCance, 1894–1970*, compiled by Patrick Elliott (Edinburgh: National Galleries of Scotland, 1990).

[95] James Hamilton, *Wood Engraving & the Woodcut in Britain, c.1890–1990* (London, 1994), 213–14, reprints the terms of Hermes's contract with the press, 30 Nov. 1930. The women's work was to be paid *pro rata*, the agreed fees for blocks ranging from £2 (1" × 2") to £15 (9" × 6").

[96] Franklin, *The Private Presses*, 129.

[97] These were later published by the press as *Wood Engravings by Gertrude Hermes: Being Illustrations to Selborne, with Extracts from Gilbert White*, with introduction by William Condry and postscript by James Hamilton (Newton, Powys, 1988).

[98] See Ch. 14.2.

As a result of his unconventional domestic affairs, Hughes-Stanton's contract was terminated in September 1932. Yet both he and McCance managed to continue working until the following year. Jones felt that the time had come to appoint 'a first class typographer instead of an artist and a wood-engraver. . . . I think it will be better to call in an artist to co-operate in illustrating a particular book, designed by the printer as to general make-up. But a first rate book-builder is harder to find than an engraver.'[99]

Loyd Haberley, a young American Rhodes Scholar who had settled in England and started his Seven Acres Press was appointed part-time controller, but he published no books with any noteworthy wood-engraved illustrations. In April 1934 Christopher Sandford wrote a letter on behalf of the Cockerel partners asking Gwen Davies if she would be willing to sell the press, to which he would no doubt have received a firm rebuff. James Wardrop's appointment as part-time controller in June 1936 gave the press a final opportunity. A distinguished authority on calligraphy on the staff of the Victoria and Albert Museum, he was responsible for five books; two of them with wood-engraved illustration were particularly attractive and in complete contrast of scale: *The History of Saint Louis* (1937), a large and sumptuous volume with initials by Alfred Fairbank and cut by Beedham, maps by Bertholde Wolpe, and armorial engravings by Reynolds Stone, who also engraved the Bewick-style vignettes for *The Praise and Happinesse of the Countrie-life* (1938).

Plate 52

War put an end to the printing activities of the press. Notwithstanding the many changes of controller, the quality of bookwork was retained throughout a wide range of designs attained partly through the use of different Monotype faces.[100] Yet, given the possibilities, the choice of illustrators was unadventurous. Only under the Hughes-Stanton/McCance regime did original wood-engraving flourish. In a sense the books produced during this period became showpieces for the exquisite work of Hughes-Stanton and Miller Parker, furthering their reputations as much as that of the Gregynog Press.

The Nonesuch Press

In contrast to the insularity of the Gregynog Press, the Nonesuch Press was notable for its bold and outward-looking attitude to publishing, while at the same time retaining a distinct style of its own.[101] Francis Meynell, the founder,[102] made a virtue of variety. Meynell had previously run his own Romney Street Press (1915–17) and Pelican Press (from 1916) to carry out good everyday printing of posters, manifestos, catalogues, and books using printers' flowers or fleurons and copies of early woodcut tailpieces and borders for decorations. Earlier, he had worked with Stanley Morison for the Roman Catholic publishers Burns & Oates where they had stimulated each other's interest in sixteenth-century types and ornaments, French Renaissance printing, and seventeenth-

[99] Thomas Jones to Dr Abraham Fletcher, 27 Aug. 1933. TJP.
[100] Typefaces used included Garamond, Poliphilus, Baskerville, Caslon, Bembo, Perpetua, Cloister, and Bell.

[101] Dreyfus, *A History of the Nonesuch Press*, 171–276, includes a catalogue of books and prospectuses.
[102] See Ch. 6.1.

century Fell types. Against this background Meynell founded the Nonesuch Press in 1923 'to choose and make books according to a triple ideal: significance of subject, beauty of format and moderation of price'.[103] Considering himself an 'architect rather than a builder of books', he was not afraid to use various commercial printers in order to exploit their particular skills and the variety of typographical material available.

Opinions differ as to whether the Nonesuch Press constitutes a private press.[104] The fact that Meynell personally oversaw every book and supervised the printing of experimental pages on the press's own printing plant, which on various occasions printed whole books, is generally considered to classify it as a private press.[105]

According to David Garnett, who worked with Meynell and Vera Mendel (later Meynell's wife) at the outset, Francis had 'a passionate love of novelty, of new technical discoveries and new materials, and was always eager to employ any new process and use it in harmony with tradition. Many of the Nonesuch successes have been due to Meynell's desire to try new methods.'[106] One example of this is his use of *pochoir*, the French stencil process, mastered so admirably by McKnight Kauffer and Paul Nash. He took a natural interest in wood-engravings, but his catholicity of taste meant that only

Plate 127 a few books were illustrated in this medium, the most significant being Nash's *Genesis*
Plates 143–5 (1924) and *The Writings of Gilbert White of Selborne* (1938) with illustrations by Ravilious. Although Meynell preferred to use a variety of processes, he employed only a small number of artists as illustrators. Other wood-engravers included Hughes-Stanton, Stone, and foreigners Karl Michel and Stefan Mrozewski.[107]

In 1936 the press was taken over by George Macy of the Limited Editions Club of New York. Meynell remained as designer and the company continued to trade under the same name. During his ownership Nonesuch played a significant part in bridging the gap between the private presses and the commercial publishers. Its influence on modern publishing was far-reaching, inspiring a wider interest in typography, illustration, and decoration. Wood-engraving was not strongly represented in Nonesuch books but the generally high standard of design must have encouraged practitioners to think in terms of illustration.

The Shakespeare Head Press

Like Meynell, Bernard Newdigate also played a key role in demythologizing the private press movement whilst adviser to the Shakespeare Head Press.[108] Founded by A. H. Bullen in 1904 for the purpose of printing the complete works of Shakespeare in Stratford-upon-Avon, the press was acquired in 1920 by a syndicate which included Basil

[103] Garnett, 'The Nonesuch Century', 47.
[104] Franklin, *The Private Presses*, 11, for instance, makes only passing reference to the press, regarding it as an extension and practical application to commercial publishing of ideas developed from private press work.
[105] The Nonesuch owned an Albion press, although the first twelve books were all produced by trade printing houses.

[106] Garnett, 'The Nonesuch Century', 47.
[107] Mrozewski also worked with the Gregynog Press. He produced a frontispiece to Helen Waddell's poem New York (1935) and blocks for *Parsifal* (1936) not printed till 1990.
[108] See also Ch. 6.1.

Blackwell, Newdigate, and H. F. B. Brett-Smith, and the printing works transferred to Oxford in 1930. Its main function was to print fine limited editions under its own imprint, of which the works of Chaucer, Froissart, Spenser, and Malory were especially outstanding, and also for other publishers, most effectively for the Cresset Press (*Pilgrim's Progress* and *Paradise Lost and Paradise Regained*), the First Edition Club (*Battle Sketches*), and the Limited Editions Club (*Confessions of an English Opium-Eater*).[109]

Newdigate's interest lay more in type than in illustration, his forte as a designer apparent in his judicious use of Caslon Old Face, close-set, well-leaded pages, and uncluttered layout. For two of the most attractive illustrated editions, both embellished with wood-engravings by John Farleigh, suitably archaic typefaces were chosen: Scholderer's New Hellenic and Poliphilus were used on facing pages for the Greek and English text of *Pindar's Odes of Victory* (1928 and 1930), and Centaur for *The Whole Works of Homer* (1930–1).
Plate 81

The one-volume Shakespeare of 1934 with frontispiece portrait by Farleigh, printed to Newdigate's specification by Billing and Son in an edition of 50,000 copies and priced at 6s., was an outstanding success. It was perhaps the many unlimited editions which emanated from the press, published both by Blackwell's and other publishers, which brought the press to the attention of the commercial sector.

Smaller Private Presses

The 1914–18 war created a typographic hiatus with most of the new generation of small private presses not emerging until the 1920s.[110] One or two were active during the war; the St Dominic's Press, in particular, continued to print books, posters, pamphlets, and other ephemera. After Gill's departure in 1924 Pepler continued to employ the Catholic artists of the community, particularly Jones, Chute, Hagreen, Mary Dudley Short, and Harold Purney.[111] Morison felt that the finest production of the press was in the field of liturgical printing, particularly the *Horae Beatae Mariae Virginis* (1923), primarily intended for the use of Dominican novices, with wood-engravings by Gill and Chute, and *Cantica Natalia* (1926), a magnificent folio volume, the largest of the press's books, illustrated by Jones, Chute, and Hagreen, with plainsong notation printed between red staves. Hagreen's elaborate woodcut borders to *A Catechism* (1931) made for an uncharac-
teristically decorative St Dominic's book, for which, in order to match their weight, Pepler was prepared to break his self-imposed Caslon rule in favour of Goudy Bould type.
Plate 116

The economic conditions of the 1930s eventually forced him to come to terms with

[109] For a selected list of books and bibliography see exhibition catalogue, *Shakespeare Head Press: An Exhibition of the Books of A. H. Bullen and Bernard Newdigate*, with introduction by Ian Rogerson (Manchester: Manchester Polytechnic [now Manchester Metropolitan University] Library, 1988).
[110] For further information see William Ridler, 'The Smaller Pre-War Presses', *Antiquarian Book Monthly Review*, 6 (1979), Part 1, 458–65 and Part 2, 526–33.

[111] For the early work of the press see Ch. 4.2. See also Joanna Selborne, 'The St Dominic's Press in the History of the British Private Press and Wood Engraving Movements between the Wars', in exhibition catalogue, *The Illustrators to the St Dominic's Press* (London: Wolsey Fine Arts, Rocket Press Gallery, 1995).

modern printing methods by introducing machine-made paper and replacing hand-set type with machine-set Monotype. His partner Cyril Costick persuaded him to acquire a small Arab-type treadle-operated platen press to speed up production. The installation of an electric motor to power it upset fellow Guild members who viewed it as a 'factory' machine for mass-production purposes only. By the time a Linotype machine was acquired in 1937 Pepler had already given up printing. In 1940 the press became a commercial firm operating under new management, and was renamed the Ditchling Press.

Notwithstanding its orthodoxy, the St Dominic's Press was unconsciously pioneering in the early years, especially in its choice of illustrators.[112] The personal nature and diversity of the press's publications, many with social or religious overtones, and Pepler's vision of 'work as worship' set the workshop practices aside from those of other contemporary presses. Yet the simple 'no nonsense' standards which it promulgated were a living example to many. Despite the relative lack of publicity, it gained a number of devotees in the 1930s and, above all, played a pivotal role in the development of the private press movement, and in the future of wood-engraving in particular.

Pepler was clearly an inspiration and encouragement to aspiring young printers. In 1929 Edward Walters, who had worked with him after studying under Mason at the Central School, set up his own printing office at Primrose Hill.[113] An accomplished wood-engraver, he frequently illustrated the books he printed, *Five Poems* (1930) being an example, with stylized scenes combining fine white lines and bolder gouged areas.[114] Having met Hagreen at Ditchling in 1935 Walters commissioned a wood-engraved frontispiece for Richard Crashaw's *Musicks Duell*—one of the artist's most attractive illustrations. Hagreen's designs for *The Quest of the Sangraal* were unfortunately destroyed by a bomb.

Plate 53

In 1932 and 1933 Geoffrey Miller produced for Walters some pictorial designs for poems by Alice Winthrow Field, Alexander Pope's *A Discourse on Pastoral Poetry*, and *The English Antiquaries of the Sixteenth, Seventeenth and Eighteenth Centuries*. For Stuart Guthrie's Cock Robin Press he contributed one print, *The Beatitudes*, for *The Gospel According to St Matthew*. In 1937 he wrote and printed his own poem, 'Evolution', and designed for it a two-coloured wood-engraving in a symbolist vein representing regeneration.

Several of the smaller private presses provided valuable experience for wood-engravers often just embarking on their careers, although the market for their books was, by its nature, small. Most owners tended to favour one or two artists rather than cast their nets wider, thereby maintaining an individual house-style. It is the presses which offered such opportunities that are briefly mentioned below.

A consuming interest in ballet led Cyril Beaumont into publishing books on the subject from his Charing Cross Road bookshop. Here in 1917 he started up the Beaumont

[112] Pepler's preference for unjustified lines, for instance, was admired and advocated by Eric Gill who most probably encouraged its use by Gibbings.

[113] See Edward Walters, 'My Days at the St Dominic's Press', *Matrix*, 2 (1982), 82–8, with accompanying checklist, 103–11. His

work is discussed in greater detail by Brocard Sewell in 'Edward Walters, Printer and Engraver', *Matrix*, 1 (1981), 35–43.

[114] Reprinted in 1931 with an extra poem by Blake and an additional wood-engraving. According to Sewell, ibid. 40, probably only one copy exists of Walters's own *A Book of Woodcuts*.

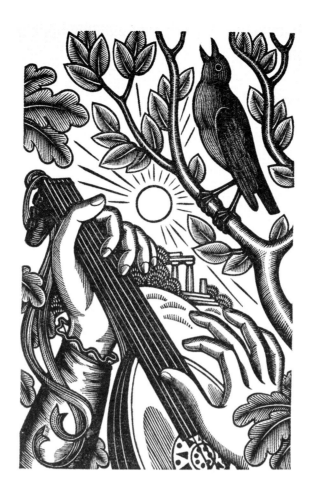

Pl. 53 (*right*). Philip Hagreen:
Richard Crashaw, *Musicks Duell*
(Edward Walters, 1935). 133 × 85

Pl. 54 (*below*). Lynton Lamb: *Lysis:
A Dialogue of Plato* (Fulcrum Press,
1930). 230 × 295

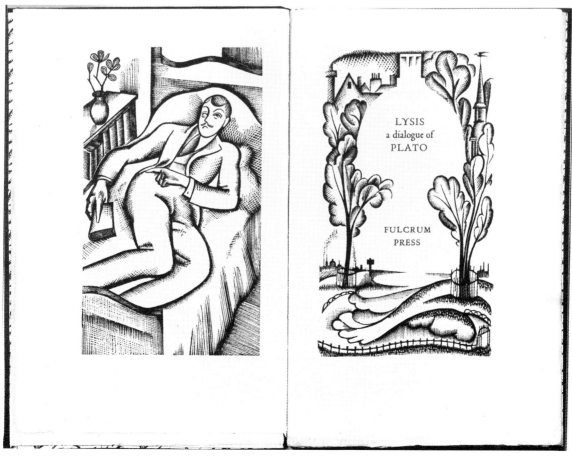

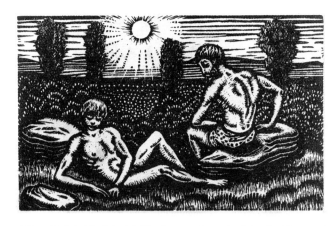

Pl. 55. Ralph Chubb: *A Fable of Love and War* (Ralph Chubb, 1925).
52 × 84

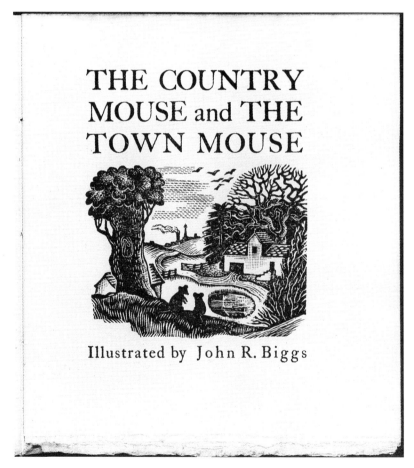

Pl. 56. John Biggs: *The Country Mouse and the Town Mouse* (Hampden Press, 1938).
114 × 105

Press to print as yet unpublished works of modern writers.[115] He learnt the basic theory of printing from *The Imprint*, and typesetting and presswork from a commercial printer and friend, Bertram Bell, purchasing an Albion Press and several sizes of Caslon Old Face from the typefounders, Messrs Miller & Richard. Books were issued in up to three states. Beaumont experimented with a variety of handmade papers, often specially made for the press, using Japanese vellum for some of the most prestigious editions. Artists, including Anne Estelle Rice, Paul Nash, and Randolph Schwabe, mainly contributed line drawings. Having discovered Ethelbert White, Beaumont introduced him to wood-engraving in 1920 for the designs for W. W. Gibson's *Home. A Book of Poems*. He produced an attractive circular device for the colophon showing the pressman Charles Wright, known as Horace, working at the press with Beaumont setting the type. Other commissions followed, the most successful and deservedly popular being for Goldoni's play, *The Good Humoured Ladies* (1922), in an eighteenth-century style. White also designed the cover in red on gold paper, one of many lively patterned cover papers, inspired by those of the Eragny Press, which distinguish Beaumont Press books. Twenty-six titles were published before the press's demise in 1931 for economic reasons.

Interesting also for its use of antique-style marbled paper and batik boards for binding, the Cayme Press was established in Kensington in 1923 by Philip Sainsbury (in succession to his Favil Press[116]) to print anything of a non-commercial character. Particular attention was given to the designing, engraving, and printing of heraldic and genealogical books and tabular pedigrees. More significantly the press provided an outlet for the wood-engraved work of Hester Sainsbury, Philip's sister, in such books as *Noah's Ark* (1926) and *Plate 153* *The Lady's New-Year's Gift or Advice to a Daughter* (1927). Joan Shelmerdine (an ex-pupil of *Plate 154* Mason) and Flora Grierson, who started the Samson Press in 1930 at Woodstock, were responsible for printing Iain Macnab's first two illustrated books, *Nicht at Eenie* (1932) *Plate 167* and *Tam O'Shanter* (1934), and, through an introduction from Macnab, Gwenda Morgan's *Plate 168* *Pictures and Rhymes* (1936), her initial attempt at illustrative bookwork and one of the *Plate 170* comparatively few children's books to be printed privately. She enjoyed working for the press and designed many greeting cards and other items for it until its closure in the early 1960s.[117] Lynton Lamb's earliest wood-engraved illustrations were for two books produced by George Churchill's Fulcrum Press: *Nebuchadnezzar and the Story of the Fiery Furnace* (1929) and Plato's *Lysis* (1930), the latter with a modish figurative *Plate 54* frontispiece.

Several presses were started up as vehicles for the owners' work. Ralph Chubb, an eccentric pupil of Leon Underwood, had his own primitive press built for him by his

[115] An indication of his printing methods is given by Beaumont in *The First Score* (London, 1927). See also Eva White, *An Introduction to the Beaumont Press* (London, 1986) for a detailed account, and also B. T. Jackson, 'The Beaumont Press, 1917–1931', *Private Library*, 8 (1975), 4–37. White's work is discussed in Ch. 12.8.
[116] Co-founded with Charles Birnstingl. In addition to jobbing work, the press issued books, mostly of poetry, including works by Osbert, Edith, and Sacheverell Sitwell.

[117] In 1935 a broadsheet of Kenneth Muir's poem 'Jonah in the Whale' with a print by Gertrude Hermes was published by the press in an edition of 50 but most were destroyed by fire. An example is held by the Department of Prints and Drawings, the Ashmolean Museum, Oxford. See Ch. 13.4.

Plate 55 brother Lawrence who taught him to wood engrave.[118] He started by printing volumes of his own poems: the homosexually inclined illustrations to *A Fable of Love and War* (1925) characterize his work. The Raven Press, run jointly from 1932 by Maynard and Bray for three years and subsequently till 1942 by Maynard, produced fine editions illustrated mainly by themselves, though they once commissioned Hermes.[119] On leaving Gregynog, Blair Hughes-Stanton also started up a press, the Gemini, in theory to make books in which there was to be a fusion between contemporary writers and artists. In practice he only produced two books, Ida Graves's *Epithalamion* (1934) and *Pastoral* (1936) by 'H.H.M.', both with his own sexually explicit visual interpretations of the text. John Biggs printed and illustrated his own poetry, in particular *Three Sonnets* and *Sinfin Songs and Other Poems* of 1932, as well as other books and pamphlets, at the Hampden Press which he founded in 1929. A graphic designer and typographer who had initially studied *Plate 56* at the Derby School of Art, his engravings for such books as *The Country Mouse and the Town Mouse* (1938) are crisply cut with type in mind.[120] An edition of Spenser's *Epithalamion* bound in Cockerell marbled paper, with Bigg's wood-engraved title, two illustrations, and borders, was included in the 'Fifty Books of the Year' exhibition in 1939. He had previously contributed topographical scenes to *Shaftsbury: The Shaston of Thomas Hardy* (1932) for the High House Press. The following year Clare Leighton illustrated Eleanor Farjeon's *Pannychis* for this press, her only privately printed book. The owner, James E. Masters, later gave Reynolds Stone one of his earliest book illustrating jobs with *Old English Wines and Cordials* (1938).

Plate 130 Occasionally smaller presses were in a position to commission well-established illustrators. A few of Paul Nash's last wood-engravings were for the Aquila Press's *A Song about Tsar Ivan Vasilyevitch* (1929), bound by the artist. Some of Hermes's finest prints, *Plate 189* twenty large, full-page flower subjects for *A Florilege* (1931), were printed at the Swan Press in Chelsea by Harry Gage-Cole, the owners L. D. O. Walters and M. H. H. Walters, mother and son, having set the type. Helen Binyon also produced illustrations for the press's 1933 edition of *Angelina* by Maria Edgeworth.

Often printed on handmade paper with plain or decorated bindings, these hand-crafted books, however amateurishly produced, were the ideal ground for displaying wood-engraved illustrations. They possessed an intimacy and tactile quality often missing from more lavish private press productions and generally totally absent from commercially published books. They played, as they still do, a key role in disseminating the art of wood-engraving.

[118] He contributed wood-engravings to vol. 1 of *The Island*, including one of nude boys to accompany a poem, 'Morning—The Shepherd Boy's Song'. For fuller discussion see Anthony Reid, 'Ralph Chubb, the Unknown. Part 1: His Life, 1892–1980', *Private Library*, 3 (1970), 141–56, and 'Part 2: His Work', with check-list of books, *Private Library*, 3 (1970), 193–213.

[119] Naomi Mitchison, *The Alban Goes Out* (Harrow, 1939). See James A. Dearden, 'The Raven Press', *Private Library*, 6 (1973), 158–91,

includes bibliography of books printed at the press, and 'Horace Walter Bray at the Raven Press (A Postscript), *Private Library*, 7 (1974), 122–3.

[120] See John R. Biggs, *Autobiographica: Graphic Work, Etc., 1929–1974* (Brighton, 1974), and John Randle, 'John Biggs and the Hampden Press', *Matrix*, 4 (1984), 129–34. In 1938 Biggs illustrated Defoe's *Robinson Crusoe* for the Penguin Illustrated Classics series.

6.3. *Commercial Publishers*

In 1924 a critic observed that Noel Rooke's realization of a new school of wood-engraved book illustration 'was not within the realm of practical politics unless the leading publishers could be convinced of a waiting public for books so illustrated, and also of a school of men well equipped to provide illustrations of such merit and distinction as to justify the change in method'.[121] The first attempts by the pioneers to impress the publishing world were hardly encouraging, wood-engraving having descended in the estimation of both publishers and printers into a reproductive craft, since supplanted by cheaper processes, with the result that 'younger members of firms were sympathetic, friendly and hopeful, but senior and controlling members obdurate'.[122] The newly emergent private press movement indisputably encouraged the commercial pro-duction of fine illustrated books. However, the role of the industry in furthering the interest in wood-engraving is all too often overlooked.

The nature of trade publishing clearly affected the physical appearance of illustrated books.[123] Even if sometimes published in limited editions, they were usually for general sale, profit being the overriding objective. The wider audience they afforded inevitably had a bearing on the publishers' choice of literature and their treatment of it.[124] Such books were not usually overseen by one person from beginning to end nor were they necessarily printed on the premises, whereas the working practices of most private press owners enabled close collaboration between artist and printer and offered a forum for originality not often available to illustrators. Yet, within the limits determined by modern technology and mass-production methods, commercial publishers and printers ultimately did most to promulgate wood-engraving both as illustration and as individual prints.

The standard of printing firms was a crucial factor in the production of fine books. In the early years of the twentieth century, before typographers were employed by publishers, it was very often the printer who was responsible for the overall design, although until 1939 few printers attempted to train their staff in typography.[125] In rare instances, with wood-engraved illustrated books of the period, publishers heeded the views of authors or illustrators, enabling them to deal direct with the printer.[126]

Nearly all the good work came from a small number of firms: in particular the

[121] G. M. Ellwood, 'Famous Contemporary Art Masters: Noel Rooke', *Drawing & Design*, 4 (1924), 236–8, p. 237.

[122] Ibid.

[123] For a general discussion on the physical structure of books see Dorothy Harrop, *Modern Book Production* (London, 1968). Geoffrey Glaister, *Glaister's Glossary of the Book* (London, 1960; 2nd rev. edn., 1979), is a useful source of information on all aspects of book production.

[124] As with the private presses, classic literature, poetry in par-ticular, biblical subjects, and contemporary fiction pre-dominated, with nature books a popular choice in the 1930s. See Ch. 7.

[125] Ruari McLean, *Modern Book Design* (London, 1958), 89. Richard de la Mare, 'Principles of Book Production', *Printing Review*, 38 (1945), 5–8, 32, p. 5, believed that the invention of the Monotype machine and the accessibility of a wider choice of types led publishers to take more interest in the design element of pro-duction.

[126] Notable examples of this practice were John Farleigh's and Clare Leighton's dealings with W. R. Maxwell of R. & R. Clark (Chs. 9 and 14.1) and Gwen Raverat's with Cambridge University Press and Faber and Faber (Ch. 10).

Curwen, Chiswick, and Westminster Presses in London, Lund Humphries[127] in Bradford, the Kynoch Press at Birmingham, the Cloister Press at Heaton Mersey, R. & R. Clark and T. & A. Constable in Edinburgh, R. MacLehose in Glasgow, and the Camelot Press in Southampton. The Baynard Press, known especially for its high-quality colour lithography, dealt with a small amount of book work, including some wood-engraved illustration.

With the appointment in 1923 of Walter Lewis, one of the most respected printers of the time, as Printer to the Cambridge University Press under the eye of Stanley Morison as Adviser,[128] and with John Johnson as Printer to Oxford University Press 1925 to 1945, the two institutions were recognized as corner-stones of fine printing. The Curwen Press, too, was among the most distinguished of companies. Oliver Simon, who joined in 1920, highlighted the firm's pioneering interest in fine printing and book design in the two typographical journals, *The Fleuron* and *Signature*.[129] He put Curwen in touch with the promising younger generation of artists, most notably Bawden, Ravilious, and Barnett Freedman. Enid Marx, who also designed for the firm, felt that Simon 'had to be persuaded to use engravings as to his mind they did not marry happily with type'.[130] Yet in *The Curwen Press Miscellany* (1931) Harold Curwen contributed a practical craftsman's essay, 'On Printing "From The Wood"'. Although the press itself published few books with wood-engraved illustrations, it printed such books for other publishers and was enlightened in its use of these artists for other printed material. According to Pat Gilmour, Harold 'always encouraged artists to supervise the proofing of their work and to deal direct with the press rather than only through the intermediary of a third party such as the publisher'.[131] The supreme example of such co-operation was Paul Nash's *Genesis*, printed in 1924 for the Nonesuch Press, marking the beginning of the artist's association with the Curwen Press.

Despite the valuable contribution of some printing firms, the impetus towards better design mostly came from publishers and advertisers, often, as Ruari McLean implies, against actual opposition from printers.[132] From the mid-1920s publishers' direct influence, which used to be rare, became the rule.[133] In 1958 McLean stated that Chatto & Windus had probably the longest unbroken record of excellence in book design of any London publishing firm still in business; from the First World War to his retirement in 1934 this was due largely to Charles Prentice, one of the partners, whose quiet, unpretentious books had an 'elusive quality of style'.[134] Although responsible for only a few wood-engraved illustrated books, Chatto & Windus was quick to recognize the

[127] This firm designed, printed, and published *Penrose's Annual* (from 1936 entitled *The Penrose Annual*), an important organ of the printing industry.

[128] See Brooke Crutchley, 'The Cambridge University Press in the Early '30s', *Matrix*, 4 (1984), 76–81.

[129] See Ch. 6.1.

[130] Enid Marx to the author, 11 Feb. 1988. One of the reasons why printers and publishers were slow to use wood-engraved illustration prior to the creation of a variety of new typefaces was that existing ones were not heavy enough for the strong blacks common to 1920s practitioners.

[131] Pat Gilmour, *Artists at Curwen* (London, 1977), 17. For a history of the press see Simon, *Song and Words*.

[132] McLean, *Modern Book Design*, 89.

[133] See Francis Meynell, *English Printed Books* (London, 1946), 45–6.

[134] McLean, *Modern Book Design*, 84–5. For brief histories of most of the publishers mentioned see Jonathan Rose and Patricia Anderson (eds.), *British Literary Publishing Houses, 1881–1965* (*Dictionary of Literary Biography*, 112, Detroit and London, c.1991).

value of the medium through their art director, Geoffrey Whitworth, a member of the firm from 1908 to 1928. The extent of his interest can be gauged from his correspondence with practitioners such as Ray Garnett, Gibbings, Craig, Hagreen, Stephen Bone, and Gill, all of whom, with the exception of Gill,[135] he commissioned.[136] Rooke considered Johnston, Lethaby, and Whitworth to have been the three prime movers in encouraging wood-engraving when it was most needed, Whitworth for his efforts 'to persuade his firm to break new ground'.[137] Stephen Bone's illustrations to his mother, Gertrude's *Furrowed Earth* (1921), for instance, were some of the earliest from the new generation of wood-engravers, whilst David Garnett's novel, *Lady into Fox* (1922), illustrated by his wife, Ray, became a best-seller, the first trade book with modern wood-engravings to achieve such popularity.

Plate 94
Plate 66

Duckworth was certainly one of the first and most enterprising publishing companies to commission wood-engravers in the 1920s, entirely as a result of Balston's inspired period with the firm from 1921 to 1934.[138] During this time he introduced the work of Paul Nash, Ethelbert White, Vivien Gribble, Mabel Annesley, and Clare Leighton among others. With certain of these publications an exceptionally high standard of production was achieved through the issue of signed limited editions as well as the ordinary unlimited ones.[139] With Balston's departure wood-engraving commissions waned.

Jonathan Cape founded his own business in 1921 with G. Wren Howard, having worked for Duckworth since 1904 and having run the firm during the 1914–18 war.[140] His interest in book design was mentioned in Newdigate's Book Production Notes in January 1922 after Cape had sent him books to show him the importance of the happy collaboration between himself and his printers. Cape was extremely percipient in his choice of wood-engravers before they had become well known. In April 1922 he suggested that Gwen Raverat should illustrate Samuel Butler's *Erewhon*.[141] Despite her willingness, for some reason the commission went to Gibbings the following year, his first book commission. Similarly he gave both Ravilious and Edward Carrick their initial illustrative work with *Desert* (1926) and *A Voyage to the Islands of the Articoles* (1928) respectively. Strong links with the Bone family led to the publication of several of Gertrude's books with illustrations by Stephen[142]—some of the earliest new style wood-engravings to appear in a commercially

Plate 135

[135] In 1927 Gill felt unable to design a phoenix in black line for the title-page of The New Phoenix Library. Although he suggested David Jones, Whitworth had already commissioned Thomas Derrick. Eric Gill to Geoffrey Whitworth [Mar.] 1927. Chatto & Windus Archives, Reading University Library.
[136] See chapters relating to individual artists for further discussion of illustrated books mentioned in this chapter.
[137] Noel Rooke, *Woodcuts and Wood Engravings*, a lecture delivered to the Print Collectors' Club on 20 Jan. 1925 (London, 1926). F. V. Burridge, the Principal of the Central School, in *The Annual Report of the Principal* (6 Oct. 1913) noted that 'The students have done successful work for Chatto & Windus for whom not only were illustrations made but specimen pages set up and the general arrangement of the book discussed'.
[138] See Ch. 5.3. For a brief history of Gerald Duckworth & Co. Ltd. see *Fifty Years, 1898–1948* (London, 1948).

[139] Examples include Keats's *Odes* (1923) and Tennyson's *Songs from The Princess* (1924), both illustrated by Vivien Gribble.
[140] See Michael S. Howard, *Jonathan Cape, Publishers* (London, 1971; repr. Harmondsworth, 1977).
[141] Jonathan Cape to A. T. Bartholomew, 6 Apr. 1922. Jonathan Cape Archive, henceforth JCA.
[142] A letter from Muirhead Bone in Nov. 1922 suggests potential book illustrators such as Gill, Rodo, Stephen Bone, Sturge-Moore, Ricketts, Raverat, Craig, John Nash, Rupert Lee, and Stanley Spencer—'a beginner but a very good artist'—and advises Cape to 'make a start by some classic about animals to be done by John Nash or Rupert Lee'. Muirhead Bone to Jonathan Cape, 7 Nov. 1922. JCA.

produced book. Other wood-engravers who worked for Cape included Gill, Hughes-Stanton, Hermes, Miller Parker, and an American, Lynd Ward.[143]

Bodley Head (formerly John Lane) was another firm to commission wood-engravers in the first few years of the revival. As early as 1921 Marcia Lane Foster illustrated Kenneth

Plate 77 Grahame's *The Headswoman*. Familiar artists included Gibbings, John Austen, and John Greenwood. Between 1927 and 1928 the Helicon Series was issued: fourteen small format books, some containing illustrations by less well-known wood-engravers such as Elizabeth Rivers[144] and Annabel Kidston.[145]

Plates 124–5 William Heinemann was early in the field with the publication in 1923 of *Places* written and designed by Paul Nash—like William Nicholson's book designs for the

Plate 194 firm, a strikingly avant-garde production. Similarly D. H. Lawrence's *The Man Who Died* (1935), designed and printed by Mason, with images (some with additional colour) by Farleigh, was typographically adventurous for a commercial publication.[146] In 1925 Leighton produced her first wood-engraved illustration for one of Heinemann's books,

Plate 57 *The Half Loaf*, as did Joan Hassall for *Devil's Dyck* over a decade later. Other artists to be commissioned included Hughes-Stanton, Gibbings, Freda Bone,[147] and Kay Ambrose.

From 1927 the imaginative Ariel Poems series was published by Faber and Gwyer and printed by Curwen, with cover design and frontispiece produced by various artists in different media, including wood-engravings by Gill, Hughes-Stanton, Ravilious, and Hermes. Under the discerning eye of Richard de la Mare, the director responsible for design and typography, the firm of Faber and Faber, as it became in 1929, built up a reputation for well-designed bookwork, especially for bindings and dust-jackets.[148] In the 1930s they published several of Gill's writings as well as works illustrated by Rivers,[149]

Plate 91 Farleigh, Gibbings, and Raverat, who, with *The Bird Talisman* (1939), revived the use of colour wood-engraving in a modern commercially produced book.[150] Ten years earlier Hodder & Stoughton had published *Red Tiger* with colour prints by Leon Underwood;[151] otherwise the firm commissioned little wood-engraved illustration, Gibbings's for *The Charm of Birds* (1927) by Viscount Grey of Fallodon being a rare and popular example.[152]

Several other publishers used wood-engraving infrequently but none the less successfully: Macmillan, for instance, for Gribble's and Leighton's interpretations for

Plates 65, 203 Thomas Hardy's *Tess of the d'Urbervilles* (1926) and *The Return of the Native* (1929), and Raverat's

Plate 90 spirited designs for *The Runaway* (1936). Further examples were provided by John Farleigh for Collins, John Nash and Clare Leighton for Longmans Green, and Hughes-Stanton and Ravilious for Martin Secker, among others. The Cambridge University Press published several noteworthy books illustrated by Greenwood, Raverat, Reynolds Stone, and

[143] Lynd Ward's *God's Man* and *Madman's Drum* (1930) were 'novels in woodcuts' without text: a style developed from Frans Masereel's reinterpretation of the medieval blockbook.
[144] See Ch. 12.8.
[145] Matthew Arnold's *The Forsaken Merman* and *The Scholar Gypsy* (No. 4). See Ch. 12.9 n. 235.
[146] See Ch. 13.5.
[147] Daughter of Sir David Bone, author of books about the sea, and first cousin of Stephen Bone.

[148] See Richard de la Mare, *A Publisher on Book Production* (London, 1936), the sixth of the J. M. Dent Memorial Lectures, and 'Principles of Book Production'.
[149] All written by Walter de la Mare and published in 1930.
[150] See Ch. 10.
[151] See Ch. 13.2.
[152] The limited edition was oversubscribed before publication, and the book was reprinted 14 times between 3 Dec. 1927 and 30 Sept. 1947 (77,050 copies).

Miller Parker. With rare exceptions, however, Oxford University Press were restrained in their use of the medium for illustrative purposes until their revival of it in the 1950s.[153]

Between 1925 and 1927 Constable published several books of poetry by Walter de la Mare (an especially popular author at the time) which included some small and attractive stylized white-line scenes by a wood-engraver with the pseudonym of Bold. In 1926 Gibbings was commissioned to illustrate Viscount Grey's *Fallodon Papers* which were reprinted many times. Considering the popularity of the book, with rare exceptions[154] the firm showed comparatively little interest in wood-engraving in the 1920s. None the less it is generally accredited with bringing the medium to the notice of a wider public through publication of George Bernard Shaw's *The Adventures of the Black Girl in her Search for God* in 1932, the first edition of 25,000 copies being priced at 2*s.* 6*d*. This affordable little book displaying Farleigh's startling cover and endpaper designs and provocative illustrations certainly heralded the resurgence of interest in the medium and set standards to be followed by modern producers. Farleigh produced three further books for the firm and Gibbings one. Yet again Constable did not exploit the success, leaving other publishers to capitalize on it.

Plates 82–3

One such was J. M. Dent who had previously published Edward Gordon Craig's *Woodcuts and Some Words* (1924), Samuel Johnson's *The History of Rasselas, Prince of Abyssinia* (1926), and Katharine Chorley's *Hills and Highways* (1928) with illustrations by Craig, Douglas Percy Bliss, and Margaret Pilkington respectively. Gill's contributions to the Temple Shakespeare and the Aldine Bible (1934–6), and Ravilious's decorative endpapers, redesigned for the Everyman Series in 1935, attracted a vast audience, as did the numerous books on natural history written and designed by Eric Fitch Daglish.[155] Dent specialized in series, deservedly the most popular being Gibbings's illustrated writings on rivers, beginning with *Sweet Thames, Run Softly* in 1940.[156]

Plates 9, 133
Plate 71

Post-war nostalgia for the British landscape tradition had created a market for books on nature and the countryside.[157] Collins broke new ground with Clare Leighton's prestigious *The Farmer's Year* (1933) but Victor Gollancz's subsequent publications on country matters illustrated by Leighton, Miller Parker, and others,[158] and Putnam's immensely popular edition of Henry Williamson's *Tarka the Otter* (1932), one of several books with wood-engravings by Charles Tunnicliffe,[159] reached a much wider public.

Plate 205

The introduction of paperback Penguin Books, conceived by Allen Lane in 1935,

[153] Examples include *Cotswold Characters* (published on commission for Yale University Press, 1921), *Border Ballads* (1925), *Heroes and Kings* (published jointly with the Sylvan Press, 1930), *Poems by Thomas Hennell* (1936), *A Book of Fabulous Beasts* (1939), and *Letters to a Musical Boy* (1940) with illustrations by Paul Nash, Douglas Percy Bliss, Norman Janes, Eric Ravilious, Dorothy Fitch, and Barbara Greg respectively. (See Plates 58 and 59)

[154] For instance G. L. Ashley Dodd's *A Fisherman's Log* (1929) with wood-engraved scenes by Barbara Greg.

[155] Daglish (1894–1966) worked as a field naturalist, broadcasting and writing, wood-engraving and painting in watercolours. His representational illustration, mainly of wildlife, is engraved in a fine scraperboard-like manner with little concession to modernity.

[156] In *The Wood-Engravings of Robert Gibbings* (London, 1949), 26–7, Balston states in his introduction that 'in England alone, in spite of paper restrictions, it went through ten large editions in seven years'.

[157] In the 1930s John Betjeman, as editor of the Shell Guides to the English countryside, did much to inspire nostalgia for buildings and landcape. Country Life publications commissioned wood-engraved scenes from Farleigh, Ravilious, and Geoffrey Miller for books on rural subjects.

[158] For further information on the firm see Sheila Hodges, *Gollancz: The Story of a Publishing House, 1928–1978* (London, 1978).

[159] The illustrative work of Tunnicliffe (1901–79) was prolific and his traditional naturalistic renderings of agricultural scenes and wildlife were well received.

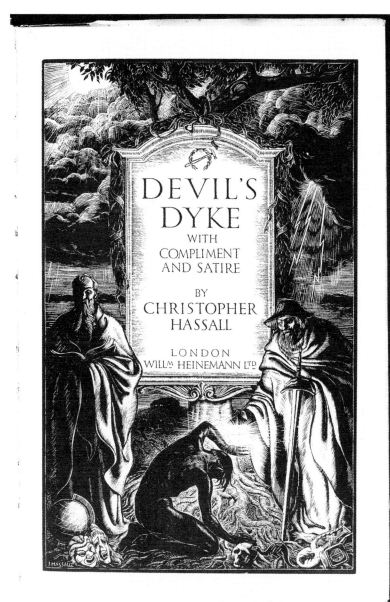

Pl. 57. Joan Hassall: Christopher Hassall, *Devil's Dyke* (Heinemann, 1936). 203 × 140

Pl. 58. Norman Janes: Charles Williams, *Heroes and Kings* (Sylvan Press, 1930). 89 × 113

revolutionized book marketing, as many as twenty thousand copies of individual titles selling at only *6d.* each. The Penguin Illustrated Classics[160] first published in 1938 and edited by Gibbings, a series of contemporary writing entitled Penguin Parade, and various individual books all containing wood-engravings, did more to popularize the medium than any previous publications.

Many of the most imaginative illustrated books emanated from a handful of small publishing imprints run on the lines of the Nonesuch Press, their publications masterminded by their owners but printed off the premises by reputable firms. For a short time Frederick Etchells, the Vorticist painter, ran such an enterprise with Hugh Macdonald before becoming an architect.[161] Etchells and Macdonald published two of John Nash's most attractive illustrated books as part of the Haslewood Books series: *Ovid's Elegies* (1925) and *Poisonous Plants* (1927), the latter printed by the Curwen Press. Four of Hester Sainsbury's books were also included in their list. *Plates 157, 159*

From the Cresset Press Dennis Cohen and A. I. Myers produced fine editions, reprints of classics and neglected works, and some contemporary literature.[162] Eclectic in their choice of illustration methods, they were responsible for commissioning some of the more important wood-engraved books of the period, most especially *Pilgrims' Progress* (1928), *The Apocrypha* (1929), and *Birds, Beasts and Flowers* (1930) printed at the Shakespeare Head, Curwen, and Shenval Presses respectively. Of lesser significance, *Enigmas of Natural History* (1936) and *More Enigmas of Natural History* (1927) contained scenes by Barbara Greg. *Plate 187* · *Plates 176, 188, 200 and frontispiece*

A distinguised series of long short stories by younger authors was issued by Furnival Books, a publishing imprint of William Jackson Books Ltd. Printed at the Chiswick Press, it included illustrative work by Gibbings, Garnett, Garwood, and Leighton. From the late 1920s Hubert Foss, Oxford University Press's music editor and disciple of Francis Meynell, was closely involved in the Sylvan Press. He commissioned Norman Janes to illustrate Charles Williams's *Heroes and Kings* (1930) which was printed by Henderson and Spalding and published jointly by the two presses. *Plate 58*

In 1930, to consolidate his success as a typeface designer,[163] Gill set up a printing business with his son-in-law René Hague at his home at Pigotts using an Albion and a motorized platen press. Purposely *not* a private press, they produced several books and pamphlets under their own imprint and a quantity of jobbing work, as well as printing for nearly twenty publishers. Severely affected by the Depression Hague and Gill was taken over by J. M. Dent, several of whose publications they had earlier printed.[164]

[160] Artists included Gibbings, Raverat, Bliss, Hermes, Binyon, Macnab, White, Biggs, and Theodore Naish. See William Emrys Williams, *The Penguin Story, MCMXXV–MCMLVI* (Harmondsworth, 1956) for a complete list of books. Edward Young was Production Manager of the series

[161] See Peter Tucker, *Haslewood Books: The Books of Frederick Etchells & Hugh Macdonald* (Oxford, 1990), and 'Three Artists at Haslewood Books', *Matrix*, 11 (1991), 102–9. Publication of John Rodker's *Carnivorous and Other Objectionable Plants* with hand-coloured

wood-engravings was also planned but never completed owing to the financial slump.

[162] See John Dreyfus, 'Dennis Cohen and The Cresset Press', *Matrix*, 12 (1992), 83–93.

[163] Gill's typeface, Joanna, was designed in this year for their productions and acquired by J. M. Dent.

[164] See Christopher Skelton, 'René Hague and the Press at Pigotts', *Matrix*, 2 (1982), 75–81. For a checklist of books see James Davis, *Printed by Hague & Gill* (Los Angeles, 1982).

Although not British the Limited Editions Club of New York deserves mention.[165] A book club conceived by George Macy as a means of selling well-printed, beautifully illustrated editions of the classics to subscription members, its first publications appeared in 1929. Wherever possible Macy chose illustrators from the country of origin of the texts, Gill, Farleigh, Gibbings, and Miller Parker among others. Of the commercial printing houses he particularly favoured the Curwen, and Oxford and Cambridge University Presses, while for certain editions he looked to selected privately owned presses: for instance, the Golden Cockerel for Gibbings's *Le Morte D'Arthur* (1936), the Raven for Miller Parker's *Elegy Written in a Country Churchyard* (1938), and Hague and Gill for *Hamlet* (1933). Such commissions from abroad helped to keep these enterprises buoyant at a time when demand for such illustration was poor in Britain.

Plate 101
Plate 212

A plaintive note from Duckworth to John Nash in 1939 indicates the insecurity felt by the book trade 'hit hard as any industry by continuing depression. People seem to have no leisure for reading.'[166] The economic pressures facing publishers and printers of wood-engraved illustrated books was nothing new. In about 1912 Gwen Raverat had written: 'I'm quite sure that no ordinary publisher would think of publishing anything with *woodcut* illustration—it's too expensive.'[167] Twenty-one years later Faber and Faber's printer was complaining that the high quality of paper and printing demanded by her work deemed it 'a matter of impossibility to make any profit—and in most cases, to even meet costs—on this valued customer's work'.[168] With the introduction of new technology after the Second World War, wood-engraved illustration generally proved economically unviable although the picturesque narrative and realistic country scenes of Miller Parker, Hassall, Gibbings, Stone, and Tunnicliffe, in particular, remained in demand. Unadventurous as these representational images were, their popularity demonstrated the inherently conservative taste of British readers.

Despite the increasing interest shown in commercially produced wood-engraved books during the inter-war period, their circulation was low compared with unillustrated light fiction,[169] or with magazines and periodicals. With the competing attraction of colour, they never attained the truly popular status they had in the previous century, but they were none the less largely responsible for keeping the medium alive and publicized.

[165] For further discussion see, for example, *Forty-six Years of Limited Editions Club Books, 1929–1976* (New York, 1980).

[166] Duckworth (sender unnamed) to John Nash, [Apr.–June 1939], Duckworth Papers, University of London Library.

[167] Gwen Raverat to Elinor Darwin, n.d. [*c*.1912]. In the possession of the family.

[168] Latimer, Trend & Co. Ltd. to [David Bland], [31 June 1933]. Faber Archives, Faber and Faber Ltd., henceforth FA.

[169] According to Joseph McAleer, *Popular Reading and Publishing in Britain, 1914–1950* (Oxford, 1992), 51 and 54, cheaply produced light fiction by such authors as Arnold Bennett and Cosmo Hamilton were the most consistently popular type of literature among 'the new reading public' between the wars. Claud Cockburn, *Bestseller: The Books that Everyone Read, 1900–1939* (London, 1972), includes the authors Robert Hichens, H. de Vere Stacpole, Erskine Childers, Jeffrey Farnol, Mary Webb, and Michael Arlen, none of whose writings, with the exception of the latter (see Ch. 9 n. 30), was, to the present author's knowledge, illustrated with wood-engravings.

PART III

A CRITICAL ANALYSIS OF BRITISH
WOOD-ENGRAVED BOOK ILLUSTRATION
1920–1940

7

NEW APPROACHES TO WOOD-ENGRAVING

In 1934 Douglas Percy Bliss wrote of the 'pioneer spirit' among wood-engravers ten years earlier: 'There was excitement, stir and endless experiment. Gouging upon soft wood was much indulged in, and the "courage to be crude" was so common that it ceased to appear a virtue.'[1] Partly in reaction to the dull greyness of reproductive processes and partly through lack of experience, the first generation of modern wood-engravers had responded with a more robust and vigorous treatment. Using a wide range of tools of varying shapes and sizes they achieved dramatic effects, often throwing black forms into relief to create powerful contrasts of light and dark. This freeing from the conventions of naturalistic shading was an exciting innovation for a medium of which texture, pattern, and tone were to become the *raison d'être*, without in any way detracting from the interpretative function of book illustration.

For some critics such rugged handling was detrimental to the cause, as was the emphasis on black. Bliss, for instance, felt that during the 1920s blackness had become a fetish and that the effect of most exhibitions of modern woodcuts had been 'one of funereal gloom'[2] while another likened over-black prints to 'interesting coal cellars'.[3] A reviewer of *Contemporary English Woodcuts* considered modernist works of such artists as Gibbings to be merely 'chunks of black and white ingeniously arranged with hardly the faintest tremor of feeling'.[4] These were no doubt minority views, reflecting the strongly held opinions of critics and artists alike on the subject of technique. Nor did they abate later in the 1930s when wood-engravers, particularly those of the Underwood group, were frequently criticized for over-dexterity in their use of exquisitely fine lines and shimmering greys. The two extremes of bold and intricate cutting were a constant cause for concern amongst observers of the wood-engraving scene who tended to confuse these deliberate styles with, on the one hand, a lack of concern for technique, and on the other, an obsession with increasing technical refinement. The practical problems of printing such engravings which often beset publishers cannot be overlooked when assessing these works as illustrations.

The subject of black- versus white-line engraving remained another debatable cause of dissension, such respected critics as Furst, for example, insisting that 'the black line method keeps the woodprint in a servile reproductive state'.[5] Although most modern practitioners, in their quest to dissociate their work from nineteenth-century trade engraving, laid emphasis on the white line, those, such as Gill, who used black line in

[1] Douglas Percy Bliss, 'The Last Ten Years of Wood-Engraving', *Print Collector's Quarterly*, 21 (1934), 251–71, p. 253.
[2] *Scotsman*, 30 Nov. 1929.
[3] *Manchester Guardian*, Mar. 1927. Quoted from the Society of Wood Engravers' press-cutting book. SWEA.

[4] *Bookman's Journal*, 7 (1923), 114. For further anti-modernist feeling see Ch. 4.4.2, 'Robert Gibbings', n. 176.
[5] Herbert Furst, *The Modern Woodcut* (London, 1924), 10.

an individual and creative way could by no means be viewed as working in an entirely retrograde fashion. As will be seen, the range of approaches to the medium was in fact much wider than the narrow definition of 'original' work implies.

The rarity of abstract illustration was due to the narrative tradition of British art and literature rather than to the reluctance of artists to appear avant-garde. A strong romantic strain, passion for detail, and innate love of nature, the countryside, and everyday English life, evidenced in illustrated books from the *Luttrell Psalter* through to eighteenth-century chapbooks, and the works of Blake, Bewick, and the Pre-Raphaelites, were perpetuated into the twentieth century. Paul Nash was one of the few wood-engravers to use abstraction to express physical imagery with his scenes of the Creation for *Genesis*. For him wood seemed 'to yield to the evolution of an abstract design or a decorative arabesque as stone excites the sculptor to the creation of pure form'.[6] Several of his contemporaries shared his delight in the decorative potential of the medium, Gill, Ravilious, Marx, and Garwood among them, using abstract patterning for bindings and endpapers as well as for page design.

Of the prevailing modernist trends, Surrealism rarely found its way into books illustrated with wood-engraving. As with abstraction, most publishers were reticent about using such subjective artistic styles, preferring more easily read representations. Sandford, for example, turned down three of his previous illustrators because they 'have gone to symbolism & refuse to work in any other way'.[7] Farleigh's late illustrations, especially those for G. B. Shaw's *Back to Methuselah* (1939), were rare examples of the use of surrealist imagery, as were John Aldridge's dream-like interpretations of Laura Riding's *The Life of the Dead* (Arthur Barker 1933) engraved by Beedham,[8] and some of Ravilious's scenes for Thomas Hennell's poems (1936).

Plate 195

Plate 59

Only a few of the wood-engravers under discussion were directly affected by modernist tendencies; an insularity partly due, in the early years at any rate, to ignorance of continental art.[9] Most practitioners were more interested in the creative potential of wood-engraving itself than in any particular artistic fashion. Their individual styles largely evolved in response to the technical demands of the medium. As Garrett maintained, they gained little from the various 'isms' since, being an essentially linear discipline, few of the aesthetic concepts were workable in engraving.[10] Such non-reliance on the stylistic notions of mainstream art resulted in an unusually independent attitude amongst wood-engravers.

Despite the restrictions imposed on illustrators, working for books gave artists opportunities to think about prints in a new way. The format of the book, its size and shape,

[6] Paul Nash, 'Woodcut Patterns', *The Woodcut*, 1 (1927), 30–8, p. 33.

[7] Christopher Sandford to John Buckland Wright, 11 May 1936. Golden Cockerel Press Archive, henceforth GCPA. He mentioned no names but Hughes-Stanton's was most probably one.

[8] An illustration is reproduced in James Hamilton, *Wood Engraving & the Woodcut in Britain, c.1890–1990* (London, 1994), 121.

[9] John Nash, for instance, admitted: 'As far as I know, none of us were aware that either Dufy or Derain had ever cut a block

or illustrated. If one looked back at all, it was to Ricketts and Lucien Pissarro.' Quoted from John Lewis, *The Twentieth Century Book* (London, 1967), 162. See also Ch. 4.4, 'Robert Gibbings', n. 169. Some modern-minded practitioners were most probably affected by Gauguin's startlingly expressive woodcut illustrations to his poem 'Noa-Noa' which were included in the Dec. 1923 Society of Wood Engravers' exhibition.

[10] Albert Garrett, *A History of British Wood Engraving* (Tunbridge Wells, 1978), 123.

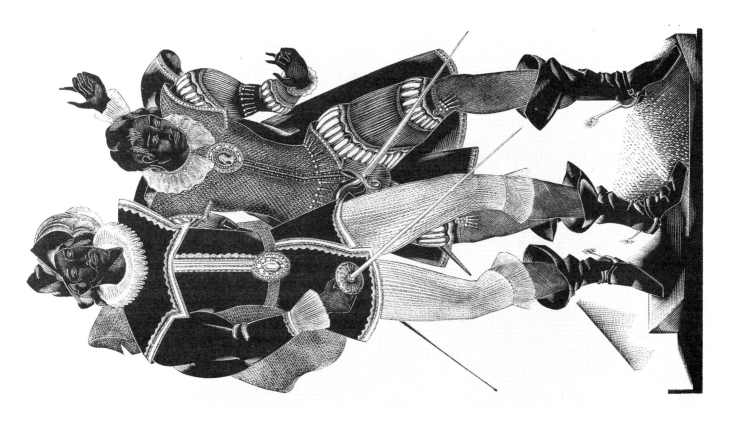

Pl. 59 (*above*). Eric Ravilious: Thomas Hennell. *Poems by Thomas Hennell* (Oxford University Press. 1936). 70 × 89

Pl. 60 (*right*). Blair Hughes-Stanton: John Milton. *Comus* (Gregynog Press. 1931). 183 × 96

the paper used, the layout, the printing methods, all required a different approach from single prints. Integration with text often made for non-rectilinear designs, for example. Similarly, the textual content enabled practitioners to tackle subjects outside their normal realm and to vary the handling of them. As Ian Jeffrey so percipiently remarked about the 'private' nature of Ravilious's illustrative work, 'books implied seclusion and reverie as opposed to the public circumstances associated with painting'.[11]

Economic factors and the conservative attitude of many publishers, printers, and the reading public meant that the types of books illustrated with wood-engravings were limited, as the following brief assessment of subject matter shows. Most books were of a fictional nature, the standard repertoire of literary genres, requiring representational interpretations of narrative text: the Bible and Shakespeare, classical works, British and foreign literature including contemporary novels, plays and, most especially, poetry. Books illustrated were generally chosen for their pictorial scope. Post-1918, themes were consciously unaggressive with scenes of war notably absent. Apart from Pepler's St Dominic's Press publications and some of Gill's and G. B. Shaw's writings, political polemics rarely contained wood-engravings, unlike books of a religious nature where they proliferated. Few practitioners specifically set out to treat modern life as social
Plate 151 commentary, Gill, Jones, Dickey, Leighton, and Garwood being among the exceptions. Nevertheless, images of the contemporary scene inevitably evoke the period, those by Jones, Garnett, Garwood, and Lamb aptly describing society life. Figurative work predominates. The nude body frequently recurs, most especially in biblical works, reflecting in many instances the predelictions of private press owners and their subscribers. The illustration of period literature involved much historical research for accuracy of dress and surroundings, with artists such as Raverat, Farleigh, and Miller Parker, for instance, taking infinite trouble. Hughes-Stanton's male characters for Mil-
Plate 60 ton's *Comus*, most particularly *The Brothers*, are elegantly clothed but, like Gill's, his historical and biblical figures were more often dressed, if at all, in timeless costume. David Jones, too, preferred to treat such subjects in a stylized or symbolic manner, whilst John Nash's Swift scenes, and other examples, were merely pastiche.

Pure landscape was a rarity. In common with contemporary painting, when featured it was generally tamed and pastoral rather than wild and romantic as depicted by various illustrators in the 1940s. Geoffrey Miller's intricately worked views in Christopher Whitfield's *A World of One's Own* (Country Life, 1938) anticipate Neo-Romantic illustration. The Nash brothers, and Webb, White, and Ravilious among others, formalized nature, the latter investing it 'with the functional look of modern design'.[12] Symbolism and associated meanings abound in the landscape illustrations of Paul Nash and Ravilious especially. Images of the country generally include figures or animals, as epitomized by the rural scenes of Raverat, Gibbings, Leighton, and Miller Parker.
Plates 35, 76 Wadsworth's prints for *The Black Country* and Dickey's cover design for *Workers* are among the few examples of industrial views in the period.

[11] Ian Jeffrey, *The British Landscape, 1920–1950* (London, 1984), 15. [12] Ibid. 14.

Since photography and other technical processes removed the need for wood-engraving as a precise visual aid, few factually informative books contained such prints. The illustrations for Sandford's historical documentaries and books on travel and seafaring, for instance, were designed for aesthetic appeal rather than to educate. Some publishers, however, chose to employ wood-engraving in a naturalistic vein accurately to depict factual details, most obviously those specializing in country and nature subjects, such as Dent and Gollancz, several of whose publications were aimed at children. Others opted for a more decorative treatment in the form of picture books, Gertrude Hermes's *Florilege* being a prime example. Nature prints such as those which appear in this book *Plate 189* are among the most inventive wood-engravings of the period.

Story books for children containing wood-engravings were unusual at this time, doubtless because photographic processes were considered more appropriate and cost-effective, particularly where the more popular colour illustration was involved. Also, with a few exceptions, private presses concentrated on adult readership. Through various publications Gwen Raverat promoted the use of the medium for children's books, most especially in her use of colour for *The Bird Talisman* while, among others, *Plate 91* the lesser-known C. T. Nightingale illustrated his wife Madeleine's tales for Blackwell's, *Plate 95* Cecily Englefield some delightful animal stories for John Murray, and Elizabeth Rivers children's rhymes for Sidgwick & Jackson.

Such a range of subject matter gave artists plenty of scope for individuality. Although it is difficult and presumptuous to categorize too specifically, for the purposes of analysis, however, they have been placed in stylistic groups, emphasizing the distinctive patterns which emerged from the art schools. Only Farleigh embraced the complete spectrum of styles and techniques, while Gill's extensive experiments occasionally veered from his precise, typographical approach. The intractability of the medium made painterly wood-engravers such as Raverat rare, whereas the decorative possibilities of black and white and toolmark patterns encouraged the bold expressionism of Paul Nash and others. The delicate, sinuous line of the Underwood group pushed the technique to its limits; a style far removed from the robust blackness of Rooke and his early followers, or the clearly defined black and white work of Gill, Ravilious, and others which is more sympathetic with type and, therefore, possibly better suited to illustration.

The same criteria have been applied to each artist: the type of books illustrated, whether commissioned by private press or commercial publisher, and the working methods employed. The treatment, however, differs according to their importance, the scope of their work, and the primary material available. Biographical aspects are emphasized in order to reveal practitioners' attitudes towards wood-engraving and their creative processes, and, most especially, to establish their working relationships with publishers, printers, and authors. By this means it should become clear that the innovatory contribution of twentieth-century British engravers was not their use of modernism so much as their wide-ranging experimental approach to the medium and its subsequent effect on book illustration as a result of their typographic awareness and craftsman-like feel for design.

IMP· CAES·
DIV· AVG·

AND IT CAME TO PASSE IN THOSE
DAYES, THAT THERE WENT OUT
a decree from Cesar Augustus, that all the
world should bee taxed. (And this taxing was
first made when Cyrenius was governor of
Syria.) And all went to be taxed, every one
into his owne citie. And Joseph also went up
from Galilee, out of the citie of Nazareth,
into Judea, unto the citie of David, which is
called Bethlehem, (because hee was of the
house & linage of David), To be taxed with
Mary his espoused wife, being great with
child. And so it was, that while they were
there, the dayes were accomplished that she
should be delivered. And shee brought foorth

C2 37

Pl. 61. Noel Rooke: *The Birth of Christ* (Golden Cockerel Press, 1925). 215 × 297

AND IN THE SIXT MONETH, THE ANGEL
GABRIEL WAS SENT FROM GOD, UNTO A
CITIE OF GALILEE, NAMED NAZARETH.

TO A VIRGIN ESPOUSED TO A MAN WHOSE
NAME WAS JOSEPH, OF THE HOUSE OF
DAVID; & THE VIRGINS NAME WAS MARY.

Pl. 62. Noel Rooke: *The Birth of Christ* (Golden Cockerel Press, 1925). 215 × 297

༄ 8 ༄

BOLD BEGINNINGS: NOEL ROOKE
AND HIS EARLY PUPILS

In 1936 Campbell Dodgson noted: 'I have good opportunities (as British Museum Keeper of the Modern Prints collection) of observing how much of the modern progress of wood-engraving is due to Mr. Rooke's skilful tuition.'[1] By this date there were few wood-engravers who had not come under his influence either directly or indirectly. His most distinguished pupils were Robert Gibbings, John Farleigh, and Clare Leighton, but it is the lesser-known ones to emerge from his early classes who will be discussed in this chapter: Vivien Gribble, Ray Garnett, Margaret Pilkington, Mabel Annesley, and Marcia Lane Foster.[2]

Pressure of teaching prevented Rooke from illustrating more than a few books himself, only two of which were significant for their wood-engravings: *The Old Vicarage,* *Grantchester* (Sidgwick & Jackson, 1916) and *The Birth of Christ* (Golden Cockerel Press, 1925). As with the majority of his single prints, the frontispiece for the former is boldly handled in a woodcut-like style, strong contrasts of black and white predominating. Rooke's experimental approach to *The Birth of Christ* shows him grappling with the problem of balancing illustration with text. For example, the figures of Joseph and Mary stand out from the blackness of the full-page block, their faces and hands deeply gouged, while ox and ass in the stable, and stars and the shepherds beyond are merely suggested, their outlines finely tooled; altogether a rather weighty impression in relation to the area of type on the opposite page. In contrast, this bears as a headpiece a small black-line profile of Caesar Augustus with lettering. Cleared white areas around the figures of the Angel Gabriel and the Virgin Mary, who face each other across two pages, produce a feeling of space which is absent from the more solid blocks in the book. The decorative floral arch shares similarities with Pissarro's designs and to a lesser extent those of Morris, to whom Celia Rooke felt he owed much of his meticulousness.[3]

Despite the stress he laid on harmonizing wood blocks with type, Rooke's early pupils tended to admire and emulate his more robust technique, no doubt partly in reaction to the black line or grey tonality of the reproductive engravers. The interaction with his pupils is intriguing. As Howes points out, despite an obvious Rooke workshop style in some of the early work of, for example, Gibbings and Gribble, their range on the

Plate 18
Plates 61–2

Plate 61

Plate 62

[1] Letter of reference to the Central School of Arts and Crafts recommending Noel Rooke for the post of Principal, 11 Mar. 1936. In the possession of Celia M. Rooke. Rooke's lecture to the Print Collectors' Club in 1925, later published as *Woodcuts and Wood Engravings* (London, 1926), gave wider prominence to the subject.

[2] Hester Sainsbury, though not a student, possibly learnt wood-engraving techniques from Garnett and Gribble and was early to enter the field of book illustration. See Ch. 12.6.

[3] Conversation between Celia M. Rooke and the author, 22 Feb. 1983.

whole is immensely varied, reflecting 'the direct artistic expression of the time rather than Rooke's personal style; more the "Central School" rather than "School of Rooke".'[4] In turn, his later, more technically complicated prints were undoubtedly influenced by their work.

Of all Rooke's better-known pupils only Vivien Gribble (1888–1932) evolved a distinctive black-line method, used mainly for book illustration which Bliss described as being of '"gentlemanly" restraint and severity'.[5] After studying at the Slade, she had joined his first wood-engraving class in 1912 together with Gibbings. Of a highly strung and artistic temperament, she was sufficiently talented to be singled out by Rooke in her first year to illustrate *Three Psalms*, produced and printed by Mason. Already she had formulated her individualistic style: a minimalist approach to the medium which gave maximum impact to the text. The stark two-dimensional rocks pierced with parallel-lined shading (page 7), and the jagged profile of enemy swords looming up behind a diagonally striped hill (page 4) are both glaringly expressive designs which match well the extra-large typeface. This is a significant book in that it is the first to be illustrated by a member of the new school of wood-engravers.

Gribble's twelve illustrations for Apuleius's *Cupid and Psyche* (1916), translated by Mason, are more assured than her earlier work.[6] Perspective is flattened as in a frieze, the formal black-line figures in a classical setting, posed yet not static. Judith Butler likens them to those on a Greek vase, 'since they are certainly not overtly derivative, but they have the same quality of frozen action, which gives them a certain tension'.[7]

In 1919 Gribble contributed three wood-engravings to the second volume of *Change*.[8] Her strong sense of design and symmetry is evident from *Pastoral*—a scene of a mother holding her child in a cornfield. Gribble's incisive cutting reveals a sureness of touch, her feeling for pattern displayed in a variety of toolmarks: unbroken horizontal lines for the sky, short flecks for stubble, and fine erect strokes for the corn stooks which effectively frame the lighter figures.[9]

Not only did Campbell Dodgson consider her work important enough to include in *Contemporary English Woodcuts*,[10] he also asked her for a cover design—a clear-cut, decorative motif which worked well with the lettering above. Further illustrative commissions followed from Duckworth, for *Sixe Idillia of Theocritus* (1922), John Keats's *Odes* (1923), and Tennyson's *Songs from The Princess* (1924). The most distinctive feature of *Sixe Idillia* are the frieze-like black-line headpieces which span two pages. Appropriately classical in spirit, they balance well with the early Venetian-style typeface. For the *Odes*

Plate 63

Plate 64

[4] Justin Howes, 'A Teacher Taught', in exhibition catalogue, *Noel Rooke, 1881–1953* (Oxford: Christ Church Picture Gallery, 22 Oct. 1984), unpaginated. A large portfolio of the work of some of Rooke's pupils was exhibited.

[5] Douglas Percy Bliss, *A History of Wood-Engraving* (London, repr. 1964), 225.

[6] Publication of the book, which was planned as early as 1910, was withheld until the Arts and Crafts Exhibition Society's exhibition in Nov. 1935, three years after the artist's death. Intended 'as an example of book printing for the love of the work, for the printer and his friends', only about 130 copies were printed.

[7] Judith Butler, 'Vivien Gribble, 1888–1932: An Under-Rated Illustrator', *Private Library*, 4 (1982), 119–35, p. 123.

[8] Herbert Simon, *Song and Words* (London, 1973), 149, mentions Gribble's wood-engraving for the Decoy Press, *A Book of Vision* (1919), a miniature book measuring 5" × 3¾".

[9] This and other prints which appeared in the *Studio* (1919) were particularly admired by Mason in a review in his Book Notes for *London Mercury* (Feb. 1920).

[10] No. 9, *Rabbits in the Corn*, and No. 10, *Milking*.

all evil : he shall preserve thy soul.
The Lord shall preserve thy going
out and thy coming in from this
time forth, and even for evermore.

I CRIED UNTO THE LORD WITH MY VOICE; WITH MY

voice unto the Lord did I make
my supplication. I poured out my
complaint before him ; I shewed
before him my trouble. When my
spirit was overwhelmed within
me, then thou knewest my path.

7

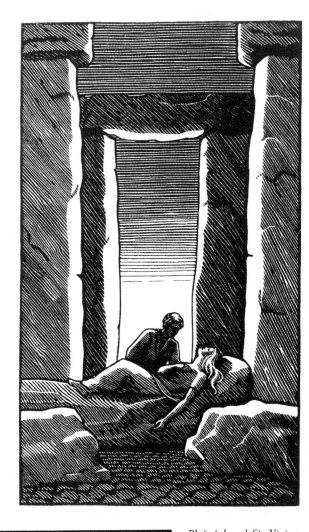

Goe to, and feede apace, and al your bellies fill,
That part your Lambes may haue, and part my milking paile.
Then Daphnis in his turne sweetly began to sing.

DAPHNIS

And me not long agoe faire Daphne wistle eide
As J droue by, and said J was a paragone ;
Nor then indeede to her I churlishlie replide,
But looking on the ground, my way stil held J one.
Sweete is a cowcalfes voice, and sweet her breath doth smell,
A bulcalfe, and a cow doe lowe ful pleasantlie ;
Tis sweete in summer by a spring abrode to dwell,
Acornes become the Oke, apples the Appletree,
And calfes the kine, and kine, the Netcheard much set out.
Thus sung these Yuthes ; the Gotehearde thus did ende the dout.

GOTEHEARD

O Daphnis, what a dulcet mouth, and voice thou hast !
Tis sweeter thee to heare, than honie-combes to tast.
Take thee these pipes, for thou in singing dost excell.
Jf me a Gotehearde thou wilt teach to sing so well,
This broken horned Goate, on thee bestowe I will,
Which to the verie brimm, the paile doth euer fill.

24

So then was Daphnis glad, and lept, and clapt his handes,
And danst, as doth a fawne, when by the damm he standes.
Menalcas greeud, the thing his mind did much dismaie,
And sad as Bride he was, vpon the marrige daie.
Since then, among the Shepeheards, Daphnis chiefe was had,
And took a Nimphe to wife, when he was but a lad.

DAPHNIS his Embleme. MENALCAS his Embleme.
Me tamen vrit amor. *At haec Daphne forsan probet.*

GOTEHEARDES Embleme.
Est minor nemo nisi comparatus.

25 0

Pl. 63 (*above left*). Vivien
Gribble: *Three Psalms*
(Central School of Arts
and Crafts, 1912). 381 × 255.
© Central Saint Martins
Art and Design Archive

Pl. 64 (*left*). Vivien
Gribble: Theocritus, *Sixe
Idillia* (Duckworth, 1922).
300 × 428

Pl. 65 (*above right*). Vivien
Gribble: Thomas Hardy,
Tess of the d'Urbervilles
(Macmillan, 1926). 162× 97

white line is used for textures and shading to a greater extent than in the earlier book, while the figures are livelier and more mobile. Gribble was intrigued by Isadora Duncan's free dancing style, owning various books on the subject and practising in the garden. The sprightly headpiece of a girl in a loose flowing robe dancing between two children in pixie-like garments may well have been inspired by this interest. Her attempts at figures in modern dress are mildly comical, as can be seen from the illustration to Tennyson's 'Ask Me No More', in which the 1920s-style suit and trilby of the young man talking over the gate contrasts oddly with the more classical costume of the other characters she depicts. As Butler so rightly suggests, 'the timeless, idyllic quality which is Vivien Gribble's hallmark is lost: the incongruity jars'.[11]

Hardy's *Tess of the d'Urbervilles* (Macmillan, 1926), Gribble's largest illustrated work, is arguably her masterpiece. The book contains forty-one wood-engravings, largely head- and tailpieces, and several full-page prints, all enclosed in rectangular frames, unlike most of her previous work which was generally free of boundaries. Although measuring the same width as the text, they tend to print rather too heavily in relation to the type. They are more naturalistic in treatment than her previous illustrations, which the pastoral setting of the narrative clearly demands, yet there remains a decorative element, as in the sensitive illustration of Tess lying in the grass contemplating the water. Such stylization creates an appropriate feeling of *angst* especially in the more dramatic scenes *Plate 65* like *Stonehenge*, where Tess, sprawled on the stones in the shadow of the monument, is anxiously watched over by Angel Clare. The characters resemble Vivien and her husband and, according to Butler, the tensions between them were genuine. In this respect these illustrations are all the more poignant, especially that of Tess the milkmaid with her cow at the water's edge sadly resisting Mr Clare's advances, although their rigid demeanour is somewhat dispassionate. The book was warmly received by the critics (though many presumed the artist to be male), Squire noting in the *London Mercury* of July 1927 how much finer and more under command her line had become, and welcoming her use of white line as well as black.

In a remarkably short time Gribble perfected her particular style of engraving, which, unlike Gill's hard-edged and precise black line, possessed a fluid and lively quality. It was never frigid. Yet, at the same time, her limited technique and narrow range of images prevented her from exploiting the outline method to the extent that Gill did, using it decoratively around the text for a more effective *mise en page*. None the less her early work has an immediacy and originality lacking from many of her later illustrations. Gribble exhibited ten prints between 1921 and 1925 with the Society of Wood Engravers, though for some reason she was never invited to become a member.[12]

Ray Garnett (1891–1940, *née* Rachel Marshall), Gribble's close friend and contemporary at the Central which she also joined in 1912, was neither a member of nor an exhibitor

[11] Butler, 'Vivien Gribble', 130.
[12] Ibid. 125; Butler suggests that this may have been because she was thought to have given some financial support to the publication of her work.

with the society.[13] Rooke took a special interest in her work, introducing her to Chatto & Windus who in 1913 published *The Happy Testament* containing her coloured line drawings. In the same year she produced a wood-engraving of a young girl in a hat, together with three hand-coloured drawings, for a Central School publication, *The Vulgar Little Lady*.[14] Further wood-engravings printed in blue appeared on the title-page and after the colophon in *Archibald*, another student production of 1915. For Chatto & Windus she illustrated her own children's story, *A Ride on a Rocking Horse*, in 1917. Her eye for design can be seen in the subtle coloured drawings (sensitively printed by Edmund Evans), a small wood-engraved roundel of a fritillary on the title-page, and the daisy-patterned endpapers.

Ray's marriage to David Garnett in March 1921 brought her into contact with his Bloomsbury circle of friends. Breakthrough into the wider public domain came the following year with the publication by Chatto & Windus of David's novel, *Lady into Fox*, with illustrations by Ray. The book became a best-seller both in Britain and America, having reached its seventh impression by 1924. No other commercially published book with modern wood-engravings had ever achieved such popularity. A collaborative effort, the illustrations, which are entirely in keeping with the narrative, greatly contributed to this success. David Garnett had sent the typescript for the story (designed to be illustrated with twelve of Ray's wood-engravings) to the publisher on 28 June 1922.[15] On 1 August he enclosed a list of the blocks with particulars as to where they should appear in the text and their measurements (all 3" wide except one intended for a single page), indicating the size the type should be on the page. It is symptomatic of the enlightened attitude of the art editor, Geoffrey Whitworth, that these instructions were adhered to, the result being an unusually well-produced book for a commercial publisher at this time.

The frontispiece and title-page are especially effective and well balanced as a double-page spread. A rectangular full-page block depicts Mr and Mrs Tebrick standing rather formally before the fireplace, their elbows on the mantelpiece, a dog stretched out on the rug at their feet. Rooke's teaching is evident in the loose handling and tendency towards black, yet the white line is finely worked, with delicate patterning on the wallpaper and other furnishings. Already Ray Garnett's capacity to capture facial expressions with minimal lines shows, particularly in the quizzical gaze of Mr Tebrick and his wife's soulful look. The title-page is a notable feature of the book. Framed in a narrow Renaissance-style patterned border, a small vignette of the couple beside a gate rests comfortably beneath the titling. Head- and tailpieces and mid-page illustrations are scattered throughout the book, several depicting Mrs Tebrick in the guise of a fox,

Plate 66

[13] For a thorough investigation of her work see J. Lawrence Mitchell, 'Ray Garnett as Illustrator', *Powys Review*, 10 (1982), 9–28. Unless otherwise noted, all correspondence referred to is quoted from this article on which the present author has drawn heavily.

[14] The second version was published as a supplement to *The Imprint* (Apr. 1913). The third appeared in Harold Monro's Poetry Bookshop Rhymesheets No. 7.

[15] According to his autobiography, *The Familiar Faces* (London, 1962), this book was inspired by an outing in the country with Ray looking for fox cubs. Mitchell, 'Ray Garnett', 15, suggests that it may have been an edition of Ovid's *Metamorphoses* with woodcuts by Geoffrey Tory, given to Garnett by his wife, which was the inspiration to write and illustrate *Lady into Fox*.

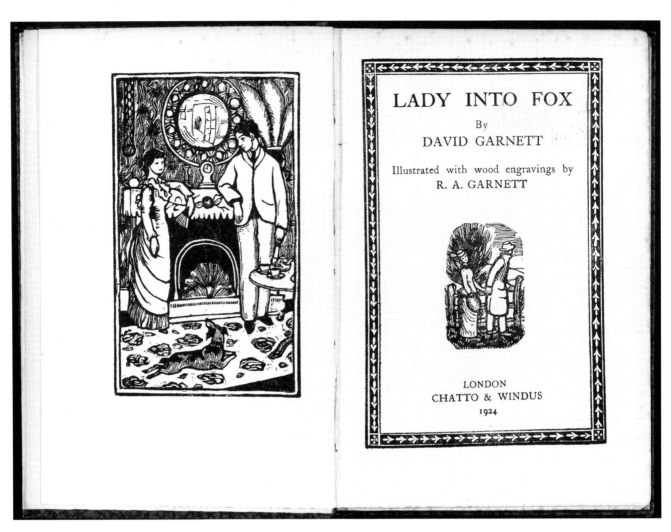

Pl. 66. Ray Garnett: David Garnett, *Lady into Fox* (Chatto & Windus, 1922). 188 × 248

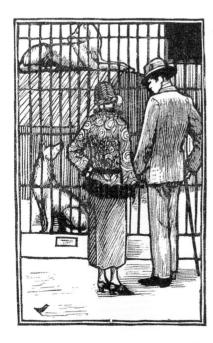

Pl. 67. Ray Garnett: David Garnett, *A Man in the Zoo* (Chatto & Windus, 1924). 126 × 80

Pl. 68. Ray Garnett: David Garnett, *The Grasshoppers Come* (Chatto & Windus, 1931). 121 × 82

Pl. 69. Ray Garnett: T. F. Powys, *Black Bryony* (Chatto & Windus, 1923). 124 × 78

chasing ducks and rabbits or sitting on chairs, heartfelt rather than absurd as is the novel. Especially decorative is a single-page scene of the little girl Polly in pinafore and bonnet looking up at the fox on the branch of a tree, the rounded edges of the grass and the pendulous branches forming an oval shape, happily freed from any hard rectangular frame. The design in many ways anticipates Raverat's *Olga in the Tree* for *The Runaway.* *Plate 90*

With a few exceptions, Ray worked almost entirely for Chatto & Windus, largely contributing to further novels by her husband.[16] In *A Man in the Zoo* (1924) a full-page rectangular wood-engraving shows a couple nonchalantly watching two caged dingos, *Plate 67* their dress and stance instantly evoking the period. Garnett's use of white line throughout the book is here more assured. Her little endpiece of lovers walking through the park is one of her most appealing illustrations. In 1925 she designed a frontispiece (which appeared also on the dust-jacket) for *A Sailor's Return*—an expressive bare-breasted black woman anticipating Farleigh's *Black Girl* illustrations.[17] *The Grasshoppers Come* (1931), a flying book, includes dramatic scenes of an aeroplane crashing into a gulley, and the *Plate 68* silhouetted figure of the pilot, covered with swarming locusts, watching his plane burn. Such macho images were rare amongst wood-engraved illustration of the period.

As well as illustrating her husband's books, Ray Garnett produced designs for several works by T. F. Powys.[18] Correspondence in July 1923 reveals a commission from Whitworth for five full-page 'woodcuts' for *Black Bryony* which she accepted in August and completed by 3 October.[19] Her acute emotional sensitivity is evident from these illustrations which effectively describe the feelings of the characters and the drama of the narrative, often emphasized by a dark and menacing style, as in the scene of silhouetted figures watching as 'a tall figure, burning like a torch, came out of the house on to the lawn'. Powys was pleased with the wood-engravings and the general appearance *Plate 69* of the book. In 1924 Garnett wrote to Chatto & Windus saying she would like to illustrate Powys's *Mr Tasker's Gods* for which only a dust-jacket of pigs in a farmyard was commissioned. Pigs featured also in a frontispiece to Powys's *The Key of the Field* (1930), the first issue of William Jackson's Furnival Books, a signed and limited edition which set the pattern for the rest of the series.

Ray Garnett's output was small but extraordinarily competent and original for the early 1920s. She has been greatly underrated, having been completely ignored by Garrett and many other critics. Though small, her output of wood-engraved illustration was expressive and witty, sensitive but never sentimental. Admittedly her style did not develop much, but this was probably due to the constraints in her life. By 1931, owing to family commitments, she had ceased to illustrate. She succumbed to illness in the late 1930s and died in 1940. She deserves to be better known, particularly for her pioneering contribution to commercial publishing, having produced wood-engraved illustrations

[16] For the Nonesuch Press she produced 8 coloured line drawings for *The Book of the Bears* (1926).

[17] See Ch. 9.

[18] For Chatto & Windus she also designed a wood-engraved oval vignette of a teapot and cups for the title-page for Sylvia Townsend Warner's *The True Heart* (1929).

[19] Whitworth to Ray Garnett, [? July] 1923. From publisher's Letter Book, Chatto & Windus Archives, RUL.

for a best-seller ten years ahead of John Farleigh. Certainly her contribution to the revival of the medium was of vital importance.

Margaret Pilkington (1891–1974) joined Rooke's class in 1914.[20] She was noticeably more influenced by his teaching than were her contemporaries,[21] yet equally affected by Lucien Pissarro, as a letter from him reveals:

> Of course I am glad you think that I have influenced you, but I did not teach you to engrave which Noel Rooke did, therefore you really are his pupil even if your work is more congenial to mine—You see there is a great difference between being the pupil of an artist and being influenced by an artist. . . . All the same I am flattered that I should have inspired such a talented student, tho' I have seen you so very little.[22]

As early as 1915 she had shown Pissarro some early wood-engravings for his comments. He responded:

> I must say I was quite surprised at your rapid progress—I mean in the cutting—for I already knew your drawing was sometimes very good. . . . I detect in your woodcuts very few of those accidents that genuinely happen to beginners. . . . I like your 'Wilderness Spirit' very much, specially the black cats. They are full of life and movement . . . both realistic and very decorative, whereas the figure is rather too much of an academic convention.[23]

In 1924 she sent Rooke proofs of her first illustrations in book form for his advice. These were to accompany her father Laurence Pilkington's *An Alpine Valley and Other Poems* (Longmans Green, 1924), a subject after Rooke's own heart.[24] He particularly admired the frontispiece of mountain scenery entitled 'What called me to the Height' which he felt had much character. Not unnaturally his influence is evident in its robust, woodcut-like appearance, as it is in a similar frontispiece scene for Katherine Chorley's
Plate 70 *Hills and Highways* (Dent, 1928). Rooke's lengthy discussion on her treatment of the initials for *An Alpine Valley* is more interesting for its disclosure of his ideas on the subject and for his powers of description than for the attention he draws to her mistakes. He mentions particularly page 13, *Noonday*, and page 66, *Voices*, as being in serious trouble

because the N and V are both pure initial letters put on to do quite other work for which they are unsuited. . . . An initial calls attention to itself as the first of the army of letters so that you can know where to begin, & begin in grand style. But the moment it is left alone without the great body of text to which it is head, it is like a general whose army has deserted him—run away, & left him disgraced with only a few staff officers left behind to make it more marked. But if you take an initial letter and use him as part of a title, he is like a Field Marshal in an army which has never consisted of more than seven bandsmen. Quite seriously, the black space after

[20] See David Blamires and Patricia Jaffé, *Margaret Pilkington, 1891–1974*, with catalogue of engraved work by Sarah Hyde (Buxton, 1995).

[21] A letter to Pilkington shows the lengths to which Rooke would go to help his pupils. In answer to a printing enquiry he recommended an Albion as the best press (the same as she used at the Central) or a Reliance. He gave details of the platens of both with hand-drawn diagrams and suggested she read Jacobi's

Printing or Southward's *Practical Printing*. Noel Rooke to Margaret Pilkington, 1 Dec. 1916. MPA.

[22] Lucien Pissarro to Margaret Pilkington, 10 Nov. 1919. MPA.

[23] Lucien Pissarro to Margaret Pilkington, 19 Jan. 1915. MPA.

[24] As a keen mountaineer, Rooke's intimate knowledge of mountains and their structure resulted in some complex wood-engravings and cuts, some in colour, as well as some water-colours.

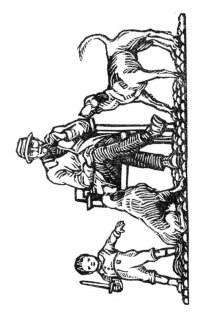

AN ENGLISH HUMORIST

LATE one afternoon in the autumn of 1860, Edwin Waugh, the Lancashire poet, and a friend of his, who were tramping in the Lake country, set out from Gatesgarth at the foot of the Honister Pass to walk over Scarf Gap and Black Sail to Wasdale. They had intended hiring a guide, but none were at liberty, so they undertook this adventurous passage by themselves, were caught by mists and heavy gusts of rain, waded the Liza and the boggy ground in the bed of Ennerdale, toiled up Black Sail and finally, wet through but greatly relieved at the safe termination of their adventure, walked in at the kitchen door of the Huntsman's Inn at Wasdale Head just as night was blotting out the huge mountain forms enclosing the valley. The warm room, scented and misty with tobacco smoke and half revealed by fire-flames gleaming through the haze, must have seemed extraordinarily hospitable to these late comers. A maid was about to set candles on a long table for supper ; and

142

Pl. 70 (*above*). Margaret Pilkington: Katherine C. Chorley, *Hills and Highways* (J. M. Dent, 1928). 115×88

Pl. 71 (*right*). Margaret Pilkington: Katherine C. Chorley, *Hills and Highways* (J. M. Dent, 1928). 185×127

the letter under -OONday and -OICES does not do. It is not structural. Anybody with a knowledge of book structure would agree. The whole of a title of head piece must be planned as one thing.[25]

He goes on to describe and illustrate with small ink diagrams how best to arrange the initials in the titles, advice which is duly taken.

In this book Pilkington employs a variety of styles. An animated design of a family group crowded on to a seat in a train carriage translates a scene from the poem 'Bank Holiday'. Her powers of observation are apparent from several sketchbooks containing competent drawings and watercolours of rock formations, mountain scenery, farmyard scenes, and country people, often in regional costume—source material for many of her prints.[26] An ability to capture the personality of rural characters can be seen, for example, from various headpieces for *Hills and Highways*, notably one for an essay entitled
Plate 71 'An English Humorist'. Other similarly unframed illustrations harmonize with the light-weight type more successfully than do the rectilinear head- and tailpieces. Forceful use of black and white, a feeling for light and shade, and loose handling are all hallmarks of Pilkington's wood-engravings which are not always as successful for book illustration as for single prints where her decorative skills, so admired by Pissarro, are often more apparent.

Lady Mabel Annesley (1881–1959) acknowledged her debt to Margaret Pilkington (ten years younger than her) when in later life she wrote: 'I was a very untrained 40 when I began [wood-engraving] and you and Noel Rooke were uncommonly good to me.'[27] Her late start was due to the fact that she had inherited an impoverished family estate in Northern Ireland which she attempted to manage single-handedly after the death of her husband—a background vividly portrayed in her unfinished autobiography, *As the Sight is Bent*, published posthumously in 1964 and containing many of her earlier wood-engravings. In it she described the thrill of discovering wood-engraving at the Central where she studied from 1920 to 1921 under 'a delightful man called Rooke':

The clean cut of graver and scoop of gouge across the grain of wood gave a sensation of complete joy that no stroke of burin had ever given. . . . I realized, when I began to decorate a book, that it was not only illustration and decoration: it was something functional that had to be accomplished.[28]

'Of the moderns', she wrote, 'Paul Nash has seemed to me the person with the most to say.' Several of her wood-engravings such as the dynamic, two-dimensional landscape
Plate 72 on page 37 reflect his influence. The work of David Jones also impressed her.[29]

Annesley illustrated only three books, her first in 1924 for Duckworth entitled *County Down Songs*, appropriately written by her fellow countryman Richard Rowley. A large rectangular frontispiece of mountains and a lake is handled in a characteristically

[25] Noel Rooke to Margaret Pilkington, 24 Oct. 1924. MPA.
[26] Held in the MPA.
[27] Mabel Annesley to Margaret Pilkington, 20 Sept. [?]. MPA. See exhibition catalogue, *The Collected Works of the Lady Mabel Annesley, 1881–1959*, Nelson (New Zealand: Bishop Suter Art Gallery, 1981).
[28] Mabel Annesley, *As the Sight is Bent* (London, 1964), 20.
[29] Ibid. 124.

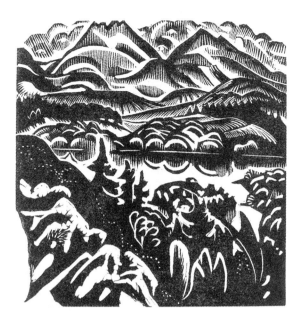

CLANAWHILLAN

I've got a farm, an' a score o' sheep
An' a barn that the brown hens lays in,
A fine thatched house, an' a mountain-side
Wi' forty acres o' grazin'.
I've an oul' spavined mare, an' a rickety trap,
An' I owe no man a shillin',
Say, will ye come for a farmer's wife
Up to Clanawhillan?

26

Pl. 72 (*above*). Mabel Annesley: *As the Sight is Bent* (Museum Press, 1964). 110 × 107

Pl. 73 (*right*). Mabel Annesley: Richard Rowley, *County Down Songs* (Duckworth, 1924). 210 × 165

Pl. 74 (*below*). Mabel Annesley: Richard Rowley, *Apollo in Mourne* (Duckworth, 1926). 208 × 326

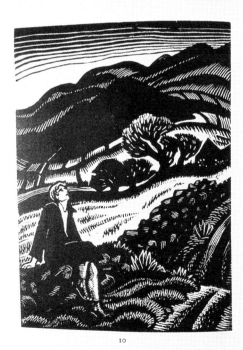

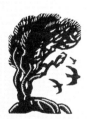

SCENE II

Late Autumn Twilight—A road in the Mourne Mountains.
Apollo is leaning against the stone dyke that borders the road. He
wears above his robes a long shabby frieze overcoat, which reaches
to his heels. His feet are stuck into a pair of rough country boots.
A very old hat is pressed down on his golden hair.

APOLLO Surely this dark country
Is far enough removed from high Olympus
That I can curse old Jove with unreined tongue
For planning such an exile. Curses on him,
May he turn mortal, suffer from old age,
Have rheumy eyes, a toothless mouth, racked limbs
Twisted with endless pains. Juno deceive him,
And when he goes a-wooing on the sly
May all the golden girls reject his love
And laugh him into madness. Curses on him,
Only his malice could invent this land,
These barren hills, these roads befouled with mire,

10 11

Plate 73

vigorous fashion; head- and tailpieces are mostly bordered with a black line. These images all convey her enjoyment of shapes and marks as in that for 'Clanawhillan' where the structure of the landscape has been formalized: angular farm buildings perched on a hill, bare branches, and textured wall and fields—a patchwork of pattern. A small tailpiece of a black and white cow sitting on a mound of grass is reminiscent of Gibbings's silhouette prints. Annesley had studied briefly at Frank Calderon's School of Animal Painting. Her depiction of animals, particularly dogs and horses, is both naturalistic and humorous.

Plate 168

In 1925 she produced eighteen blocks for the Golden Cockerel Press *Songs from Robert Burns*. Here again rectangular shapes are mostly used, her sturdy technique creating a woody effect. The dramatic element of Burns's songs is skilfully interpreted, particularly through facial expression and gesture, anticipating Iain Macnab's striking illustrations to Burns's *Tam O'Shanter* (1934).

Plate 74

Richard Rowley's one-act play *Apollo in Mourne*, published by Duckworth in 1926 with Annesley's illustrations, was in a similar format to *County Down Songs*. The familiar Mourne mountains feature more than once, in the frontispiece and in the background to a single-page print of Apollo leaning against a stone dyke bordering the road. The artist's understanding of Irish characters and domestic life is evident in 'McAleenan's Pub' showing Mary Blane washing glasses in a large bowl on the table.

By 1931 Annesley was already in great pain from septic arthritis and was having a problem with holding the tools. Undaunted, she arranged for Lawrence, the block maker, to construct some tools with cork handles to make them easier to hold.[30] Annesley was a brave woman who suffered great personal hardships in her early married life, discovered wood-engraving late, and then had a possible career cut short through ill health. Yet in the space of ten years she produced a small quantity of highly original and inventive work.

Fellow Ulsterman, Edward O'Rourke Dickey (1894–1977), engraved in a very similar vein and, although not a pupil of Rooke, deserves mention at this point. He is the least well known of the founder members of the Society of Wood Engravers to whose exhibitions he contributed regularly up till 1924.[31] Of the few books he illustrated Richard Rowley's *Workers* (Duckworth, 1923) includes wood-engravings. As with his single prints, these display a modernist approach to the medium: massed black and white areas, purposeful tool effects of gouging, parallel lines, dots, and other patterning. The lighting effects and emotional content also reveal Dickey's sense of drama, most especially in 'Machinery', where a woman covers her face to hide the grim spectacle of a ghost-like black figure carrying a coffin. The powerful industrial view on the cover represents a rare example of social commentary in contemporary wood-engraved illustration. His work was reproduced in journals, including *Drawing and Design* (April 1921) to which he contributed a Sickert-like theatre scene.

Plate 75
Plate 76

[30] In a diary entry for 20 Feb. 1931, Pilkington mentioned that Annesley was at work on blocks for a book by Enid Clay but the present author has found no record of any illustrations. MPA.

[31] During 1939–45 Dickey was Secretary to the War Artists' Advisory Committee.

Pl. 75. Edward O'Rourke Dickey: *Machinery* from Richard
Rowley, *Workers* (Duckworth, 1923). 64 × 76

Pl. 76. Edward O'Rourke Dickey: Cover for Richard Rowley, *Workers*
(Duckworth, 1923). 262 × 198

I

 T was a bland, sunny morning of a mediæval May,— an old-style May of the most typical quality ; and the Council of the little town of St. Radegonde were assembled, as was their wont at that hour, in the picturesque upper chamber of the Hôtel de Ville, for the dispatch of the usual municipal business. Though the date was early sixteenth century,

B

Pl. 77 (*left*). Marcia Lane Foster: Kenneth Grahame, *The Headswoman* (Bodley Head, 1921). 189 × 126

Pl. 78 (*below, left*). Marcia Lane Foster: Anatole France, *The Merrie Tales of Jacques Tournebroche* (Bodley Head, 1923). 108 × 76

Pl. 79 (*below, right*). Celia Fiennes: Matthew Stevenson, *The Twelve Moneths* (Cresset Press, 1928). 154 × 95

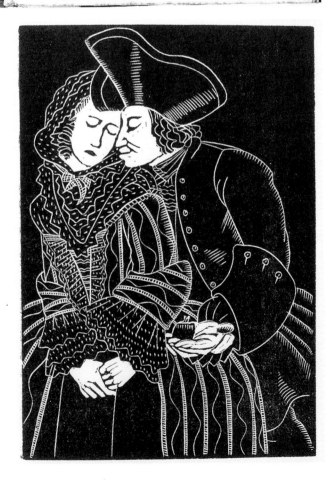

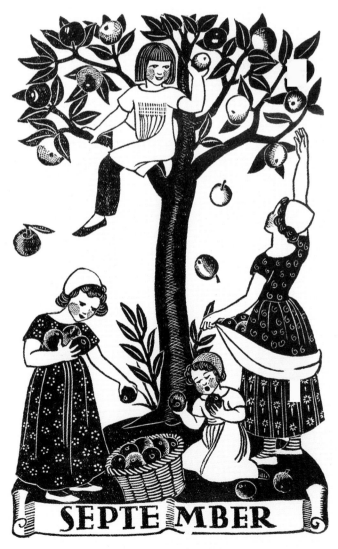

SEPTEMBER

A pupil from the Rookery who has received little attention, apart from her drawings of children used often for advertising, is Marcia Lane Foster (1897–?). Of her many illustrations, especially those of the 1950s and 1960s, most were line drawn. Yet, like Ray Garnett, she was ahead of the commercial publishing field with her wood-engraved designs for Kenneth Grahame's *The Headswoman* (Bodley Head, 1921). Appropriately for a story set in a small French town in the sixteenth century, her pictures are engraved in a medieval woodcut style. Framed rectangular headpieces and initials present a *Plate 77* chapbook-like appearance, the comical gestures of the figures in keeping with the nature of the text. Unusually some whole-page images in square format are coloured with mechanical tints.

Lane Foster's most original wood-engraved illustrations appear in Anatole France's *The Merrie Tales of Jacques Tournebroche* (Bodley Head, 1923). Furst considered these to be *Plate 78* 'aesthetically superior to the realistic black and white half-tone cuts by which she was represented in the "Contemporary English Woodcuts"'.[32] He called them 'white contour prints' since they are predominantly black with finely engraved outlines. Faces and hands of figures are generally cleared, and sparing use is made of white line for textural details. As in *The Headswoman* Lane Foster brings out the flavour of the period in the contemporary costumes, often rich in pattern. Her sense of humour suits the earthy texts.

A pupil of Rooke, Celia Fiennes (b. 1902), whom he married in 1932, was one of the earliest Golden Cockerel illustrators with her sprightly black silhouette wood-engravings for *The Fables of Aesope* (1926). Her output was small, twelve whole-page designs for the Cresset Press *The Twelve Moneths* (1928) being the most successful, as seen from the 1920s-style scene for 'September'. *Plate 79*

For all its vitality the work of Rooke's early pupils was not seriously taken up by commercial publishers until the 1920s—the time it took for the trade to acknowledge wood-engraving as a viable method of illustration. With the exception of Gribble's black-line style, all these artists shared a common language. In the excitement of discovering a new creative medium they and their contemporaries did not always heed Rooke's advice to think in terms of the weight of the type. But with experience and the growing awareness of publishers and printers, this problem was largely resolved by the end of the decade.

[32] Herbert Furst, *The Modern Woodcut* (London, 1924), 226.

JOHN FARLEIGH: EARLY WORK

While Rooke played a quiet and persistent role in the development of wood-engraving between the wars, John Farleigh's vociferous proselytizing was equally effective. As a teacher in the Central School's Book Production department,[1] he was respected and influential; as a designer, painter, wood-engraver, and book illustrator, his artistic talents were widely known; as a prolific writer and broadcaster on design, craft, book production, and illustration, and author of the classic autobiographical textbook, *Graven Image*, his personal views were well publicized.[2] Yet, although one of the few wood-engravers to articulate his thoughts on the subject to such an extent, his illustrative work has been only summarily discussed by other writers.[3] The following survey of salient books reveals how his method varied according to the nature of the commission, gradually evolving towards a more idiosyncratic approach in the mid-1930s. More essentially, it indicates the role he played in popularizing wood-engraving through commercial book illustration.

Farleigh was born in London in 1900 and remained passionately fond of the city all his life. For five years from 1914 he was articled as an apprentice to the Artists Illustrators Agency in Balham, at the same time studying drawing at evening classes at the Bolt Court School life classes. Between odd jobs at Balham he learnt, among other things, lettering, wax-engraving, typing, map construction, and black and white drawing for press advertisements. Here he acquired the habits and pleasures of a craftsman and the love of materials: 'the smell of printing ink and oil; the noise and chatter of printing presses' and the 'feel' of tools.[4] Before finishing his apprenticeship he was called up in 1918 to serve in the Army for six months. With the help of a government grant he started in the following September to study full-time at the Central under Bernard Meninsky, Rooke, and James Grant. Rooke introduced him to wood-engraving whilst Meninsky strongly influenced his figure drawing style.

In *Graven Image* Farleigh acknowledged his debt to Rooke and the conducive atmosphere for wood-engraving which he created both within and outside the school. His first attempt, a striking white-line self-portrait, was extraordinarily competent. Subsequently he evolved a method for beginners based on his early efforts that incorporated knowledge of tool work and freedom of drawing.[5] After his third block, Farleigh did no

[1] After many years in the department he followed Rooke as head in 1947.

[2] Official appointments included Chairman of the Arts and Crafts Society (1940–6), Fellow of the Royal Society of Painter-Etchers and Engravers (1948), and Chairman of the Crafts Centre of Great Britain (1950–64) which he was largely responsible for founding in 1946.

[3] Monica Poole gives the fullest account in *The Wood Engravings of John Farleigh* (Henley-on-Thames, 1985).

[4] John Farleigh, *Graven Image* (London, 1940), 18–19. Unless otherwise stated all quotations cited are from this book.

[5] Much of this technical information was included in *Graven Image*. His manual *Engraving on Wood* was published by the Dryad Press in 1954.

more engraving for two years. He spent from 1922 to 1925 as an assistant art instructor at Rugby School before returning to the Central to teach antique and still life drawing.[6]

As a teacher he continued in Rooke's tradition of technical and experimental development. Like him, his approach to book illustration was intellectual, based on his wide knowledge and love of literature and illustrated books, particularly those of Hogarth, Cruikshank, Doré, and Bewick and followers. Monica Poole, a pupil, recounts how he urged his students to read widely and to study all forms of art, in the belief that a book illustrator must be a cultured person.[7]

Farleigh did not only confine his work to small-scale wood-engravings for book illustration. He recognized the importance of producing large single prints and felt that the limitations of the medium must always be strained before any real progress could be made. Through independent prints such as the magnificent *Hemlock* (1928), 'I have', he considered, 'made all my discoveries and felt my way to a freedom and invention that needs but little adaptation to be absorbed into my bookwork.'[8]

His first illustrating commissions came from private presses: initially in 1925 for the Golden Cockerel via an introduction to Gibbings arranged at the Central by Rooke.[9] (Of outside artists only John Nash and Gill had so far illustrated under Gibbings's regime). Since Farleigh's suggestion of *Pilgrim's Progress* was deemed unmarketable,[10] and another book, *Gulliver's Travels*, was already allotted to David Jones, Jonathan Swift's *Selected Essays* were chosen instead.[11] The blocks were to be about two inches square and Gibbings apologized for not being able to pay more than four guineas for each. Despite signs of technical ineptitude these illustrations are remarkably assured for such early work. It is no coincidence that the small scenes bear such a resemblance to those by Nash for Swift's *Directions to Servants* published by the press the previous year. In both books the bi-columnar page was used (according to the press bibliography, probably a retrograde experiment), hence the small type which appears lightweight in relation to the inevitably darker blocks. Although there are stylistic similarities, technically Farleigh's use of white line is more assertive. Both artists' satirical treatment, their purposeful naïvety and exaggerated facial expressions and gestures, are apposite to Swift's archaic language. *The Scold*—a woman scattering the crowd with the stamp of her foot—is full of movement and foreshadows Farleigh's lively interpretations of Shaw's works. With the tailpiece entitled *Meditation on a Broomstick* he shows signs of overcoming earlier technical inexperience, the introduction of a black-line figure anticipating his next phase. As is common in his work, these little illustrations are packed with action, texture, and pattern, with no attempt at symmetry. Farleigh admits to having no conscious working method with this first book, having 'made the *Plate 80*

[6] He first exhibited in 1925 when he became an associate member of the Society of Wood Engravers, at the same time joining the English Wood Engraving Society.
[7] *The Wood Engravings of John Farleigh*, 7.
[8] Farleigh, *Graven Image*, 195.
[9] Gibbings had admired Farleigh's wood-engraving of a negress which he had shown at the SWE exhibition.

[10] See n. 29.
[11] Two volumes were planned but as 400 of the first volume were destroyed by storm damage, the second volume had to be cancelled.

engravings, one by one, and dropped them into position in the type and hoped for the best'.[12] He later devised a working formula which he described and advocated in various writings.

Apart from two devices for the 1928 Golden Cockerel Press prospectus, Farleigh did no more book illustration for Gibbings until 1935.[13] As the result of a meeting with Basil Blackwell engineered by Rooke in 1927 he worked almost exclusively for the Shakespeare Head Press up till 1931 illustrating limited editions. Text for the two-volumed *Pindar's Odes of Victory* was printed as a double spread with the translation in Poliphilus type facing the Greek original set in New Hellenic. Newdigate required headpieces to appear on opposite pages at the beginning of each Ode. Farleigh was sent page proofs with spaces left for the blocks. His final illustrations were based on designs for Greek vases which he spent days drawing and studying as source material in the British Museum. These frieze-like drawings in turn inspired him to use black line in imitation of cuts which pleased publisher, printer, and translator. Certainly the simple lines harmonized well with the Greek type while the static figures were appropriately classical in feel.

The regular routine of producing a block a day for Newdigate and clearing it sufficiently for T. N. Lawrence to rout the larger spaces with a machine gave Farleigh an insight into this arduous process.[14] In later years he was slightly apologetic about the 'process of rationalization that made me enthusiastic over black line engraving'. He put it down partly to the influence of Gill's beautiful work for the Golden Cockerel Press, and partly to the purist influence of Mason. Yet he was still prepared to defend the 'architectural quality of a built-up line' even when he had abandoned it himself.

Farleigh considered his designs for *Pindar's Odes* to be decorations rather than illustrations; a subtle distinction based on his belief that poems should be decorative in treatment and implication rather than graphic, as Gribble had shown in her approach to classical poetry. Although Blackwell visualized his illustrations for *The Whole Works of Homer* to be illustrated in the same style, Farleigh felt that the epic nature of the book required a different treatment, with a full-page block to every book of the *Iliad* and *Odyssey*.[15] It was a mammoth undertaking which required five or six weeks' intensive reading for the historical research. Technically the early blocks were not dissimilar from the ones for the Pindar book apart from a little more use of white line for tonal effects. Those for the third volume, however, mark a departure from black line towards richer tones.

A distinctive characteristic of Farleigh's illustrations is the way in which successive incidents are compressed into one scene. In *Homer* several images were divided into geometrical compartments, an effective way of separating the Greek gods from ordinary mortals. In *Graven Image* Farleigh mentioned a metacube theory 'in the air' at the time. This he failed to explain but most probably he was referring to the concept of geometric abstraction apparent in the works of Ben Nicholson and others. Evidently he absorbed

[12] Farleigh, *Graven Image*, 156.
[13] This was for Jack Lindsay's *Storm at Sea*.
[14] He later left all clearing to Beedham.

[15] Five volumes were published between 1930 and 1931 with 51 full-page wood-engravings.

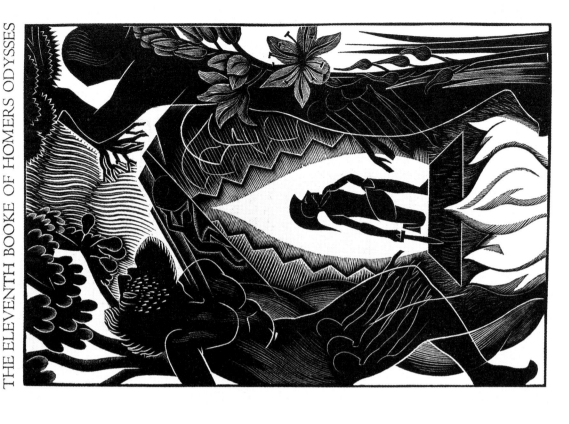

Pl. 8ı. John Farleigh: *The Odyssey: The Whole Works of Homer*, iii
(Shakespeare Head Press, 1931). 176 × 113

¶ "The next sort for whom I would gladly provide, and who for several generations have proved insupportable plagues and grievances to the good people of England, are those who may properly be admitted under the character of incurable scolds. I own this to be a temper of so desperate a nature, that few females can be found willing to own themselves any way addicted to it; & yet, it is thought that there is scarce a single parson, 'prentice, alderman, squire, or husband, who would not solemnly avouch the very reverse. I could wish, indeed, that the word scold might be changed for some more gentle term, of equal signification; because I amconvinced that the very name is offensive to female ears, as the effects of that incurable distemper are to the ears of the men; which, to be sure, is inexpressible. And that it has been always customary to honour the very same kind of actions with different appellations, only to avoid giving offence, is evident to common observation. For instance: how many lawyers, attorneys, solicitors, under-sheriffs, intriguing chamber maids, & counter-officers, are continually guilty of extortion, bribery, oppression,

and many other profitable knaveries, to drain the purses of those with whom they are any way concerned! And yet, all these different expedients to raise a fortune pass generally under the milder names of fees, perquisites, vails, presents, gratuities, and such like; although in strictness of speech they should be called robbery, and consequently be rewarded with a gibbet. Nay, how many honourable gentlemen might be enumerated, who keep open shop to make a trade of iniquity; who teach the law to wink whenever power or profit appears in her way; and contrive to grow rich by the vice, the contention, or the follies of mankind; and who, nevertheless, instead of being branded with the harsh-sounding names of knaves, pilferers, or public oppressors, (as they justly merit,) are only distinguished by the title of justices of the peace; in which single term, all those several appellations are generally thought to be implied. But to proceed. When first I determined to prepare this Scheme for the use and inspection of the public, I intended to examine one whole wardin this city, that my computation of the number of incurable scolds might be more perfect and exact. But I found it impossible to finish my progress through more than one street. I made my first application to a wealthy citizen in Cornhill, common councilman for his ward; to whom I hinted that if he knew e'er an incurable scold in the neighbourhood, I had some hope to provide for her in such a manner, as to hinder her from being further troublesome. He referred me with great delight to his next-door friend; yet whispered me, that with much greater ease & pleasure, he could furnish me out of his own family ——; and begged the preference. His next-door friend owned readily that his wife's qualifications were not misrepresented, and that he would cheerfully

38

Pl. 8o. John Farleigh: *Selected Essays of the Reverend Jonathan Swift*
(Golden Cockerel Press, 1925). 250 × 171

the theory into some of the *Homer* designs but, dissatisfied with them, decided to 'abandon the thrills of geometry' and 'rely on plain drawing and instinctive design'. While none is in any way abstract, they already show signs of a move away from pure representation towards a more symbolic, iconographic statement as, for example, in *Plate 81* his composition for the eleventh book of *The Odyssey*.[16]

In his writings Farleigh frequently refers to the importance of good communication between illustrators, printers, and publishers, a lesson he had learnt and taught early on. Working for Blackwell and Newdigate over a period of four years gave him an exacting apprenticeship that formed the basis of his views on books and wood-engraving. The effort involved designing for expensive limited editions, however, prevented him from embarking on more widely accessible books. An unexpected letter from Bernard Shaw in May 1932, asking him to illustrate his latest book, *The Adventures of the Black Girl in her Search for God*, to be published by Constable, instantly resolved the problem. The phenomenal success of the book, led to a seven-year partnership with Shaw, discussed more fully in a later chapter.[17] *The Black Girl* is one of the most thoroughly documented illustrated books of the period, not only through Farleigh's detailed account of its progress in *Graven Image*, including letters and progressive proofs, but also through subsequent exhibitions and reappraisals.[18] For this reason only the innovative aspects of the book and Farleigh's working methods are investigated here.

The main reason for the success of *The Black Girl* was the extraordinarily harmonious collaboration between Shaw, Farleigh, and the printer, William Maxwell of Clark's of Edinburgh who had originally recommended the artist. Rarely had author and illustrator co-operated so closely to achieve so exactly their joint intentions, Shaw taking a passionate interest in both illustrative and typographical matters. Farleigh, in turn, warmed to the subject and its 'contemporary flavour', a witty and biting satire on Man's evolutionary concepts of the idea of God. In his opening letter Shaw suggested twelve subjects with descriptive details; a unique situation, as Farleigh noted: 'An author had visualized his book as a series of pictures, and that very first problem of the illustrator was done for me.'[19] These subjects he used as a basis, later adding further scenes as 'embellishments'. Anxious to please in the early stages, his preliminary drawings were finished and literal to indicate his final intentions—an uncharacteristic practice since he preferred to work from looser sketches to allow for a more creative interpretation. Shaw's suggested alterations were generally carried out. His comments make amusing reading and Farleigh appreciated his satirical and witty approach: his ideas, for example, on how to prevent Ecclesiastes looking dead and frieze-like and how to depict Christ

[16] With the portrait of Chapman for the frontispiece Farleigh first started rocking a multiple tool although he did not exploit its possibilities for some years. His illustrations to the press's *Bede's History of the Church of England* (1930) were virtual facsimiles of the original woodcuts translated from a photographic image photographed onto the block by Lawrence. In 1934 he engraved a head of Shakespeare (after an early woodcut) for the press's *The Complete Works of Shakespeare*.

[17] See Ch. 13.5.

[18] Much of the primary material is held in the Burgunder Shaw Collection, Cornell University, New York. See William Zeltmann, 'Shaw, Farleigh and a Collection', *Shaw Review*, 4 (1961), 24–8. Selected correspondence is published in *Graven Image* and other publications. Several drawings and proof states of the wood-engravings and Shaw's correspondence with Maxwell are held at HRHRC. The National Library of Scotland hold a trial title-page in the R. & R. Clark Archive.

[19] Farleigh, *Graven Image*, 217.

smiling without having to 'express nothing at all and cover up the failure with a sort of abstract holiness that makes him acutely dislikeable'.[20] Shaw considered himself 'an execrable draughtsman' but 'a skilled and observant stage manager, always on the look-out for the right expression and movement'. He sent rough sketches, occasionally in watercolour, which Farleigh found 'mature and highly skilful in thought and intention; their value to me lay in their intellectual clarity'.[21] Certainly he followed them fairly closely, as in the scene of the girl and old gentleman preventing the 'redhaired' Irishman (Shaw himself) from escaping, the first version of which he altered in accordance with Shaw's instruction to 'keep me young, callow, fair and scared out of my wits. ... I think I must have one leg over the gate; nothing else will give the impression of headlong flight'.[22] As a measure of his increasing confidence, before completing his illustrations in October 1932 Farleigh managed to persuade Shaw to add a few lines to the story to fit into *his* designs on the last page.

Plate 82

The book contains a title-page, two headpieces, four full-page illustrations, and eleven within the text. One of the most unusual features of the book is its decorative cover and repeat-pattern endpapers. The title-page is startlingly innovative: a solid rectangular area relieved with fine stippling and white lines delineating a nude black girl, lion, and totem figures amongst tropical foliage. Thin upper case sans serif lettering stands out effectively from the dark background. This page perfectly sets the scene for the incidents that follow, most of which have been cut away from the rectangular shape of the block. In all of them the girl's blackness contrasts with white areas and varying grey tones and textures. Most blocks are rather too heavy for the light-weight Fournier typeface.

Plate 83

In *Graven Image* Farleigh describes his close involvement with Maxwell for whom he elaborately cut up galley proofs, page by page, line by line, to arrange the layout and size of his blocks. 'I intended my designs to merge into the text; to come into direct contact with the actual paragraph that was to be illustrated. The illustrations were to flow into the text and read on with it.'[23] His highly finished drawings were photographed on to the block, hence the exactness of the final engraving.

The following example shows how Farleigh's illustrations evolved. As a trial effort from Shaw's list, Farleigh chose to illustrate 'Christ posing on the cross for sixpence an hour with the image maker (say yourself) at work, and Mahomet, very handsome, looking on'. Apart from some small changes, the final print is very similar to the trial engraving.[24] The stance and clothes of the earlier artist are altered to appear as a self-portrait with cigarette taken from a photograph.[25] Progressive proofs show how Farleigh began with the main white outlines and textures on the block.[26] In his opinion:

as soon as any doubt occurs about tone values the block should be cleared. It will be seen by these progressions that the tone of the engraving is very different when the background is clear.

[20] Ibid. 236.
[21] Ibid. 240.
[22] Ibid. 242. Shaw's version is reproduced on p. 241.
[23] Ibid. 223. See also James Shand, 'Author and Printer: G.B.S. and R. & R. Clark: 1898–1948', *Alphabet and Image*, 8 (1948), 32–45.

[24] Reproduced in *Graven Image*, 218.
[25] In the possession of the family.
[26] Reproduced in *Graven Image*, 264.

This must be borne in mind from the beginning of the engraving or the work will be engraved too fine, as tones look lighter while the block is solid.[27]

Shaw's text concerning the unabashed exploits of a native African girl, 'a fine creature [with] satin skin & shiny muscles', in her search for God, was daring enough to guarantee popular interest but it was Farleigh's correspondingly *risqué* illustrations, together with the extreme cheapness (2s. 6d.) of the book, which accounted for its runaway success. The fact that it attracted so much nation-wide criticism for obscenity and blasphemy no doubt encouraged further sales. Farleigh is often credited with introducing black figure wood-engraving, yet other engravers, notably Craig, Gill, and Hughes-Stanton, had previously used such figures in private press limited editions.[28] Farleigh's innovation was to feature them in a mass-produced book. The demand for copies of *The Black Girl* brought wood-engraving to the attention of a far wider audience, thereby popularizing the medium for commercial book illustration.

The artist received instant recognition for his success but in later years he did not consider this book to be his greatest work. Although introspective and sensitive, he never openly professed to any Christian beliefs, as various friends and relations confirm, yet his later commissions were often religious subjects. Morris Kestelman, a colleague of his at the Central in the 1930s, suggested that the sense of drama he found in these stories must have appealed to him.[29] Judging from his later work he particularly appreciated the mystical element in religious subject matter.[30]

Having so recently been accused of blasphemy for his *Black Girl* interpretations Farleigh was surprised to find himself commissioned by Faber and Faber the following year to illustrate Walter de la Mare's *Stories from the Bible* for children.[31] 'Who', he wrote, 'would want an illustrator who had so "impertinently smoked a cigarette over the body of Christ?". Yet, such is the perversity of things, this was only the first of many biblical books I was to illustrate: perhaps I owed the other to de la Mare's book—it is difficult to say one way or the other.'[32] A visit to the writer at Taplow to discuss his sketches for the book led to an involved conversation on mysticism, followed by a letter from de la Mare approving of all the drawings except *Samson*. Since the book was a reissue and the typescript had, therefore, already been printed, Farleigh was unable to inset his engravings and had to make full-page blocks that could be 'let in'. There was just enough room for about thirty long, narrow headpieces to be inserted. In some of the full-page illustrations the objects or figures burst through their frames, as does Samson who is depicted pushing down huge cylindrical pillars, literally breaking out of the space around him. This powerful sense of action and movement—a characteristic of Farleigh's

[27] Farleigh, *Graven Image*, 260.
[28] See Ch. 8 for Garnett's contribution to a dust-jacket for a commercial book.
[29] Conversation with Morris Kestelman, Sept. 1988. Farleigh apparently regretted to the end of his life that he never illustrated *Pilgrim's Progress*, for which he had designed some blocks, having failed to persuade Sandford to publish it.
[30] See n. 41.

[31] A series of illustrations for a detective story, 'The Cavalier of Ladies', by Michael Arlen in *The Strand Magazine* (July 1933) is uncharacteristic of his work at this time. Three of the four illustrations spread over two pages (presumably engraved on two blocks). They brilliantly conjure up a mood of high drama and excitement in an appropriately 1930s style.
[32] Farleigh, *Graven Image*, 302.

work—increased in later years. *The Fall of Jericho*, showing buildings being blasted to pieces by long, vertical, chimney-like trumpets, is a quirky interpretation. In contrast to the headpieces which were handled lightly with small specks and stippled white lines, the full-page illustrations are black and heavy in relation to the area of type. Farleigh regretted that they were ruined by being over-inked in the printing.

A further biblical text followed in 1934: *The Story of David* published by A. & C. Black. Farleigh's comment that the subject 'made a good thriller with David as an early example of a gangster who put a husband on the spot' confirms his penchant for dramatic and emotional subject matter. Like Gill, he was also attracted by the more suggestive elements which, as in *The Black Girl*, he depicted in a quasi-erotic manner. As a result he was accused by some of blasphemy, the nude figure of David who 'danced before the Lord' being considered particularly *risqué*; so much so that the publishers were unable to sell the book and it was remaindered. Farleigh's fetish for the nude body was not just prurient but was derived from his interest and teaching in life drawing and the human figure, encouraged by Meninsky's early teaching. As Gill and others found, the 'black figure' was an ideal subject, both technically and stylistically, for wood-engraving. The contrast of shiny blacks and silvery white lines and stippling created a texturally sensual feeling unique to the medium, most apparent from the exquisite Gill-like engraving of 'a woman washing herself', daringly repeated on the dust-jacket. With oversize thighs *Plate 84* her black body tapers into a small head weighted in an arc by a swirling waterfall of hair. The bulky seated female and symbolic scrawls on page 46 show Farleigh moving away from a realistic depiction of the body. Particularly effective are the silhouetted images of the head of the Philistine in David's hand and his long fingers plucking fine harp strings.

Apart from these last two books for other publishers Farleigh was largely preoccupied with illustrations for further Constable editions of Shaw's writings published in 1934: *Short Stories, Scraps and Shavings*, incorporating *The Black Girl*, and *Prefaces*. The former contains a frontispiece, twelve headpieces and a tailpiece, four full-page illustrations, and seven within the text. Initially Farleigh sent a number of drawings for Shaw's approval. On 20 August he received permission to continue the programme and a cheque for a hundred guineas in advance payment. Shaw included some sketches and ideas for alterations, paying particular attention to the accurate depiction of musical instruments. On the drawing of the horn player he wrote, 'Horn blowers always look intensely melancholy'—a mood which Farleigh reflected in his headpiece to 'The Serenade'.

Throughout these illustrations Farleigh showed a sense of humour and empathy with Shaw's writing. In keeping with the author's ideas some images are distinctly theatrical, as is a full-page illustration to 'The Theatre of the Future' in which Farleigh's abstract tendency begins to emerge. Inspired by Shaw's satirical wit he caricatured G. K. Chesterton, Shaw's favourite and nearest rival, as Immenso Champernoon—'a man of colossal mould, with the head of a cherub on the body of a Falstaff, which he carries with ease and not without grace'—banging a dinner gong before a Virginia Woolf-like pianist.

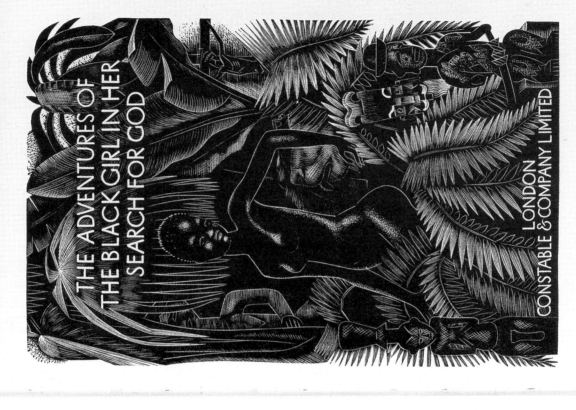

Pl. 82 (*above*). John Farleigh: George Bernard Shaw, *The Adventures of the Black Girl in her Search for God* (Constable, 1932).
150×92

Pl. 83 (*right*). John Farleigh: George Bernard Shaw, *The Adventures of the Black Girl in her Search for God* (Constable, 1932).
206×133

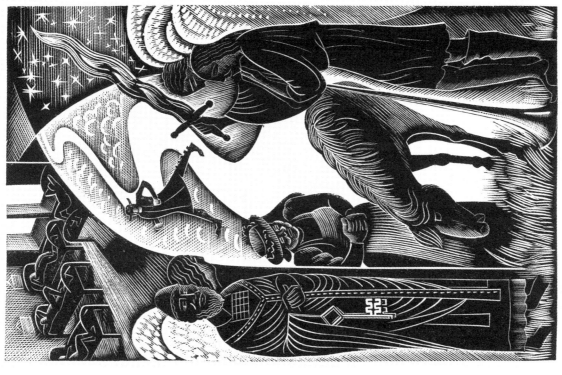

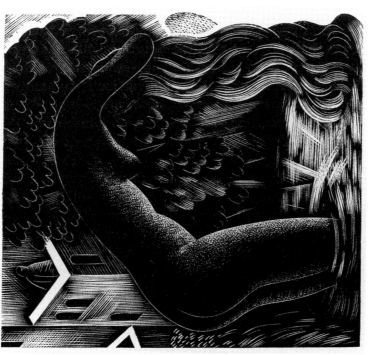

Pl. 84 (*above*). John Farleigh: *The Story of David* (A. & C. Black, 1934). 97 × 88

Pl. 85 (*right*). John Farleigh: George Bernard Shaw, *Short Stories, Scraps and Sharings* (Constable, 1934). 148 × 93

Plate 85 A full-page scene for 'Aerial Football' contains a number of successive incidents within the text. The decorative frontispiece aptly describes the book's title: curled wooden shavings are dated for each story, the edges of the block left roughly finished, the point of a graver shown pushing up a further scrap of wood. Farleigh felt that this lesser-known volume contained better engravings than *The Black Girl*. Certainly they are more idiosyncratic.

Maxwell played a significant role in the development of Farleigh's wood-engraving style. Partly in response to his request for him to engrave in such a way as to make printing easier on the rougher, yellow-toned paper used for *Short Stories*, Farleigh began to alter his technique. Less solid treatment is apparent from several blocks. For the title-page to Shaw's *Prefaces* he exploited this new method as Maxwell felt that the thin paper used called for a lightweight block. Shaw considered Farleigh's original design— a reproduction of a seventeenth-century pictorial title-page—'damned ugly' and 'more like a picture page than a frontispiece'. 'However,' he wrote, 'let yourself rip and fix your own price: damn the expense!'[33] Farleigh followed the author's idea of using his portrait head (taken from a photograph) with manuscripts pouring out of it from cornucopias and with the black girl leaping from his forehead. His particular interpretation displayed *Plate 86* an inventive sense of design carried out with fine technical control.[34] In *Graven Image* he described in detail the scenes and characters which appear in the niches and throughout, and reproduced four progressive proofs, from solid black with white outline to almost the reverse—an interesting insight into his working procedure.[35] Apart from a portrait frontispiece of Shaw for *Shaw Gives Himself Away* (Gregynog Press, 1939), this was the last purely descriptive work for the author.

Samuel Butler's *The Way of All Flesh* (Collins, 1934), the first novel Farleigh illustrated, required different treatment both in outlook and in preliminary preparation from previous commissions. With this job Farleigh evolved a method that he felt could be applied to all novels. His description of it in *Graven Image* and some accompanying comments are quoted here in brief:

1. *A rapid reading of the whole book*. Any suggestion of a possible illustration is marked in the margin. This first impact is important—it is the most personal moment of the artist; when his imagination alone is colouring the narrative...

2. *Selection of illustrations from the first list*. The final number must depend on fees and the artist's market value. The designs must be spread through the book to appear at approximately regular intervals.... Careful selection must give prominence to designs in the sections of the book that are prominent in themselves; the smaller designs should lead up to the important ones. Thus, waves of illustrations will correspond to the ebb and flow of the story. A careful word picture should be made of each illustration, with a rapid sketch of the complete set of drawings, each one in relation to its final status on the printed page...

3. *Second reading of the book*. This is done slowly and with care, for it is a search for any detail that will throw light on the incidents and characters to be illustrated. A chart is made of these details that will save the designer any further trouble of re-reading.... Every characteristic, every

[33] Ibid. 326. [34] Shaw had sent him two self-portrait sketches. [35] Farleigh, *Graven Image*, 337–8 and 343–4.

habit and scrap of description that seems of importance to the true delineation of character must be written down. In this way the illustrator will get to know the characters as well as the author must have done. . . . Information of backgrounds should be gathered in this second reading.

4. *The final drawings are made.* The first rough sketches should be scrutinized carefully ... Many a finished drawing has lost all originality and vigour owing to the first rough sketch being ignored. With the help of the chart this sketch can be developed into the final drawing.[36]

For historical details Farleigh recommended collecting and studying books of reference. Such specific instructions are an indication of his immensely thorough, scholarly, and yet imaginative approach to book illustration.

Poole suggests that Farleigh was not quite 'at home' with Butler. 'The satirical element seems overstrained; the cutting, clean and lively though it is, a bit brash.'[37] Shaw, on the other hand, thought these illustrations 'diabolically good for such a dangerous job!'[38] If there is any brashness it is in the awkward gestures, stylized facial expressions, and at times rather heavy handling, but these effects in turn add potency to the drama. Farleigh exploited Butler's method of stressing situations psychologically: human emotions are particularly well captured, for example, in the scene where the bride Christina 'sat crying in one corner of the carriage' while the bridegroom Theobald 'sulked in the corner'. Expressive landscapes begin and end the book, the letter 'W' cleverly incorporated into the opening scene. Green printed ivy trellis endpapers further reveal his decorative skills.

Plate 87

With his magnificent print *Hemlock* Farleigh displayed an ability to portray plants. A commission to illustrate Ethel Armitage's *A Country Garden* (Country Life, 1936) gave him the opportunity to broadcast this skill. Written in diary form, the book contains whole-page and smaller engravings of flowers, fruits, vegetables, and rural scenes. A certain stiffness and formality about his depictions imply acute observation rather than an innate understanding of botany. By his own confession Farleigh was not especially interested in gardening and nature but 'learned economy of statement by studying the flowers closely; and simplicity of outlook from the garden magazines of the past'.[39] In later years he used plant forms as a means of conveying both texture and symbolism, expressed most effectively in flamboyant single prints such as *Dahlia, Cactus,* and *Gloxinia.*[40]

A Country Garden marks the end of Farleigh's naturalistic phase. A large print, *Creation of Eve* (1933), had heralded his interest in more metaphysical concepts.[41] An element of abstraction which, as has been seen, began to creep into his illustrative work, was

[36] Ibid. 345–9.
[37] *The Wood Engravings of John Farleigh,* 10.
[38] Farleigh, *Graven Image,* 349.
[39] Ibid. 374.
[40] Sacheverell Sitwell commissioned lithographs for his book, *Old Fashioned Flowers* (Country Life, 1939).
[41] The first of his large independent allegorical, religious

prints, it is loaded with symbolism, notably the oversize passion flower to the left. Farleigh was obviously disappointed with the print when he wrote 'I wanted to shroud the subject in the mystery of dark tones and probably overdid it', a remark which indicates his interest in the mystical element of religion. *The Wood Engravings of John Farleigh,* 10.

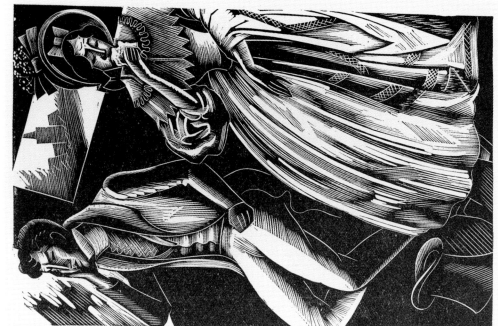

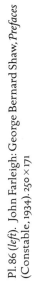

developed to a greater extent at the end of the decade.[42] Despite the immense popularity of his *Black Girl* wood-engravings his peculiarly individual style was admired rather than imitated. His greatest contribution to the medium was as a promulgator.

[42] See Ch. 13.5.

THE PAINTERLY STYLE: GWEN RAVERAT'S LATER WORK, STEPHEN BONE, C. T. NIGHTINGALE, AND ALEX BUCKELS

In 1920 Herbert Furst chose to launch his new series *Modern Woodcutters* with the work of Gwen Raverat, considering her to be 'undoubtedly one of the most gifted, and certainly the most versatile woodcutter and wood-engraver of the younger generation'.[1] In the same year exhibitions with the Society of Wood Engravers, of which she was a founder member, and with the Royal Society of Painter-Etchers and Engravers, the New English Art Club, and at the Adelphi Gallery further established her reputation before her departure to France. All the elements of her mature style developed in the series of single prints which she produced during the next five years; mainly figure groups and landscapes, those of Provençal streets, squares, and groves are among the most intensely localized of all her images.[2] Her style, affected by the strong southern sunlight, gradually altered to reflect shimmering light and strong shadows. The French painterliness which she so admired she now translated into her own language based on actual observation. She evolved her unique impressionist technique partly as a result of her spontaneous approach to the medium.

Domestic pressures accounted for the relatively small output before her return to London in 1925. However, her professional attitude to her work ensured that it was not forgotten in the intervening years between moving to France and settling back in Cambridge, at the Old Rectory, Harlton, in 1928. In 1922 she was in correspondence with Jonathan Cape who wanted her to illustrate Samuel Butler's *Erewhon*. Although apparently willing to do half-page cuts, chapter headings, and tailpieces,[3] for some reason this commission came to nothing and went instead to Gibbings.[4] From 1923 to 1926 she had been the most prolific artist included in the socialist periodical, *The New Leader Book*, while Furst included her work in an 'Exhibition of International Woodcuts' at the Little Art Rooms in February 1924 together with that of Edward McKnight Kauffer, Charles Ginner, Ludovic Rodo, Frank Brangwyn, Elinor Darwin, John Greenwood, William Kermode, and Clifford Webb. In 1927 a retrospective exhibition of her wood-engravings was held at the Redfern Gallery, followed by one of wood-engravings, drawings, and lithographs at the St George's Gallery in April 1928. Throughout this period

[1] Herbert Furst, 'The Modern Woodcut: Part 2', *Print Collector's Quarterly*, 8 (1921), 267–98, p. 294.

[2] See Christopher Cornford, Preface to exhibition catalogue, *Gwen Raverat: Aspects of her Life and Work, 1885–1957* (Royston: Manor Gallery, 14 Feb.–31 Mar. 1987).

[3] Jonathan Cape to A. T. Bartholomew, 6 Apr. 1922. JCA.

[4] See Ch. 11.1.

she continued to exhibit annually with the Society of Wood Engravers, and contributed also to some English Wood-Engraving Society exhibitions.

Despite her exceptional technical skills, Gwen Raverat was not herself concerned with immaculate precision nor with exact reproduction. Often self-effacing about her work, when asked by Martin Hardie to demonstrate at the Print Collectors' Club she replied: 'I have always been rather make-shift and unorthodox in my methods of work & I don't hold my tools right. So please consider whether I am a good example to the public. I can't work except by a light on the table.'[5] Overtly honest and disapproving of virtuosity *per se*, she never strove for effect, nor followed fashion for its own sake. She was unaffected by the black- versus white-line controversy, for instance, and did not subscribe to Underwood's 'black figure' school wryly noting in a review of Hughes-Stanton's work how curious it was 'that all nude ladies have turned black, ever since Mr. Bernard Shaw fell in love with the Black Girl'.[6] Trained as a painter she was more interested in tonal values. She used her tools in a personal and inimicable manner to feel her way into the block in a sculptural way, as a modeller rather than carver.

A firm dislike of 'arty-crafty' pretentiousness meant that she distanced herself from the esoteric private press movement. (She was one of the few major wood-engravers, who, despite Sandford's invitation, never collaborated with the Golden Cockerel Press.[7]) None the less she was more typographically knowledgeable and aware of the 'feel' of a good book and the *mise en page* than some of her critics claim. Stone wrongly thought that 'like mid-Victorian illustrators she was not concerned with book production',[8] whilst Edward Hodnett dismissively stated that 'her blocks tend to vary unattractively in size and to make rectangular holes in the page' and suggested that 'better planning for harmony, not uniformity, could have made the several volumes more appealing'.[9] Far more than just an illustrator, she considered first the text, then the format of the book, its architecture, the page layout, endpapers, binding, and dust-jacket, as well as the wood-engravings themselves and their balance with type. About 332 of her wood-engravings were for illustration— over half her output—while others were book related. Through her enthusiastic and intelligent involvement in the whole process of book production she brought a new dimension to wood-engraved book illustration which has been greatly underestimated. Fortunately a wide range of primary material including letters, sketches, blocks, proofs, and paste-ups enables a closer study of her work than that of most of her contemporaries.

Paradoxically for someone not in close contact with private presses her first major commission came from C. H. St John Hornby's Ashendene Press, probably the result of Jacques's year as an assistant in 1909.[10] Her illustrations for Longus's *Les Amours pastorales de Daphnis et Chloé* were some of her most successful. With this well-documented book,

[5] Gwen Raverat to Martin Hardie, n.d. University of California Library, Special Collections.

[6] *Time and Tide*, Mar. 1935, 319.

[7] Lettice Sandford to the author, 28 Jan. 1989, but no confirmation in the records of the press.

[8] *The Wood Engravings of Gwen Raverat*, selected with an intro-duction by Reynolds Stone (repr. Swavesey, Cambridge, 1989, with postscript and additional selection by Simon Brett), 15.

[9] Edward Hodnett, *Five Centuries of English Book Illustration* (Aldershot, 1988), 277.

[10] The book took five years to complete. The ink used to print the 1931 edition was slow to dry, transferring from the newly

discussed more thoroughly elsewhere,[11] she laid the foundations of her working practice, having first learnt the value of exercising her own judgement on the appearance of her books when dealing with Monro. From the start she expressed an interest in the layout, asking Hornby for a specimen page proof in order to see the intended typeface, the size of the page, and the text area. Her request to use a headpiece of about 3" × 4" and a tailpiece to each of the four books instead of full-page wood-engravings which she found hard to manage was rejected. The final version contains four full-page frontispieces, together with twenty-five inset wood-engravings, headpieces the width of the text, and a final tailpiece, all contained within rectangular frames. Numerous preliminary sketches and working drawings, many of which she sent to Hornby for his approval before proceeding to engrave the blocks, reveal her preliminary preparation and the evolution of her ideas. As she once explained: 'I myself make several rough sketches and then place the composition very carefully on the block, but I leave all details to be worked out as I go; for the design seems to stay more alive this way; and I do a great deal of work after I have seen the effect of the first proof.'[12] Her rapid figure sketches in blue-black ink, sometimes several to a page, generally progress from fluid pen to heavy brush lines and washes. In several instances a spontaneous idea is distilled into a smaller, more stylized scene or spread over two pages as with the figures of

Plate 88 Daphnis and Chloe in love. Raverat took pains to balance her illustrations with the archaic-style Ptolemy typeface; several of her blocks required further working to let in more light. She was business-like in her dealings with Hornby, although the fees of £189–200 which she asked were very reasonable.[13] Cost-conscious as she was, she became more realistic about her fees for later books. A request to have a few copies of the advertisement to send out already showed her marketing sense which she applied to future jobs.

Raverat found *Daphnis et Chloé* 'a most heavenly book & just what I enjoy doing'.[14] As with *Spring Morning* she was more concerned with extracting the essence of the text than with translating it literally. The sensitive nature of the text is implied from her intimate compositions and subtle handling. The elongated nude figures (reminiscent of Sturge Moore's), with outstretched limbs, dancing or idly languishing in a timeless bucolic landscape recall the Neo-Pagan philosophy of life. Sydney Cockerell found the figures to his eye sometimes 'a little too matter of fact—they lack the idyllic sauciness of the text'.[15] Certainly for all their amorousness the two lovers are charmingly chaste; Raverat's approach to nudity was quite different both in sentiment and style from Gill's blatant eroticism. Evidently she felt inhibited from being more explicit since several sketches, for some of which Jacques posed, disclose that she often conceived them in a

printed impressions to the underside of the vellum sheets laid upon it ('set-off'). Hornby consequently destroyed all but 10 copies, reprinting the second edition with various alterations in 1933 on Batchelor handmade paper, with 20 special copies on true vellum.

[11] See Joanna Selborne and Lindsay Newman, *Gwen Raverat, Wood Engraver* (Derby Dale, 1996).

[12] 'Wood Engraving in Modern English Books', unpaginated typescript for Gwen Raverat, 'Traesnit i moderne engelske Bøger', *Bogvennen*, 2 (1939), 97–108.

[13] Hornby eventually paid her £210.

[14] N.d. Quoted by Colin Franklin, *The Ashendene Press* (Dallas, 1986), 181.

[15] Ibid. 185.

more intimate vein than they appear in the final image, as, for instance, with *Chloe kisses Daphnis* and *The End of the Story*. Raverat managed to capture not just the mood of the characters but also the *genius loci* in this and other books. Her empathy for people and surroundings stemmed from her acute powers of observation fostered since childhood. The background to several scenes including *Summer on the Mountain* evoke the landscape around Vence.

With one exception,[16] all Raverat's subsequent wood-engraved illustrations were for commercial publishers. The working methods which she had evolved through designing for privately printed limited editions, she subsequently adapted to suit the constraints of trade publishing. Her wood-engravings for *Time and Tide* which appeared between 1930 and 1932, most especially an attractive series entitled 'The Monthly Calendar',[17] had introduced her work to a number of publishers who were beginning to take an interest in the aesthetics of the book. Several recognized her potential as an illustrator, most vitally Cambridge University Press. The importance of co-operation between illustrator, publisher, and printer (and ideally author, too) has already been stressed. At Cambridge the printers usually took their orders from the publisher but often, particularly with the Press's books, they were responsible for the page design. Raverat was fortunate to be allowed a hand in designing her books and to consult Lewis direct. According to Brooke Crutchley, Lewis's successor, she was often in the Press getting help from the foundry, cutting wood, splitting blocks, and so forth.[18] The usual practice was to print from her original blocks which accounts for the crisp definition of her wood-engravings in first impressions as opposed to the degraded images printed from electros or stereos in later ones.

Of the major books with wood-engraved illustrations which Raverat produced between 1932 and 1939 three were for Cambridge University Press: Kenneth Grahame's *The Cambridge Book of Poetry for Children* (1932), Frances Cornford's *Mountains & Molehills* (1934), and *Four Tales from Hans Andersen* (1935). Documentary material reveals the extent of her participation in the development of her books. With the children's poetry book, for example, before embarking on the illustrations she enquired about their number and placing. The final book contains fifty-four small vignettes which she scattered throughout the text, either inset or as head- and tailpieces. The rectangular edges have been cut off several blocks to soften the effect on the page. According to a note in the first illustrated edition the Press reset the type to harmonize with her fine-lined tonal engraving. Later she would adapt her technique to meet printers' requirements by engraving more incisively and creating greater areas of white.

Raverat was not afraid to admonish both publisher and printer and her firm opinions on the appearance of her books were frequently heeded. When, for example, her editor George Barnes sent her a specimen page of *Mountains & Molehills*, she announced that

[16] Ellic Howe, *The London Bookbinders, 1780–1806* (Dropmore Press, 1950).

[17] Issued as independent publications in 1954 and 1972. See Ch. 5.4.

[18] Brooke Crutchley to the author, 26 Jan. 1989.

the size of the page was excellent but the 'poems looked rather muddled up too close, like a school book' and too high on the page.[19] Her letters and sketches throughout the 1930s show a recurring interest in layout and the subtle placing of illustrations. With *Mountains & Molehills* Raverat broke away from the small-scale, regular formula of her previous work and chose a distinctly idiosyncratic arrangement of blocks of differing shapes and sizes: thirty-four—a title-page, two full-page designs and head- and tail-pieces—are distributed irregularly throughout the book. The idyllic pastoral landscape spanning two pages of text for the poem 'Cambridge Autumn' was the outcome of her request for a double-page spread.

The use of double-page spreads, for which Raverat had a penchant, was a relatively unusual practice at the time, probably because of the added expense and complications. Seven sheets of working material for *Four Tales from Hans Andersen* contain a sketched layout for each story, with titles and illustrations pencilled in.[20] Raverat's comments are added, while some proof wood-engravings have been pasted in revealing the care taken to achieve an effective opening. This is dramatically successful in an illustration to 'Little Ida's Flowers' where the old chamberlain is seen entering the ballroom on the left-hand page while the length of the huge empty ballroom spreads across to the right-hand page, extended by the long moonlit shadows of the window frames. Remarkably, a feeling of continuity exists despite there being two separate blocks, due to Raverat's precise instructions on the layout that they must be parallel to each other.

Plate 89

One of her most appealing books, it is in small octavo format with forty illustrations, including initials to opening paragraphs, an oval portrait of the author on the title-page, and, most unusually, a coloured frontispiece. This was an experiment with which she was, in fact, rather disappointed but it indicates a pioneering spirit at a time when coloured wood-engraved book illustration was uncommon.[21] Even though dark, the clarity of these illustrations prevents them from overpowering the delicate Bodoni typeface. As to type, Raverat was generally more concerned with correct proportions and spacing than with the choice of face, which she was usually prepared to leave to the publisher.

Working for commercial publishers called for a professional approach which Gwen Raverat maintained throughout her career. Letters to Cambridge University Press and to Macmillan & Co. show her establishing her right to own her cuts and asking for copyright.[22] Her persuasive manner over the value of her illustrations to *The Runaway* (1936) resulted in a pleasing royalty from Macmillan of 1s. on each 6s. edition which, by mid-1937, amounted to £70. Of those publishers for whom she worked Macmillan was especially accommodating.[23] The idea of republishing the Victorian novel *The Runaway*

[19] Gwen Raverat to George Barnes, [1934]. Cambridge University Press Archives, Cambridge University Library, henceforth CUPA. Reproduced by kind permission of the Syndics of Cambridge University Library.

[20] Held in the Prints and Drawings Department, Fitzwilliam Museum, Cambridge.

[21] See Ch. 1.

[22] For *Mountains & Molehills* she accepted 10% royalty and full rights, being allowed to sell hand prints of up to 20 hand-pulled prints.

[23] Her plan to contribute a title-page wood-engraving to an edition of Yeats's plays, entitled 'Wheels and Butterflies', was taken up in 1934. This was followed by a commission for a book jacket design for *Mr Theobald's Devil* (1935).

Les réflexions
de Daphnis et
de Chloé

les paroles du vieillard: "Les amants souffrent,
nous souffrons; ils ne font compte de boire ni de
manger, aussi peu en faisons nous; ils ne peuvent
dormir, ni nous clore la paupière; il leur est avis
qu'ils brûlent, nous avons le feu au-dedans de
nous; ils désirent s'entrevoir, las! pour autre

chose ne prions que le jour revienne bientôt. C'est
cela sans point de doute qu'on appelle amour;
tous deux sommes enamourés, et si ne le savions
pas. Mais si c'est amour ce que nous sentons, je
suis aimé; que me manque-t-il donc? Et pour-
quoi sommes nous ainsi mal à notre aise? A quoi

Comment pren-
dre le garçonnet,
comment lui
échapper?

faire nous entre-cherchons-nous? Philétas nous
dit vrai: ce jeune garçonnet qu'il a vu en son jar-
din, c'est lui-même que jadis apparut à nos pères
et leur dit en songe qu'ils nous envoyassent gar-
der les bêtes aux champs. Comment le pourra-t-on
prendre? Il est petit et s'enfuira; de lui échapper
n'est possible, car il a des ailes et nous atteindra.
Faut-il avoir recours aux Nymphes? Pan n'aida

52

de rien Philétas quand il aimoit Amaryllide. Es-
sayons les remèdes qu'il a dits, baiser, accoler,
coucher nue à nu. Vrai est qu'il fait froid; mais
nous l'endurerons." Ainsi leur étoit la nuit une
seconde école en laquelle ils recordoient les en-
seignements de Philétas.

LE lendemain au point du jour ils menèrent
leurs bêtes aux champs, s'entrebaisèrent l'un
l'autre aussitôt qu'ils se virent, ce qu'ils
n'avoient oncques fait encore, et croisant leurs
bras s'accolèrent; mais le dernier remède..., ils

Ils n'osent es-
sayer le dernier
remède

n'osoient, se dépouiller et coucher nus. Aussi
eût-ce été trop hardiment fait, non pas seulement
à jeune bergère telle qu'étoit Chloé, mais même à
lui chevrier. Ils ne purent donc la nuit suivante
reposer non plus que l'autre, et n'eurent ailleurs
la pensée qu'à remémorer ce qu'ils avoient fait,
et regretter ce qu'ils avoient omis à faire, disant
ainsi en eux-mêmes: "Nous nous sommes
baisés, et de rien ne nous a servi; nous nous

53

LITTLE IDA'S FLOWERS

garden of the great castle where the King lives
in summer? Then you must have seen the
swans which swim up to you, when you offer
them breadcrumbs. There are wonderful dances
out there, I can tell you!"

"I was out in that garden yesterday with
my mother", said Ida, "but the leaves were
all off the trees, and there wasn't a single
flower left. Where are they? I saw so many
there last summer."
"They are inside the castle", said the stu-
dent. "You see, directly the King and all his

60

LITTLE IDA'S FLOWERS

Court come back to town, the flowers at once
run up from the garden into the castle and
make merry. You should just see them! The
two finest roses go and sit on the throne—they
are King and Queen. All the red cockscombs

line up on both sides and bow—they are
gentlemen-in-waiting. Then come all the
prettiest flowers, and there is a grand ball.
The blue violets are young naval cadets, and
they dance with the hyacinths and crocuses,
whom they call Miss. The tulips and the large
yellow lilies are old dowagers, who keep an

61

Pl. 88 (*above*). Gwen Raverat: *Daphnis
Loves Chloe* facing *Chloe Loves Daphnis*
from Longus, *Les Amours pastorales de
Daphnis et Chloé* (Ashendene Press, 1933).
255 × 346

Pl. 89 (*left*). Gwen Raverat: R. P. Keigwin
(trans.), *Four Tales from Hans Andersen*
(Cambridge University Press, 1935).
177 × 222

by Elizabeth Ann Hart with her wood-engravings was hers: 'It would be amusing to illustrate it with pictures in the dresses of the sixties' she wrote to the firm.[24] She even went so far as to propose that Cambridge University Press printers would be most convenient to her: 'They are used to printing from wood blocks & are most excellent printers, & are no dearer than other printers I think.'[25] Although her suggestion of colour wood-engravings never materialized in the book, Macmillan gave her an exceptionally free hand to arrange it as she wished, allowing her to abridge the original text, design the layout of her illustrations, and add her own preface.

Preliminary sketches and a few layouts for the book reveal her working procedure.[26] Whereas employment by a private press had allowed time and scope to experiment, using only rapid sketches, more detailed drawings were generally required when dealing with commercial publishers and printers. The initial designs are blue watercolour brush sketches, sometimes with several scenes to a page, freely executed, with a few figures drawn in pen and ink. Loose brush strokes emphasize areas of light and shadow. Most of the final sketches, however, are more carefully worked out, presumably to ensure greater accuracy when transferring the design to the block. Certain scenes, such as *Ann Afraid*—a frightened maid running, casting a long shadow behind her—are outlined in detail and have been squared up for sizing on to the block. A pencil and black wash sketch of Clarice kneeling in undergrowth has been altered in the first block. The trial proof has been cut round, pasted up, and the foliage sketched in white and black gouache or watercolour. The final wood-engraving which appears in the book is yet another slightly different version printed from a second block.

Sixty illustrations flow effectively through the text. Individual figures converse across the pages and some illustrations are placed at an unusual angle. Perhaps the most decorative of all her illustrations shows a girl climbing along a branch of a tree which *Plate 90* spreads up and over two pages. The endpapers are particularly successful, the principal characters spread in a semi-circle across two pages.

The comparatively dull format of A. G. Street's *Farmer's Glory* which Raverat illustrated for Faber and Faber in 1934 partly reflects her lack of involvement in the creation of the book. The weight of the engravings (thirty-six rectangular head- and tailpieces, full-page blocks, and a title-page design) is not always consistent, ranging from over-black (*Farmer in Bed*) to soft grey (*Threshing in England*). Such contrasts were due to her varied handling rather than to uneven presswork.[27]

Her illustrations to Faber's *The Bird Talisman*, on the other hand, are crisply cut and evenly balanced in comparison, the book beautifully printed by Cambridge University Press. Correspondence with Brooke Crutchley and Richard de la Mare, Faber's director responsible for design and typography, shows the close collaboration with Raverat,

[24] Gwen Raverat to Macmillan & Co., n.d. [1935]. Macmillan Archives, British Library Manuscripts Collections, henceforth MA (BLMC).

[25] Ibid.

[26] Held in the Prints and Drawings Department, Fitzwilliam Museum, Cambridge.

[27] A second edition was reset in 1956, excluding all full-page illustrations, and printed from electros with selected white lines strengthened (not totally successfully) by Raverat. For comparative illustrations see Patricia Jaffé, *Women Engravers* (London, 1988), 30.

resulting in the acceptance of her ideas on paper, layout, placing of blocks, and even the format of the book which was made smaller at her request. The overall design is refreshingly uninhibited. Forty-seven black and white wood-engravings are spread randomly through the text: in the opening paragraphs of chapters, down one side, across the middle and corners. Although some blocks, such as *The Soldier Asleep*, are rectangular, many have the corners removed or the backgrounds cut away to form interesting shapes: the base of *The Owl's Parachute*, for instance, juts sharply into the text below. Her idea of putting together individual tailpieces of birds printed in green to fly across the endpapers is most effective.[28]

Plate 91

With her eight full-page coloured blocks Raverat took a new direction.[29] Determined to improve on her earlier attempt, she considered different methods of printing, including ways to avoid cutting a new wood block for each colour such as using scraperboard instead. She eventually resorted to the traditional method of printing from the wood, however, using a key block printed in black and separate registered blocks for the coloured areas. Her plan was to outline the colour herself on to West Indian boxwood and 'to have all the cutting away done by a man I found whom I can trust', most probably Beedham.[30] In her commanding way she oversaw the job with the printers. Although she was delighted with the final plates (apart from the shiny paper) not all seem equally successful. The combination of blue, burnt sienna, and mustard appears somewhat hard and unvarying, while the dominating black key block overpowers the weight of the type.[31]

The publication which perhaps did most to bring Raverat's name to the attention of general readers was Laurence Sterne's *A Sentimental Journey*, the second book in the Penguin Illustrated Classics series of 1938. For her twelve designs she kept to a rectangular format with no attempt to soften the edges of the block or spread them over the pages. Doubtless the nature of the commission required a more formal approach and economical layout. Certainly the cheap yellow paper did little justice to the printing of her wood-engravings.[32]

Fortunately for Raverat her circumstances generally enabled her to choose the books she wished to illustrate. The eight books with wood-engraved illustrations produced between 1932 and 1939 embrace the full range of her imagination and experience. Half of these were for children at a time when few such books contained wood-engravings, the outcome of a lifelong interest in adventure stories and fairy tales, and an empathy with childish emotions and humour. Her 'sharp child's eye'[33] is nowhere more apparent than in her minute narrative scenes for *The Cambridge Book of Poetry* which have a potency disproportionate to their scale, as in the intimate family gathering for 'The Land of

Plate 92

[28] These only appear in the first edition.
[29] Elinor Monsell's coloured line-drawn illustrations to the *Mr Tootleoo* series of children's books begun in the 1920s may well have been an inspiration. Dust-jackets were one area in which publishers allowed Raverat to indulge in colour.
[30] Gwen Raverat to Richard de la Mare, 15 Apr. 1939. FA.
[31] A hand-coloured proof of *The Procession* and correspondence indicate an earlier scheme to use green, crimson red, and rouge-

red, rather brighter and more appropriately oriental in appearance.
[32] A comparison of these illustrations, which were printed from stereos into which Raverat had cut additional whites, with those in the 1940 Thomas Nelson edition shows how much definition was lost in the reworked stereos.
[33] *The Wood Engravings of Gwen Raverat*, 14.

which,

peeping out at her,

looked like the bodiless angel heads in old pictures, wanting only the wings instead of a neck to be the angel-head complete. "I can imitate animals just as well as birds," cried a gay sparkling voice, "so that they all come flocking round me, only I dare not do it here, you know, as cows and horses cannot be supposed to live in this glade."

"Come down, naughty child," said Clarice quite fondly, and down ran Olga like a squirrel, and nestled by her side.

"I have found my bag," cried she, "and only think, the mouth was open, and half the things had tumbled out, but I hope I have collected them all; and Oh, Clarice! as I was picking them up, only just fancy, I saw a man looking at me over the hedge—he was in the lane outside you know; but wasn't it rude?"

"I don't know," answered Clarice; "he must

As suddenly as it had commenced, the concert ceased, and a joyous, chuckling, girl laugh followed, while the rustling leaves made place for a golden head and fair face,

Pl. 90. Gwen Raverat: Elizabeth Anna Hart, *The Runaway: A Victorian Story for the Young* (Macmillan. 1936). 185 × 245

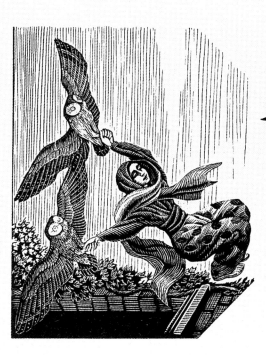

No sooner said than done. The prin-cess grasped the legs of the friendly owls, and threw herself from the balcony; down they went all three with a tremendous rushing of wings, and the princess fell on the springy branches of the bush without receiving any hurt at all, and letting go the legs of the owls they flew up again to the ruin, while she scrambled through the branches to the ground.

As soon as she was clear of the bush, she looked about to see which way she had better go to escape the danger of pursuit, when she caught sight of the soldiers, who were just coming towards the ruin to take her. Fortunately, they could not see her; and she immediately darted away

59

Pl. 91. Gwen Raverat: Henry Allen Wedgwood, *The Bird Talisman: An Eastern Tale* (Faber and Faber, 1939). 210 × 154

TOYS AND PLAY, IN-DOORS AND OUT

THE LAND OF STORY-BOOKS

At evening when the lamp is lit,
Around the fire my parents sit;
They sit at home and talk and sing,
And do not play at anything.

Now, with my little gun, I crawl
All in the dark along the wall,
And follow round the forest track
Away behind the sofa back.

There, in the night, where none can spy,
All in my hunter's camp I lie,
And play at books that I have read
Till it is time to go to bed.

39

Pl. 92. Gwen Raverat: Kenneth Grahame (ed.), *The Cambridge Book of Poetry for Children* (Cambridge University Press. 1932). 202 × 127

Story-Books'. Her robust figures for *Four Tales from Hans Andersen*, like carved wooden puppets, are in keeping with the Nordic character of the tales. Through a contrast of both frightening and reassuring incidents Raverat manages to combine emotional excitement with tenderness and warmth. For *The Runaway* which recounts the escapades of the schoolgirl Olga, rectangular scenes and cut-out figures vividly portray Raverat's favourite themes and people: children, old men, servants, ghosts, shadows, interiors, windows, and gardens. In each tiny illustration she manages to conjure up varying atmospheres—calm, bustling, frightening, mysterious—as always relying on strong contrasts of light and shade to intensify the drama.[34] By thorough research and through studies from life she accurately recaptured the period and climate without ever relapsing into mere pastiche. She took immense trouble to depict costumes and furnishings correctly, the breadth of her reading on anthropology and archaeology contributing to the authenticity of her images. The house and garden in *The Runaway* are based on her own at Harlton while, according to the preface, the huge curtained bed on page 157 is similar to her grandmother's and Clarice's dress is copied from J. L. Lawson's original illustrations.[35]

Nostalgia for history and historical characters together with childhood memories of Darwin family dramatics sharpened her imagination. Relations, friends, and their children were sometimes used as models for book illustration, Jacques, as we have seen, appearing in *Daphnis et Chloé*.[36] An illustrated diary from a visit to Persia may well have provided first-hand material for the oriental figures in *The Bird Talisman* since Raverat admitted in the preface that she had made no 'effort to be accurately Indian'. The story had originally been privately printed for the Darwin and Wedgwood families with pen and ink drawings by the author, Raverat's great-uncle Harry Wedgwood. According to the preface, as a child she had found the book 'rather arid'. In contrast, her animated scenes are full of Eastern promise, intrigue, and adventure.

A Sentimental Journey was the only standard work of English literature which Raverat illustrated. Her posed, costumed figures, though in keeping with the eighteenth-century text, suggest that she felt less at ease in this field than with poetry, myths, fairy tales, and books with a countryside theme. The evocative illustrations for *Farmer's Glory*, for instance, several based on her observations of Cambridgeshire farming life, capture precisely the rural character of Street's already popular text and, following in the wake of Leighton's *The Farmer's Year*, were well received. Poetry held a particular fascination, whilst responding to poetic language in pictorial terms was a recurring preoccupation. Her sensitive interpretations of Cornford's poems, such as the wistful 'After a Fever' in *Mountains & Molehills*, tangibly reflect intangible associations.

[34] Her stirring images of *The Old Man* and *Old People* which she used to illustrate her story 'An Image of Truth' in *Time and Tide* (Nov. 1932), 1302–4, anticipated these illustrations with their element of family domesticity and emotional drama.

[35] Several of her interiors with figures are reminiscent of popular wood-engraved 1860s illustration especially the work of Arthur Hughes, with which she was probably familiar.

[36] Quentin Keynes modelled for the standing boy in 'The Reapers' in *The Cambridge Book of Poetry for Children*. Conversation between Lindsay Newman and Stephen Keynes, 26 Sept. 1991. Elizabeth Vellacott, one of Raverat's oldest friends, recalled posing once or twice for some illustrations. Elizabeth Vellacott to the author, 2 Feb. 1989.

In comparison with most of her contemporaries, Raverat's illustrations and single prints were reproduced in an unusually large number of magazines and journals, among them the *Apple*, the *London Mercury, Country Life*, the *New Statesman*, the *Listener*, the *Adelphi*, and the *Spectator.* Apart from illustration and other book-related work such as dust-jackets, endpapers, bindings, and bookplates, she received plenty of other wood-engraving commissions, advertisements being probably the most lucrative.[37] Family connections and social contacts were of vital importance, providing her with advice, moral support, and jobs. Some of her smaller bookwork commissions were for title-pages and frontispieces: for example, a frontispiece portrait of Brooke facing an appropriately Neo-Pagan title-page of a nude man piping for *The Collected Poems of Rupert Brooke*, and single wood-engravings for Geoffrey Keynes's bibliographies of Sir Thomas Browne and John Evelyn. In Cambridge she was in demand to provide programmes, costumes, and scenery for local theatrical and concert societies, in particular for the Cambridge University Musical Society's Handel opera performances. Other ephemeral work included wood-engraved designs for Christmas and greetings cards, posters, and pamphlet covers.

The war, in effect, put an end to Raverat's wood-engraving career. She was employed as a factory hand at the Cambridge Scientific Instrument Company and subsequently as a draughtsman for Naval Intelligence, not returning to Harlton until 1946. Apart from some work for a limited edition in 1950,[38] she did no more black and white wood-engraved illustration after 1939, although de la Mare felt that Faber's could still afford to keep her on as a line drawing illustrator. She indulged briefly in single-colour prints until a stroke in 1951 paralysed her left side making engraving impossible. Undeterred she continued to paint and draw, and in the following year produced perhaps her most engaging book, *Period Piece.* Whereas her line-drawn illustration always bordered on the caricature, her wood-engravings were distinctly more sensitive and atmospheric: a more truthful reflection of herself, perhaps.[39]

At first glance Gwen Raverat's wood-engraved book illustration appears quite traditional, almost retrograde in some instances. Although her designs were inventive she adhered to pictorial images believing a degree of representation to be necessary; her treatment of subject matter was limited; her work was not didactic; she never illustrated a contemporary novel and avoided depicting the harsh realities of modern, especially urban, life. Yet, despite her poignant descriptive landscape scenes, she was never a sentimental ruralist, her particular visual language and individual technique preventing her wood-engravings from becoming overtly English in the Bewick tradition. Her remarkable ability to capture the essence of the subject matter and to elevate the ordinary and familiar arose from her acute observation of human behaviour and a strong feeling for 'the spirit of the place'. The total involvement in the architecture of many of the books she illustrated was unusual and accounted for some highly original

[37] See Ch. 5.4.
[38] See n. 16.
[39] It is interesting to note the cross-fertilization of idea and images which frequently occur between her wood-engraved and line-drawn illustrated children's books.

overall designs. Through her children's books she introduced the medium to a whole generation of younger readers in England and America, when few other wood-engravers had entered this field,[40] and with the publication of *The Bird Talisman* she reinstated colour wood-engraved illustration. Quite unwittingly Raverat was a pioneer in her approach to wood-engraving, most especially as illustration.

One of the few practitioners before the Second World War to have lived on the Continent and to have direct contact with French art and artists, Gwen Raverat brought a refreshing painterly angle to the insular world of British wood-engraving. Stephen Bone (1904–58), who studied first with his father Sir David Muirhead Bone, then (1922–4) under Tonks at the Slade, was a frequent traveller and, therefore, like Raverat was more in tune with continental, particularly French, graphic art than most of his contemporaries.[41] In 1925 he won a gold medal at the Paris International Exhibition for his illustrations for books, four of which were written by his mother, Gertrude. His wood-engravings for *Mr Paul* (Jonathan Cape, 1921) are some of the earliest in the modern white-line style to appear in a commercially published book: the *paysan* figures disclose a strong affinity with those of French Realist printmakers such as Camille Pissarro and *Plate 93* J. F. Millet, while his freely handled technique shows impressionist tendencies, as exemplified in the roundel frontispiece to *The Furrowed Earth* (Chatto & Windus, *Plate 94* 1921).

In *Fine Prints of the Year* of 1924 Salaman noted 'two new and very gallant adventurers on the wood block', C. T. (Charles Thrupp) Nightingale (1878–?) and Alec Buckels (fl. 1923–45). Both artists illustrated largely for Blackwell's children's publications. Much of Nightingale's work accompanied his wife Madeleine's verses for children, the text sometimes reproduced in his calligraphic script. These engravings combine decorative, linear elements of Morris and Sleigh with a looser, less constrained style. In *Nursery Lays Plate 95* *of Nursery Days* (Basil Blackwell, 1919) and other books, some of the illustrations break out of their frames and spread over one or occasionally two pages several years before Raverat refined this approach to layout.[42]

Buckels illustrated the poetry of Walter de la Mare for the woodcut supplement to the Royal College of Art magazine *Gallimaufry* (June 1922), before contributing with Nightingale and others to Blackwell's new children's periodical *Joy Street* (1923). His *Plate 96* decorative manner, as seen in his interpretation of 'Friendless', with textures created by small specks *à la manière criblée*, and the absence of solid blacks, contrast with the more robust style of many of the wood-engravers in the early 1920s.[43]

[40] *The Cambridge Book of Poetry for Children* was published in the same year as *The Adventures of the Black Girl in her Search for God* and was instantly popular, with five new impressions printed between 1942 and 1962.

[41] An official war artist with the navy in the Second World War, he later became an art critic for the *Manchester Guardian*. He was a prolific figure and landscape painter. In 1929 he married Mary Adshead with whom he collaborated on a number of children's books with line-drawn illustrations.

[42] He exhibited with the SWE in 1921 and 1922 (one print each time), and between 1922 and 1927 at the Royal Academy and provincial galleries. The author is grateful for being alerted by David Knott, Rare Books Librarian, Reading University Library, to an exhibition of Nightingale's illustrated books held in the Library in 1995.

[43] Painter and etcher as well, Buckels both wrote and illustrated children's books, several with colour line drawings. He was a major illustrator to Blackwell's *Merry-Go-Round* and also contributed colour wrappers and plates to *Joy Street*.

Pl. 93 (*right*). Stephen Bone: Gertrude
Bone, *Mr Paul* (Jonathan Cape, 1921).
115 × 80

Pl. 94 (*below, right*). Stephen Bone:
Gertrude Bone, *The Furrowed Earth*
(Chatto & Windus, 1921). 101 diam.

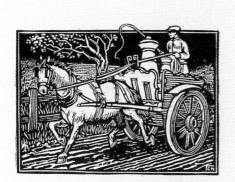

THE MILKMAN.

t's jolly when you're restless (as one generally feels
Lying very still in bed and making plans)
Just to hear his harness jingle and the
rattle of his wheels
And the clang-a-clang of all his shiney cans.
For when you know that lying still is such a great mistake,
It's nice to know the milkman knows you're really
wide awake.

I hear him say "Whoa back there !" & then he calls "Mee-yook",
And when he bangs his can-lid extra loud
I scramble very quietly on the window-sill and look,
And if he waves his whip I'm very proud.
For though the milkman brings the milk for
breakfast and for tea,
He told me once he really comes to say Good-day to me.

7

Pl. 95 (*above*). Charles Thrupp Nightingale:
Madeleine Nightingale, *Nursery Lays of
Nursery Days* (Basil Blackwell, 1919).
190 × 286

Pl. 96 (*left*). Alex Buckels: 'Friendless' from
Number One: Joy Street (Basil Blackwell, 1923).
102 × 102

Although only minor artists the distinctive painterly style of these last three practitioners, and the concentration on children's books by Nightingale and Buckels, set them aside from most of their contemporaries.

THE HARD-EDGED TYPOGRAPHIC APPROACH

11.1. *Robert Gibbings: Later Work*

In later years Robert Gibbings asserted that it was the discipline of wood-engraving, its 'austere quality' and 'clear, precise statement', that initially attracted him to the medium.[1] By natural progression 'he threw himself into the even stricter discipline of engraving for books'.[2] The necessity to harmonize blocks with type encouraged him to formulate a hard-edged typographic technique which, as a stone sculptor, came as naturally to him as it did to Eric Gill. Elements of Gibbings's pre-1920 silhouette style lingered on in his Golden Cockerel illustration which soon began to show the influence of Gill's black-line approach. Towards the end of the 1930s his wood-engraving style became more textural, as exemplified in the illustrations to his famous 'River' series of the 1940s and 1950s. Yet, despite the popularity of these, and the stylishness of his Golden Cockerel Press designs, his most original work remains his startling modernist style discussed earlier.[3]

Gibbings was a burly, bearded man with enormous energy and enthusiasm. His wood-engraving output was prolific: it included illustrations to over sixty books (of which he was the author of fourteen) and other book-related work such as designs for dust-jackets and press devices.[4] An amusing and fluent writer and lecturer, he did much to promote wood-engraving. As owner of the Golden Cockerel Press he played a key role in nurturing new talent, most especially that of Gill, Jones, and Ravilious. Although there is a scarcity of unpublished documentary material and artwork from which to assess his working methods, a file of correspondence with Ravilious,[5] and a few other letters, offer an insight into his approach to printing and illustration, as well as cast light on his financial problems and personal life.[6]

In the early 1920s Gibbings's commissions consisted mainly of wood-engravings for advertising companies and journals.[7] He was greatly helped by Balston who frequently bought his work and encouraged his progress.[8] In a letter to him dated April 1922,

[1] Robert Gibbings, 'Thoughts on Wood', repr. *Matrix*, 9 (1989), 8–10, p. 9.

[2] Thomas Balston, 'The River Books of Robert Gibbings', *Alphabet and Image*, 8 (1948), 39–49, p. 39.

[3] See Ch. 4.4, 'Robert Gibbings'.

[4] See A. Mary Kirkus, *Robert Gibbings: A Bibliography*, ed. Patience Empson and John Harris (London, 1962).

[5] Held in the GCPA, HRHRC. See Ch. 6.2, 'The Golden Cockerel Press', in particular n. 80.

[6] By his own admission he kept few records of the press, never having had a formal agreement with any authors or artists whom he employed. Robert Gibbings to Owen Rutter, 1 Feb. 1934. GCPA.

For further discussion on Gibbings's press practices see Roderick Cave and Sarah Manson, *The History of the Golden Cockerel Press* (in preparation).

[7] In 1922 he and his wife Moira produced a little publicity booklet entitled *The Zoo* with 17 wood-engravings for the London Metropolitan Railways (later London Transport).

[8] See John Dreyfus (ed.), 'Some Correspondence between Robert Gibbings and Thomas Balston', *Matrix*, 9 (1989), 37–51, with an appendix, 'Comments by Robert Gibbings on his Wood-Engravings made for Book Illustration', 51–4. Correspondence held at WACML. (This volume is largely dedicated to Gibbings's work.)

Gibbings wrote that he 'should very much like to do some decorations for really first class books especially where it would be possible to keep in touch with the printer and treat the book as a whole, not so many pages of letterpress with so many illustrations'.[9] His proposal to collaborate with the Portuguese-American writer Don Passos on a book about Spain, however, came to nothing. After initial doubts about Balston's proposed publication of *Contemporary English Woodcuts* Gibbings expressed an interest in contributing and approved of the idea of an introduction by Campbell Dodgson. He thought that the book ought to interest a new public in the medium.[10]

No book illustration work was forthcoming by December although Gibbings had engraved some blocks for dust-jackets and was 'playing with small decorations, tail pieces etc in the hope of finding a use for them later'.[11] His break came with a commission (originally intended for Gwen Raverat) from Jonathan Cape to illustrate Samuel Butler's *Erewhon* which he considered 'the kind of stuff I want to do, much more satisfactory than adverts for aperients'.[12] His thirty-eight wood-engravings consisted of a frontispiece, title-page design, and head- and tailpieces. The rectangular frontispiece (the same size as the title-page border) depicts a seated female figure naked and grotesque. Robustly *Plate 97* handled in woodcut fashion, the gouged surface of the body, which is edged with short parallel toolmarks, contrasts with the heavy black, lightly flecked background. For some of the small vignettes Gibbings employs the vanishing line technique, while others, such as one of a sprightly horse and accompanying animals leaping across the page, are executed in a silhouette style. Most of these illustrations, however, tend to overpower the lightweight type. Gibbings considered them 'a pretty poor effort'.[13] Inexperienced at illustrative work, he had not managed to achieve the harmony for which he had hoped.

By the time Balston suggested that he might like to illustrate *Songs from Shakespeare* Gibbings had inadvertently been swept into purchasing the Golden Cockerel Press from Harold Taylor and was unable to consider this idea. He had hoped to have some spare time for his own work but admitted that he was too busy supervising production, as well as illustrating three books himself. Owning a press gave Gibbings his first opportunity to treat the book as a whole. He interpreted Brantômes's bawdy text for *Lives of Gallant Ladies* with seductive scenes of naked women.[14] The rectangular blocks are predominantly black, the surface broken by large white areas. Outlines are shaded with small parallel lines, a technique which Gibbings favoured at this time. Each discourse begins with a coloured initial. The twenty silhouetted illustrations for Henry Carey's *Songs and Poems*, lightly engraved in white line are, like the chapbook woodcuts they resemble, appropriate to the ballad-style text although rather too heavy for the hard, white Arnold paper and Caslon Old Face type. A similar engraving style is used for Henry Thoreau's *Where I Lived and What I Lived For* of the same year.

[9] 21 Apr. 1922, ibid. 39.

[10] Balston had requested him, as one of the Society of Wood Engravers' organizers, to try to persuade Gill to contribute. Relationships were apparently strained at this time, Gibbings pointing out that Gill 'is a very difficult man to manage'. 24 July 1922, ibid. 41.

[11] 28 Dec. 1922, ibid. 44.

[12] 6 Mar. 1923, ibid. 46.

[13] Quoted from 'Comments by Robert Gibbings', 51.

[14] The book was subsequently printed for subscribers only and set a precedent for the press for publishing mildly erotic literature. See Ch. 6.2, 'Private Presses'.

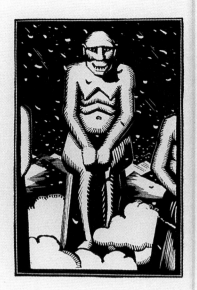

Pl. 97 (*right*). Robert
Gibbings: Samuel Butler,
Erewhon (Jonathan Cape, 1923).
c.123 × 265

Pl. 98 (*below*). Robert
Gibbings: *Samson and Delilah*
(Golden Cockerel Press, 1925).
260 × 374

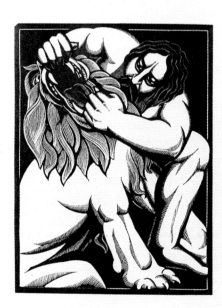

be a Nazarite to God from the womb to the day of his
death. ℭ And the woman bare a son, and called his name
Samson: and the child grew, and the Lord blessed him.
And the Spirit of the Lord began to move him at times in
the camp of Dan between Zorah and Eshtaol. ℭ And
Samson went down to Timnath, and saw a woman in
Timnath of the daughters of the Philistines. And he came
up, and told his father and his mother, and said, I have seen
a woman in Timnath of the daughters of the Philistines;
now, therefore, get her for me to wife. Then his father
and his mother said unto him, Is there never a woman
among the daughters of thy brethren, or among all my
people, that thou goest to take a wife of the uncircumcised
Philistines? And Samson said unto his father, Get her for
me; for she pleaseth me well. But his father and his
mother knew not that it was of the Lord, that he sought
an occasion against the Philistines: for at that time the
Philistines had dominion over Israel. Then went Samson
down, and his father and his mother, to Timnath, and
came to the vineyards of Timnath: and, behold, a young
lion roared against him. And the Spirit of the Lord came
mightily upon him, and he rent him as he would have
rent a kid, and he had nothing in his hand: but he told
not his father or his mother what he had done. And he
went down, and talked with the woman: and she pleased

5

In October 1925 Gill agreed to engrave exclusively for the press and it was from him that Gibbings learnt most about illustration and typography. Gill's *The Song of Songs* was published in the same month as Gibbings's *Samson and Delilah*, the latter, according to Sandford, the first of a very successful series of quarto 'picture-books'.[15] The pictures consist of some large, whole-page engravings with smaller ones inset above the text. Gibbings's massive bodies are in a modern idiom, his bulky, four-square approach to figure engraving mirrored in his sculptural work. The rectangular illustrations are heavily framed and, as before, the emphasis is on strong black and white areas with outlines and tones represented by stylized white lines. This monumental approach is rather more suitable to the story of Samson's feats of power, as in the scene where he grapples with the lion's open jaws, than to the lighter-weight Caslon type, but the overall *Plate 98* impression is one of increased assuredness and enjoyment. Indeed Gibbings felt that most of these illustrations had 'a strength in them that is quite interesting'.[16]

Gill and Gibbings shared a common fascination for nudity, even to the extent of playing tennis and working at the press sometimes with nothing on, much to one apprentice's embarrassment.[17] Gibbings subscribed to the *Nudist* magazine and contributed several wood-engravings. Both men engraved the naked female figure with enthusiasm but with surprisingly little tenderness, partly due to their hard-edged and hence rather cold technique. An illustration of Samson with a harlot stretched out on a pillow shows Gill's influence, particularly in the use of almond eyes and fixed expressions, and the decorative patterning of textures and backgrounds. These features can be seen in some of the illustrations Gibbings did next for E. Powys Mathers's oriental tale, *Red Wise* (1926): one illustration depicts a couple in similar pose to that in the *Samson* engraving and another a dancer with outstretched arms, swathed in scanty robes, set against a patterned backdrop and enclosed in an ornamental border. The line here is much finer and lighter and more in harmony with the type.

Since his Irish boyhood Gibbings had developed a passion for nature and the countryside with the result that birds, fishes, sea, rivers, and rocks are common subjects in his repertory of wood-engravings. Yet none of his Golden Cockerel publications is specifically nature oriented, possibly, though surprisingly if so, because he found no suitable text to interpret. His first break into countryside illustration, for which he was to make his name, was a commission by Constable for Viscount Grey's *Fallodon Papers* (1926) with fifteen head- and tailpieces. A hangover of his early style can be seen in the expressive mountain landscape of the final tailpiece. Depictions of wildlife are stylized rather than naturalistic. Gibbings was displeased with the book. The following year he illustrated Lord Grey's *The Charm of Birds* for Hodder & Stoughton. Twenty-one small vignettes, mainly of birds but including a few of figures, cows, and boats, grace the chapters of this popular book.[18] The engraving style is softer with more white lines

[15] Christopher Sandford and Owen Rutter, *Bibliography of the Golden Cockerel Press* (Folkestone, 1975), No. 30, 22.
[16] 'Comments by Robert Gibbings', 51.

[17] Conversation between the author and the late John G. Murray, 25 Apr. 1991.
[18] See Ch. 6.3 n. 152.

anticipating those of his River Series prints. This bird book, his first serious introduction to the subject, started off his interest in such illustration.

Gibbings illustrated no more countryside books until *The Roving Angler* (Dent, 1933) in which scenes of fishes, anglers, and tackle, some repeated, are more lifelike than the earlier nature engravings. His illustrations for *A Bird Diary* (Dent, 1936) point to a new direction: more assured and clearly based on observation, yet, paradoxically, less vital and original. Gibbings himself felt that the blocks seemed rather cold, though some had got more humanity.[19] *Blue Angels and Whales*, published in 1938 as a Pelican Special by Penguin Books, was his first attempt at writing a natural history book.[20] The illustrations include a fine coloured frontispiece wood-engraving of a fish and an attractive device incorporating a blue angel fish, a whale, a quill, a graver, and the initials 'RG'. The rest are competent if unexciting studies from life.[21]

Other books up to this date contain examples of this descriptive naturalist style but Gibbings was generally at his best with more imaginative designs. Stylized headpieces of birds, a butterfly, and a squirrel, among other animals, appear in A. E. Coppard's *The Hundredth Story* (1931), the first press book in Golden Cockerel Press's Guinea Series of illustrated modern authors.[22] Some of Gibbings's most sensitive images were for a little book of poems of the Didinga and Lango Tribes translated by J. H. Driberg entitled *Initiation* (1932).[23] Birds and animals are delicately and stylishly handled particularly the black leopard which 'crouches, eyes flaming, poised' which Gibbings considered 'the best in the book by a long way'.[24] In Flaubert's *Salambo*[25] (1931) an eye-catching black-line title-page shows a cockerel in the centre framed by columns, with a black snake (a recurring motif in Gibbings's work at this time) wrapped round the base of the right-hand column. The most exciting of his wildlife images occur in Llewelyn Powys's *Glory of Life* (1934). Gibbings delighted in ornamented foliage and other nature patterning, as exemplified in the magnificent *Snake in Forest*, one of the most decorative of all his blocks. He empathized with Powys's philosophy and the animals and birds depicted are symbolic rather than descriptive interpretations of the text.[26]

Plate 99

The earliest indication of Gibbings's interest in the *mise en page* was his designs for *The True Historie of Lucian the Samosatenian* which was published in December 1927 in quick succession to *Troilus and Criseyde*, the first of Gill's books for the press with elaborate decorated borders. The original Greek text and translation on opposite pages were surrounded by Gibbings's blocks, his initial attempt at border design no doubt influenced by Gill, although his engravings are mostly enclosed in black-line frames

[19] 'Comments by Robert Gibbings', 53.

[20] A series of 3 school science textbooks by Eleanor Doorly contained fairly factual illustrations—*The Insect Man* and *The Microbe Man* (W. Heffer, 1936 and 1938) and *The Radium Woman* (William Heinemann, 1939)—as did J. H. Fabré's *Marvels of the Insect World* (New York: D. Appleton, 1938).

[21] The book also contains extraordinarily accurate pencil sketches which were made on xylonite by the author under water.

[22] Also the first of the press's books to use the new Golden Cockerel Face type.

[23] Sandford considered the book 'an interesting and successful experiment in the use of sans serif type for bookwork combined with decorative [ink] coloured wood-blocks'. *Bibliography of the Golden Cockerel Press*, No. 79, 36.

[24] 'Comments by Robert Gibbings', 52.

[25] Alternative spelling to Flaubert's original title, *Salammbô*.

[26] According to Gibbings the little block of two lovers sitting under pollarded willow trees by a river are symbolic of life and death. Robert Gibbings, 'Llewelyn and Theodore', *Matrix*, 6 (1986), 1–5, p. 4.

LOVE in a hut, with water and a crust,
Is—Love, forgive us!—cinders, ashes, dust;
Love in a palace is perhaps at last
More grievous torment than a hermit's fast:—
That is a doubtful tale from faery land,
Hard for the non-elect to understand.
Had Lycius liv'd to hand his story down,
He might have given the moral a fresh frown,
Or clench'd it quite: but too short was their bliss
To breed distrust and hate, that make the soft voice hiss.
Beside, there, nightly, with terrific glare,
Love, jealous grown of so complete a pair,
Hover'd and buzz'd his wings, with fearful roar,
Above the lintel of their chamber door,
And down the passage cast a glow upon the floor.

15

Pl. 100. Robert Gibbings: John Keats, *Lamia and Other Poems*
(Golden Cockerel Press, 1928). 305 × 185

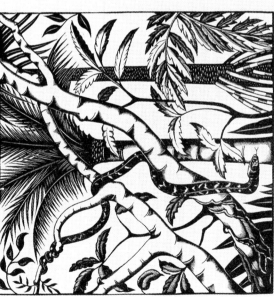

and if any ask the reason for our uncorrupted loyalty it is best to essay no answer. ❋ It is sexual and mother love that has with the passing of the generations prompted men and women to refined responses, and it is just here that man's yard-long staked-out claim of freedom allows him to sophisticate the mandates of nature. It would be base not to forward the cause of such an unforeseen chivalry. As this magnanimous sensibility grows more and more common so will the happiness of mankind prosper. Compassion under the discipline of scientific knowledge may well inaugurate the long-expected Utopia. We have no illusions about

19

Pl. 99. Robert Gibbings: Llewelyn Powys, *Glory of Life*
(Golden Cockerel Press, 1934) 332 × 230.

THE IMPRESSION OF LOITERING TRAVELLERS is that the finest country in the world (while they are in it) is Ireland, and the best part of Ireland is just where they happen to be at the time—you couldn't say more for heaven itself, or even the National Gallery. But to a native the best part of Ireland is always some other part you have not yet seen—and he is right. In Dublin once—but it was years ago—I said to a man it was a fine city, with noble buildings, breweries, courts, colleges, post offices, and all the amenities of monuments, museums, and grand police; it was this, it was that, O yes, but, well, didn't it have just rather more than its fair whack of things like slums?

'Begod!' said he. 'Have ye ever been to Belfast? No! Well, if it's slums you want, that's the holy place!'

B 1

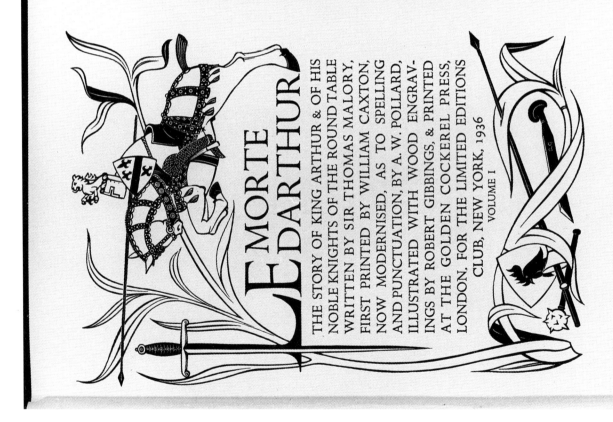

LE MORTE DARTHUR

THE STORY OF KING ARTHUR & OF HIS NOBLE KNIGHTS OF THE ROUND TABLE WRITTEN BY SIR THOMAS MALORY, FIRST PRINTED BY WILLIAM CAXTON, NOW MODERNISED, AS TO SPELLING AND PUNCTUATION, BY A. W. POLLARD, ILLUSTRATED WITH WOOD ENGRAVINGS BY ROBERT GIBBINGS, & PRINTED AT THE GOLDEN COCKEREL PRESS, LONDON. FOR THE LIMITED EDITIONS CLUB, NEW YORK, 1936
VOLUME I

Pl. 101 (*left*). Robert Gibbings: Thomas Mallory, *Le Morte d'Arthur* (Limited Editions Club, 1936). 310 × 188

Pl. 102 (*above*). Robert Gibbings: A. E. Coppard, *Rummy* (Golden Cockerel Press, 1932). 240 × 152

and are consequently less free-flowing. Again many of his figures are sculptural, with Gill-type expressions. Some smaller rectangular engravings are embedded into the text. The double spread across the top of both pages shows Gibbings attempting to unify text and image.

In Sandford's eyes one of Gibbings's greatest triumphs was John Keats's *Lamia and Other Poems* (1928) which he considered to be 'an almost perfectly proportioned book of which the Press is duly proud'.[27] Gill's stylistic influence is apparent from the angular foliage and the narrow-eyed faces of the embracing couple in the scene to *Ode to Psyche* *Plate 100* and from the use of outline and solid blacks, evident also in the beautiful title-page sporting a bamboo leaf surround.[28] Engravings are no longer framed in black but freely profiled as with the powerful figure of Apollo striding out with garments blowing in the wind. The lightness of the blocks enables them to harmonize with the type. With his wood-engravings for *Salambo* he partly achieves this balance by removing a section of various headpiece blocks to accommodate the chapter title.

Gibbings's most effective designs and layout were for *Glory of Life*. A full-page front-ispiece of a gull faces the title-page of vast red lettering reading THE GLORY OF LIFE. Both designs take up the same amount of space and match each other perfectly. The tips of the bird's wings are not hemmed in by a frame at the top, allowing a feeling of open space. Most of the remaining engravings are rectangular but not all are framed, several being in the familiar solid black style with large areas of white. In some, of mountains and rock formations particularly, Gibbings's modernist tendency is still present. Sandford pronounced that 'his magnificent title-page engraved in wood was an innovation, and titles of this kind would enhance the beauty of many publishers' books'.[29] Since Gibbings did not particularly enjoy working in black line his design was a conscious move away from the ornate border style so beloved of Gill.

For the title-page of Malory's *Le Morte d'Arthur*, published by the Limited Editions *Plate 101* Club in 1936, however, Gibbings reverted to a floriated border in a similar vein to that for *Lamia*. George Macy found it 'magnificent, not only delightful but exactly what I had in mind. It is not often that a publisher can say this to an artist.'[30] His suggestion to make various interchangeable border blocks[31] for the margins of the book was taken up by Gibbings who sent him progress proofs of a few commenting that the blocks 'could be joined in holy matrimony while allowing each of them a fair proportion of licence outside the marriage bed!!'[32] Having completed the final proofs he agreed with Francis Newbery at the press that the book could do with some more small decorations; he subsequently sent ten supplementary blocks. The designs for the final book (published in three volumes) are made up of sixty-three blocks repeated in a variety of com-binations: the title-page appears in each volume as do many of the leafy borders

[27] *Bibliography of the Golden Cockerel Press*, No. 62, 32.
[28] Although Gibbings produced 5 decorated initials, Gill designed the remaining initial letters including the words 'LAMIA' on the title-page and 'IT' on p. 18.
[29] *Bibliography of the Golden Cockerel Press*, No. 91, 40.
[30] George Macy to Robert Gibbings, 24 May 1934. Limited Edi-

tions Club Archive, HRHRC, henceforth LECA. Reproduced by kind permission of MBI, Inc., as are all successive quotations from this archive.
[31] Electros were to be made from the blocks.
[32] Robert Gibbings to George Macy, 31 July [1934]. LECA.

incorporating swords, shields, medieval figures, and castles at the corners of some, but not all, pages. A few headpieces of jousting knights in armour and elegant ladies are a distinctive feature. Yet, despite these adornments, the overall impression is rather spare and uninspiring and in need of a greater pictorial element. Gibbings, however, found it 'a splendid theme'. ' For myself' he wrote to Macy, ' I am quite convinced that they are far & away the best set I have ever done & I hope you will feel likewise.'[33] For reasons of authenticity the commission involved a large amount of research. Suffering as he was from perennial financial problems, Gibbings was disappointed with the fee of £200.

As early as 1930 he had complained to Balston that he was so overworked with the Golden Cockerel Press that he felt 'tempted to sell the blooming bird'.[34] Three years later he sold the press to Sandford, Newbery, and Rutter and early in 1934 moved to Cornwall for a year to recover from the strain of his financial situation and unsettling marital affairs.[35] A major reason for the dramatic drop in the output of the press had been his extensive travels to the Caribbean. A commission to illustrate Esther Forbes's *A Mirror for Witches* (1928) for Houghton Mifflin of New York had inadvertently led to an arrangement to do a book in Tahiti with James Norman Hall. After a stay of three months in Tahiti making numerous drawings, Hall's text came to nothing owing to pressure of work. None the less Gibbings compiled and illustrated a largely imaginary account of his visit which Houghton Mifflin published in 1932 as *Iorana! A Tahitian Journal*. The forty-one wood-engravings, though based on observation, are highly stylized and hard-edged. Some are enclosed in rectangular frames and some are black outline vignettes, especially the bulky figure studies. Strong contrasts of black and white predominate. Gibbings particularly enjoyed the silhouette effect of tree trunks and jagged palm leaves; he liked also the tropical fishes on page 48. Looking back twenty years later he found these pictures very true to the life of the place though he considered the cutting crude compared with his more recent work.[36]

The making of *Iorana* launched him on a career as author and illustrator, particularly of books relating to his extensive travels. In 1930 he produced a delightful little picture book entitled *The 7th Man: A True Cannibal Tale of the South Sea Islands Told in Fifteen Wood Engravings and Precisely One Hundred and Eighty Nine Words*. A comic-strip effect is created by a series of small square-framed caricatures with a line of text above and below. He followed this formula up with *A True Tale of Love in Tonga*, 'told in 23 engravings and 337 words'. He had offered it to the Golden Cockerel Press considering it 'quite as good fun or better than the "7th Man"' but his fee of £100 could not be met. The book was then published by Faber and Faber in 1935, since he 'simply couldn't afford to be philanthropic—*with the best will in the world*'.[37] Llewelyn Powys particularly admired the two

[33] Robert Gibbings to George Macy, 19 Sept. 1934. LECA.
[34] Robert Gibbings to Thomas Balston, 3 June 1930. LECA.
[35] Correspondence reveals an idea for the press to publish Gibbings's collected engravings, which he rejected. Robert Gibbings to Owen Rutter, 28 Sept. 1934. GCPA.
[36] 'Comments by Robert Gibbings', 52.
[37] Robert Gibbings to Owen Rutter, 29 Mar. [?]. GCPA.

swimmers whom he thought 'marvellous, like seaweed they floated together. I thought the reaction of the tiny figures in the boat spoilt the woodcut a little.'[38]

Gibbings's views on black figure engravings echoed those of Farleigh: 'For dark-skinned people it is the perfect medium, because with them it is a matter of engraving lights on dark. But for light-skinned people one needs dark accents on white, and you cannot engrave dark accents: you can only engrave round them, and I have always disliked the black line.'[39] The large, sculptural figures of Caribbean people in *XIV Engravings on Wood* from drawings made on Orient Line cruises are especially stylish.[40] His sense of humour is obvious from the animated scenes of cannibals and other characters for his children's story, *Coconut Island* (1936) again for Faber and Faber who the following year published his historical narrative *John Graham, Convict, 1824*, featuring yet more natives in exaggerated poses.

Up to this time Gibbings had rarely illustrated contemporary British life, so some of his twenty-eight wood-engravings for Llewelyn Powys's *The Twelve Months* (Bodley Head, 1937)—poetical essays on the months of the year originally contributed to the *Daily Herald*—are uncharacteristic subjects. The courting couples in 1930s-style clothes appear awkward and unconvincing. He is more successful as a caricaturist. Early examples of this approach include chapbook-style figures such as the *Fruit Seller* for Jonathan Swift's *Miscellaneous Poems* (1928), their robustness in keeping with the text.[41] Some of Gibbings's wittiest portrayals are for the writings of A. E. Coppard: for example, *Crotty Shinkwin: A Tale of the Strange Adventure that Befell a Butcher in County Clare*, or *Rummy: That Noble Game Expounded in Prose, Poetry, Diagram and Engraving* in which he features himself and the author (with added comments)—both books published in 1932 in the Golden Cockerel *Plate 102* Guinea Series.

Gibbings's final five books for the press, mainly for the Sea Log Series, were competent but unadventurous. He enjoyed marine subjects and *The Voyage of The Bounty's Launch* (1934) enabled him to use familiar images of palm trees, boats, ropes, and anchors, some of which themes he repeated in *The Wreck of the Whale-Ship Essex* (1935). The figures of the mutineering sailors on the *Bounty*'s deck are surprisingly stiff and expressionless.[42]

In general Gibbings was less comfortable with historical subjects than with illustrations based on observation. This can be seen most clearly from his designs for the Limited Editions Club *Othello* (1939) which he produced when under particular financial and domestic pressure.[43] The previous March, Macy had expressed disappointment with the proofs so far, apart from the frontispiece: 'Nearly everyone says that the engravings for Acts 3 & 4 & 5 are not done with your usual spirit, that you have permitted a

[38] Llewelyn Powys to Robert Gibbings, 27 Dec. [?]. GCPA. 15 undated and unpublished drawings with captions in manuscript and typescript held at WACML are evidence that Gibbings was considering another little picture storybook in a similar format.

[39] Quoted in *The Wood-Engravings of Robert Gibbings*, 35.

[40] Printed at the Golden Cockerel Press in 1932 for the Orient Line, with signed proofs priced at 2 gns. each.

[41] The layout of 2-column text is the same formula that the press used for the Nash and Farleigh editions of Swift of 1925 and 1926.

[42] His last engravings for the press were for a tiny book translating Pushkin's *The Tale of the Golden Cockerel* (1936).

[43] Gibbings was unhappy with the fee when he saw the 'whacking' size of the volume. He asked for payment in advance since 'with two wives, five children & the hell of an overdraft, not to mention John Lane going bust, I find the "half year" most depressing'. Robert Gibbings to George Macy, 20 and 27 Jan. 1938. LECA.

wooden quality to come into their composition, which rather serves to rob the illustrations of their dramatic value.'[44] Gibbings retaliated by objecting to the idea of single plates which he felt certain was the cause of the trouble: 'To put in frontispieces to every act is like explaining the joke before you tell it.'[45] He would have preferred to fit smaller decorations into the type in his usual fashion and was prepared to redesign all the plates to make them an integral part of the book. Macy, however, felt that he must stick to the 'Shakespeare' format. It is certainly not one that suited Gibbings who was unused to engraving large-scale, dramatic figure scenes. The starkly contrasting whites and strong blacks of these images with little tonal relief are somewhat overpowering. The frontispiece which depicts Othello standing before a picture incorporating scenes from the play is an ingenious conception if rather heavily worked, but the figures in the other prints are cumbersome. In the final scene an ugly Desdemona reclines on her deathbed while Othello looks on with a lack of concern. Gibbings regretted later that he had not made Desdemona better looking, wryly remarking: 'I'm no hand with pretty girls. I suppose it's my saintly life for I never seem to be able to draw kissable lips or a lovable nose.'[46]

In 1936 Gibbings had been appointed Lecturer in Book Production at Reading University where for three days a week he taught wood-engraving in connection with typography. His subsequent illustration was largely for commercial publishers. In 1938 he was appointed Art Editor to the Penguin Illustrated Classics series and contributed characteristic scenes of sailors, boats, and dancing natives to the eighth volume, Herman Melville's *Typee*. The following summer he began exploring the Thames in a flat-bottomed boat which he designed and built in the university's woodwork department.[47] Exempted from active war service as a result of old war wounds, he continued to discover the river, partly on patrol in the Naval Home Guard. The outcome of these forays was the publication by Dent of *Sweet Thames, Run Softly* in 1940 with his own text and fifty wood-engravings. It was an instant success both in England and America[48] and led to further immensely popular books on rivers and on Ireland and the South Seas which he wrote and illustrated himself. His river book formula was always the same: small vignettes of observed scenery—rivers, bridges, boats, flowers, birds, fishes, anglers, and other country topics. They are appealing and apposite interpretations of his anecdotal text. Sketches, a diary, and manuscript notebooks for *Sweet Thames* reveal extensive research and reading, with notes on birds and flowers taken from other authors.[49] His skill at achieving such fine lines is remarkable, his task made easier by the fact that his sketches were mostly reproduced photographically on the surface of the blocks before being engraved, which accounts, perhaps, for a certain lack of spontaneity.[50]

[44] George Macy to Robert Gibbings, 14. Mar. 1938. LECA.

[45] Robert Gibbings to George Macy, 22 Mar. 1938. LECA.

[46] Robert Gibbings to George Macy, 16 Sept. 1939. LECA.

[47] See John Hadfield, 'Robert Gibbings: A Memoir', *Matrix*, 1 (1981), 53–9.

[48] First published at 12s. 6d. in an edition of 2,500 copies, frequent reprints amounted to 40,950 copies by 1948. See Balston 'The River Books of Robert Gibbings', and Sue Walker and Martin Andrews, 'Robert Gibbings and the "Willow"', *Matrix*, 9 (1989), 69–73.

[49] Held at WACML.

[50] See exhibition catalogue, *Robert Gibbings, 1889–1958* (Reading: Reading Museums and Art Gallery, 1989), with introduction by Martin Andrews.

Gibbings believed that his compositions for the River Series were his best work to date since they were the first he had been able to work on in his own time. Yet although his assured and stylish sense of line emerges in engravings such as the kingfisher,[51] most are more prosaic, repetitive, and craftsmanlike and fall into the traditionally British category, characterized by Bewick, of naturalistic decoration. Like Gill and Ravilious, Gibbings considered himself more a decorator than an illustrator, 'partly', he wrote, 'because I find decoration the easier of the two but also because I feel that only in the rarest cases do illustrations, as such, help the text'.[52] Unlike Gill or Ravilious, however, Gibbings failed to make a virtue of the design potential of wood-engraving in his later works, which lacked the startling originality and inventiveness of his early prints.

11.2. *Eric Gill: Later Work*

The field of Eric Gill has been ploughed over many times particularly in relation to his letter-cutting, typography, and sculpture and above all to his idiosyncratic views and controversial personal life.[53] Less has been written on his total *œuvre* of wood-engraved book illustration viewed in relation to his design ideas and working methods. His various styles, which changed dramatically according to the nature of the commission, are consequently discussed here in greater depth with special reference to those books where documentary material and artwork are available and as yet largely unpublished.

Eric Gill's wood-engravings are most often praised for their immaculate precision and typographical quality as epitomized by those designed for *The Four Gospels*. Needless to say as a stone carver and letter cutter he had the eye and the manual dexterity for painstaking work, but his style and technique, within their limitations, were far more varied and original than is generally recognized. Malcolm Yorke, for instance, considers him neither technically nor experimentally innovative.[54] Gill certainly did not believe in skill for skill's sake nor, according to David Kindersley, was he 'interested in self-expression or in expressing the material in which he was working'.[55] His rigidly controlled and incisive technique contrasts with the more tonal or free-flowing linear methods of many of his contemporaries. His subject matter is distinctly limited, generally religious, domestic, or erotic, or often all combined: figurative yet impersonal, symbolic rather than naturalistic. Yet, despite these restrictions, Gill experimented with the medium more than most wood-engravers of his time, consciously attacking the purist viewpoint.[56] He invented his own shallow woodcut method, tried out intaglio

[51] *Sweet Thames*, 45.
[52] MS note written on an illustration to *Othello*. LECA.
[53] For a frank account of his life see Fiona MacCarthy, *Eric Gill* (London, 1989; repr. 1990).
[54] Malcolm Yorke, *Eric Gill* (London, 1981), 170.
[55] David Kindersley, *Recollections: Mr Eric Gill* (San Francisco, 1967), 22.

[56] He wrote, for instance, 'It is a bit of a lark to come out with a technical innovation [intaglio wood-engraving] which upsets the theories.' Quoted from Eric Gill, 'Intaglio Printing from Wood Blocks', *The Woodcut*, 1 (1927), 27–9, p. 28. See also n. 62.

work, considered colour, toyed with the multiple tool, used two completely contrasting black- and white-line techniques in the same period, and turned some of his blocks into sculptured shapes. His illustrative wood-engravings reveal the extraordinary diversity of styles and techniques which evolved in the course of production: from the simple silhouette to his precise typographic black line, from delicate stippling to the loose, even shaky lines of his last years.

Gill was a meticulous record-keeper, hoarder, and self-publicist. He wrote diaries, chronological lists of prints, records of sales, and itemized account sheets listing hours spent on each book and cost of materials. He made scrapbooks of newspaper photographs and design ideas and even employed a press-cutting agent in later years. He was a compulsive letter and article writer on all manner of subjects and kept letter books. In his businesslike way he systematically retained hundreds of his engravings, drawings and other working material. Most of this source material has been preserved in various libraries and collections,[57] with the result that Gill is probably the most thoroughly documented and researched wood-engraver of the period. With exceptions, particularly diary entries and account sheets, only a small amount of written primary material directly relates to individual book illustration, but there is plenty of visual evidence to enable an analysis of his working methods and stylistic and technical development over the years.

As far as Gill's wood-engraving was concerned the Ditchling period was a time of experiment. Working under Pepler he began to value the importance of handwork although initially he showed no particular interest in the typographical aspects of book illustration. For his early compositions Gill followed his stylistic advice to novice wood-engravers to begin with patterns and pictures of white lines on black, starting with silhouettes,[58] hence the preponderance of black in these works. He was more adventurous when not confined to book illustration, that for St Dominic's publications being on a small scale and mainly of a religious or decorative nature. Some of his most sensitive wood-engravings at this time were depictions of his own family, such as *Girl in Bath II* (1923). In *Divine Lovers I* (1922) he reveals his strong sexuality and begins to expound his
Plate 20 theory of human love being a glorification of divine love.[59] *The Nuptials of God* marked the end of his Ditchling period and the beginning of a new approach in which the combination of religious and sexual elements were to dominate his work.

Gill's move to Capel-y-ffin in August 1924, following differences with Pepler and resignation from the Guild of St Joseph and St Dominic, freed him from the restraints of working in a confined community of Catholic craftsmen and the limitations of

[57] Notably in HRHRC, WACML, VAM, Richard A. Gleeson Library, University of San Francisco (RAGL), The Newberry Library, Chicago (NL), and the St Bride Printing Library.

[58] Eric Gill, Appendix to R. John Beedham, *Wood Engraving* (London, 5th rev. edn., 1938), 51.

[59] He made two wood-engravings on this theme, printing from two separate blocks. The second block with the background cut away, was engraved and printed, then carved into a free-standing sculpture—one of several examples in which a wood-engraving design has been reused in sculptural form (see n. 92). The interconnection between wood-engraving and sculpture is a significant and vital aspect of his work which merits closer investigation. Various examples are reproduced in exhibition catalogue, *Eric Gill: Sculpture*, selected by Judith Collins (London: Barbican Art Gallery, 11 Nov.–7 Feb. 1993). The frieze-like foliage for the 1932 stone relief *Odysseus welcomed from the Sea by Nausicaa* (Cat. No. 93), for instance, shows strong similarities with his *Troilus and Criseyde* designs.

mainly non-secular commissions. Although Capel-y-ffin itself was isolated, Gill freely came and went, always returning to his wife and family while pursuing a fairly libidinous lifestyle, as on visits to his new-found friends, Moira and Robert Gibbings, with whom he first stayed after lecturing to the Society of Wood Engravers in November 1924. This fortunate friendship between Gill and Gibbings, who shared not only professional interests but a sense of humour, fun, and 'the right and proper naughtiness of life', resulted in several fruitful collaborative years producing some of the finest Golden Cockerel Press books, most especially *The Four Gospels*.

Having acquired a large and a small hand press and a copper plate press, Gill enthusiastically discovered printing to be 'great sport',[60] and soon realized that selling prints could be a lucrative business. From now on all his prints were methodically numbered, listed, and priced. He received considerable technical advice from George Friend[61] and was inspired to experiment with the intaglio method on wood which he considered a 'technical innovation'.[62] But he had yet to take a close interest in typographical matters.

Gill learnt most about printing for books from Gibbings, sharing with him the belief that 'the engraver and printer *must* be one "firm"'.[63] Yet it was some time before they collaborated closely, partly due to religious differences.[64] It was J. G. Wilson of Bumpus's bookshop who, in the summer of 1924, suggested to Gill's sister Enid Clay that Gibbings should take over the printing of her book of poems, *Sonnets and Verses*, illustrated by her brother.[65] Gill began the drawings on 8 September without even seeing proofs of the manuscript. A month later he was already 'printing Enid's blocks all day long with PH [Philip Hagreen]'.[66] All the blocks, mainly rectangular, but some silhouetted, head- and tailpieces, are engraved in his earlier style of fine line on a heavy black background: a nude couple awkwardly embracing, delicate flowers, two sensitive yet stiff figures of a young naked girl, a quasi-religious study of *Death and the Lady*, and a domestic interior very similar in mood and style to the *Autumn Midnight* frontispiece. These eight anecdotal scenes, though lyrical in mood and appropriate to the text, are somewhat mannered and overweight for the type. According to Gill 'the printers complained that such black blocks could not be printed with type. Since then, with rare exceptions, I have given up using white line on black'[67]—by no means an accurate statement but significant in that he publicly rejected the white-line principle in favour of black line.

This was the turning-point towards a new, more typographic style, partly encouraged by his recent understanding of the difficulties of printing and partly as a result of

[60] Eric Gill to Desmond Chute, 23 May 1925. Quoted from *Letters of Eric Gill*, ed. Walter Shewring (London, 1947), 187.

[61] Noted engraver, punch-cutter, and part-time lecturer at the Central School of Arts and Crafts. See John Dreyfus, 'George Friend, 1881–1969: A Memoir', *Journal of the Printing Historical Society*, 5 (1969), 81–6.

[62] According to Christopher Skelton, *The Engravings of Eric Gill* (Wellingborough, 1983), p. xx, correspondence with George Friend (held at WACML) shows Gill's keenness to master the copper plate press. Friend advised him on transforming the image to metal (photographic methods were recommended), engraving, and printing. The printing of his first copper and zinc engravings encouraged Gill to try a similar intaglio method with wood-engravings. See n. 56.

[63] Eric Gill to Enid Clay, 1 Mar. 1924. WACML.

[64] For Gibbings's comments on these see Robert Gibbings, 'Memories of Eric Gill', *Book Collector*, 3 (1953), 95–102, pp. 95–6.

[65] Before Gill's rift with Pepler the book was to be printed at St Dominic's Press.

[66] Diary, 9 and 12 Nov. 1924. WACML. Further references to dates in the text refer to diary entries.

[67] *Engravings by Eric Gill*, 7. *Sonnets and Verses* was chosen by the Double Crown Club as the best printed book of the year.

realizing the value of relief black line in relation to type. His interest in lettering was revived through a visit from his old patron Count Kessler to go 'through lettering for Virgil book'[68]—a project begun twelve years earlier in which Aristide Maillol had collaborated with Gill on the designs for wood-engraved initials for *The Eclogues*.[69] In March he was working on some geometric patterned initials for the Golden Cockerel Press *An Apology for the Life of Colley Cibber.*

By October Gill had agreed to engrave exclusively for Gibbings's press.[70] *The Song of Songs*, to which he contributed a few initials and nineteen wood-engravings including some whole-page prints, is a key work: the first in Gill's Golden Cockerel style, combining both religious and erotic elements with a more confident, black-line technique which reveals his typographic awareness. Few of his illustrated books are so well documented: primary material, including sketches, finished drawings and proofs, accounts, and diary entries,[71] enables an insight into both his working procedure and his stylistic approach. From this material it is apparent that he exercised a conscious restraint not previously recognized.

Gill did not actually begin planning his illustrations until the end of July, although, according to his diary, he discussed the printing of the book at the Gibbings's home in Waltham St Lawrence on a couple of occasions before then. On 24 September he looked over the final proofs with Gibbings and corrected them four days later. There was much discussion about the book but minimal planning between the two men on the layout, Gibbings recalling that he 'may have sent Eric proofs of the type in galley slips and asked him to paste them up as he thought fit with the illustrations that he had already engraved. . . . The blocks and the type had little more than a brotherly-sisterly relationship.'[72] Writing to Chute the year following publication, Gill considered that the black and white engravings and typography were fairly successful but that there were too many pictures for the amount of text.[73] A small sketch on a figure study for *The Dancer* shows an open book with rectangular illustrations as headpieces to the text, most probably his original intention for the layout.

Through working for a private press Gill was able to exploit the *risqué* tendencies in his work in a way that might have been unacceptable in commercial publishing houses. Yet he never consciously broke with convention for the sake of it, believing his illus-

[68] Diary, 20 Jan. 1925. WACML.
[69] See Ch. 4.2 n. 43. The revised Latin text was published by Insel-Verlag in 1926. Printing at the Cranach Press was begun in 1914, interrupted by the war, resumed in June 1925, and finished in Apr. 1926. The edition contains title and initial letters cut by Gill, and 43 woodcuts by Maillol. Further editions followed, including one in Latin with English translation which contained an extra set of Maillol's woodcuts printed separately on Chinese paper. In the same year Gill was commissioned by Morison to design an alphabet for a new type, Perpetua, for the Monotype Corporation which first appeared in *The Fleuron* (vol. 8). In characteristic contradictory fashion, Gill was quite prepared to design typefaces to be printed by the latest mechanical methods at the same time as defending the use of the hand press.
[70] Noted by Sandford in entry for *The Song of Songs* in *Bib-liography of the Golden Cockerel Press*, No. 31, 22. Stanley Morison believed that Gill's contract with the press limited his reputation as a sculptor. See Douglas Cleverdon, 'Stanley Morison on Eric Gill', *Matrix*, 7 (1987), 4–15, p. 11.
[71] Timing is sometimes confusing as the dates in Gill's diary do not always tally with his detailed accounts sheets which show dates of the number of hours worked, travel expenses, and the cost of Lawrence's woodblocks.
[72] Gibbings, 'Memories of Eric Gill', 96.
[73] Set in 18-pt. Caslon Old Face type and printed in black and red on Batchelor handmade paper, the book, measuring $10\frac{1}{2}'' \times 7\frac{1}{2}''$, was published in Oct. in an edition of 750 numbered copies: 30 hand coloured and signed by Gill at 5 gns., the remainder at 1 gn.

trations to be perfectly plausible interpretations of the Bible or classic literature. In his eyes sex and religion were inseparable, as he had pointed out in an article on *The Song of Solomon* in *The Game* of 1921. The text of *The Song of Songs* held a fascination for him, its sensuality masked in biblical propriety.[74] Yet, as Fiona MacCarthy observes, his designs for this book are 'more concentrated and sequential, less Catholic-polemical, more blatantly erotic' than the work he had done for Pepler at Ditchling.[75] This liberated style was encouraged by his new employer whose own engravings for *Samson and Delilah*, published in the same month, as well as those for Powys Mathers's *Red Wise*, were equally explicit.[76] From the evidence of preliminary artwork,[77] Gill altered several of the designs of nude figures to make them more decent but they none the less still caused great offence among some of his Catholic colleagues, arousing suspicions of provocative behaviour. As he grew in confidence, his style loosened up and, under the influence of D. H. Lawrence, whose views on sex and marriage (and also on the emasculation of workers by industrialization), he greatly admired, his illustrations became more sensual and suggestive.

Artwork for this book also throws light on the way in which Gill approached illustration. He was methodical and thorough, working through a series of drawings for each block, some squared up,[78] with tracings and several trial proofs.[79] Although the final engravings are incisively hard-edged some of the early sketches are rapidly drawn. The sequence of material for *The Dancer*, depicting Solomon's words 'How comely is thy stepping in the sandals O Prince's daughter', perhaps best illustrates Gill's working process at this time. Two loosely handled pencil sketches of a backview of a naked dancing girl with a contemporary bobbed hair style are inscribed by Gill 'discarded'. A further, frontal version is included in a sketch for the final scene: Solomon sits on the right applauding, with black attendant, while two lovers flirt on the left. Significantly, *Plate 103* over this drawing Gill has placed a hinged overlay of yet another version of the girl, this time long-haired with her arms and other knee up—no less provocative a pose but a more stylized, less full-bodied depiction and the one he eventually used. There is a *Plate 104* separate drawing for this figure with an additional pencil sketch of the pubic area, and a traced version. The first trial proof of the engraving shows the background removed up to the edge of the figures. Presumably Gill left this clearing work for Beedham as he certainly did with subsequent engravings.

The drawings for *The Lust of Solomon* relate to the *Dancer* series. A discarded drawing[80] consists of a strange concoction of naked female parts—hair, thighs, stomach, breast—

[74] A diary entry reveals him reading Havelock Ellis's *Psychology of Sex* while working on the book.

[75] Fiona MacCarthy, 'Gibbings and Gill: Arcady in Berkshire', *Matrix*, 9 (1989), 27–36, p. 29.

[76] A drawing by Gill for *Red Wise* held at WACML was discarded in favour of Gibbings's illustrations.

[77] Held at HRHRC.

[78] The reversed finished drawing for *The Serenade*, for example, has been squared up for enlargement for transference on to the block.

[79] In another context Graham Williams, in his essay 'Gill's Engraving for Chute', in John Dreyfus and Graham Williams, *Eric Gill for Father Desmond* (London, 1993), 36–8, describes his process of transferring the design to the block and its preparation for engraving.

[80] Inscribed by Gill, 'love regards the whole person but desires the parts'.

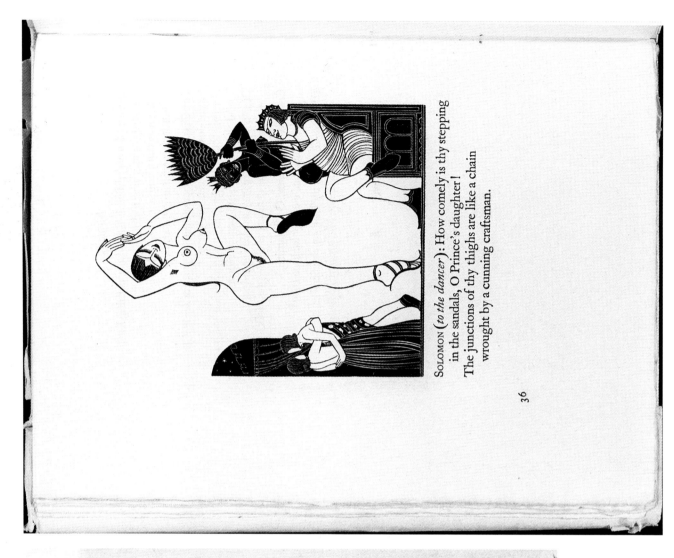

SOLOMON (*to the dancer*): How comely is thy stepping
in the sandals, O Prince's daughter!
The junctions of thy thighs are like a chain
wrought by a cunning craftsman.

36

Pl. 103 (*above*). Eric Gill: *The Dancer*. Preliminary drawing with hinged overlay from *The Song of Songs* (Golden Cockerel Press, 1925). Pencil and black crayon with added pencil inscriptions. 158 × 130

Pl. 104 (*right*). Eric Gill: *The Dancer from The Song of Songs* (Golden Cockerel Press, 1925). 256 × 189

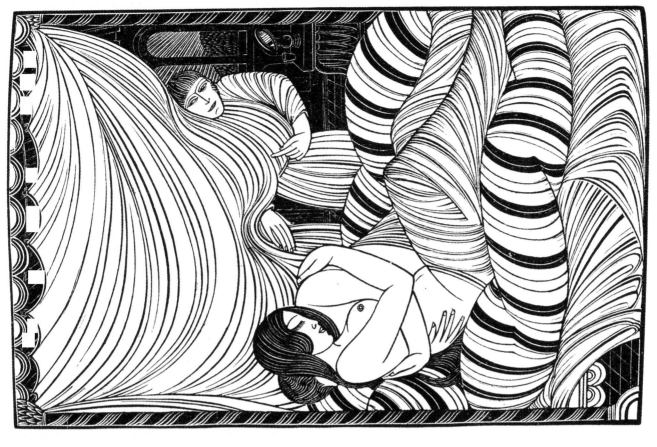

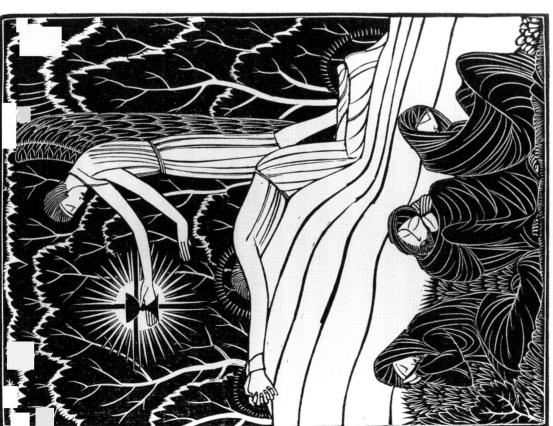

Pl. 105 (above). Eric Gill: *The Agony in the Garden* from *The Passion of the Lord Jesus Christ* (Golden Cockerel Press, 1926). 154 × 112

Pl. 106 (right). Eric Gill: *Approaching Dawn* from Geoffrey Chaucer, *Troilus and Criseyde* (Golden Cockerel Press, 1927). 174 × 113

over which Gill has drawn two vast, stylized eyes 'like fish-pools' in answer to the lyrical anatomical descriptions in the text. In the final version all these elements are compressed into a tiny triangular print as a purely symbolic device, possibly inspired by hieratic and erotic elements of Hindu art.[81] It is important to observe that he evolved this symbolistic imagery through naturalistic means, a manner in which he continued to work and one which is easily overlooked by those who have not seen his preliminary drawings. From the drawings it is clear that in his final prints Gill consciously restrained himself from being too expressive or fleshy. In two drawings for *The Harem* and *The Watchmen*, for instance, he pasted a skirted woman over a scantily dressed one. Although he liked *The Dancer* he was concerned that even she was too naturalistic: 'The dancer is good—it's a pity about her belly. . . . I tried hard to get at a decent convention & spoilt it in the effort so had to leave it in that semi-naturalistic state.'[82] On the other hand he fails to explain his reasons for depicting as white the woman who, in the text for *Inter Ubera Mea*, declares 'black I am but I am comely'—a perverse representation, especially considering the suitability of wood-engraving as a vehicle for the negroid figure.

Gill had much to say on the subject of life drawing in which he avidly indulged in later life.[83] For illustration, however, life drawings were only points of reference and his figures were consciously depersonalized as in medieval art. In *The Song of Songs*, as in his earlier Ditchling work, this aspect is especially apparent in the anonymous, timeless costumes with parallel folds and the two-dimensional element of the figures, their faces often in profile with almond-shaped eyes. In translating the amorous text with its earthy allusions, Gill combines medieval, oriental, and biblical imagery, as in the little *hortus conclusus*—the enclosed garden, ancient symbol of courtly love, or the 'love garden' of eastern mythology. He favours the intimacy of confined space and close embrace, yet his rather cold, bas-relief style detracts from the otherwise erotic nature of the text. In later years, in answer to the criticism that he showed a lack of emotion in his wood-engravings, he wrote, 'I think that the business of wood-engraving is very much like the business of typography. . . . I think tenderness and warmth in such things are not to be looked for except in the workmanship. You do not want the designer of printing types to wear his heart on his sleeve—my engravings are, I admit, only a kind of printer's flowers.'[84]

As earlier suggested Gill varied his style according to the nature of the commission. Though thoroughly archaic and two-dimensional, the rectangular illustrations to *The Passion of the Lord Jesus Christ* (1926) show a distinct loosening-up of style, the black line in *The Agony in the Garden* being particularly ragged. Figures are elongated in a mannerist vein and as such are much more expressive and emotional than those depicted in *The Song of Songs*, explained perhaps by the harrowing nature of the biblical text that allowed Gill to conceive his designs purely in religious rather than religio-erotic terms.

Plate 105

[81] Gill told Kessler that he was dying to illustrate an Indian treatise on love-making. (Source unlocated.) See also Ch. 4.2.
[82] Eric Gill to Desmond Chute, 5 May 1926. Quoted from *Letters of Eric Gill*, 212.

[83] See Ch. 4.2 for further discussion on his views on the subject.
[84] *Engravings by Eric Gill*, unpaginated.

His next major commission from Gibbings and their most ambitious project to date, Chaucer's *Troilus and Criseyde* (1927), introduced yet another illustrative style which echoed the marginal illumination of early manuscripts.[85] The pagan love poem encouraged humorously saucy designs in the form of decorated borders. In a different vein are the full-page illustrations. *Approaching Dawn* reveals the flattened perspective and sense of pattern hinted at in earlier prints: pleated garments blend with wide-striped bedding, and linear curtain folds. The delicate combination of calligraphic lettering and leafy borders enclosing figurative medallions on the title-page shows Gill's typographic flair, aided by Albert Cooper's faultless presswork. The style of his pure blackline foliated borders is in direct succession to Morris's medievalism, yet there is a modernity about the figures depicted which is new and thoroughly contemporary.[86] In typical contradictory style he mixes elements in a hotch-potch manner, confusing historical periods and displaying various stages of undress: a satirical *Chaucer & Cupid*, half-draped young lovers, and fleshy naked girls all disport themselves up the side of the text. John Rothenstein considered that the decorations were 'infinitely remote from the spirit of Chaucer'.[87]

Plate 106

In answer to criticisms that he had no sense of history, Gill agreed but felt strongly that his illustrations should be timeless, like the world, neither ancient nor modern.[88] This is particularly apparent in his choice of costume, as seen in *Troilus and Criseyde*, and more so in *The Canterbury Tales*, his next Golden Cockerel commission, where figures (several repeated from the earlier Chaucer) climb up and perch on leafy branches gesturing to each other across the pages. Among the characters depicted in the borders are a fashionable woman with black top, ruffled skirt, and high heels climbing a 'floreated phallus', a girl 'with lace-edged drawers', a scantily draped cook, and a medievally dressed Wife of Bath with spurs who later appears fleshy and unclothed. In the Chaucer works there is a bawdy, comical element about his nude figures, as with those for 'The Miller's Tale'. Otherwise, with a few exceptions, women in his book illustrations are rarely entirely naked though they are often only minimally covered. This complies with his sexist theories enunciated in his *Autobiography* that women should dress decorously at all times in keeping with their God-given roles as mothers, nurses, servant-maids, or nuns to avoid being provoking. Nakedness, however, was positively acceptable and indeed expected among family and friends who acted as models for some of his most sensuous and intimate wood-engravings. Significantly these tend to be white line.

Plate 107

Gill makes much play of outstretched limbs entwined around stems, the short and

[85] Correspondence with Gibbings reveals that copper engravings were originally intended. Gibbings gave suggestions for the layout but he allowed Gill to make the book 'as sumptuous as you can … in any way that may occur to you'. Robert Gibbings to Eric Gill, 25 June 1926. RAGL. The eventual book measuring $12\frac{1}{2}'' \times 7\frac{1}{4}''$—slightly larger than previous commissions—contained 5 full-page and 4 tailpiece and 60 border wood-engravings. Gill charged Gibbings £180 for $117\frac{1}{4}$ hours not including travelling expenses, rent of room, postal expenses, and frequent visits to Lawrence for blocks, making a total of £196. 10s. 7d.

[86] John Russell Taylor in *The Art Nouveau Book in Britain* (London, 2nd edn., 1979), 152–3, sees the influence of Ricketts's Vale Press in the *mise en page* of this and other of Gill's books. He notes also Gill's preference, like Ricketts's, for unregistered line-endings on the right-hand edge of each page.

[87] 'Troilus & Criseyde', review by John Rothenstein in *Bibliophile's Almanack for 1928* (London, 1928), 75.

[88] Cleverdon, *Eric Gill: Engravings*, unpaginated, quotes Gill as saying 'as to my lack of historical stense, it is true I have none'.

upright nature of which contrast with the flowing branches in the Kelmscott *Chaucer*. An element of sophistication is introduced in his designs for various opening initial letters and corner decorations in which small narrative scenes are enveloped in foliage. Gill's line gets progressively more fluid and his designs more inventive. The image of a mother and child in a boat for 'The Lawyer's Tale' is echoed in his magnificent wood-engravings for *The Green Ship* (1936). Gibbings felt that *The Canterbury Tales* was the first book in which he and Gill were true partners, as the perfect balance of decorations to type confirms.[89] In all Gill charged for a total of 138 hours—extraordinarily fast work for such a quantity of engraving, although there are references to Beedham (and Tegetmeier once when he was ill) for scorping and to Lawrence for photographic transfer on to the block.[90]

Plate 114

Most of the blocks were engraved at Pigotts, the farmhouse near High Wycombe where Gill moved with his family in October 1928. The next few years were productive and experimental as far as wood-engraving was concerned, including various attempts at using the multiple tool, some strange curlicue white-line illustrations for Laurence Sterne's *Tristram Shandy* (Golden Cockerel Press, 1929), and elegant foliated initials and borders for *The Phaedo of Plato* (Golden Cockerel Press, 1930).[91] More significantly he experimented with modelling the surface of the block with stippling in a style not unlike *manière criblée*. One of his first prints in this technique was *Belle Sauvage I*, a comely nude figure in a leafy surround, which he contributed to *The Legion Book* (1929). A white-bodied version was used as the frontispiece to the ordinary edition of his *Art Nonsense and other Essays* (Cassell & Co., 1929).[92] At the same time Gill produced three beautiful wood-engravings in a similar vein for Aldous Huxley's *Leda*, on some proofs of which he wrote a dedicatory inscription to Leonard Woolf. The soft, velvety effect and luminescent outline was in complete contrast to his frigid hard-line technique. When used for illustration he confined it almost entirely to more sexually explicit literature, mostly for private circulation. For instance, two prints of *Lady C* and *Mellors* (using himself as a model for the latter) were intended as illustrations to *Lady Chatterley's Lover*,[93] but were never used in any edition, although *Mellors* did appear in Gill's *Clothing without Cloth* (1930).

The most effective use of stippled wood-engraving for illustrative purposes was for the Cranach Press *Canticum Canticorum Salomonis*, a Latin version of *The Song of Songs* published in Weimar in 1931.[94] Like the Golden Cockerel version it is well documented in an album which contains a detailed list of chapters and the placing of the blocks,

[89] Four volumes were printed in 18-pt. Caslon Old Face between 6 June 1928 and 29 Jan. 1931 and published between Feb. 1929 and Mar. 1931; 500 copies (15 special on vellum and 485 ordinary on Batchelor handmade paper with Cockerel watermark) sold out quickly.

[90] Gill's first charge for work on this book in the accounts sheet is on 3 Dec. 1927 (for travel), while in his diary he mentions drawing border specimens on 23 Dec. For some reason the last reference to work on the book is for two hours on 19 Nov. 1931, eight months after publication of the last volume.

[91] These *Phaedo* blocks are actually entirely cut by Beedham to Gill's drawings which accounts possibly for the more fluid line.

[92] Other versions were used as a device by Cassell & Co. See Ch. 5.4. The subject was also used as the basis for two later sculptures. The model was Beatrice Warde. Gill drew many portraits of her and she was one of his models for *Twenty-five Nudes*. See MacCarthy, *Eric Gill*, 232–6. See also Chs. 5.4, and 6.1 n. 12.

[93] The gesso-filled block of *Mellors* is held at HRHRC. On 30 Oct. 1930, Gill 'read Lady Chatterley in train & after supper'. Diary.

[94] 268 copies of the book containing 11 wood-engraved illustrations and 18 initial letters were printed by Harry Gage-Cole.

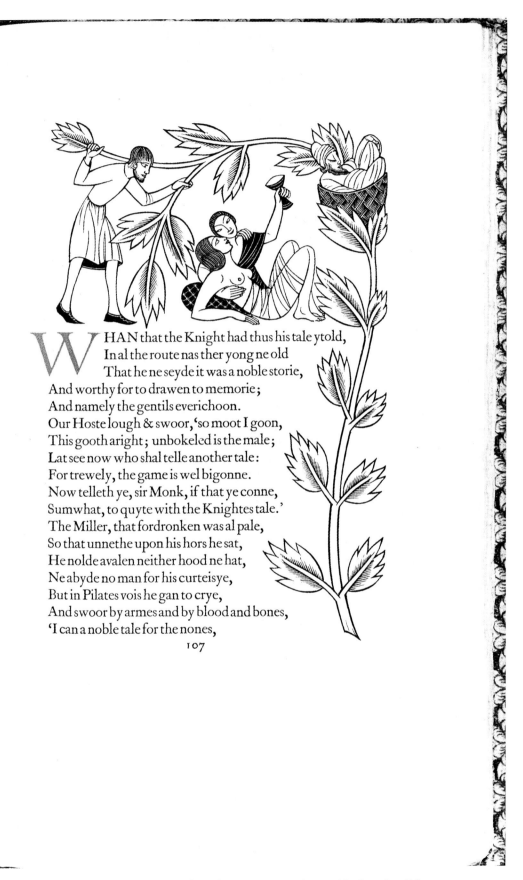

WHAN that the Knight had thus his tale ytold,
In al the route nas ther yong ne old
That he ne seyde it was a noble storie,
And worthy for to drawen to memorie;
And namely the gentils everichoon.
Our Hoste lough & swoor, 'so moot I goon,
This gooth aright; unbokeled is the male;
Lat see now who shal telle another tale:
For trewely, the game is wel bigonne.
Now telleth ye, sir Monk, if that ye conne,
Sumwhat, to quyte with the Knightes tale.'
The Miller, that fordronken was al pale,
So that unnethe upon his hors he sat,
He nolde avalen neither hood ne hat,
Ne abyde no man for his curteisye,
But in Pilates vois he gan to crye,
And swoor by armes and by blood and bones,
'I can a noble tale for the nones,

107

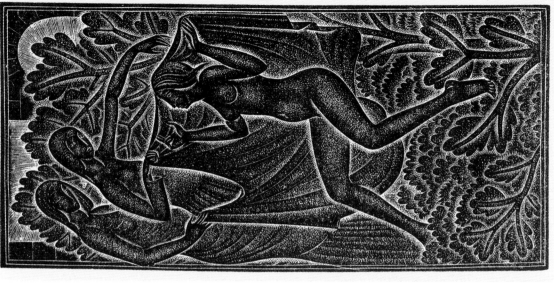

CANTICUM CANTICORUM

Pl. 110. Eric Gill: *Nigra Sum sed Formosa* from *Canticum Canticorum* (Cranach Press, 1931). 150 × 69

Pl. 109. Eric Gill: Trial proof for *Nigra Sum sed Formosa* from *Canticum Canticorum* (Cranach Press, 1931). 178 × 79

Pl. 108. Eric Gill: Preliminary drawing for *Nigra Sum sed Formosa* from *Canticum Canticorum* (Cranach Press, 1931). Pencil and black ink with wash. 241 × 119

original designs, first proofs of the engravings, and second and final states.[95] Correspondence with Kessler further discloses the extent of Gill's involvement in the layout. He suggested that the type should be set leaving spaces for initials. He would then divide this into pages and make a paste-up placing proofs of the engravings into what seemed to him the best positions, after which Kessler could make any alterations he felt necessary.[96] The two men first discussed the book at the end of 1927.[97] A few references in the diary and times of work listed in the accounts sheet show that he began work in July 1929.[98] A numbered black-line wood-engraving of *Ecce Tu Pulchra Es* (with touches of stippling on the figures) and fifteen trial proofs overprinted in various combinations (including the woman's robe in blue), testify to Gill's experimental approach to the medium: he hoped to print in colour using four blocks in all. Possibly Kessler wanted a richer, more sensuous effect than the earlier *Song of Songs* illustrations gave. His views that 'big slabs of *black* are alright in a woodcut but big slabs of unbroken colour are quite different', and that colour should be 'infinitely broken up', most probably encouraged Gill in his efforts.[99] Originally intended for the book, *Ecce Tu Pulchra Es* was not eventually used since Gill disliked the scale and clumsiness of the figures and the 'bad' cross-hatching.[100] Subsequent designs—a frontispiece, ten other illustrations, and some initials—were all executed in his new-found technique.

His working drawings are also in a new mode from those of the 1925 version. The preliminary artwork for the frontispiece, *Nigra Sum sed Formosa*, serves as a clear comparison. A light pencil drawing depicting two seated women with two more figures above and below is loosely overdrawn with black brush strokes, some areas lightly watercoloured in green and pink, which suggests that he intended to employ colour woodblocks.[101] Sketches such as this reveal that he did not always work in the precise *Plate 108* style for which he is best known. The finished prints are more painterly than his earlier technique not just because of the softer handling but because they were conceived tonally from the start. A second, much blacker brush drawing shows only three figures, a reverse image of the final print, and remarkably similar in composition, if not in style, to the discarded *Ecce Tu Pulchra Es*. The outlines of the bodies and foliage have been left white while small criss-cross lines have been painted along the limbs to signify contours. According to the accounts sheet the drawings for this book were photographically transferred on to the blocks. Two trial proofs and a finished print point to Gill's engraving procedure. In the first, the white line is scantily engraved, with small dashes indicating folds in the draped cloth. Fine cross-hatching in the second gives greater luminosity to the outlines, whilst delicate stippling applied to the final print creates warmly muted *Plate 109* blacks. *Plate 110*

[95] Held at HRHRC.
[96] Eric Gill to Count Kessler, 6 May 1930. Kessler Papers. By kind permission of the John M. Wing Foundation, Newberry Library, Chicago, henceforth KP.
[97] Count Kessler to Eric Gill, 23 Oct. 1927. KP.
[98] He had recently completed the title-page for the Cranach Press *Hamlet* and was working on other lettering projects for Kessler.

[99] Count Kessler to Eric Gill, 23 Oct. 1927. KP.
[100] Eric Gill to Count Kessler, 26 May 1929. KP.
[101] He abandoned the idea feeling it was incompatible with his engraved luminous lines. Eric Gill to Count Kessler, 26 July 1929. KP.

Plate 111 Gill's illustrations are entirely personal works with no help from Beedham. Although some of his anonymous, mannered figures are blatantly explicit, through his sensitive handling they somehow possess an intimacy and a spirituality in keeping with his views on sex and religion. (His previous interpretation of *Ibi Dabo Tibi*, in contrast, is much more robust.) With these designs he is not concerned with the typographic element; yet, despite the darkness of the blocks, they blend surprisingly well with the area of type. There are few hard lines or angles. Gill's intricately patterned initials unite text and illustrations. The overall effect of these small illustrations is rich and glowing and infinitely tactile, particularly in the vellum copies of the book with hand-gilded initial letters.[102] The small narrow format of the book is a pleasure to handle. This little volume, which is often overlooked in favour of Gill's more typographically perfect *Four Gospels*, is perhaps his most personal and unselfconscious work.

Much has been written about *The Four Gospels* which is generally considered to be one of the most distinguished illustrated books of the twentieth century.[103] In this context, therefore, it is surveyed only briefly in order to evaluate its importance in Gill's *oeuvre* and its wider significance. The ideal 'marriage of wood and metal' was accomplished as a result of the perfect partnership between Gill and Gibbings, carefully documented by Gibbings.[104] He explains how a large format was necessary for Gill's specially designed 18-point Golden Cockerel typeface and how Gill left the format and the typography entirely to him.[105] They carefully worked out the layout together, planning where the emphasis of illustration should fall. They felt that the opening page of each Gospel must have a large, if not a full-page block. Gill mentioned places where, if the type fell right, he would like to do a smaller ornament, suggesting that if two of the more important subjects came rather close together in one Gospel one of them could be left over to a succeeding narrative.

Gibbings had to set the type before any blocks could be cut since, as he explained, 'from the beginning we both realised that the type must be in command of the page'. It was a complicated job to balance type and illustrations. Gibbings sent Gill the proofs for him to fit his designs into the blank spaces: generally either a large rectangle to the left for the initial or an oblong rectangle across the full width of the page.[106] Gill's most glorious achievements are the outsize decorated initials and opening words in which *Plate 112* black figures with white line predominate. People wrap themselves round the letters on which they sit, use as a ladder, point through (as in *The Deposition*), lean, and even lie on. Although most are in dressed in ageless robes Gill cannot resist introducing an occasional contemporary characterization, for example the dancing Salome showing a leg in a 1930s-style short skirt.

[102] Each of the 8 numbered copies on vellum contained an extra set of the engravings, printed under Gill's supervision and signed by him.

[103] For a thorough investigation see John Dreyfus, *A Typographical Masterpiece* (San Francisco, 1990; repr. London, 1993).

[104] Gibbings, 'Memories of Eric Gill', 97.

[105] James Mosley, 'Eric Gill and the Golden Cockerel Type', *Matrix*, 2 (1982), 17–25. The book was originally intended to be

modelled on *Troilus and Criseyde* but Gill and Gibbings were dissatisfied with the use of Caslon Old Face in relatively large sizes to harmonize with wood-engravings. As to typesetting Gibbings gave way to Gill's suggestion of unjustified lines of text.

[106] The 276 pages contain 8 full-page illustrations, 32 decorated words and initials, and 14 minor engraved initials, leaving many pages unadorned.

Then up early to the vineyard,
 to see if the vine-stocks be in bud,
 if the tendrils be unfolding,
 if the pomegranate flower:

 there will I give my breasts to thee.
 The love-apple smells sweet, every fruit
 is at our gate; both new and old, dear love,
 I have laid up for thee.
·Oh! that thou wert given me for brother,
 suckled at my mother's breast, so that
 finding thee without I could kiss thee
 and none make scorn of me therefor!

39

Arguably these are not illustrations so much as typographic decorations, what Gill described as 'printer's flowers'. Certainly he thought of himself as a decorator rather than an illustrator and a page rather than wall decorator. Yet, remarkably, within the limitations of space, each ornamental initial and word is packed with incident and tells a story. The letters act as supports to the illustrations at the same time as being integrally part of the text. Neither technically as innovative nor stylistically as expressive as the Cranach *Canticum Canticorum* or even some of his later, much neglected, work, it is in the unification of illustration and text that Gill's great originality lies. Although these designs are telling images, it is the book as a whole, as a combined effort, that is the work of art rather than the individual engravings *per se*. The 76½ hours work on the engravings, once again an extraordinarily short time, was accomplished between December 1930 and October 1931. Superbly printed by Albert Cooper on specially watermarked Batchelor paper, the book was an instant success on publication in November 1931.[107]

The Four Gospels marked the end of Gill's partnership with Gibbings. He had switched his allegiance to his extended family at Pigotts, setting up with his son-in-law René Hague a small commercial printing business, emphatically not a private press.[108] His ideas on hand work had changed since Ditchling days. He partly used the press as a vehicle to publish his own writings but also for outside work. On 24 March 1931 George Macy wrote suggesting that Gill and Hague produce *Hamlet* for the Limited Editions Club.[109] Initially Gill was cautious because of the large scale of the work for such a small printing firm but by April he had agreed to design illustrations and possible decorations and to plan and print the play for $1,500, plus paper and other expenses.

The finished book contains a title-page, five headpiece illustrations, fifteen initial letters, and a tailpiece. The title-page is in a similar vein as that for *Troilus and Criseyde*—calligraphic lettering and foliate borders enclosing five scenes in medallions, the backgrounds most probably cleared by Beedham. Gill introduces yet another engraving style based on a combination of black line, white line, and the more tonal effects of his *Canticum Canticorum* blocks, except that, instead of cross-hatched outlines and stippled shading, he uses a series of minute parallel lines to emphasize the stiffly folded garments. For the five illustrations he has reverted to the framed rectangular formula, crowding the confined space with action. Typically, the Shakespearian characters, apart from *Hamlet and the Ghost*, are dressed in dateless costumes. There is even a biblical element about the scenes, particularly *The Play Scene* which resembles the treatment of the earlier

Plate 105 *The Agony in the Garden*. Angular, bony figures gesticulate anxiously throughout in a theatrically posed way. The tragedy seems almost farcical. Gill does not seem at home with Shakespeare and according to Speaight he had little knowledge of or liking for him.[110] Macy, however, was delighted with the *Hamlet* designs: 'I consider the block to

[107] Of 500 copies 12 were printed on vellum.
[108] See Ch. 6.3.
[109] George Macy to Eric Gill, 24 Mar. 1931. LECA.
[110] Robert Speaight, *The Life of Eric Gill* (London, 1966), 216. In his *Autobiography* (London, 1940), 248, Gill wrote of his architectural

sculpture of *Prospero and Ariel* commissioned by the BBC the same year: 'The idea was grand but I was incapable of carrying it out adequately. . . . *The Tempest* and romance and Shakespeare and all that stuff!'

illustrate Act Four a glorious piece of work. . . . Eric Gill is the first book artist of our time, and his blocks in this case prove that Hamlet was made for him.'¹¹¹

Following the success of *Hamlet* in July 1933 Macy suggested that Gill might illustrate *Morte d'Arthur*. Macy initially corresponded with Hague about the plan, using *Troilus and Criseyde* as a model, with a readable text in modern English, not Caxton's. Hague agreed to print two foolscap folio volumes with about a hundred different pairs of borders at a cost of £3,000 including £1,000 for the engraving which Macy considered far too expensive. He could possibly consider £1,500 if the design were altered to only twenty-one engravings and a different layout. He suggested to Gill that an edition could be hand printed at Pigotts, while a machine-printed edition could be produced by Sandford at the Golden Cockerel Press plant. Gill felt he could not undertake the illustrations but he thought that Stephen Gooden might be approached to do some copper engravings. In fact, Gibbings himself eventually undertook the work. One can only surmise that Gill refused this commission because he had progressed from his decorative border style and lacked the time for further large-scale illustration.

Three years later, however, Macy approached him again, this time to illustrate *Henry VIII*. Gill's excuse this time was that the format was not typographical enough for him to consider but he was persuaded to do a title-page and four illustrations. These full-page blocks are in a loosely engraved black-line style far removed from his Chaucer designs. Swirling leaves encircle figures which are no longer stiff and angular; they even have facial expressions: for example, Henry VIII boldly winks at a coy nude lady whom he holds in a pair of scales while, in *The Fall of Wolsey*, the naked cardinal, clutching on to his hat, tumbles headlong through a leafy decoration. Although far removed from Shakespeare's text Macy thought these illustrations 'enchanting'.¹¹² That Gill found such literary commissions difficult is revealed in his comment to Macy: 'I have never been successful in the making of pictures depending for their interest upon the power to interpret the meaning of the author.'¹¹³

Among Gill's most inventive designs at this time were eight illustrations to four volumes of *The Aldine Bible* published in 1934 by J. M. Dent to whose *New Temple Shakespeare* he had recently contributed. Large-scale saints or biblical characters hold unfurled scrolls depicting stories from the relevant book or, as with *St Paul* or *The Apocalypse*, are incorporated within the background scene. These extraordinary designs required great ingenuity to handle the complex perspectives which, as in *Woman with Ship*, Gill once *Plate 113* again tackled two-dimensionally—a trait which he shared with his close friend and admirer David Jones who also favoured large-eyed Botticelli-like women.¹¹⁴ To complement these intricate designs a further engraving style is presented, one which becomes more sophisticated in the later volumes: a halo of black lines softened with minutely

¹¹¹ George Macy to [?], 24 Jan. 1933. LECA.
¹¹² George Macy to Eric Gill, 4 Sept. 1937. LECA.
¹¹³ Eric Gill to George Macy, 24 Oct. 1936. LECA. Two previous Shakespeare commissions had been less taxing: a frontispiece to Cassell's *Sonnets* (1933) and half-title and title-page designs for Dent's *New Temple Shakespeare* series (1934–6).

¹¹⁴ He was greatly influenced by Jones in these later years. Jones's up-turned, flattened perspective and sketchy line may well have affected his late style as demonstrated in a white-line engraving he executed of a design by David Jones for an Ordination Card of *Paul Taking Bread in the Boat* (1937).

THEN COMETH JESUS WITH THEM UNTO A PLACE CALLED GETHSEMANE, AND SAITH UNTO THE DISCIPLES, SIT YE HERE, WHILE I GO AND PRAY YONDER. AND HE TOOK WITH HIM Peter and the two sons of Zebedee, and began to be sorrowful and very heavy. Then saith he unto them, My soul is exceeding sorrowful, even unto death: tarry ye here, and watch with me. And he went a little farther, and fell on his face, and prayed, saying, O my Father, if it be possible, let this cup pass from me: nevertheless not as I will, but as thou wilt. And he cometh unto the disciples, and findeth them asleep, and saith unto Peter, What, could ye not watch with me one hour? Watch & pray, that ye enter not into temptation: the spirit indeed is willing, but the flesh is weak. He went away again the second time, and prayed, saying, O my

69

fine parallel lines surrounds and shades the figures—the reverse of his *Hamlet* technique. Significantly his line is beginning to be more shaky, more personal and idiosyncratic, less hard and typographical.

In the same year Gill was back with the Golden Cockerel Press designing a frontispiece for *The Lord's Song*.[115] Sandford had hoped that Gill would illustrate Powys Mathers's *Love Night* with 'amorous engravings' but he wrote in December that he had too much to do.[116] He was already engaged on six engravings for the press for Enid Clay's book *The Constant Mistress* (uniform with *Sonnets and Verses*) in another new style, his long thin lines and cross-hatched shading creating a soft, greyish effect. *The Empty Bed* is a rare and pleasing excursion into a domestic interior, with no figures involved. Gill asked for page proofs so that he could criticize the placing of the blocks. Even with new management he was still taking an active interest in the overall appearance of his Cockerel illustrations. One of his most successful typographical designs for Sandford was the frontispiece to Patrick Miller's *The Green Ship* (1936): a two-page spread of rolling waves engulfing six little scenes from the book, variants of which are repeated within its pages. *Plate 114* Silvery lines are offset by startling black and white areas, whilst strips of elegant white lettering on a black background are incorporated at the head and foot of the block. It is a magnificent and highly original design looking back to art nouveau frontispieces of the 1890s and Dent's Everyman series at the turn of the century.

Gill's wood-engraving appears to get more frenzied and *mouvementé* towards the end of his career. At the same time his output slows down greatly. In the autumn of 1938 he was much preoccupied with doing nude drawings from life, preparing them for Lawrence to photograph on to the wood, and engraving the blocks for their appearance in Dent's *Twenty-five Nudes*. The original drawings are sensitive and skilful life studies but the engravings lack spontaneity, being direct white-line copies. With the exception of these prints, his illustrations to commercial books are generally more restrained than those which appeared in privately printed books.

Gill's two last works show him at his most quirky. Theodore Besterman, the translator of *The Travels & Sufferings of Father Jean de Brébeuf* (1938), suggested Gill to the Golden Cockerel as the illustrator 'for he is obviously the right man for the job'.[117] Rather than a frontispiece Gill designed a double-spread title-page as for *The Green Ship*. Two rectangular scenes act as a continuous narrative across two pages beneath large-lettered titling. Scrawny Red Indians in frozen poses attack and taunt Father Jean. The background is engraved in an abstract, marblized pattern of thin parallel lines, quite unlike any earlier work. Perhaps his strangest illustrations are the four wood-engravings for what was to be his last book, *The Holy Sonnets of John Donne* (1938), elegantly printed by Hague and Gill for Dent. He treats these intense words (about a deeply religious soul confronting death) in a highly idiosyncratic, mystical way. His images are figurative yet

[115] The first Golden Cockerel Press book to be printed in the new 14-pt. version of Perpetua Roman and Felicity Italic type.
[116] Eric Gill to Christopher Sandford, 20 Dec. 1934. LECA. The commission went to John Buckland Wright. See Ch. 13.6. Dis-

cussion with Bernard Thompson in Oct. about proposed designs for an edition of *Arabian Nights* also came to nothing.
[117] Theodore Besterman to Owen Rutter, 15 Sept. 1937. GCPA.

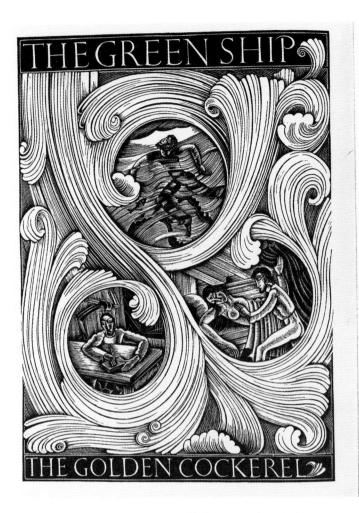
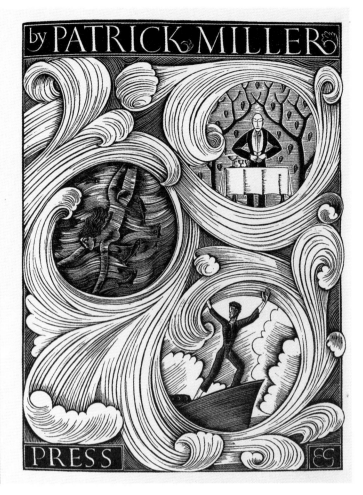

Pl. 114 (*above*). Eric Gill: Patrick Miller,
The Green Ship (Golden Cockerel Press,
1936). 227 × 365

Pl. 115 (*left*). Eric Gill: 'Death be not Proud'
from *The Holy Sonnets of John Donne* (J. M.
Dent, 1938). 120 × 88

at the same time symbolic, as is that for 'Death be not Proud'. Ragged, sinuous contour *Plate 115*
lines and seething emaciated bodies add to the tension. This loose and sketchy handling
is a far cry from his hard-edged style and archaicizing, frieze-like approach to religious
subjects. It is more personal and metaphysical; more expressive of his inner feelings
than he allowed in earlier work or other media.

The aim of this survey of Eric Gill's wood-engraved book illustration has been to
reveal his widely varied techniques and imaginative stylistic ideas and to investigate
how and why they evolved. Although Gill thought of himself as a decorator he should
perhaps be considered as an illustrator with a decorator's eye since he usually depicts
narrative incidents in the text. At times, however, his interpretations, particularly of
texts of a religious nature, are so quirky and opinionated that they say more about Gill
than the words they illustrate. Frequently he is admired for his achievement with *The
Four Gospels*, whereas it is rarely noted that he was not entirely happy with the book and
never attempted that particular stylistic approach again. Perhaps more than any of
his contemporaries, with the exception of Farleigh, he experimented with different
techniques and altered his style according to the commission or his mood. Quite apart
from his typographical awareness, it is as a result of his extraordinary technical skill
and versatility as a wood-engraver and his individuality as an interpreter that he plays
such an important role in twentieth-century book illustration—not just as a designer
of 'printer's flowers' as he and many others would have us believe. His strangely un-
English, over-zealous, theorizing, religious, anti-naturalist, anti-nature attitude to art
accounts for why he had so few followers.

11.3. *Followers of Eric Gill: Philip Hagreen, Thomas Derrick, and Mary Dudley Short*

Gill's few immediate followers were, not surprisingly, all Catholic, from the Ditchling
community. They shared some of his religious beliefs and philosophy of art and were
inspired by his hieratic, black-line style of wood-engraving.[118] Philip Hagreen's friendship
with Gill, which developed after his arrival in Ditchling in December 1923 and continued
after his move with him to Capel-y-ffin in 1924, had a decisive effect on his attitude to
wood-engraving.[119] He admired Gill's well-organized and disciplined approach to work
and appreciated the Dominican philosophy of work as worship. As a result he tended
to use the medium in a didactic way, most often to convey a religious message. Tech-
nically his work was very assured.

At Capel-y-ffin Hagreen did less wood-engraving than stone carving and lettering for
Gill's various projects which no doubt taught him to cut incisively. The austere climate,

[118] For a discussion of the early work of St Dominic's Press
illustrators see Ch. 4.2.
[119] For reproductions of his work and a biographical outline
see exhibition catalogue, *Philip Hagreen (1890–1988): Engravings*
and Woodcuts, with an essay by David Knott, 'Philip Hagreen, his
Life and Work' (London: Wolseley Fine Arts, Camberwell, 1993),
5–11. At the time of writing a definitive catalogue prepared by
John Hagreen and Meg Ryan is in preparation.

are prone to evil from our very child-
hood; and, if not corrected by self-
denial, they will certainly carry us to hell.

345. How are we to take up our cross
daily? &❧ We are to take up our cross
daily by submitting daily with patience
to the labours and sufferings of this
short life, and by bearing them willingly
for the love of God.

346. How are we to follow our Bles-
sed Lord? &❧ We are to follow our Bles-
sed Lord by walking in His footsteps
and imitating His virtues.

347. What are the principal virtues
we are to learn of our Blessed Lord? &❧
The principal virtues we are to learn of
our Blessed Lord are meekness, humil-
ity, and obedience.

348. Which are the enemies we must
fight against all the days of our life? &❧
The enemies which we must fight a-

gainst all the days of our life are the de-
vil, the world, and the flesh.

349. What do you mean by the devil?
&❧ By the devil I mean Satan and all
his wicked angels, who are ever seeking
to draw us into sin, that we may be
damned with them.

350. What do you mean by the
world? &❧ By the world I mean the false
maxims of the world and the society of
those who love the vanities, riches, and
pleasures of this world better than God.

351. Why do you number the devil
and the world amongst the enemies of
the soul? &❧ I number the devil and the
world amongst the enemies of the soul
because they are always seeking, by
temptation and by word or example, to
carry us along with them in the broad
road that leads to damnation.

Pl. 116 (*above*). Philip Hagreen: *A Catechism of Christian Doctrine* (St Dominic's Press, 1931). 193 × 264

Pl. 117 (*right*). Philip Hagreen: W. Arthur Woodward, *The Countryman's Jewel: Days in the Life of a Sixteenth Century Squire* (Chapman & Hall, 1934). 89 × 71

however, led him and his family to leave in May 1925 and in December to move to France, near Lourdes. Here he concentrated on ivory carving and discovered wood cutting for which he made his own tools. This medium particularly appealed to him and later he often used it for his more robust designs for advertisements, posters, and caricatures. Such few book illustrations as he did were line drawn[120] until 1926 when Pepler commissioned some wood-engravings for *Cantica Natalia*, a lavish folio volume for lectern with plainsong notation of the twenty carols printed between red staves.[121] His eight wood-engravings for Thomas à Kempis's *Meditations on Our Lady* (1929) were not cut specifically for the book, various blocks being selected by the printer. Perhaps his finest work for the press was for *A Catechism of Christian Doctrine* (1931). The text is framed in floriated borders and biblical scenes which blend admirably with the Goudy Bold type used by Pepler at his request. These illustrations show how Hagreen's style had regressed *Plate 116* to naïve black outline figures and decorations. His approach, particularly towards religious illustration, was one of counter-realism. He shared with Gill a deliberately archaicizing attitude towards representation and, like him, worked in a typographical manner, believing that 'the woodblock ought to be a tool for the printer'.[122]

In 1932 he returned to Ditchling to a guild cottage and workshop. From this time his gifts as an engraver on metal and wood blossomed. His most interesting illustrations, however, both technically and stylistically were non-religious commissions from other publishers which perhaps enabled greater inventiveness. For Chapman & Hall he produced a stylish white-line print for the frontispiece to W. A. Woodward's *The Country-* *Plate 117* *man's Jewel* (1934). The view of a pond, trees, a house, and distant hill is positively Nash-like in its crudely cut simplicity.[123]

In 1935 Edward Walters,[124] a friend of Pepler, reprinted the seventeenth-century poet Richard Crashaw's *Musicks Duell* with a full-page engraving by Hagreen. An image of the *Plate 53* contest between lutanist and nightingale is one of his most attractive illustrations and is a far cry from his iconic religious offerings. With its subtle combination of black-with white-line shading the print harmonizes well with the Caslon Old Face titling on the opposite page. A further commission from Walters in the winter of 1938–9 for about a dozen wood-engravings (including one for the dust-jacket) for a new edition of the Arthurian poem by Robert Stephens Hawker, *The Quest of the Sangraal*, was thwarted by rumours of impending war, with the result that the book was never published. A very small yet strong print intended for it shows a walled city poised on a cliff top. The engraved line is more fluid.

Despite an innately serious and formal approach to art, Hagreen's twinkling sense of humour and style radiate through many of his wood-engravings and woodcuts,

[120] As early as 1922 Chatto & Windus had asked him to illustrate Lady Strachey's *Nursery Lyrics* with woodcuts for £25. Although he thought woodcuts were the ideal method of book illustration, he felt unable to do the job for that price and suggested drawings, which were accepted. Chatto & Windus Archives, RUL.
[121] Other contributors were Chute, Jones, and Gill.
[122] Conversation between Philip Hagreen and the author, 12

June 1986. The *Catechism* blocks were set up together *c.*1932 and printed as a magnificent broadsheet entitled *Our Lady of the Rosary.* See *Saint Dominic's Press Bibliography*, B49, 127, for a detailed description.
[123] The author is grateful to Meg Ryan for identifying the house as Plumpton Place, near Ditchling.
[124] See Ch. 6.2, 'Smaller Private Presses'.

BATTLE SKETCHES

BY AMBROSE BIERCE
WITH EIGHT ENGRAVINGS ON
WOOD BY THOMAS DERRICK

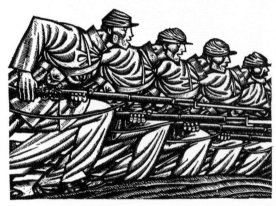

PRINTED AT THE SHAKESPEARE HEAD
PRESS SAINT ALDATES OXFORD FOR THE
FIRST EDITION CLUB BEDFORD SQUARE
LONDON M·CM·XXX

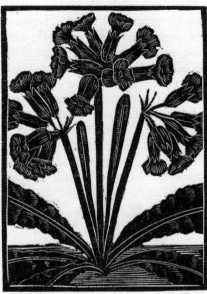

Cowslip

Pl. 118 (*left*). Thomas Derrick: Ambrose Bierce,
Battle Sketches (Shakespeare Head Press, 1930).
279 × 192

Pl. 119 (*above*). Mary Dudley Short: *The Mary
Calendar* (St Dominic's Press, 1930). 76 × 56

especially those for ephemeral purposes. This is most evident from his cheerful series of garden party and other posters, his broadsheets, and large output of bookplates. Much of his work was emblematic. A design for a dust-jacket to Harold Robbins's *The Sun of Justice* (Heath Cranton, 1938) and his cartoons for the Catholic Land Association's journal *The Cross and Plough* are wittily satirical anti-capitalist commentaries—a rare use for the medium at this period. At a stage when his work was becoming more personal and spirited he regretfully produced no more woodcut or wood-engraved illustration. Ill health forced him to abandon his tools in the late 1950s. 'I am no judge of my own work', he wrote. 'All that matters to me is that I did my best with each job. It was a way of life as a man and a Christian. Work done rightly is wholesome and I have found it jolly good fun.'[125]

The robust, humorous caricature style of Thomas Derrick (1885–1954) is perhaps more reminiscent of Hagreen's style than that of Gill, though both Derrick and Hagreen emulated his black-line technique. Like Gill they were adept at transposing medieval imagery into a modern decorative idiom, as apparent in Derrick's frieze-like woodcuts to *Everyman* (Dent, 1930). For St Dominic's Press he produced mainly ephemera but he also contributed a few illustrations including three wood-engravings for Father Vincent McNabb's *God's Book and Other Poems* (1930). His designs for Ambrose Bierce's *Battle Sketches*, printed by the Shakespeare Head Press for the First Editions Club in 1930, *Plate 118* are among his most impressive achievements. The large rectangular wood-engraved frontispiece depicts American Civil War soldiers marching into battle. For this powerful image Derrick has developed a highly individual linocut-like technique: the heavy black background is broken up with lines and minute specks, whilst areas of white are gouged out for folds in the uniforms, and shading consists of serried ranks of white line. On the title-page, beneath large upper case lettering, a static, frieze-like row of soldiers diminishing in size lunge forward with pointed bayonets. This two-page spread makes a singularly bold and original typographic statement and stands as one of the most effective title-pages of the period. Chapter headpieces are in a lighter-weight black-line style. A regular contributor to *Punch*, Derrick tended to prefer line drawing, hence his limited output of wood-engraved illustration.

Although clearly inspired by Gill's particular approach to religious illustration, Mary Dudley Short's wood-engraving style was probably more influenced by that of David Jones. She was discovered by Pepler in 1928 and contributed to the press mainly ephemeral work, including Christmas cards and rhyme sheets, but also a small amount of book illustration. Her first was for *Diary with Dominican Calendar* (1928). For the title-page Jones produced a white-line engraving of a hooded Dominican friar which subsequently became one of the press's devices. Thirteen prints of a similar nature by Dudley Short are frequently attributed to Jones. Her designs of flowers associated with the Virgin Mary for *The Mary Calendar* (1930), though quite crudely cut, have a decorative charm, as *Plate 119* do her blocks for Pepler's *Plays for Puppets* of the previous year. Later she became more

[125] Quoted from Edgar Holloway, 'Profile of an Artist: Philip Hagreen', *Bookplate Journal*, 3 (1985), 89–90, p. 90.

technically proficient, as four full-page prints in *Art Notes* of 1938 and 1939 reveal:[126] her flowing, symbolic style in the 1939 issue appears almost like a product of the Underwood group.[127]

Along with Gill and Jones, these artists formulated a Catholic idiom particularly suited to wood-engraving. Although their illustrative work was seen by only a narrow sector of the reading public, the appropriateness of purpose emphasized by St Dominic's Press encouraged wider use of the medium for illustration.

[126] *Art Notes*, 1 (1930), 24–5, and *Art Notes*, 5–6 (1939), 81–2.
[127] A minor wood-engraver little affected by Gill who produced mainly ephemeral work for the press was Harold Purney. He contributed some consciously naïve, childlike white-line engravings to *Pertinent and Impertinent* (1926).

THE EXPRESSIVE APPROACH

12.1. *David Jones: Later Work*

Apart from a few obvious influences from the Ditchling and early Capel-y-ffin days, David Jones's wood-engraving developed quite independently of Gill's, his peculiar sensitivity displayed in an expressive[1] and idiosyncratic style. His pseudo-naïve images, steeped in symbolism and incident, belie their complexity. Jones and Gill shared religious convictions and maintained a spiritual approach to illustration; both combined ancient and modern elements and pursued a medieval-revivalist, two-dimensional, narrative style. Technically they had little in common, Jones preferring white line, cross-hatching, and an altogether greyer finish which did not accord with Gill's typographic concept of the medium.[2] Yet Gill learnt much from his pupil, as can be seen from the loosening-up of line, and more ethereal, weightless quality of his later images, particularly those of female figures. Over the years he engraved several of Jones's designs. In Jones's case it was probably Gill's lettering skills which made the greatest impact on his work although their styles differed radically.

Jones's wood-engraving period was short-lived owing to eye trouble which forced him to abandon the medium in the early 1930s. Consequently he only illustrated a few books all dating from the 1920s.[3] These were all published privately, partly perhaps because his shallow-cut blocks required more individual attention than commercial printers were able to give. His designs for the St Dominic's Press, notably his witty caricatures for *Libellus Lapidum*, particularly appealed to Gibbings. After his move to Capel-y-ffin with Gill in August 1924 Jones was taken up by Gibbings as an illustrator, inspiring a new interest in wood-engraving and a change of stylistic direction. Jones's first Golden Cockerel commission, Jonathan Swift's *Gulliver's Travels*, released him from the constraints of the proselytizing Ditchling publications. He was highly imaginative, a lover of stories and myths since childhood. As a student at the Camberwell School of Art he discovered the great nineteenth-century English illustrators such as Pinwell, Sandys, and Beardsley, the Pre-Raphaelites, and the Frenchman Boutet de Monvel with,

[1] The word 'expressive' is here used in its widest sense to embrace both style and technique. It covers the expressionist symbolism of David Jones and Paul Nash, the design-orientated work of Nash's and Ravilious's followers such as Enid Marx and John O'Connor, and the stylized interpretations of Hester Sainsbury, White, Webb, and Macnab, among others. Stylistically these wood-engravers share a representational yet non-realist approach to subject matter and are technically biased towards strong and distinctive toolwork, often decoratively applied. Individual expression is the common factor rather than a collective aesthetic. Above all the *medium* is the message.

[2] Of Bewick's work Jones wrote, 'Bewick could do miracles with greys—and no one has done it so well since.' David Jones to Reynolds Stone, 23 Sept. 1958. Bodleian Library, Oxford. Quoted in Jonathan Miles and Derek Shiel, *David Jones: The Maker Unmade* (Bridgend, 1995), 71.

[3] The author located only a few letters and preliminary drawings relating to the artist's working procedure for wood-engraved illustration.

in his own words, the '*sad result*—ambition to illustrate historical subjects—preferably from Welsh history and legend—alternatively to become an animal painter'.[4] The move to Capel stirred his Welsh roots but it was a sentimental attachment to the Celtic myths and ancient Wales rather than to the contemporary local scene. Yet the 'peculiarly Welsh time-sense' which, according to Rothenstein, he inherited from his father accounted for an all-embracing time-scale that links past and present and is frequently apparent in his illustrations.[5]

Unlike Gill, Jones often worked out of doors. As he recalled, the imposing Welsh landscape was largely responsible for his change of direction: 'It was in the Black Mountains that I made some drawings that appear, in retrospect to have marked a new beginning.'[6] A wood-engraving of *Tenby from Caldy Island* done on a visit to the Benedictine monks in 1925 shows a robust, but refined woodcut-like technique, the contours of hills, waves, and fields boldly emphasized in white with fine parallel-lined shading. Geometric landscape formations such as this, with its flat planes, schematic shading, and stylized foliage, echo the work of Paul Nash. From art school days Jones had been aware also of continental art and was certainly inspired by Cézanne's interlocking of space and form.[7]

The *Gulliver* illustrations were begun on Caldy Island and the two-volume book was published in December 1925. Swift's satire gave new scope to Jones's imagination and artistic expression, though he objected to the number of wood-engravings that were required. Forty of varying shapes and sizes, mostly square or rectangular, are either inset into the text or act as head- and tailpieces; four are full-page maps.[8] Long narrow headpieces are carefully designed to the width of the type. The woodcut initials were engraved by Gill but Jones provided the calligraphic lettering for the maps, a highly individual style which he later developed further in his remarkable painted inscriptions. Although Gibbings avoided the two-column text format used for the Golden Cockerel editions of Swift published earlier in the year, Jones's robust chapbook style shares similarities with that used by John Nash and John Farleigh for these books. As with their illustrations figures and incidents are crammed into small frames, a characteristic of Jones's wood-engravings, dating from his Ditchling days, which he retained throughout his work. His sense of humour is apparent in the comical eighteenth-century costumed characters with wide-eyed expressions and exaggerated gestures. For all their stylization they remain rounded and lively rather than frieze-like and wooden. Preliminary sketches were loosely handled, as seen from *Gulliver is Knocked Down by the Apple*.[9]

The 'lewd' females are coquettishly portrayed, as in *Gulliver Kisses the Queen's Little*

[4] From *Dai Greatcoat: A Self-Portrait of David Jones in his Letters*, ed. René Hague (London, 1986), 20.

[5] John Rothenstein, 'David Jones', in *Modern English Painters* (3 vols.; London, 1956; repr. 1976), iii., 291.

[6] David Jones, *Epoch and Artist: Selected Writings* (London, 1959), 29.

[7] He was in touch with British modernist art and was proposed for the Seven and Five Society by Ben Nicholson in 1928 and elected in 1929.

[8] Jones was displeased with the hand colouring mainly done, according to him, by 'a bevy of girl students'. Quoted from William Blissett, *The Long Conversation: A Memoir of David Jones* (Oxford, 1981), 9.

[9] Reproduced in Miles and Shiel, *David Jones: The Maker Unmade*, 68.

Finger. Generally Jones was ambivalent in his depictions of women in his wood-engravings. *Plate 120*
Mostly they are clothed, sometimes scantily, and when nude are never erotic, even in such a suggestive scene as the *Female Yahoo Embracing Gulliver.* Various life drawings show a knowledge of Gill's outline technique but Jones's sketches of models (sometimes shared by both artists) tend to be more bulky and full-bodied. His later figure style, which in turn influenced Gill, became much more sketchy and fluid. The caricaturist element as exemplified in these *Gulliver* illustrations is never far from the surface even when the subject matter becomes more serious. Surprisingly Jones found the book boring.[10]

The narrative of *Gulliver* gave Jones a chance to depict a seafaring topic and one dear to his heart since his mother was the daughter of a mast- and block-maker. Clouds, stormy seas, and ships are dramatically if rather simplistically treated.[11] His next commission from the Golden Cockerel Press, *The Book of Jonah* (1926), gave full rein to his maritime interest. Of thirteen engravings some are whole page with a few lines of text underneath, some are half-page, and some border the text in an L-shape which is particularly effective over a double-page spread. The latter show Jones uncharacteristically taking an interest in the overall layout. It would be interesting to know how much typographical advice Gibbings gave him. Though rectangular and dark the engravings do not overpower the text. Black areas contrast with white. Distinctive shapes and patterning dominate. Shading consists mainly of strong parallel lines, sometimes undulating, as in the sea. Figures are angular, particularly that of Jonah, surrounded by toy-like fishes, kneeling before the whale's wooden jaws. Jones bestows an *Plate 121*
affectionate humour on these sea creatures as he does on so many of his animal studies, particularly the perky little spaniel for the frontispiece and tailpiece to *Pompey the Little,* his second Golden Cockerel Press commission that year. Whether perched on a cushion or prancing through flowers, the dog appears to be floating—a weightless quality which Jones increasingly employs in later years.

The highpoint of Jones's wood-engraving career was the year 1927 in which he held a joint exhibition with Gill at the St George's Gallery.[12] Much of his time was taken up with engraving blocks for *The Chester Play of the Deluge.* In January he wrote to Douglas Cleverdon, 'I am busy at the moment with the *last* ten blocks of my sumptuous work for the Golden Cockerel Press—The Deluge—they are huge & lengthy affairs. P.S. There are 10 in all. I believe it will really look good—if *I* may be allowed to say so!'[13]

Although it is a magnificent book—in Sandford's eyes one of the 'greatest graphic achievements of the Press'[14]—it suffers from poor definition as a result of bad printing on hard, unsympathetic, undampened handmade Batchelor paper. Jones himself was disappointed with the end result but he was partly to blame since his engravings, as

[10] Ibid. 72.
[11] He later admitted that he felt 'utterly at sea' with the technical details of ships and 'the principle of seafaring things'. David Jones to Douglas Cleverdon, n.d. Douglas Cleverdon Archive, Tate Gallery Archives, henceforth DCA. He came to see the image of the Church as the ship, the Barque of Christ, its timbers the wood of Christ's Cross.

[12] He was made a member of the Society of Wood Engravers the previous year.
[13] David Jones to Douglas Cleverdon, 27 Jan. 1927. DCA.
[14] Christopher Sandford and Owen Rutter, *Bibliography of the Golden Cockerel Press* (Folkestone, 1975), No. 52, 28.

Pl. 120 (*right*). David Jones: *Gulliver Kisses the Queen's Little Finger* from Jonathan Swift, *Gulliver's Travels* (Golden Cockerel Press, 1925). 255 × 185

Pl. 121 (*below*). David Jones: *The Book of Jonah* (Golden Cockerel Press, 1926). 256 × 388

The Author sent for to Court. The Queen buys him of his master the farmer, and presents him to the King. He disputes with his Majesty's great scholars. An apartment at Court provided for the Author. He is in high favour with the Queen. He stands up for the honour of his own country. His quarrels with the Queen's dwarf.

HE FREQUENT LABOURS I UNDERWENT every day made in a few weeks a very considerable change in my health: the more my master got by me, the more insatiable he grew. I had quite lost my stomach, and was almost reduced to a skeleton. The farmer observed it, & concluding I soon must die, resolved to make as good a hand of me as he could. While he was thus reasoning & resolving with himself, a *Slardral*, or Gentleman Usher, came from court, commanding my master to carry me immediately thither for the diversion of the Queen & her ladies. Some of the latter had already been to see me, & reported strange things of my beauty, behaviour, and good sense. Her Majesty and those who attended her were beyond measure delighted with my demeanour. I fell on my knees, & begged the honour of kissing her Imperial foot; but this gracious princess held out her little finger towards me (after I was set on a table) which I embraced in both my arms, and put the tip of it, with the utmost respect, to my lip. She made me some general questions about my country & my travels, which I answered as distinctly and in as few words as I could. She asked whether I would be content to live at court. I bowed down to the board of the table, & humbly answered, that I was my master's slave, but if I were at my own disposal, I should be proud to devote my life to her Majesty's service. She then asked my master whether he were willing to sell me at a good price. He, who apprehended I could not live a month, was ready enough to part with me, and demanded

93

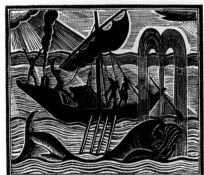

Then the men feared the Lord exceedingly, & offered a sacrifice unto the Lord, and made vows. Now the Lord had prepared a great fish to swallow up Jonah. And Jonah was in the belly of the fish three days & three nights. Then Jonah prayed unto the Lord his God out of the fish's belly, and said, I cried by reason of mine affliction unto the Lord, and he heard me; out of the belly of hell cried I, and thou heardest my voice. For thou hadst cast me into the deep, in the midst of the seas; and the floods compassed me about: all thy billows and thy waves passed over me. Then I said, I am cast out of thy sight; yet I will look again toward thy holy temple.

8

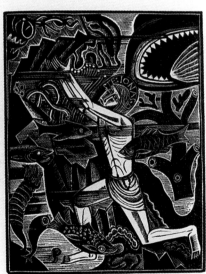

THE WATERS COMPASSED ME ABOUT, EVEN TO THE SOUL: THE DEPTH CLOSED ME ROUND ABOUT, THE WEEDS WERE WRAPPED ABOUT MY HEAD.

9

Hagreen noted, were 'the antithesis of what a printer wants':[15] a mass of shallow, silvery lines and cross-hatching which are most effective when burnished by hand, as are the proofs, on japan paper. Later he admitted the problem:

I think in the case of my work, it is particularly difficult because they do depend to some large extent on really 'sympathetic' printing, they are very easily killed. I do *not* think this is a virtue in them, far from it, perhaps, but it is a fact. The idea *only just* gets across in any case & mechanical process simply dishes 'em'.[16]

Jones's technique is most unusual, his outlining and method of cross-hatching for contours and shading greatly refined from previous work. Spots, flecks, and delicate patterns add to the complexity.

The ten rectangular illustrations are arranged as five double spreads. Jones's way of flattening the perspective and crowding narrative incidents in and around a central motif, each area subtly defined by a halo of white lines, here reaches its apogee. Gesticulating people, mostly in frieze-like groups connected by interlocking bands of white or black, create a circular rhythm, perhaps best observed in *God Speaks to Noah*. Here, a group of praying monks (reminiscent of Jones's Ditchling style), compressed within a tiny cell, are surrounded by a seething mass of sinful groups in pursuit of pleasure, whilst above the whole scene hovers the Lamb of God. The medieval aspect of this fourteenth-century mystery play is observed in the sumptuous tapestry effect of costume, patterned brickwork and foliage, stiff, anonymous figures with almond-eyed faces, and decorative bestiary animals. A Gill-like orientalism is evident in the attitude of the embracing lovers in the foreground. Harsh diagonal lines of driving rain accentuate the horror of the situation for the swirling mass of bodies and stranded beasts in *The Drowning of the Wicked*. In total contrast to these scenes of sin and destruction the calm stillness of *The Dove* proclaims the world washed clean and the hope of a new beginning for mankind. This print is seen by many as one of Jones's masterpieces. Such use of symbolic imagery in these later wood-engravings is a response to his profound religious and philosophical beliefs.[17]

Plate 122

In June 1927 Maynard and Bray invited Jones, on Gill's recommendation, to illustrate *Llyfr y Pregeth-wr* (*Ecclesiastes*) for the Gregynog Press. Previously all illustrative work had been undertaken by themselves. The outcome was a rectangular frontispiece of Christ on the Cross encircled by amorous couples, murderers, and other sinners in much the same vein as the *Deluge* illustration, *God Speaks to Noah*. Owing to heavy inking on such a lightly incised block, the printing is unsuccessful. More satisfactory is the title-page design showing a small seated figure of a man, knees bent, doubled-up in a square-shaped frame. A naked artist, similarly hunched, squeezed into a temple surmounted by a cross and the hand of God and surrounded by patterned beasts, makes for a most

[15] Philip Hagreen to the author, 21 Oct. 1986.
[16] David Jones to Douglas Cleverdon, 30 May 1928. DCA.
[17] Cleverdon in *The Engravings of David Jones*, compiled by Douglas Cleverdon (London, 1981), 13, compares the almost hieratic composition of Jones's *Deluge* illustrations with an intensity of vision that recalls the work of William Blake as exemplified in his *Wise and Foolish Virgins*.

effective frontispiece to Eric Gill's *Christianity and Art* published in the same year. Jones's typical stylistic components are all represented in these books.

In a letter of 27 January 1927 Jones expressed an interest in Cleverdon's idea of illustrating Coleridge's *The Rime of the Ancient Mariner* with copper engravings.[18] Possibly he was already beginning to feel that wood-engraving was too limiting to be able to express the language and imagery conjured up by the looser line and softer, translucent quality of watercolour, a medium which increasingly appealed to him. He was attracted also by Cleverdon's suggestion to illustrate *Morte d'Arthur*, one of his favourite books: 'I think there are about six real "ideas" in King Arthur. I mean universal ideas that one might with thought re-create into the medium.'[19] Owing to illness, however, the scheme was abandoned: 'The thing is just beyond me at the present time. What about Eric Ravillious [*sic*]. I think he might do it magnificently—he's a magnificent engraver (I think) (infinitely more able than myself in many ways) & I feel he might be able to get over the "costume" and "period" snag in Morte d'Arthur.'[20] His choice of Ravilious reflects his own taste for unnaturalistic imagery and decorative tool work.

Jones's change of direction towards greater lyricism as seen in his watercolours is *Plate 123* apparent in his final wood-engraved illustration for 'The Bride', the frontispiece to W. H. Shewring's *Hermia and some Other Poems* (St Dominic's Press, 1930).[21] A *décolletée* woman is shown lighting a candle at the foot of the crucified Christ. One of his most serene images, recurring also in his watercolours, it represents the dual nature of the Bride as the Virgin Mother and as courtesan, a subject to which he refers in his writings. Symbolism abounds and Botticelli's influence is apparent in the idealized, ethereal woman. Jones employs his usual technique though the line is more curvaceous—Renaissance rather than Gothic.

The view that *The Ancient Mariner* illustrations should be 'not essentially illustrations of bits of the text—but general ideas that immerge [*sic*] as the poem progresses' sums up Jones's attitude to illustration in general.[22] In all his illustrations he is deeply concerned with the spirit of the text which he brings out in a unique and personal way. His intensity of vision manifests itself, as in Blake's *Virgil* wood-engravings, in a technique which is spiritually expressive rather than typographically precise. In Pepler's words, 'he had the grace to love the wood and the feel of it; all his work has that fine quality of co-operation between artist and material. Eric Gill imposes his will on wood and stone alike, but David Jones discerns the nature of the substances he handles and brings their life into his own.'[23] His concentration on the world of myth and his archaizing treatment of it was not a retreat from modernity but rather a way of reasserting the cyclical process revealed by tradition. In formal and aesthetic terms Jones was part of a modernist vanguard.

[18] *The Rime of the Ancient Mariner* was published in 1929 by Cleverdon at Bristol with 8 copper engravings.
[19] David Jones to Douglas Cleverdon, 14 Feb. 1929. DCA.
[20] David Jones to Douglas Cleverdon, 13 May 1929. DCA.
[21] An unfinished wood-engraving, *He Frees the Waters in Helyon* (1932), was later used as an illustration for Jones's *The Anathemata* (Faber and Faber, 1952).
[22] David Jones to Douglas Cleverdon, n.d. DCA.
[23] Hilary D. C. Pepler, *The Hand Press* (Ditchling, 2nd edn., 1952), 24.

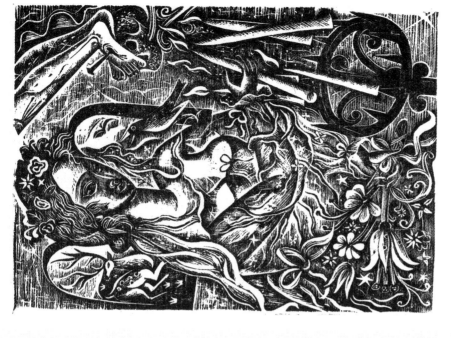

Pl. 122 (left). David Jones: *The Dove* from *The Chester Play of the Deluge* (Golden Cockerel Press, 1927). 166×144

Pl. 123 (above). David Jones: 'The Bride' from Walter Shewring, *Hermia and Other Poems* (St Dominic's Press, 1930). 114×82

12.2. *Paul Nash and his Influence at the Royal College of Art*

Paul Nash, like David Jones, was inspired as a student by nineteenth-century illustrators, particularly the Pre-Raphaelites. Both artists evolved highly personal symbolic and expressive styles with little influence from their respective art schools. Nash, however, was one of the few British artists who was directly affected by Edward Gordon Craig's revolutionary approach to art and the theatre, sharing with him poetic insight, unorthodox interpretative ideas, and an inherent sense of drama. He was first attracted to Craig's work by an exhibition of his models for *Macbeth* and other Shakespearian plays held at the Leicester Galleries in 1911 and by reading his book *The Art of the Theatre*.[24] Nash's series of Dymchurch pictures executed between 1919 and 1922 with architectural elements such as walls, stairs, and terraces may well have been conditioned by the stage designs of Craig and also of Adolphe Appia. He greatly admired Craig's ability to translate his drawings into three-dimensional models and, in 1921, as a result of a nervous breakdown, he took up stage model-making himself. Through building scenes and making drawings for these models he learnt 'more about tone & the 3 dimensional magic than in any other way';[25] yet, paradoxically, in his own work he tended to treat objects two-dimensionally. Like Craig Nash considered himself a designer as well as an artist. Their attitude to different media was all-embracing, Nash pursuing line drawing, wood-engraving, lithography, oil painting, and watercolour, and designing for stage, books, textiles, china, and furniture among other areas. Both men used recurring themes throughout their work. The two were in a category of their own: inventive, idiosyncratic, symbolist, forward-looking, and without exact imitators.

Nash was one of the few serious painter-wood-engravers of the time and, as with most of the others, he employed the medium for a short spell only—just over ten years from 1919 to 1930.[26] Most of his wood-engravings were for book illustration while many others were reproduced in periodicals. Several of his single prints, for example the *Promenade* engravings,[27] were based on a literary source. As a poet and writer himself, the written word was a constant source of inspiration, with the theatre acting as a vital link with literature. In *Room and Book* he praised the art of the book, from the textual content to its illustration and overall appearance. His view that if the artist 'is able to show a knowledge of inks, papers and types this will gain the printer's respect and slightly frighten the publisher' shows the value he placed on his own involvement in the bookmaking process.[28]

Plate 43

[24] See Paul Nash, *Outline: An Autobiography and Other Writings* (London, 1949), 166. For a discussion on Craig's theatrical work see Ch. 4.5, 'Edward Gordon Craig'. Nash also shared a lively interest in theatre design with Claud Lovat Fraser, a friend of Craig. Both artists had new ideas about decoration for the printed page and designed for Harold Monro's Poetry Bookshop publications, Nash contributing colour lithographs to *Rhyme Sheet, No. 2* (1919), *The New Broadside, No. 2* (1922), and *The Chapbook* (1923).

[25] Paul Nash to Gordon Bottomley, 22 Apr. 1925. Quoted from *Poet & Painter*, ed. Claude Colleer Abbott and Anthony Bartram (Oxford, 1955; repr. 1990), 184.

[26] In 1920 he was invited by Albert Rutherston to teach at the Cornmarket School of Drawing and Painting in Oxford and, as part of his job, to ground the pupils in wood-engraving.

[27] See Ch. 4.4, 'Paul and John Nash'.

[28] Paul Nash, essay on 'Modern Processes in Illustration', in *Room and Book* (London, 1932), 58.

Although Nash's work bears continental influences, particularly that of Cubism, Cézanne's landscape techniques, and Derain's Expressionist woodcutting, his lyricism and sense of the *genius loci* mark him as an essentially English artist in the tradition of poet-painters such as Blake. Yet, unlike Blake, his visionary landscapes are conspicuously lacking any human element, the natural features themselves taking on human meaning. Through such formalized visual language he found a means to express personal emotion. Rothenstein notes that Nash was 'peculiarly susceptible to the charm of strangeness'.[29] Abstraction and Surrealism were consequently natural paths for him to follow. Yet his painted images were rarely purely imaginative, based as they mostly were on things seen and, in later life, on *objets trouvés*. In contrast his book illustrations, their subject matter dictated by the text, relied more on literary images than on real objects: their symbolistic formulae and seemingly naïve technique accounted for their modernity. Assorted texts provided Nash with a rich source of visual imagery to which he returned throughout his work. Significantly, in several instances his illustrative wood-engravings predate his paintings of the same subject—a factor which is considered in this chapter, as is his wood-engraved illustrative style in the context of contemporary book design.[30]

His first work in this field, five figurative wood-engravings to John Drinkwater's *Cotswold Characters*, was for Yale University Press. The book was published on commission by the Oxford University Press in 1921, one of the earlier instances of the newly reinstated medium being used by a commercial publisher. On such rare occasions as Nash had previously included figures in his wood-engravings they were usually symbolically portrayed.[31] Yet he imbues these characters with distinct personalities which aptly fit Drinkwater's graphic descriptions. The boldly staring face of the thatcher, Joe Pentifer, for instance, echoes the text: 'His long, stormy beard, and his thick hair, itself thatchlike, not so much white-seeming as bleached by many winds, made him a visionary figure such as Blake might have added to his visionary portraits.' Signs of abstraction are visible in the background constructions, whilst in *Pony the Footballer* the diagonal stretching action of the player across the goalpost has a Vorticist feel. These images are bolder and more stylized than those depicted in previous engravings.[32] Technique varies from robust woodcut-like handling, as in *Thesiger Crowne, the Mason*, to fine white line in *Pony the Footballer*.

Although Drinkwater admired these figures, they were not appreciated by the *Westminster Gazette* critic who considered that the Gloucestershire stonemason looked 'like Blake's Job crossed with one of Mr. Crawhall's Chapbook heroes. . . . they are pleasant, effective pieces, but quite untrue to English life'.[33] Nash's designs, however, were purposely unrealistic, his views on such subject matter summed up at a later date

[29] John Rothenstein, 'Paul Nash', from *Modern English Painters*, iii. 111.

[30] For a fuller analysis of individual illustrations see exhibition catalogue, *Paul Nash: Book Designs*, researched and written by Clare Colvin (Colchester: The Minories, 1982).

[31] The Prints and Drawings Department of the British Museum possesses preliminary ink drawings almost exactly replicating the engravings in size and detail; evidence, as with the *Genesis* designs, also held in the British Museum, that Nash transferred detailed finished drawings on to the block rather than working more spontaneously as the loose handling might suggest.

[32] Colvin, *Paul Nash: Book Designs*, 28, suggests they are closer to the work of his contemporaries Mark Gertler and, mistakenly, Eric Ravilious, who did not seriously start wood-engraving until he had entered the RCA in 1922 and was inspired by Nash.

[33] *Westminster Gazette*, 8 June 1922.

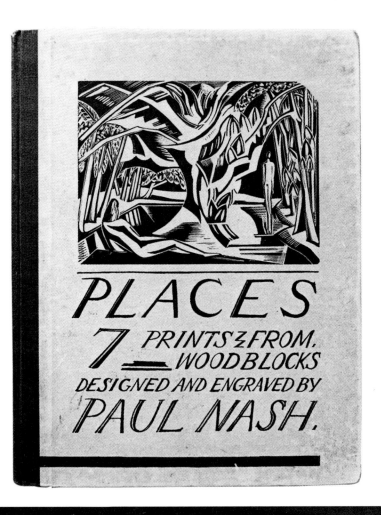

Pl. 124 (*right*). Paul Nash: Cover design for *Places* (Heinemann, 1923). 284 × 222

Pl. 125 (*below*). Paul Nash: *Dark Lake* from *Places* (Heinemann, 1923). 280 × 436

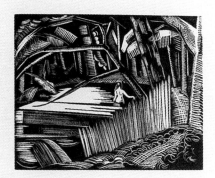

DARK LAKE.

In a black pine wood is a lake. An inscrutable, dark face staring up at the sun or into the moon's face or at the stars peering down. Above, the pines in tall columns and mighty domes and great arches stand nearly motionless. At the water's edge! rushes and irises mass their slender swords. The grey teeth of an old fence look ghostly against dark water. Beyond a platform jutting out, a woman, naked, gleams in this shadowy place.

in a letter to Martin Armstrong in which he described the sort of illustration he felt 'equal to tackling':

Romance—not romantic realism. Mystery, terror, legend, fantasy—I'm no good at all at village life and as to your theme[34] I can't see how decorations could possibly enhance it—Remember I don't care for human nature except sublimated or as puppets, monsters, masses formally related to Nature. My anathema is the human 'close-up'.[35]

The 'imaginative beauty' of *Desert* which was 'concerned with vast and primitive things not petty human affairs' appealed more readily to Nash.[36] *Cotswold Characters* was an interesting challenge which he did not repeat.

He was truer to himself with his wood-engravings for *Places* (Heinemann, 1923). Unusually these predate his poems in the book, as correspondence reveals: 'I have hopes Heinemann is going to bring out a book of my wood-engravings & I have been trying to write sort of prose poems to accompany them.'[37] Not only did Nash initiate the project but the publishers gave him a free hand with the design: the cover, title-page, *Plate 124* handwritten text, and seven illustrations are entirely his own work. In the book Nash locates the seven 'places' to all of which he had a strong personal attachment. The paths, woods, ponds, and trees which feature so often in his work in general had particular resonance for him as he recalled in his autobiography.[38] As discussed in an earlier chapter it was the mysteriousness of places—'the inner life of the subject'—that attracted him.[39] Nash's wartime experiences accounted for his change of attitude to landscape towards a more sinister and unearthly vision. Youthful innocence and ominous overtones of death are conveyed by the depiction of contrasting emotions and opposing states. In these engravings Nash began seriously to express his feeling for the metaphysical. His consciously crude handling of the blocks exudes an element of mystery and tension, as does idealized imagery such as the perpendicular, vaulted trees like 'cathedrals and mighty churches' and a lone, angular female figure which appears in most of the engravings. Only in the first print, *Meeting Place, Buntingford* (used also on the cover), does a male figure (earthly delights) appear, to tempt the naked woman (the soul) who, in *Dark Lake*, walks into the pond (salvation) signifying her willing acceptance of death. *Plate 125* These illustrations contain an erotic element which is absent in the last four, for example *Tailpiece. Iden*. The jagged cutting of these latter engravings emphasizes the foreboding death-wish mood of the subject.

As with so many of Nash's wood-engravings these illustrations contain the seeds of later work in other media, as if through the actual process of engraving new ideas were formed. His large oil painting, *The Lake* (1923), which Causey sees as Cézanne inspired, is

[34] His novel *Desert* which Ravilious illustrated that year.
[35] Paul Nash to Martin Armstrong, 20 Aug. 1926. Typewritten MS, NAL. The following year Nash illustrated Armstrong's *Saint Hercules and Other Stories* (The Fleuron) with line blocks and stencilled watercolours.
[36] Ibid.
[37] Paul Nash to Gordon Bottomley, [c.12 Sept. 1922]. *Poet and Painter*, 154.
[38] Nash, *Outline, passim*.
[39] See Ch. 4.4, 'Paul and John Nash'.

based on *Meeting Place, Buntingford*.[40] Tall, umbrella-like trees are a recurring theme and evolve architecturally into more abstract designs for arches.

Contrary to James King's belief that Nash's designs are stylistically regressive,[41] they are without doubt among the most dynamic wood-engraving of the period in the bold simplicity of their statement, both technical and stylistic. The facsimile script forms a unity with the illustrations on opposite pages and adds to the unorthodox and hand-crafted appearance of the book. Nash's total involvement in the overall design, an opportunity rarely available to illustrators, particularly with commercially produced books, accounts to a large extent for the success of *Places*.[42]

While still working on *Places* Nash was attracted by a suggestion of Ford Madox Ford (Hueffer) to illustrate a book of his poems.[43] *Mr Bosphorus and the Muses* was published in 1923 by Duckworth in a signed limited edition of seventy with a further thousand regular copies.[44] Subtitled 'A short history of poetry in Britain, variety entertainment in four acts', Colvin describes it as 'a surrealist comedy in which places, events and time are juxtaposed in a series of swiftly changing scenes with Bosphorus's discourse on litera-ture forming the main theme'.[45] As with most of Nash's book illustrations there is a theatrical element in the arrangement of these scenes.

Nash's technique is far less robust than in *Places* and his subject matter more figurative as befits the narrative. *Poor Northern Muse* depicts Mr Bosphorus soliloquizing in a dark and lonely garret. The print is predominantly black, with small white sketchy lines and some bolder cross-hatched strokes for random shading, conveying a suitably brooding *Plate 126* mood. In *Arthur in the Birken Hut* the white-line figures of King Arthur and the kneeling maid who has lured him into her hut capture the seductive intensity of the scene. *Exit Northern Muse* is dramatic in its lighting effects, the elongated silhouette of a woman with an umbrella against an open door making a startling impression. Nash's attempt to depict every detail in the text (Hueffer's script and stage instructions are extremely explicit) results in some busy and restless scenes as, for example, the harlequin figures in *Ga-Ga!*. Bosphorus's funeral takes place in Westminster Abbey with the undertaker dressed as the Dean. Inspired by the reference to 'blanched sands', with the scene for *Elysium* Nash places stark black palm trees on a bare island. In each scene both technique and style suit the mood of the text. Nash was amused by Hueffer's quirky sense of humour and pleased with the results of his illustrations, as was the author who felt that 'nothing could have been more sympathetic'.[46]

Nash's next book, *Genesis*, published by the Nonesuch Press in 1924,[47] marks the

[40] Andrew Causey, *Paul Nash* (Oxford, 1980), 128. He states that the presence of a male as well as a female figure suggests a relationship with Duncan Grant's *Venus and Adonis* (c.1919).

[41] James King, *Interior Landscapes: A Life of Paul Nash* (London, 1987), 105.

[42] An edition of 55 on japon paper with designs printed from the blocks, each numbered and signed by the artist, retailed at £1. 1s.; a further 210 unnumbered and unsigned copies retailed at 10s. 6d.

[43] Paul Nash to Gordon Bottomley, 9 Nov. 1922. *Poet & Painter*, 161.

[44] The limited edition was printed on rag paper; the regular

edition on cartridge paper was for sale at 10s. 6d., with Nash's print *Parnassus* reproduced on the cover. As was Nash's custom, additional proofs of the blocks were issued separately.

[45] Colvin, *Paul Nash: Book Designs*, 34.

[46] F. M. Hueffer to Paul Nash, 21 May 1923. Quoted by Anthony Bertram, *Paul Nash: The Portrait of an Artist* (London, 1955), 11 n. 3.

[47] A limited edition only, it was oversubscribed before pub-lication so the edition was increased from 300 to 375 and the price raised from 21s. to 25s. The prints were issued in a separate edition although the exact number of prints from each block is not known.

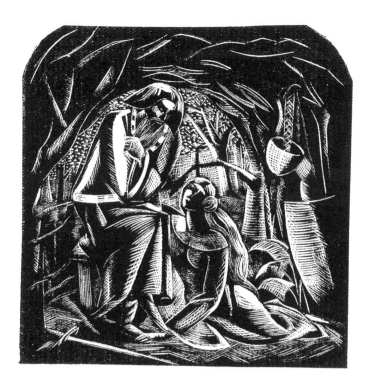

Pl. 126 (*left*). Paul Nash: Ford Madox
Ford (Hueffer), *Arthur in the Birken Hut*
from *Mr Bosphorus and the Muses*
(Duckworth, 1923). 87 × 89

Pl. 127 (*below*). Paul Nash: *Dry Land
Appearing* from *Genesis* (Nonesuch Press,
1924). 270 × 370

AND GOD SAID LET THE WATERS
UNDER THE HEAVEN BE GATH—
ERED TOGETHER UNTO ONE
PLACE AND LET THE DRY LAND
APPEAR AND IT WAS SO + AND
GOD CALLED THE DRY LAND
EARTH AND THE GATHERING
TOGETHER OF THE WATERS
CALLED HE SEAS AND
GOD SAW THAT
IT WAS
GOOD

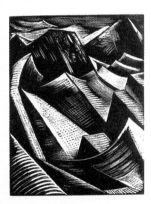

start of his fruitful association with the Curwen Press through Francis Meynell; a vital connection which not only encouraged a greater interest in the book arts but also an involvement in industrial design which became as important to Nash as his painting.[48] The radical appearance of *Genesis* is partly due to the subtle combination of Rudolph Koch's heavy Neuland type (used for the first time in England)[49] and Nash's twelve complementarily dark wood-engravings. Unconventionally arranged text and rectangular illustrations face each other on verso and recto. Into these blocks he gradually introduces more light as God creates the world, beginning from the solid black of *The Void.* As he explains in the prospectus, 'each new phenomenon of creation is a fresh primary form cut out of the blackness of this void'; hence the overall unity of the blocks. With the swirling rhythms of the *Creation of the Firmament* the images become progressively more full of movement. With each Day of Creation Nash introduces geometrical elements, reinterpretating ideas inscribed on the finished drawings: for

Plate 127 example, the rugged mountains left by the receding waters in *Dry Land Appearing* he describes as 'pyramid angular', whilst 'Arc and spiral rhythm' aptly refers to *The Fish and Fowl* with fin-like shapes and repeated undulating wing-span motif.[50] Less kinetic is *Cattle and Creeping Thing* ('rectange [sic] box form'), the creatures awkward and bulky. The distorted, tubular figures of *Man and Woman* are reminiscent of his earlier Vorticist tendencies. Signs of Surrealism are evident in scenes such as *Vegetation* with its elliptical and stylized growths, the drawing inscribed 'Dome & Cone & tube'. Only the last print, *Contemplation,* is conceived in a purely abstract vein, prismatic lines and shapes symbolizing God's spirit over the Earth on the seventh day.

Genesis is rightly considered one of the most important British twentieth-century illustrated books, its pages startlingly modern for the time. It is significant for being not only Nash's first major abstract statement but also possibly his most abstract work. His paintings never quite attained the same level of abstraction. Bottomley showed his appreciation by exclaiming, 'Ooooooh!!! to your engravings of The Creation. They electrified us & made us jump ... they leave all your engravings so far behind as to be out of sight.'[51] Certainly these radical designs played a key role in the development of Nash's *œuvre,* anticipating some of his work in other media, the flower-like sphere for *The Sun and the Moon* for instance, preceding those in his later sunflower and sun paintings.[52]

While working on these wood-engravings Nash developed and expanded new techniques, employing cross-hatching and stabbed toolmarks. Distinctive areas of black

[48] See Ch. 6.3 for his involvement with the Curwen Press, and also Pat Gilmour, *Artists at Curwen* (London, 1977), 45–53. According to Susan Lambert, *Paul Nash as Designer* (London, 1975), 5, Nash 'had taken up the cause of the artist's role in industry with more organizing verve than the other artists experimenting in this field'.

[49] See Ch. 6.2, 'Private Presses'.

[50] Drawings held in the Prints and Drawings Department of the British Museum. In his introductory essay to exhibition catalogue, *Paul Nash: Aerial Creatures* (London: Imperial War Museum, 3 Oct.–26 Jan. 1997), 7–55, p. 44, Charles Hall maintains that a few of Nash's early nocturnal drawings concerned with the interaction between either air and water, or water and earth,

and with the ambiguous struggle between life and death, anticipate the imagery of the *Genesis* series. *The Pyramids in the Snow* (1912), held in the Tate Gallery, which most closely resembles *Dry Land Appearing,* represents the creation of order and life. He suggests 'an association in Nash's mind, through his career, with night, flight and rebirth or death'. See also Ch. 4.4.

[51] Gordon Bottomley to Paul Nash, 27 Mar. 1924. *Poet & Painter,* 178.

[52] In the autumn of 1924 Nash began to work on illustrations for *Pilgrim's Progress* for publication by Stanley Morison but, owing to a quarrel with Bernard Shaw who was asked to write a preface to the book, the scheme had to be abandoned.

and white remained a constant feature. His obvious enjoyment in working in a non-representational way led to an interest in designing for textiles and, in particular, for pattern papers,[53] as he revealed in 1927 in an article on wood-engraving for *The Woodcut*:

I have become lately more interested in woodcut patterns than in woodcut pictures. It is always a relief to be rid of the responsibility of representation. . . . Wood seems to yield to the evolution of an abstract design or a decorative arabesque as stone excites the sculptor to the creation of pure form. For it is the glyptic character of engraving on wood which is its peculiar charm, so that the more the engraver cuts into his block—I do not mean literally in point of depth, in fractions of an inch—the greater his sense of contact with the reality of his expression.

Five small illustrations which Nash had been working on as early as 1923 for Robert Graves's collection of poems, *Welchman's Hose* (The Fleuron, 1925), show his flair for decoration, encouraged by Oliver Simon.[54] They are used either on single pages or as endpieces. None particularly relates to the text. *Decoration Ferns*, for instance, is semi-abstract and the final design completely so. The lively cover paper is a repeat-pattern of flowers.

Nash's emphasis on dramatic effects as displayed in *Genesis* is no more apparent than in his illustrations to *Wagner's Music Drama of the Ring* (Noel Douglas, 1925), as the preface implies: 'Paul Nash, whose work as a theatrical decorator will need no introduction to you, has invented some designs which will give a dramaturgical interest to the book beyond its literary merits.'[55] Wood-engraved scenes corresponding to the four music dramas are inserted as whole-page illustrations opposite the stage directions. Nash carries these out precisely, adding, surprisingly, a single figure in each. In the scene for *Siegfried* he schematizes the trees exactly as Leroy indicated: 'The forms of the trees are conveyed by a series of facets, the planes being partly actual, partly suggested by a painted surface.' In all four engravings the props and scenery, whether rocks, caves, trees, or walls, are straight-edged and faceted, their angularity emphasized by the harsh lighting. An eye-catching architectural repeat-pattern printed in red on grey paper used for the binding completes Nash's designs for the book. *Plate 128*

Between 1924 and 1926 he produced various semi-abstract single prints which he developed from studies of flowers and arch forms that are in the same vein as the *Genesis* designs. A strangely surreal wood-engraving entitled *Coronilla* (1925), inspired by Harold Monro's poem of the same name,[56] is a precursor to the 1929 painting of the subject which Nash then engraved again in wood. In line with his predilection for Surrealism,[57] Nash conjured up dreamlike settings for his illustrations to Jules Tellier's *Abd-er-Rhaman*

[53] Four of his designs (one repeated on the cover), lithographically reproduced by the Curwen Press, featured in *A Specimen Book of Pattern Papers* (The Fleuron, 1928) for which he wrote the introduction. Other artists included Lovat Fraser, Edward Bawden, Enid Marx, and Eric Ravilious.

[54] Edition of 525, 500 of which were for sale at 12s. 6d. This was the first book printed at the Curwen Press to be issued under the imprint of The Fleuron by Oliver Simon. See n. 53. The block of the magpie-like bird was used subsequently by the press as a stock block.

[55] Two further theatrical illustrative projects were for Ernest Benn's Player's Shakespeare, *A Midsommer Night's Dream* (1924) and *The Tragedie of King Lear* (1927). Nash's line drawings and colour plates in collotype (a photographic transfer process) are more detailed and lightweight and lack the impact of his wood-engraved illustrations.

[56] Colvin, *Paul Nash: Book Designs*, 85, believes that Nash had intended to illustrate a volume of Monro's poems. See also n. 24.

[57] For Nash's definition of the term see his essay 'Surrealism and the Illustrated Book', *Signature*, 5 (1937), 1–11.

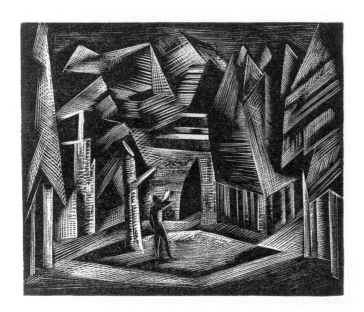

Pl. 128 (*above, left*). Paul Nash: *Siegfried, Act 2* from L. Archer Leroy, *Wagner's Music Drama of the Ring* (Noel Douglas, 1925). 77 × 93

Pl. 129 (*above, right*). Paul Nash: Jules Tellier, *Abd-er-Rhaman in Paradise* (Golden Cockerel Press, 1928). 136 × 93

Pl. 130 (*right*). Paul Nash: Mikhail Lermontov, *A Song about Tsar Ivan Vasilyevitch* (Aquila Press, 1929). 41 × 102

in *Paradise* (Golden Cockerel Press, 1928). An earlier wood-engraving entitled *Hanging Garden* consisting of verdant trees, a wall, and a bridge over a river, the whole picture plane flattened and upturned, resembles the scene for *Paradise* in conception.[58] The four whole-page engravings are much more painterly and representational than previous illustrations, and balance well with the Caslon Old Face type. Nash's looser cutting and his method of encircling a central character with figures, trees, and incidents bear similarities with the work of David Jones whose *Deluge* illustrations for the press had been published the previous year. Like Jones's images these figurative scenes are highly symbolic.

Plate 129

In complete stylistic contrast are Nash's designs for Lermontov's *A Song about Tsar Ivan Vasilyevitch* published by the Aquila Press in 1929. He was involved not only with the illustrations but with the binding and the book's format, choosing the typeface to suit the Russian poem. The four engravings printed in red, white, and black are strikingly geometric, the strong vertical and horizontal lines echoed on the binding design. The Tsar's narrow, upright, rectilinear throne features opposite the title-page. One headpiece is divided into three sections, two with intersecting lines and the third containing an abstracted head of a woman; another headpiece is patterned only, while the endpiece consists of heavy black and red vertical lines incorporating the word *Finis*. Only in the first two illustrations is there a vague allusion to the text. These designs are decorative rather than interpretative, their solid construction harmonizing with the heavy Gothic type.

Plate 130

Tsar Ivan Vasilyevitch was Nash's last attempt at wood-engraved book illustration. As his move towards Surrealism intensified, so a lighter, more fluid, and potentially colourful medium better suited his visual imagery. He pursued his love of black and white, however, in a series of photographs which acted as source material for his paintings. His last and most extraordinary illustrations were facsimile collotypes (of chalk drawings) with watercolour stencils, for Sir Thomas Browne's *Urne Buriall and The Garden of Cyrus* printed for Cassell by the Curwen Press in 1932. These strange metaphysical images contrast with earlier wood-engraved ones although there is a similarity in feel between the plate for *Vegetable Creation* in this book and the engraving of vegetation in *Genesis*.[59]

Paul Nash's wood-engraving was confined almost entirely to the 1920s but in that short time he produced some of the most exciting book illustration of the period. Working mainly with private presses or for commercially published limited editions enabled him to experiment with illustration and to widen his skills in other areas of book design. Through his expressive methods of interpretation and breadth of vision he was, like Craig, avant-garde. For this reason, perhaps, his modernist approach to illustration and the book as a whole was rarely pursued to the same extent by contemporary artists or publishers, his aesthetic ultimately having greater effect on the Neo-Romantic illustrators of the 1940s.[60]

[58] He may well have been influenced by John Nash's illustration of *Paradise* in *Ovid's Elegies* (1925). See Ch. 12.7.

[59] See Causey, *Paul Nash*, 228. [60] See Conclusion, n. 5.

None the less, both stylistically and technically, his work had a profound effect, in particular on various students at the Royal College of Art where, from 1924, he taught part-time for a year in the Design School,[61] his inspiring methods expounded by Edward Bawden:

he talked to each of us individually in the manner of two artists exchanging their personal experiences. There was no artificial barrier, no talking down as between God and man, teacher and the one who was being taught. Nash brought into the dingy mustiness of the room a draught of fresh air. He spoke of Samuel Palmer, of Lovat Fraser, the Curwen Press, the processes of graphic reproduction and so forth; he looked at work most carefully seeking to discover our thought, what we were trying to do and never, never did he impose his own point of view.[62]

Paul Nash's prescient comments on his teaching underestimate his achievement: 'I cannot deny I am able to help people there & this is a great temptation. Even if I have to give up at the end of the year, I can feel I've done some good & very little harm.'[63]

12.3. *Douglas Percy Bliss*

Three students deeply affected by Paul Nash's teaching, Douglas Percy Bliss, Edward Bawden, and Eric Ravilious, formed an inseparable trio when they arrived at the Royal College of Art in 1922. Following a degree in English from Edinburgh University, Bliss (1900–84) joined the Painting School under William Rothenstein, but soon gravitated towards the Design School where Bawden and Ravilious belonged.[64]

In his biography of Bawden, Bliss conjures up the atmosphere of excitement at the college where the typographical renaissance was beginning to make itself felt.[65] Edward Johnston, teaching lettering, attracted a loyal following. The pioneering journals *The Imprint* and *The Fleuron* were available in the Students' Common Room to all those interested in fine printing and illustration. Here they could read about the old and new heroes of the printing world, learn about paper, type, and design, and discover the publishing houses and printers which encouraged the use of good modern design and the harmony of type and illustration. The proximity of the college to the Victoria and Albert Museum gave students an opportunity to see for themselves some of the best examples. Viewing the Kelmscott exhibits was for Bliss one of the 'greatest aesthetic experiences'.[66] Although students received no official wood-engraving instruction, he and Ravilious, among others, were encouraged by Nash to experiment.

[61] He taught for 1½ days a week from autumn 1924 to summer 1925, and from Jan. 1938 for two periods a week until the college evacuated in autumn 1940.

[62] Quoted by Justin Howes in his introduction to *Edward Bawden: A Retrospective Survey* (Bath, 1988), p. xiii. For further discussion on Nash's role at the RCA see following chapter.

[63] Paul Nash to Percy Withers, n.d. [1924]. NAL.

[64] Significantly Design ranked as Applied Art, its status con-sidered to be inferior by the Fine Art departments of Painting, Sculpture, and Engraving.

[65] Douglas Percy Bliss, *Edward Bawden* (Godalming, 1979), 18–20. For Bawden (1903–84) wood-engraving was too small-scale and limiting a medium. He preferred line drawing, linocutting, and lithography.

[66] Conversation between D. P. Bliss and the author, 3 May 1983.

A quiet, modest man, Bliss 'combined an intense interest in books with an acute intelligence and corrosive wit'.[67] His quirky sense of humour is apparent from some of his earliest attempts at wood-engraving. These appeared in the *Students' Magazine* which he edited from 1923. A small headpiece to some jokey epitaphs in the June 1924 edition shows an illustrative style that recurs throughout his career: lively silhouetted figures, slightly caricatured, with strident white-line textures on buildings and foliage. Figures in a churchyard reveal his penchant for gloomy, forbidding subjects. In June 1925 two prints were reproduced in the newly named magazine, *Gallimaufry. Tattie Bogle*, dominated by a grimacing scarecrow, and *The Catch*, an amusing caricature of a portly fisherman proudly displaying a small fish to a thin, empty-handed companion. The latter print was initially designed for a dust-jacket for A. M. Young's *The Story of the Stream* for Heinemann, an early instance of a wood-engraver working for a commercial firm.

Even at this early stage Bliss was thinking in terms of the overall design of a book. His views on the importance of the wood-engraving for bookwork were expressed in a small technical leaflet he wrote for Dryad Handicrafts: 'Personally I look upon wood-engraving chiefly as a means of book illustration, that is as something small in scale, rich in tone and texture and decorative in character and small blocks are more easily obtained.'[68]

As a student Bliss possessed unusual entrepreneurial talents. Conscious of the importance of the illustrator's involvement in the process of book making, he was aware of the fact that trade conditions did not always enable such co-operation. In 1928 he wrote that the artist 'is given no specimen page of type for which to design and his advice is not wanted in the general "layout", which is planned by publishers who have no more aptitude for book design than bankers or stockbrokers can be expected to have'.[69] Bawden's collection of Poetry Bookshop broadsheets inspired the two friends to set up their own press to produce similar work, 'the pleasantest and easiest way into publication'.[70] But lack of printing expertise led them to abandon the scheme. In order to sell his idea of a book entitled *Border Ballads*, Bliss made up a dummy with wood-engraved illustrations which he hawked round publishers, eventually persuading Humphrey Milford of Oxford University Press to publish it in 1925.[71] As a Scotsman and keen admirer of Scottish literature and mythology, Bliss, according to the book's foreword, succeeded to a remarkable degree in communicating 'that strange world of the popular imagination which the ballads evoke, not realistic, charged with atmosphere, dreamlike, imaginative, almost symbolic, yet with touches of homely, even humorous, detail'.[72] Grierson particularly noted the Blake-like inspiration of the tailpiece to 'Sir Patrick Spens'. Bliss's method of placing dark figures or horses against stormy skies, and patterns of soldiers' lances and trees in frieze-like silhouette, creates a sense of tragedy and foreboding, as in the two headpieces to 'The Lament of the Border Widow' which *Plate 131*

[67] Quoted by Howes in introduction to *Edward Bawden*, p. xiii.
[68] Douglas Percy Bliss, *Wood-Engraving* (Leicester, [1952]), 11.
[69] Douglas Percy Bliss, *A History of Wood-Engraving* (London, repr. 1964), 251.
[70] Bliss, *Edward Bawden*, 29.

[71] A note indicates that the text of all poems was taken from *The Oxford Book of Ballads*.
[72] Foreword by H. J. C. Grierson to *Border Ballads* (Oxford, 1925), p. xii.

effectively span two pages. Interior scenes, on the other hand, are often crowded and awkward.

Thirty-four mostly rectangular head- and tailpieces adorn the book. A bold woodcut-style block printed in red appears at the opening, and a smaller one used within the text is repeated on the binding. Although excellently printed by the Westminster Press, Bliss was dissatisfied with the blackness of his illustrations in relation to the weight of the type which he had hoped would be heavier, thus confirming his belief that ideally artists should see a page of type before engraving.[73]

With his illustrations to another of his compilations, *The Devil in Scotland*, published by Maclehose nine years later, he achieved the harmony he sought, largely because the printers were advised by the Hornsey College of Art, where he had been teaching part-time since 1932, and had set up a specimen page of type, the size and density of which was more suited to his thirty-nine wood-engravings. Although the blocks are still rather black with strongly contrasting white areas, Bliss's touch is lighter in some of the fine-lined shading. Following his introductory essay on demonology in Scottish life and literature, he treats this collection of stories, all in a similar vein to *Border Ballads*, with equal vitality, wit, and imagination. Facial expressions are exaggerated, sometimes to the point of grotesqueness with huge rolling eyes and open mouths, as in *Thrawn Janet*. Limb movements and gestures are overemphasized, as with the silhouetted horses flying *Plate 132* over the bridge and the wild dancing women in Burns's *Tam O'Shanter*. Bliss vividly conjures up the harshness of Scottish rural life and the spirit of Robert Burns, Walter Scott, and Robert Louis Stevenson in these illustrations. The paper-bound cover with its chequer-board pattern of scarecrows, ploughed fields, and birds, made by reusing the endpiece block, is one of the more distinctive of the period.

In 1926 Bliss broke new ground in the commercial publishing world. Following Craig's *Woodcuts and Some Words* (1924), Dr Johnson's *The History of Rasselas, Prince of Abyssinia* was the first of J. M. Dent's books to contain the new-style wood-engraving, in this instance nine full-page and various smaller illustrations. Once again Bliss felt the typeface was not quite right.[74] He clearly enjoyed the satirical aspects of the text, however. In *Portrait of Dr Johnson in Easter Garb* the bulky potentate-like character towers above a small praying figure. The 'young men of spirit and gaiety' who deride Rasselas in *Exit the Moralist* are revealed as grotesque characters leering, smoking, and whoring. Generally, Bliss chose for narrative illustrations the most dramatic and emotional moments which he conveyed through expression and gesture. A spirited design for *The Happy Valley* depicts exotic young couples dancing under a tall palm tree to the accompaniment of *Plate 133* two musicians. Some minute figures prancing across a hill in the background bring a sense of perspective to the scene. Bliss introduced a wide variety of textures in the sky and foliage, tightening up his technique. His wry sense of humour can be seen on page 118 where an angel flies over a gravestone inscribed 'All bliss lies here'.

The following year Paul Nash, impressed with a portfolio of his work, introduced

[73] See n. 66. [74] Ibid.

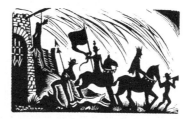

THE LAMENT OF THE BORDER WIDOW

I

MY love he built me a bonny bower,
And clad it a' wi' lilye flour;
A brawer bower ye ne'er did see,
Than my true love he built for me.

II

There came a man, by middle day,
He spied his sport, and went away;
And brought the King that very night,
Who brake my bower, and slew my knight.

III

He slew my knight, to me sae dear;
He slew my knight, and poin'd his gear;
My servants all for life did flee,
And left me in extremitie.

IV

I sew'd his sheet, making my mane;
I watch'd the corpse, myself alane;
I watch'd his body, night and day;
No living creature came that way.

(28)

V

I took his body on my back,
And whiles I gaed, and whiles I sat;
I digg'd a grave, and laid him in,
And happ'd him with the sod sae green.

VI

But think na ye my heart was sair,
When I laid the moul' on his yellow hair;
O think na ye my heart was wae,
When I turn'd about, away to gae?

VII

Nae living man I'll love again,
Since that my lovely knight is slain;
Wi' ae lock of his yellow hair
I'll chain my heart for evermair.

(29)

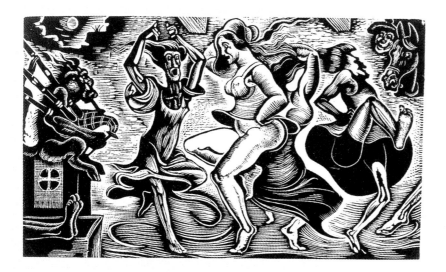

Pl. 131 (*above*). Douglas Percy
Bliss: Herbert Grierson
(Foreword), *Border Ballads*
(Oxford University Press, 1925).
245 × 303

Pl. 132 (*left*) Douglas Percy Bliss:
The Devil in Scotland (Maclehose,
1934). 64 × 108

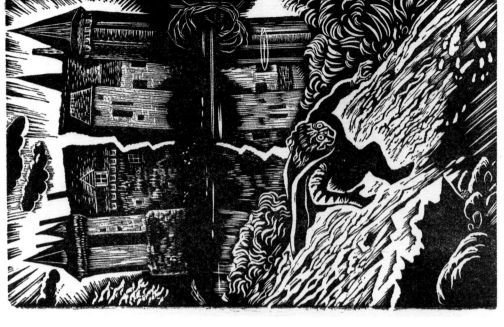

Pl. 133 (*left*). Douglas Percy Bliss: *The Happy Valley* from Samuel Johnson, *The History of Rasselas, Prince of Abyssinia* (J. M. Dent, 1926). 166 × 104

Pl. 134 (*above*). Douglas Percy Bliss: Edgar Allan Poe, *Some Tales of Mystery and Imagination* (Penguin Illustrated Classics, 1938). 133 × 83

Bliss to the St George's Gallery where, together with Ravilious and Bawden, he exhibited watercolours.[75] In 1928 he was appointed art critic for the *Scotsman* and his extensive research on the history of wood-engraving was published by Dent. Not till 1934 did he become a member of the Society of Wood Engravers.[76]

Surprisingly for someone so keen on the close involvement of artist with publisher Bliss did not illustrate a wood-engraved book for any private presses before the war.[77] Aware of Ravilious's disappointment with Gibbings's over-inking,[78] he possibly avoided the Golden Cockerel Press. In 1938, however, he accepted Gibbings's request to illustrate Edgar Allan Poe's *Some Tales of Mystery and Imagination* for the Penguin Illustrated Classics series. He contributed a decorative frontispiece and various suitably horrific scenes of figures in melodramatic poses, digging for treasure, being chased, or dying. The one full-page plate for *The Fall of the House of Usher* interprets the text literally and shows the story-teller fleeing in terror from a house rent in two by a zigzag fissure. Bliss's line in these illustrations is more fluid; they were to be his last before the war.

Plate 134

In the final paragraph to his *History of Wood-Engraving*, Bliss concluded: 'Wood-engraving is the true brother of Typography and the problem of keeping them together in peace and harmony in the House of the Book must be faced today.'[79] Although an early champion of wood-engraving as book illustration, he was not entirely happy using the medium for this purpose, never quite managing to overcome to his satisfaction the problem of blackness against which he railed in a later article.[80] For this reason he experimented with hand-stencilled line drawings as illustration to Cervantes's *The Spanish Ladie* (Oxford University Press, 1928)[81] and to W. Painter's *The Palace of Pleasure* (Cresset Press, 1929). These designs show an affinity with the French illustrator Edy Legrand whom he greatly admired.

The oldest of the trio of friends, Bliss, although the least distinguished as an artist, initially did most to set the cause of wood-engraving in motion. A prime mover in gaining commercial commissions, such enterprise acted as a catalyst to his peers. His seminal, low-priced leaflet on technique enabled a broader range of individuals, including schoolchildren, to take up the medium; with his pioneering discourse on wood-engraving he placed the modern movement in the context of its historical background, introducing readers to a variety of images, both traditional and new. His widely accessible writings on the subject were admired and respected by scholars and practitioners alike with far-reaching results.[82]

[75] All three artists were commissioned by the Curwen Press for ephemeral work.

[76] From 1946 to 1964 he held the post of Director of the Glasgow School of Art.

[77] In 1952 he illustrated one more wood-engraved book, *The Memoirs of Prince Alexy Haimatoff*, for the Folio Society.

[78] See n. 66.

[79] Bliss, *History of Wood-Engraving*, 251.

[80] Douglas Percy Bliss, 'The Last Ten Years of Wood-Engraving', *Print Collector's Quarterly*, 21 (1934), 251–71, pp. 251 ff. See also his comments in Introduction to Part III.

[81] Shown in the British Museum 'Best Books of the Year' exhibition.

[82] See exhibition catalogue, *Douglas Percy Bliss: A Retrospective Exhibition* (Derby: Derby Museum and Art Gallery, 14 Sept.–20 Oct. 1996).

12.4. *Eric Ravilious*

If Douglas Percy Bliss promoted wood-engraving through his writings, Eric Ravilious (1903–42) did so in a more practical way. Like Paul Nash he was one of the foremost artists and designers of his generation, leaving a remarkably varied body of work ranging from wood-engravings, watercolours, and lithographs, to murals, furniture, and decorated china. Through his distinctive wood-engraving style and wide-ranging use of the medium he helped to create a new market. His prints, especially those for book illustration and for commercial projects, mark him as one of the most original and influential practitioners between the wars.

Descriptions of Ravilious depict him as kind, vivacious, witty, and sociable.[83] With Bawden and Bliss he shared a sense of humour and the *joie de vivre* apparent in so much of their work. Yet there was an elusive and guarded side to his personality which probably stemmed from his strict Methodist upbringing as a child in Eastbourne. Sir James Richards recalled that 'he never lost a kind of wariness against all allegiances and personal involvements'.[84] A talker rather than a writer, with strongly held views which he did not impose, he was distinctly not a self-publicist. In consequence he left comparatively little documentary evidence of his ideas on art and his working practices. Primary material such as sketches and preliminary drawings is scarce, as are his letters, since he was not a prolific letter writer. The survival of correspondence between him and Gibbings covering all his commissions for the Golden Cockerel Press from 1926 to 1933 is all the more valuable for the insight it provides into his book illustration and methods of work which have hitherto been difficult to ascertain.[85]

Ravilious was primarily a designer, having studied in the Design School at the Royal College of Art from 1922 to 1925, in his last year under Paul Nash. Even as a young boy his drawings display a precision and clarity of line and reveal his interest in patterns and shapes of buildings and everyday objects;[86] characteristics which he retained throughout his work in whatever medium he chose to use. Frequent visits to the nearby Victoria and Albert Museum enabled him to view some of the best examples of nineteenth-century watercolours and prints by artists whom he most admired, particularly J. S. Cotman, Francis Towne, and Samuel Palmer, with whom he shared 'a poetic vision and an acute eye for the character of places'.[87] In one sense his own work belongs to the English topographical tradition;[88] yet, through his stylized imagery and precise

[83] See, in particular, Bliss, *Edward Bawden*, 18–19, and Robert Gooden, 'In Memoriam, Eric Ravilious', *Architectural Review*, 94 (1943), 146.

[84] James Maude Richards, *Memoirs of an Unjust Fella* (London, 1980), 95.

[85] GCPA held at HRHRC. For edited correspondence see Joanna Selborne (ed.), 'Eric Ravilious and the Golden Cockerel Press, 1926–29', *Matrix*, 14 (1994), 15–39, and 'Eric and Tirzah Rav-

ilious and the Golden Cockerel Press, 1929–33', *Matrix*, 16 (1996), 67–87.

[86] Sketchbooks in the possession of the family.

[87] Richards, *Memoirs*, 98.

[88] Jeff Hand, 'Eric Ravilious and Englishness', MA thesis (University of Wales at Lampeter, 1990), and Freda Constable, *The England of Eric Ravilious* (London, 1982).

but expressive line, inspired to a large extent by Nash's designs,[89] Ravilious created a new aesthetic most particularly suited to wood-engraving.[90]

Encouraged to take up the medium by Nash, Ravilious contributed a few competent but unexciting wood-engravings to the *Students' Magazine* in 1923 and again the following year when he and Bawden were judged top students in the Design School and awarded Travelling Scholarships. Ravilious went to Italy from where he sent back several wood-engravings. The Professor of Design Robert Anning Bell was encouraging: 'I was very pleased and interested to get your wood-engravings. This new experimental movement in the white line is well worth working at, and you appreciate the beauty of a line which some of our rasher young men do not seem to do—they prefer lumps and appear to assault the helpless wood block with an axe.'[91] In June 1925 Ravilious designed a striking cover for the new magazine, *Gallimaufry*, using a line drawing with stencil colouring. He also contributed two wood-engravings in a new, more textured style, as exemplified by *Sussex Church*. The publication was succeeded in May 1926 by *The Mandrake*, edited by Cecilia A. Dunbar,[92] which contained a title-page by Ravilious of a naked woman lying on a four-poster bed in front of a huge landscape mural. This wood-engraving encapsulates many of his later ideas for book illustration: quirky subject matter, crowded interiors, overall patterning, and an emphasis on geometrical lines.

Although still at an experimental stage Ravilious had already evolved a bold and individual technique using a variety of tools to create a tapestry of patterns and textures. According to Bliss he made 'his own tools out of old keys and such like rods of metal cut out to shapes as scrapers and gouges and stuck in champagne-cork handles'.[93] 'I crawl like a fly over all these finicky bits of wood and it's a slow job' he once wrote, but he was not deterred by such painstaking work.[94] Bawden recalls that he never made the slightest mistake or showed the faintest indecision. He 'must have had a remarkably clear mental image of what he intended to do, and he demonstrated how extraordinary this faculty was, and how fast it worked—unconsciously—when playing "heads, bodies and legs".'[95] Bliss remembers that he made a very careful drawing in pencil on a white ground on the block and never took a print until he had nearly completed the cutting. The extraordinary meticulousness and precision of many of his blocks thus makes them works of art in themselves.[96] A few preliminary drawings on tracing paper showing minimal detail suggest that Ravilious preferred to work out the tones and textures direct on the block.

[89] A reference to Derain's work in a letter of 23 May 1935 to Helen Binyon suggests this as a possible influence also. Letter in the possession of the family as are others to Binyon quoted below.

[90] For tributes see Christopher Sandford, 'In Memoriam' in *Cockalorum* (London, 1950), 73–81 (transcript of BBC Third Programme talk, 20 Jan. 1948), and also John O'Connor's recollections in 'Eric Ravilious', *Cockalorum*, 82–3.

[91] N.d. Quoted by Helen Binyon, *Eric Ravilious: Memoir of an Artist* (Guildford, 1983), 36.

[92] After leaving the RCA Cecilia Dunbar Kilburn, later Lady Semphill, opened a shop at 15 Albermarle Street, London W1, with Athole Hay; the shop was called Dunbar Hay and sold objects of applied art. Ravilious designed a chair and engraved a trade card for the shop.

[93] N.d. Quoted by Mary Beckinsale, 'The Work of Eric Ravilious: Its Origins and Originality', BA thesis (University of Cambridge, 1968), 9.

[94] Eric Ravilious to Helen Binyon, 28 Mar. 1933. Here he refers to work for the Curwen Press.

[95] N.d. Quoted by James Maude Richards in introduction to *The Wood Engravings of Eric Ravilious* (London, 1972), 14.

[96] Robert Harling, *Notes on the Wood-Engravings of Eric Ravilious* (London, 1946), 11, states that his wood-engravings were usually printed from electros for commercial work.

With his multifarious talents as artist, craftsman, and designer, Ravilious was naturally attracted to the book arts. He was, however, wary of the traditionalist, rarefied, anti-machine philosophy of Morris and the Arts and Crafts movement, as a letter to Gibbings implies: 'I hear you were speaking the other night at the Art Workers' Guild. I hope you made a stir in those dry old bones. They used to be hundreds of years behind the times.'[97] This forward-looking attitude made him admirably suited to working with commercial firms, whose commissions, in the wake of Bliss's success with Oxford University Press, he was prompt to accept.

Apart from Stephen Bone, Ravilious was the first of the modern wood-engravers to illustrate for Jonathan Cape. In 1926 he produced a frontispiece and thirty-three other blocks for Martin Armstrong's *Desert* which, according to the contemporary dust-jacket, 'tells of the struggle between fleshly love and the love of the spirit in Early Christian Egypt'—a subject with which Ravilious was apparently ill at ease, particularly the human element. As always in his wood-engravings, characters are wooden, slightly *Plate 135* quaint and comical, as in the scene of Malchus being pursued by wild creatures. He carefully avoids illustrating the more indelicate, 'fleshly' moments in the text. Even the embracing lovers on page 179 appear self-consciously coy. As he was evasive in real life, so was he in his depictions of people which are anecdotal rather than psychologically penetrating. He was more interested in situations than moods, taking a particular delight in his later illustrations in the whimsical aspects of domestic life.[98] Social commentary was not his conscious aim.

In the book vignettes of waves and water, wind, sun, moon, stars, and flowers are treated in a Nash-like symbolistic manner, two of the abstract designs later multiplied as pattern papers for the Curwen Press. Ravilious's experiments with toolmarks were not yet fully developed. Over-inking accounts for the loss of definition in the finely engraved areas. His disappointment with the printing led him to experiment further and so to evolve a more incisive technique which reached maturity in a remarkably short time.

In September 1925 Ravilious had begun part-time teaching at the Eastbourne School of Art. The following month Paul Nash proposed him for membership of the Society of Wood Engravers. He was accepted as an associate member and became a full member in September 1927, exhibiting as many as forty-six wood-engravings before his resignation in 1936. Through the society he came into contact with Gibbings who was sufficiently impressed with *Desert* to suggest that Ravilious might like to illustrate a Golden Cockerel Press book, even to the extent of asking for some ideas. Correspondence throws light on his literary interests and reveals that he was free with suggestions to Gibbings.[99] Ravilious was an avid reader, enjoying especially books about places and people and their situations: Mark Twain's *Huckleberry Finn* and the novels of

[97] Eric Ravilious to Robert Gibbings, 5 June [1931]. GCPA.
[98] He much admired Max Beerbohm and owned some of his caricatures. He had also been 'bowled over' by an exhibition of conversation pieces by Zoffany.
[99] See n. 85.

By this time all were stoln aside
To counsel and undress the Bride;
　　　But that he must not know:
But yet 'twas thought he ghest her mind,
And did not mean to stay behind
　　　Above an hour or so.

When in he came (*Dick*) there she lay,
Like new-faln snow melting away,
　　　('Twas time I trow to part.)
Kisses were now the only stay,
Which soon she gave, as who would say,
　　　God Bw'y'! with all my heart.

8

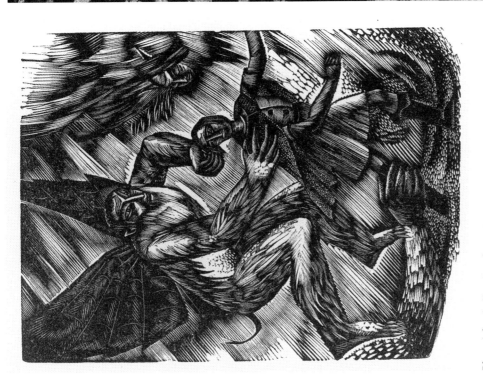

Pl. 135 (*above*). Eric Ravilious: Martin Armstrong, *Desert* (Jonathan Cape. 1926). 121×89

Pl. 136 (*right*). Eric Ravilious: Sir John Suckling, *A Ballad Upon a Wedding* (Golden Cockerel Press. 1927). 194×124

P. G. Wodehouse were particular favourites. His collection of rare books included chapbooks and private press publications, although he did not share Gibbings's fascination for erotic literature. Poetry gave him pleasure, especially that of Edward Thomas and the mystic poet Thomas Traherne. In his letters he frequently alludes to classical as well as seventeenth- and eighteenth-century works, an interest developed in his student days which was strongly influenced by Bliss.

Not unnaturally he was attracted by Gibbings's proposal for him to illustrate *A Ballad Upon a Wedding* by the seventeenth-century writer Sir John Suckling. The final number of blocks amounted to eight including a music page, with a head- or tailpiece to most pages. The toolwork is as yet fairly unadventurous but the loose circled patterning at the bottom of the music block shows signs of his later style. Gibbings was 'frightfully bucked' with these illustrations but pointed out that the edges of some of the blocks were too aggressive and suggested trimming down two which were a little deeper than the verses.[100] Ravilious was receptive to criticism, particularly relating to the printing of his blocks. From Gibbings he soon learnt to engrave more incisively for the hard handmade paper used for all his books for the press. Conscious of the weight of illustration in relation to text, he regretted that he had not cut the head of the girl on page 3 deeper and hoped that the blackness of the block could be remedied by the printing.[101] The illustrations are certainly rather dark for the small, spiky Caslon Old Face typeface. Ravilious retains the period flavour of the ballad, portraying the costumed

Plate 136 characters, especially the foppish guests and the bride 'so round and plump', with stiff demeanour as they would have appeared in contemporary woodcuts.

The Twelve Moneths, by a minor Elizabethan poet, Nicholas Breton, was Ravilious's next Golden Cockerel commission, published in 1927 only three months after *A Ballad Upon a Wedding*. The book, written in calendar form with lists of flowers, birds, and seasonal happenings, particularly appealed to him. Around the half-title Ravilious placed a leafy border, an almost exact interpretation of Gibbings's suggested design, the idea doubtless inspired by Gill's floreated borders which the press was due to publish the following month. The remaining layout consists of a page of text for every month facing a calendar with rectangular vignettes of the same width above and below it. Ravilious's designs, in a similar vein to those for the Suckling book, are suitably archaic in style, yet, perversely, they are not always a direct translation of the text and the people are shown in modern dress. The boy bird-nesting for *April* is not mentioned nor, needless to say, are the 1920s-

Plate 137 style tennis players—the lively tailpiece to *May*. Ravilious was fun-loving and enjoyed tennis and other sports and games. He was an extremely accurate billiards player which Richards put down to his sense of underlying geometry, apparent in so much of his work. Gibbings was evidently well satisfied with the overall effect of the book and Ravilious was 'awfully pleased with the calendars'.[102]

A commission from the Lanston Monotype Corporation in 1928 for a headpiece to an advertisement which appeared in the *The Fleuron* led Stanley Morison to approach

[100] Robert Gibbings to Eric Ravilious, 17 Feb. 1927. GCPA.
[101] Eric Ravilious to Robert Gibbings, 10 May 1927. GCPA.
[102] Eric Ravilious to Robert Gibbings, 24 Dec. [1927[. GCPA.

Ravilious to make twelve wood-engravings for the Corporation's Almanack. As with *The Twelve Moneths* his choice of motifs is fairly arbitrary, with zodiacal and mythical figures floating across the recognizable Sussex landscape. Richard Morphet observes that Ravilious's art, like Paul Nash's, 'shows an unusual awareness of time and space, yet at the same time suggests an inherent concern with matters of the imagination and of the spirit which lie beyond measurement'.[103] This he partly achieves by combining his inward vision with close observation of day to day reality. But although in much of his work he manages to capture the *genius loci*, Morphet exaggerates the mystical or spiritual aspects of Ravilious's art. He was neither a keen practising Christian nor metaphysically inclined. It is more likely that his interest in imagery, symbols, patterned effects, and objects *per se*, accounted for these odd juxtapositions and quasi-surreal images and, in later work, his abstract images.[104] In the preface Ravilious explained that the chalk figure in the engravings for April and May had no reference to the Zodiac. It was in fact the Long Man at Wilmington—a favourite motif which he used purely as decoration in the landscape. For March he designed a witty pun on the text: 'Fly Fishing begins' showing two fishes flying in the sky above the Downs.

His sense of humour and enthusiasm radiate from his letters to Gibbings with whom there was an obvious rapport. Both enjoyed a good story and Ravilious was delighted to be asked to illustrate Aaron Smith's *The Atrocities of the Pirates*:

It would be good to illustrate, I think, the more desperate and bloody incidents, especially as this seems to be a true account; I'll try and avoid making the illustrations suggest a sort of picnic in the south seas, you know what I mean I expect, the kind of pictures with handsome decorative looking ruffians standing about, and parrots, lagoons, palm trees and the rest.[105]

Gibbings liked these ideas; 'the more "bloody" they are, the better.' After much discussion about measurements he pronounced that the proofs were 'A1 and fill us with delight'.[106] Ravilious in turn enjoyed doing the illustrations enormously. These consisted of a frontispiece, five small rectangular engravings the same width as the text, and four vignettes, for which he charged a fee of £50. Although the little scenes depicting clumsy figures in exaggerated poses are rather more comical than 'desperate and bloody', they are appropriately melodramatic for the boyish nature of the adventure story. Printed *Plate 138* on Van Gelder handmade paper, these and the small vignettes of a hat, shoes, an anchor, and a woman in a spotted bandanna appear rather too heavily inked. Ravilious's style is transitional, between his early, looser method and his mature, assuredly worked technique. A splendid complement to the book are the bright vermilion covers with a black spine used at his suggestion.

Gibbings was not always receptive to Ravilious's ideas for books to illustrate and rejected several potentially interesting proposals,[107] including editions of Marlowe's

[103] Richard Morphet, 'Eric Ravilious and Helen Binyon', introduction to Binyon, *Eric Ravilious*, 9.
[104] Two descriptive wood-engravings for Walter de la Mare's mysterious little poem *Elm Angel* in Faber's Ariel Poems series have much in common with these designs.

[105] Eric Ravilious to Robert Gibbings, 7 Nov. [1928]. GCPA.
[106] Robert Gibbings to Eric Ravilious, 31 Dec. 1928. GCPA.
[107] Examples include poems of John Fletcher, *The Odyssey*, *The Golden Asse of Apuleius*, and Samuel Butler's *Erewhon*.

his crew at all times, to travel from one part to another. These passes, from what I could understand, are passports issued and signed by the different magistrates, without which, persons travelling are liable to be thrown into prison, unless they can give a good account of themselves.

The captain was at this time very much intoxicated,

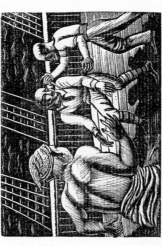

as was usually the case with him in the afternoon; and when in that state, was wantonly cruel. Something just then excited his brutal temper, and he hastily drew his knife, and told me to go down into the cabin, and not come on deck any more, and that I must in future lie on the bare floor. I pleaded my ill health and begged a mattress; but he replied that

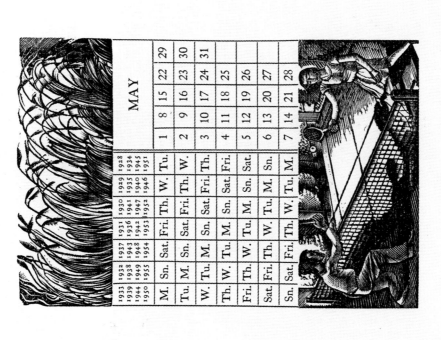

Pl. 137 (*left*). Eric Ravilious: Nicholas Breton, *The Twelve Moneths* (Golden Cockerel Press, 1927). 218 × 140

Pl. 138 (*above*). Eric Ravilious: Aaron Smith, *The Atrocities of the Pirates* (Golden Cockerel Press, 1929). 186 × 124

Hero and Leander and *The Tragical History of Doctor Faustus* for which he had produced some drawings. A wood-engraving of *Doctor Faustus Conjuring Mephistophilis* which he contributed to *The Legion Book*[108] the same year displays a strong linear framework in the structure of the building—vertical supports, horizontal gallery, diagonal stairs—with theatrical figures crowded into a confined and dramatically lit space. Similar elements were present in his mural decorations representing scenes from Shakespeare's plays and old English dramas for the Refreshment Room of Morley College on which he had started work in September 1928, his first major commission and one he shared with Bawden. His ambition to illustrate a book by Marlowe was fulfilled with Christopher Sandford's request for four full-page scenes for his Golden Hours Press *The Famous Tragedy of the Jew of Malta* (1933). These were given much the same treatment as the *Dr Faustus* print although the design is less complex and the technique more assured. Desmond Flower, reviewing the book, felt that 'Abigail throwing down the bags of treasure to her father' was one of the finest book illustrations he had seen for years.[109] A wood-engraving of *The Three Holy Children* for the Cresset Press's *The Apocrypha* (1929) bears architectural similarities with both his Marlowe prints and his mural designs. The naked boys, looking more like young men, stand rigidly, unperturbed by the flames lapping round them, staring blankly at the angel overhead—a supreme example of Ravilious's emotional detachment with respect to figurative scenes.

In February 1930 the Morley College murals were unveiled by Stanley Baldwin. In July Ravilious married one of his ex-pupils from the Eastbourne School of Art, Tirzah Garwood, herself a competent and highly original wood-engraver. He began teaching one day a week at the Royal College of Art and took over from John Nash the responsibility of teaching wood-engraving part-time at the Ruskin School of Drawing in Oxford.

By the autumn Ravilious's designs for the Golden Cockerel Press *Twelfth Night* were being incubated. This illustrative project, which he initiated, was his most ambitious so far and was plagued with technical problems before its publication over two years later. Correspondence reveals the extent of Ravilious's involvement and enables an assessment of how his designs evolved and why changes had to be made to the initial layout. Before this was planned Gibbings proposed to set the whole text in Gill's new Golden Cockerel type of which he had ordered about three hundredweight: 'When this arrives we will get down to the comping. Then we can chop it about and paste up to taste and then you can carry on with the whole book.'[110] On 5 January 1931 he sent Ravilious page proofs of the title-page and *dramatis personae*, promising for the following week the whole of Act I in type 'which we can cut about and paste up as you wish. You can move these lumps of type about as you feel inclined. The paper they are on is the actual size of the book. I hope this will enable you to proceed.'[111]

The 1931 prospectus announced that the format was to be Crown Folio (15" × 10"). On

[108] Printed by the Curwen Press and published by Cassell & Co.
[109] *Book Collectors' Quarterly*, 14 (1934), 88.
[110] Robert Gibbings to Eric Ravilious, 20 Oct. 1930. GCPA. Gibbings offered a fee of £200 for the job.
[111] Robert Gibbings to Eric Ravilious, 5 Jan. 1931. GCPA.

seeing page proofs of the title-page, Gibbings felt that Ravilious's design, measuring $12\frac{1}{2}'' \times 8\frac{3}{4}''$ overall, rather cramped the margins. He consequently had a line block made of the border design only which was reduced by about an inch, thereby allowing little space within its boundaries for the letterpress titling and rectangular scene of Maria

Plate 139 meeting the Clown in a bowered garden. Gibbings, however, thought these designs 'simply spiffing . . . far and away our best title page yet and I hope very much the volume is going to set a new standard for us as well as for everybody else'.[112]

The original intention was to have several full-page illustrations. In the finished book, however, most illustrations are half-page engravings, with many head- and tailpieces, and decorated margins some of which incorporate figures and ornaments. A white-line cartouche with the delicately ornamented words *Twelfth Night* appears on the opening page. The list of *dramatis personae* is encased in a border made up of the characters in boxed compartments. Geometrical patterning and architectural props such as chequer-board floors, brick walls, pillars, arcades, and trellises, familiar from the Morley College murals, recall fifteenth-century Italian woodcut designs, most especially those for *Hypnerotomachia Poliphili* which Ravilious may well have known.[113] He had studied prints in the British Museum and had been especially impressed with the *manière criblée* method, an effect he imitated, for instance, in the pointillist grass and hedging of the title-page engraving.

The format of the book bears a resemblance to the majestic Elizabethan and Jacobean folios. As a result of his research for the mural designs Ravilious was well versed in the visual arts and customs of the period. A scrapbook[114] includes a drawing of Pantaloon and Brighellan with a mandolin, and many undated costume sketches, of which some, according to his inscription, were copied from two volumes of *Shakespeare's England* and an edition of *Grotesque Modie*.[115] He clearly delighted in the decorative aspects of dress, savouring details such as sleeves, trouser folds, bodices, and ribbons. Although these sketches are loosely handled, his finished characters remain stiff and expressionless, as if cut out and pasted on to the background. He was more interested in the theatrical setting than the human content of the play.

The borders are perhaps Ravilious's most inventive designs to date, becoming more original as the book progresses. Unlike Gill, he made no attempt at stylized naturalism, preferring more abstracted shapes and patterns such as swirling ears of wheat like Catherine wheels and strange tubular scrolls emitting black tadpole-like leaves. Various page proofs showing some of these borders with the background left uncut disclose Ravilious's working method.[116] He relied on Tirzah and most probably Beedham to clear the background.

[112] Robert Gibbings to Eric Ravilious, 4 Feb. 1931. GCPA. The 1931 Autumn List discloses a change of mind in the final size of the book, reducing it to $13\frac{1}{4}'' \times 9\frac{1}{4}''$, virtually the same size as Gill's recent *The Four Gospels*.

[113] He considered one particular drawing (untitled) 'a little too Florentine in spirit'. Eric Ravilious to Robert Gibbings, 2 Mar. 1995. GCPA.

[114] In the possession of the family.

[115] Bibliographic details of these books unlocated.

[116] Reproduced in *The Wood Engravings of Eric Ravilious*, Nos. 53–5.

ACT V.

SCENE I. Before OLIVIA'S house.

Enter CLOWN and FABIAN.

FAB. Now, as thou lovest me, let me see his letter.
CLO. Good Master Fabian, grant me another request.
FAB. Any thing.
CLO. Do not desire to see this letter.
FAB. This is, to give a dog, and in recompense desire my dog again.

Enter DUKE, VIOLA, CURIO, and Lords.

DUKE. Belong you to the Lady Olivia, friends?
CLO. Ay, sir; we are some of her trappings.
DUKE. I know thee well: how dost thou, my good fellow?
CLO. Truly, sir, the better for my foes & the worse for my friends.
DUKE. Just the contrary; the better for thy friends.
CLO. No, sir, the worse.
DUKE. How can that be?

64

Pl. 140. Eric Ravilious: William Shakespeare, *Twelfth Night*
(Golden Cockerel Press, 1932), 326 × 230

Pl. 139. Eric Ravilious: William Shakespeare, *Twelfth Night*
(Golden Cockerel Press, 1932), 326 × 230

Novel aspects of the book are the odd shapes and unsymmetrical placing of the blocks: few are totally rectilinear, and several are ingeniously designed to be cut into at the lower edge (by Lawrence) to incorporate typeset stage instructions at the opening to certain acts—an indication of Ravilious's attempt to blend illustrations with type. The difficulties he encountered with heavy inking on handmade paper led him to experiment with opening up his lines and using black line. The text throughout is printed in black ink, but the illustrations are printed in blue-grey or reddish brown. (He had tried Gibbings's idea of using two colours but felt it was more practicable to use only one.) Despite his initial enthusiasm for grey 'because it is almost impossible to engrave to quite the lightness of type that is needed',[117] the ink does not contrast well enough and Ravilious was disappointed with the final results of the experiment. None the less the publication of the book in April 1932 marked the turning-point in his wood-engraving career, bringing him greater recognition.

Plate 140

Cover designs for a series of prospectuses for the Golden Cockerel Press gave Ravilious particular satisfaction and added to his reputation. A loosely engraved white-line floral border encircling Gill's Golden Cockerel lettering for the Spring 1930 cover anticipates his *Twelfth Night* designs. Gibbings himself was wittily portrayed in the 1931 and 1932 prospectuses. Individual cockerel motifs began to appear, some obviously inspired by Gibbings who, for the 1931 Autumn List, suggested one of 'those comic cockerel motifs they have on roundabouts … with a somewhat luscious nude lady on its back as shown in the rough sketches'.[118] Ravilious followed his instructions to the letter producing one of his most amusing and uninhibited wood-engravings to date. He generously offered without charge his magnificent design of a large, unusually naturalistic cockerel, engraved with the date '1933' and initials 'GCP', because the press was in such bad straits.

Plate 49

Christopher Sandford, who took over in August 1933, although a great admirer of Ravilious, eventually published only one Golden Cockerel book with his illustrations, L. A. G. Strong's *The Hansom Cab and the Pigeons: Being Random Reflections upon the Silver Jubilee of King George V*, in March 1935. The frontispiece of a battered hansom cab 'tenanted by pigeons', together with a lively opening headpiece of a train steaming over a viaduct with an aeroplane flying overhead, show enormous strides in the imaginative portrayal of workaday objects, particularly machinery. Foliage and background details are simplistically yet stylishly handled. Four narrow rectangular vignettes, repeated throughout the text, and an abstract tailpiece incorporate symbols—the initials 'GR', a rose, crown, drum, and fireworks—signifying the Jubilee celebrations. Ravilious had a particular fascination for fireworks and bonfires, themes which frequently recur in his work,[119] revealing his most familiar qualities: linear, geometric, patterned, and two-dimensional. Here the finely printed grey-toned engravings perfectly complement the Perpetua

Plate 141

[117] Eric Ravilious to Robert Gibbings, 17 June [1931]. GCPA.
[118] Robert Gibbings to Eric Ravilious, 7 Sept. 1931. GCPA.
[119] Evident in a mural design begun with Tirzah in the same

year for the circular tearoom of the Midland Railway Hotel in Morecombe.

typeface.[120] Sandford considered that from almost every aspect this little book was one of the press's most successful efforts up to March 1938.[121]

Ravilious turned down Sandford's next suggestion, Pushkin's *The Tale of the Golden Cockerel*, since he disliked the text. He offered instead some coloured lithographs of shops for a possible book, but Sandford was slow to respond and these were eventually taken up by Noel Carrington and published, together with a wood-engraved front-ispiece and J. M. Richards's text, as *High Street* in 1938 by Country Life Books.

Increasing demand from commercial presses for ephemeral work provided a vital source of income. Following the success of *The Hansom Cab* Curwen requested a Jubilee advertisement for a booklet produced by the Southern Railway of England entitled *Thrice Welcome*, to strike a 'Rural and Regal Note, maximum joyousness—without colour printing'.[122] A splendid headpiece for the *Social and Sporting Season* chapter contains a variety of sports—tennis, racing, sailing, cricket—the criss-cross of diagonal lines creating a surprising amount of movement for such a small scale. Some of his most striking designs were for press advertisements for the London Transport Board and for a diary and notebook for the Kynoch Press. Commissions for bookwork and periodicals included dust-jackets, pattern papers, and bookplates, and, more widely distributed, cover designs for John Murray's *The Cornhill Magazine*, Wisden's *Cricketer's Almanack*, and devices and endpapers for Dent's Everyman Library. These and many other wood-engravings of the 1930s made for publicity purposes, aptly described by Oliver Simon as 'Attention Getters',[123] were among Ravilious's most successful and original images and show his skill as a designer to the utmost: an ability to handle small-scale decoration which he applied with equal flair to his designs for Wedgwood china from 1935.[124]

Ravilious called on a wide and varied repertoire of ideas for designs as can be seen from his scrapbooks of drawings, tracings, newspaper and other cuttings, and photographs.[125] He was perhaps most comfortable depicting domestic objects and rural scenes, inspired particularly by his surroundings in Essex where from 1930 he and Tirzah shared a holiday house at Great Bardfield with the Bawdens and later, in September 1934, rented a house of their own at Castle Hedingham where their three children were born. Although not a gardener he loved the appearance of farm and garden produce[126] and equipment, especially old machinery. Some accurate sketches of a wheelbarrow, watering can, sieve, and other tools appear in his scrap book, as do various drawings of imaginary buildings and architectural ornament. All these objects reappear in various guises throughout his work. Trees feature especially, their prominent shapes doubtless affected by Paul Nash's treatment.

Apart from some stylish abstract patterns for Martin Armstrong's *54 Conceits: A*

[120] Ravilious considered the Basingwerk Parchment which Sandford had introduced for wood-engravings, and which he used for the ordinary edition, 'a great discovery'. Eric Ravilious to Owen Rutter, 16. Mar. [1935]. Quoted from entry No. 85, Collinge & Clark catalogue 16, 1995.
[121] Sandford and Rutter, *Bibliography of the Golden Cockerel Press*, No. 105, 45.
[122] Eric Ravilious to Helen Binyon, 17 Mar. 1935.

[123] See Gilmour, 'Eric Ravilious', in *Artists at Curwen*, 62.
[124] For an indication of the scope of his ephemeral work see Ch. 5.4.
[125] In the possession of the family.
[126] In 1937 he contributed 11 oval wood-engravings—enlarged still-lifes of ingredients in the foreground of a landscape—to Ambrose Heath's *Country Life Cookery Book*.

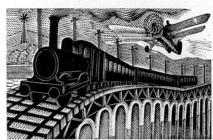

Pl. 141 (*right*). Eric Ravilious:
L. A. G. Strong, *The Hansom Cab and
the Pigeons* (Golden Cockerel Press,
1935). *c*.239 × 154

Pl. 142 (*below*). Eric Ravilious:
Martin Armstrong, *54 Conceits*
(Martin Secker, 1933). 171 × 255

ONE AFTERNOON A FEW YEARS AGO MY
mother and I found ourselves in a Devon
village at tea time. A cottage said TEAS, and
we went in. They suggested we should have our tea in
the orchard. It was a sunny day, and we agreed. The or-
chard was full of a number of strange discarded objects,
of which the most conspicuous was the upright body of
a hansom cab, minus wheels and shafts. It was tenanted
by pigeons, some of which sat on the top, others on the
seat, and a couple on the open remains of the folding
doors.
Presently a typical Devon woman, fat and hot, came out
to the orchard with two children, and sat at a table for tea.
The children were at once fascinated by the hansom.
'Oh my, mother,' said one. 'Whatever's that there?'
'That there?' replied the woman. 'That there's a 'ansom
cab. People used to ride about in they, back along; but
they days is went.'

5

A Young Airman

I loved to slide between the earth and sun,
Laughing at sulky Death, till Death, as one
Who loses patience with a teasing fly,
Brought me to earth and in this earth I lie.

12

A Suicide

Denied the comfort of your breast,
In the cold sea I sought my rest,
Slowly through twilight deeps to fall
To my unhallowed burial.

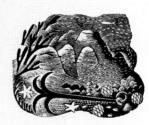

13

Collection of Epigrams and Epitaphs Serious and Comic (Martin Secker, 1933), most of these little designs are an awkward attempt to interpret the witty, cynical, sometimes mystical, four-line epigrams. Ravilious's prophetic vision of 'A Young Airman' in which an aero- *Plate 142* plane, ringed by billowing clouds, casts a cross-shaped shadow of death on the hill below, recurs three years later in a scene for *Poems by Thomas Hennell* (1936). An unexpected letter from the author had resulted in a commission from Oxford University Press to illustrate this book with four wood-engravings. In *Garden Memories and Associations* a *Plate 59* draped urn stands beside a diagonally placed screen with rectangular opening, echoed beyond by a doorway in an ivy-clad wall. Such surrealist elements evoke Nash's work in this style. Although none of these illustrations exactly interprets the words, their mysterious nature reflects Hennell's text.

Various critics have accused Ravilious of clumsy handling of wood-engraved lettering when this is incorporated into an overall design.[127] He was intrigued by letter forms, especially individual letters of the alphabet. A sketch-book displays several highly original examples. These generally play on the decorative aspects of lettering, as seen to best effect in his animated Kynoch Press type alphabet and engraved initials for Lanston Monotype's *Calendar* (1933). Unlike Gill, Ravilious had no formal training as a letter-cutter but developed an interest as a natural adjunct to book illustration. With considerable dexterity he successfully achieved a fluent eighteenth-century copper-plate effect for the script on the two title-pages to *The Writings of Gilbert White*. *Plate 143*

In May 1937, Harry Carter, the production manager of the Nonesuch Press, had written asking if he would consider illustrating a two-volume limited edition.[128] He suggested about twenty-four small wood-engravings of rural scenery rather than careful pictures of the birds and flowers which White mentions. Ravilious was delighted at the prospect of illustrating one of his favourite books, promptly setting off with Tirzah to explore the village. Although not particularly interested in natural history and flora and fauna for their own sake, with his eye for detail and unerring sense of place this commission greatly appealed to him. White combined acute scientific observation of nature with a sentimental attachment to certain romantic elements of the eighteenth-century landscape ideal. Similarly Ravilious's country scenes, though some are closely observed, are viewed through a designer's eye. Small decorative vignettes of fruit and leaves are interspersed with larger headpieces of views and incidents which, for the most part, are accurate if fanciful interpretations of the text. Birds, animals and people are placed unnaturalistically in the landscape. The rigid figure of White contemplates an even *Plate 144* stiffer dead moose strung up from the roof of an out-of-scale greenhouse; the wood in *Plate 145* which the boy climbs the tree to look for the honey-buzzards' nest bears no resemblance to the steep beech wood behind the village; an imagined church nave opens through an arch on to a garden with greenhouse, while a magical little landscape endpiece of cornstooks silhouetted against the setting sun is pure invention. An elemental quality

[127] See, for instance, Harling, *Notes on the Wood-Engravings of Eric Ravilious*, 8.

[128] Quoted in Binyon, *Eric Ravilious*, 102. H. J. Massingham wrote the introduction and selected and edited the text.

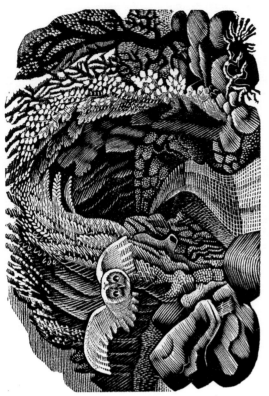

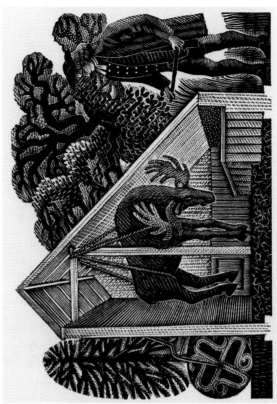

and a feeling of detachment and loneliness which is present in all his landscapes, watercolours included, reflect his intensely private side.

Engraving over thirty blocks Ravilious found was 'mortal slow work', but on 23 January 1938 he declared triumphantly, 'Selborne is finished (today)'.[129] The publishers and editor were delighted and on 19 April Carter sent him a copy of the book with his congratulations: 'The printing is poor in places but I do not think you ever appeared to better advantage.'[130] This was to be his last illustrated book. Like various fellow wood-engravers, he found he could not keep up the interest in such an intensely demanding and limiting medium. Ironically, having earlier turned down Gibbings's request to contribute to one of the newly launched Penguin Illustrated Classics, he now confessed to a revived interest in wood-engraving, the result, he was sure, of 'being given a congenial book to engrave for at last, after years of Golden Cockerel nonsense. ... Now I feel quite sorry not to do more which I couldn't have believed possible last year.'[131] Yet he continued to move away from the medium, preferring watercolour and lithography, and designing for Wedgwood and other commercial firms.

Voluntary work at the Hedingham Observation Post in the autumn of 1939 was followed by an appointment as Official War Artist, leading to his untimely death in a plane crash in 1942 while serving with the Royal Marines in Iceland. Only a few wood-engravings are datable to this wartime period, including a handsome title-page device for *English Wits*, a cover design for a brochure for the British Pavilion at the New York Fair, and some pattern papers.

With an instinctive feel for the decorative possibilities of the medium, combined with an inspired sense of design—simple yet sophisticated—Ravilious evolved a new aesthetic. He pioneered a modern and inventive approach to the wood-engraved vignette based on a wide repertoire of toolmarks which emphasized the woodiness of the wood—an essential aspect of the medium which so many of his contemporaries undervalued in their attempt to produce ever finer, more complex lines. With his Selborne images he broke away from the English naturalistic tradition of illustration typified by Bewick and his followers. Yet, for all his achievements in designing for books, his most inspired wood-engravings were done when his imagination was allowed free range, unfettered by the constraints of text and private press work. In his capacity as a wood-engraver Eric Ravilious will be remembered as an inspired designer rather than an illustrator, who, like Paul Nash, succeeded in blurring the distinction between fine and applied arts, and whose style had a lasting influence on twentieth-century graphic design.

[129] Eric Ravilious to Helen Binyon, 23 Jan. 1938.
[130] Quoted in Binyon, *Eric Ravilious*, 103.
[131] Eric Ravilious to Helen Binyon, 23 Jan. 1938.

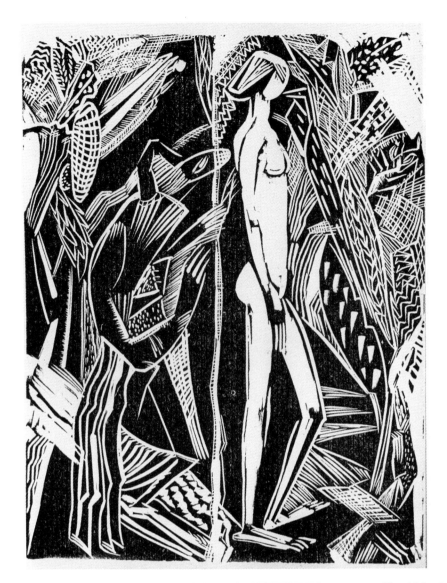

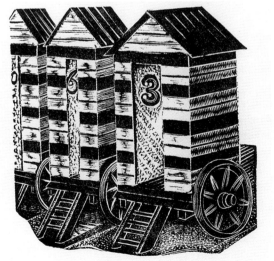

Pl. 146 (*above*). Enid Marx:
From *Gallimaufry*, Royal
College of Art, June 1925.
Royal College of Art
Library. 140 × 110

Pl. 147 (*left*). Enid Marx:
Francesca Allinson, *A
Childhood* (Hogarth Press,
1937). 65 × 66

12.5. *Enid Marx, Helen Binyon, John O'Connor, and Geoffrey Wales*

Of Ravilious's fellow students and pupils at the Royal College of Art several were noticeably affected by his style as illustrators.[132] In 1922, after two years at the Central School, Enid Marx (born 1902) joined the Painting School. She soon found herself drawn to the Design department where, since Sir Frank Short would not allow her to join the students, Ravilious surreptitiously 'sneaked' her in after hours and helped her to wood-engrave. She also 'learnt a lot from old Lawrence when I went to his place to buy tools'.[133] She found wood-engraving an ideal decorative medium, appreciating its woody and naïve qualities. Paul Nash was a vital inspiration to her at this time.[134] The effect of his free cutting and painterly handling of tone can be seen in two loosely sketched expressionistic wood-engravings which she contributed to *Gallimaufry* (June 1925). *Plate 146* Attendance at part-time evening classes at Underwood's school may well have accounted for her modernist treatment of the nude figure. Further sources of influence in these early years were the West African exhibits at Wembley in 1924 and the designs for Diaghilev's Ballets Russes which she visited regularly. As she recalls, 'the search for the primitive . . . was in the air'.[135] At the same time she was all too aware that lack of sophistication for its own sake could have unsatisfactory results.

Many of her design ideas are inspired by popular folk art and traditional patterns. Together with Ravilious and Bawden she became interested in old broadsheets and chapbooks, particularly those issued by the Leadenhall Press, and by the Pollock toy theatres.[136] A childhood interest in nature study is revealed in her wood-engravings of butterflies, fish, cats, flowers, and fruit—all seen with an eye for pattern. Her delight in the depiction of simple domestic objects such as mugs, plates, bowls, toys, and baskets owes much to her mother's love of 'old things and flowers' and to Nash who alerted her to the 'designs of everyday life'.[137]

Both the books which she illustrated with wood-engravings before the war have cheerful chapbook-like blocks scattered throughout the pages. Francesca Allinson's *A Childhood* (Hogarth Press, 1937) contains little vignettes such as a basket of fruit, a breakfast tray, beetles, and bathing huts. *A Book of Nursery Rhymes* was published in 1939 as part of *Plate 147* Chatto & Windus's Zodiac Series. A cock, fish, spider, dog, long-whiskered cat, parrot on a kettle, and stripy snail are just a few of her quaint and witty little compositions. In all these prints her technique is generally more fluid than that of Ravilious. Through

[132] In 'Eric Ravilious', 83, John O'Connor recollects that Ravilious 'advocated the method of drawing, quite freely and normally, on a slightly whitened wood with pencil; thereby setting the tones of grey and the pattern. This was his own method. He did not actually *teach* wood-engraving and students were wisely left to work out technical matters for themselves. He never drew for a student.'
[133] Conversation between Enid Marx and the author, 26 Nov. 1987.
[134] For Nash's influence see Ch. 5.2. See also Enid Marx, 'Student Days at the RCA', *Matrix*, 16 (1996), 145–59.

[135] Quoted by Cynthia R. Weaver in her foreword to exhibition catalogue, *Enid Marx and her Circle* (London: Sally Hunter Fine Art, Aug. 1992), unpaginated.
[136] She has written widely on chapbooks and popular folk art. See, for example, Enid Marx, 'The Running Stationer or the Chapman's Wares', *Matrix*, 5 (1985), 37–40, and Margaret Lambert and Enid Marx, *English Popular Art* (London, 1951).
[137] *Enid Marx and her Circle*.

ample use of white lines and spaces, and by cutting round the outlines to leave the blocks in shapely silhouette rather than solid rectangles, Marx manages to achieve a better balance with the area of type than many of her colleagues.

Her flair for design was recognized by the Curwen Press for whom she engraved some lively abstract pattern papers, and by Chatto & Windus who commissioned devices and designs for books and catalogues. Dust-jackets were another area of book production which she tackled. Most of her book illustration, however, was done as line drawing or autolithography after the war.

In 1932 Marx had been invited by Paul Nash to contribute some textiles to his 'Room and Book' exhibition at the Zwemmer Gallery, the outcome of his efforts to eliminate the division between the arts, both fine and applied. This important exhibition revealed his crucial role as mediator to this effect.[138] As Weaver so aptly suggests, it 'exemplified the ability to conceptualise in two and three dimensions which had proved so inspirational to his disciples and epitomised the archeypal, Marx-esque, multi-disciplinary designer of "modern" Britain; in [Enid Marx's] case, enabling her shift in the 1930s and 40s, from engraving and hand-block printing[139] to designs for mass-produced wovens for Pick's London Transport and G. Russell's Utility Furniture Scheme'.[140]

Helen Binyon (1904–79), twin daughter of the poet and art historian Laurence Binyon, was a Design School contemporary and close friend of Ravilious, the two profoundly influencing each other's work.[141] Her wood-engravings share technical and stylistic similarities with his, although her figures are more naturalistic, her illustrations more descriptive and detailed. (A spell as a draughtsman at the College of Arms demonstrates her gift for meticulous precision.) Of her three wood-engraved books, all depict characters in period costume which she recorded with accuracy. Two were published by private presses: Maria Edgeworth's *Angelina, or L'Amie Inconnue* for the Swan Press (1933), and her father's *Brief Candles* for the Golden Cockerel Press (1938). Despite the somewhat stiff figures in the latter book she conjures up an emotional atmosphere and sense of drama in these tiny scenes. Gibbings was sufficiently impressed with them to commission her to illustrate *Pride and Prejudice* for the Penguin Illustrated Classics edition (1938). Her last wood-engraved illustrations, they display her love of patterning.[142]

Plate 148

In 1933 John O'Connor (born 1913) moved from the Leicester College of Art to the Royal College where John Nash and Ravilious were tutors in the Design School and Paul Nash also visited. A chance sight of his early attempts at engraving with a friend's

[138] Exhibits included fabrics by Phyllis Barron, Dorothy Larcher, and Ben Nicholson, furniture by Serge Chermayeff, paintings and drawings by John Armstrong, Ivon Hitchens, Paul Nash, David Jones, Ben Nicholson, Ravilious, and Wadsworth, pottery by Bernard Leach, rugs by Marion Dorn, sculpture by Barbara Hepworth, Henry Moore, and Gertrude Hermes, wallpaper by Bawden, and printed work, including pattern papers and stencilling, by the Curwen Press.
[139] From 1931 to 1937 she taught wood-engraving at the Ruskin School of Drawing, Oxford.
[140] Ibid. For a fuller discussion of her work see Michael Taylor, 'Enid Marx, RDI, Designer and Wood-Engraver', *Matrix*, 7 (1987),

99–102, and Alan Powers, 'Sources of Inspiration', *Crafts*, 103 (1990), 34–7.
[141] See Richard Morphet, 'Eric Ravilious and Helen Binyon', from Binyon, *Eric Ravilious*, 7–19. She later studied engraving at the Central School under W. P. Robins and worked as a part-time teacher at the Eastbourne College of Art and the North London Collegiate School. After the war she taught at the Willesden School of Art and at the Bath Academy (1950–65) where her specialist interest in shadow puppets was developed.
[142] In the 1940s Oxford University Press published a series of at least ten books for children, written by her sister Margaret and illustrated with pen and ink drawings, some coloured, by Helen.

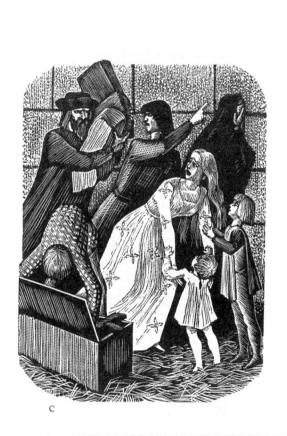

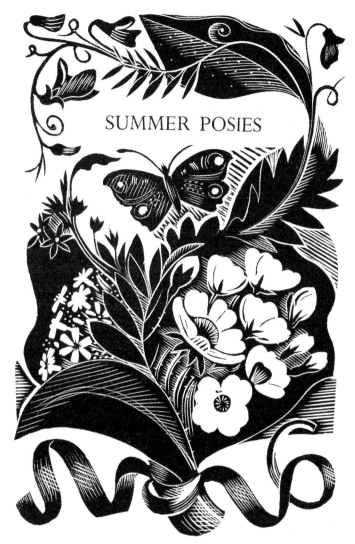

SUMMER POSIES

Pl. 148 (*above, left*). Helen Binyon: Laurence Binyon, *Brief Candles* (Golden Cockerel Press, 1938). 93 × 68

Pl. 149 (*above, right*). John O'Connor: Joan Rutter (ed.), *Here's Flowers: An Anthology of Flower Poems* (Golden Cockerel Press, 1937). 140 × 89

Pl. 150 (*left*). Geoffrey Wales: Theodore Besterman (ed.), *The Pilgrim Fathers* (Golden Cockerel Press, 1939). 64 × 114

tools on linoleum led Ravilious to send him to Lawrence's firm where he bought a boxwood block and a spitsticker, scorper, and chisel.[143] After several successful prints the Principal of the college, Professor Jowett, suggested that he and several other students should study book printing and typography under Rooke for a few hours each week at the Central School. In an exhibition of students' work he showed four wood-engravings illustrating Irish stories.

A visit to Ravilious's home in Essex furthered his technical knowledge of the medium and his enthusiasm for its uses. As a result of an introduction by Ravilious to Sandford, O'Connor's first wood-engraved illustrations were for a Golden Cockerel Press book published in 1937: *Here's Flowers: An Anthology of Flower Poems* compiled by Joan Rutter and introduced by Walter de la Mare. Sandford thought it 'one of the happiest and gayest of our smaller books' and the decorations 'delightful garlands to bind the posies'.[144] The eight flower prints are highly personal interpretations, based on nature but decoratively portrayed, with much gouging and scorping for petal effects, sweeping white lines for stems, and parallel strokes to lighten the shading. Both flowers and butterflies have much in common with Marx's images. Like her and Ravilious, O'Connor uses wood-engraving in an imaginative rather than realistic way, making play of tooling: patterned textures, geometric shapes, expressive lines, and strong contrasts of black and white characterize his work. Most of his bookwork dates from after 1940. His experiments combining engraved woodblocks with coloured lino blocks in later post-1940 illustrations were an exciting and valuable addition to the repertoire of British book design.[145]

John O'Connor's exact contemporary at the college, Geoffrey Wales (1912–90), was for a time distinctly influenced both by him and Ravilious, one of his teachers, as can be seen from his eight wood-engravings for *The Pilgrim Fathers* (Golden Cockerel Press, 1939) edited by Theodore Besterman. Doll-like figures in formalized landscapes, ships, tools, and domestic objects are all described with emphatic toolwork: parallel and cross-hatched lines, speckled effects, strident patches of white and black. Sandford expressed dismay that as 'one of the nicest books we have ever made—agreeable in its proportions, tasteful binding, beautiful binding, elegant typography, and exceptionally pleasant and dexterous engravings, all harmonizing with the charming content' it none the less 'did not attract more attention among our American patrons'.[146] After the war Geoffrey Wales emerged as one of the most inventive British abstract wood-engravers, describing his work 'as metaphors rather than representations'[147]—a far cry from these early descriptive interpretations.[148]

Plate 149

Plate 150

[143] See Jeannie O'Connor's commentary in *The Wood-Engravings of John O'Connor* (Andoversford, 1989), 2.
[144] Sandford and Rutter, *Bibliography of the Golden Cockerel Press*, No. 124, 21, 23.
[145] In the autumn of 1937 he started teaching at Birmingham College of Art. Some of his wood-engravings of London parks were used to illustrate an article he wrote for the college journal, *The Torch*. In 1938 he began to teach at the West of England College of Art in Bristol.

[146] Sandford and Rutter, *Bibliography of the Golden Cockerel Press*, No. 140, 37.
[147] Quoted from Alan Horne (ed.), *Dictionary of 20th Century British Book Illustrators* (Woodbridge, 1994), 432.
[148] From 1937 to 1952 he taught at art schools in the Canterbury area. See Hilary Chapman, *Geoffrey Wales* (London, 1998).

12.6. *Tirzah Garwood and Hester Sainsbury*

Tirzah Garwood (1908–51), Ravilious's most talented pupil at the Eastbourne School of Art, came strongly under his influence. Yet, despite his championing of her wood-engraving in the early years, she did not attempt to compete with his successes and gave up the medium after only five years. Her output, mainly produced between 1926 and 1929, was small and consisted mainly of single prints or ephemeral work, most of which appeared in journals or other publications. She exhibited in four of the Society of Wood Engravers' annual exhibitions; but, though favourably reviewed at the time, her wood-engraved work has since been unjustifiably neglected by historians of the medium.[149]

Garwood's first wood-engravings, a series of The Four Seasons, were produced at art school in 1927. From the start she was technically assured with a clean, incisive line and an interesting variety of toolmarked textures which she no doubt learnt from Ravilious. Already in these prints she had formulated a personal style consisting of large rectangular scenes dominated by figures, with background details multifariously patterned: undulating waves, speckled pebbles, stripy wallpapers and curtains, and stippled carpets. She shared with Ravilious a wry sense of humour and an enjoyment in satirizing domestic life and the social scene. She had an eye for oddities in her subjects which Harling considered were 'like herself, unpredictable, delightful, mildly dotty'.[150] Her fondness for animals, particularly cats and dogs, is evident from their frequent and characterful appearance in her work.

Three wood-engraved illustrations of 1928 to La Fontaine's *Fables*, *The Petticoat of the Parson's Cook*, *Women and Secrets*, and *Cat into Wife*, may well have been a final year project at art school. The latter was reproduced in *The New Woodcut* (1930) and given particular mention by Salaman. With all three scenes she chooses the moment of most dramatic incident, the expressive faces of the people portrayed revealing their personalities; a characteristic of her work which was largely absent from that of Ravilious.[151] In 1929 a print entitled *Yawning* of a dressing-gowned woman with cavernous open mouth was included in *The Woodcut, No. III* by Furst who offered to exhibit her work in his gallery, The Little Art Rooms—a proposal which was not followed up.

Her first commission came in 1928 from the BBC to illustrate the libretto of an oratorio of *The Pilgrim's Progress* for the tercentenary of John Bunyan's birth. Her three wood-engravings are in an uncharacteristically loose style, but still the emphasis is on figures in action and patterning. As well as numerous line drawings for the *Listener*, she

[149] Neither Albert Garrett, *A History of British Wood Engraving* (Tunbridge Well, 1978), nor James Hamilton, *Wood Engraving & the Woodcut in Britain* (London, 1994), mentions her name, although monographs by her daughter Anne Ullmann, *The Wood-Engravings of Tirzah Ravilious* (London, 1987), and 'Tirzah Garwood', *Private Library*, 10 (1987), 100–7, and by Olive Cook, 'The Art of Tirzah Garwood', *Matrix*, 10 (1990), 3–10, and retrospective exhibitions held at the Towner Art Gallery, Eastbourne (1987) and the Fry Art Gallery, Saffron Walden (1994) have helped to draw attention to her work.

[150] Robert Harling, 'Recollections: II', from *The Wood-Engravings of Tirzah Ravilious* (London, 1987), 10.

[151] She sometimes helped him with human figures which he disliked drawing.

also engraved new heraldic arms for the Corporation in a solid black-line style—an indication of her technical versatility.

Although not strictly for book illustration, most of Garwood's wood-engravings contain a narrative element, as epitomized by a series called 'Relations' for a Curwen Press calendar, a commission resulting from Ravilious's contact with Oliver Simon. Only eight prints appear to have been completed. These are probably her finest wood-engravings and among the most vivid portrayals of 1920s middle-class life by a contemporary practitioner: young society women with bobbed hair and low-waisted party dresses with their stiff-shirted companions in *Table Turning*; a starchy uniformed nanny pushing a baby in huge low-slung pram; prim black-stockinged, felt-hatted schoolgirls walking in pairs along a chequered pavement in *The Crocodile*; a tweed-jacketed man in breeches holding a spotted handkerchief to his nose while he leads a string of dogs past a masculine-looking lady tending her Scottie dog in *The Dog Show*; fashionable shoppers in *Kensington High Street*; and various relations such as *The Wife* in cluttered domestic interiors. People and possessions predominate, individual objects taking on a meaning of their own. Garwood often chose a close-up view, rarely confronting it straight on: she placed furniture and figures at an angle, sometimes perversely cutting off chairs or limbs at the block edge. The use of all-over patterning and her way of seeing has much in common with Ravilious's. Her scenes, however, are more closely observed, intimate revelations of everyday life somewhat mockingly described. Four were reproduced in the *London Mercury* in March 1930; yet no others were forthcoming for this journal despite Squire's request for more.

Plate 151

Tirzah's and Eric's marriage on 5 July that year marked the decline in her wood-engraving output. A few single prints were followed by a commission from Furnival Books for a frontispiece to L. A. G. Strong's *The Big Man* published in 1931. In the scene, party-goers sit round a card table, the chairs in the lower half cut off by the picture edge. Expressions, gestures, and decorative toolwork convey an air of jollity. Four specimen borders which Garwood designed for the Kynoch Press further reveal her keen sense of design.

Her final commissions were for the Golden Cockerel Press at the time when Ravilious was working on his *Twelfth Night* engravings and she was helping to clear some of the blocks. In a letter to Ravilious about this book, Gibbings added a footnote 'pour madame' apropos the 'Taplow' book: 'It would be fun if you could devise a few new and exclusive ones [decorative borders] and seeing as 'ow you are so good at this kind of thing it might be a solution for the book.'[152] Although he liked her designs and kept several, he abandoned the idea of the book. Most probably one of her blocks was that used for the cover of A. E. Coppard's *The Hundredth Story* published in January 1931 and the first of the successful Guinea Series. Garwood's bold star-shaped repeat design incorporating the

[152] Robert Gibbings to Eric Ravilious, 20 Oct. 1930. GCPA. For further discussion see Selborne, 'Eric and Tirzah Ravilious and the Golden Cockerel Press'. 'Taplow' book unidentified but possibly a title by Walter de la Mare who lived at Taplow. In a letter to the author (14 Feb. 1994) Roderick Cave mentions correspondence between Hamish MacLaren and Moira Gibbings regarding a potential book of ballads for the press, maybe the one in question. MacLaren had recently published some humorous rhymes entitled *Sailor with Banjo* (Victor Gollancz, 1929).

Pl. 152. Tirzah Garwood: Helen Simpson (trans.), *Heartsease and Honesty, being the Pastimes of the Sieur de Grammont* (Golden Cockerel Press, 1935). 234 × 160

Pl. 151. Tirzah Garwood: L. A. G. Strong, *The Big Man* (Furnival Books, 1931). 164 × 108

author's and press's initials was used in different colour combinations for other books in the series. An equally stylish tile-like pattern featured on the cover of *Salambo*, published later in the year. Other designs, including a delicate all-over leaf and flower *Plate 152* patterned paper binding, was utilized by Sandford for *Heartsease and Honesty* (1935).

Tirzah Garwood's wood-engraving career came to an end when in 1932 she and Ravilious moved to Great Bardfield in Essex to share a house with Charlotte and Edward Bawden.[153] Subsequent artistic activities included oil and watercolour painting, and making paper models, collages, and marbled paper, before her early death in 1951. As far as her prints were concerned Salaman believed that she had a streak of Ravilious's 'trickiness, with much irony of her own'.[154] Certainly his influence was far outweighed by the individuality of her style and her penetrating and quirky observations of contemporary life which are quite unlike those of any of her contemporaries and sadly short-lived.

Tirzah Garwood's large figurative studies have much in common with those of Hester Sainsbury (1890–1967), several years her senior, whose individualistic compositions and unusual toolwork make for some of the most original wood-engravings to emerge between the wars. Recognized at the time,[155] her work until recently has been largely neglected.[156]

Sainsbury started her career as a dancer. Tucker suggests that a strong desire to portray women dancing may well have been the driving force behind her decision to take up the medium, most probably encouraged by friends who were at art school, Ray Marshall, in particular, and possibly Vivien Gribble who shared her fascination for dance.[157] Self-taught, she was, like them, amongst the first wood-engravers of the period to embark on book illustration. *Poems*, a book of poetry which she wrote to accompany her particular method of dancing, was printed by the Westminster Press as early as 1916. It included six hand-coloured woodcuts or wood-engravings,[158] the black outline style, used for the rhythmic figures in 'Spring', for instance, resembling that of Rooke and some of his pupils, most especially Gribble. The silhouetted scene for 'May Day', on the other hand, shares similarities with Nicholson's and Craig's work, and with the modernist woodcuts of the Omega group in whose circle, and among the artistic and theatrical friends of Nina Hamnett, she moved between about 1915 and 1918.

Sainsbury exhibited in the second and third Society of Wood Engravers' annual exhibitions and became a member in September 1927, exhibiting as many as seven engravings in 1926 and 1928 but no more after 1929. Between 1921 and 1930 she contributed illustrations to seventeen books, eleven containing wood-engravings or -cuts. The majority were produced by private presses, most significantly her brother Philip's Favil

[153] The two couples had been renting Brick House since the summer of 1930. In 1935 the Raviliouses moved to a house at Castle Hedingham a few miles away.
[154] Malcolm C. Salaman, *The New Woodcut* (London, 1930), 20.
[155] Her single wood-engravings were reproduced in prominent publications such as *The New Leader Book* (1926), *The Woodcut of Today* (1927), *The Woodcut, No. III* (1928), *The New Woodcut* (1930), and *Wood-Engraving and Woodcuts* (1932).

[156] See Peter Tucker, 'Hester Sainsbury: A Book-Illustrator of the 1920s', *Private Library*, 3 (1990), 112–36, and 'Hester Sainsbury: Some Further Notes', *Private Library*, 5 (1992), 80–9
[157] Tucker, 'Hester Sainsbury: Some Further Notes', 85.
[158] Some of her early work may well be cut rather than engraved. She possibly experimented using both cutting and engraving tools on the same block.

and Cayme Presses[159] which enabled her to publish her own writings.[160] *Holy Women and Other Poems* (1921), the Favil Press's first book, was issued as a thirty-two page pamphlet. It includes two crudely cut headpieces and eight single-page illustrations, all figurative, mainly of well-built women, described with a sketchy white line. For her next book, *Meanderlane* (Cayme Press, 1925), a collection of folk tales, the wood-engraved blocks are printed in a terracotta colour on thick paper. Although still fairly robust, the handling is more mature with a greater variety of line. A lively print of a woman and basket with two children holding a flag and balloon is pasted to the cover. The frontispiece, in contrast, is a heavy, over-inked scene of willows by a winding river. The white-line deer on the title-page shows a strong affinity with Japanese art of which she had knowledge through her close friendship and collaboration with the Japanese dramatist, Torahiko Kohri, in London.[161] Clothes are a feature of her work, inspired perhaps by Ballets Russes costume designs.[162] In the illustration to 'The Maid in the Moon' a bride in eighteenth-century attire is crowned with a wreath by a classically draped figure. For 'The Sailor's Wife' a woman in peasant dress is depicted. A rough-cut tailpiece of a curtained window with brightly radiating moon outside is Paul Nash-like in its expressionist simplicity.

Sainsbury's illustrations to her book of poems entitled *Noah's Ark* (Cayme Press, 1926) reveal her experimental approach to wood-engraving. A rectangular print of an animal is printed at the top of each poem, its outline and decorative detail picked out in white.[163] *Plate 153* Further patterning is created with a multiple tool. With her nine whole-page wood-engravings for *The Lady's New-Years-Gift* (Cayme Press, 1927) she established her unique style: rectangular framed scenes dominated by large-scale figures, decoratively conceived through a variety of techniques. These prints combine loose white-line engraving, fine-line multiple tool work, sometimes cross-hatched, and bold scorping to the point of roughness at the edges of the block, as in *Vanity and Affectation* in which large *Plate 154* black areas are thrown into silhouette. The naïve two-dimensional compositions well match the archaic seventeenth-century text by the Marquis of Halifax which offers advice to a daughter on such subjects as religion, husbands, behaviour, and conversation. The same period treatment recurs in the five full-page illustrations to John Taylor's *A Dog of War* published in 1927 by Etchells and Macdonald in the Haslewood Books series. These strongly patterned, hand-coloured wood-engravings are printed on all rag paper, the mixture of fine and scorped line balancing well with the typeface opposite, both in weight and size. The comical dog is coloured purple throughout.

Hester Sainsbury illustrated three other books for the Haslewood Books series, two with wood-engravings. Some of her most attractive appeared in *Eve's Legend* (1928) by Lord Holland, an amusing story in which the only vowel used is the letter 'E'. Four

[159] See Ch. 6.2, 'Smaller Private Presses'.
[160] A rare contribution to a commercial publication was a full-page wood-engraving for the dust-jacket of Henry Williamson's *Tarka the Otter* (Putnam, 1927).
[161] She translated his plays which she helped to produce, and designed costumes. She visited Japan after Kohri's death in 1924. Her copperplate engravings for E. Powys Mathers's *Eastern Love* published in 12 volumes (1927–30) by John Rodker's Ovid Press,

and 6 full-page wood-engravings to Paul Morand's *Earth Girdled* (Knopf, 1928), depicting Siamese dancers, animals, fish, and seascapes, demonstrate her knowledge of Eastern culture.
[162] See Ch. 4.4, 'The Bloomsbury Group'.
[163] In 'Hester Sainsbury: A Book-Illustrator', 117, Tucker suggests that these prints are possibly influenced by Roald Kristian's animal woodcuts of which she owned complimentary copies. See Ch. 4.4, 'The Bloomsbury Group'.

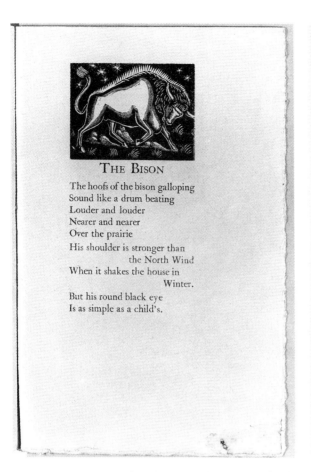

THE BISON

The hoofs of the bison galloping
Sound like a drum beating
Louder and louder
Nearer and nearer
Over the prairie
His shoulder is stronger than
 the North Wind
When it shakes the house in
 Winter.
But his round black eye
Is as simple as a child's.

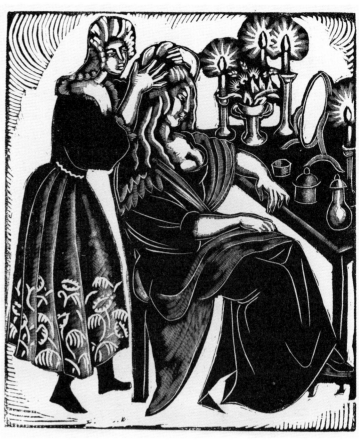

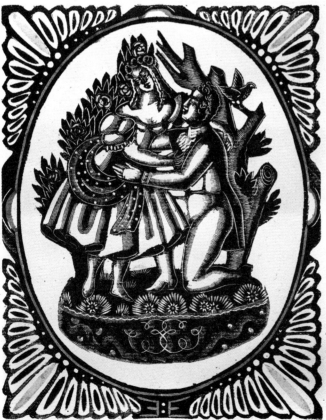

Pl. 153 (*above, left*). Hester Sainsbury: *Noah's Ark* (Cayme Press, 1926). 229 × 148

Pl. 154 (*above, right*). Hester Sainsbury: *Vanity and Affectation* from George Savile, Marquis of Halifax, *The Lady's New-Years-Gift* (Cayme Press, 1927). 157 × 134

Pl. 155 (*left*). Hester Sainsbury: Lord Holland, *Eve's Legend* (Haslewood Books, 1928). 155 × 122

cheerful pages lead into the text: an oval border of baskets, fruits, swags, and putti surrounds the script on the title-page, followed by a jolly parrot screeching 'EEEE'; then a single-page print of flowers in an oval with an 'E' at each corner, after which follows an oval-shaped 'E' enveloping baskets, flowers, trees, shepherds' crooks, and two birds. Pages of text are succeeded by single-page images surrounded by variously shaped ornamental borders, one heartshaped, echoing the frivolously romantic text. Hand colouring adds to the gaiety and wit. There is a quaint folk-art feeling about the stiff, expressionless figures, most especially the young swain Stephen who embraces Eve, the couple resembling an eighteenth-century figurative china ornament. A contemporary reviewer considered that these engravings were 'absolutely charming, and convey the atmosphere of the period with a little twentieth century irony thrown in'.[164]

Plate 155

Further private press commissions were forthcoming but mostly not for wood-engravings. The Golden Cockerel Press commissioned copper engravings in 1928 and again in 1930 when, for *Lucina sine Concubitu*, Sainsbury also produced an unusual semi-abstract wood-engraved pattern paper. To the 1929 Cresset Press *Apocrypha* she contributed a large full-page wood-engraving of *The Prayer of Manasses*, the scene dominated by a monumental kneeling figure sculpted with a multiple tool. Her distinctive style in this and earlier prints was partly a result of her extensive use of this tool at a time when few engravers were using it. After her marriage to Frederick Etchells in 1932 little is heard of her, to the extent that Bliss noted in 1934 that 'Hester Sainsbury, once so clever with the multiple-tool, has disappeared'.[165]

12.7. *John Nash: Later Work*

John Nash (1893–1977) was not a product of the Royal College of Art nor was he lastingly influenced by his brother Paul, although, as mentioned earlier,[166] for a brief moment in the early 1920s they worked in a similar manner. Like Paul, John learnt to wood-engrave mainly from friends and through experimenting. Stylistically John's art was essentially pastoral and homely in comparison to Paul's more intellectual and metaphysical aesthetic. A countryman and passionate gardener, he was keenly observant of nature, particularly plants. He was equally observant of people: with an endearing sense of humour and eye for the oddities of human behaviour he started his artistic life as a comic cartoonist. As with Paul, few figures feature in his paintings but many of his wood-engravings and drawings include both people and animals, often in a domestic setting—an anecdotal element absent from most of Paul's work.

[164] From *Drawing & Design* (Dec. 1928) quoted in Tucker, 'Hester Sainsbury: A Book-Illustrator of the 1920s', 128.
[165] Douglas Percy Bliss, 'The Last Ten Years of Wood-Engraving', *Print Collector's Quarterly*, 21 (1934), 251–71, p. 259.
[166] See Ch. 4.4, 'Paul and John Nash'.

With such an approach to graphic art John was naturally drawn to illustration.[167] In an article in the *London Mercury* in 1928 he maintained that

It is in the illustration of books, the ideal combination of type, block and the printed page, that the future of wood-engraving would seem to lie . . . as wall decorations they compete unsuccessfully, I think, with easel paintings and drawings, owing to the lack of colour and limited size, and are, therefore, more suitable for portfolios, but the use of them in books provides an aim worth achieving, a two-fold aim of decoration and illustration.[168]

It is a contradiction that such a spontaneous artist should consider wood-engraving to be more suited to book illustration than to single prints; he evidently came to this conclusion himself at the end of his wood-engraving career. The relative rigidity of the medium no doubt partly accounts for why his narrative illustrations, at any rate, are not as successful in wood-engraving as they are in line drawing. His depictions of plants, on the other hand, which require no characterization and are both scientifically observed and decoratively engraved, are masterpieces of botanical illustration.

Despite his claim that the printed page was the ideal place for wood-engraving, Nash appears to have shown comparatively little interest in the overall appearance of his wood-engraved books. Although he worked largely for private presses there is scant evidence of his direct involvement in the process of production, or of his concern for layout, typography, or the balance between illustration and typeface.[169] However, he took a keen interest in paper and its precise size and dimensions in relation to his illustrations. Dust-jacket design was another aspect which attracted him.

In his article, 'The History of the Woodcut', Nash describes the exacting approach required in designing for the block: 'Engraving demands a tight control and respectful deliberation. Moreover, the design must be carefully planned out beforehand and the engraver should know exactly what he is about to do within the limit of his block. Here chance and extemporare decisions, happy or otherwise, are the last elements to depend on.'[170] Yet he was not a believer in technical virtuosity for its own sake. Once the design was transferred to the block[171] he worked boldly and freely, mainly with spitstickers and square and round scorpers. Respecting the woodiness of the wood, he produced rich blacks scored with a multiplicity of toolmarks and blatantly contrasting white areas. He employed both black- and white-line methods within the same print to great advantage. For publishing purposes his wood-engravings were sometimes printed from electrotypes and were to scale, whereas his drawings, printed from line blocks, were often reduced in size.

In 1950 Nash wrote with hindsight: 'The best books to illustrate are those written by

[167] For a detailed analysis of his illustrated work see exhibition catalogue *John Nash: Book Designs*, researched and written by Clare Colvin (Colchester: The Minories, 1986); also John Lewis, *John Nash: The Painter as Illustrator* (Godalming, 1978).

[168] John Nash, 'The History of the Woodcut', *London Mercury*, 19 (1928), 49–50, p. 50. For this reason his wood-engravings done for books were only issued in very small separate editions.

[169] Primary material is limited since, according to Jeremy

Greenwood in *The Wood-Engravings of John Nash* (Liverpool, 1987), 14 , 'he was evidently not a very enthusiastic keeper of records and they are not reliable'.

[170] Nash, 'The History of the Woodcut', 50.

[171] Extant blocks (photographs reproduced in *The Wood-Engravings of John Nash*, 45 and 134–5) show that he drew the design on to the wood in black ink. The image is often not reversed on the block.

the illustrator—a matter between him and his artistic conscience. The next best those by defunct authors—the artist and the publisher only are involved. The most difficult those written by living authors—this means either a tripartite conflict or a dangerous two to one against the illustrator.'[172] Apart from *Poisonous Plants* for which he wrote the introduction, he never illustrated his own book. Of the eleven books to which he contributed wood-engravings between 1925 and 1935 most were written by contemporary authors.

In 1924 Nash joined the staff at the Ruskin School of Drawing at Oxford. At about this time he contributed some line drawings to Harold Monro's Poetry Bookshop rhyme sheets. Correspondence reveals that he was considering a commission from Monro for some small woodcuts of animals for a Ford Madox Hueffer manuscript: 'I will guarantee his illustrations shall not be comic but then as I say I don't think they can be more than romantically homely and rustic.'[173] He was, however, unable to do these for the suggested price. Colvin notes that Nash was anxious to contribute illustrations to T. E. Lawrence's highly successful book, *The Seven Pillars of Wisdom*, but the samples which his brother Paul sent Lawrence were not taken up.[174] It is not known what was his chosen medium.

John Nash's first two wood-engraved books were by his so-called 'defunct' authors. With his illustrations to the Golden Cockerel Press edition of Jonathan Swift's *Directions to Servants* (February 1925) he was only the second wood-engraver to be commissioned under Robert Gibbings's new management. The book, as Sandford wrote later, was 'an experiment, possibly in this case retrograde, in the revival of the bi-columnar page'.[175] Nash's small, dark, rectangular blocks are constricted to the narrow column width and consequently are too heavy for the 11-point Caslon Old Face type. Vigorously engraved with strong contrasts of black and white—a deliberate chapbook style perhaps—his handling is somewhat rudimentary. The caricatured figures are in keeping with the satirical nature of the text, but their facial features are oversimplified and repetitive. Nash revels in the more dramatic moments in the text, for example, where the directions to the coachman state that 'a good coachman never drives so well as when he is drunk'. The lively sense of movement, avoidance of straight lines, and expressive quality *Plate 156* in these prints are characteristics present in most his figurative illustrations. He was paid £45 for the work.

Earlier contact with Frederick Etchells probably accounted for a commission, also in 1925, to illustrate *Ovid's Elegies* (translated by Christopher Marlowe) and *Epigrams* of Sir John Davies, the two books published in one volume. Nash produced nine wood-engravings, including six whole-page blocks, for which he was paid £24. Not confined to a limited space, he worked more happily with these scenes, particularly the single-page prints. The frontispiece depicting the sacred wood conjures up a suitably elegiac atmosphere with stark tree trunks and branches enveloping a pagan statue, though it lacks the mystical element present in similar works by Paul. John firmly believed that

[172] John Nash, 'Book Illustration', *Ark*, 1 (1950), 21–2, p. 21.
[173] John Nash to Harold Monro, n.d. HRHRC.
[174] *John Nash: Book Designs*, 18.

[175] Sandford and Rutter, *Bibliography of the Golden Cockerel Press*, No. 23, 18.

an artist should not impose his will on the text. In an article on book illustration in the Royal College of Art magazine *Ark* he described how he approached the interpretation of text in general: 'I myself read a book in a very practical manner, marking passages that appeal to me or present a vivid picture and indulging in periods of research necessitated by the desire for naturalistic details or the exploration of costume. I then read and re-read until an almost traumatic state is induced from which more imaginative ideas proceed.'[176] The results in this book are sometimes rather incongruous, as, for instance, in *In Haywodum*, where a burly man is shown pulling up a bucket from a well, translating literally the simile of 'my light muse' not being put down 'as Buckets are put downe into a well'. Although a tense atmosphere is created between the lovers in *Corinnae Concubitus*, the stance of Corinna ('in a long loose gown, her white neck hid with tresses hanging down') is extremely awkward. In most of his illustrative work Nash's figures are either caricatured or rather bulky and unnatural; a surprising fact bearing in mind several sensitive nude wood-engravings of around 1920 and some fleshy nude etchings probably of the same period. It is almost as if he were self-conscious about the depiction of nakedness in his illustrations.

Plate 157 In *Paradise* a dark, mysterious forest of exotic birds is punctuated by a winding black river on which glide two pure white swans—an unusually two-dimensional work for Nash, revealing a possible cross-influence with his brother. A year earlier Paul engraved *Hanging Garden* which may well have inspired John's image. This in turn shows a similarity with Paul's depiction of *Paradise* in *Abd-er-Rhaman in Paradise* of 1928.[177]

The third non-contemporary book to which John Nash contributed, the Cresset Press's *Apocrypha* (1929), contained one of his strangest and least satisfactory wood-engraved illustrations, a scene from the Book of Judith. (He was a confessed non-believer and otherwise studiously avoided any biblical subjects.) The monumental figure of Judith, looming over the collapsed and headless body of Holofernes, watches while a kneeling maid shovels the head into a bag. Anachronistically dressed, these characters are portrayed in a singularly gauche fashion. Rather more successful is Nash's treatment of the furnishings: the wavy patterning of the curtain and the melon-striped bolster reflect his sense of design and delight in texture—characteristics which are generally more prominent in his single prints which allowed him greater imaginative freedom.

Most of Nash's wood-engraved commissions for books by living authors were for narrative illustrations. Several for frontispieces came from commercial publishers, including Putnam for Bernadette Murphy's *The House in the Country* (1927), and Longmans Green for Kathleen Woodward's *Jipping Street* (1928). The first shows a bonneted woman leaning over a wall—a pleasing composition which Nash liked sufficiently to reproduce in his *Ark* article.[178] The *Jipping Street* engraving of three silhouetted men in a boat pulling a body out of the water is an uncharacteristically sombre scene—a style quite in keeping with the tragedy. These and other frontispieces were reused for the dust-jackets.

[176] Nash, 'Book Illustration', 20–1. [177] See Ch. 12.2. [178] See n. 172.

With a few exceptions, Nash's wood-engraved illustrations were commissioned entirely by private press owners. For the Blackamore Press he produced six blocks for Stephen Hudson's *Celeste* (1930). These acted as frontispieces to each of the short stories. As with many of his wood-engravings for books the images lie heavily on the page: the overriding impression is of blackness relieved with white, as in the night scene for 'Southern Women'. A fondness for chiaroscuro is apparent from much of his engraved work, especially domestic scenes of his wife or sister Barbara sewing or reading by lamplight, or a cat curled up, or a still life in front of a window. By showing figures from the back or with head bent, in shadow or silhouetted, Nash avoids characterization in his illustrations. His depiction of females, as has been seen, was often unflattering. The hefty lady in the print for 'Southern Women' and Marnie Brady in the frontispiece to 'Transmutation', both with blank eye sockets, are especially unattractive. For this last story he deals with the problem of describing two incidents together by superimposing the figure of Bobby lying on the bed on to a screen or mirror which appears to be propped up against the embracing couple on the right. He adds an element of drama to the figureless scene for 'Sounds' by making play of the geometry, light, and patterns created by the open window with flapping blind.

By the time of his second Golden Cockerel Press book, T. F. Powys's *When Thou Wast Naked* (1931), Nash's wood-engraving technique had greatly matured, as had Gibbings's presentational skills. The second in the Guinea Series and printed in 14-point Golden Cockerel type, the book has a modern appearance, most conspicuous in its title-page with Nash's image of a naked girl by a river: a rather more sensuous female than in his previous illustrations. Three other small rectangular prints are spread through the text culminating in a delightful tailpiece of an open workbasket. Colvin points out that both the receding road with telegraph poles and the uprooted tree were subjects which *Plate 158* fascinated Paul but which John handled in a much less innovative way.[179] Around 1915 John had done a similar drawing of 'monster-like' tree roots but then, as now, he was more interested in the complex pattern of the branches than in their symbolism. The stripy dresses of two girls up apple trees, and the triangular shape formed by the figures of the huntsmen halloeing at them from below, make for a particularly effective composition. Nash's wry humour is commonly present in his narrative scenes, as is his powerful sense of design.

Nowhere is his flair for decoration more apparent than in his illustrations of flowers, fruit, and vegetables. Three small prints for *Ovid's Elegies* were his first horticultural wood-engravings to appear as book illustration. They are relatively crudely handled compared with a few earlier examples, two of which were reproduced in the magazine *Form* (October 1921). Coloured line drawings for a *Catalogue of Alpine and Herbaceous Plants* (1926) for Clarence Elliott's Six Hills Nursery first established him as a botanical illustrator. An opportunity to wood-engrave for a book specifically related to flowers came in 1927 with a commission from Etchells and Macdonald for an introductory text,

[179] *John Nash: Book Designs*, 37.

post of honour left you; there you will meet many of your old comrades, & live a short life and a merry one, and make a figure at your exit, wherein I will give you some instructions. The last advice I give you relates to your behaviour when you are going to be hanged; which, either for robbing your master, for housebreaking, or going upon the highway, or, in a drunken quarrel, by killing the first man you meet, may very probably be your lot, & is owing to one of these three qualities; either a love of good fellowship, a generosity of mind, or too much vivacity of spirits. Your good behaviour on this article will concern your whole community. Deny the fact with all solemnity of imprecations: a hundred of your brethren, if they can be admitted, will attend about the bar, and be ready, upon demand, to give you a character before the court. Let nothing prevail on you to confess, but the promise of a pardon for discovering your comrades: but I suppose all this to be in vain; for if you escape now, your fate will be the same another day. Get a speech to be written by the best author of Newgate; some of your kind wenches will provide you with a Holland shirt and white cap, crowned with a crimson or black ribbon: take leave cheerfully of all your friends in Newgate; mount the cart with courage; fall on your knees; lift up your eyes; hold a book in your hands, although you cannot read a word; deny the fact at the gallows; kiss and forgive the hangman; and so farewell: you shall be buried in pomp, at the charge of the fraternity; the surgeon shall not touch a limb of you; and your fame shall continue, until a successor of equal renown succeeds in your place.

22

CHAPTER IV.
DIRECTIONS TO THE COACHMAN.

YOU ARE strictly bound to nothing but to step into the box, and carry your master or lady. Let your horses be so well trained that, when you attend your lady at a visit, they will wait until you slip into a neighbouring alehouse to take a pot with a friend. When you are in no humour to drive, tell your master that the horses have got a cold, that they want shoeing, that rain does them hurt, & roughens their coat, & rots the harness. This may likewise be applied to the groom. If your master dines with a country friend, drink as much as you can get; because it is allowed that a good coachman never drives so well as when he is drunk; & then show your skill by driving to an inch by a precipice, and say you never drive so well as when drunk. If you find any gentleman fond of one of your horses, and willing to give you a consideration besides the price, persuade your master to sell him, because he is so vicious that you cannot undertake to drive him, and is foundered into the bargain. Get a

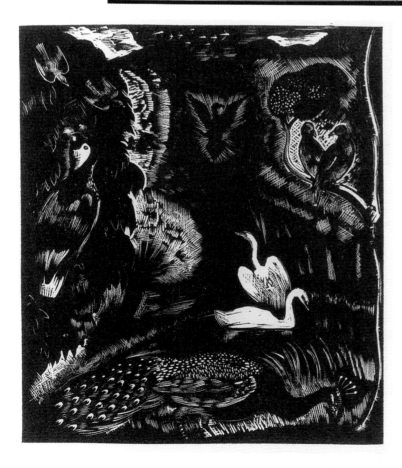

Pl. 156 (*left*). John Nash: Jonathan Swift, *Directions to Servants* (Golden Cockerel Press, 1925). 257 × 192

Pl. 157 (*below, left*). John Nash: *Paradise* from Christopher Marlowe (trans.), *Ovid's Elegies* (Etchells and Macdonald, 1925). 121 × 108

Pl. 158 (*below, right*). John Nash: T. F. Powys, *When Thou Wast Naked* (Golden Cockerel Press, 1931). 70 × 100

Pl. 159 (*left*). John Nash: *Horned Poppy* from W. Dallimore, *Poisonous Plants: Deadly, Dangerous and Suspect* (Etchells and Macdonald, 1927). 151 × 113

Pl. 160 (*below, left*). John Nash: *Autumn* from H. E. Bates, *Flowers and Faces* (Golden Cockerel Press, 1935). 145 × 125

twenty whole-page prints, and a head- and tailpiece for *Poisonous Plants* dedicated to Elliott.[180] These large, single blocks allowed Nash the space and scope to develop his unique style of botanical engraving without the constraints of textual interpretation. Colvin considers the book to be one of the finest produced between the wars by a private press.[181] Certainly it was a pioneer book of its kind and a model for subsequent wood-engravers of plants such as Hermes, Leighton, and Miller Parker. Nash's prints, however, are more painterly than those of most of these artists: expressively handled yet accurately observed, imaginative in their settings, and above all 'alive and fugitive'.[182]

From the earliest dated block, *Anemone Pulsatilla* (begun in December 1925)—a rather lightweight, sketchy engraving—Nash's work noticeably matured. He used both white and black line throughout, varying his technique depending on each individual plant, from a black silhouette of *Deadly Nightshade*, to a skeletally lacy white *Hemlock*, through to a combination of the two in *Helleborus Foetidus*.[183] Some blocks retain the solid rectangular shape while others, as with that for *Spurge Laurel*, are cut away on some sides for a more interesting profile. Nash avoided background details which would detract from the central image, notable exceptions being the gravestones in *Yew* and the speckled sand dunes behind the *Horned Poppy*.[184] Many of the plants are viewed from a close perspective, their leaves and petals often truncated by the picture edge. With such an idiosyncratic visual approach each plant is imbued with personality. A tiny tailpiece showing a girl with her dog running back to her nurse pursued by a huge, presumably poisonous plant makes a witty coda. Etchells and Macdonald had planned a book on carnivorous plants but Nash produced only one wood-engraving before the firm closed down.

Plate 159

A still life of fruit with a decanter and long-stemmed dish brimming with melon, peaches, and grapes for the frontispiece and dust-jacket of E. A. Bunyard's *The Anatomy of Dessert* (Dulau & Company, 1929) anticipated his final and most successful wood-engraved illustrations for *Flowers and Faces*, published in 1935 by the Golden Cockerel Press under its new management. To H. E. Bates's descriptive memoir Nash contributed a title-page border design of intertwined flowers with a radiating sun, trug, and watering can, and four whole-page prints of seasonal fruits and flowers. His handling of the large blocks is assured and tightly controlled but never rigid. Backgrounds are mostly cut away leaving varied outline shapes. In the most refined engraving, *Autumn*, Nash delights in the tones and textures of the plants, particularly the glorious striped marrow, jagged-edged sunflower, and lacy-ringed carnation. As in earlier prints he uses fine cross-hatching to create a shiny finish on the apple and pear. Only the cumbersome hand lifting the flowerpot off the hellebores in *Winter* detracts from the clarity and precision

Plate 160

180 These were printed from electrotypes by the Curwen Press on Renker's handmade paper. The edition of 350 numbered copies retailed at £2. 12s. 6d.
181 *John Nash: Book Design*, 29.
182 John O'Connor's description in *The Wood-Engravings of John Nash*, 8. Nash worked only from live specimens.
183 An earlier version of *Buttercup* (reproduced in *The Wood-Engravings of John Nash*, 100), a mirror image of the final print,

shows the plant in black silhouette. An impression of this proof was printed on to a new block and re-engraved (a technique Nash used occasionally) retaining more background than before.
184 A variant of *Datura* which was not used (reproduced in *The Wood-Engravings of John Nash*, 90), shows a garden, spade, and various other objects which he possibly found too cluttered for the final version.

of these illustrations. Although for some reason Bates felt that they ruined his book,[185] Nash regarded them as his best.

These splendid illustrations mark the end of John Nash's wood-engraving career.[186] Two letters from around 1935 written to Margaret Pilkington as Secretary of the Society of Wood Engravers explain his apathy:

I have a cupboard full of the fruits of my labour—I do not remember ever having sold more than 2 editions right out & they were limited to 20 prints! The business of cutting new blocks, selling one or two prints & then supporting the accumulating weight of boxwood in idleness deter me from further activity.[187]

I fear I am no use to the Society as I hardly ever do any engravings now unless I am commissioned to illustrate a book & I find the occasion increasingly rare now—Also I am rather tired of the medium & have, as I say, turned to a different medium for a change.[188]

This was lithography which he used to particular advantage in the 1930s for dust-jacket designs. After the war, when wood-engraving commissions were less forthcoming, Nash reverted almost exclusively to his favoured medium of line drawing for book illustration which best suited his comic and spontaneous approach, as epitomized by his animated scenes for *The Natural History of Selborne* (Lutterworth Press, 1951). Although much of his wood-engraved work was reproduced in periodicals and for publicity purposes, with the exception of some of his flower prints, his illustrations, commissioned mainly by private presses, were not widely disseminated. His intensely personal style had little influence on contemporary wood-engravers, except perhaps on Farleigh in his early years.

12.8. *Ethelbert White, Clifford Webb, Norman Janes, and Others*

Among the new generation of wood-engravers Ethelbert White (1891–1972) was one of the first to receive a commission for book illustration.[189] He was also the earliest Golden Cockerel Press illustrator. His strong and emphatic wood-engraving style, which mirrors that of his painting, exemplifies the new and experimental approach to the medium common amongst practitioners in the 1920s. His illustrative output, however, was small and, with the exception of his compositions for *The Story of My Heart*, his single prints are generally more distinguished than those for books.

White received no official wood-engraving teaching at the St John's School of Art

[185] *John Nash: Book Designs*, 43.
[186] Sandford approached Nash to illustrate Gwyn Jones's *The Green Island* ten years later but nothing materialized. This book was illustrated by John Petts in 1946.
[187] John Nash to Margaret Pilkington, 14 Feb. 1935. SWEA.
[188] John Nash to Margaret Pilkington, undated. SWEA.

[189] For further discussion and illustrated examples of his work see Thomas Balston, 'The Wood Engravings of Ethelbert White', *Image*, 3 (1949–50), 49–60; also Hilary Chapman, *The Wood Engravings of Ethelbert White* (Wakefield, 1992), and exhibition catalogue, *Ethelbert White, 1891–1972*, with introduction by David Coke (Chichester: Pallant House, 12 Feb.–6 Apr. 1991).

where, from 1911 to 1912, he studied under Leonard Walker.[190] While still a student he became friendly with avant-garde artists, Gertler and Nevinson in particular; he soon established himself as a painter, exhibiting with the London Group in 1915.[191] Commissioned by Cyril Beaumont in 1919 to illustrate with line drawings Herbert Read's book of poems, *Eclogues*, and three books in the Impressions of the Russian Ballet Series, for publication by his Beaumont Press,[192] he was asked the following year to produce some colour wood-engravings for W. W. Gibson's collection of poems entitled *Home* to be printed at the press. In his autobiography Beaumont described how he showed White the basic rudiments: 'At this time he had no experience of woodcutting so I explained to him the process and the kind of tools necessary, according to my recollection of those used by Tytgat.[193] White produced several wood-blocks and tools similar to the pattern suggested, and after a few trials cut the key block and two others.'[194] The resulting circular scene of a cottage, trees, and a garden in pinkish-brown and two shades of green is reminiscent of the designs of Lucien Pissarro, and also of Tytgat. His black and white press device used for the colophon shows greater originality.[195]

A startling silhouette-style wood-engraving, *Weeping Ash*, which White showed in the first annual exhibition of the Society of Wood Engravers in 1920, reveals his modernist tendencies. The *Country Life* review of the second exhibition particularly mentioned him as one of the most promising members. Elected in 1921, and active on the committee, he changed allegiance in 1925 to the English Wood-Engraving Society whose members considered themselves more *au fait* with contemporary art. His own form of modernism, however, was generally constrained in his book illustration by the conventional nature of the commissions.

Such was the case with the next wood-engraved book for Beaumont, whose requirements for Carlo Goldoni's *The Good-Humoured Ladies* (1922) were extremely explicit. According to Delaney he wanted the head- and tailpieces 'to be derived from Massine's ballet of the play, and partly from related contemporary episodes as painted by Guardi and Longhi' with headpieces framed in an eighteenth-century manner.[196] For the frontispiece a scene showing two costumed ladies with a seated man is set as if on stage, enclosed within an enormously elaborate black-line frame decorated with the masks of comedy and tragedy. In the headpiece to Act I, a maid is arranging Costanza's hair, both ladies posing in a theatrical manner. White makes play of patterning in the narrow decorative borders, the elegant clothes, and the chequered flooring which emphasizes the receding stage as in fifteenth-century Venetian woodcut illustrations. Ravilious, as has been seen, used the same effect in *Twelfth Night* at a later date.[197] Further rectangular headpieces and small vignette tailpieces include views of Venice. White's graceful

[190] Painter and stained-glass artist.

[191] *Tum-Tiddly-Um-Tum-Pom-Pom* was painted jointly with Nevinson and exhibited at the Allied Artists Exhibition in 1913.

[192] See Ch. 6.2, 'Smaller Private Presses'.

[193] Edgard Tytgat (1879–1957), a Belgian artist whose works were an expressionist version of Flemish popular art; Beaumont had published some of his coloured woodcut illustrations.

[194] Cyril Beaumont, *The First Score* (London, 1927), 44.

[195] See Ch. 6.2, 'Smaller Private Presses'.

[196] Paul Delaney, 'Great Illustrators: Ethelbert White', *Antiquarian Book Monthly Review*, 8 (1981), 300–5, p. 302.

[197] See Ch. 12.4.

Chinese-style design of boats, trees, and pagodas for the cover paper presumably account for Bliss's comment that 'his work shows undoubted reminiscences of Spode willow-pattern plates'.[198]

White employs a combination of both white- and black-line engraving, with shading limited to parallel lines and short strokes, though solid blacks and whites predominate. Beaumont apparently had difficulty printing these blocks which did not balance well with the light-weight type chosen for its period quality. After many experiments they were printed in a bluish-grey ink which toned them down. Less successful in this respect were his few illustrations, printed on handmade unbleached Arnold paper, for *The Wedding Songs of Edmund Spenser* (1923), the first of two illustrated Golden Cockerel books commissioned by Taylor before Gibbings took over the press. For the frontispiece the framed picture of a minstrel playing his lute under the trees rests on an elaborate black-line cartouche. One other whole-page white-line scene of a couple of lovers is *Plate 161* enclosed in a tendril-like surround. A tiny print depicting a box-like marriage bed concludes the tale. All the blocks are printed in sepia ink with the addition of green and yellow for the frontispiece. Although their consciously *retardataire* style is unadventurous, White's cutting is by now more assured.

Legendary Bohemian figures of their day, Ethelbert White and his wife Betty travelled extensively in their caravan both at home and abroad, often collecting folk songs as they went. Some of his earliest pictures depict hard-worked labourers, testifying to his socialist sympathies.[199] Like the Nash brothers he was in tune with the spirit of the English countryside and worked best with rural scenes, some of his boldest prints depicting farmyards, barns, fences, trees, furrowed fields, and undulating hills, often with figures and animals. His thirty-six designs to Richard Jefferies's *The Story of My Heart* (Duckworth, 1923) represent his first attempt at landscape illustration and are some of the finest examples of white-line wood-engraving of this early period. The text is a record of the author's own spiritual development in relation to the spiritual forces of the natural world. White sensitively translates Jefferies's elemental feelings about nature, capturing both the mood and *genius loci*. Apart from a rectangular frontispiece relating to the first chapter, the remaining chapters are preceded by a single-page wood-engraving facing a long narrow headpiece the width of the text, and conclude with a much smaller tailpiece. White conjures up the solitariness of the author resting in 'a green concave opening to the sea' silently admiring the immensity of the sea, the sky, and the distant horizon. On another page a lamb's skull, 'white and bleached', lies symbolically on the grass. The strange procession of people 'called up alive from their tombs' walking down into the valley from a hillside cemetery is reminiscent of Samuel Palmer's visionary Shoreham period, although some figures are more comic than lyrical; in the facing *Plate 162* headpiece a sensitive if romanticized ploughman works his horses against a vivid sky. The destructiveness of earth, sea, fire, and air is dramatically described in the opening scenes to chapter 9. As with his single prints, White formalizes these views; like John

[198] Bliss, *A History of Wood-Engraving*, 217.
[199] See Peyton Skipworth, Introduction to exhibition catalogue, *Ethelbert White, 1891–1972: A Memorial Exhibition* (London: The Fine Art Society, 3–21 Dec. 1979), unpaginated.

Pl. 161 (*right*). Ethelbert White:
The Wedding Songs of Edmund Spenser
(Golden Cockerel Press, 1923). 182 × 110

Pl. 162 (*below*). Ethelbert White:
Richard Jefferies, *The Story of My Heart*
(Duckworth, 1923). 354 × 236

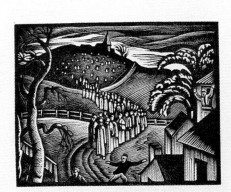

' *If the whole of the dead in a hillside cemetery
were called up alive from their tombs, and walked
forth down into the valley . . .* ' (*page 117*)

CHAPTER X

UNITED effort through geological time in front is but
the beginning of an idea. I am convinced that much
more can be done, and that the length of time may be
almost immeasurably shortened. The general prin-
ciples that are now in operation are of the simplest
and most elementary character, yet they have already
made considerable difference. I am not content with
these. There must be much more—there must be
things which are at present unknown by whose aid
advance may be made. Research proceeds upon the
same old lines and runs in the ancient grooves.
Further, it is restricted by the ultra-practical views
which are alone deemed reasonable. But there should
be no limit placed on the mind. The purely ideal is
as worthy of pursuit as the practical, and the mind is
not to be pinned to dogmas of science any more than
to dogmas of superstition. Most injurious of all is the
continuous circling on the same path, and it is from
this that I wish to free my mind.

114

Nash, he appreciated the rhythm and pattern of landscape, often simplifying it by concentrating on planes and textures. In a view of the Royal Exchange—an uncharacteristic urban subject—he draws on architectural shapes, and peoples the scene with familiar doll-like figures.

White's technique is bold and precise consisting mainly of parallel lines varying in length and width, short furrows, scorped marks, and occasional cross-hatching. Gouged areas of white contrast with heavy blacks. Double-page spreads are carefully planned, with the top edge of each block level with that opposite. Like most white-line illustrations of this period, however, they are rather too dark to balance well with the area of type. Working for a commercial firm White presumably had little chance for close involvement in the process of production. He had even less opportunity with his only other wood-engraved book commission: designs for the Penguin Illustrated Classics edition of Thoreau's *Walden* published in 1938. His freer, more naturalistic style, apparent in a series of large forest prints of the early 1930s is absent from these illustrations. Although White captured the essence of the wooded New England landscape, these engravings are roughly hewn and too heavy for the flimsy yellowish paper used for this cheap pre-war paperbacked series.

By 1940 he had abandoned the tight limitations of wood-engraving in favour of watercolour and oil painting. For all their individuality his wood-engraved illustrations were never in a truly modern idiom, his early books being firmly based on eighteenth-century models, the later books on British landscape tradition. None the less White's visually arresting images and well-considered layout for *The Story of My Heart* make this one of the most significant illustrated books of the period.

Clifford Webb (1895–1972), an almost exact contemporary of White, took up illustration later, producing the major proportion of it after 1940. Both artists had a similar approach to wood-engraving with an emphasis on patterning and tonal textures and on clearly defined light and dark areas. Both avoided abstraction yet simplified and stylized landscape and narrative scenes, describing them in expressionistic terms rather than in a realistic or purely decorative manner.

Webb started his career as an apprentice to a London firm of lithographers. He received no official art training until after the First World War when he attended the Westminster School of Art under Walter Bayes and Bernard Meninsky from 1919 to 1922. He taught himself wood-engraving around this time as he was 'intrigued with pattern and wood is such a good medium for learning something about it'.[200] His earliest illustrations appeared in 1927 in a paper-covered booklet, *Four Parables from the Holy Bible*, printed under the direction of Leonard Jay by the Printing Department of the Birmingham Central School of Arts and Crafts where from 1923 to 1926 Webb had taught,

[200] T. W. Earp, 'The Work of Clifford Webb', *Studio*, 101 (1931), 168–73, p. 168. He exhibited at the annual exhibitions in 1924 and 1926, then with the English Wood-Engraving Society, before returning, on its demise, to the original society in 1932, becoming a member in 1936. For further discussion of his work see exhibition catalogue, *A Retrospective Exhibition of the Work of Clifford Webb, RE, RBA* (Leicester: Kimberlin Exhibition Hall, 6–12 Feb. 1982).

specializing in animal drawing.[201] Four rectangular single-page figurative scenes and a small block of a bird and spider's web (most probably alluding to Webb) on the cover are uncomplex but assured engravings using a distinctive range of toolmarks. In *The Prodigal Son*, for instance, thin white outlines, sometimes with a button-hole stitch or wider serrated edging, and shading made up of varying widths of parallel lines, stabs, or dots, stand out against a solid black background pierced in places with white. Heavily gouged trees are seen through the door in *The Labourers in the Vineyard* in which the figures appear frozen in action.

Surprisingly Webb did not produce further wood-engraved illustrations until a decade later, perhaps because during this time he was engaged on illustrating various children's books, mainly written by himself, with line drawings.[202] His most important illustrative work was commissioned by the Golden Cockerel Press between 1937 and 1954. The three books which appeared before 1940 contain some of his finest and most sensitive engraving. The six illustrations to Patrick Miller's *Ana the Runner* (1937) are incisively cut with strong directional lighting throwing dark areas into relief. In the frontispiece the slender, naked figure of the young Ana is outlined in white and softly stippled where the light falls. Interesting textural effects are produced from a variety of toolwork: fine parallel diagonal lines on the sheer rock face, cross-hatched edges to the nearer stones, sweeping zigzag white lines for palm-like leaves, minute dots for the foal's coat, stabbing marks for the pathway, and delicate spots for the land beyond. The contrast between Ana's smooth dark skin and the stark white profile of the horse's neck and flank adds to the drama of the situation, as do the rigid diagonals created by limbs

Plate 163 and boulders, apparent also in the scene of the girl running alongside the sheik's horse and another where her svelte outstretched body spans a perilous crevice. The latter print, though representational, conveys a modernist feel in the angular rock shapes, subtle variations of shading, and ethereal quality of the figure. Webb's approach to the female nude, unlike that of several of his contemporaries, is sensitive rather than sensual.

In comparison to White, Webb was more interested in figure and animal subjects than landscape *per se*. His peculiar affinity with animals and specialist drawing skills led him to portray creatures in a more lifelike manner than people. As Sandford noted, the variety and excitement of army life from 1914 to 1919, especially in India, made him 'aware of the movement in all life and its contrasting speeds—its time and rhythm. There is always movement in Webb's pictures—the panther steals, the horse rears, the mob mills, ships toss and tack into the wind'.[203] A large number of his illustrations include animals, particularly those for his children's books.[204] In his scenes for V. G. Calderon's *The White Lama* (1938) they appear frequently: horses, lamas, pigs, and even a boa-constrictor protecting an Indian child by squeezing a tiger, are sympathetically

[201] From 1934 to 1939 he taught at Westminster School of Art where he took students to the zoo and arranged a special room where they could draw animals. See Simon Brett, 'Clifford Webb, 1895–1972', *Multiples*, 16 (1996), 243–4, p. 243.

[202] Webb's wife, Ella Monckton, wrote the words for several picture books published under his name.

[203] Christopher Sandford, 'Clifford Webb', in Christopher Sandford and Owen Rutter, *Cockalorum* (London, 1950), 67.

[204] In 1936 he illustrated some humorous animal poems by Marmaduke Dixey for Faber and Faber entitled *Words, Beasts & Fishes* with line drawings in the style of wood-engravings.

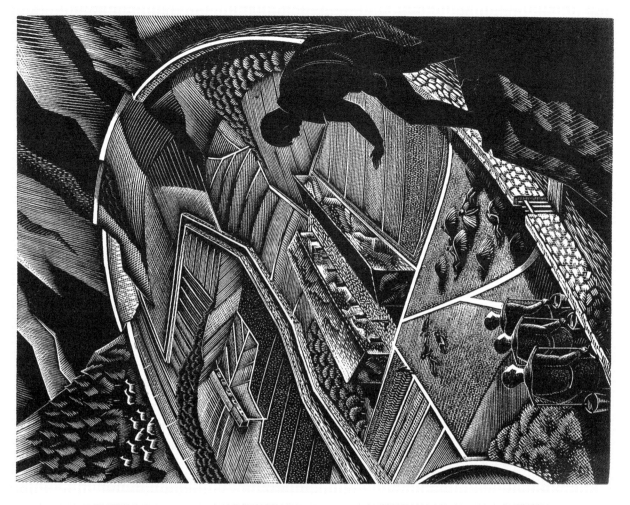

Pl. 164. Clifford Webb: H. G. Wells. *The Country of the Blind*
(Golden Cockerel Press, 1939). 163 × 124

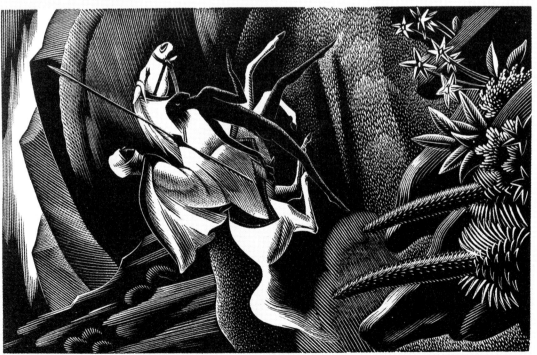

Pl. 163. Clifford Webb: Patrick Miller, *Ana the Runner*
(Golden Cockerel Press, 1937). 144 × 92

handled. In the frontispiece a lama 'decked out for a festival', delicately engraved in white line, anxiously watches on as a sinister man on horseback with cape and hat, framed against the moonlit sky, whips a kneeling peasant. Powerful lighting and emphatic gestures used throughout these action-packed incidents contribute an air of mystery and excitement, as do the varied textural effects from soft stippling to gouged slabs of white and uncleared blacks.

Webb's technical diversity is best displayed in his illustrations to his final Golden Cockerel book, H. G. Wells's *The Country of the Blind* (1939). Although blatant contrasts of light and shade are still present, some of the solid blacks are softened with grey specks and fine white graver marks which he uses liberally for grass, stones, and other materials,

Plate 164 most noticeable in the scene in which three blind men, observed from above by a threatening black figure, follow the curved line of the wall surrounding a stripy patchwork of fields. As so often the subject is viewed from an unusual angle: in this instance, from a high viewpoint, as it is in the scene where Nuñez defends himself from the men, shown here receding along a diagonal crazy-paving path which meets another at an angle; Webb frequently uses diagonal compositional devices in his work. Hodnett claims this particular print to be 'one of the finest wood-engravings made during this great period of autographic wood-engraving'.[205] Sandford, in contrast, felt that, apart from the frontispiece, these illustrations did not quite come off.[206]

Webb's later illustrations for the press, *The First Crusade* (1945) and *The Amazons* (1948), although praised by Sandford and others, were more prosaic and technically less refined. Although he continued to exploit the use of silvery greys and powerful blacks and whites, the factual nature of the subject matter possibly accounted for his less inventive interpretations. Webb's style and technique, like Farleigh's at times, lay between the distinctive mark-making of illustrators such as Ravilious, and the sinuous, fine-lined approach of the Underwood school. His individual wood-engravings are often more effective and original than his illustrative work. He went on to play an important role in the development of colour linocutting.

Norman Janes (1892–1980), though principally a landscape watercolourist and etcher, did several wood-engravings, those of city and industrial life being of particular interest for the scarcity of such subject matter in the medium.[207] He learnt to wood-engrave from W. T. Smith at the Slade where he studied from 1919 to 1920 following lessons in commercial art at the Regent Street Polytechnic before the war. He took evening classes in etching and printmaking at the Central School and from 1923 to 1924 studied under Sir Frank Short at the Royal College of Art. His few wood-engraved books include Charles Williams's *Heroes and Kings* (The Sylvan Press, 1930) with characterful, mainly

Plate 58 black-line illustrations. Despite poor sales, John Johnson, Printer to the Oxford University Press which helped to market the book, pronounced that 'if ever a book was

[205] Edward Hodnett, *Five Centuries of English Book Illustration* (Aldershot, 1988), 286.
[206] Sandford and Rutter, *Bibliography of the Golden Cockerel Press*, No. 142, 40.

[207] See obituary of Norman Janes in *Journal of the Royal Society of Painter-Etchers and Engravers*, 7 (1988), 26–7.

faultless in technique, surely this is'.[208] Friendship with Hubert Foss, the Music Editor of the Press, led to other small commissions from the firm for Janes and his wife Barbara Greg (1900–83), a fellow student at the Slade.[209] In 1940, for instance, Greg contributed eleven wood-engravings of musical instruments to Mervyn Bruxner's *Letters to a Musical Boy*. The majority of her illustrations were of nature and wildlife subjects, the first for G. L. Ashley Dodd's *A Fisherman's Log* (Constable, 1929), followed by scenes for E. L. Grant Watson's *Enigmas of Natural History* (Cresset Press, 1936), and *More Enigmas of Natural History* (1937). These were competent and accurate renderings inspired by Bewick but without great originality. Her earliest book production work included wood-engraved and linocut designs for endpapers. Together with her husband, Greg produced a number of designs for pianola rolls from 1926 to 1930.

Lynton Lamb (1907–77), Production Adviser to the Oxford University Press from 1930, studied wood-engraving and book illustration under Rooke, and lithography with A. S. Hartrick at the Central School (1927–30). Using a variety of techniques he became an important and influential illustrator and designer of books and other commercial work. For his earliest books, mainly for private presses, he employed wood-engraving, the frontispiece to the Fulcrum Press edition of Plato's *Lysis: A Dialogue* (1930) being an especially modish interpretation. He illustrated three Golden Cockerel Press books: *Plate 54* H. E. Bates's *A German Idyll* and Hugh Walpole's *The Apple Trees*, both published in the Guinea Series in 1932, and William Bligh's *The Log of the Bounty* (1937). Thorough historical research accounts for accurate documentary details in the last book, yet the designs for the earlier fictional books are somehow more imaginative.[210] After the war Lamb concentrated on lithography and pen and ink drawing for illustrative work for which he is better known.

John Austen (1886–1948), who worked mainly with line drawing, produced a small output of wood-engraved illustration, some of his earliest, such as for Anatole France's *The Gods are Athirst*, for Bodley Head.[211] In A. B. Cooper's *Poets in Pinafores* (Alston Rivers, 1931), a parody of nursery rhymes by dead and living poets, the stylized designs and simplified patterning are appropriately whimsical and fun: William Shakespeare as Humpty Dumpty, for instance, or Edith Sitwell, for 'Hush-a-Bye-Baby', on a desert island banging a drum. Austen's thick black-line classical figures for Aristophanes's *The Frogs* *Plate 165* (Limited Editions Club, 1937) again suit the nature of the text.

Elizabeth Rivers (b. 1903)[212] is another artist commissioned by Bodley Head whose work has subsequently been shamefully neglected. Figurative scenes for her two books

[208] Quotation provided by Peter Foden, Archivist to the Oxford University Press. See also Ch. 6.3. Janes also produced a wood-engraved dust-jacket for Marischel Murray's *Ships and South Africa* published by the Press in 1930.

[209] See Ch. 5.2. See also Marian Janes's obituary of Barbara Greg, *Journal of the Royal Society of Painter-Etchers and Engravers*, 6 (1984), 31.

[210] Wood-engravings exist for a projected Penguin Illustrated Classics edition of Browne's *Religio Medici and Urn Burial* which was never published.

[211] See Dorothy Richardson, *John Austen & the Inseparables* (London, 1930), with foreword and illustrations, including self-portrait frontispiece, by the artist; Martin Steenson, 'The Book Illustrations of John Austen', *Antiquarian Book Monthly Review*, 9 (1982), 222–7, and Herbert B. Grimsditch, 'Mr John Austen and the Art of the Book', *Studio*, 88 (1924), 62–7. See also Ch. 6.3.

[212] Rivers studied at Goldsmiths' College (1921–4) under Edmund Sullivan, at the Royal Academy Schools (1925–30), and in Paris (1931–4).

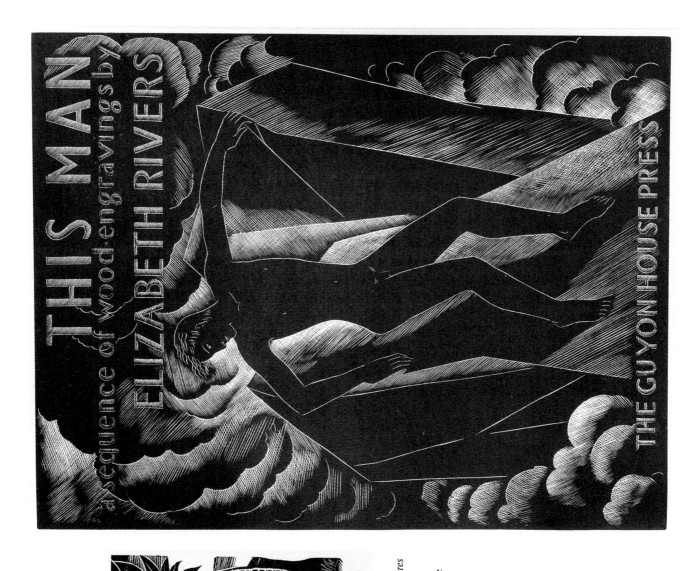

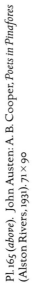

Pl. 165 (*above*). John Austen: A. B. Cooper, *Poets in Pinafores* (Alston Rivers, 1931). 71 × 90

Pl. 166 (*right*) Elizabeth Rivers: *This Man* (Guyon House Press, 1939). 267 × 203

for the Helicon Series[213] are dark and romanticized, in contrast to her lively little images of a pair of shoes, and a child with a doll, among others, for Ffrida Wolfe's *The Very Thing: Read-out-able Rhymes for Children* (Sidgwick & Jackson, 1928)—one of the few wood-engraved children's books of the period. Her designs for a Faber edition of Walter de la Mare's *On the Edge* (1930), with a symbolic eye, a skull and hourglass, ghostly figures, and candlelit faces anticipate her masterpiece, *This Man*, a sequence of twenty-four outsize wood-engravings facing her own short text: a spiritual quest of one man from child-hood, through unknown paths of the universe, to love and consummation. Printed by Theodore Besterman in 1939 at his Guyon House Press, assisted by Vivian Ridler and F. J. Coton, it is one of the most original artist's books of the period.

Plate 166

Of the five illustrated books which contain wood-engravings by Edward Gordon Craig's son, Edward Anthony (b. 1903),[214] André Maurois's *A Voyage to the Islands of the Articoles* (Jonathan Cape, 1928) is the most interesting. Among the four single-page scenes, that showing young Beos girls waiting on an effete Articole, his long limbs draped over the armchair in imitation of Lytton Strachey, is a witty, satirical interpretation of the text which describes the Articoles—writers, artists, musicians—as purely artistic in function. The five black-line wood-engravings (four of them octagonal) for Virgil's *Georgics* (At the Sign of the Dolphin, 1931), though lyrical, lack the vitality of his earlier designs. As Lindsay Newman suggests, 'once freed from the constraints imposed by his father, his independent vision and its expression were quite distinctive',[215] as indeed were those of all the artists mentioned in this chapter.

12.9. *The Grosvenor School of Modern Art: Iain Macnab and his Pupils*

Iain Macnab (1890–1967) is probably best remembered as an inspired teacher and founder of the Grosvenor School of Modern Art.[216] He was a fine painter and draughtsman, coming late to wood-engraving via other print media, etching in particular. He exhibited for the first time with the Royal Society of Painter-Etchers and Engravers in 1927 at the Royal Watercolour Society Galleries.[217] Book illustration accounts for only a small proportion of his wood-engraved *œuvre* which mostly dates from the 1930s. His single prints—usually landscapes or figurative scenes—differ in style from his illustrative work and were generally more influential.

Having studied at the Glasgow School of Art in 1917 and the Heatherley School of Art in 1918, Macnab spent the following year in Paris before returning to become the Joint Principal at Heatherley's, later, in 1925, founding his own school. He had originally

[213] *The Second and Seventh Idylls of Theocritus* (1927) and Tennyson's *The Day Dream* (1928). See Ch. 6.3.

[214] Used pseudonym Edward Carrick.

[215] L. M. Newman, 'Edward Anthony Craig', *Matrix*, 14 (1994), 10–14, p. 13.

[216] See Ch. 5.2. For a fuller discussion see Albert Garrett, *Wood*

Engravings and Drawings of Iain Macnab of Barachastlain (Tunbridge Wells, 1973). The Iain Macnab Papers (proofs of wood-engravings, woodblocks, miscellaneous sketchbooks, and other material) are held at the National Library of Scotland, Edinburgh.

[217] A wood-engraving entitled *Winter*.

intended to become a sculptor but, owing to war injuries, was not strong enough for such physically demanding work. As he explained so lucidly in his practical guide on wood-engraving, he was attracted to this medium by its very limitations.[218] With infectious enthusiasm he impressed its peculiar qualities on his Grosvenor School students in informal classes, stressing the importance of 'truth to the medium' rather than 'truth to nature'. His prints, which are always representational—many of trees, roof-lines, buildings, paths, boats, and figures—have a linear, three-dimensional quality. With varied tooling he wove a tapestry of pattern and textures: an original style which was later developed by his pupils.

Essentially Macnab had a feeling for character. He was a likeable, fun-loving man who, in his own words, loved 'people and all their idiosyncratic vagaries'.[219] (Early in his career he had wanted to be a cartoonist.) He did many figure studies from life, including nudes, and wrote a textbook on the subject.[220] Sketches of men sitting in cafés or standing around, arms crossed or hands in pockets, testify to his acute observation of people and his strong sense of rhythm and curvature, both of which he considered to be expressive of an emotional experience[221]—a particularly relevant factor with his illustrations which, unlike the majority of his single prints, invariably depict moments of drama and action. Garrett suggests that in art the Scots are more emotional than the English and, like the French, are more sensuous and emotionally direct.[222] Certainly the old Scottish ballads combine elements of violence, humour, and romance. It is no coincidence that the two Scotsmen, Douglas Percy Bliss and Iain Macnab, should both choose to illustrate these texts. Few English wood-engravers at the time portrayed the human figure with such exuberance.

Macnab's first illustrations were for a book of old nursery rhymes: 170 copies of *Nicht at Eenie: The Bairns' Parnassus* were printed and published at the Samson Press in 1932. An attractive title-page scene of a moonlit house and hillside is followed by numerous small images, some repeated, acting as head- and tailpieces or interspersed between poems. Some are silhouetted, some are framed, and all are confined to the width of the narrow column of text. Macnab has chosen a chapbook style in keeping with the unsophisticated nature of the rhymes. Many fine white lines relieve the otherwise rather dominant blackness of the blocks, the diminutive size of which prevents them from *Plate 167* being too heavy for the text. Exaggerated facial expressions, such as that of *The Meenister* bring out the humour of the situations. Hand printing accounts for the crisp and fresh quality of these animated designs.

Macnab's next book, Robert Burns's *Tam O'Shanter*, was also printed by the Samson Press; 250 copies were produced, with thirteen rectangular, text-width headpieces. These are mainly black with thin white outlines and stippled shading and, although rather dark, evoke the mood of the text. Macnab dramatically emphasizes light and shadows. *Plate 168* The wild dancing of the ghoulish 'warlocks and witches' makes an interesting comparison

[218] Iain Macnab, *Wood-Engraving* (London, repr. 1947), 2. For quotation see Ch. 1.

[219] Garrett, *Iain Macnab*, 79.

[220] Garrett, Iain Macnab, *Figure Drawing* (London, 1936).

[221] *Iain Macnab*, 52.

[222] Ibid.

THE MEENISTER in the pulpit
He couldna say his prayers,
He laughed and he giggled,
And fell down the stairs.
The stairs gien a crack,
And he broke his humphy back,
And a' the congregation
Gaed quack, quack, quack.

KATIE BEARDIE had a coo,
Black and white about the mou'.
Wasna that a bonnie coo ?
 Dance, Katie Beardie !
Katie Beardie had a hen,
Cackled but and cackled ben.
Wasna that a bonnie hen ?
 Dance, Katie Beardie !
17

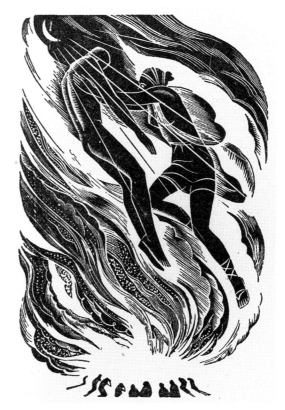

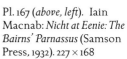

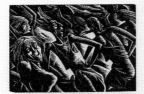

Which even to name wad be unlawfu'.
Three Lawyers' tongues turn'd inside out,
Wi' lies seam'd like a beggar's clout ;
Three Priests' hearts, rotten black as muck,
Lay stinking vile, in every neuk.

As Tammie glowr'd, amaz'd, and curious,
The mirth and fun grew fast and furious ;
The Piper loud and louder blew.
The Dancers quick and quicker flew,
They reel'd, they set, they crossed, they cleekit,
Till ilka Carlin swat and reekit,
And coost her Duddies on the wark,
And linket at it in her sark !

Now Tam, O Tam ! had thae been queans,
A' plump and strapping in their teens !
Their sarks, instead o' creeshie flainen !
Been snaw-white seventeen-hunder linen ;
9

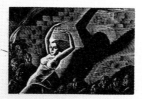

Thir breeks o' mine, my only pair,
That ance were plush, o' guid blue hair,
I wad hae gien them off my hurdies,
For ae blink o' the bonie burdies !
But wither'd beldams, auld and droll,
Rigwoodie hags wad spean a foal,
Loupin an' flingin on a crummock,
I wonder did na turn thy stomach.

But Tam kend what was what fu' brawlie ;
There was ae winsome wench and waulie,
That night enlisted in the core,
(Lang after ken'd on Carrick-shore ;
For mony a beast to dead she shot,
And perish'd mony a bonie boat,
And shook baith meikle corn and bear,
And held the Country-side in fear) ;
Her cutty sark, o' Paisley harn,
That while a lassie she had worn,
10

Pl. 167 (*above, left*). Iain Macnab: *Nicht at Eenie: The Bairns' Parnassus* (Samson Press, 1932). 227 × 168

Pl. 168 (*left*). Iain Macnab: Robert Burns, *Tam O'Shanter* (Samson Press, 1934). 227 × 305

Pl. 169 (*above, right*). Iain Macnab: *Artemis and Hippolutos* from Robert Browning, *Selected Poems* (Penguin Illustrated Classics, 1938). 126 × 84

Plate 132 with Bliss's version of the subject in *The Devil in Scotland* published in the same year. Both images are similarly grotesque and eerie but Macnab's is more crowded and frenzied. In several scenes he concentrates on the upper torso and faces of the characters which show greater individualism than those of Bliss. Macnab, more than most wood-engravers, imbues each figure with personality, often a difficult task on such a small scale. Both artists depict Tam O'Shanter as a silhouetted horseman stampeding across a stormy sky. A striking repeat-pattern design of the rider printed from a linocut block is used for the endpapers.

In 1938 Macnab illustrated Robert Browning's *Selected Poems* in the Penguin Illustrated Classics series. The sixteen wood-engravings, some whole page and some head- and tailpieces, are irregularly dispersed throughout the text. Apart from the decorative title-page (incorporating a glass-cased penguin) and a moonlit coastal scene, most of the illustrations are figurative and are more fluidly handled than earlier work. There is a monumentality and calmness about them which is absent in his more boisterous illustrations. The headpiece to 'Pippa Passes' shows the young girl in bed by an open window awaking to the rising sun, whilst in the tailpiece she is seated by a candle, gazing at the starlit sky. Both prints are executed in the simplest white, textured outline, the reflection of the sun and candlelight on the face being most sensitively described. In complete contrast, an uncharacteristically metaphysical image accompanies the florid poem 'Abt Vogler'. A tiny naked man kneels within the arms of a monumental bearded figure while other people reach up below, all enveloped in swirling lines reminiscent of Underwood-style subject matter, if not so sensuously handled. On the whole Macnab seems less at ease in this symbolic vein, although the image of the goddess Artemis bearing the body of Hippolutos [*sic*] above the flames of the funeral

Plate 169 pyre in 'Artemis Prologizes' is a satisfying interpretation.

Macnab's most technically accomplished illustration appears in *The Sculptured Garden* published by the Dropmore Press in 1948. Although by this time his line is more fluent and sculptural, and he is more concerned with harmonizing blocks with text, his designs somehow lack the vitality and vigour of his earlier work. Most of his illustration, however, was a diversion from his individual wood-engravings and other work. It was the distinctive style of these prints and his teaching methods which made such an impression on his pupils, especially Gwenda Morgan, Peter Barker-Mill, Alison and Winifred McKenzie, and Guy Malet.

When in 1929 J. G. Platt came to teach wood-engraving at Goldsmiths' College School of Art, the medium immediately appealed to Gwenda Morgan (1908–91), a final year student.[223] She went on to study at the Grosvenor School from 1930 to 1936 where she was encouraged by Macnab to join his informal wood-engraving class. She recalled particularly his sense of humour and his keenness on design, hallmarks of her own

[223] See Ch. 5.2. See also *The Wood-Engravings of Gwenda Morgan*, selected with an introduction by John Randle (Andoversford, 1985), and John Randle, 'Gwenda Morgan, 1908–1991', *Matrix*, 11 (1991), 169–71.

work.[224] Macnab, who considered her to be his most talented pupil, introduced her to the owner of the Samson Press, Joan Shelmerdine, who commissioned her first book illustration, and to Christopher Sandford, for whom she illustrated four books between 1937 and 1956. It is these Golden Cockerel Press books for which she is best known, particularly *Gray's Elegy* (1946), one of Sandford's favourite productions. Yet Gwenda Morgan was never entirely happy with her illustrations. Shy and self-effacing, she disliked the pressure of working for publishers and preferred what she called 'exhibition' prints. Much of her wood-engraved work was for greetings cards and other ephemera printed at the Samson Press.[225]

In the early 1930s she had been asked by a friend, Christine Chaundler, who wrote children's verses and girls' school stories, to illustrate some of her verses.[226] She did some wood-engravings but they were unable to find a publisher who liked both poems *and* illustrations. A few years later, Shelmerdine asked D. G. Bunting to write verses to suit the engravings which she published together as *Pictures and Rhymes* in 1936. With a poem to a page, Morgan arranged her designs as head- and tailpieces and within the text. Most are figurative—a lad boot-cleaning, a butcher boy, a cook—with small scenes of wheelbarrows, a bus, sunflowers, rabbits, and mice. The blocks are all strongly and crisply cut with areas of black and white broken up with robust parallel lines, sometimes cross-hatched, and grass and flowers patterned with small flecks and striations. An unusually thick black line surrounds most of the images giving them a naïve, cut-out appearance. The *mise en page* is carefully considered, the engravings breaking up the text and flowing from one to the next. A reversed L-shaped block for 'The Tree' and facing roundel for 'The Apple King' combine with the text to create a particularly effective double-page spread. This rare little book contains some of Morgan's most appealing illustrations.[227]

Plate 170

Six single-page wood-engravings for T. F. Powys's *Goat Green*, published by the Golden Cockerel Press in 1937, put Gwenda Morgan's work on the map. In the press bibliography Sandford writes of 'T. F. Powys at his most satirical, abetted by Gwenda Morgan with her subtle "tapestries in wood"'.[228] While she denied the influence of Macnab, such effects made up of incisive and varying toolmarks are certainly strong elements in his wood-engraved *œuvre*. She particularly admired the work of Ravilious, Bliss, and O'Connor and it is perhaps Ravilious's stylized design and clean-cut technique that hers most resemble, though her naïve and idiosyncratic style belies her immense technical skill. She disliked ultra-fine work, thinking it too sophisticated, and was concerned with decorative design rather than symbolism.

Her interpretations match the humour of Powys's text. In the frontispiece a bowler-hatted man sits in the road watched by a bemused goat while the Reverend Humble is

[224] Conversation between Gwenda Morgan and the author, 6 July 1983.

[225] Although she exhibited at the Society of Wood Engravers' exhibitions during the 1930s, she never became a full member but was a member of the Royal Society of Painter-Etchers and Engravers.

[226] Gwenda Morgan to the author, 10 Nov. 1990.

[227] A commission from the publishers Arthur Barker for some chapter headings for Margaret Duley's *The Eyes of the Gull* was carried out the same year.

[228] Sandford and Rutter, *Bibliography of the Golden Cockerel Press*, No. 128, 27.

Plate 171 seen running up the church path. Lack of competence at drawing figures accounts for their wooden appearance. This is particularly apparent in the scene of Mr Pike with Jenny Honeybun hooked on his fishing line, both looking exceedingly gawky. Morgan was unhappy with the couple on page 28 and the girl's face on page 51.[229] She objected to the over-romantic subject matter of the book and did not like her illustrations to it, preferring country scenes to figurative satire.

Not surprisingly she was taxed by her next Golden Cockerel commission, A. E. Coppard's *Tapster's Tapestry* (1938), described by Sandford as the work of 'the inimitable Coppard in thoughtful and ironically allegorical mood'.[230] She produced ten, mostly whole-page, wood-engravings. The small landscape vignettes are pleasing but the figures in most of the single-page scenes are static and awkward, particularly that of the Arab

Plate 172 executioner cutting off a soldier's head which lies gaping on the ground. Morgan felt that the back view of the three standing men on page 4 looked amateurish. Her toolwork in these blocks lacks the variety evident in that for individual prints.

Although Morgan's third Golden Cockerel book, *Gray's Elegy written in a Country Church-yard*, was published in 1946, it is worth mentioning here since in it her particular skills are pursued to perfection. Meticulously engraved lines create a lyrical feeling and warmth not achieved in her earlier illustration. Through subtle treatment of contrasting tones the landscape, softened with shadows, basks in mellow sunlight. Even the figures seem more relaxed. In general Morgan liked to put as much detail as possible on the block, leaving few blank areas; here she achieves her aim without in any way cluttering the scenes. Sandford was justifiably delighted with these engravings which 'though entirely in the modern vein, proved a perfect complement to the eighteenth century text. Technically dexterous, they were also delightfully interpretative of village life in England and the unchanging face of the land.'[231]

While some of Morgan's landscapes were of the Sussex countryside, a large number of her views were imaginary, made up of 'bits and pieces' she had sketched when out walking. (In her later work she liked to compartmentalize several incidents in one picture rather in the way that the contemporary wood-engraver John Lawrence chooses to do.) She had a 'particular fondness for straight and diagonal lines' and described her working method thus:

When I had thought out my composition I made a quite detailed pencil drawing and shaded it so that I knew just where the light went behind dark and dark behind light. The drawing was usually on paper thin enough to use for tracing on to the block (through red carbon paper). … I like a print to look bright and not gray due to too much cross-hatching and I like it to be on white paper.[232]

She used the spitsticker rather more than the graver, avoiding tint and multiple tools which she thought too mechanical. Having first sent her galley proofs, Sandford always

[229] Conversation between Gwenda Morgan and the author, 6 July 1983.
[230] Sandford and Rutter, *Bibliography of the Golden Cockerel Press*, No. 172, 35.

[231] Ibid.
[232] Answers to a questionnaire, *Multiples*, 27 (1991), 325–6, p. 325.

THE TREE

I know an
ordinary tree,
easy to climb —
like going upstairs,
which nobody ever
climbs but me
on my most
personal affairs.

Deep on the
very topmost bough
I've carved my name
against the time
when, lurking
mournfully below,
I fear I'm
far too old to climb.

THE APPLE KING

Admire the Apple King,
His Most Complacent Majesty.
But leave him alone :
His present throne
Looks pretty perilous to me.

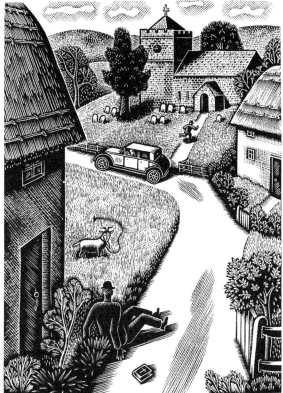

Pl. 170 *(top)*. Gwenda Morgan: D. G. Bunting, *Pictures and Rhymes* (Samson Press, 1936). 229 × 338

Pl. 171 *(above, left)*. Gwenda Morgan: T. F. Powys, *Goat Green* (Golden Cockerel Press, 1937). 142 × 113

Pl. 172 *(above, right)*. Gwenda Morgan: A. E. Coppard, *Tapster's Tapestry* (Golden Cockerel Press, 1938). 141 × 101

Pl. 173. Peter Barker-Mill: Owen Rutter (introd.), *The First Fleet* (Golden Cockerel Press, 1937). 102 × 127

saw her preliminary drawings and gave her a fairly free hand; yet she was still not always happy with the results. She was especially disappointed with her last Golden Cockerel Press illustrations, for *Grimm's Other Tales* (1956), which were printed on rough paper and were over-inked, but at least the more vigorous style which she had by then developed could stand up to this handling better than her earlier work.

Gwenda Morgan will best be remembered for her stylized country scenes and puppet-like figures portrayed with clear-cut precision. Like Ravilious she brought a refreshing modernity to the traditional Bewick aesthetic and enlivened contemporary literature with her whimsical interpretations.

Peter Barker-Mill (b. 1908) studied at the Grosvenor School of Art from 1931 to 1933. He illustrated four books for the Golden Cockerel Press, two in 1937: *Bligh's Voyage in 'The Resource'* and *The First Fleet*. His fine-line technique is sensitive and his style, though representational, is individual: full of movement and rhythmic line. His most imaginative work, however, dates from the 1940s. In Sandford's eyes his prints for Anders Sparrman's *A Voyage Round the World* (1944), which included semi-abstract depictions of icebergs, 'were revolutionary, and a highly successful step forward in the adaption of the wood-engraving medium to modern art'.[233]

Plate 173

Although it appears that Alison McKenzie (1907–82), another of Macnab's pupils, did no book illustration, her wood-engraved frontispiece to Milton's ode and hymn, *On the Morning of Christ's Nativity*, printed by the Gregynog Press in 1927, is worthy of note.[234] As Dorothy Harrop notes, it is one of the most attractive and valued pieces of ephemeral printing ever produced at the press.[235]

[233] Sandford and Rutter, *Bibliography of the Golden Cockerel Press*, No. 162, 20.
[234] Used as a Christmas card by the Davies sisters.
[235] Dorothy A. Harrop, *A History of the Gregynog Press* (Pinner, 1980), 160. Alison and her sister Winifred McKenzie moved to St Andrews and, with Annabel Kidston (b. 1896), started a wood-engraving and drawing class for the troops stationed there. With the Polish artist Jozef Sekalski, they formed the St Andrews Group. Kidston, who had studied wood-engraving at the Slade under Thomas Smith, produced some strong illustrations for Matthew Arnold's *The Forsaken Mermaid, and The Scholar Gypsy* (Bodley Head, 1927).

⤳ 13 ⤳

THE SINUOUS LINE: A TONAL APPROACH

13.1. *The Underwood School and its Followers*

In 1934 Bliss noted that 'the whole progress in the art [of wood-engraving] during the last ten years has been away from the funereal grimness that made former exhibitions so depressing'.[1] In the early 1920s the predominance of blacks and stridently contrasting whites, with little tonal variety, came about partly through lack of technical skill, partly as a reaction against the insipid greyness of Victorian reproductive engravings, and partly as a result of 'a craze for large handling and smashing pattern'.[2] Yet, by the mid-1920s, various practitioners were reverting to a more tonal approach to the medium. Bliss was among a number who broke away from the Society of Wood Engravers to join the supposedly more forward-looking English Wood-Engraving Society. As discussed earlier,[3] one of the reasons for the establishment of a rival society was that new stylistic and technical ideas were beginning to emerge both independently and from art schools, especially from that of Leon Underwood at Brook Green.[4]

Underwood (1890–1975) was an exceptionally broad-minded and cosmopolitan teacher and his school, which set out to break away from 'the harmful and repressive influences of orthodox training',[5] was more continental in outlook than many other art schools. Also, as Katharine Eustace points out, the students' socialist leanings 'were as much a part of everyday life as the serious business of learning to draw'.[6] Unusually, Underwood encouraged from the start the instructive discipline of printmaking, installing an etching press. But it was a young American student, Marion Mitchell (1903–94), who first introduced wood-engraving to the classes in 1923.[7] Inspired by Underwood's experimental approach to printmaking and his spiritual concept of a work of art, other students, Blair Hughes-Stanton and Gertrude Hermes in particular, developed and refined the technique using long, sinuous white lines and a complex range of textures and tones. They considered the Society of Wood Engravers' exhibitions to be old-fashioned in their range of subject matter and technique and disagreed with the emphasis laid by some committee members on book illustration which they thought was less

[1] Douglas Percy Bliss, 'The Last Ten Years of Wood-Engraving', *Print Collector's Quarterly*, 21 (1934), 251–71, p. 251.

[2] Ibid.

[3] See Ch. 5.1.

[4] See Ch. 5.2.

[5] Prospectus, quoted in Christopher Neve, *Leon Underwood* (London, 1974), 45.

[6] Katharine Eustace, 'Underwood's Children', in exhibition catalogue, *The Wood Engravings of Gertrude Hermes and Blair Hughes-Stanton* (Oxford: Ashmolean Museum, 1995), 12.

[7] See following chapter. Thomas Balston, *English Wood-Engraving, 1900–1950* (London, 1951), 13, inaccurately states that she had been taught by Gibbings. She had in fact initially been inspired by his simplified silhouette style and sharp contrasts. His modernness encouraged her to experiment in the summer of 1923, having joined Underwood's school in April. Conversation between Marion Mitchell and the author, 19 Mar. 1985.

imaginatively creative than were artists' prints.[8] Although several critics felt that the younger society, initiated by members of the Underwood group, showed more originality, its exhibitions did not prove to be especially radical.[9] When it was dissolved in 1932 several members joined the original society and proceeded to exhibit both single and illustrative prints.

The use of the multiple tool or *vélo*[10] was a cause for concern amongst some critics who felt that it made wood-engraving appear facile and mechanical;[11] a view which Enid Marx declares 'was in line with a sort of negative puritanism of the time'.[12] Confusion exists over its use amongst Underwood's circle. Balston's claim that Mary Groom introduced the tool to Brook Green is inaccurate.[13] According to Marion Mitchell a 1923 exhibition catalogue of Dmitri Galanis's wood-engravings inspired her to learn from the artist in Paris how to arrive at the effects he achieved so magically.[14] She brought back two or three multiple gravers and taught the others to use them. Underwood himself was excited by wood-engraving having already produced many fine etchings. An ex-pupil, Margaret Wells, feels that the medium excited him because of its uncompromising nature but suggests that he, too, was not entirely in favour of the multiple tool for its mechanical results.[15] Several contemporary critics believed that it was constantly used by him and his pupils to achieve their translucent tonal effects. The fact is that they used the tool only briefly as an experiment and largely abandoned it once they had evolved greater linear variation with other tools, particularly the tint tool. None the less, the brief period of use was of vital significance since it acted as a catalyst for further explorations with more fluid tonal techniques and what the group called 'new stitches', the collective hallmarks of their wood-engravings.

At the 1934 Society of Wood Engravers' exhibition Bliss particularly admired the way the younger artists enriched their work with finer cutting, more varied textures, and greater colouristic range by using the tint tool and spitsticker for modelling forms and laying tints and by contrasting 'the fine gossamer passages with others of more robust cutting with scorpers'.[16] It is interesting to speculate to what extent these techniques coincided with the desire to express more sensual subject matter. (Gill, as has been seen, softened his line for some of his more seductive illustrations.[17]) Most of the engravers discussed in successive chapters (not all of whom had studied under Underwood) were at some stage obsessed with the nude figure. Both Marion Mitchell and Lettice Sandford talked of D. H. Lawrence being 'in the air'.[18] Margaret Wells recalls that his books were

[8] For further discussion of the rival societies see Ch. 5.1.

[9] Richard Godfrey, *Printmaking in Britain* (London, 1978), 121, considers that, as in other English art of the period, the modernist approach of the group is expressed 'more in a distortion of figurative types than in any new approach to formal structure and this uneasy alliance is often mannered and eclectic'.

[10] See Ch. 1.

[11] For instance, though Clare Leighton, *Wood-Engraving and Woodcuts* (London, 1932), 9, found it 'useful for even greys', she considered it 'a very dangerous tool, apt to make the work look cleverer than it is and mechanical'.

[12] Enid Marx to the author, 9 Oct. 1990.

[13] Balston, *English Wood-Engraving*, 14.

[14] Marion Stancioff (née Mitchell) to the author, 22 Sept. 1987. From the blockmaker, Lawrence, she learnt that the multiple graver was the tool that the Victorian reproductive engravers used to get their tonal effects.

[15] Margaret Wells to the author, 13. Oct. 1990.

[16] Bliss, 'The Last Ten Years of Wood-Engraving', 263, 265.

[17] See Ch. 11.2.

[18] Conversations between the author and Marion Mitchell and Lettice Sandford, 1987. Frieda Lawrence's daughter, Barbara Weekley, was a pupil at Brook Green.

making a great impact and that his influence 'was very definitely a part of Leon's ambience'.[19] In his biography of the author, Anthony Burgess writes that the 1930s 'were great days for the young who looked for sex in books, and they can never be recovered in an age of permissiveness. Literature was the way into a forbidden world.'[20] This statement not only explains the interest taken in Lawrence's philosophy of freedom of thought and in moral issues as expressed in his writings which seemed so excitingly liberating and unconventional to art students, it also accounts for the demand for the mildly erotic productions of private presses such as the Golden Cockerel.[21] The *Connoisseur* critic noted this 'creeping tendency' in limited editions and 'a definite streak of unpleasantness'.[22] Certainly the organic rhythms of Lawrence's writing and his symbolical and sexual imagery manifested themselves in much of Hughes-Stanton's and, to a lesser extent, Hermes's work. The undulating line and silver tones of their work, and that of others of their circle, were aptly suited to such subject matter. Depiction of the human body in an imaginative, often suggestive, vein was the dominant theme. Yet, as with Gill's nudes, there is a paradox between the blatant sensuality of the figures and their impersonal charmlessness.

The initial aim among Brook Green wood-engravers to concentrate on individual prints failed largely as a result of the financial climate; the economic slump of the 1930s affected the print business more than any other branch of art dealing. Private presses also had their problems. As has been seen Gibbings was forced to sell the Golden Cockerel Press to Sandford in 1933. Only by using commercial printers did the press survive. In 1932 T. E. Lawrence believed the Gregynog Press to be 'almost the only precious press still putting work out' in 'a bad season for rich books'.[23] On the other hand the popularity of mass-produced wood-engraved books such as Constable's *The Adventures of the Black Girl* provided practitioners with new incentives to illustrate for a wider audience. Ironically, therefore, it was book illustration through which the Underwood School of wood-engravers made their reputation. Yet, for all their success in this field, the three most significant artists, Underwood himself, Hughes-Stanton, and Hermes, ought properly to be considered as printmakers rather than illustrators or book decorators. The analysis of their illustrative work which follows seeks to justify this contention.

[19] Margaret Wells to the author, 13 Oct. 1990.
[20] Anthony Burgess, *Flame into Being* (London, 1986), 2. On 8 Dec. 1932 'indecent' prints by Hughes-Stanton and Gill were seized by the US Customs.
[21] See Ch. 6.2, 'Private Presses'.

[22] *Connoisseur*, Feb. 1930. SWEA.
[23] T. E. Lawrence to William McCance, 14 Oct. 1932. Quoted from Kathleen Ladizesky, 'Aspects of the Gregynog Press, 1930–33', *Private Library*, 7 (1984), 79–98, p. 94.

13.2. *Leon Underwood*

It is a paradox that what is now known as the Underwood School of wood-engraving is largely based on the work of his pupils, in particular Hughes-Stanton and Hermes and *their* followers, rather than on his own work. He learnt as much from them as they did from him, though in most instances his technique is much less refined. Best known for his contribution to British sculpture, his wood-engraved *œuvre*, confined to the early 1920s to mid-1930s, forms a relatively small proportion of his total output.[24]

Underwood's artistic theories were partly based on an affinity with primitive art, particularly palaeolithic cave paintings and the sculpture of Mexico and Africa. He firmly believed in the primacy of subject in art—the antithesis of Fry's 'significant form'—with the human figure dominating both his and his followers' works. The common aim of the short-lived Neo-Society of which he was President was 'to revive the problem or symbolic picture in modernist or even cubist terms'.[25] Although Underwood purposely avoided abstraction, for him the spiritual content of a work of art was all important.

The Underwood School philosophy was articulated in *The Island*, a magazine which ran to four issues in 1931, financed by a pupil Eileen Agar and edited by Joseph Bard. Intended to represent a synthesis of art and literature, it contained articles, poems, and pictures, many of them wood-engraved, by artists including Underwood, Hughes-Stanton, Hermes, Chubb, Agar, Mary Groom, Nora Unwin, and, most interestingly, Henry Moore, who contributed his only two wood-engravings, both semi-abstract. Not strictly illustrations since they rarely relate directly to the often rather pretentious text, these designs are significant as a reflection of the Brook Green house-style which was scorned by the *Apollo* reviewer among other critics: 'The "Islanders", however, seem to be moving, in so far as their graphic art is concerned, in a negroid circle with an embryonic complex, in which Mr. Hughes-Stanton's and Gertrude Hermes' wood-engravings on pages 11 and 32 excel. Messrs. Underwood and Moore must forgive one for regarding their wood-engravings as rather lamentable nonsense.'[26] Yet, notwithstanding their detractors, both the Islanders and the Neo-Society 'formed the vanguard which softened up public awareness in advance of Surrealism'.[27]

Although Underwood's earliest attempts at wood-engraving around 1925 are fairly crudely handled (showing the influence of Derain's and Gauguin's Expressionism),[28] there is a feeling of modernity about the monumental rhythmic figures and open cutting with grid-like cross-hatching. *Human Proclivities*—a set of eight allegorical white-

[24] *Leon Underwood: His Wood Engravings*, with an introduction by George Tute (Wakefield, 1986), is a useful record with illustrations printed from the original blocks.
[25] *Daily News*, 9 May 1930. Quoted from Leon Underwood's press-cuttings book. Conway Library, Courtauld Institute of Art, London, henceforth CIA. The society's only exhibition was held in Godfrey Phillip's Gallery in 1930.
[26] *Apollo*, 14 (1931), 235. CIA.

[27] James Hamilton, *Wood Engraving & the Woodcut in Britain, c.1890–1900* (London, 1994), 119. Frances Carey and Antony Griffiths, *Avant-Garde British Printmaking, 1914–1960* (London, 1990), 90, consider that many of the prints in *The Island* 'show a precocious awareness of Surrealism'.
[28] Gauguin's print, *Noa-Noa*, was shown in the Society of Wood Engravers' exhibition in 1923.

line figure subjects, cut as an experiment on lino with a graver—are startling images.[29] Other, finer-lined wood-engravings, such as *Co-Eternal*, are equally powerful. His knowledge of stone carving is evident from the faceted treatment of the bodies' surface form. Underwood's leitmotif of primal nude figures is more apparent in his single prints than in his book illustrations which are mostly anecdotal. In these he seems to be more aware of the typographic possibilities of wood-engraving than were his pupils, adapting his technique to balance with the overall page.

During 1926 and 1927 he visited America where he executed a number of page drawings for *Vanity Fair* and received his first wood-engraving commission from the New York firm of John Day and Company: eight illustrations for *Music from Behind the Moon*, a collection of mildly pornographic poems translated from the French by James Branch Cabell. Christopher Neve considers that Underwood injected into them a good deal more poetry than the text deserves.[30] Certainly in the frontispiece, depicting the title of the book, Underwood gives full rein to his poetic imagination. A reclining naked man, lyre in hand, gazes up at a voluptuous female whose profile floats on the face of the crescent moon; her curvaceousness contrasts with his bony angularity, their limbs highlighted in white, lightly fringed with parallel lines. Finely engraved, some areas are more tightly handled and textured than others. A scene of a man in a fractured

Plate 174 architectural setting, his contorted muscular legs straddling the Vorticist-like stairs,
Plate 178 bears a strong resemblance to Hughes-Stanton's image in *The Seven Pillars of Wisdom*.

Towards the end of 1926 Underwood wrote and illustrated his own book, *Animalia, or Fibs about Beasts*. He adopted the idea of Apollinaire's *Le Bestiaire ou Cortège d'Orphée* with woodcuts by Dufy. The boldness of his cutting in the wood-engravings likens them to
Plate 175 linocuts. The use of the scorper is particularly evident in the illustration for *Elephant*: the two-fingered tip of its trunk pointedly breaks through the frame to pick up a needle. A marvellously decorative frieze-like picture of dolphins reveals Underwood's sense of design and feeling for the printed page, with lettering and verse carefully balanced with the weight of the print. In contrast to these robustly handled black and white designs, the endpiece depicting *The Ark*, inspired by a visit to the caves of Altamira in 1925, is executed in a thin, scraperboard-like manner, with white-line creatures and figures scratched on the looming black mountain which is surmounted by a silhouetted Ark.[31]

Underwood's narrative for *The Siamese Cat* (1927), published by the New York firm of Brentano's, articulates many of his ideas, including the superiority of intuition over logic. Like his text, his seventy illustrations are witty yet symbolic. His interest in the *mise en page* is evident from the unusual way in which he randomly incorporates the blocks at all angles within the text, allowing a row of mice to scamper over the top of every page. The title-page is particularly effective, the lettering being surrounded by incidental scenes in a clean-cut, typographically sympathetic style. Representational yet idiosyncratic, these have an affinity with Paul Nash's figurative illustrations.

[29] Issued as a portfolio by the St George's Gallery in 1925.
[30] *Leon Underwood*, 92.
[31] The book was awarded the New York Publishers' prize for book design. *Bird and Fish* was advertised as print of the year by the Weyhe Gallery, New York, which published the designs and others on the same theme in editions of 50 signed proofs.

According to Neve a series of illustrations for Eugene O'Neill's *Emperor Jones* was rejected by the publishers.[32] This may well be a set of eight large prints, most probably linocuts reduced in size which were used for Phillips Russell's *John Paul Jones: A Man of Action* (Brentano's, 1927).[33] These narrative renderings of sailors firing cannons at a pirate's ship, an admiral on deck, a costumed ball scene, and other naval happenings are surprisingly retrograde for Underwood at this stage both in style and technique. Only a specific illustrative commission could have accounted for this kind of work.

On a trip to Mexico in 1928 Underwood was deeply influenced by Mayan and Aztec art. He produced some of his most impressive single wood-engravings around this time. His illustrations for Phillips Russell's *Red Tiger: Adventure in Yucatan and Mexico* (Brentano's/Hodder & Stoughton, 1927) consist of an unusual mix of black- and white-line drawings and whole-page colour wood-engravings: the first and virtually the only commercially printed book using such prints until the appearance of Raverat's *The Bird Talisman* ten years later. For his seven plates he used in almost every case four colours (a dark blue key block, light blue, green, and orange) to vivid effect.[34] Despite an English edition, his work was less known and appreciated in England than in America. Nevertheless he was chosen as one of the fourteen contributors to the Cresset Press *Apocrypha* in 1929, for which he depicted *The Dream of Mardocheus* with volcanoes and dragons in an appropriately mythological vein. In complete contrast to his American illustrations, the *Plate 176* four for his manifesto, *Art for Heaven's Sake* (Faber and Faber, 1934), are in line with his more spiritually inclined single prints. In this little paper-covered pamphlet he stresses the supremacy of intuition and imagination in the tradition of Blake while respecting the literary streak in English painting. His reference to heaven and religion is not so much Christian in essence as symbolic of a reaching upward of the spirit, as inspired by Blake's *Glad Day* and personified by the unclothed kneeling figure with hands outstretched towards a smiling heavenly face, the scene framed by philosophical text. The *Plate 177* primitive white-outlined figures, softly shaded with parallel lines and cross-hatching, lack technical subtlety. Preoccupied with sculpture and painting among many other activities, Underwood's interest in wood-engraving dwindled around this time.

As Katharine Eustace so aptly notes, Underwood drew out of his students 'a catholicity of approach, a way of looking at the world that was inclusive and embracing, a visual Humanism'.[35] Apart from his philosophical and artistic sensibility, those who took to wood-engraving were most affected by his attitude to life drawing and his experimental approach to printmaking. A contemporary advertisement for his Brook Green School includes a press notice by R. H. Wilenski which sums up his importance as a teacher:

[32] *Leon Underwood*, 97–8. He mentions also a set of drawings and coloured linocuts for a children's book, *The Adventures of Andy* (George H. Doran, 1927).

[33] An edition is held in the Hammersmith and Fulham Archives and Local History Centre which holds various other works by Underwood. A set of prints is held in the Prints and Drawings Department of the Ashmolean Museum, Oxford.

[34] It is debatable whether all the blocks were engraved, since some of the lines, particularly the orange ones, seem too fluid. For reasons of economy, these blocks were most probably lithographically printed.

[35] Eustace, 'Underwood's Children', 21.

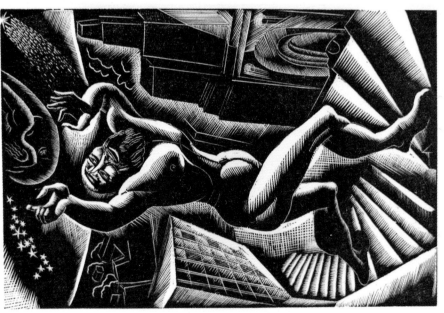

Pl. 174 (*above*). Leon Underwood: James Branch Cabell, *Music from Behind the Moon* (John Day, New York, 1926). 154 × 102

Pl. 175 (*right*). Leon Underwood: *Animalia, or Fibs about Beasts* (Payson & Clarke, 1926). 187 × 162

FOR THE SCRIPTURES OF HIS RELIGION DEFINE HIS HEAVEN

MAN MUST HAVE ART FOR HEAVEN'S SAKE

THROUGH INTUITION & IMAGINATION

BY THE MOST PERFECT SUBLIMATION OF HIS OLD DESIRES

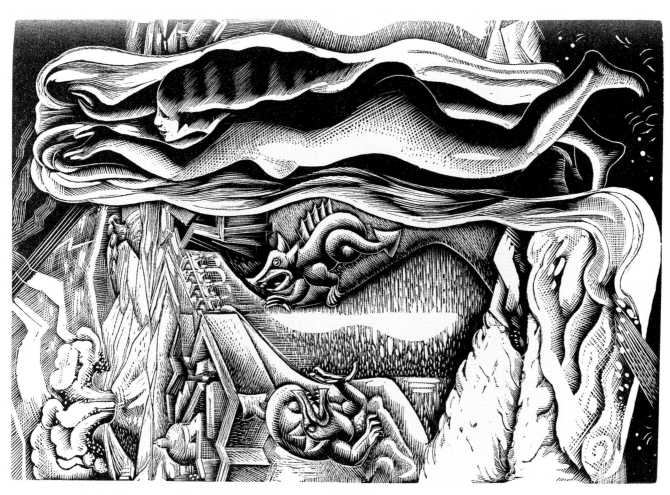

Pl. 176 (*left*). Leon Underwood: *The Dream of Mardocheus* from *The Apocrypha* (Cresset Press, 1929). 181 × 127

Pl. 177 (*above*). Leon Underwood, *Art for Heaven's Sake* (Faber and Faber, 1934). 143 × 92

When we find this rhythmic throb giving life to the idiom of to-day, it is usually the work of some artist who has passed at some time through the Underwood School. There is no English artist of his generation who can inspire those who believe in him with more enthusiasm or who has made more influence on other English artists of his age.[36]

13.3.　*Blair Hughes-Stanton*

Blair Hughes-Stanton (1902–81), son of the landscape painter Sir Herbert Hughes-Stanton, RA, was a paradoxical figure. He was one of the most original and technically adroit creative printmakers of the period, yet the majority of his wood-engravings were for book illustration. Considering himself an interpreter rather than an illustrator,[37] he evolved an unashamedly personal iconography which recurs repeatedly throughout his illustrative work. Although in some cases these images capture the essence of the text, they are often too subjective for comprehension and reflect his own psyche rather than the author's text. More than most wood-engravers, Hughes-Stanton claimed a semi-professional interest in printing and typography, working for several years at the Gregynog Press and briefly running his own press.[38] Nevertheless, with a few notable exceptions, he rarely achieved a perfect balance between type and illustration. His phenomenally skilful tonal technique frequently made for difficulties with the printing of his blocks.

Hughes-Stanton was really too individualistic, both technically and stylistically, to meet the traditional criteria of British book illustration. Unlike the French *éditions de luxe* with text subordinated to artists' pictures, the British literary inheritance was such that even private press books required descriptive visual interpretations rather than more conceptual ones—one reason why so few painters of the period illustrated by choice. The conservative attitude towards book illustration and the craft of printing which confronted Hughes-Stanton is revealed in remarks about his subjective wood-engraving style by Stanley Morison who felt that painting was a more suitable medium to express 'cosmic chaos' and that 'the sort of interpretation of mystical or quasi-mystical impressions and imitations requires a certain degree of intellectual formulation in order to have a consistent place in book production'.[39] Unlike most of his contemporaries who felt constrained by illustration to alter their style according to the demands of the text and type, the words themselves inspired Hughes-Stanton to create his own personal language: 'All the time that I work, I seem to feel word rhythms, and that is why I like to work with books.'[40] At the same time he considered that the place

[36] From Underwood's press-cuttings book. CIA. Source not stated.

[37] Conversation between his daughter, Penelope Hughes-Stanton, and the author, 17 Oct. 1990.

[38] See Ch. 6.2.2, 'Gregynog Press', and Ch. 6.2, 'Smaller Private Presses'.

[39] Stanley Morison to William McCance, 28 Jan. 1931. Quoted in Ladizesky, 'Aspects of the Gregynog Press', 87–8.

[40] Quoted by Penelope Hughes-Stanton, *The Wood-Engravings of Blair Hughes-Stanton* (Pinner, 1991), 31.

for prints was alongside fine arts such as painting and sculpture rather than craft-related arts. It is arguable, therefore, that his interpretations are more relevant as individual prints than as illustrations, as will be demonstrated by considering them in relation to both text and type.

Blair Hughes-Stanton studied first at the Byam Shaw School of Art and then at the Royal Academy Schools (1922–3). Concurrently he attended the evening life class of the Brook Green School which he joined full-time in 1923. Of his fellow students, who included Hermes, Moore, Mitchell, and Groom, he was perhaps the most radically affected by Underwood's teaching, particularly his emphasis on draughtsmanship, the human body, and the importance of the creative imagination. The unconventional teaching methods gave him a rare opportunity to experiment with wood-engraving in a competitive environment which encouraged the invention of new techniques, as well as dexterity. The ease and, in particular, the speed of Hughes-Stanton's engraving had a significant effect on his final results. According to McCance, he worked from 'the merest scribble' on the surface of the block at great speed,

leaving a trail of textures like that of a comet beyond the actual forms and shapes associated with the subject. He was an expressionist. But to find an expressionist who is able to take an intractable medium like wood-engraving and make it a flexible instrument for his fancy and sensuous flights is unique. His actual hands were tireless: they seemed to gain energy from contact with the wood and graver. It looked as though his mental associations were shaped by the medium before they even reached his consciousness.[41]

Although Underwood was the prime inspiration for his students' imaginative and 'sensuous flights', Hughes-Stanton led the way in technical developments and was directly responsible for the new direction of wood-engraving. Surprisingly he was unaware of Bewick's work or that of contemporary wood-engravers such as the Nash brothers when he started engraving. Use of the multiple tool, deployed briefly around 1924 and 1925, stimulated him to evolve his own sinuous line technique with other tools, especially the tint tool. Such virtuosity gained him both admirers and detractors, the latter accusing him, for example, of overpolish and glossy superficiality.

G. M. Ellwood wrote of Underwood's teaching of 'digested anatomy': the elimination of unnecessary bones and muscles and 'the insistence on essential, life conveying surface forms, freely placed in relativity to the whole design'.[42] Hughes-Stanton's wood-engravings, which are mostly figurative, consistently follow this format. The human body is always stylized, developing through quasi-Cubist, Mannerist, angular, and finally semi-abstracted styles. Nude figures permeate his work, yet, as with Gill's, their impersonal quality more often than not diminishes their blatant sensuality.

R. H. Wilenski, reviewing the 1935 Society of Wood Engravers' exhibition, included Hughes-Stanton's *Initiation* (from *Epithalamion*) as an example from one of the exciting new artists 'who, emulating Blake in his last phase, invent graphic symbols for passionate

[41] Quoted by Paul Collet, 'Blair Hughes-Stanton on Wood-Engraving', *Matrix*, 2 (1982), 45–50, p. 48.

[42] G. M. Ellwood, 'Art Teachers & Teaching: Leon Underwood', *Drawing & Design*, 5 (1925), 187–91.

life with lines that rise and fall and flow with elemental rhythms'.[43] Yet it is doubtful whether he was directly influenced by Blake's poetry, or the Bible for which he illustrated several times. As for Underwood, it was the spiritually uplifting and rhythmic qualities of these texts which inspired him rather than a specifically Blakeian philosophy or Christianity *per se*. None the less, although not a serious reader, and distinctly inarticulate, he was obviously a deep thinker who appreciated language: 'I do seem to get my imagination from words, and even when I am doing things of my own, it is as if it comes to me in words like a poem, and I put it into forms.'[44] Clearly he found it easier to express his intuitive thoughts pictorially. He disliked intensely having to explain his subject matter, the metaphysical nature of which often defies description.

The poet and critic, John Gould Fletcher, an Underwood School contemporary of Hughes-Stanton and an admirer of his work, considered him to be quintessentially English, 'not in the sense of the beef-and-beer England of Rowlandson or Hogarth, but the more Celtized, fantastic England of Calvert, Turner, Blake or Gordon Craig'.[45] In fact, Hughes-Stanton was strongly affected by continental art. Formative foreign trips included a visit to Paris in 1924 where he was struck by the Impressionists and Post-Impressionists, especially Cézanne and Cubist artists, Picasso in particular. An interest in tribal and ethnic art, inspired by Underwood, cast him as one of the less insular British artists of the time. His overt sensuality was very un-British and cannot honestly be described as Blakeian or Calvertian. Rather, his style is an amalgam of both British and continental traits, rare amongst British wood-engravers.

Between 1926 and 1940 Hughes-Stanton contributed wood-engravings to nearly thirty books, a large proportion of which were privately or hand printed—a significant factor since the individual attention of the printer enabled him to be more technically experimental than mechanized commercial printing would allow. He was fortunate in his first patron, T. E. Lawrence, through whose art editor, Eric Kennington, he received a commission for ten wood-engravings for *The Seven Pillars of Wisdom* (privately printed in 1926 with more than a hundred other wood-engravings and reproductions of illustrations by artists including Kennington, William Roberts, Augustus John, Paul Nash, and Gertrude Hermes). Lawrence took a personal interest in the overall appearance and production of the book to the point of requiring that Hughes-Stanton's engravings 'had the balance of print about one black to eight white in area'.[46] A strange full-page picture depicting a vast curved staircase teeming with male figures for the dedicatory poem to *Plate 178* 'S.A.' was included as an extra in a few copies. Already in these prints he has established an unconventional format, with distorted perspective, chunky, William Roberts-like figures, and symbolic references, prompting Lawrence to consider his images very subtle but '"mad"—like the war itself'.[47] Seemingly unrelated to the text they reflect

[43] R. H. Wilenski, Foreword to catalogue, *The 16th Annual Exhibition of the Society of Wood Engravers* (London: Redfern Gallery, 1935).
[44] See n. 40.
[45] John Gould Fletcher, 'Blair Hughes-Stanton', *Print Collector's Quarterly*, 21 (1934), 353–72, p. 358.

[46] T. E. Lawrence to Eric Kennington, 1 Apr. 1926. Quoted by Jeremy Wilson, *T. E. Lawrence*, (London, 1988), 171.
[47] Ibid.

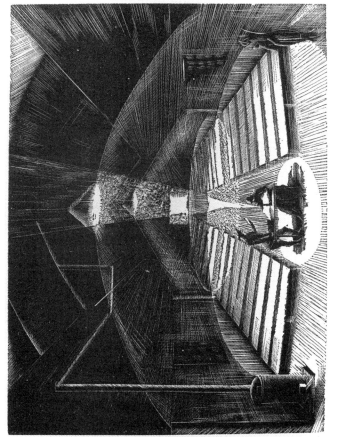

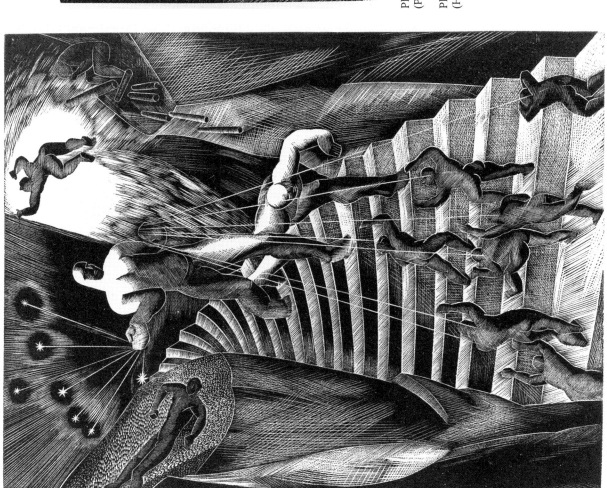

Pl. 178 (*left*). Blair Hughes-Stanton: T. E. Lawrence, *Seven Pillars of Wisdom* (Privately published, 1926). 179 × 134

Pl. 179 (*above*). Blair Hughes-Stanton: Velona Pilcher, *The Searcher* (Heinemann, 1929). 96 × 127

rather the author's philosophy and ideas as expressed in his musings on honour and belief.

In 1926 Hughes-Stanton married Hermes and for a time their work shares stylistic similarities, as can be seen from their joint contributions to the two-volume *Pilgrim's Progress* (Cresset Press, 1928) printed by Bernard Newdigate at the Shakespeare Head Press.[48] Typically most of his figures in the six full-page engravings are large black or white nudes or semi-nudes. In his symbolic, rather than literal, interpretations several incidents surround the central scene, as in *The River of Death*; a baroque effect is caused by the sweeping gestures and strongly contrasting patterns of light—recurring features of his work. The welter of techniques used, from bold scorper marks to simple white line and areas of fine cross-hatching, demonstrate the extent to which Hughes-Stanton experimented with tools. Such variety of cutting caused problems for Newdigate who would have preferred to print black-line wood-engravings like those of Gill. Hughes-Stanton's 'black mass' figure style (which anticipates Farleigh's *Black Girl* by several years) was firmly established by 1929, as seen both in individual engravings such as *Standfast and Mrs Bubble*, and in a full-page illustration of *Susannah and the Elders* for the Cresset Press *Apocrypha*. In this last print signs of the structural format he was to favour are again evident: the vertical, upward-reaching figure of Susannah propped weightlessly against a crumpled drape dominates the centre-stage, while misaligned architectural props such as leaning columns disturb the perspective. The sexual connotations of this subject obviously appealed to Hughes-Stanton who was producing similar, rather Freudian, single prints of women around this date, to some extent inspired by Hermes's female figure studies.[49]

Around this time he received a few commissions from commercial publishers. He produced a full-page wood-engraving for the cover of Walter de la Mare's *Seaton's Aunt* (Faber & Gwyer, 1927) and cover and title-page designs for the same author's poems, *Alone* and *Self to Self*, published in 1927 and 1928 in Faber's Ariel Poems Series. In the following year he engraved nine illustrations for Heinemann's edition of *The Searcher*, a war play by Velona Pilcher, one of *The Island* writers. He concentrates on the architectural setting of the stage directions—a long tunnel-like aisle of a military hospital ward—which he *Plate 179* transforms into different scenes by subtle variations of lighting. People are disproportionately small. A surprisingly abstracted motif of the sun, moon, and stars appears as a tailpiece. The uncharacteristic style of these wood-engravings shows that Hughes-Stanton was capable of illustrating both literally and imaginatively.

Through Pilcher, instigator of the Gate Theatre at Charing Cross, he designed a playbill for a 1930 production of Simon Gantillon's play *Maya*. This, in turn, led to a commission from Gibbings for thirteen illustrations for a Golden Cockerel Press version. The story, about a prostitute who, according to the foreword, was 'to be con-

[48] Eustace, 'Underwood's Children', 14, points to the powerful influence on them both of Samuel Palmer, an exhibition of whose work was shown at the Victoria and Albert Museum in 1926.

[49] Penelope Hughes-Stanton, *The Wood-Engravings of Blair Hughes-Stanton*, 15, notes similarities between Hughes-Stanton's *The Turkish Bath* (1929) and that of Hermes (1926).

sidered in her passive rhythm, as clay to be moulded to the desire of man', gave Hughes-Stanton much greater scope to express his ideas on the male/female relationship than had previous illustrations. His particular iconography is now firmly established: contrasting black and white naked figures, some enveloped in womb-like shapes,[50] with recurring phallic and other explicit symbols. He handles his line in an equally suggestive way, with sperm-like loops, savage jabs, speckled dots, and zip-like patterning caused by rocking the tool. Once again problems occurred with printing the heavy blacks and fine lines on rough, undampened paper. The artist's empathy with the subject matter more closely identifies these prints with the text, although Gould Fletcher felt them 'akin to a musical accompaniment of the words'.[51] From this time illustration was a means for Hughes-Stanton to work out his confused psychology, using human sensuality partly as a means of expressing his deeper, unresolved spiritual yearnings.

The writings and philosophy of D. H. Lawrence, whom he met in 1926, profoundly influenced his work and lifestyle, to the extent that Arthur Calder-Marshall remembers being fascinated by seeing Hughes-Stanton and his lover Ida Graves 'living their lives according to the gospel of D. H. L.'[52] In general his visual translations of Lawrence's writings are his most apposite, matching the author's elemental and rhythmic language and the pictorial imagery and sexual symbolism. He illustrated only two of his books, the first being for the Cresset Press edition of *Birds, Beasts and Flowers* in 1930. The ten large full-page engravings and two smaller head- and tailpieces are sufficiently crisply engraved, with varying toolmarks and clear-cut tonal contrasts, to print beautifully. They are never purely abstract, with recognizable birds, animals, flowers, and figures formed into fantastic shapes and patterns: in the frontispiece representing the Garden of Eden, a zig-zagged serpent slithers past the recumbent body of Eve who is encased in a glowing sunburst roundel; beside her floats Adam in a bubble of his own. As in *The Fig*, illustrating 'when they break and show the seed, then we look into the womb and see its secrets', Hughes-Stanton's suggestive images accurately mirror the words. Like Lawrence, he often included symbolic flowers in his work.[53] For his second Lawrence book, *The Ship of Death and Other Poems* (published by Martin Secker in 1933), in which the author expresses his views on life, death, and mortality, Hughes-Stanton provides equally imaginative interpretations. In 'The Triumph', for instance, beneath the wing span of two vast birds, a long-limbed couple rise gracefully above a fragmented cityscape symbolizing urban chaos. The thirteen finely engraved blocks are exceptionally well printed for a commercial firm.

Frontis-piece

Plate 180

It is ironical that someone with such liberated views as Hughes-Stanton should have been employed by the Calvinistic Methodist Davies sisters as artist in residence at the Gregynog Press from 1930 for three years.[54] Not only were his engravings of 'delectable

[50] Agar, in an article in *The Island* (Dec. 1931) wrote of 'womb magic' being prevalent subject matter.
[51] Fletcher, 'Blair Hughes-Stanton', 364.
[52] Penelope Hughes-Stanton, *The Wood-Engravings of Blair Hughes-Stanton*, 34.

[53] Lawrence obviously liked these interpretations as he suggested an illustrated 'unexpurgated *Pansies*—that sells'. Lawrence to Hughes-Stanton, 30 Aug. 1929. Quoted in Penelope Hughes-Stanton, *The Wood-Engravings of Blair Hughes-Stanton*, 19.
[54] See Ch. 6.2, 'The Gregynog Press'.

ladies' a cause for their concern but he had no typographical experience.[55] Even a month's intensive training at the Baynard Press was apparently of little use to him since it was largely spent in the composing room.[56] William McCance, the Controller, was also typographically untrained and was partly responsible for some of his less well-balanced books. It was largely due to the incomparable skill of the printer Herbert Hodgson that Hughes-Stanton's Gregynog illustrations were so immaculately produced, even if not always harmonious with the type. Hodgson's expertise not only encouraged him 'to cut finer and finer every time' as 'a sort of game' but it also gave him an unrealistic idea of what was technically possible for book illustration.[57]

His first commissioned wood-engravings, for W. H. Davies's *The Lovers' Song-Book*, were rejected, ostensibly on grounds of poor typographic layout. Correspondence, however, reveals that their erotic content was the main objection of the Press Board.[58] It is regrettable that only a trial edition was printed, since the arrangement of Hughes-Stanton's sepia-coloured initials and tailpieces, with double rules down the gutter and along the tail, is refreshingly unorthodox.[59]

For his first published press book, John Milton's *Comus* (1931), six full-page and two smaller blocks were superbly hand printed on Japanese vellum which well suited Hughes-Stanton's closely worked engraving style. His immaculate textural effects are

Plate 60 best seen in the costume material for *The Brothers* and the diaphanous garment immodestly draped over the shapely black body of Sabrina—an engraving which Morison considered particularly fine. These idiosyncratic yet sensitive illustrations are an ideal match for Milton's 'dainty piece of entertainment'. By clearing the background Hughes-Stanton creates a lighter, airier feel than with many of his other illustrations, although the balance is not perfect with the Baskerville typeface. Overall, however, *Comus* is one of his most attractive and unpretentious books. It is interesting to compare it with his later Milton book, *Four Poems* (1933). The engraving here is even more delicate, particularly his handling of flowers, but his depiction of overtly seductive nymphs and shepherds is more a sublimation of his emotions, accentuated by his torrid affair with Ida, than an appropriately poetic translation.

Hughes-Stanton's work during his time at Gregynog and after was dramatically affected by his marital problems and confused emotional state. Two press books, however, escaped the full-blown sensual treatment by the nature of their subject matter. A volume of Welsh poems by W. J. Gruffydd, *Caniadau* (1932), contains shadow initials and four narrative engravings in an untypically anecdotal style, including an historical scene of a knight in armour on a tomb. The artist's method of crowding incidental scenes and figures around the central action becomes a favoured device and anticipates Agnes Miller Parker's later work. The unsuitablility of the stone-coloured Barcham

[55] Gwen Davies to Thomas Jones, 3 May 1930. TJP.
[56] Blair Hughes-Stanton to Thomas Jones, 19 May 1950. TJP.
[57] Collet, 'Blair Hughes-Stanton on Wood-Engraving', 46.
[58] See Ladizesky, 'Aspects of the Gregynog Press', 87–90, and 'Letters of Stanley Morison to William McCance at Gregynog', *Private Library*, 8 (1985), 117–43, pp. 124–9. See also Dorothy Harrop,

A History of the Gregynog Press (Pinner, 1980), 83–4, and Penelope Hughes-Stanton, *The Wood-Engravings of Blair Hughes-Stanton*, 23–6.
[59] A double-page spread is reproduced in Penelope Hughes-Stanton, *The Wood-Engravings of Blair Hughes-Stanton*, 96–7.

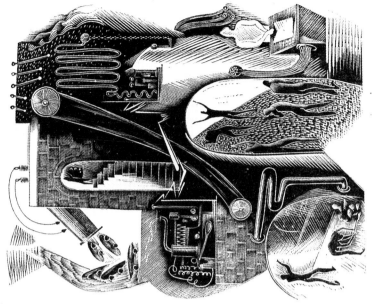

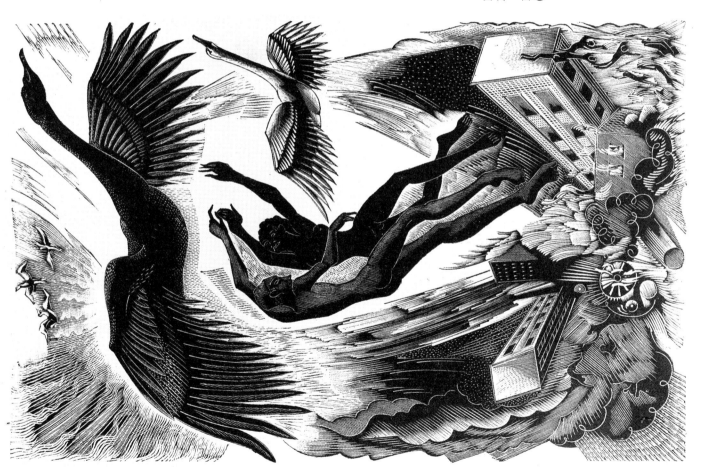

Pl. 180 (*left*). Blair Hughes-Stanton: D. H. Lawrence, *The Ship of Death and Other Poems* (Martin Secker, 1933). 198 × 154

Pl. 181 (*above*). Blair Hughes-Stanton: Samuel Butler, *Erewhon* (Gregynog Press, 1933). 101 × 83

THE IV CHAPTER OF THE BOOK

I LOOKED,
AND BEHOLD,
A DOOR WAS OPENED IN HEAVEN:
AND the first voice which I heard was as it were of a trumpet
talking with me; which said, Come up hither, and I will shew
thee things which must be hereafter. And immediately I was
in the spirit: and behold, a throne was set in heaven, and one
sat on the throne. And he that sat was to look upon like a
jasper and a sardine stone: and there was a rainbow round about
the throne, in sight like unto an emerald. And round about the
throne were four and twenty seats: and upon the seats I saw
four and twenty elders sitting, clothed in white raiment; and
they had on their heads crowns of gold. And out of the throne
proceeded lightnings & thunderings and voices: and there were
seven lamps of fire burning before the throne, which are the
seven spirits of God. And before the throne there was a sea of
glass like unto crystal: and in the midst of the throne, & round
about the throne, were four beasts full of eyes before and behind.
And the first beast was like a lion, & the second beast like a calf,
and the third beast had a face as a man, and the fourth beast was
like a flying eagle. And the four beasts had each of them six
wings about him; & they were full of eyes within: and they rest
not day & night, saying, Holy, holy, holy, Lord God Almighty,
which was, and is, and is to come. And when those beasts give
glory & honour and thanks to him that sat on the throne, who
liveth for ever and ever, the four and twenty elders fall down
before him that sat on the throne, and worship him that liveth
for ever and ever, & cast their crowns before the throne, saying,
THOU ART WORTHY, O LORD, TO RECEIVE
GLORY AND HONOUR AND POWER: FOR THOU
HAST CREATED ALL THINGS, AND FOR THY
PLEASURE THEY ARE AND WERE CREATED.

THE REVELATION OF SAINT JOHN

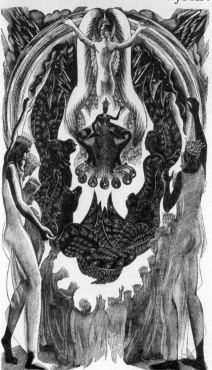

HOLY, HOLY, HOLY, LORD GOD ALMIGHTY,
WHICH WAS, AND IS, AND IS TO COME

Pl. 182 (*above*). Blair Hughes-Stanton: *The Revelation of Saint John the Divine* (Gregynog Press, 1933). *c.*345 × 408

Pl. 183 (*below*). Blair Hughes-Stanton: *The Lamentations of Jeremiah* (Gregynog Press, 1934). 65 × 164

Green Charles I paper to both illustrations and the Perpetua type is as much a reflection of McCance's typographical inexperience as of Hughes-Stanton's.

Twenty-nine headpieces to Samuel Butler's *Erewhon* (1933) give a rare insight into Hughes-Stanton's literal as opposed to his more imaginative work. Although the quality of the engravings is inconsistent and the combination of nudity and part-modern, part-classical dress unsatisfactory, these small scenes have a certain appeal. It is interesting to note Hughes-Stanton's depiction of mechanistic modern society in such surrealist images as *The Book of the Machines*, in which a Heath Robinson-like contraption spews out cars. His rarely revealed ability to depict figures in a landscape is also evident, and is demonstrated once again to better advantage in his delightful seasonal views of country life for *The National Mark Calendar of Cooking* (1936).

Plate 181

The Revelation of Saint John the Divine (1933) and *The Lamentations of Jeremiah* (1934) are generally considered to be the artist's finest work and two of the most important Gregynog Press publications. McCance was reluctantly forced into the 'delicate arms' of the 'precious book' because it was cheaper to produce books with more illustrations by the resident artist than to pay for a large amount of hand-setting.[60] As a result, Hughes-Stanton engraved as many as forty-one blocks for *The Revelation*: fifteen small blocks, thirteen with lettering, and thirteen full page. For the first time he worked side by side with the compositor, pressman, and binder throughout the book's progress. In consequence the layout, with decorated chapter openings facing large-scale wood-engravings, rivals that of Gill for *The Four Gospels*. Yet the typographical outcome was not entirely satisfactory. Dorothy Harrop feels that the illustrations are enhanced by the text,[61] but these startling blocks seem to overpower the lightweight Bembo type, while the intertwined Perpetua type capitals at times appear too heavy for the delicately engraved decorations surrounding them. In comparison with Gill's deliberately archaicizing, typographic approach, Hughes-Stanton's exuberant handling is distinctly uninhibited.

Plate 182

Penelope Hughes-Stanton suggests that the text of *The Revelation* 'appears to serve merely as a vehicle to display the virtuosity of the engravings'.[62] Hughes-Stanton evidently appreciated its fantastic, visionary iconography which D. H. Lawrence had hoped to discuss with him. Yet, though many of his pictorial details directly relate to the words, his creative imagination leads him far beyond the traditional Christian iconography; a point that offended many critics, including Newdigate, who felt that the artist had 'failed in his interpretation of the apocalyptic vision'.[63] Certainly there is a weird, menacing quality which is more akin to pagan than to Christian ritual.[64] Hughes-Stanton's familiar repertoire of devices and techniques is concentrated in these blocks: a chain of figures encircling the central action, flowing, upward movement, wiry, mannerist bodies, emotionless faces, emphatic blacks and whites broken up with serpentine lines,

[60] Ladizesky, 'Aspects of the Gregynog Press', 81.

[61] Harrop, *The Gregynog Press*, 110.

[62] Penelope Hughes-Stanton, *The Wood-Engravings of Blair Hughes-Stanton*, 30.

[63] Review by Bernard Newdigate in *London Mercury*, 28 (1933).

[64] Eustace, 'Underwood's Children', 18, suggests derivations from Japanese Noh theatre masks and Khmer sculpture.

and translucent textures. Heaped up illusory planes and varied directional lighting add to the complexity of the images. Apart from the obvious sensuality of the nudes and certain implied symbolism, Hughes-Stanton has avoided too much autobiographical reference, with the result that his prints can fairly be considered as illustration.

With *The Lamentations of Jeremiah*, however, Hughes-Stanton felt free to interpret the text in a more characteristically subjective way, reflecting his complex and unresolved attitude to male/female relationships. (According to Penelope Hughes-Stanton the *Plate 183* voluptuous daughter of Jeremiah is recognizable as Ida.[65]) In the five full-page chapter headings and other smaller engravings, he changes to a less refined style, placing monumental, angular black figures as if on stage before an austere classical backdrop. Yet, despite dramatic gesticulation and more emotional facial expressions than in early illustrations, a paradoxical coldness and impersonal quality permeates much of Hughes-Stanton's most sensual work. The predominance of black, accentuated by uncut white areas, tends to overpower the Baskerville italic type.

Hughes-Stanton's affair finally forced him to leave the Gregynog Press in September 1933,[66] when he set up his own Gemini Press with financial support from Robert Sainsbury. According to the prospectus for its first publication, *Epithalamion*, 'A Poem by Ida Graves with Associate Wood-Engraving by Blair Hughes-Stanton', his intention was 'to be able, when occasion arises and unhampered by any outside prejudices, to make books in which there is a real fusion between contemporary writer and artist, and where possible a definite collaboration from the start, so that the book is integral and not a decorated or illustrated vehicle of text'. Ida's overtly explicit verse celebrating love, consummation, and conception is even more suggestive than the twenty-three large, full-page engravings, with their predictable imagery: voluptuous female figures, sperm and womb-like shapes, snakes and flowers. The intimate fusion between writer and artist is all too apparent. Yet, even when free to design and print for his own press, Hughes-Stanton fails to produce a harmonious balance between type and engraving. Poor sales owing to the economic climate led him to abandon the press after two further publications. The last—sardonic verses by Ida's husband, Herbert Marks, entitled *Pastoral, or Virtue Unrequited* (1935)—contains lecherous, modern-life party scenes; consciously unsympathetic interpretations which are quite out of character with the artist's later work.[67]

Hughes-Stanton's individual wood-engravings of the 1930s, such as *Creation* (1936) or *Figures I* and *II* (1937), represent some of his most progressive work with their formal, semi-abstract structure. In contrast, his final illustrations, while showing signs of surrealism and abstraction, lack the dynamism and inventiveness of his single prints. The fact that they more readily match the weight of the type is largely due to Christopher

[65] Penelope Hughes-Stanton, *The Wood-Engravings of Blair Hughes-Stanton*, 32.

[66] Miller Parker, in a letter to Gibbings about her departure from the Gregynog Press, suggests that Hughes-Stanton had caused the owners 'to hold up their hands in holy horror, which attitude the Welsh had discovered they like, so they dole out

extensions on his time limit here in the hope that he will continue to gratify their emotions, religious or otherwise'. Agnes Miller Parker to Robert Gibbings, n.d. [?1932]. GCPA.

[67] Penelope Hughes-Stanton, *The Wood-Engravings of Blair Hughes-Stanton*, 42. There is a similarity with one of his earliest wood-engravings, *Evening Party* (1924).

Pl. 184 (*left*). Blair Hughes-Stanton: Arthur Calder-Marshall, *A Crime Against Cania* (Golden Cockerel Press, 1934). 76 × 101

Pl. 185 (*below*). Blair Hughes-Stanton: *The Book of Ecclesiastes* (Golden Cockerel Press, 1934). 102 × 153

Sandford's influence. Sandford, who considered Hughes-Stanton to be the 'Prince' of the new movement of wood-engravers, had in 1932 commissioned him to do four wood-engravings for Marlowe's *The Tragicall Historie of Doctor Faustus* for his Golden Hours Press.[68] In 1934 he employed him on three further books. *Primeval Gods*, which Sandford wrote in a Lawrentian style and published from the Boar's Head Press, included eight small engravings (as headpieces to the poems and for the title-page) in a similar vein. Sandford's insistence that the engravings be cut with the rough quality of the paper in mind, together with the expertise of the Chiswick pressmen, ensured superb printing. The amoebic-shaped mother and bulky Picasso-esque figures in Hughes-Stanton's

Plate 184 engravings for the Golden Cockerel Press *A Crime Against Cania* by Arthur Calder-Marshall announce a new direction in printmaking. (The man before the volcano, with outsized arms reaching heavenwards, bears an uncanny resemblance to Underwood's

Plate 177 image in *Art for Heaven's Sake* published in the same year.) By cutting in a robust manner Hughes-Stanton dissociated himself from the virtuosic tonality of his earlier illustrative work. Thirteen engravings in a typical amatory vein for the Golden Cockerel *The Book of Ecclesiastes* are typographically some of his most successful if not necessarily most

Plate 185 attractive. Incisively cut in an appropriately classical black-line style, they harmonize with the area of type and are judiciously placed on the page. Sandford considered the presswork in this book to be almost perfect.[69]

Freed from the constraints of the Gregynog Press, Hughes-Stanton felt able to experiment with printmaking in a bolder, more contemporary way which, in turn, filtered back into his book illustration, albeit in a watered-down manner.[70] His talents as a printmaker were recognized in 1938 when he was awarded an International Prize in the Venice Biennale. Inclusion of his work in the British Museum exhibition, *Avant-Garde British Printmaking, 1914–1960* confirms its significance. Although Hughes-Stanton produced some magnificent illustration, it is in his ability as a printmaker who exhibited in books, rather than as an illustrator, that his importance lies.

13.4. *Gertrude Hermes*

It is difficult to dissociate Gertrude Hermes (1901–83) from Blair Hughes-Stanton to whom she was married from 1926 to 1933.[71] So close were her emotional ties throughout her life that much of her work was affected by him, both directly and indirectly. Starting

[68] See David Chambers, 'Boar's Head & Golden Hours', *Private Library*, 8 (1985), 2–33, p. 6.
[69] Christopher Sandford and Owen Rutter, *Bibliography of the Golden Cockerel Press* (Folkestone, 1975), No. 97, 43. In the same year Hughes-Stanton produced a full-page frontispiece for the Nonesuch Press, *The Devil and All*, by John Collier.
[70] During 1934–5 he attempted individual colour wood-engraving, abandoning the process when he realized its limitations.

[71] See, for instance, John Gould Fletcher, 'Gertrude Hermes and Blair Hughes-Stanton', *Print Collector's Quarterly*, 16 (1929), 183–98, and Eustace, 'Underwood's Children'. A monograph, *The Wood-Engravings of Gertrude Hermes*, ed. her daughter Judith Russell, with essays by Simon Brett and Bryan Robertson (Aldershot, 1993), includes a chronology of her life and a catalogue and reproductions of her prints.

their wood-engraving careers together, both displayed strong similarities in their print style for a short period, though Hermes's remained highly individual and in many ways more varied and innovative than Hughes-Stanton's. During her brief and unhappy spell at Gregynog, and after their separation in 1932, Hermes's work became intensely introverted as a result of these traumatic experiences. Unlike Hughes-Stanton, however, she largely confined her autobiographical work to single prints and sculpture rather than to book illustration, with the result that in many respects she is more successful in this field. She was fortunate that most of her commissions were for private presses and hand printed which enabled her to use exceptionally large blocks and to experiment with technique.

Regrettably her illustrative output was comparatively small. This was partly for family reasons,[72] partly as a result of creative paralysis during her separation, and partly because, unlike Hughes-Stanton who had few financially rewarding outlets other than wood-engraving, she was also a successful sculptor and wood-engraving was not her only means of income. She had a feeling for literature and like several other sculptor-engravers, notably Gill, she was sensitive to the relief, and hence the typographical, element of wood-engraving so often missing in Hughes-Stanton's illustration.

Like his, her first commission came via Kennington for *The Seven Pillars of Wisdom* (1926) to which she contributed one wood-engraving: *Explosion* depicts billowing clouds *Plate 186* of smoke, shattered fragments, and sparks flying out in all directions. While accurately describing the text, it is daring in its semi-abstract Vorticist-style composition. Hermes's fascination for dramatic lighting effects achieved through distinctive marks can be gauged from the way in which fine multiple-tooled shading contrasts with bright white flecks and gouged areas and with strong blacks.[73]

With her next two books, both for the Cresset Press, she once again shared a platform with her husband. Yet, while their philosophical concepts were similar, under the influence of Underwood and Lawrence, stylistically Hermes was more literal in her interpretations and at the same time more expressionistic with her bold toolwork and strong sense of pattern. Overall, however, the quality of their full-page wood-engravings for *Pilgrim's Progress* (1928) is inconsistent and unbalanced. In *The Valley of the Shadow of Death*, one of Hermes's four illustrations, a vivid streak of lightning flashes across a rocky chasm through which a raging torrent runs. It is a soulless scene, lacking human or vegetable life, apart from a pin-sized figure. The composition relies, rather unsatisfactorily, on Hughes-Stanton's device of massed areas of black and white without sufficient relief from engraved marks. In *The Slough of Despond*, on the other hand, the *Plate 187* scorped white reflections on the figures and the circular motion of bodies and water are particularly effective,[74] deep lines of cross-hatching in the sky and finer parallel tint tool lines breaking up flat areas of black. Leighton notes especially 'the grey of the

[72] Her daughter Judith and son Simon were born in 1927 and 1928.

[73] Hermes used the multiple tool briefly around 1924–5 in single prints and continued to use it sporadically even in her last major wood-engraving, *Stonehenge* (1963).

[74] Water and circular patterns recur throughout Hermes's work, at a later stage most probably symbolic of death and the cyclical nature of life.

background on the extreme left made by wriggling the wide flat chisel tool from side to side along the block'.[75] As a result of her varied and incisive engraving, Hermes's blocks better combine with the facing area of type than do Hughes-Stanton's more strongly contrasting images.

It is interesting to compare their treatment of the human body. In Hermes's placing of figures movement is generally more natural compared with the frozen fluidity and symmetrical positions of Hughes-Stanton's figures. Both artists favour the Underwood characteristic of mannered bulkiness but Hermes's people are firmer and more angular; in sculptural terms carved, as opposed to his more modelled outlines. As Bryan Robertson suggests, 'the balance between atavistic and so-called primitive art, and the discipline of modern form is in a good deal of her work'.[76]

Plate 188 In complete contrast to Hughes-Stanton's seductive *Susannah and the Elders* in the *Apocrypha* (1929), Hermes's contribution, *Tobit and the Fish*, depicts a monumental figure, lapped by waves, grappling with a fearsome shark-like creature. Wide-scorped water reflections contrast with the finely textured undulations of the hills behind and Nash-like umbrella-topped trees seen against a radiating sun. Rich blacks are not too overpowering. Hermes's expressionist technique and stylized interpretation of fish and vegetation reveal her modernist leanings.

Her next and most significant illustrations, for Irene Gosse's *A Florilege* (Swan Press, 1931), gave her the opportunity to exploit such skills and her powerful response to nature without the constraints of biblical text. Twenty full-page engravings describe extracts from various old herbals which are set in Baskerville type, the whole immaculately hand printed by Gage-Cole on handmade paper. Unlike Hughes-Stanton, Hermes observed nature closely, as her childhood botany books and later sketchbooks reveal. Like him, influenced in part by Lawrentian symbolism, she often depicts flowers and animals in a metaphysical way, using darkness and light to achieve her own visual language. Yet, however stylized, surface pattern always relates to organic form.

The commission for *A Florilege* came in late 1929 although it was not published until 1931. Possibly some of Hermes's extraordinary and sometimes rather disconcerting images of flowers affected Hughes-Stanton's work for *Birds, Beasts and Flowers* which he engraved during the same period. Both books follow a similar format with extra-large rectangular engravings facing pages of text. Flowers are decoratively handled in both but Hughes-Stanton's are further imbued with an erotic quality present in Lawrence's text. Hermes's prints show great originality and modernness in view of the traditional informative role of herbals. They were without precedent in wood-engraved botanical illustration. Only Paul Nash, and later John Farleigh, seriously attempted symbolic interpretations of flowers. The more naturalistic plant engravings by practitioners such as John Nash, Miller Parker, and Leighton became increasingly popular from around 1935 onwards.

[75] Leighton, *Wood-Engraving and Woodcuts*, 48.
[76] Bryan Robertson, Introduction to exhibition catalogue, *Gertrude Hermes* (London: Whitechapel Gallery, 1967).

Large plants dominate the *Florilege* blocks. Some of the images are semi-abstract while others, such as *Borage*, are more conventional. In *Henbane* the design is so complex and calligraphic that it is difficult to identify the actual flower; the zig-zagged borders to *Houseleek* and *Arum* are distinctly Art Deco in feel. Backgrounds tend to be abstracted and the overriding impression of all the blocks is of pattern and texture created with a wide variety of toolmarks: tiny specks and fine tint tool shading and cross-hatching combine with jabbed scorper marks, swirling lines, and solid blacks and whites, as in *Waterlilies*. With some blocks the edges are cut away to produce a more interesting *Plate 189* profile. Typographically the blocks are not entirely successful as they are deeper and heavier than the area of text and tend to dominate the double-page spread, making it perhaps more of a picture book.

The seven wood-engravings that Hermes made in 1931 and 1932 for the Gregynog Press's *The Natural History of Selborne* are among her finest prints.[77] Stress caused by the break-up of her marriage prevented her from completing these illustrations to schedule and in November 1932 the directors resolved 'that the book be postponed until a more favourable time'.[78] It was not until 1988 that the press eventually published them, hand printed by David Esselmont, with accompanying chapters on Gilbert White's text and Hermes's involvement. Since no mention is made of the preliminary drawings which give an insight into her working method, these are discussed here.[79]

In order to study White's surroundings and absorb the spirit of his writings Hermes lodged with the village postman. Three sketchbooks contain preliminary drawings for *Selborne*, among others of babies and young children and for her sculptures *Adam and Eve* and *Bird in Hand*. In the first book, eight small square designs of flowers and animals— a snail, deer, spider, swallow, and snake—were intended as note indicators, 'like little coptic hieroglyphics'.[80] Although thirty to thirty-five wood-engravings were commissioned, not all were completed. Other sketches of birds in a nest, cuckoos, orchids, an owl, frogs, a tortoise, and White's gravestone were ideas which were useful observations for the larger prints. Sweeping lines and crescent shapes predominate. The second sketchbook contains four of the finished drawings ready for tracing. It is evident from these that only the main lines and shading are drawn, the detail being worked out on the block itself, which demonstrates a certain confidence and a remarkably steady hand. For *Carp* there is a page of carefully worked sketches of fishes and water-boatmen. In the finished drawing key lines are shown but border decorations are left vague; in the print the border designs, graduating in size, mimic the shapes of the ripples and fish scales. These patterned frames are an attractive feature of some of Hermes's later book illustration and show the originality of her compositional ideas.[81] Above all, these engravings reveal her extraordinary technical skill, the surface of the block cut with

[77] Six prints were submitted, excluding *Swallows*. See n. 80.

[78] Quoted by James Hamilton, 'Gertrude Hermes at Gregynog', in *Wood Engravings by Gertrude Hermes: Being Illustrations to Selborne with Extracts from Gilbert White*, with introduction by William Condry (Newtown, Powys, 1988), 25.

[79] Sketchbooks in the possession of the family.

[80] William McCance to Gertrude Hermes, 3 May 1932. Quoted in *Wood-Engravings of Gertrude Hermes*, No. 70 n*, 114.

[81] McCance's idea to add borders to enlarge the *Swallows* block accounted for Hermes's tentative experiments 'with straight lines and beading'. Ibid, No. 71, notes.

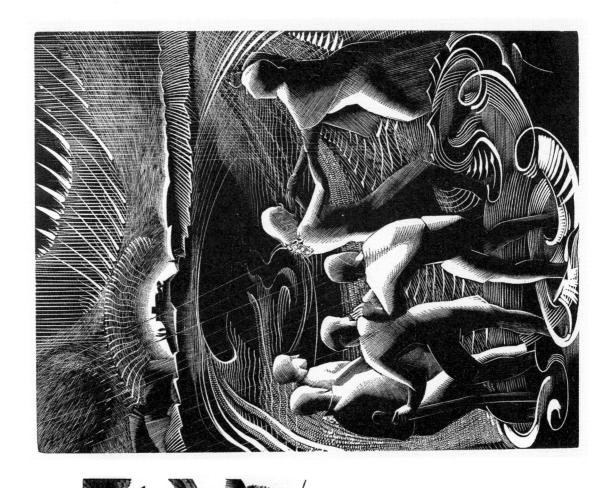

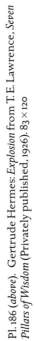

Pl. 186 (*above*). Gertrude Hermes: *Explosion* from T. E. Lawrence, *Seven Pillars of Wisdom* (Privately published, 1926). 83 × 120

Pl. 187 (*right*). Gertrude Hermes: *The Slough of Despond* from John Bunyan, *The Pilgrim's Progress*, ii (Cresset Press, 1928). 235 × 177

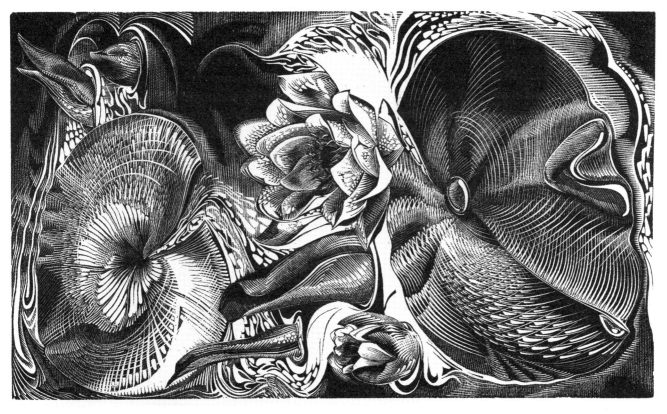

Pl. 188 (*above*). Gertrude Hermes: *Tobit and the Fish* from *The Apocrypha*
(Cresset Press, 1929). 182 × 127

Pl. 189 (*right*). Gertrude Hermes: *Waterlilies* from Irene Gosse, *A Florilege*
(The Swan Press, 1931). 227 × 134

hard precision and with an inventive mix of fine tints and heavier lines—speckles, strokes, dots, stabs—and planes of black and white. In particular the needle-fine lines and grey tones in the near-naturalistic *Bat and Spider* contrast to the hard-edged delineation of the ornate and hieratic *Heron* guarding her eggs. In *Snake and Tortoise* realism

Plate 190

and stylization combine to startling effect.

With the exception of *Bat and Spider*, however, none of these illustrations conveys the true nature of White's text. They are too dominating and subjective to match his gentle, minutely perceptive and humorous observations. Nothing could be less appropriate than the illustration entitled *Tree*: a starkly phallic apple tree with sperm-like roots enwrapping the trunk in a womb shape. The third sketchbook contains lifelike drawings of trees and leaves which become increasingly abstract. The same book contains two sketches for a single print *Serpent at the Nest* which symbolizes Hermes herself protecting her two children from the predatory serpent.[82] Even White's *Selborne* was invaded by emotional conflict and introspective reflections on birth and death and male/female relationships which manifested themselves in all her work until the mid-1930s, especially in her Bird and People Series.[83]

In 1934 Sandford commissioned illustrations for two Golden Cockerel books: four wood-engravings for R. H. Mottram's *Strawberry Time* and some copper engravings for Franz Toussaint's *The Garden of Caresses*. *Strawberry Time* contains two light-hearted short stories which Hermes interpreted in a lively vein, pleasingly setting the scenes between stripy-curtained frames as though on stage. The flirtatious couple in *The Banquet* disclose

Plate 191

her wry sense of humour. The line is loose and sketchy, especially for the facial features. In these and subsequent illustrations Hermes's feeling for design and understanding of the typographical potential of wood-engraving is most noticeable, possibly through Sandford's and, later, Gibbings's influence.

Throughout her life she valued the help and advice of a wide circle of friends, some of whom acted as patrons, as did Naomi Mitchison. A rare modern-life frontispiece scene for Mitchison's book *The Fourth Pig* (Constable, 1934) represents Hermes's first significant commission for a commercial publication.[84] In 1939 she contributed some wood-engravings to her poem *The Alban Goes Out* printed and published by the Raven Press: a night fishing scene based on a view from Carradale, the Mitchison's Scottish home, two fishes in a net, and, for the cover, a diving gull. A series of tailpieces for Mitchison's poems were produced privately as broadsheets and Christmas cards. Unusually, Hermes's wood-engraving of *Jonah and the Whale* (1933) was the inspiration of a poem of the same name by Kenneth Muir which was printed as a broadsheet together with her print by the Samson Press.[85]

In the second half of the 1930s Hermes concentrated more on sculpture. Up to that time her illustrative wood-engravings were undertaken largely for private presses, with

[82] Ibid., No. 68. In 1931 she contributed this print and *Bird's Eye* to *The Island*.

[83] Ten emblematic amatory wood-engravings for a revised Gregynog Press edition of *The Lovers' Song-Book* were, like Hughes-

Stanton's, regarded as unsuitable. See Harrop, *The Gregynog Press*, 116.

[84] See n. 87.

[85] See Ch. 6.2, 'Smaller Private Presses', n. 117.

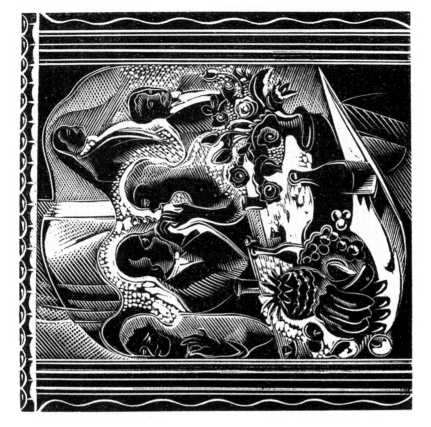

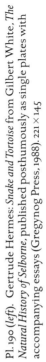

Pl.190 (*left*). Gertrude Hermes: *Snake and Tortoise* from Gilbert White, *The Natural History of Selborne*, published posthumously as single plates with accompanying essays (Gregynog Press, 1988). 221 × 145

Pl.191 (*above*). Gertrude Hermes: R. H. Mottram, *Strawberry Time* (Golden Cockerel Press, 1934). 106 × 105

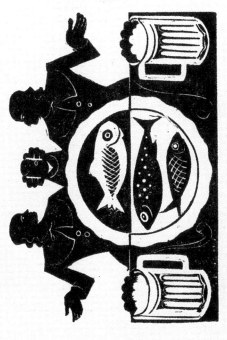

THE COMPLEAT ANGLER

BY IZAAK WALTON

WITH WOOD ENGRAVINGS BY GERTRUDE HERMES

PENGUIN BOOKS

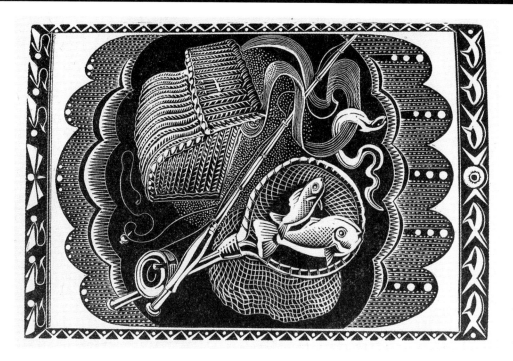

Pl. 192 (*above*). Gertrude Hermes: Isaak Walton, *The Compleat Angler* (Penguin Books, 1939). 126 × 85

Pl. 193 (*right*). Gertrude Hermes: Cover for Isaak Walton, *The Compleat Angler* (Penguin Books, 1939). 181 × 112

a limited circulation. Two commissions from Penguin Books helped to publicize her work. A request by Gibbings in 1938 to illustrate Richard Jefferies's *The Story of my Heart* for the Penguin Illustrated Classics series resulted in thirteen wood-engravings. Mainly descriptive, including an emblematic heart, a butterfly, a snake, and a frog, they reveal little of her earlier analytical style. Only the frontispiece showing the author lying contemplatively in the grass, and three other scenes of him swimming, standing under a tree, and gazing out to sea, reveal the soul-searching mood of the text. Generally these engravings stand up well to bad printing on poor quality paper. Hermes's ten illustrations for a Penguin edition of *The Compleat Angler* (1939) are among her most stylish and least recognized. The decorative frontispiece—a concoction of rod, nets, baskets, a pair of fishes, and an eel, framed in a patterned border of fish and flies—is engraved with utmost precision and craftsmanship. Humorous angling scenes combine with accurate depictions of pike, carp, and other fish. An eye-catching design appears on the cover: an uncharacteristically simplistic two-dimensional decoration of fishes on a plate between a mirror image of two drinkers and beer mugs, like a folded paper cut-out.

Plate 192

Plate 193

The start of the war in effect put an end to Hermes's illustrating career. In 1940 she took her children to Canada where she was employed to make precision drawings and tracing for shipyards and aircraft factories; an occupation that made her 'heartily sick of black and white'.[86] On her return to London in 1945 many of her subsequent woodcuts and linocuts were printed in colour, as was the background (printed from lino) to some of her wood-engravings.[87] For all her innovation and technical virtuosity, her distinctive wood-engraved prints and book illustration were too personal to have a significant effect on the stylistic direction of the medium. It was as a much-loved and inspiring teacher at Camberwell and St Martin's Schools of Art, and later at the Central School and the Royal Academy Schools, that her influence was most keenly felt.

13.5. *John Farleigh: Late Work*

In line with the trend towards abstraction and surrealism amongst British artists in the mid-1930s,[88] John Farleigh began to develop a more subjective, metaphysical approach— one which, in some respects, was allied to Leon Underwood's philosophy. Yet, unlike the Brook Green artists, he stressed the value of wood-engraving for book illustration,

[86] Quoted by David Brown in introduction to exhibition catalogue, *Gertrude Hermes, RA* (London: Royal Academy of Art, 1981). In New York she did a series of line drawings to illustrate P. L. Travers's *I Go by Sea I Go by Land* (Harper Bros., 1941).

[87] A black key block with two colours added which she contributed to one of Faber's Ariel Poem Series, T. S. Eliot's *Animula* (1929), was a rare incursion into colour wood-engraved illustration.

[88] Oct. 1935: First entirely non-representational exhibition held

in England organized by Ben Nicholson for the Seven and Five Society. Feb.–June 1936: 'Abstract and Concrete' exhibition held in Oxford, Liverpool, London, and Cambridge, including works by Hepworth, Nicholson, Moore, John Piper, and leading European artists such as Moholy-Nagy, Miró, Mondrian, Gabo, Calder, and Giacometti. June 1936: 'International Surrealist Exhibition' held at the New Burlington Galleries, London, to which Paul Nash and Moore were the foremost British contributors.

combining creative imagery and modernist styles with a sound knowledge of typography and a sensitivity towards the authors' intentions. This can clearly be traced in his later book illustrations which are among the more unorthodox of the period.

As mentioned in an earlier chapter,[89] Farleigh was fortunate to work with some of the most distinguished typographers and printers, in particular Maxwell and Mason, to whom he frequently acknowledged his debt.[90] Both men were concerned for a sense of unity between type and illustration and, according to Farleigh, worked in a similar way, using word pictures to evolve their final designs.[91] Mason took a new typographic direction with his remarkable title-page for D. H. Lawrence's *The Man Who Died* (Heinemann, 1935) displaying a narrow column of red capitals broken up with lines of black Gothic titling inspired by early psalters. Farleigh's illustrations were designed to enliven Mason's solid page of even grey type without paragraphs or quotation marks. Of the ten illustrations, seven of them full page, nine have a second block overprinting the black with red.[92] Farleigh describes how the 'story is of the struggle from death to life—a breaking free from restrictions. As an illustrator, what better use could I make of Mason's static format than by breaking free into the generous margins, allowing each design to create its own flowing vignette'.[93] The red block symbolizes the surge of returning life.

Farleigh's imagery is in keeping with the intense and sensual nature of Lawrence's text. There is a monumental quality about the figures which become progressively more futuristic and faceless, foreshadowing his illustrations for *Back to Methuselah*. A sense of movement is achieved in the curvaceous outline shapes as exemplified in *Plate 194* Farleigh's depiction of the lovers, arms encircled, their torsos joined as one. Mason wanted light blocks with plenty of white and grey and the minimum of black. In the preliminary drawings[94] Farleigh experimented in simple wash with broad sweeps of the brush, hence the lack of texture in the engravings, with plain blacks and grey areas contrasting with open parallel-line shading. The illustrations, together with Mason's unconventional typesetting, were impeccably printed by Lewis at the Cambridge University Press. These elements combine to create one of the more visually startling books of the period. Farleigh was right to consider it one of his 'best jobs', the publication of which he was entirely responsible for arranging with Frere Reeves of Heinemann.

In the same vein but less original were his illustrations the following year for Margaret Goldsmith's *St John the Baptist*—a more mundane commission from the publisher Arthur Barker. The figure style is handled in a similar manner to that in *The Man Who Died* but the rectangular format and crowded picture space lack subtlety. Farleigh progressively altered his style and technique depending on the nature of the commission, his urge to

[89] See Ch. 9.
[90] See, for instance, John Farleigh, *Graven Image* (London, 1940), 361, and Leslie Thomas Owens, *J. H. Mason, 1875–1951, Scholar-Printer* (London, 1976), 138–40.
[91] Owens, *J. H. Mason*, 139.
[92] Progressive proofs to some of the illustrations are held in the VAM.

[93] Quoted in *The Wood Engravings of John Farleigh*, with text by Monica Poole (Henley-on-Thames, 1985), 10–11.
[94] Whereabouts unknown by the author. See Farleigh, *Graven Image*, 361.

experiment, and his growing introspection. For him technique was 'not a thing separate from feeling'.[95] Two further books in 1936 required different treatments. Scenes for *A Country Garden*, published by *Country Life* and discussed earlier, he depicted naturalistically.[96] For W. J. Brown's *The Gods Had Wings*, a Constable publication, he produced fifteen full-page illustrations as openings to each chapter. He used the textual symbolism as a basis for his abstracted images of birds which, in turn, grew out of natural forms. He discovered 'how important a part texture will play in the significance of motive. A vulture is a loathsome animal and I had to find a loathsome texture'[97]—in this instance wiry, scratched lines. Some prints are more loosely engraved, others hard-lined. No blocks are uniform in shape: beaks, wings, and claws appear to break through the frames. A boldly surreal frontispiece faces an abstract title-page design. These curious compositions disclose Farleigh's sardonic humour and assured decorative sense.

In 1937 his illustrative style changes yet again. Two headpieces and six small rectangular engravings adorn Herbert Marks's *Pax Obbligato* (Cresset Press). Grimacing mask-like heads and seething figures are freely sketched in white line, with prominent scorper marks, and signs of the *vélo* and a rocked tool for certain finer textures. Figures in the three full-page illustrations to William Lamb's *The World's End* (Dent) are more modelled and monumental, the background details yet more scrawled.

In October 1936 Farleigh had accepted George Macy's invitation to illustrate Shaw's *Back to Methuselah* for the Limited Editions Club with Mason as typographical adviser. He became seriously involved in this ponderous 'Bible for Creative Evolution' in which, according to the preface, Shaw exploits 'the eternal interest of the philosopher's stone which enables men to live for ever'. Farleigh felt that the deep underlying motive of the play could not be represented on the stage and hoped that his compositions might help to illuminate it. He was prompted, having read the play and made notes for the illustrations, to engrave a large allegorical single print of *Lilith*. It evolved over a period of time from a vaguely scribbled drawing to a complex and, in his words, 'elusive', print completed in 1937. Farleigh's conception of Lilith is an entirely Shavian one. He saw her 'as the beginning and the end, and there emerged in my mind a vague image of this effort to live'.[98] More abstracted than the earlier print of *Melancholia* (1935), the vast body of Lilith is fragmented in a Cubist manner, a web of symbolistic patterning overall. This strange engraving forms the basis for his numerous illustrations to the book which moves from the mythological past, through the twentieth century, to 31,920 AD. Style and technique vary according to the mood of each scene; although most are representational, they are generally distorted in some way or other.

Farleigh took two years over this commission. He made a day to day diary of the first year's work which, regrettably, he tore up. He refers to the book in *Graven Image* only briefly.[99] A series of pen-and-wash drawings were sent to Shaw for his comments.[100] The

[95] Ibid. 194–5.
[96] See Ch. 9.
[97] Farleigh, *Graven Image*, 371.
[98] Ibid. 382.

[99] Ibid. 378.
[100] Some examples held in the Rare Books Department of New York Public Library (Arents Tobacco Collection).

following letter accompanying some of them gives an insight into Farleigh's conscious change of direction:

Lilith is not intended to have a face. I am aware that my work is very different now from the time when I did the Black Girl but apart from my own difference I find the play is such a very different problem. The imaginative range in your play needs all the imagination I can muster to do it as I feel it should be done. The drawings are a little bigger than the engravings will be; and I have made no attempt to imitate engravings as I did in the past. I can only ask you to criticize them as such. It might be easier for you to make your comments on the drawings themselves.[101]

Correspondence between the two men was scarce since, as Farleigh noted, Shaw 'expressed himself always on the drawings—and very adequately'.[102] The fact that he felt able to ignore some of the author's advice, as the following observations reveal, shows the extent to which he had grown in confidence since his tentative suggestions for *The Black Girl*.

Plate 195 According to Poole, the semi-abstract scene, *Lilith Gives Birth to Adam and Eve*, for the frontispiece to *In the Beginning* represents the struggle 'to produce the parents of the human race at one birth'.[103] Apart from the surface texture, Farleigh's engraving is almost identical to his drawing, notwithstanding Shaw's wry comments:

These tree ends, being all cut, suggest the stone axe: rather a late date for Lilith.

What is this?

This looks like a huge bass viol.

This obstetric enormity is a key subject, and ought to make a magnificent frontispiece.

To a suggestion from Macy that he should do an engraving for the title-page, Farleigh replied: 'The 1st big block of "Lilith" is to face it as a frontispiece & a small block opposite would look impertinent.'[104] On a drawing dated '37' of *Eve Brooding* Shaw draws a little elephant and comments: 'This is a lively design; but the unlucky suggestion of an elephant's trunk on the left should be quite definitely and unmistakeably the serpent whispering to Eve.' Farleigh heeds his advice in a further drawing dated '38' to which Shaw adds: 'Make the figure masculine and you have a perfect Adam brooding on the horror of immortality.' The faceless female figure in the second drawing remains unaltered in the final print.

For Act I of *In the Beginning* Farleigh submitted two drawings for the little rectangular headpiece of *The Garden of Eden*. Despite the fact that Shaw preferred the figures in the second and though the receding hills in the first reminded Shaw of grave mounds in the Chinese fields, or molehills, Farleigh kept to his original idea. The disjointed snake and unearthly landscape possess a dream-like quality: one which recurs in his work at

[101] John Farleigh to George Bernard Shaw, 9 Jan. 1938. Shaw Papers, BLMC.
[102] John Farleigh to George Macy, 25 Feb. 1939. LECA. A small undated [?1940] booklet published by the Limited Editions Club

entitled *With the Advice of G. B. S.* contains reproductions of the drawings and Shaw's handwritten comments.
[103] See *The Wood Engravings of John Farleigh*, 12.
[104] John Farleigh to George Macy, 25 Feb. 1939. LECA.

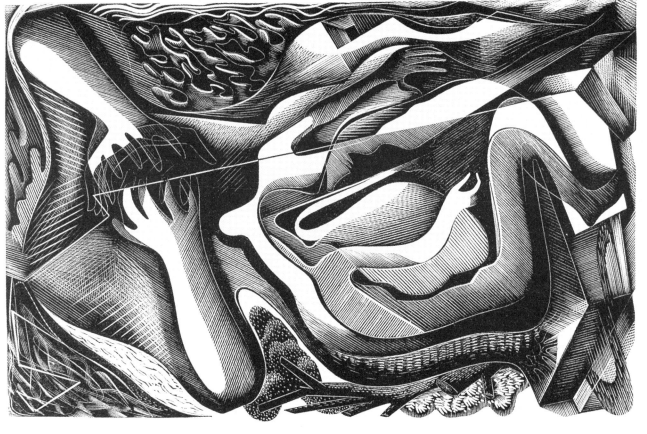

Pl. 195. John Farleigh: *Lilith Gives Birth to Adam and Eve* from George Bernard Shaw, *Back to Methuselah* (Limited Editions Club, 1939). 190 × 122

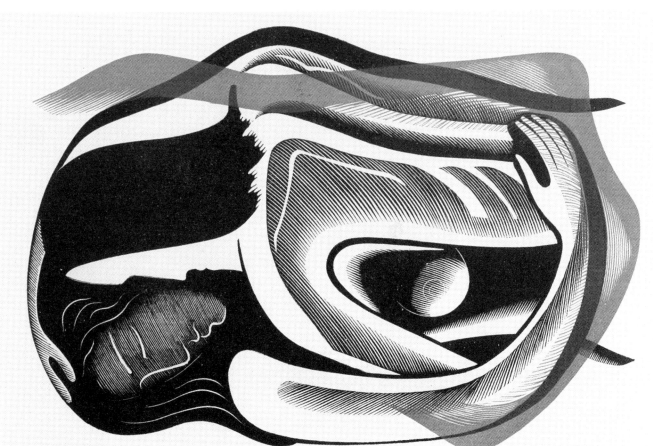

Pl. 194. John Farleigh: D. H. Lawrence, *The Man Who Died* (Heinemann, 1935). 188 × 121

this time, as one of the few wood-engravers to attempt Surrealism in book illustration. His style alters again in his designs for Part II, *The Gospel of the Brothers Barnabas*. These consist mainly of figures depicted representationally but fractured by geometric lines. His scribbled-line technique recurs in the blank, oval faces of the two automatons. The heads of Mrs Lutestring and the Archbishop in Part III are severer and more angular with tones more finely textured. On the caricatured drawing of Falstaff and Napoleon, Shaw remarks that Napoleon's littleness should be suggested, that his whistle should be removed because it looks like a cigarette, and that Falstaff 'should be laughing uproariously', all of which Farleigh corrects in the final image. Part V takes place in 31,920 AD which accounts for the timeless figure of the Ancient.

Back to Methuselah was published in 1939. Macy was not entirely satisfied with the modernity of these illustrations feeling that some of them 'seem to require a deal of explanation for even the most sympathetic of readers'.[105] In defence Farleigh sent him Shaw's delighted response to the engravings: 'Nothing more exactly right for a unique edition could be imagined. The 1500 copies will sell like Blake's some day. G.B.S.'[106] Farleigh felt he had 'never put so much into one book . . . it means a lot to me and has a lot of personal development in it'.[107] For British audiences, however, such complex and subjective interpretations had a limited appeal. Farleigh did not illustrate a book with wood-engravings again until 1944. By this time his innovative ideas in this field were spent. Yet through teaching, writing, broadcasting, and campaigning for crafts, he did much to keep the interest in wood-engraving alive.[108]

13.6. *Late Golden Cockerel Press Illustrators: Lettice Sandford, John Buckland Wright, Mary Groom, and Dorothea Braby*

When Christopher Sandford took over the Golden Cockerel Press he continued Gibbings's policy of publishing contemporary literature together with occasional 'old favourites'.[109] At the same time he introduced various new illustrators, several of whom favoured fluid lines and risqué subject matter. The first of these was his wife Lettice (née Rate, 1902–93) who had studied at the Byam Shaw School and Vicat School of Art, Kensington, and then, from 1926 to 1929, at the Chelsea Polytechnic. There she learnt wood-engraving from Robert Day and etching and copper engraving from Graham Sutherland, who at this stage was strongly influenced by F. L. Griggs and whose enthusiasm for the work of Palmer and Calvert inspired her earliest prints. Altogether she

[105] George Macy to John Farleigh, 15 Aug. 1938. LECA.
[106] John Farleigh to George Macy, 27 Aug. 1938. LECA.
[107] John Farleigh to George Macy, 10 Aug. 1938. LECA.
[108] For official positions held see Ch. 9 nn. 1 and 2. A selected

list of his publications appears in *The Wood Engravings of John Farleigh*, 119.
[109] 'Printing for Love', in Christopher Sandford and Owen Rutter, *Cockalorum* (London, 1950), 96–7.

illustrated over twenty-five books, mostly for private presses, many with copper engravings.[110]

Apart from illustrating some Tibetan folk tales recounted by Barbara Bingley for the *Illustrated London News*, Lettice Sandford's earliest attempts were for her husband's Boar's Head Press for which she contributed to nine books. Initially her technique was tentative, as can be seen in *The Magic Forest* (1931) and *Clervis & Belamie* (1932). The naïvety of her style suits the medieval tales written by her husband. A folk-art element pervades the simple decorative images engraved in white outline against a heavy black background—a method she used also for her oriental scenes to Bingley's *Tales of the Turquoise* (1933). The picture of the dancing sailor with his 'frolicking rollicking' mistress in *Clervis & Belamie* shows her inherent sense of linear rhythm.[111]

Plate 196

On seeing Hughes-Stanton's illustrations to *Comus* (1931), Lettice Sandford was immediately drawn to a more metaphysical, quasi-erotic, black figure style. Like members of Underwood's circle, she discovered the liberating influence of D. H. Lawrence who 'was "in the air" with his open emphasis on the female form'.[112] Her subsequent illustration was largely in this vein, beginning with several books in 1932. In Spenser's *Thalamos* a black silhouetted girl draped in diaphanous robes wanders through the wood flanked by two naked nymphs, the group enclosed within an oval-shaped block. The varied marks used to describe foliage indicate her delight in surface pattern and texture. A full-page engraving depicting her son Jeremy as the young boy in *Sappho* adds an autobiographical element to the book, one of her husband's favourite Boar's Head publications. Hughes-Stanton's observations are as much a commentary on his own approach to illustration as on that of Lettice:

The lady on her back hasn't quite come off and she isn't as good a figure as you can do. . . . I do think you ought to decide when you do a book wether [*sic*] you are going to keep the confines of the block, or do unsymmetrical blocks, or Symmetrical ones. I always try to, also I try to keep a feel of the same scale. This is harder but I think should be aimed at.[113]

Plate 197

A full-page block for the Marius Lyle's *The Virgin*, showing a Hughes-Stanton-like woman with the outline of a baby revealed in her womb, shocked the printer—an indication of the generally prudish attitude in those days of censorship. As Lettice Sandford commented: 'You had to tread the path carefully.'[114] The elusive symbolism and mildly erotic nature of her twelve illustrations to Bingley's *The Painted Cup* (1935), for instance, caused the author to doubt 'what all dear relations will say to it'.[115] These roundel engravings in a classical vein, some of her most attractive illustrative scenes, are delicately handled, with strong blacks and whites and intricate stippling and patterning.

Plate 198

Lettice Sandford contributed to seven Golden Cockerel Press books, mostly copper

[110] For a fuller account of her work see *Wood Engravings: Lettice Sandford*, with an introduction and checklist compiled by David Chambers (Pinner, 1986).

[111] According to Jeremy Sandford in *Figures and Landscapes: The Art of Lettice Sandford* (London, 1991), unpaginated, she and her sisters performed in a folk dance and music group.

[112] Lettice Sandford to the author, 24 June 1988.

[113] Quoted in *Wood Engravings: Lettice Sandford*, 11.

[114] Conversation between Lettice Sandford and the author, 12 May 1988.

[115] *Wood Engravings: Lettice Sandford*, 19.

engravings. In many ways these are more sensitive than her wood-engraved illustrations which vary widely in technical proficiency. The treatment of female figures for *The Golden Bed of Kydno* (1935) shows her ability to handle a continuous line, inspired by Matisse's 'sparse technique'.[116] The designs were drawn in pencil and engraved in white line on wood, and prints taken from the blocks. These were then photographically reversed white-to-black (enlarged or reduced) and printed in collotype with a greyish background. In his use of photomechanical methods to make these designs appear like etchings, Sandford, unlike Gibbings, was no purist.[117] Circulated to subscribers only, this mildly lesbian tale avoided the full force of the censors.[118]

In contrast to the refined figurative prints for *The Golden Bed of Kydno* her white-line wood-engravings for *Cupid and Psyches* (1934) show little technical advance from her earlier work. Shallowly cut, the figures are somewhat stiff, and are even more so in Christopher Whitfield's *Lady from Yesterday* (1939). Lettice Sandford appears less comfortable when dealing with modern romantic subjects, as can be seen from the gawky couple rowing or gauchely embracing in a woodland setting. Facial expressions are vapid. Her technique shows affinity with Gwenda Morgan's in these illustrations but without her immaculate, hard-edged precision and wide range of pattern. The elementary white contour lines in the cemetery scene show a deterioration of technique.

After the war Lettice Sandford's various illustrations for the Folio Society were mostly drawings which lack the clarity of her earlier work. Although less sophisticated than much of Hughes-Stanton's wood-engraved illustration, it is her subtle but unpretentious designs rather than technical prowess that makes her pre-war work so characterful.

John Buckland Wright (1897–1954), the least British of contemporary wood-engravers, was the first of the Golden Cockerel Press artists to be employed under the new triumvirate of Christopher and Anthony Sandford, and Owen Rutter. Chosen by Christopher, his sensual engraving style mirrored his own tastes exactly, as their lengthy correspondence confirms.[119] Born in New Zealand, he was educated in England where he began a career in architecture. A change of direction led him to settle in Brussels in 1924, then, from 1929 to 1939, in Paris where he worked and taught with Stanley Hayter in Atelier 17. As a result of this spell abroad he was little known in England until his return in 1939 when his reputation was made mainly from his wood- and copper engravings for the Golden Cockerel Press.

Buckland Wright's engraved work is exceptionally well documented, with, among other writings, publication of much of his correspondence with Sandford, and a

[116] See n. 114.
[117] Method described and reproduced by David Chambers in 'Lettice Sandford's Engravings', *Matrix*, 4 (1984), 89–92. It is uncertain whether Sandford employed this method as an experiment or as an economy. For whatever reason, he chose not to disclose the fact in the press bibliography (No. 107) where he described the illustrations as line engravings, possibly to give the book an air of luxury. See Hilary Chapman, 'A White Lie', *Print Quarterly*, 13 (1996), 190–1.

[118] Two copies of *The Song of Songs* (1936) with 12 copper engravings by Lettice Sandford were seized by the US Customs.
[119] See, for instance, Roderick Cave (ed.), '"A Restrained but Full-Blooded Eroticism": Letters from John Buckland Wright to Christopher Sandford, 1937–1939', *Matrix*, 8 (1988), 55–75, and 'The Making of the "Vigil of Venus"', *Matrix*, 9 (1989), 146–71.

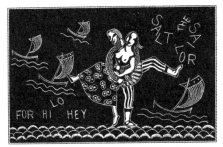

We reeled and rumbled and bumbled away
like a rumbling lumbering waggon of hay
in a humbling jumbling sort of way
howling Salt-the-sailor's for Hilo-hey!

TWICE had the moon waxed and waned while the car-
penters were at work on the new bridge over the Rhone.
At last it was finished but none as yet had crossed over.
They waited for Count Clervis-the-lusty who was coming from
the tower of Saisneport with his captains, while before him went
the singing-boys & those that bore his gonfalon. All the people
were lined along the cliffs at either side of the Rhone, the scat-
tered *menestrals* among them dancing, jumping, juggling, singing,
and making gay music of harp, viol, lyre, citole, rebec, & guitar.

Meantime a fleet sailed up to Nimpole, & the first ship that
cast anchor had sky-blue sails & rigging of spun silver. Belamie
and her train were brought ashore and they climbed up to the
cliffs. When the people of Nimpole saw the fleet of ships below,
and Belamie among them again and in such fine array, some

21

OFFERINGS TO ARTEMIS

No more a child am I, therefore I come
To offer up those loved and childish things
That now I must put by. O Artemis,
Within whose woods I played, I bring my toys:
This bird of painted clay who could not sing;
This puppet wrapped in rags I rocked and kissed;
Her cradle too; and here close by are piled
My spinning top, small cups and dishes three;
My coloured ball;—last and most treasured, take
The boat with bellying sail my father made
Beside the winter fire, the while I watched
His keen blade carve the white-grained ilex wood

14

Pl. 196 (*above, left*). Lettice Sandford:
Christopher Sandford, *Clervis & Belamie* (Boar's
Head Press, 1932). 253 × 185

Pl. 197 (*above*). Lettice Sandford: E. M. Cox (ed.),
Sappho (Boar's Head Press, 1932). 148 × 86

Pl. 198 (*left*). Lettice Sandford: Barbara Bingley,
The Painted Cup (Boar's Head Press, 1935). 260 × 169

Pl. 199. John Buckland Wright: E. Powys Mathers, *Love Night*
(Golden Cockerel Press, 1936). 161 × 106

monograph edited by his son.[120] He was a self-taught wood-engraver, having initially been inspired by Craig's *Woodcuts and Some Words*. Other influences included Laboureur (for copper engraving), Frans Masereel, Greek sculpture, and the sculpture of Maillol. He began illustrating in 1930 for continental publishers, mainly esoteric private presses, the Dutch Halcyon Press in particular, whose owner, A. A. M. Stols, appreciated his penchant for sexually explicit subject matter. Buckland Wright had already contributed wood- and copper engravings to around twenty-two books when Sandford discovered and commissioned him to illustrate E. Powys Mathers's *Love Night* in 1936. This book alone is discussed here since it contains the only wood-engraved illustration he did in England before 1940.[121]

For *Love Night* (according to Sandford, 'Powys Mathers at his most exotic'),[122] Buckland Wright set his fifteen 'amorous engravings' in a Laotian jungle setting, using an attractive orchid-flower border for the title-page. Although he worked closely with Sandford, and was aware of the importance of harmonizing image with type,[123] the rectangular blocks are still rather too dark for the elegant Perpetua face. The overall blackness is relieved *Plate 199* with glossy white areas for skin, jagged-lined foliage, and intricate tonal effects (some made with a multiple tool). Hard-edged outlines along the contours of bodies, softened with fine cross-hatching, became a favourite formula. (Early Italian line engravings, particularly those of Mantegna, had a decisive affect on his technique.) The influence of classical sculpture in the frieze-like depiction of the figures is apparent; none the less their rhythmic groupings and lush surroundings are romanticized. There is an un-English voluptuousness and realism about his female nudes, more especially in his copper engravings, which is absent from most of his contemporaries' work.[124] Yet, considering the avant-garde nature of some of his single prints from his Paris days and the vigorous expressionist style seen in his designs for the Halcyon Press's *Sonnets of Keats* (1930), these compositions are singularly unmodern, doubtless largely due to the nature of Sandford's commission.[125] His post-1940s illustration, most notably for his *magnum opus*, Keats's *Endymion* (1947), is, however, more conceptual and experimental, perhaps because, as he admitted, he preferred 'the freer, more or less abstract sphere of poetry, or synthesizing of a whole story into one cut, which creates an atmosphere rather than picturing any definite scene. I dislike pure illustration as much as anecdote.'[126]

Buckland Wright considered himself in the mould of the French *peintre-graveur*. As such, he was severely limited by the constraints of book illustration. For all his ability

[120] *The Engravings of John Buckland Wright* ed. with introduction by Christopher Buckland Wright, (Aldershot, 1990) includes an essay, 35–42, on his illustrated books by Eunice Martin. See also Anthony Reid, *A Checklist of the Book Illustrations of John Buckland Wright* (Pinner, 1968). For a tribute from Sandford see 'John Buckland Wright', in *Cockalorum*, 65–71.

[121] For his ephemeral designs for the press see Christopher Buckland Wright, *Cockerel Cavalcade: John Buckland Wright's Devices Engraved on Wood, 1939–1945* (London, 1988). (See *Tailpiece*.)

[122] Sandford and Rutter, *Bibliography of the Golden Cockerel Press*, No. 113, 9.

[123] 'No technical difficulty should be allowed to destroy a reasonable balance between illustration and text.' Letter from

John Buckland Wright to A. A. M. Stols published in *Halcyon*, 1 (1940) as 'Open Letter to an Editor on Wood Engraving', and reprinted in *The Engravings of John Buckland Wright*, 50–2, in which he also describes his working method.

[124] Six rather more *risqué* special prints were added as extras to 80 de luxe copies. Of these the 5 special editions printed on vellum were priced at 50 gns. each compared with 2 gns. for the ordinary edition.

[125] In *The History of the Golden Cockerel Press*, Manson and Cave establish from correspondence that Sandford encouraged him to use naturalistic rather than abstract images.

[126] Anon., 'The Wood Engravings of John Buckland Wright', *Studio*, 107 (1934), 124–8.

in this field he is best remembered as an inspirational teacher[127] and proselytizer of graphic art, whose manual, *Etching and Engraving* (1953), inspired many practitioners.[128] John Piper, a former pupil, believed he 'did a lot to launch British engraving into the excited waters of contemporary European art'.[129]

Other lesser-known illustrators introduced to the Golden Cockerel Press before 1940 include Peter Barker-Mill, Clifford Webb, John O'Connor, Gwenda Morgan, Helen Binyon, Geoffrey Wales, and Averil Mackenzie-Grieve, whose work is discussed in earlier chapters. Only Mary Groom and Dorothea Braby attempted seductive, linearly fluid images of the type particularly favoured by Christopher Sandford. Mary Groom (1903–58) was a contemporary of Hughes-Stanton and Hermes at Underwood's school.[130]

Plate 200 An unusually sketchy print for the Cresset Press *Apocrypha* shows traces of the multiple tool. She contributed wood-engravings to *The Island*, notably a frontispiece cut in the same shallow white line—a technique which became her trademark and one which was rarely used by her contemporaries, most probably because, although inventive, the scraperboard-like effect seems to deny the aesthetic qualities peculiar to wood. Her thirty wood-engravings for the luxurious Golden Cockerel Press edition of *Paradise Lost*

Plate 201 (1937)[131] were in a similar vein: one which, despite the faultless presswork, Sandford considered did not entirely suit the type of display required which was based on the style of heading for *The Four Gospels*. In his eyes the artist 'did not achieve a sufficient co-ordination between the headpieces, with their dropped initial letters, and the rest of the [Golden Cockerel type] titling'.[132] Although Groom's designs were 'extremely interesting & refreshingly original' he found them rather too reminiscent of Flemish primitives to accord with Milton's poetry. In contrast, literary scholar Wendy Furman believes Groom to be the best visual interpreter of *Paradise Lost* since Blake. The first woman illustrator of the book, her vision is 'at once humanist and feminist'.[133] For her scenes from the Old Testament for *Roses of Sharon* (1937) Sandford would have preferred an entirely new conception rather than 'a rehash of the popular Italianesque'.[134] Once again the finely cut white-line engravings lack depth and contrast and appear too black for the page. Sales of the book were disappointing. Mary Groom's single prints are generally more appealing than those for illustration.

The wood-engraved work of Dorothea Braby (1909–87) was particularly liked by

[127] He taught at the Camberwell School of Art (1948–52), transferring to the Slade in 1952.

[128] *Etching and Engraving: Technique and the Modern Trend* published by Studio Publications in 1953, and reprinted in paperback in 1973.

[129] Foreword to *The Engravings of John Buckland Wright*, 11. His work is well represented in the Prints and Drawings Department at the British Museum.

[130] She joined the school in Jan. 1923, later attending the Royal College of Art (1927–9) and the Slade School of Art (Jan.–June 1927 part-time), at the same time continuing her association with the Underwood group. She exhibited with the SWE, 1928–38, becoming an associate member in 1934 and a member after the war. The author is indebted to Wendy Furman for this biographical information.

[131] At 100 gns. for the vellum edition (4 copies) it was the press's most expensive book.

[132] Sandford and Rutter, *Bibliography of the Golden Cockerel Press*, No. 119, 15.

[133] Wendy Furman, '"Consider first, that great / or bright infers not excellence": Mapping the Feminine in Mary Groom's Miltonic Cosmos', from 'Riven Unities', in *Milton Studies*, 8, ed. Wendy Furman and others (Pittsburgh, Pa., 1992), 46. The author believes, 128, that Groom was 'able to see beyond the patriarchal surface of Milton's text to its deep structure of feminine conscious'.

[134] Sandford and Rutter, *Bibliography of the Golden Cockerel Press*, No. 127, 25.

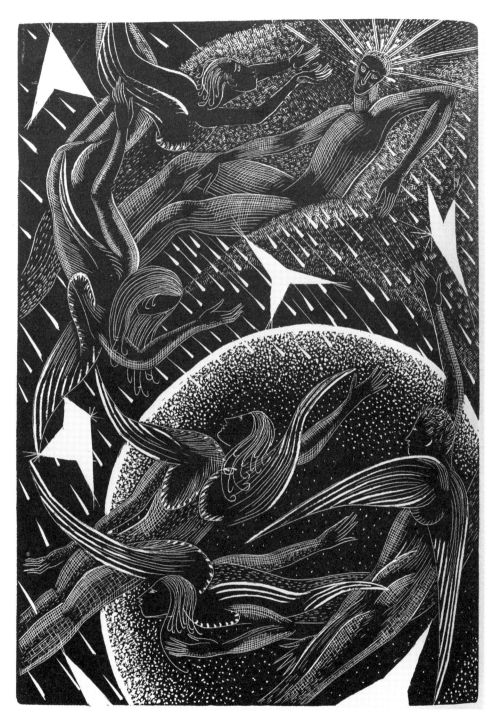

Pl. 200 (*above*). Mary Groom: *The Apocrypha* (Cresset Press, 1929). 182 × 127

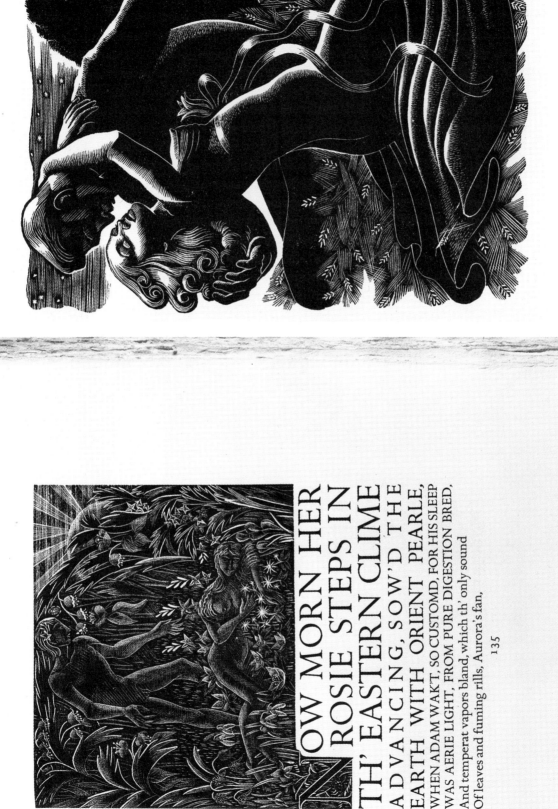

NOW MORN HER
ROSIE STEPS IN
TH' EASTERN CLIME

ADVANCING, SOW'D THE
EARTH WITH ORIENT PEARLE,
WHEN ADAM WAK'T, SO CUSTOMD, FOR HIS SLEEP
WAS AERIE LIGHT, FROM PURE DIGESTION BRED,
And temperat vapors bland, which th' only sound
Of leaves and fuming rills, Aurora's fan,

135

Pl. 201 (*left*). Mary Groom: John Milton. *Paradise Lost* (Golden Cockerel Press, 1937). c.328 × 230

Pl. 202 (*above*). Dorothea Braby: Christopher Whitfield, *Mr Chambers and Persephone* (Golden Cockerel Press, 1937). 140 × 103

Sandford.[135] In 1926 she had studied at the Central School under John Farleigh and from 1928 to 1930 at the Heatherley School of Art, studying also in Florence and Paris. Most of her illustrations were done for private presses, especially the Golden Cockerel, which was responsible for her first commission: five engravings for Christopher Whitfield's love story, *Mr Chambers and Persephone* (1937). These were in suitably romantic vein, although the glamorous image of the couple, Persephone in a revealingly clinging dress, *Plate 202* is perhaps more redolent of contemporary film posters. Braby's sense of rhythm is apparent in the sinuous contours. Her blocks are at times oppressively dark. Her most interesting work, in particular the Golden Cockerel *Mabinogion* and *Gilgamesh*, dates from after 1940, and is in a more imaginative mythological and spiritual vein. With her How to Do It book, *The Way of Wood Engraving* published in 1953, Braby made a vital contribution to the canon of literature, as did Buckland Wright, at a time when the medium was no longer fashionable.

To Christopher Sandford these 'modern school' artists were all illustrators whose work was 'admirable in combination with the new psychology and idiom of con-temporary poetry and prose'. At the same time it lacked 'that blending of simplicity, austerity and power requisite to a correct interpretation' of historical or classic texts.[136] His arbitrary division points up the perceived disparity between the metaphysically inclined 'sinuous line' wood-engravers and the more representative painterly, typo-graphic, or decoratively minded practitioners.

[135] She worked also in pen and ink and scraperboard and contributed to a number of magazines including the *Radio Times*.
[136] 'Clifford Webb', in *Cockalorum*, 71.

ꕥ *14* ꕥ

TWO INNOVATIVE ILLUSTRATORS
OF NATURE AND RURAL LIFE

14.1. *Clare Leighton*

Clare Leighton (1898–1989) was one of the most gifted and prolific wood-engravers of the period covered in this book, whose prints, unusually, were mostly done for illustrative purposes.[1] Her voluminous writings include two books on wood-engraving[2] and a remarkable series on country matters which she illustrated herself. By 1940 she had contributed wood-engravings to over twenty books, among the most significant of her illustrating career. Early recognition came from such influential critics as J. C. Squire,[3] Malcolm Salaman,[4] Martin Hardie,[5] and Hilaire Belloc whose introduction to a limited edition volume of her wood-engravings[6] was a glowing testimony to her talent. In recent times her work has been given due recognition through exhibitions and a short monograph.[7] With the use of unpublished correspondence and primary material this section aims to show Leighton's intense interest in typographical matters and layout— aspects of her illustrating skills which have been largely overlooked.[8]

Clare Leighton studied at the Brighton College of Art before attending the Slade. In 1922 she joined evening classes at the Central School under Rooke who inspired her interest in wood-engraving and suggested that she start with three tools.[9] Friendship with Gill and first-hand knowledge of his work may well have been partly responsible for her lifelong respect for the human body and its sculptural qualities. One of her first prints, *The Malthouse*, bought by Gill, was also accepted by Noel Brailsford for publication in *The New Leader* in April 1924. Through Belloc's recommendation it appeared, together with two other of her wood-engravings, in Squire's prestigious The *London Mercury* thereby establishing her reputation early in her career.[10] A *New Leader* print entitled *Kate Dickson*[11] for a story by Winifred Holtby reveals a romantic tendency fostered by an

[1] For a checklist of her prints and illustrated books see exhibition catalogue, *Clare Leighton: American Sheaves, English Seed Corn*, with an introduction by William Dolan Fletcher (Boston: Boston Public Library, [1977]).

[2] Both for Studio Publications: *Wood-Engraving and Woodcuts* (London, 1932), the second in the How to Do It Series, and *Wood Engravings of the 1930s* (London, 1936).

[3] *Studio*, 93 (1927), 173–6.

[4] 'No English wood-engraver of the moment seems to be more popular than Miss Clare Leighton'. *The Woodcut of To-Day at Home and Abroad* (1927), 87.

[5] Hardie encouraged and collected her work much of which he bequeathed to the Ashmolean Museum, Oxford. See Ch. 5.3.

[6] *Woodcuts: Examples of the Work of Clare Leighton* (London, 1930).

[7] See, in particular, exhibition catalogue, *Clare Leighton: Wood Engravings and Drawings*, with essays by Anne Stevens and David Leighton (Oxford: Ashmolean Museum, 1992), and *The Wood Engravings of Clare Leighton*, selected with an introduction by Patricia Jaffé (Cambridge, 1992). At the time of writing, a biography by the last author is in preparation.

[8] Regrettably the author was unable to locate any working page proofs.

[9] Conversation between Clare Leighton and the author, 25 Aug. 1983.

[10] In 1926 four prints of agricultural subjects were reproduced in *The Forum*.

[11] Specially engraved to illustrate 'Lovers meeting'.

unconventional upbringing by eccentric parents: a beautiful, egocentric mother who 'lived upon romance' and wrote melodramatic serials for the Northcliffe Press and a father who wrote Wild West and boys' adventure stories.[12] Through her parents' literary and artistic circles and her close relationship with Brailsford she was drawn to socialist ideals which manifest themselves in her empathetic descriptions, both in prose and pictures, of working people. Shy and sensitive in her youth, and innately perceptive, she later became a good mixer and dynamic speaker. An immensely hard and disciplined worker herself, she maintained a firm streak of independence, holding strong and often unconventional opinions. The discipline and craftsmanship of wood-engraving suited her both ideologically and artistically.

Unlike most of her contemporaries Leighton shunned private presses, preferring to introduce her work to a wider range of readers.[13] In her quest to find publishers and in her dealings with them she was extremely businesslike, assisted by useful contacts and extensive foreign travel. Brailsford, for instance, found her an agent in America where she lectured sporadically before settling there in 1939. She worked for numerous publishers, among them Heinemann, Longmans Green, Macmillan, Duckworth, Collins, and Gollancz, several of whom had publishing arrangements with their American equivalents. Like Gwen Raverat, whom she knew and admired, she took an active interest in the marketing of her books. In 1929, as a result of her efforts, her first significant book, Hardy's *The Return of the Native*, was published jointly by Harper & Brothers, New York, and Macmillan. In a letter to a Mr Camphill at Harper, she had expressed her desire for it to be published in England, 'as I want my English press notices. Mr. J. C. Squire likes the woodcuts immensely and has undertaken to do his utmost for the book when it appears.'[14] Generally she ensured the availability for sale purposes of a certain number of proofs of her illustrations in order to supplement fees and royalties,[15] in one recorded instance bargaining with the publishers over these.[16] As will be seen, with experience behind her she became more involved in the production of the book, formulating the ideas, helping to plan the design, and, with *Under the Greenwood Tree*, dealing with the printer direct.

Leighton's approach to technique can best be envisaged from the text and photographs of her at work in her manual *Wood-Engraving and Woodcuts*. Reproductions of several of her prints show her ingenious use of tools, most especially the multiple tool for 'useful even greys'. Wood-engraving, she suggests, 'appeals to any artist who loves strong, clean, deliberate drawing'.[17] Certainly sound draughtsmanship was the basis of

[12] Leighton's family life is vividly portrayed in her book, *Tempestuous Petticoat* (London, 1948), an account of her childhood. Her elder brother Roland, killed in the First World War, had been engaged to Vera Brittain.

[13] Several of her publishers produced limited editions signed by her; for instance Macmillan/Harper & Brothers with *The Return of the Native* (1929), and Duckworth which produced both trade and limited editions of *Wuthering Heights* (1930).

[14] Clare Leighton to [?] Camphill, 25 Oct. 1928. MA (RUL).

[15] Other useful sources of income included advertising for such organizations as the London General Omnibus Company, the Empire Marketing Board, and London Transport, for the last two of which she produced colour lithographed posters. See Ch. 5.4 n. 95.

[16] She was dissatisfied with Macmillan's fee of £250 (with no royalties) for *Under the Greenwood Tree* which was much less than she was paid for *The Return of the Native*. She was prepared to waive royalties for a fee of £400. Clare Leighton to [?] Lovat Dickson, 29 Mar. 1939. Macmillan Publishers' Archive, Macmillan Publishers, Ltd., henceforth MP.

[17] Leighton, *Wood-Engraving and Woodcuts*, 96.

all her work. An avid sketcher from an early age, her preliminary drawings for book illustration are of particular interest.[18] Ideas often evolve over a period of time from 'a few vague scribbled lines . . . that hold the essence of the final print'.[19] Her wide-ranging observations, predominantly of the rural environment, include local characters, costumes, machinery and tools, animals, and plants, many of which are recognizable in her own books. For her fictional images, too, figures and objects are frequently drawn

Plate 203 from life, as for example the basket in *Tamsie on the Ladder* in *The Return of the Native*. Several small sketches framed in pencil are obviously working models for illustrations which she drew direct on to a white-coated block, often working with a mirror to overcome the problem of image reversal. So fluent and assured was her line, it is unlikely she felt the need to use tracing paper. White highlights appear on various black chalk drawings, indicating where these areas were to be cut. Working proofs for *Under the Greenwood Tree* show corrections in chinese white for subsequent alteration on the blocks.[20] Leighton was all too aware of the dangers of 'shoddy, facile, over-black prints'.[21] Progressive proofs of one of her large, immaculately engraved single prints, *Cutting*, demonstrate the problems of printing such blocks without clogging up the lines with ink.[22] As she admits, 'any original effects of printing . . . are impossible when the block has to be handed over to the professional printer',[23] the main reason for her frequent disappointment at the final appearance of her illustrations.

In her early books, however, over-blackness is as much to do with her heavy-handed treatment as with the printing. This can be seen from her first commissioned wood-engraved illustration, a single print for A. Muir Mackenzie's *The Half Loaf* (Heinemann, 1925) in which dark figures are only lightly touched with white line. The fact that her wood-engraving technique remained overridingly black throughout her career implies that it was an essential element of her style. She felt there was a spiritual quality in the ability to draw light from the block: 'almost a Biblical feeling that you're making light—a sort of Genesis.'[24] Subtle chiaroscuro in her illustrations reinforces the mood of the text, as in the flickering firelight scene of Mr Earnshaw's death in *Wuthering Heights*, or in the view of Tamsie in the shadowy barn in *The Return of the Native* 'gazing abstractedly at the pigeon hole, which admitted sunlight so directly upon her brown hair and transparent tissues that it almost seemed to shine through her'. Leighton's interpretations at this period are often melodramatic, as apparent from her penchant for theatrically posed figures and for placing silhouetted trees and romantic couples against stark white skies. Her responsiveness to the emotional aspects of the text and the atmosphere of its setting is most obvious from her rectangular, whole-page images

Plate 204 for *Wuthering Heights*, and in her treatment of Thomas Hardy's work for which she had a special affection. 'While I was illustrating *The Return of the Native*', she recalled, 'I *was* Egdon Heath, feeling the hooves of the cropper ponies and the turn of the

[18] Those seen by the author are in the possession of the family.
[19] Quoted from her unpublished Memoirs. In the possession of the family.
[20] Held in the Department of Prints and Drawings at the Fitzwilliam Museum, Cambridge.

[21] Leighton, *Wood-Engraving and Woodcuts*, 96.
[22] Ibid. 88–93.
[23] Ibid. 95.
[24] Conversation between Clare Leighton and the author, 25 Aug. 1983.

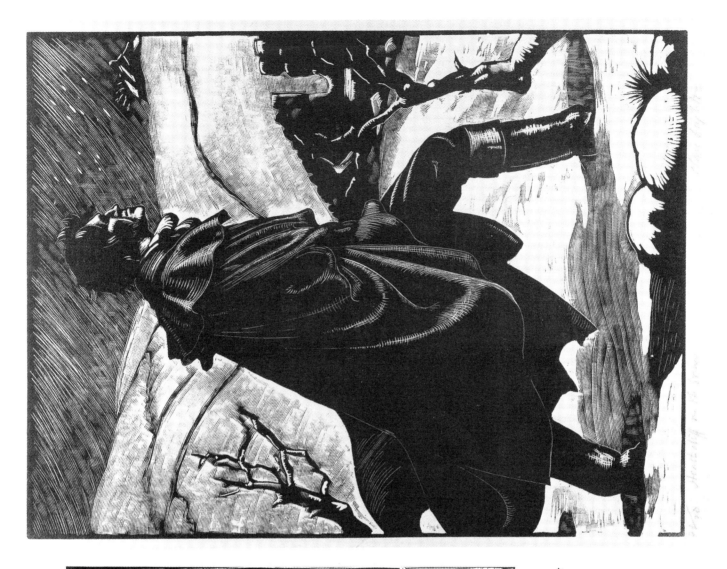

Pl. 203 (*above*). Clare Leighton: *Tamsie on the Ladder* from
Thomas Hardy, *The Return of the Native* (Macmillan/Harper
& Brothers, 1929). 124 × 95

Pl. 204 (*right*). Clare Leighton: *Heathcliff in the Snow* from
Emily Brontë, *Wuthering Heights* (Duckworth, 1931). 179 × 135

undergrowth.'[25] Her fifty-nine engravings (a frontispiece, and full-page and head- and tailpiece blocks) depicting country people—women, children, farmworkers, and other locals—against a backdrop of fields or village street complement Hardy's evocations of Wessex rural life. In August 1929 she visited his wife who was delighted with the illustrations.[26] Although some are no longer confined to a frame, these images, only lightly relieved with white, are heavily black in relation to the area of type, and Leighton was unhappy with the over-inking and poor printing of some of the blocks.[27] At this time she was less concerned with the overall appearance of the page than she was later to become. The following year she wrote to Macmillan to ask if the firm would be interested in another Hardy book which she was arranging to do for Harper—either *The Mayor of Casterbridge* or *Far from the Madding Crowd*. 'I have no doubt whatever that *Far from the Madding Crowd* is incomparably more illustratable—at any rate, for me—with all its wonderful farming scenes',[28] a remark which makes clear her preference for such subjects.

The few wood-engraved books she illustrated up to 1933 which are not set against a rural English backdrop include Thornton Wilder's *The Bridge of San Luis Rey* (Longmans Green, 1930) and H. C. Tomlinson's *The Sea and the Jungle* (Duckworth, 1930).[29] The pictorial scenes they contain, though imaginative, lack subtlety. The transformation of her style occurred when she began to map out the writing of *The Farmer's Year: A Calendar of English Husbandry.* 'I found myself revelling in sensuous, verbal descriptions of colour,' she wrote. 'The one medium was not enough. It is as though I was permitted to be both painter and graphic artist.'[30] This book, published by Collins in 1933, was a pioneering venture in several ways.[31] The second of some eleven written and largely illustrated with her own wood-engravings or drawings, it anticipated the demand for illustrated books on country matters.[32] More significantly its oblong, folio-sized format, with whole page engravings facing complementary text, was unprecedented, as was Leighton's use of large figures (a feature of her single prints) which dominate the pages. A further innovative aspect for a commercial book was the harmonious blend of illustration and typography, with decorated initials opening each month's text. There is nothing quaint or traditional about these powerful naturalistic scenes of life on the land. Leighton was keenly observant and knowledgeable about farming, as seen from her writings and sketchbooks. Varying textures add to the painterliness of her visual descriptions. In *May:*

Plate 205 *Sheep Shearing* the smoothness of the sheep's shorn bellies contrasts with the woolly-textured fleeces; the bright sunlight falling on the backs of the shearers throws their faces into shade; intent on their work, their curved, rhythmic postures create a sense

[25] Memoirs.

[26] Clare Leighton to [?] Ratcliffe, 13 Aug. 1929. MA (RUL).

[27] The single-page blocks were printed on thin paper and tipped in to the book.

[28] Clare Leighton to [Daniel?] Macmillan, 17 July 1930. MA (RUL). In fact she produced no more Hardy illustrations for Harper and none for Macmillan until 1940.

[29] A frontispiece to a limited edition (260 copies) of Thornton Wilder's *The Angel that Troubled the Waters, and Other Plays* (Longmans, 1927) represents her only attempt at colour wood-engraved illustration. Her children's book, *The Musical Box*, published by Gollancz in 1932, contained coloured drawings.

[30] Memoirs.

[31] According to Vera Brittain, Collins were furious that Gollancz had approached Leighton to do the book. Clare Leighton to Victor Gollancz, 31 Jan. 1936. Victor Gollancz Archive, Victor Gollancz, Ltd., henceforth VGA.

[32] *The Farmer's Year* ran to three English editions and an American one in three months.

of action. Some characters, such as the ploughman in *November*, profiled against a setting sun, appear somewhat idealized. Yet, as with her American prints of labourers, her characterizations transcend specific individuals, representing instead the universal and elemental nature of agricultural work.

The next book illustrated and written by Leighton, *Four Hedges* (1935), produced in a smaller, more accessible format than *Farmer's Year*, became a best-seller. The first of a series of country books published by Victor Gollancz for a mass market, it was largely responsible for popularizing wood-engraved nature illustration. Correspondence shows the extent of Leighton's collaboration with the publisher. In her initial letter to Gollancz enclosing the rough draft of her text she expressed her ideas for the book's appearance:

All the small subjects in each month will have to have a crescendo and a rhythm. . . . I want to keep the balance between the flowers & plants themselves (for this isn't to be a professional gardening book, but only a year in an ordinary garden), the living things in the garden & the effect of the garden upon me, too, as a living thing.

I propose that each month should be roughly 3,000 words, it will inevitably vary with the months. I suggest one full page engraving to each month, and smalls to decorate the pages to the extent of about 90 (making 100 in all).[33]

She did not want too large a book and suggested meeting to discuss the type and the format. The book appeared more or less as she intended with slightly fewer illustrations: eighty-one small and medium-sized wood-engravings incorporated into the text and as head- and tailpieces, and six whole-page prints. Her close observations of flowers, fruit, vegetables, birds, and animals, many sketched in her Buckinghamshire garden, reveal her deep understanding and love of nature. Although purely naturalistic compositions, they are alive and expressive, with their shapely design and cut-out effects. Once again figures are monumental and rhythmic, as epitomized by the swinging body of the apple gatherer in *September*. The crisply cut wood-engravings complement the large type.[34] An *Plate 206* attractive repeat-pattern dust-jacket no doubt added to the immediate appeal of the book.

Leighton had originated this formula for Gollancz and resented the fact that her idea was copied by Agnes Miller Parker equally successfully in *Through the Woods* in the same series the following year.[35] In a letter dated 14 November 1936 Gollancz chastised her for her acrimonious correspondence with Miller Parker: 'Isn't your memory at fault in thinking that you designed FOUR HEDGES? My impression is that all of us here (and especially our typographical adviser, Stanley Morison) took immense pains in the sale of the book—of course in consultation with you.'[36] Leighton apologized for her prima donna attitude but stressed the importance of her role:

[33] Clare Leighton to Victor Gollancz, 23 Oct. 1934. VGA.
[34] Leighton's suggestion of 'rather nice 14-point Walbaum type [a revised old German typeface]', a sample of which she had been sent by Harold Curwen, was not taken up.
[35] Conversation between Clare Leighton and the author, 25 Aug. 1983.
[36] Victor Gollancz to Clare Leighton, 14 Nov. 1936. VGA.

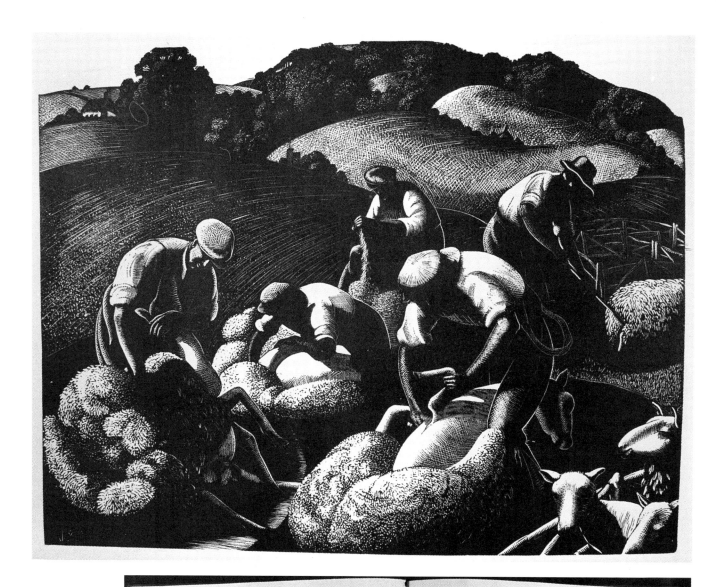

Pl. 205 (*above*). Clare Leighton, *The Farmer's Year* (Collins, 1933). 230 × 265

Pl. 206 (*right*). Clare Leighton, *Four Hedges* (Victor Gollancz, 1935). 260 × 392

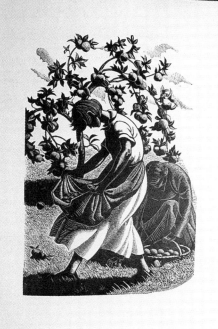

FOUR HEDGES

balsams. It has never been more beautiful. No longer do we shrink from looking at our plants as we did during the summer's drought, for the rains have swelled the leaves once more, the flowers are happy in their second blooming and the grass at last is really green.

I mow the lawn. How many people know the right way it should be done ? Feet should be bare ; grass should be slightly damp. The cold, moist clover strikes up from the mower upon my bare feet, and blades of cut grass and bits of slashed weeds stick between my toes. I remember one of my moments in life : I had been bicycling among the foothills of the Pyrenees at the time of the grape harvest, and, turning a corner had come upon a shouting clump of peasants. They were laughing as they sang odd little songs, and some of them were dancing. In the midst of them, and all among them, and surrounding them, were squat fat tubs, some full of grapes, others purple pools of juice. And in others again were men and women treading the grapes. They beckoned to me, and I, too, trod with bare feet. The grape stalks and the pressed skins were caught between my toes, and as I drew my feet up, there was a resisting, sucking noise, as if I were pulling against a tide. It was

84

You may remember that Stanley Morison was sick the year that we did 'Four Hedges', so that it did happen that it was I who chose the type, and type area. I specially remember this because knowing nothing about book designing I felt much more funky about doing it than ever I told you. (And may I say that I must admit that Agnes has gone several better than I in her designing of her small engravings in the page).[37]

Gollancz was sufficiently pleased with Leighton's 'pretty pictures' to ask for another book in the same format. He was impressed by her series of essays about country people and their occupations written, according to her preface, as 'a record of an enduring world'. He published them as *Country Matters* in 1937.[38] Each character is imbued with classic dignity whether tramp, smithy, chair bodger, or bell ringer. Leighton delights in details of village life and labour, people and pastimes, including some cheerful fairground scenes, which conjure up a haven of rural tranquillity. Her first-hand studies of nature are also incorporated into the text: for example, a leaping hare (anticipating Miller Parker's version), and an L-shaped design of black bryony. Blocks are lightened with fine speckles, short lines, and cross-hatching, creating an extraordinarily rich variety of textures.

Leighton was further annoyed with Gollancz for publishing Miller Parker's *Down the River* in the same year as her book. No doubt partly as a result of this fracas she announced, 'I have a feeling that I want to break off from doing books & run away somewhere and paint murals'[39]—a forewarning of her imminent departure to America. Once there, having unburdened herself with a semi-autobiographical work, *Sometime … Never*, for Macmillan, New York, which she illustrated with drawings, she accepted a commission from the London firm in 1940 for a Hardy centenary edition of *Under the Greenwood Tree*. Although the war prevented her returning from America to study the Dorset countryside, she took a close interest in the book's design from the start. Before beginning work she asked to see specimen pages. On receipt of these she commented favourably on the sizes of type and sent a sketch to Daniel Macmillan to indicate the spaces she wanted left between the top line of type and title, and the bottom line of the engraved design: 'I can assure you that I can do so very much better if I have the set-up with the exact spaces left at the ends of the chapters.'[40] As there were so many short chapters she suggested having only six full-page blocks—one to prefix each part and one as frontispiece to avoid overloading the book.[41] Later, in a letter to the printer, William Maxwell, she decided against having a frontispiece but asked him to design a title-page with space for a vignette similar in weight to that for *Country Matters*.[42] For this she engraved a courting couple, while the head- and tailpieces consisted of rustic scenes, many in similar vein to *Country Matters*, but with more precise detail and greater tonal variety. Most were reversed images of pencil sketches she had made in an unillustrated 1929 Macmillan edition of the book as a guideline to the design and layout.[43]

[37] Clare Leighton to Victor Gollancz, 16 Nov. 1936. VGA.
[38] Although he requested as many, or nearly as many, full-page illustrations as before and even more smaller prints, the final number of engravings was fourteen less than for *Four Hedges*.
[39] Clare Leighton to Victor Gollancz, 29 June 1937. VGA.
[40] Clare Leighton to Daniel Macmillan, 23 Oct. 1939. MP.
[41] Ibid.
[42] Clare Leighton to William Maxwell, 9 Apr. 1940. MA (RUL).
[43] In the possession of the family.

Leighton was particularly pleased with this work, believing that she was 'putting into it all the nostalgia that I am feeling at the moment',[44] as evident from her sentimental scenes of young lovers. Although in sympathy with romantic texts, she does not always seem comfortable or inspired with this type of illustration.

Up to this time the repertoire of literature she chose to illustrate was limited. Earlier she had scrapped plans to illustrate *Richard III* for the Limited Editions Club because of an 'inherent dislike of anything historical'.[45] She was beginning to tire of portraying the English scene, later admitting that she felt the need 'to escape into something new and unknown'.[46] In the circumstances her ten wood-engravings for Penguin Books' wartime edition of *The Natural History of Selborne* (1941) were unexciting, not enhanced by the printing on poor quality paper.

Undoubtedly Clare Leighton's most impressive and original illustrations are those which accompany her own writings, especially in books with which she was involved in the production. With *The Farmer's Year*—one of the best examples of bookmaking of the period —and her successive books on rural matters, she not only revived the British pastoral tradition for wood-engraved illustration but encouraged higher aesthetic standards for trade books. New practitioners were gained through her seminal book, *Wood-Engraving and Woodcuts*, the first widely available technical manual of the period. She is perhaps most admired for her exceptionally fine technique and bold, often large-scale, figurative scenes with their underlying sociological message. A comment from a fellow wood-engraver, the American John Taylor Arms, sums up her art: 'I learn much from your work. Spiritual enrichment for others is, I believe the finest quality our work can possess.'[47]

14.2. *Agnes Miller Parker*

Despite a superficial similarity with the work of Clare Leighton, Agnes Miller Parker's style, technique, and aims are significantly different. Miller Parker (1895–1980) never wrote her own text and considered herself a decorator rather than an illustrator of books:

My feeling for books is firstly that the artist comes in, after the typographer, as embellisher and decorator and has a minor place which he cannot or ought not to overstep. To me it would be an impertinence for the artist-illustrator (if it is illustration that is wanted) to try to compete with the author who is writing a whole novel or play on character.[48]

[44] See n. 42.
[45] Clare Leighton to [? George Macy], 17 Nov. 1936. LECA.
[46] Quoted from Jaffé, *The Wood Engravings of Clare Leighton*, 12.
[47] John Taylor Arms to Clare Leighton, 18 Mar. 1949. Quoted from Caroline Mesrobian Hickman, *Graphic Images and Agrarian Traditions: Bayard Wootten, Clare Leighton, and Southern Appalachia*,

10, based on paper entitled 'Visions of Simplicity and Strength: Women Graphic Artists in Southern Appalachia', presented at the North America Print Conference, Atlanta, Gia., 14–17 Mar. 1990, and published in *Graphic Arts and the South*, 1993.
[48] Agnes Miller Parker to Philip Gibbons, 29 Oct. 1957. NAL.

Working initially with private presses, she became aware of the problems of over-black engravings. She consequently developed an immaculate tonal technique which, together with her appealing subject matter, particularly her animal studies, marks her out as one of the finest and most popular wood-engravers of her time. Like Leighton, she produced most of her more inventive illustration in the inter-war years. Her work has been well documented, notably in a catalogue of the Agnes Miller Parker Collection held in Manchester Metropolitan University Library, and in a subsequent monograph.[49] A survey of unpublished material helps to determine her approach to her most significant book illustration.

Agnes Miller Parker entered the Glasgow School of Art in 1918 where she received no formal training in wood-engraving. In the same year she married fellow student William McCance.[50] For a short time both were affected by Cubism and English Vorticism, most especially the work of William Roberts, whose influence on Miller Parker can be seen from her earliest wood-engravings dating from 1926, in particular *Sheep Dipping in Wales* (1927) which won the Brewster Prize in the first International Exhibition of Engraving and Lithography in Chicago in 1929. Variously shaded, angular planes, with blocks of figures or animals surrounded by areas of white, are features which appear in much of her early work. In many ways her mature style is less original even if more technically refined.[51]

Her first commission came in 1930 from Cambridge University Press through Rhoda Power: thirty-one illustrations for her book of myths and legends, *How it Happened*. These strong, simple images of animals, cut in lino—a rare use of the medium by a commercial press—are stylistically reminiscent of an early woodcut of cliffs and hills.[52] In October the McCances joined Gertrude Hermes and Blair Hughes-Stanton at the Gregynog Press, William acting as controller, Blair as artist, and Gertrude and Agnes both engaged as wood-engravers for a retaining fee of £100 as an advance against work done.[53] Much has been written about Miller Parker's remarkable illustrations for *The Fables of Esope* (1932).[54] The book is universally recognized as one of the corner-stones of fine book-making and was largely responsible for establishing the press's reputation. Hodgson's successful printing of Hughes-Stanton's translucent tones no doubt encouraged Miller Parker to experiment with finer lines. The result was her beautiful *Esope* wood-engravings which balance in weight, if not in size, with McCance's engraved initial letters, and with the Bembo type. Several blocks which initially were too heavy for the type were lightened by Hodgson mixing white into the ink. The title-page is a *tour de force* of design,

[49] Ian Rogerson, *The Agnes Miller Parker Collection*, Manchester Polytechnic [now Manchester Metropolitan University] Library (Manchester, 2nd edn, 1989), and *Agnes Miller Parker: Wood-Engraver and Book Illustrator, 1895–1980*, with recollections of the artist by John Dreyfus (Wakefield, 1990). Dreyfus includes 'A Note on Technique', 50–8.

[50] See Ch. 6.2, 'The Gregynog Press'.

[51] In 1930 she exhibited in the Neo-Society exhibition held at the Godfrey Phillips Galleries together with McCance and Underwood, whose work she greatly admired.

[52] Dated '1923'. Held in the Agnes Miller Parker Archives at the National Library of Scotland, Edinburgh, henceforth AMPA.

[53] Dorothy A. Harrop, *A History of the Gregynog Press* (Pinner, 1980), 73. See also Ch. 6.2, 'The Gregynog Press', n. 95.

[54] See in particular Ian Rogerson, *Agnes Miller Parker: Wood Engravings for 'Esope'* (Newtown, Powys, 1996). The date of 1931 on the title-page indicates the time of completion rather than publication.

with elegant lettering and a delicately executed engraving of a grasshopper, perched on
a blade of grass, contemplating Caxton's manuscript, with other creatures carefully
Plate 207 fitted in the angular spaces between the blades. Indeed, in all these engravings, both
animals and figures, rhythmical in their shape and posture, are placed in their own
Plate 208 space stressing their individuality and dignity, as in the *Catte and Chyken*. Already Miller
Parker had refined her technique (mainly with the use of a very fine tint tool) to an
intricate method of diagonal cross-hatching and stippling. According to Leighton, it
was about the 'cleanest' work being done and at the same time the most solid, combining
sensitiveness with precision yet conscious throughout of realized form.[55]

Her next and only other Gregynog Press commission was for a title-page and seven
chapter headings to *XXI Welsh Gypsy Folk-Tales* collected by John Sampson.[56] As with her
Esope illustrations, animals are more convincing than people who tend to be stiffer and
Plate 209 sometimes frieze-like, as they appear in *The Fiery Dragon*. Like most of Miller Parker's
compositions to date these are confined to a rectangular frame thereby restricting
movement. Her tendency to place characters and incidents in separate compartments
anticipates some of her later illustration. The success of her spirited designs for both
of her Gregynog books owes as much to her suggestions on the appearance of the page
as to the superb compositing and presswork.

The McCances left the press in the autumn of 1933 just before *XXI Welsh Gypsy Folk-
Tales* was published. The previous year Agnes, to her delight, had been asked by Gibbings
to illustrate a Golden Cockerel Press book: one of the contemporary short story series,
Rhys Davies's *Daisy Matthews and Three Other Tales*. A letter to Gibbings reveals her dis-
enchantment with the Gregynog Press: 'Fortunately I'm free of the press here now. I did
not like my agreement & resigned & am now enjoying a sense of freedom. . . . The idea
of a lady playing with a polar bear or a swan appeals to me. I'm all ready for a new job
now that I've finished the long Esope book & had a breather.'[57] Further correspondence
charts the extent of her collaboration with Gibbings and George Churchill, the printer.
Initially Churchill sent her page proofs of the first two story openings with the book's
overall size outlined in pencil and with spaces allowed for her engravings, placed so
that each story should end within a few lines of the bottom of the page.[58] He suggested
that the blocks be vignetted to allow decoration to come down either side of the 24-point
titles.[59] As before her animals are more mobile than her figures: her cats particularly
impressed Gibbings.[60] He expressed concern, however, at the fineness of texture which
he thought might not print well on hard handmade Batchelor paper. (He admitted that
the printer had been unable to make a good job of her first block.) In order to test the
suitability of her engraved line for the remaining three prints, Miller Parker exper-
imented with printing her blocks on several types of paper, including interleaving paper,

[55] Leighton, *Wood-Engraving and Woodcuts*, 50.
[56] For fuller discussion see Ian Rogerson, *Agnes Miller Parker:
XXI Welsh Gypsy Folk-Tales* (Newtown, Powys, 1997).
[57] Agnes Miller Parker to Robert Gibbings, 16 Apr. 1932. GCPA.
[58] Further page proofs printed on transparent paper were also
enclosed in case she preferred working with them.

[59] George Churchill to Agnes Miller Parker, 24 May 1932. GCPA.
[60] A later idea of an anthology of cats (a particularly favourite
subject of hers) came to nothing. Robert Gibbings to Agnes
Miller Parker, 20 Nov. 1943. GCPA.

THE FABLES OF ESOPE

TRANSLATED OUT OF FRENSSHE IN TO
ENGLYSSHE BY: WILLIAM CAXTON

WITH ENGRAVINGS ON WOOD BY AGNES MILLER PARKER

THE GREGYNOG PRESS: NEWTOWN
MONTGOMERYSHIRE: - MCMXXXI

Pl. 207. Agnes Miller Parker: William Caxton (trans.), *The Fables of Esope* (Gregynog Press, 1931). 305 × 215

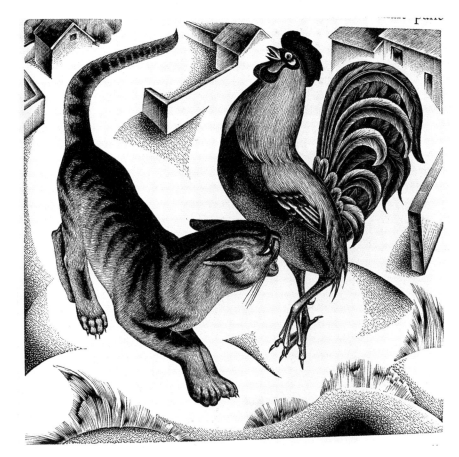

Pl. 208 (*right*). Agnes Miller
Parker: *Catte and Chyken* from
William Caxton (trans.), *The
Fables of Esope* (Gregynog
Press, 1931). 118 × 125

Pl. 209 (*below, right*). Agnes
Miller Parker: *The Fiery Dragon*
from John Sampson, *XXI
Welsh Gypsy Folk-Tales*
(Gregynog Press, 1933). 117 × 127

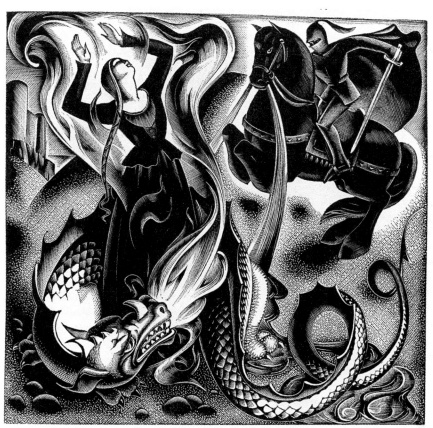

and Japanese vellum; the effect on the latter she found 'a bit mechanical ... though your printer will find them useful in seeing where I want soft edges, etc.'[61] From the flower and swan blocks she was able to work out the amount of cutting that was right for the press's paper. She was paid £20 for the blocks, and produced four more the following year for a further book in the same series, H. E. Bates's *The House with the Apricot*. A large rectangular headpiece to the opening chapter with a piece cut away at the bottom for the titling, as Churchill had suggested for the previous book, shows the house in an imaginary and stylized landscape. Miller Parker's later landscapes were to become more naturalistic.

With the take-over by Sandford in August 1933, no further work was forthcoming from the press.[62] By December 1934 Miller Parker felt the need for more book illustration since her various small freelance jobs did not really pay.[63] When, however, in the following November she was commissioned by Cape to illustrate Hugh Edward's novel, *Helen Between Cupids*, and Adrian Le Corbeau's *The Forest Giant*, she complained that after Gregynog's printing 'I find it difficult to get reconciled to the slap dash style of mass production'.[64] Yet, despite her criticism, her reputation was made through commercial publication of her work. Following the success of Clare Leighton's *Four Hedges*, Gollancz approached Miller Parker to illustrate the second in this new series of countryside books.[65] She was fortunate to be able to deal with a sympathetic publisher and printer whose interests in matters of design and typography accounted for the excellent quality of the series. From correspondence it is evident that her advice was sought from the start. She had plenty of ideas for a book 'written from a fishing village, with all the fisher folk glamour' and the shells, sea-weed, boats, nets, and sea birds.[66] Not a writer herself she suggested her husband as a possible author. Gollancz, however, decided on H. E. Bates, requesting him to write about thirty thousand words on the English woodland during the four seasons for a book to be entitled *Through the Woods*.[67] Bates agreed but his slowness at producing the text exasperated Miller Parker: 'I'm doing odd things until Bates produces some words',[68] she wrote. 'I'm doing animals, birds & waterfowl and he'll have to write round my illustrations if he doesn't hurry up.'[69] On 1 May 1936 Bates wrote that he would be able to send Miller Parker draft copies of several chapters that week. McCance, who by now was dealing with all his wife's correspondence owing to the pressure of her work (sixteen tailpieces to be done in a fortnight), wrote enthusiastically to Philip Gibbons: 'Agnes is going to do *the* book of the year—or many years as far as popular unlimited editions are concerned. . . . Gollancz is a gem to work for. He accepts every suggestion with enthusiasm—a difference from Wales.'[70] His wife was a

[61] Agnes Miller Parker to Robert Gibbings, 21 Aug. 1932. GCPA.
[62] Humbert Wolfe's suggestion (via his literary agent, A. D. Peters) of publication by the press of a sonnet sequence he had written to be illustrated by Miller Parker was not pursued as the author suddenly arranged to have it published elsewhere. Owen Rutter to Agnes Miller Parker, 15 Apr. 1935. NAL.
[63] These included a bear device for the Nonesuch Press and a design for the cover of Kenneth Muir's *The Nettle and the Flower and Other Poems* (1933) for Oxford University Press. Later ephemeral

work included 18 vignettes for the Kynoch Press Notebook (1936) and advertising material for London Transport.
[64] Agnes Miller Parker to Philip Gibbons, 28 Nov. 1935. NAL.
[65] For Leighton's adverse reaction see previous section.
[66] Agnes Miller Parker to Victor Gollancz, 4 Nov. 1935. VGA.
[67] Victor Gollancz to H. E. Bates, 31 Jan. 1936. VGA.
[68] Agnes Miller Parker to Philip Gibbons, 3 Mar. 1936. NAL.
[69] Agnes Miller Parker to Philip Gibbons, 20 [?] 1936. NAL.
[70] William McCance to Gibbons, [?] July 1936. NAL.

fast worker. By August she had finished all the blocks except the jacket design and was in need of payment since her bank balance was 'in a shocking state'—a constant problem for her as for most other wood-engravers at the time.

The seventy-three blocks—head- and tailpieces, some set within the text and a few used for single pages—are meticulously detailed scenes from nature based on close observation. The artist's scientific knowledge can be seen from her sketchbook which contains drawings of mushrooms, mice, acorns, brambles, and tree trunks, with botanical notes on fungi.[71] Her bird studies reveal anatomical details of ducks, while there are several pages of rough sketches of the keeper drawn from life, including some of his head only. All these drawings show her fascination for texture which is reflected in her *Plate 210* minutely handled engraving style. Her treatment of fur, for instance, in that of a fox, is especially tactile. The finished pencil drawing for this illustration, ready for tracing, *Plate 211* shows dark and light areas only, leaving the finer details to be worked out on the block. Even though these are naturalistic depictions, they are also highly personal and original compositions, no longer confined within frames but alive with movement and rhythmic shape.

Miller Parker enjoyed doing the book and illustrating for Bates whom she considered 'a fine chap—I've never worked with such a nice lot of folks before'.[72] Bates, in turn, thought the book delightful and the wood-engravings 'masterly'.[73] Gollancz was overjoyed with the results and hoped that Miller Parker would not be tempted by other publishers: 'If I may pat ourselves on the back, people are quite freely saying that this is the best bit of production in the ordinary way of commerce that has been done in our time.'[74] Published in October 1936 it did indeed become one of the most popular illustrated books of the period.

A month before publication Gollancz was already requesting another book in a similar vein from the same partnership, to be entitled, at Miller Parker's suggestion *Down the River*, as she wished 'to do some water subjects'.[75] Bates sent her a long list of things he would be describing: 'These are all fresh for both of us & will not, I think, clash at all with Clare Leighton's ideals.'[76] As has been seen, Leighton thought otherwise. (The two uncharacteristically large, black figures of *Skaters* are noticeably imitative of Leighton's work.) Some of Miller Parker's eighty-three engravings are more stylish and inventive than others, especially *Sea Gulls Flying*, with wings interweaving in a criss-cross pattern, and *Cows in Stream*: two massive animals surrounded by a white ring of water. Many of her compositions have become more exact representations and as a result are rather less personal, anticipating some of her later nature illustration, in particular that for a series of books by Richard Jefferies published by the Lutterworth Press between 1946 and 1948. The extent of her research and microscopic accuracy can be seen from her sketchbook in which a piece of lace has been stuck in for precise copying.[77] Proof

[71] Held in AMPA.
[72] Agnes Miller Parker to Victor Gollancz, 24 Aug. 1936. VGA.
[73] H. E. Bates to Victor Gollancz, 13 Oct. 1936. VGA.
[74] Victor Gollancz to Agnes Miller Parker, 13 Oct. 1936. VGA.
[75] Agnes Miller Parker to Victor Gollancz, 19 Sept. 1936. VGA.
[76] H. E. Bates to Victor Gollancz, 30 Nov. 1936. VGA.
[77] Held in AMPA.

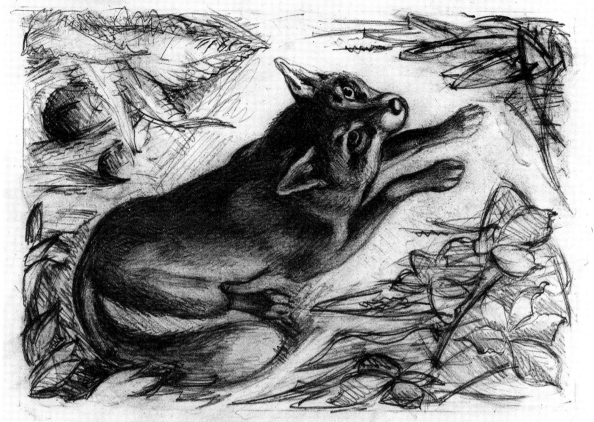

Pl. 211. Agnes Miller Parker: Preliminary drawing for *Fox* from H. E. Bates.
Through the Woods (Victor Gollancz, 1936). 174 × 124

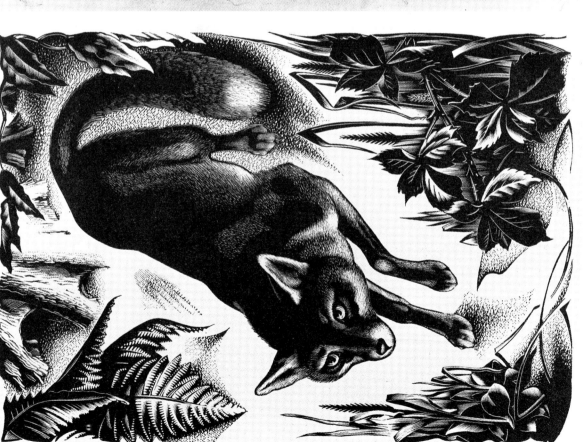

Pl. 210. Agnes Miller Parker: *Fox* from H. E. Bates, *Through the Woods*
(Victor Gollancz 1936). 175 × 120

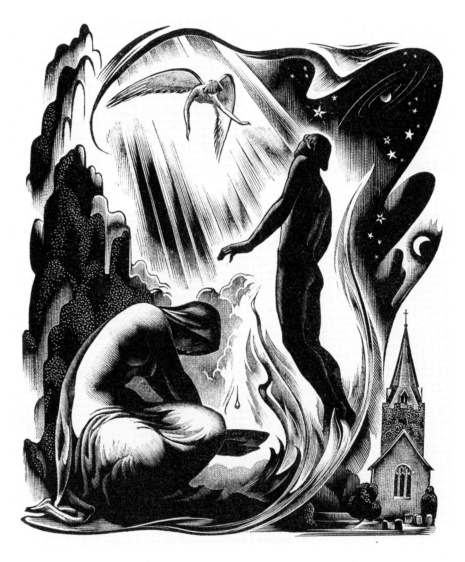

Pl. 212. Agnes Miller Parker: 'Large was His Bounty and His Soul Sincere' from Thomas Gray, *Elegy Written in a Country Churchyard* (Limited Editions Club, 1938). 135 × 115

pages with comments about the positioning of blocks and with various corrections show her interest in the *mise en page*. In Bates's view the book was an improvement on their previous one and the wood-engravings, especially some of the little tailpieces, were better than ever. In both publications these were printed from electros, the high quality of production made possible through the excellent presswork of the Camelot Press at Southampton.

While she was working for Gollancz, George Macy wrote to Miller Parker asking if she would be interested in illustrating Gray's *Elegy written in a Country Churchyard* for the Limited Editions Club. He required a 'sizeable woodblock illustrating or expressing the mood of the verse' to appear as a full-page print opposite each stanza.[78] On her behalf McCance replied that, although frantically busy, she would welcome the change from mass-produced work to illustrating finely produced books for a more discriminating public. He suggested a fee of £330 for thirty-two full-page engravings and title-page design. Miller Parker initially worked out a unifying scheme, vignetting the content of each stanza, with part of the churchyard in the foreground, in 'a kind of 2 in 1 design'.[79] For the purpose she made drawings in the actual churchyard at Stoke Poges and collected photographs of old tombstones and cemeteries. She apologized to Macy about her problem with the time-scale as the work was extraordinarily time-consuming: a week for each block. 'I'm really hurrying all I can but the Elegy is the most serious piece of work I've tackled yet and I want it to be my best.'[80] Certainly her compositions match the intensity of Gray's verses. The theme of immortality gave her the first opportunity seriously to express human emotion and spirituality which she does with tenderness and feeling—a quality which, in a less idiosyncratic way, she was later to exploit in her Thomas Hardy illustrations. Her method of compartmentalizing scenes, first noticeable in *Welsh Gypsy Folk-Tales*, is most effective. There is a strong feeling of movement in the undulating, womb-like shapes which envelop the central themes, as in her interpretation of the words 'large was his bounty and his soul sincere', in which a dark figure appears to float heavenward from the engulfing flames. Miller Parker is not always *Plate 212* comfortable, however, with these transcendental images, as, for instance, the strange, monumental figure of God embracing a tiny child-like man.

Some of the engravings are a little too black and tend to overpower the 18-point Baskerville type opposite. Yet there is a sympathetic 'feel' to the book, mainly due to the superb printing by Maynard and Bray at the Raven Press in 1938.[81] The illustrations delighted Macy: 'These are unquestionably the most dexterous wood-engravings which have appeared in any of the books I have published.'[82] Through her contributions to his Hardy and Shakespeare volumes (the first of which, *Richard the Second*, was published in 1940), Miller Parker later became one of the Limited Editions Club's most distinguished illustrators. Unlike Leighton, she enjoyed historical subjects and did an immense

[78] George Macy to Agnes Miller Parker, 19 Aug. 1937. LECA. For further discussion see *The Monthly Letter of the Limited Editions Club*, 112 (Sept. 1938).
[79] William McCance to George Macy, 19 Oct. 1937. LECA.
[80] Agnes Miller Parker to George Macy, 1 June 1938. LECA.

[81] The pages of type were printed on dry, handmade rag paper. Each sheet was then dampened and put through the press a second time for the printing of the engravings.
[82] George Macy to Agnes Miller Parker, 12 Sept. 1938. LECA.

amount of research, making descriptive notes and sketches of historical and topo-graphical details. For George Harrap's 1940 edition of A. E. Housman's *A Shropshire Lad*, Miller Parker combined both literal and imaginative elements in her irregular-shaped images set in a half imaginary Shropshire, 'a land of lost content'. Reminiscent of Gray's *Elegy* are the use of composite pictures and the frequent portrayal of the narrator, whether farm-boy or soldier, in an appropriately elegiac graveyard setting. With relief she finished the book in July, admitting: 'I enjoyed the work but everyday the war and its horrors nagged at me more and more and gave me no peace.'[83]

Agnes Miller Parker is rightly praised for her outstanding technical virtuosity which was an inspiration to many wood-engravers.[84] Yet, unlike so many of the Underwood School tonal engravers whose work she greatly admired, both she and Clare Leighton made serious efforts to adapt their engraving styles to suit the needs of publishers and printers. Her immense skill and highly individual sense of composition account for the lively and innovative nature of her illustrations up to about 1940, her *Gray's Elegy* scenes anticipating Neo-Romantic book illustration. Undoubtedly her work for Gollancz made a greater impact on the reading public than that for limited editions, fine though this was, and, with Clare Leighton, she was largely responsible for the rise in popularity of wood-engraved books on nature and rural life.

[83] Agnes Miller Parker to Philip Gibbons, 1 Oct. 1940. NAL. Critical of cheap commercial production, Maynard considered it 'a rotten book from the typographical point of view'. Possibly due to an excess of work an invitation from Gibbings to illustrate for the Penguin Illustrated Classic series came to nothing.

[84] George Mackley (1900–83), for instance, wrote to her, 'All I know of wood-engraving I learnt by a study of your work'. Undated letter. AMPA.

CONCLUSION

'It is not yet clear how far the wave will spread, but it may lose its force in time and die down in gentle ripples, at a distance from the wellspring of enthusiasm that bubbles up at the centre, at many centres, of the movement.'[1] With these prophetic words Campbell Dodgson unwittingly predicted the rise and fall of the British wood-engraving movement before the outbreak of the Second World War.

By the mid-1930s, largely due to the success of the countryside books of Clare Leighton and Agnes Miller Parker, wood-engraved illustration had indeed increased in popularity, the demand for accurately rendered rural and domestic scenes reflecting the conservative taste of a British public which looked back nostalgically to Bewick. The proliferation of descriptive illustration by certain artists who, though technically proficient, had failed to move on from the innovations of their predecessors, prompted John Farleigh, in a 1942 essay on the future of wood-engraving, to emphasize the virtue of having something important to say: 'No more do we need portraits of thistles full-blown nor portraits of village pumps.'[2] Although some interesting work continued to be produced in the 1940s, the extraordinary vitality and creativity of the pioneering wood-engravers of the previous three decades could not be sustained. The years of experimenting had pushed the medium to its limits.

Once again technological changes and financial pressures had taken their toll on wood-engraving. The market for single prints had never fully picked up since the Depression and there had been a shift of taste towards colour and large decorative wall prints. The advent of the war and the resulting economic climate meant that wood-engravers lost the support of publishers and new commissions for illustration were not forthcoming. Scarcity of paper, developments in printing technology, and mass-production by commercial printers gave little incentive to private press owners who were discouraged by the decline in the market for expensive books.[3] The fact that the demise of wood-engraving coincided with the waning of the typographical renaissance is an indication of the close alliance of the medium with the book arts, both of which relied on traditional technical skills and craftsmanship of which, by 1940, there was a severe shortage in the printing industry. Up to this time, through their awareness and knowledge of design and typography, wood-engravers had made a significant impact on the appearance of the printed page, transforming good books into works of art and influencing modern standards of book production. In order to assess the importance

[1] Campbell Dodgson, Preface to Douglas Percy Bliss, *A History of Wood-Engraving* (London, 1928; repr. 1964), p. ix.

[2] John Farleigh, 'The Future of Wood-Engraving', in *It Never Dies* (London, 1946), 43.

[3] In 1947 Charles Ede founded the Folio Society with the aim of producing books which were beautiful yet affordable. The society commissioned (and still continues to do so) a number of wood-engravers.

of their legacy, the unorthodox methods by which they achieved such results are here summarized.

The technical volte-face was by far the most significant factor in the rise of the modern wood-engraving movement. Based on Edward Johnston's credo that an artwork must depend on the nature of the tool used to make it, Noel Rooke's teaching transformed the medium from an imitative one into an autonomous art form, thereby raising the status of practitioners. In their urge to free themselves from reproductive methods and photomechanical processes they evolved a new language which spoke for itself rather than as a translator. As a rediscovered medium wood-engraving was highly experimental; yet, despite its limitations of size, intractability, and lack of colour, it emerged as one of the most varied and versatile of the graphic arts. In its directness it was also one of the more personal, thus making work easily identifiable, with practitioners generally too individualistic to be influenced significantly by each other. The medium *itself* was the message; the engravers' understanding of the inherent aesthetic qualities peculiar to wood determined their modernness, not necessarily the images *per se*. None the less a wide variety of styles were pursued, in many instances mirroring and occasionally even pre-empting those used in painting. The radical woodblock designs of Wadsworth, Gibbings, and the Bloomsbury Group, in particular, with their robust cutting and modernist compositions were some of the most startling images of the period. The predominance of landscape and figure as subject matter reflected the insular pastoral and literary traditions inherent in British art and, as such, should not necessarily be seen as retrograde. As Harrison points out

the need to acknowledge the quality and historical importance of French painting at the end of the nineteenth and the beginning of the twentieth centuries has tended to obscure the fact that many English artists who were neither irretrievably naive nor unremittingly reactionary still saw good reason in the twenties to draw upon a tradition in English art which had remained broken over this same period. Those, for instance, who responded most sympathetically and most intelligently to the art of the Pre-Raphaelite Brotherhood . . . saw it as evidence of the extent to which faithful observation and representation could serve imaginative lyrical or 'spiritual' subject matter and 'transcendental' ends.[4]

Certainly Paul Nash, John Farleigh, and members of the Underwood School especially, responded in just such a way, many of their subjective compositions transforming the illustrated page and anticipating later surrealistic painting. With their symbolistic landscapes more in line with those of Palmer and Blake, Nash and Eric Ravilious moved away from the naturalistic versions typified by Bewick and his followers, this aspect of their work looking forward to that of the 1940s Neo-Romantic illustrators.[5] Inter-war nostalgia for a vanishing rural Britain (its traditions as well as its landscape) was reinforced by the immense success of the idyllic rural scenes of Raverat, Leighton, and Miller Parker among others, which in turn increased the demand for the genre. Stylish

[4] Charles Harrison, *English Art and Modernism, 1900–1939* (London, 2nd rev. edn., New Haven and London, 1994), 168–9.
[5] These included Graham Sutherland, Keith Vaughan, John Minton, Michael Ayrton, and John Craxton, who used largely line drawing or lithography. See Rigby Graham, *Romantic Book Illustration in England, 1943–55* (Pinner, 1965).

and inventive though their illustrations were, as already demonstrated they inadvertently opened the floodgates to a host of more parochial 'neo-picturesque' work by such practitioners as Joan Hassall and Reynolds Stone.

Apart from introducing new technical and stylistic approaches, many wood-engravers succeeded in breaking down the divisions between author, illustrator, publisher, and printer. In contrast to their predecessors, the twentieth-century engraver-illustrators, with no intermediaries or photographic methods employed to translate or reproduce their designs, had a direct route to their publishers who, in many instances, involved them to varying extents in the production process. Well documented collaborations such as that of Gill and Gibbings, and between Farleigh, Shaw, and Maxwell, have tended to overshadow equally significant examples. Close study of unpublished correspondence has shown the extent to which, contrary to the perceived view, commercial publishers and printers looked to illustrators for ideas on the overall aesthetic appearance of their publications. A prime example is Gwen Raverat who, at different stages in her career, concerned herself not only with the text, illustration, and most other physical aspects of her books, but also with their marketing and sales. A growing interest in typographical matters accounted for the greater care taken by both engravers and printers to harmonize woodblocks with areas of type, which in turn affected the appearance of other forms of illustration on the page. Although wood-engraved books themselves were seen by only a small proportion of the reading public, many of the illustrations were made more widely available through exhibitions. Their display, together with newly designed typefaces, on dust-jackets, publicity material, and advertisements, helped to generate public interest and create an 'eye' for crisp black and white line with consequential effects on everyday graphic design.

Modern wood-engravers were able to make a contribution which extended beyond the aesthetic aspects of the book. For many, a love of literature was the guiding reason for taking up illustration. As has been seen, several had the opportunity to choose the books they wished to illustrate or, more significantly, to write the text themselves, as author-illustrator, thereby further enhancing their status. With graphic art no longer the *essential* means of visual information owing to the improved quality of photographic and, from the 1920s, cinematic images, the interpretative role of illustration altered, enabling wood-engravers to translate classic texts in a less representational, more imaginative vein.

Like the new artists they commissioned, the major private presses broke the traditional mould by introducing new writing and treating classic literature in novel ways. Few of their limited illustrated editions were unreadable works of art. By also publishing unlimited editions, many of which were machine-printed, they bridged the gap between private and trade publishing, thereby enabling wider sales. If private press owners created the typographical and printing conditions in which artists' wood-engraving thrived, commercial publishers for their part did most to promote such illustration, especially through new sales ideas such as thematic series and paperback

books—'commodities to be marketed and sold like soapflakes'.[6] Although such pub-
lications did not appreciably attract working-class readers in the way that popular
magazines did, they none the less brought together the language of high and low culture:
hand-crafted illustration and well-printed, high quality texts in a cheap, mass-produced,
easily handled format. By so doing they made wood-engraving more readily accessible.

As with illustrations down the ages, those in the books discussed represent a micro-
cosm of contemporary cultural life and social habits: buildings, domestic interiors,
transport, leisure pursuits, culinary tastes, and clothes and hairstyles—all feature in
their pages. In contrast, mainly owing to the unpolemical nature of the texts chosen to
be illustrated, the political context is scarcely evident: the propagandist publications of
the Ditchling Press and the socialist tenor of Clare Leighton's books are perhaps the
most conspicuously didactic. The more liberated moral climate of the later 1930s is
reflected in the proliferation of quasi-erotic nude figures which, in line with the demand
for D. H. Lawrence's work, found their way from privately printed to commercial books.

Just as stylistic parallels can be found in contemporary literature, so the tones and
rhythms of English music are echoed in the tonality and linear qualities of wood-
engraving: for instance, the strident blacks and whites of the Bloomsbury Group and
their 1920s successors reflect the syncopated tunes of the Jazz Age or the spiky orches-
tration of William Walton; the lyrical landscapes of Raverat, among others, recall music
of the 'pastoral' school of composers personified by Ralph Vaughan Williams, while
the metaphysically inclined Underwood treatment evokes the luxuriant harmonies of
Frederick Delius, the more mystical tones of Holst, or the poignant melodies of Gerald
Finzi.

Despite the new direction of modern wood-engraved book illustration, it was none
the less, like other forms of art in Britain, firmly rooted in literary, pastoral, and spiritual
traditions. Such traditions account for a seeming insularity and conventionality when
compared with continental illustrative styles: the boldness and dynamism of German
Expressionism or the French *éditions de luxe*, for example. Yet although, in the context of
mainstream twentieth-century European art, British wood-engraving remains a minor
backwater, in terms of graphic art, illustration in particular, the movement is one of
the most exciting and inventive. The words of the contemporary critic P. G. Konody
most eloquently describe the subtle correlation between literature and artists' wood-
engraving:

In the wood-engraving of to-day, as in painting, the trend is always toward economy of means
and the reduction of the greatest things in simple terms. ... It is this power of putting so much
into so little which is the essence of literature—and wood-engraving—and imparts that vitality
which seems to provide such work with a permanent strength and significance.[7]

⁶ Joseph McAleer, *Popular Reading and Publishing in Britain, 1914–1950* (Oxford, 1992), 54.
⁷ P. G. Konody, Introduction to exhibition catalogue, *The*
English Wood-Engraving Society (London: St George's Gallery, Nov.–Dec. 1926).

Over and above typographic considerations, it is this special alliance which sets wood-engraved book illustration of the period aside from that in other media, and ensures its unique status in the field of graphic art.

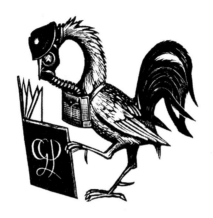

Select Bibliography

PUBLISHED MATERIAL

Anon., 'The Wood Engravings of John Buckland Wright', *Studio*, 107 (1934), 124–8.

Annesley, Mabel, *As the Sight is Bent* (London, 1964).

——*The Collected Works of the Lady Mary Annesley, 1881–1959* (Nelson, New Zealand: Bishop Suter Art Gallery, 1981).

Backemeyer, Sylvia (ed.), *Object Lessons: Central Saint Martins Art and Design Archive: A Centenary Publication* (London, 1996).

——and Gronberg, Theresa (eds.), *W. R. Lethaby, 1857–1931: Architecture, Design and Education* (London, 1984) in conjunction with exhibition held at Central School of Arts and Crafts.

Bain, Iain, *The Workshop of Thomas Bewick: A Pictorial Survey* (Newcastle upon Tyne, 1979; repr. Cherryburn, Northumberland, 1989).

Baldry, A. L., 'The Future of Wood Engraving', *Studio*, 14 (1898), 10–16.

Balston, Thomas, 'The River Books of Robert Gibbings', *Alphabet and Image*, 8 (1948), 39–49.

——*Wood-Engraving in Modern English Books*, introduction to exhibition catalogue, London: National Book League (Cambridge, 1949).

——'The Wood Engravings of Ethelbert White', *Image*, 3 (1949–50), 49–60.

——*English Wood-Engraving, 1900–1950* (London, 1951; rev. edn. of *Image*, 5 (1950), 3–84).

Bawden, Edward, *Edward Bawden: A Retrospective Survey*, with introduction by Justin Howes and preface by Halina Graham (Bath, 1988).

Beaumont, Cyril, *The First Score: An Account of the Foundation and Development of the Beaumont Press* (London, 1927).

Beedham, R. John, *Wood Engraving* (Ditchling, 1920; 7th rev. edn., London, 1948).

Bertram, Anthony, *Paul Nash: The Portrait of an Artist* (London, 1955).

Bewick, Thomas, *A Memoir of Thomas Bewick written by Himself*, ed. with introduction by Montague Weekley (London, 1961).

Biggs, John R., *Illustration & Reproduction* (London, 1950).

——*The Craft of Woodcuts* (London, 1958).

——*Autobiographica: Graphic Work, Etc., 1929–1974* (Brighton, 1974).

Binyon, Helen, *Eric Ravilious: Memoir of an Artist* (Guildford, 1983).

Blake, William, *The Illustrations of William Blake for Thornton's Virgil*, with introduction by Geoffrey Keynes (London, 1937).

——*William Blake: Wood Engravings for Dr Robert Thornton's Third Edition of Virgil's Pastoral Poems, 1821*, exhibition catalogue with introduction by G. C. Campbell (Exeter: Exeter University, 1977).

Blamires, David, *David Jones: Artist and Writer* (Manchester, 1971).

——and Jaffé, Patricia, *Margaret Pilkington, 1891–1974*, with catalogue of engraved work by Sarah Hyde (Buxton, 1995).

Bland, David, *The Illustration of Books* (London, 1951; 2nd rev. edn., 1953).

——*A History of Book Illustration: The Illuminated Manuscript and the Printed Book* (London, 1969).

Bliss, Douglas Percy, *A History of Wood-Engraving* (London, 1928; repr. 1964).

—— 'Tools of the Wood Engraver', *The Woodcut*, 2 (1928), 23–35.

—— 'The Work of Eric Ravilious', *Artwork*, 13 (1928), 64–8.

—— 'Modern English Book Illustration', *Penrose's Annual*, 31 (1929), 107–15.

—— 'The Development of Wood-Engraving', *Listener*, 9 Dec. 1931, 1000–2.

—— 'The Wood-Engravings of Eric Ravilious', *Penrose's Annual*, 35 (1933), 53–5.

—— 'The Last Ten Years of Wood-Engraving', *Print Collector's Quarterly*, 21 (1934), 251–71.

—— *Wood-Engraving* (Leicester, [1952]).

—— *Edward Bawden* (Godalming, 1979).

—— *Douglas Percy Bliss: A Retrospective*, exhibition catalogue (Newcastle upon Tyne: Hatton Gallery, 1981).

—— *Douglas Percy Bliss: A Retrospective Exhibition*, exhibition catalogue (Derby: Derby Museum and Art Gallery, 1996).

Blisset, William, *The Long Conversation: A Memoir of David Jones* (Oxford, 1981).

Braby, Dorothea, *The Way of Wood Engraving* (London, 1953).

Brady, Elizabeth A., *Eric Gill: Twentieth Century Book Designer* (rev. edn., Metuchen, NJ, 1974).

Brett, Simon, *Out of the Wood: British Woodcuts and Wood Engravings, 1890–1945* (London, 1991).

—— *Wood Engraving: How to Do It* (Swaresey, Cambridge, 1994).

—— 'Clifford Webb, 1895–1972', *Multiples*, 16 (1996), 243–4.

British Wood Engraving of the 20's and 30's, exhibition catalogue with introductory essays by Yvonne Deane and Joanna Selborne (Portsmouth: Portsmouth City Museum and Art Gallery, 1983).

Brown, Philip A. H., *Modern British and American Private Presses (1850–1965), Catalogue of the Holdings of the British Library* (London, 1976).

Buckland Wright, Christopher, *Cockerel Cavalcade: John Buckland Wright's Devices Engraved on Wood, 1939–1945* (London, 1988).

Buckland Wright, John, 'Open Letter to an Editor on Wood Engraving', *Halcyon*, 1 (1940), repr. in *The Engravings of John Buckland Wright* (see below), 50–2.

—— *Etching and Engraving: Technique and the Modern Trend* (London, 1953; repr. New York, 1973).

—— 'The Society of Wood Engravers', *Studio*, 146 (1953), 134–41.

—— 'Burin Engraving on Metal and Wood', *Penrose Annual*, 49 (1955), 41–4.

—— *The Engravings of John Buckland Wright*, ed. with introduction by Christopher Buckland Wright (Aldershot, 1990).

Burridge, F. V., *The Annual Report of the Principal*, Central School of Arts and Crafts (London, 1913).

Butcher, David, 'The Printed and Published Wood-Engravings of Eric Ravilious', *Signature*, 1 (1935), 31–41.

Butler, Judith, 'Vivien Gribble, 1888–1932: An Under-Rated Illustrator', *Private Library*, 5 (1982), 119–35.

Campbell, Colin, *The Beggarstaff Posters: The Work of James Pryde and William Nicholson* (London, 1990).

—— *William Nicholson: The Graphic Work* (London, 1992).

Cannon, Rupert, *The Bolt Court Connection: A History of the LCC School of Photoengraving and Lithography, 1893–1949* (Privately printed, London, 1985).

Carey, Frances, and Griffiths, Antony, *Avant-Garde British Printmaking, 1914–1960*, with a contribution by Stephen Coppel (London, 1990).

Carrick, Edward, 'The Revival of Wood Engraving', *Penrose's Annual*, 32 (1930), 53–5.

—— 'Book Decoration versus Book Illustration', *Penrose's Annual*, 33 (1931), 60–5.

Carrington, Dora, *Carrington: Letters and Extracts from her Diaries*, ed. with introduction by David Garnett (London, 1970; 2nd edn., Oxford, 1979).

Causey, Andrew, *Paul Nash* (Oxford, 1980).

Cave, Roderick, *The Private Press* (London, 1971; 2nd rev. edn., New York and London, 1983).

—— 'The Lost Years of the Golden Cockerel Press, *Printing History*, 4 (1982), 3–5.

—— (ed.), 'From County Cork to Chiswick and Cockerel: Reminiscences of Christopher Sandford', *Matrix*, 6 (1986), 6–27.

—— (ed.), ' "A Restrained but Full-Blooded Eroticism": Letters from John Buckland Wright to Christopher Sandford, 1937–1939 ', *Matrix*, 8 (1988), 55–75.

—— (ed.), 'The Making of the "Vigil of Venus": Letters from John Buckland Wright to Christopher Sandford, 1937–1939 ', *Matrix*, 9 (1989), 146–71.

—— and Manson, Sarah, *The History of the Golden Cockerel Press* (in preparation).

Chamberlain, Walter, *Manual of Wood Engraving* (London, 1978).

Chambers, David, 'Check List of Books Illustrated by T. Sturge Moore', *Private Library*, 4 (1971), 38–46.

—— 'Lettice Sandford's Engravings', *Matrix*, 4 (1984), 89–92.

—— 'Boar's Head & Golden Hours', *Private Library*, 8 (1985), 2–33.

—— 'Sandford, Gibbings, Newbery and Rutter', *Private Library*, 8 (1985), 34–40.

Chapman, Hilary, *The Wood Engravings of Ethelbert White*, with introduction by Peyton Skipwith, includes checklist of books illustrated with engravings and engravings editioned as prints (Wakefield, 1992).

—— 'A White Lie', *Print Quarterly*, 13 (1996), 190–1.

—— *Geoffrey Wales* (London, 1998).

Chatto, William Andrew, and Jackson, John, *A Treatise on Wood Engraving: Historical and Practical* (London, 2nd edn., with new chapter by Henry G. Bohn, 1861).

Childe, Harold, 'Modern Illustrated Books: Arts and Typographer Set a Standard for the Connoisseur', *Studio*, 100 (1930), 33–41.

Clair, Colin, *A History of Printing in Britain* (London, 1965; repr. 1976).

Cleverdon, Douglas, 'Stanley Morison and Eric Gill, 1925–1933', *Book Collector*, 32 (1983), 23–40.

—— 'Stanley Morison on Eric Gill', *Matrix*, 7 (1987), 4–15.

Cobden-Sanderson, Thomas J., *The Ideal Book or Book Beautiful* (London, 1900).

Cockburn, Claud, *Bestseller: The Books that Everyone Read, 1900–1939* (London, 1972).

Collet, Paul, 'Blair Hughes-Stanton on Wood-Engraving', *Matrix*, 2 (1982), 45–50.

Collins, Judith, *The Omega Workshops* (London, 1983).

Constable, Freda, *The England of Eric Ravilious* (London, 1982).

Cook, Olive, 'The Art of Tirzah Garwood', *Matrix*, 10 (1990), 3–10.

Cooper, Albert C., 'Reminiscences of Albert Cooper, Pressman at the Golden Cockerel Press', recorded by Sue Walker and Martin Andrews, *Matrix* , 9 (1989), 11–17.

—— 'Notes on the Printing Methods of the Golden Cockerel Press', with introduction by Patience Empson, *Matrix*, 9 (1989), 18–22.

Coppel, Stephen, *Linocuts of the Machine Age: Claude Flight and the Grosvenor School* (Aldershot, 1995).

Cork, Richard, 'Edward Wadsworth's Vorticist Woodcuts', *Print Collector's Newsletter*, 16 (1985), 41–4.

—— 'Wadsworth and the Woodcut', in Jeremy Lewison (ed.), *A Genius of Industrial England: Edward Wadsworth, 1889–1945* (Bradford, 1990), 12–26.

Craig, Edward Anthony, 'Edward Gordon Craig's Hamlet', *Private Library*, 10 (1977), 35–48.

—— *William Nicholson's 'An Alphabet': An Introduction to the Reprint from the Original Woodblocks* (Andoversford, 1978).

Craig, Edward Gordon, *Woodcuts and Some Words* (London, 1924).

—— *Edward Gordon Craig: An Exhibition of Wood-Engravings and Woodcuts*, exhibition catalogue with introduction by Tessa Sidey (York: University of York, 1982).

—— *Black Figures: 105 Reproductions with an Unpublished Essay*, presented with introduction and documentation by L. M. Newman (Wellingborough, 1989).

—— *The Correspondence of Edward Gordon Craig and Count Harry Kessler, 1903–1937*, ed. L. M. Newman (Leeds, 1995).

Crutchley, Brooke, *Walter Lewis and Stanley Morison at Cambridge* (Cambridge, 1968).

—— *To Be a Printer* (London, 1980).

—— 'The Cambridge University Press in the Early '30s', *Matrix*, 4 (1984), 76–81.

Curwen, Harold, 'On Printing "From the Wood"', from *The Curwen Press Miscellany* (London, 1931), 91–101.

Darton, Frederick, *Modern Book-Illustration in Great Britain & America* (London, 1931).

Davis, James, *Printed by Hague & Gill*, with a checklist of books printed (Los Angeles, 1982).

Dearden, James A., 'The Raven Press', *Private Library*, 6 (1973), 158–91.

—— 'Horace Walter Bray at the Raven Press (A Postscript)', *Private Library*, 7 (1974), 122–3.

De la Mare, Richard, *A Publisher on Book Production* (J. M. Dent Memorial Lecture, 6; London, 1936).

—— 'Principles of Book Production', *Printing Review*, 38 (1945), 5–8, 32.

Delaney, Paul, 'Great Illustrators: David Jones', *Antiquarian Book Monthly Review*, 7 (1980), 480–7.

—— 'Great Illustrators: Ethelbert White', *Antiquarian Book Monthly Review*, 8 (1981), 300–5.

Delany, Paul, *The Neo-Pagans: Friendship and Love in the Rupert Brooke Circle* (London, 1987).

De Vinne, T. L., 'The Printing of Wood Engravings', *Print Collector's Quarterly*, 1 (1911), 365.

Dodgson, Campbell, *Contemporary English Woodcuts* (London, 1922).

Doust, Leonard Arthur, *A Manual on Wood Engraving* (London, 1934).

Dreyfus, John, 'George Friend, 1881–1969: A Memoir', *Journal of the Printing Historical Society*, 5 (1969), 81–6.

—— *A History of the Nonesuch Press* (London, 1981).

—— (ed.), 'Some Correspondence between Robert Gibbings and Thomas Balston', *Matrix*, 9 (1989), 37–51.

—— Gerard Meynell and the Westminster Press', *Matrix*, 10 (1990), 55–68.

—— *A Typographical Masterpiece* (San Francisco, 1990; repr. London, 1993).

—— 'Dennis Cohen and The Cresset Press', *Matrix*, 12 (1992), 83–93.

—— 'The Cranach Press', in *Into Print: Selected Writings on Printing History, Typography and Book-Production* (London, 1994), 71–81.

—— 'Eric Gill's Approach to Type Design & Book Illustration', in *Into Print: Selected Writings on Printing History, Typography and Book-Production* (London, 1994), 125–38.

—— and Williams, Graham, *Eric Gill for Father Desmond* (London, 1993).

[Duckworth] *Fifty Years, 1898–1948* (London, 1948).

Earp, T. W., 'The Work of Clifford Webb', *Studio*, 101 (1931), 168–73.

Easton, Malcolm, 'Thomas Sturge Moore, Wood-Engraver', *Private Library*, 4 (1971), 24–37.

1890–1940. Fifty Years: The Renaissance of English Printing, exhibition catalogue with introduction by Douglas Cleverdon (London: British Council, 1950).

Ellwood, G. M., 'Famous Contemporary Art Masters: Noel Rooke', *Drawing & Design*, 4 (1924), 236–8.

—— 'Art Teachers & Teaching: Leon Underwood', *Drawing & Design*, 5 (1925), 187–91.

Elphick, Timothy, 'The St Dominic's Press and the Guild of St Joseph and St Dominic', in exhibition catalogue, *The Illustrators to the St Dominic's Press* (London: Wolseley Fine Arts, Rocket Press Gallery, 1995), 16–21.

Engen, Rodney, 'Wood Engraving', in Robin Garton (ed.), *British Printmakers, 1855–1955* (London, 1992), 81–5.

English Wood-Engraving Society, *The English Wood-Engraving Society*, exhibition catalogue with introduction by P. G. Konody (London: St George's Gallery, 1926).

Eustace, Katharine, 'Underwood's Children', in exhibition catalogue, *The Wood Engravings of Gertrude Hermes and Blair Hughes-Stanton* (Oxford: Ashmolean Museum, 1995), 9–23.

Farleigh, John, *Typography and Illustration*, paper delivered to the Royal Society of Arts (London, 1928).

—— *Graven Image* (London, 1940).

—— 'The Future of Wood Engraving' and 'Design and Book Production', in *It Never Dies* (London, 1946), 41–4, 79–94.

—— *Engraving on Wood* (Leicester, 1954).

—— *The Wood Engravings of John Farleigh*, with text by Monica Poole (Henley-on-Thames, 1985).

—— *John Farleigh, Wood Engravings*, exhibition catalogue with introductory essay by Anne Stevens (Oxford: Ashmolean Museum, 1986).

Farr, Dennis, *English Art, 1870–1940* (Oxford, 1978; 2nd edn., 1984).

Feather, John, *A Dictionary of Book History* (London 1986).

—— *A History of British Publishing* (London, 1988).

Fildes, P., 'Phototransfer of Drawings in Wood Block Engraving', *Journal of Printing Historical Society*, 5 (1969), 87–97.

A Fine Line: Commercial Wood Engraving in Britain, exhibition catalogue (London: Victoria and Albert Museum, 1995).

The First Exhibition of Original Wood Engraving, exhibition catalogue (London: The Dutch Gallery, 1898).

Fletcher, Frank Morley, *Wood-Block Printing* (London, 1916).

Fletcher, John Gould, 'The Wood Engravings of Paul Nash', *Print Collector's Quarterly*, 15 (1928), 209–33.

—— 'Gertrude Hermes and Blair Hughes-Stanton', *Print Collector's Quarterly*, 16 (1929), 183–98.

—— 'The Wood Engravings of Gwendolen Raverat', *Print Collector's Quarterly*, 18 (1931), 330–50.

—— 'Blair Hughes-Stanton', *Print Collector's Quarterly*, 21 (1934), 353–72.

Fletcher, William T., and Carey, Graham (eds.), *Philip Hagreen: The Artist and His Work* (New Haye, 1975).

Franklin, Colin, *The Private Presses* (London, 1969; repr. 1970, rev. edn., Aldershot, 1991).

—— *Emery Walker: Some Light on His Theories of Printing and His Relations with William Morris and Cobden-Sanderson* (Cambridge, 1973).

—— *Fond of Printing: Gordon Craig as Typographer & Illustrator* (London, 1980).

—— *The Ashendene Press* (Dallas, 1986).

Frayling, Christopher, *The Royal College of Art: 150 Years of Art and Design* (London, 1987).

Furst, Herbert, 'The Modern Woodcut: Part 1' and 'The Modern Woodcut: Part 2', *Print Collector's Quarterly*, 8 (1921), 151–70, 267–98.

—— *The Modern Woodcut* (London, 1924).

—— (ed.), *The Woodcut: An Annual*, 4 vols. (London, 1927–30).

—— 'Wood Engraving in Modern Illustration', *Penrose Annual*, 41 (1939), 77–80.

Garnett, David, 'The Nonesuch Century', *Penrose Annual*, 9 (1937), 45–9.

Garrett, Albert, *Wood Engravings and Drawings of Iain Macnab of Barachastlain* (Tunbridge Wells, 1973).

—— *A History of British Wood Engraving* (Tunbridge Wells, 1978; new edn., 1986).

—— *British Wood Engraving of the 20th Century: A Personal View* (London, 1980).

Garton, Robin (ed.), *British Printmakers, 1855–1955* (London, 1992).

Garwood, Tirzah, *Tirzah Garwood, 1908–1951*, exhibition catalogue with introductory notes by Henry Swanzy (Eastbourne: Towner Art Gallery, 1987).

See also under Tirzah Ravilious.

Gibbings, Robert, 'The Golden Cockerel Press', *The Woodcut*, 1 (1927), 13–26.

—— 'The Art of the Book: The Golden Cockerel Press', *Studio*, 97 (1929), 98–101.

—— 'The Golden Cockerel Press', *Colophon*, 7 (1931), unpaginated.

—— *The Wood-Engravings of Robert Gibbings*, with introduction by Thomas Balston (London, 1949).

—— 'Wood Engraving in Modern Books: Mr Robert Gibbings on its Rise and Development', *Bookseller*, 22 Oct. 1949, 950, 952.

—— 'Memories of Eric Gill', *Book Collector*, 3 (1953), 95–102.

—— 'Thoughts on Wood', *The Saturday Book*, 17 (1957), 207–13, repr. *Matrix*, 9 (1989), 8–10.

—— *The Wood Engravings of Robert Gibbings*, ed. Patience Empson with introduction by Thomas Balston (London, 1959).

—— 'Llewelyn and Theodore', *Matrix*, 6 (1986), 1–5.

—— 'Comments by Robert Gibbings on his Wood-Engravings made for Book Illustration', *Matrix*, 9 (1989), 51–4.

—— *Robert Gibbings, 1889–1958*, exhibition catalogue with introduction by Martin Andrews (Reading: Reading Museums and Art Gallery, 1989).

Gill, Eric, 'The Society of Wood Engravers', *The Architect*, 104 (1920), 300.

—— 'Intaglio Printing from Wood Blocks', *The Woodcut*, 1 (1927), 27–9.

—— (Preface), *Engravings by Eric Gill: A Selection* (Bristol, 1929).

—— *An Essay on Typography* (London, 1931).

—— (Preface), *Engravings, 1928–1933, by Eric Gill* (London, 1934).

—— *Autobiography* (London, 1940).

—— *Letters of Eric Gill*, ed. Walter Shewring (London, 1947).

—— *The Engraved Work of Eric Gill*, compiled with catalogue by John Physick (London, 1963).

—— *The Eric Gill Collection at Chichester*, ed. Timothy J. McCann (Chichester: West Sussex County Council, 1982).

—— *The Eric Gill Collection of the Humanities Research Center: A Catalogue*, compiled by Robert N. Taylor with the assistance of Helen Parr Young (Austin, Tex.: Humanities Research Center, University of Texas at Austin, 1982).

—— 'The Artist & Book Production', lecture to the Double Crown Club, 8 Apr. 1926, repr. with introduction by John Bidwell in *Fine Print*, 8 (1982), 96–7, 110–11.

—— *The Engravings of Eric Gill*, ed. Christopher Skelton with introduction by Douglas Cleverdon (Wellingborough, 1983; repr. 1991, as *Eric Gill: The Engravings*).

—— *Eric Gill and the Guild of St Joseph and St Dominic*, exhibition catalogue, ed. Timothy Wilcox (Hove: Hove Museum and Art Gallery, 1991).

Gill, Evan, *Bibliography of Eric Gill* (London, 1953; repr. 1974).

Gilmour, Pat, *Artists at Curwen* (London, 1977).

—— *The Mechanised Image: An Historical Perspective on Twentieth Century Prints* (London, 1978).

Glaister, Geoffrey Ashall, *Encyclopedia of the Book* (London, 2nd edn., with new introduction by Donald Farren, 1996).

Godfrey, Richard T., *Printmaking in Britain* (London, 1978).

Golden Cockerel Press, *A Catalogue of an Exhibition of Engravings on Wood and Copper from Books Printed and Published by the Golden Cockerel Press*, with preface by Campbell Dodgson (Manchester: Whitworth Art Gallery, 1928).

—— *The Illustrators of the Golden Cockerel Press*, exhibition catalogue with foreword by Christopher Sandford (Oxford: Studio One Gallery, 1978).

—— *The Illustrators of the Golden Cockerel Press*, exhibition catalogue (Hereford: The Mayor's Parlour, 1980).

Goldman, Paul, *Victorian Illustrated Books, 1850–1870: The Heyday of Wood-Engraving* (London, 1994).

—— *Victorian Illustration: The Pre-Raphaelites, the Idyllic School and the High Victorians* (Aldershot, 1996).

Gooden, Robert, 'In Memoriam, Eric Ravilious', *Architectural Review*, 94 (1943), 146.

Graham, Rigby, *Romantic Book Illustration in England, 1943–55* (Pinner, 1965).

Grant, Joy, *Harold Monro and The Poetry Bookshop* (London, 1967).

Graven Images: The Art of British Wood Engraving, exhibition catalogue with introductory essay by Francesca Calvorcoressi (Edinburgh: Scottish Arts Council, 1979).

Gray, Basil, *The English Print* (London, 1937).

—— 'The Present State of Wood-Engraving', *Listener*, 16 Feb. 1938, 363–4.

Greenwood, John, *The Dales are Mine* (London, 1952).

Gregson, Wilfred, *A Student's Guide to Wood Engraving* (London, 1953).

Griffiths, Antony (ed.), *Prints and Printmaking* (London, 1980).

—— *Landmarks in Print Collecting: Connoisseurs and Donors at the British Museum since 1783* (London and Houston, 1996).

Grimsditch, Herbert B., 'Mr John Austen and the Art of the Book', *Studio*, 88 (1924), 62–7.

Guthrie, James, 'Wood Engraving from a Printer's Standpoint', *Book Craftsman*, 2 (1935), 25–7.

Hadfield, John, 'Robert Gibbings: A Memoir', *Matrix*, 1 (1981), 53–9.

Hagreen, Philip, *The Book Plates of Philip Hagreen*, with introduction by John Bennett Shaw (Nappanee, Ind., 1982).

—— *Philip Hagreen (1890–1988): Engravings and Woodcuts*, exhibition catalogue with introductory essay by David Knott (London: Wolseley Fine Arts, 1993).

Hamilton, James, *Wood Engraving & the Woodcut in Britain, c.1890–1990* (London, 1994).

Harling, Robert, *Notes on the Wood-Engravings of Eric Ravilious* (London, 1946).

Harrison, Charles, *English Art and Modernism, 1900–1939* (London, 1981; 2nd rev. edn., New Haven and London, 1994).

Harrop, Dorothy A., *Modern Book Production* (London, 1968).

—— *A History of the Gregynog Press* (Pinner, 1980).

—— *Sir Emery Walker, 1851–1933* (London, 1986).

Harrop, Dorothy A., *Catalogue of the William Ridler Collection of Fine Printing*, (Birmingham, 1989).

Harthan, John, *The History of the Illustrated Book: The Western Tradition* (London, 1981).

Hassall, Joan, *Wood Engraving: A Reader's Guide* (London, 1949).

——*Joan Hassall: Engravings & Drawings*, compiled by David Chambers (Pinner, 1985).

Hawker, Violet, 'Edward Johnston at the Royal College of Art, 1920–35', *Alphabet and Image*, 1 (1946), 52–8.

Hermes, Gertrude, *Gertrude Hermes*, exhibition catalogue with introduction by Bryan Robertson (London: Whitechapel Gallery, 1967).

——*Gertrude Hermes, RA*, exhibition catalogue with introduction by David Brown (London: Royal Academy of Arts, 1981).

——*Wood Engravings by Gertrude Hermes: Being Illustrations to Selborne, with Extracts from Gilbert White*, with introduction by William Condry and postscript by James Hamilton (Newtown, Powys, 1988).

——*The Wood-Engravings of Gertrude Hermes*, ed. Judith Russell, with essays by Simon Brett and Bryan Robertson (Aldershot, 1993).

——*The Wood Engravings of Gertrude Hermes and Blair Hughes-Stanton*, exhibition catalogue, ed. Kate Eustace (Oxford: Ashmolean Museum, 1995).

Hickman, Caroline Mesrobian, *Graphic Images and Agrarian Traditions: Bayard Wootten, Clare Leighton, and Southern Appalachia*, based on paper entitled 'Visions of Simplicity and Strength: Women Graphic Artists in Southern Appalachia', presented at the North America Print Conference, Atlanta, Ga., 14–17 Mar. 1990, and published in *Graphic Arts and the South*, 1993.

Hill, Jane, *The Art of Dora Carrington* (London, 1994; repr. 1996).

Hind, Arthur M., *An Introduction to a History of Woodcut* (2 vols.; London, 1935; repr. New York, 1963).

Hodges, Sheila, *Gollancz: The Story of a Publishing House, 1928–1978* (London, 1978).

Hodgson, Pat, *The War Illustrators* (London, 1977).

Hodnett, Edward, *Image and Text: Studies in the Illustration of English Literature* (London, 1982; repr. Aldershot, 1986).

——*Five Centuries of English Book Illustration* (Aldershot, 1988).

Holloway, Edgar, 'Profile of an Artist: Philip Hagreen', *Bookplate Journal*, 3 (1985), 88–90.

Holmes, Charles, 'Original Wood Engraving', *Architectural Review*, 6 (1899), 106–16.

Holmes, Linda, 'Margaret Wells and Leon Underwood', *Matrix*, 14 (1994), 154–8.

Horne, Alan (ed.), *The Dictionary of 20th Century British Book Illustrators* (Woodbridge, 1994).

Howard, Michael S., *Jonathan Cape, Publishers* (London, 1971; repr. Harmondsworth, 1977).

Howe, E., 'From Bewick to the Half-Tone: A Survey of Illustration', *Typography*, 3 (1937), 19–23.

Howes, Justin, 'Noel Rooke: The Early Years', *Matrix*, 3 (1983), 118–25.

——*Edward Johnston* (London, 1996).

Hubert, Renée Riese, *Surrealism and the Book* (Los Angeles, 1988).

Hughes-Stanton, Penelope, *The Wood-Engravings of Blair Hughes-Stanton* (Pinner, 1991).

Hunter, Dard, *Papermaking: The History and Technique of an Ancient Craft* (London, 1947; 2nd rev. edn., 1978).

Hyde, Sarah, 'British Wood-Engraving in the Early Twentieth Century', *Apollo*, 130 (1989), 242–8.

Ivins, William, *Prints and Visual Communication* (London, 1953).

Jackson, B. T., 'The Beaumont Press, 1917–1931', *Private Library*, 8 (1975), 4–37.

Jackson, Holbrook, *The Printing of Books* (London, 1938).

Jacobi, Charles, *Some Notes on Books and Printing* (London, 1892; rev. edn., 1902).

——'The Work of the Private Presses: 7. The Golden Cockerel Press', *Penrose's Annual*, 30 (1928), 17–20.

Jaffé, Patricia, *Women Engravers* (London, 1988).

Janes, Marion, 'Barbara Greg, RE [Obituary]', *Journal of the Royal Society of Painter-Etchers and Engravers*, 6 (1984), 31.

Janes, Norman, *Norman Janes, RE, RWS, RSMA, 1892–1980*, exhibition catalogue (London: Highgate Gallery, 1984).

——'Norman Janes [Obituary]', *Journal of the Royal Society of Painter-Etchers and Engravers*, 7 (1988), 26–7.

——*Norman Janes, RE, 1892–1980*, exhibition catalogue (London: The 20th Century Gallery, 1996).

Jay, Kenneth (ed.), *Book Typography, 1815–1965, in Europe and the United States of America* (London, 1966).

Jefferson, George, 'The Furnival Books', *Private Library*, 8 (1985), 62–7.

Jeffrey, Ian, *The British Landscape, 1920–1950* (London, 1984).

Jennet, Sean, *The Making of Books* (London, 1951; 5th edn., 1973).

Johnston, Edward, *Writing & Illuminating, & Lettering* (London, 1906 and numerous impressions).

Johnston, Paul, 'The Golden Cockerel Prospectuses', *Book Collector's Packet*, 1 (1932), 13–14.

Johnston, Priscilla, *Edward Johnston* (London, 1959; 2nd edn., 1976).

Jones, David, *Epoch and Artist: Selected Writings* (London, 1959; rev. edn., 1973).

——'Word and Image': *David Jones*, exhibition catalogue with introduction by Douglas Cleverdon (London: National Book League, 1972).

——*The Engravings of David Jones*, compiled by Douglas Cleverdon (London, 1981).

——*The Art of David Jones*, exhibition catalogue compiled by Paul Hills (London: Tate Gallery, 1981).

——*Dai Greatcoat: A Self-Portrait of David Jones in his Letters*, ed. René Hague (London, 1986).

Kainen, Jacob, 'Why Bewick Succeeded: A Note in the History of Wood Engraving', in 'Contributions from the Museum of History and Technology' in *United States National Museums Bulletin*, 218 (1959), 186–201.

Keynes, Margaret, *A House by the River* (Cambridge, 1976; reissued 1984).

Kindersley, David, *Recollections: Mr Eric Gill* (San Francisco, 1967).

King, James, *Interior Landscapes: A Life of Paul Nash* (London, 1987).

Kirkus, A. Mary, *Robert Gibbings: A Bibliography*, ed. Patience Empson and John Harris (London, 1962).

Klemin, Diana, *The Illustrated Book: Its Art and Craft* (New York, 1970).

Ladizesky, Kathleen, 'Aspects of the Gregynog Press, 1930–33', *Private Library*, 7 (1984), 79–98.

——'Letters of Stanley Morison to William McCance at Gregynog', *Private Library*, 8 (1985), 117–43.

Lamb, Lynton, *Lynton Lamb, Illustrator: A Selection of his Work*, arranged and introduced by George Mackie (London, 1978).

Lambert, Susan, *Paul Nash as Designer* (London, 1975).

Lang, Lothar, *Expressionist Book Illustration in Germany, 1907–1927* (London, 1976).

Lee, Brian North, 'A Visit to Philip Hagreen', *Bookplate Journal*, 3 (1985), 83–7.

Lee, Sydney, *Aquatints, Etchings, Mezzotints, Wood-Engravings and Woodcuts by Sydney Lee, RA, RE*, exhibition catalogue with foreword by Sydney Lee (London: P. & D. Colnaghi, 1937).

Leighton, Clare, *Woodcuts: Examples of the Work of Clare Leighton* with introduction by Hilaire Belloc (London, 1930).

—— *Wood-Engraving and Woodcuts* (London, 1932).

—— *Wood Engravings of the 1930s* (London, 1936).

—— *Tempestuous Petticoat* (London, 1948).

—— *The Wood Engravings of Clare Leighton*, selected with an introduction by Patricia Jaffé (Cambridge, 1992).

—— *Clare Leighton: Wood Engravings and Drawings*, exhibition catalogue with essays by Anne Stevens and David Leighton (Oxford: Ashmolean Museum, 1992).

—— *Clare Leighton: American Sheaves, English Seed Corn*, exhibition catalogue with introduction by William Dolan Fletcher (Boston: Boston Public Library, [1977]).

Lewis, John, 'The Wood-Engravings of Blair Hughes-Stanton', *Image*, 6 (1951), 26–44.

—— *The Twentieth Century Book* (London, 1967; 2nd edn., 1984).

—— *John Nash: The Painter as Illustrator* (Godalming, 1978).

—— and Brinkley, John, *Graphic Design* (London, 1954).

Lewison, Jeremy (ed.), *A Genius of Industrial England: Edward Wadsworth, 1889–1949* (Bradford, 1990), in conjunction with exhibition held at Cartwright Hall, Bradford.

Limited Editions Club, *Forty-six Years of Limited Editions Club Books, 1929–1976* (New York, 1980).

Lindley, Kenneth, *The Woodblock Engravers* (Newton Abbot, 1970).

Lipke, William, 'The Omega Workshops and Vorticism', *Apollo*, 91 (1970), 224–31.

McAleer, Joseph, *Popular Reading and Publishing in Britain, 1914–1950* (Oxford, 1992).

McCance, William, *William McCance, 1894–1970*, exhibition catalogue compiled by Patrick Elliott (Edinburgh: National Galleries of Scotland, 1990).

MacCarthy, Fiona, *Eric Gill* (London, 1989; repr. 1990).

—— 'Gibbings and Gill: Arcady in Berkshire', *Matrix*, 9 (1989), 27–36.

McGoldrick, Linda Clark, *Norah S. Unwin, Artist and Wood Engraver* (Aldershot, 1990).

Mackley, George, *Wood Engraving* (London, 1948; repr. Old Woking, 1981).

McLean, Ruari, *Modern Book Design* (London, 1958).

—— *Manual of Typography* (London, 1980; repr. 1992).

McMurtrie, Douglas C., *The Book: The Story of Printing & Bookmaking* (London, 1938; repr. 1989).

Macnab, Iain, *Wood-Engraving* (London, 1938; repr. 1947).

Marx, Enid, *Enid Marx and her Circle*, exhibition catalogue with foreword by Cynthia R. Weaver (London: Sally Hunter Fine Art, 1992).

—— 'Student Days at the RCA', *Matrix*, 16 (1996), 145–59.

Meynell, Francis, *English Printed Books* (London, 1946).

—— *My Lives* (London, 1971).

Miles, Jonathan, *Eric Gill and David Jones at Capel-y-ffin* (Bridgend, 1992).

—— and Shiel, Derek, *David Jones: The Maker Unmade* (Bridgend, 1995).

Mitchell, J. Lawrence, 'Ray Garnett as Illustrator', *Powys Review*, 10 (1982), 9–28.

Modern British Woodcuts & Wood-Engravings in the Collection of the Whitworth Art Gallery, with introduction by A. C. Sewter (Manchester: Whitworth Art Gallery, 1962).

Moore, Thomas Sturge, *A Brief Account of the Origin of the Eragny Press and a Note on the Relation of the Printed Book as a Work of Art to Life* (London, 1903).

Moran, James, *Printing Presses: History and Development from the Fifteenth Century to Modern Times* (London, 1973).

—— *The Double Crown Club: A History of Fifty Years* (London, 1974).

Morgan, Charles, *The House of Macmillan* (London, 1943).

Morgan, Gwenda, *The Wood-Engravings of Gwenda Morgan*, selected with an introduction by John Randle (Andoversford, 1985).

—— Answers to a questionnaire, *Multiples*, 27 (1991), 325–6.

Morison, Stanley, *Four Centuries of Fine Printing* (London, 1924; 3rd rev. edn., 1960).

—— *First Principles of Typography* (Cambridge, 1936; 2nd rev. edn., 1967).

—— *The Typographic Book*, with supplementary material by Kenneth Day (London, 1963).

Mosley, James, 'Eric Gill and the Golden Cockerel Type', *Matrix*, 2 (1982), 17–25.

Mumby, Frank Arthur, *Mumby's Publishing and Bookselling* (London, 5th edn., 1974).

Myers, Robin, *The British Book Trade from Caxton to the Present Day: A Bibliographic Guide to the Libraries of the National Book League and St Brides Institute* (London, 1973).

Nash, John, 'The History of the Woodcut', *London Mercury*, 19 (1928), 50.

—— 'Book Illustration', *Ark*, 1 (1950), 21–2.

—— *John Nash: Book Designs*, exhibition catalogue researched and written by Clare Colvin (Colchester: The Minories, 1986).

—— *The Wood-Engravings of John Nash*, compiled by Jeremy Greenwood (Liverpool, 1987).

Nash, Paul, 'Woodcut Patterns', *The Woodcut*, 1 (1927), 30–8.

—— *Room and Book* (London, 1932).

—— 'Surrealism and the Illustrated Book', *Signature*, 5 (1937), 1–11.

—— *Outline: An Autobiography and Other Writings* (London, 1949).

—— *Poet & Painter: Being the Correspondence between Gordon Bottomley and Paul Nash, 1910–1946*, ed. Claude Colleer Abbott and Anthony Bertram (Oxford, 1955; repr. 1990, with preface by Andrew Causey).

—— *Paul Nash: Book Designs*, exhibition catalogue researched and written by Clare Colvin (Colchester: The Minories, 1982).

—— *The Wood-Engravings of Paul Nash: A Catalogue of the Wood-Engravings, Pattern Papers, Etchings, and an Engraving on Copper*, compiled by Jeremy Greenwood, with introductory essay by Simon Brett (Woodbridge, 1997).

Needham, Paul and Dunlap, Joseph, *William Morris and the Art of the Book* (New York and Oxford, 1976), in conjunction with exhibition held at the Pierpoint Morgan Library, New York, 1976.

Neve, Christopher, *Leon Underwood* (London, 1974).

Newdigate, Bernard, *The Art of the Book* (London, 1938).

Newman, Lindsay, Gordon Craig Archives: International Survey (London, 1976).

—— 'Artist and Printer: A Problem of the Cranach Press "Hamlet" Resolved', *Matrix*, 4 (1984), 1–12.

—— 'Edward Anthony Craig', *Matrix*, 14 (1994), 10–14.

O'Connor, John, 'Eric Ravilious', in Christopher Sandford and Owen Rutter, *Cockalorum* (London, 1950), 82–3.

—— *The Technique of Wood Engraving* (London, 1971).

—— *The Wood-Engravings of John O'Connor*, with commentary by Jeannie O'Connor (Andoversford, 1989).

The Omega Workshops, 1913–19: Decorative Arts of Bloomsbury, exhibition catalogue with introduction by Fiona MacCarthy (London: Crafts Council, 1984).

Owens, Leslie Thomas, *J. H. Mason, 1875–1951, Scholar-Printer* (London, 1976).

Pennell, Joseph, *Modern Illustration* (London, 1895).

Pepler, Hilary D. C., *The Hand Press* (Ditchling, 1934; 2nd edn., 1952).

—— 'Eric Gill', *Aylesford Review*, 7 (1965), 37–9.

Peppin, Brigid, and Micklethwait, Lucy (eds.), *Dictionary of British Book Illustrators: The Twentieth Century* (London, 1983).

Peterson, William S., *The Kelmscott Press: A History of William Morris's Typographical Adventure* (Oxford, 1991).

Petro, Pamela, 'The Limited Editions Club: The Macy Years, 1929–1956', *Private Library*, 8 (1985), 48–61.

Pickering, Charles, *The Private Press Movement*, an Address given to the Manchester Society of Book Collectors, privately printed by the Maidstone College of Art (Maidstone, 1966–7).

Pissarro, Camille, *Camille Pissarro: Letters to his Son Lucien*, ed. John Rewald (London, 1944; 4th edn., 1980).

Pissarro, Lucien, *The Letters of Lucien to Camille Pissarro, 1883–1903*, ed. Anne Thorold (Cambridge, 1993).

—— *The Wood Engravings of Lucien Pissarro & a Bibliographical List of Eragny Books*, selected with an introduction by Lora Urbanelli (Cambridge and Oxford, 1994).

Plant, Marjorie, *The English Book Trade: An Economic History of the Making and Sale of Books* (London, 1939; 3rd edn., 1974).

Pople, Kenneth, *Stanley Spencer* (London, 1991).

Portenaar, Jan, *The Art of the Book and its Illustration* (London, 1935).

Postan, Alexander, *The Complete Graphic Works of Paul Nash* (London, 1973).

Powers, Alan, 'Sources of Inspiration [Enid Marx]', *Crafts*, 103 (1990), 34–7.

Randle, John, 'The Development of the Monotype Machine', *Matrix*, 4 (1984), 42–53.

—— 'John Biggs and the Hampden Press', *Matrix*, 4 (1984), 129–34.

—— 'Gwenda Morgan, 1908–1991', *Matrix*, 11 (1991), 169–71.

Ransom, Will, *Private Presses and their Books* (New York, 1929; repr. 1963).

Raverat, Gwen, *Gwendolen Raverat: Modern Woodcutters, No. 1*, with introduction by Herbert Furst (London, 1920).

—— 'Wood Engraving of To-Day', *Studio*, 117 (1939), 42–51.

—— *Period Piece: A Cambridge Childhood* (London, 1952 and numerous impressions).

—— *The Wood Engravings of Gwen Raverat*, selected with an introduction by Reynolds Stone (London, 1959; repr. Swavesey, Cambridge, 1989, with postscript and additional selection by Simon Brett).

—— *Exhibition of Wood Engravings & Lithographs by Gwen Raverat*, exhibition catalogue with introduction by Christopher Cornford (Cambridge: The Wren Gallery and C. P. Stockbridge, 7–8 King's Parade, 1973).

—— *Gwen Raverat: Aspects of Her Life and Work, 1885–1957*, exhibition catalogue with preface by Christopher Cornford (Royston: Manor Gallery, 1987).

—— *Gwen & Jacques Raverat: Paintings & Wood-Engravings*, exhibition catalogue compiled by L. M. Newman and D. A. Steel (Lancaster: University Library, 1989).

Ravilious, Eric, *The Wood Engravings of Eric Ravilious*, with introduction by James Maude Richards (London, 1972).

Ravilious, Tirzah, *The Wood-Engravings of Tirzah Ravilious*, compiled by Anne Ullman, with recollections by Henry Swanzy and Robert Harling (London, 1987).

——*Tirzah Ravilious, 1908–1951*, exhibition catalogue with introductory notes by Henry Swanzy (Saffron Walden: The Fry Art Gallery, 1994).

See also under Tirzah Garwood.

Reid, Anthony, *A Checklist of the Book Illustrations of John Buckland Wright* (Pinner, 1968).

——'Ralph Chubb, the Unknown. Part 1: His Life, 1892–1980', *Private Library*, 3 (1970), 141–56.

——'Ralph Chubb. Part 2: His Work', with a checklist of books, *Private Library*, 3 (1970), 193–213.

Reid, Forrest, *Illustrators of the Sixties* (London, 1928; repr. 1975 as *Illustrators of the Eighteen Sixties*).

Renton, Michael, 'Edward Johnston and Wood Engraving', *Multiples*, 2 (1994), 67–70.

Rhein, Donna E., *The Hand Printed Books of Leonard and Virginia Woolf at the Hogarth Press, 1917–1932* (Ann Arbor, 1985).

Richards, James Maude, *Memoirs of an Unjust Fella* (London, 1980).

Richardson, Dorothy, *John Austen & the Inseparables*, with foreword by the artist (London, 1930).

Ridler, William, *British Modern Press Books* (London, 1971; rev. edn., 1975).

——'The Smaller Pre-War Presses: Part 1', *Antiquarian Book Monthly Review*, 6 (1979), 458–65.

——'The Smaller Pre-War Presses: Part 2', *Antiquarian Book Monthly Review*, 6 (1979), 526–33.

Robb, Brian, 'The Wood-Engravings of Lucien Pissarro', *Signature*, 6 (1948), 36–47.

Rogerson, Ian, *The Agnes Miller Parker Collection*, Manchester Polytechnic [now Manchester Metropolitan University] Library (Manchester, 2nd edn., 1989).

——*Agnes Miller Parker: Wood-Engraver and Book Illustrator, 1895–1980*, with recollections of the artist by John Dreyfus (Wakefield, 1990).

——*Agnes Miller Parker: Wood Engravings for 'Esope': The Story of a Remarkable Book* (Newtown, Powys, 1996).

——*Agnes Miller Parker: Wood Engravings for XXI Welsh Gypsy Folk-Tales* (Newtown, Powys, 1997).

Rooke, Noel, *Woodcuts and Wood Engravings* (London, 1926).

——'Written Beauty', BBC broadcast talk on Edward Johnston, printed in *Listener*, 22 Nov. 1945, 583–4.

——'The Work of Lethaby, Webb and Morris', *Journal of the Royal Institute of British Architects*, 57 (1950), 167–75.

——'Sir Emery Walker (1851–1933)', *Penrose Annual*, 48 (1954), 40–3.

——*Noel Rooke, 1881–1953*, exhibition catalogue with introductory essay by Justin Howes (Oxford: Christ Church Picture Gallery, 1984).

Rose, Jonathan, and Anderson, Patricia (eds.), *British Literary Publishing Houses, 1881–1965* (*Dictionary of Literary Biography*, 12; Detroit and London, *c*.1991).

Rosner, Charles, *The Growth of the Book-Jacket* (London, 1954).

Rothenstein, John, 'David Jones', in *Modern English Painters* (3 vols.; London, 1956; repr. 1976), iii., 291.

Rubens, Godfrey, 'W. R. Lethaby and the Revival of Printing', *Penrose Annual*, 69 (1976), 219–32.

Rutter, Frank, 'The Revival of Wood-Engraving', in *Modern Masterpieces: An Outline of Modern Art* (London, 1940).

Ryder, John, *The Bodley Head, 1857–1957* (London, 1970).

St Bernard, Gui, 'The Year's Wood-Engraving: The Society of Wood Engravers and the English Wood Engraving Society at the Redfern and St George's Galleries', *Studio*, 101 (1931), 193–202.

Saint Dominic's Press, *The Illustrators to the St Dominic's Press*, exhibition catalogue with essays by Joanna Selborne and Timothy Elphick (London: Wolseley Fine Arts, Rocket Press Gallery, 1995).

Salaman, Malcolm C., 'The Woodcuts of Sydney Lee, A.R.E.', *Studio*, 63 (1914), 19–26.

—— *Modern Woodcuts and Lithographs by British and French Artists* (London, 1919).

—— 'The Woodcuts and Colour Prints of Captain Robert Gibbings', *Studio*, 76 (1919), 3–9.

—— *British Book Illustration, Yesterday and To-Day* (London, 1923).

—— *The Woodcut of To-Day at Home and Abroad* (London, 1927).

—— *The New Woodcut* (London, 1930).

Sandford, Christopher, 'The Toned Page in Type and Wood Engraving', *Book Collector's Quarterly*, 12 (1933), 76.

—— 'John Buckland Wright', *Studio*, 134 (1947), 74–7, repr. in *Cockalorum* (see below), 61–3.

—— 'In Memoriam', BBC Third Programme talk, 20 Jan. 1948, repr. in *Cockalorum*, 73–81.

—— 'Clifford Webb', *Studio*, 138 (1949), 52–5, repr. in *Cockalorum*, 65–71.

—— 'The Wood Engraved Illustration', *Studio*, 139 (1950), 50–5.

—— 'A Note on the Golden Cockerel Type', *Matrix*, 2 (1982), 23–5.

[—— and Rutter, Owen], *Aphrodite's Cockerel: A Pleasant Myth, Together with Some Notes on the Golden Cockerel Press Books …* (London, 1939).

—— and —— *Chanticleer: A Bibliography of the Golden Cockerel Press, April 1921–1936 August*, with Introduction by Humbert Wolfe, Foreword and Notes by the Partners (London, 1936).

—— and —— *Pertelote: A Sequel to Chanticleer, being a Bibliography of the Golden Cockerel Press, October 1936–1943 April*, with Foreword and Notes by the Partners (London, 1943).

—— and —— *Cockalorum: A Sequel to Chanticleer and Pertelote, being a Bibliography of the Golden Cockerel Press, June 1943–December 1948* (London, 1950).

—— and —— *Bibliography of the Golden Cockerel Press, 1921–1949*, reprint of *Chanticleer*, *Pertelote*, and *Cockalorum* (Folkestone, 1975).

—— and Chambers, David, *Cock-a-Hoop: A Sequel to Chanticleer, Pertelote, and Cockalorum, being a Bibliography of the Golden Cockerel Press, September 1949–December 1961*, with a List of Prospectuses, 1920–62 (Pinner, 1976).

Sandford, Jeremy, 'In Memory of my Dad', *Matrix*, 2 (1982), 1–4.

—— *Figures and Landscapes: The Art of Lettice Sandford* (London, 1991).

Sandford, Lettice, *Wood Engravings: Lettice Sandford*, with introduction and checklist compiled by David Chambers (Pinner, 1986).

Sarzano, Frances, 'The Engravings and Book Decorations of John Nash', *Alphabet and Image*, 3 (1946), 20–36.

Schapiro, Meyer, *Words and Pictures: On the Literal and the Symbolic in the Illustration of a Text* (The Hague, 1973).

Schoeser, Mary, *Bold Impressions: Block Printing, 1910–1950* (London, 1995), in conjunction with exhibition held at Central Saint Martins College of Art & Design.

Schwabe, Randolph, 'British Book Illustration', *Studio*, 114 (1937), 210.

Selborne, Joanna, 'The Society of Wood Engravers: The Early Years', *Craft History*, 1 (1988), 153–68.

—— (ed.), 'Eric Ravilious and the Golden Cockerel Press: Correspondence with Robert Gibbings. Part 1: Selected Letters 1926–29', *Matrix*, 14 (1994), 15–39.

—— 'The St Dominic's Press in the History of the British Private Press and Wood Engraving Movements Between the Wars', in exhibition catalogue, *The Illustrators to the St Dominic's Press* (London: Wolseley Fine Arts, Rocket Press Gallery, 1995), 9–18.

—— (ed.), 'Eric and Tirzah Ravilious and the Golden Cockerel Press: Correspondence with Robert and Moira Gibbings. Part 2: Selected Letters Dec. 1929–Feb. 1933', *Matrix*, 16 (1996), 67–87.

Selborne, Joanna, 'The Wood Engraving Revival', in *Object Lessons: Central Saint Martins Art and Design Archive: A Centenary Publication* (London, 1996).

—— and Newman, Lindsay, *Gwen Raverat, Wood Engraver* (Denby Dale, 1996).

Sewell, Brocard, 'Four Private Presses', *The British Printer*, 80 (1967), 135.

—— *Three Private Presses: Saint Dominic's Press, the Press of Edward Walters and Saint Albert's Press* (Wellingborough, 1979).

—— 'Edward Walters, Printer and Engraver', *Matrix*, 1 (1981), 35–43.

—— 'My Days at the St Dominic's Press', *Matrix*, 2 (1982), 82–8.

Shakespeare Head Press, *Shakespeare Head Press: An Exhibition of the Books of A. H. Bullen and Bernard Newdigate*, exhibition catalogue with introduction by Ian Rogerson (Manchester: Manchester Polytechnic [now Manchester Metropolitan University] Library, 1988).

Shall we Join the Ladies: Wood Engraving by Women Artists of the Twentieth Century, with introduction by Betty Clark and essays by George Mackley and Dorothea Braby (Oxford, 1979), in conjuction with exhibition held at the Museum of Oxford.

Shand, James, 'Author and Printer: G.B.S. and R. & R. Clark, 1898–1948', *Alphabet and Image*, 8 (1948), 32–45.

Sheringham, George, 'The Woodcuts and Watercolours of Clifford Webb', *Studio*, 92 (1926), 401–5.

Shipcott, Grant, *Typographic Periodicals Between the Wars: A Critique of 'The Fleuron' and 'Signature' and 'Typography'* (Oxford, 1980).

Shone, Richard, *The Century of Change: British Painting since 1900* (Oxford, 1977).

Simon, Herbert, *Song and Words: A History of the Curwen Press* (London, 1973).

Simon, Oliver, *Printer & Playground: An Autobiography* (London, 1956).

Simons, Anna, 'Moderne englische Pressen', *Imprimatur*, 2 (1931), 135–84.

Skelton, Christopher, 'René Hague and the Press at Pigotts', *Matrix*, 2 (1982), 75–81.

Slade School of Fine Art, *Early Slade Wood Engraving, 1920–49*, exhibition catalogue (London: Strang Print Room, University College, London [1992]).

Sleigh, Bernard, 'A Note on Wood Engraving', *Bookplate Magazine*, 2 (1919), 49–51.

—— *Wood Engraving since Eighteen-Ninety* (London, 1932).

Society of Wood Engravers, *First Annual Exhibition of the Society of Wood Engravers*, exhibition catalogue with introduction by Campbell Dodgson (London: Chenil Gallery, 1920).

—— *Engraving: Then & Now: The Retrospective 50th Exhibition of the Society of Wood Engravers*, exhibition catalogue with introduction by Simon Brett [London, 1987].

Speaight, Robert, *The Life of Eric Gill* (London, 1966).

Spencer, Stanley, *Stanley Spencer, RA*, exhibition catalogue (London: Royal Academy of Arts, 1980).

Steenson, Martin, 'The Book Illustrations of John Austen', *Antiquarian Book Monthly Review*, 9 (1982), 222–7.

Strachan, Walter John, *The Artist and the Book in France: The 20th Century livre d'artiste* (London, 1969).

Symons, A. J. A., Flower, Desmond, and Meynell, Francis, *The Nonesuch Century: An Appraisal, a Personal Note and a Bibliography of the First Hundred Books Issued by the Press, 1923–34* (London, 1936).

Taylor, John Russell, *The Art Nouveau Book in Britain* (London, 1966; 2nd edn. with new preface, 1979; repr. Edinburgh, 1980).

Taylor, Michael, 'Enid Marx, RDI, Designer and Wood-Engraver', *Matrix*, 7 (1987), 99–102.

—— and Sewell, Brocard, *Saint Dominic's Press: A Bibliography 1916–1937*, with memoir by Susan Falkner and appendix by Adrian Cunningham (Risbury, 1995).

Tedesco, A. P., *The Relationship between Type and Illustration in Books and Book Jackets* (New York, 1948).

Text and Image: English Woodblock Illustration: Thomas Bewick to Eric Gill, exhibition catalogue with introduction by Eric Chamberlain (Cambridge: Fitzwilliam Museum, 1985).

Thirties: British Art and Design before the War, exhibition catalogue (London: Hayward Gallery, 1980).

Thorold, Anne, *Lucien Pissarro: Influence on English Art* (Canterbury, 1986).

Thorp, Joseph, *Printing for Business* (London, 1919).

——*Design in Modern Printing, 1927–8: The Yearbook of Design and Industries Association* (London, [1928]).

——'A Significant Period of Our Printing (1900–1914)', *Printing Review*, 50 (1945), 5–28.

——*B. H. Newdigate, Scholar-Printer, 1869–1944* (Oxford, 1950).

Thorpe, W. A., 'The Wood Engravings of John Nash', *The Woodcut*, 3 (1929), 13–24.

Three Wood Engravers: Mabel Annesley, Robert Gibbings and Gwen Raverat, exhibition catalogue (Manchester: Whitworth Art Gallery, 1960).

Tompkinson, G. S., *A Select Bibliography of the Principal Modern Presses, Public and Private, in Great Britain and Ireland*, with introduction by B. H. Newdigate (London, 1928; repr. San Francisco, 1975).

Townsend, W. G. Paulson, 'A Short Historical Account of Woodcuts and Wood Engraving', *Penrose's Annual*, 30 (1928), 81–92.

Tucker, Peter, *Haslewood Books: The Books of Frederick Etchells & Hugh Macdonald* (Oxford, 1990).

——'Hester Sainsbury: A Book-Illustrator of the 1920s', *Private Library*, 3 (1990), 112–36.

——'Three Artists at Haslewood Books', *Matrix*, 11 (1991), 102–9.

——'Hester Sainsbury: Some Further Notes', *Private Library*, 5 (1992), 80–9.

Turner, Graham, *The Private Press: Its Achievement and Influence*, Association of Assistant Librarians, Midland Division, 1954.

Twentieth-Century British Wood Engraving: A Celebration … and a Dissenting Voice, exhibition catalogue with introductory essay by Hal Bishop (Exeter: Royal Albert Memorial Museum, 1997).

Twyman, Michael, *Printing 1770–1970: An Illustrated History of its Development and Uses in England* (London, 1970).

Ullman, Anne, 'Tirzah Garwood', *Private Library*, 10 (1987), 100–7.

Underwood, Leon, *Art for Heaven's Sake* (London, 1934).

——*Leon Underwood and 12 Girdler's Road*, exhibition catalogue with introduction by Annette Armstrong (London: New Art Centre, 1976).

——*Leon Underwood: His Wood Engravings*, with an introduction by George Tute (Wakefield, 1986).

Vorticism and its Allies, exhibition catalogue with introduction by Richard Cork (London: Hayward Gallery, 1974).

Vox, Maximilian, 'British Wood Engraving of the Present Day', *Studio*, 99 (1930), 154–72.

Wadsworth, Barbara, *Edward Wadsworth: A Painter's Life* (Salisbury, 1989).

Wadsworth, Edward, *Edward Wadsworth: Modern Woodcutters, No. 4*, with introduction by O. Raymond Drey (London, 1921).

Walker, R. A., 'The Engravings of Eric Gill', *Print Collector's Quarterly*, 15 (1928), 144–66.

Walker, Sue, and Andrews, Martin, 'Robert Gibbings and the "Willow"', *Matrix*, 9 (1989), 69–73.

Wallis, Leonard William, *Leonard Jay, Master Printer-Craftsman, 1925–53* (London, 1963).

Walters, Edward, 'The Wood Block', *Aylesford Review*, 1 (1940).

——*The Wood-Engraver's Craft* (Marlborough, 1944).

——'Hilary Pepler, Printer', *Aylesford Review*, 7 (1965), 31–2.

—— 'My Days at the St Dominic's Press', *Matrix*, 2 (1982), 82–8.

Watkinson, Raymond, *William Morris as Designer* (London, 1967).

Warde, Beatrice, 'George Macy and The Limited Editions Club', *Penrose Annual*, 48 (1954), 35–9.

—— 'Some Notes on the British Typographical Reformation, 1919–1939', *Printing Review* reprint (London, 1971).

Warner, Oliver, *Chatto & Windus: A Brief Account of the Firm's Origin, History & Development* (London, 1973).

Webb, Clifford, *A Retrospective Exhibition of the Work of Clifford Webb, RE, RBA*, exhibition catalogue with introduction by Simon Brett (Leicester: Kimberlin Exhibition Hall, Leicester Polytechnic, 1982).

Weekley, Montague, *Thomas Bewick* (Oxford, 1953).

Wees, William C., *Vorticism and the English Avant-Garde* (Manchester, 1972).

White, Ethelbert, *Ethelbert White, 1891–1972: A Memorial Exhibition*, exhibition catalogue with introduction by Peyton Skipwith (London: The Fine Art Society, 1979).

—— *Ethelbert White: 1891–1972*, exhibition catalogue with introduction by David Coke (Chichester: Pallant House, 1991).

White, Eva, *An Introduction to the Beaumont Press* (London, 1986).

Williams, Graham, 'The Printing of Wood-Engravings', *Matrix*, 5 (1985), 100–8.

Williams, William Emrys, *The Penguin Story, MCMXXV–MCMLVI* (Harmondsworth, 1956).

Williamson, Hugh, *Methods of Book Design* (Oxford, 1956; 3rd edn., 1983).

The Woodcut Revival, exhibition catalogue compiled by Diane Johnson (Kansas City: Museum of Art, University of Kansas, 1968).

Woolf, Virginia, *The Letters of Virginia Woolf*, ed. Nigel Nicolson and Joanne Trautmann (London, 1975–80; rev. edn., 1995).

Woolmer, J. Howard, *The Poetry Bookshop, 1912–1935: A Bibliography* (Revere, Pa., 1988).

Yorke, Malcolm, *Eric Gill: Man of Flesh and Spirit* (London, 1981).

Zeltmann, William, 'Shaw, Farleigh and a Collection', *Shaw Review*, 4 (1961), 24–8.

UNPUBLISHED MATERIAL

Sources listed alphabetically under subject; theses and dissertations precede artwork, manuscripts, and correspondence. Dates of correspondence are presented in the relevant footnotes.

General

Rogerson, Ian, 'The Origins and Development of Modern British Wood-Engraved Illustration', Ph.D. thesis (University of Loughborough, 1984).

Timewall, Alison, 'The Revival of Printing Between the Wars', BA thesis (University of Manchester, 1982).

Commercial Publishers and Printers

Jonathan Cape Archive, RUL.

Chatto & Windus Archives, RUL.

R. & R. Clark Archive, NLS.

The Curwen Press Archive, CUL.

Duckworth Papers (*c.*1936–56), ULL.

Faber Archives.
Victor Gollancz Archive.
Limited Editions Club Archive, HRHRC.
Macmillan Archive, RUL.
Macmillan Archives, BLMC.
Macmillan Publishers' Archive.

Private Presses
Ashbrook, Susan, 'The Private Press Movement in Britain, 1890–1914', Ph.D. thesis (University of Boston, 1991); available from University Microfilms Int., Ann Arbor.
Elphick, Timothy, 'The Formation and Early Years of the Guild of Saints Joseph and Dominic to 1924', BA dissertation (University of Cambridge, 1984).
Setford, Stephen, 'Hilary Pepler and the St Dominic's Press', BA thesis (Oxford Polytechnic, 1982).
Golden Cockerel Press Archive, HRHRC.
Gregynog Press, Thomas Jones Papers, NLW.
Nonesuch Press Archive, CUPA.
St Dominic's Press, The Guild of St Joseph and St Dominic Archive, Archive of Art and Design, NAL.
——Letter from Brocard Sewell to the author.

The Society of Wood Engravers and the English Wood-Engraving Society
Minutes of the Society of Wood Engravers, press-cuttings, and other material, Society of Wood Engravers' Archive.
Margaret Pilkington Archive, JRUL.
Stancioff, Marion (née Mitchell), Letters to the author.

Individual People
Annesley, Mabel, Letter to Margaret Pilkington, MPA.
Balston, Thomas, Letter from Anthony Powell to the author.
Bates, H. E., Correspondence with Victor Gollancz, VGA.
Bliss, Douglas Percy, Letters to the author.
Bone, Stephen and Muirhead, Correspondence with publisher, JCA.
Cleverdon, Douglas, Archive, TGA.
Craig, Edward Gordon, Collection of artwork and early Daybooks, HRHRC.
——Collection of artwork and later Daybooks, BN.
——Correspondence with Margaret Pilkington, SWEA.
——Letter to Emery Walker, NL.
Farleigh, John, *The Black Girl Collection*, BSC.
——Miscellaneous artwork and correspondence, HRHRC.
——Selected preliminary drawings for G. B. Shaw's *Back to Methuselah*, NYPL.
——Trial title-page to *The Adventures of the Black Girl in Her Search for God*, R. & R. Clark Archive, NLS.
——Correspondence with George Macy, LECA.
——Correspondence with George Bernard Shaw, Shaw Papers, BLMC.

Garnett, Ray, Letter from Richard Garnett to the author.
—— Letter from Geoffrey Whitworth to Ray Garnett, Chatto & Windus Archives, RUL.
Gibbings, Robert, Selected artwork, manuscripts, and correspondence, WACML.
—— Collected correspondence, GCPA.
—— Collected correspondence, LECA.
—— Correspondence with Eric Gill, RAGL.
—— Correspondence with George Macy and Thomas Balston, LECA.
—— Correspondence with Hugh Walpole, the King's School Library, Canterbury.
Gill, Eric, Collection of artwork, Iconography Collection, HRHRC.
—— Collection of drawings and prints, VAM.
—— Diary, account books, and manuscripts, WACML (Microfilm of diary, TGA).
—— Collected correspondence, GCPA.
—— Correspondence with Jonathan Cape, JCA.
—— Correspondence with Robert Gibbings, RAGL.
—— Correspondence with Count Harry Kessler, Kessler Papers, NL.
—— Correspondence with George Macy and Christopher Sandford, LECA.
—— Letters from Douglas Cleverdon and Michael Renton to the author.
Hagreen, Philip, Letters to the author.
Hermes, Gertrude, Miscellaneous artwork and sketchbooks held by the family.
Hughes-Stanton, Blair, Collected correspondence, TJP.
—— Letter from D. H. Lawrence to Blair Hughes-Stanton, HRHRC.
—— Letters from Lettice Sandford and Penelope Hughes-Stanton to the author.
Jones, David, Correspondence with Douglas Cleverdon, DCA.
Leighton, Clare, Sketchbooks and artwork held by the family.
—— Working proofs for *Under the Greenwood Tree*, FM.
—— Typescript of Memoirs held by the family.
—— Correspondence with Victor Gollancz, VGA.
—— Correspondence with publisher, MA (RUL); MP.
—— Letter to [George Macy], LECA.
—— Letters to the author.
McCance, William, Correspondence with Philip Gibbons, NAL.
—— Correspondence with George Macy, LECA.
Mackley, George, Letter to Agnes Miller Parker, AMPA.
Macnab, Iain, Miscellaneous sketches, woodblocks, proofs of wood-engravings, and other material, Iain Macnab Papers, NLS.
Marx, Enid, Letters to the author.
Morgan, Gwenda, Letters to the author.
Nash, John, Collected correspondence, John Nash Archive, TGA.
—— Correspondence with Thomas Balston, RUL.
—— Correspondence with Harold Monro, HRHRC.
—— Correspondence with Margaret Pilkington, SWEA.
Nash, Paul, Preliminary drawings for *Cotswold Characters* and *Genesis*, Department of Prints and Drawings, BM.
—— Collection of manuscripts, press-cuttings, and other material, NAL.
—— Collected correspondence, Paul Nash Archive, TGA.

Parker, Agnes Miller, Sketchbooks and artwork, Agnes Miller Parker Archive, NLS.
—— Correspondence with Robert Gibbings and George Churchill, GCPA.
—— Correspondence with Philip Gibbons and Owen Rutter, NAL.
—— Correspondence with Victor Gollancz, VGA.
—— Correspondence with George Macy, LEAC.
Pilkington, Margaret, Artwork, manuscripts, diaries, and letters, Margaret Pilkington Archive, JRUL.
—— Assorted correspondence, SWEA.
Pissarro, Lucien, Correspondence with Margaret Pilkington, MPA.
Raverat, Gwen, Miscellaneous artwork and sketchbooks, manuscripts, and correspondence held by the family.
—— Miscellaneous artwork, prints, and woodblocks, FM.
—— Collected correspondence, Gwen Raverat Papers, CUL.
—— Correspondence with Elinor Darwin held by the family.
—— Correspondence with publisher, CUPA
—— Correspondence with publisher, CA.
—— Correspondence with publisher, FA.
—— Correspondence with publisher, MA (BLMC).
—— Correspondence with Stanley and Gilbert Spencer, Stanley Spencer Archive, TGA.
—— Letter from Gwen Raverat to Martin Hardie, UCLAL.
—— Letters from Gwen Raverat to Frances Cornford, BLMC.
—— Letters from Sophie Gurney, Christopher Cornford, Ursula Mommens, and Brooke Crutchley to the author.
Ravilious, Eric, in Mary Beckinsale, 'The Work of Eric Ravilious: Its Origins and Originality', BA thesis (University of Cambridge, 1968).
—— Andrew Davidson, 'The Work of Eric Ravilious', MA thesis (Royal College of Art, 1981).
—— Jeff Hand, 'Eric Ravilious and Englishness', MA thesis (University of Wales at Lampeter, 1990).
—— Annabel Wall, 'The Work of Eric Ravilious', BA thesis (University of Manchester, 1977).
—— Collection of artwork and correspondence held by the family.
—— Correspondence with Moira and Robert Gibbings, GCPA.
—— Letters from Enid Marx, Douglas Percy Bliss, and Edward Bawden to the author.
—— Letters from Eric Ravilious to John G. Murray, John Murray Ltd.
Rooke, Noel, Typewritten manuscript, *The Qualifications and Experience of Noel Rooke*, General Statement given by Noel Rooke, and Notes written by T. M. Rooke, Celia M. Rooke.
—— Correspondence with Margaret Pilkington, MPA.
—— Letters from Celia M. Rooke, Charles Pickering, and Leon Vilaincourt to the author.
Sandford, Lettice, Letters to the author.
Spencer, Stanley, Archive, TGA.
Underwood, Leon, Press-cuttings books, Leon Underwood Archive, Conway Library, CIA.
—— Letters from Lettice Sandford, Margaret Wells, Marion Stancioff (née Mitchell), and Enid Marx to the author.
Wadsworth, Edward, Letter to [Eric Newton], HRHRC.
Wells, Margaret, Letters to the author.
White, Ethelbert, Correspondence with G. H. B. Holland, 1935–6, NAL.

Index

DUBLIN

Donated to

**Visual Art Degree
Sherkin Island**